The Story of The Face

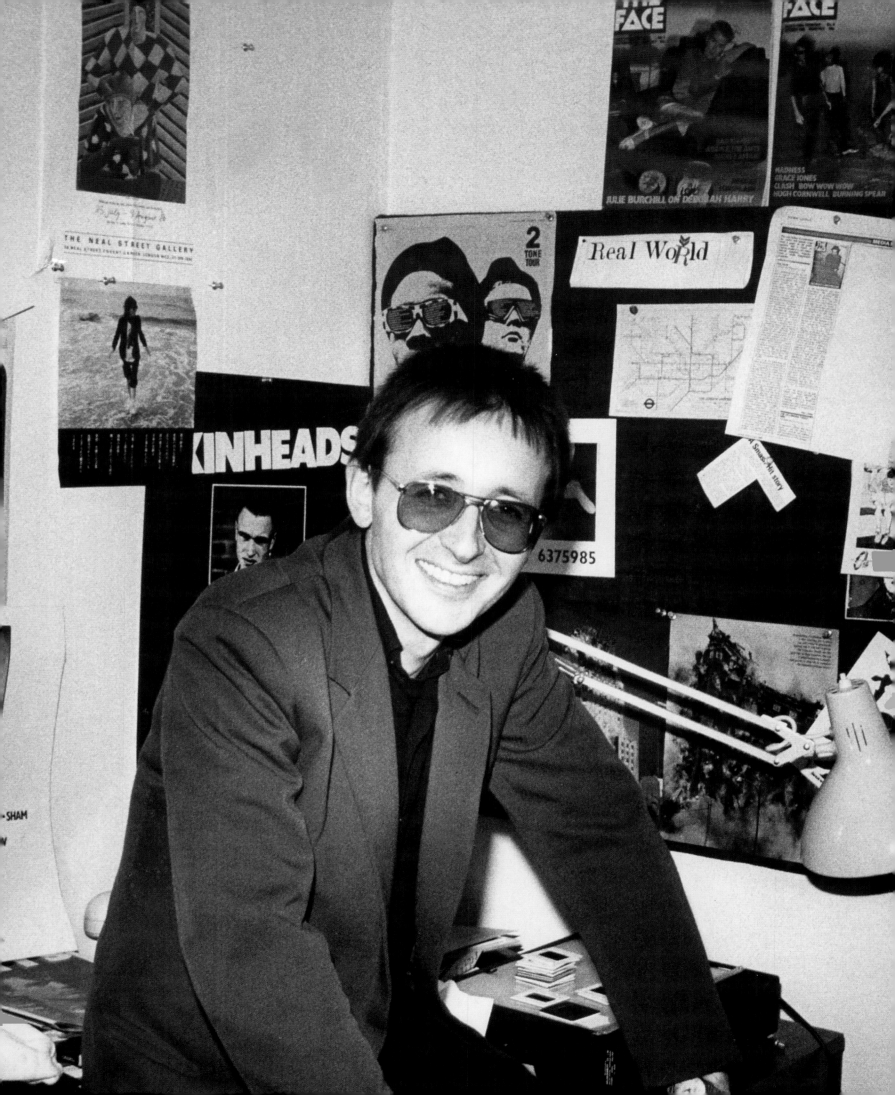

Paul Gorman

The Story of The Face

The Magazine That Changed Culture

Thames & Hudson

*This book is dedicated to the
memory of Julie Logan (1947–2016)*

page 2: Nick Logan at *The Face* offices in Mortimer Street,
London, 1985. Photograph by Sheila Rock.

The Story of The Face © 2017 Thames & Hudson Ltd, London
Text © 2017 Paul Gorman
Foreword © 2017 Dylan Jones
For illustration credits, see page 350

Designed by Therese Vandling

First published in 2017 in the United States of America
by Thames & Hudson Inc., 500 Fifth Avenue, New York, New York 10110
www.thamesandhudsonusa.com

Library of Congress Control Number: 2017934763

ISBN 978-0-500-29347-8

Manufactured in China by Imago

Contents

Foreword
Dylan Jones

Nineteen Eighty was year zero. At least as far as modern independent publishing was concerned. In the space of eight months three magazines were launched; these would soon define certain aspects of the decade and, almost by serendipity, simultaneously build it as they were eagerly cataloguing it. The *Face*, *i-D* and, to a slightly lesser extent, *Blitz*, were magazines that came from wildly different places; together they forged a new micro-sector of the magazine publishing industry.

They became known as style magazines: publications that developed an ability to care unduly about the way things looked. In a pejorative sense, this obsession with surface, this analysis of presentation, was perceived as a shallow pursuit best suited to being bundled up in the pages of magazines devoted — or so the uninitiated thought — to an intoxicating mix of fashion, music, film, sport and lifestyle. However, these titles not only covered a much wider section of the social waterfront than most people realized but became the culture itself.

Of the three magazines, *The Face* was initially the most orthodox, being a glossy monthly that incorporated ancillary content including fashion and film. In the space of a few months it was the benchmark of all that was important in the rapidly emerging world of British and — in a heartbeat — global 'style culture'.

I remember buying the first issue, from the corner shop opposite my flat above a greengrocer's in Stamford Hill, north-east London. It was a Sunday; back when Sundays really were Sundays, when little was open but pubs at lunchtime. Having been a long-term consumer of the *New Musical Express* and, having spent a year at Chelsea School of Art and being halfway through studying a graphics course at St Martins, I was a slam-dunk target reader.

I loved *The Face* immediately. The man who started it, Nick Logan, was already a peripheral hero in my eyes because he had reinvented the *NME* in the early 1970s, making my adolescence, and those of 250,000 other like-minded music fans, a rich and vibrant time. The *NME* was how we discovered everything from esoteric pop music to galvanizing politics and sceptical over-the-top cultural criticism; it was our own national newspaper, a place where passion and cynicism were encouraged in equal measure.

After I left St Martins, I joined Terry Jones's *i-D*, first as a writer/gofer/professional ligger, but then as the editor, immersing myself in a world for which I rather grandly thought I was partially responsible. We had a friendly rivalry with *The Face*, and a shared — and perhaps slightly irrational — hatred of *Blitz*, a magazine that snootily we didn't think was fit to wipe our boots.

So I knew Nick long before I went to work for him, having spent four exhausting years at *i-D*. When I joined, *The Face* and *Arena* (the men's magazine that Nick launched in 1986, and which caused another tsunami of publishing activity, including British *GQ*) both operated from a converted Victorian laundry in Ossington Buildings, just off Marylebone High Street. For a while this was the citadel of London cool, a place where everyone from Bob Elms, Nick Kent and Tony Parsons to Ray Petri, Jean-Baptiste Mondino and Boy George would congregate, all metaphorically tugging their forelocks whenever Nick appeared.

The Face's raison d'être was simple: what was the correct thing to do? We would sit in the downstairs 'War Room' and discuss what was right and what was wrong. In the year leading up to the publication of the one-hundredth issue in September 1988 we spent many nights in there, excitedly compiling a list of the most important events of the decade, from the emergence of Go Go music to the proliferation of the Filofax. And having shouted at each other for an hour or four, we would trudge to the Soho Brasserie in Old Compton Street to drink expensive imported beer and carry on late into the night.

There are two things you need to know about *The Face*. It was incredibly hard work and it was a hell of a lot of fun. I think some people imagine the staff walked around in Regency fancy dress, perhaps with monocles or aggressively tinted sunglasses, leafing though fashion magazines and laughing at photographs of the great unwashed. Nothing could have been further from the truth. The staff that worked on *The Face* was not only small in

number but rapidly developed all the skills needed to put a magazine or newspaper together.

Nick Logan could do everything – he had almost single-handedly put out the *NME* week after week when a strike at the paper in the mid-1970s barred everyone but the editor from passing pages at the printers – and everyone who worked for him was expected to learn on the job.

I remember sitting in the repro house in Kilburn late one night during the final week of production, as we put to bed an issue of *Arena*, watching Nick spend more than an hour carefully editing the introduction to a tightly worded column on the back page. Having worked his way though yet another packet of cigarettes, he approved the page, sat back and said, with as much satisfaction and enthusiasm as I ever heard him muster, 'There. Now fifty more people might read it.'

This may have been the decade of the power lunch and the cocktail hour for some, but in the world of Wagadon (Nick's small publishing company), all hands were needed on deck at all hours of the day. We arrived, we worked and then we left. Many times we went out, gallivanting around town, but often we simply went home to finish an article we couldn't afford to commission anyone else to write.

It was a tough office in some respects, at least in so far as any hint of pretension was seized upon as a weakness. Express the wrong opinion about a film, a song or someone's appearance on *Newsnight* (with which for a while I remember Nick being obsessed, probably because it was the only TV programme he had time to watch), or – it has to be said – turn up to work in an unnecessarily jaunty hat, and you would be laughed at for weeks.

The Old Laundry was fun, though, and there are times when, huddled around the lightbox – no doubt peering at some awful fashion photographs a hapless photographer had sent in – with Neville Brody, Robin Derrick (who would go on to art direct *Vogue*), Christian Logan (Nick's son), Kathryn Flett (the features editor) and Rod Sopp (the extraordinarily un-PC ad director), I thought I might never stop laughing.

I remember the day we got our first fax machine. A member of staff had successfully sent *The Face*'s first ever fax, only to see the original piece of A4 paper still languishing in the tray. 'It's still here,' she said, incredulous. 'It's not matter transfer,' muttered Rod, on his way to force someone at Tag Heuer to give us another page of advertising.

Finally, saliently, never let it be said that *The Face* was anything but Nick's baby. He came up with the idea, paid for it, launched it and worked on it day and night. Sure, the magazine soon attracted a disparate wealth of amazing contributors – and some, like me, who just happened to be in the right place at the right time – but it was Nick whose vision they pursued, Nick who carried the torch.

Once, on a quiet Thursday, when the magazine had gone to bed, the office had emptied early, and the rain was pouring down on the windows on the roof, the buzzer rang. Thinking it was a courier, Christian opened the door to find a seemingly disturbed woman in her late thirties or early forties pushing through the entrance and storming around the downstairs floor, screaming. 'Where's Nick? Where's Logan? Is he here? Where is he?' She looked a bit mad, or drunk, and could have easily passed for a homeless person. Christian soon bundled her out – *The Face* always had more than its fair share of nutters – but not before she issued her final salvo: 'Logan was always the one, he was always the coolest one. Logan was *The Face*, he was always *The Face*.' We never told Nick, as we thought he'd be embarrassed. He didn't willingly talk about his Mod days, although it was a Mod sensibility that had informed his magazine. But there we had it in a nutshell. Nick was not only *The Face*, he was always *The Face*.

Dylan Jones is the editor of British *GQ* and editor-in-chief of *GQ Style*. He was editor of *Arena* and a contributing editor to *The Face*.

Preface
Paul Gorman

In 2012, London's Victoria and Albert Museum staged an exhibition to coincide with the city's hosting of the summer Olympic Games. Entitled 'British Design from 1948: Innovation in the Modern Age', this was a blockbuster described as 'an exciting story, encompassing the diversity of British creativity… showing how Britain has responded previously to hard times and tremendous change'.[1] Amid the Festival of Britain artefacts and designer Jamie Reid's punk posters there were copies of a particular magazine, *The Face*, exhibited to emphasize Neville Brody's typographical achievements during his tenure as its art director.

I was invited to the private view party, having sourced some of the objects on display, and took as my guest Nick Logan, the founder, editor and publisher of *The Face*. In this way Logan gained entry to the party, since he hadn't been invited.

After touring the show we perused the trinkets in the museum's gift shop. Among them were notebooks with covers reproducing 'classic' issues of *The Face*. All were credited to Neville Brody.

It was fitting that Brody received recognition, and Logan and I were pleased to bump into him amid the throng. But through no fault of the designer's, some of the notebook covers had been miscredited: a couple, in fact, had been created by Logan. Similarly, Logan's name did not appear anywhere in the exhibition or in the companion four-hundred-page catalogue.

On that night I resolved to produce this book, and not just because of those particular omissions. These were as nothing to the general erasure of Nick Logan from the story of British – and arguably the world's – development across visual culture, from advertising, broadcast media, fashion, film and graphics to interiors, journalism, magazine publishing, photography, retailing and street style. Put simply, without Logan's dogged – and sometimes single-handed – pursuit of the best in these disciplines, our present would look and feel very different.

This pertains in the digital sphere: in certain regards, browsing the pages of *The Face* in the 1980s and 1990s prefigured contemporary consumption of visual information. 'It was like Wikipedia to me,' recalls British fashion editor Ashley Heath. 'Every month I'd pick up a copy and understand two things but come across two hundred more which I would investigate and then join the dots between them.'[2]

As the American gallerist David Kordansky has written of Swiss artist John Armleder, Nick Logan and his magazine 'flattened cultural boundaries in the same way the digital space does today'.[3] And so this book follows Logan's launch of *The Face* in May 1980 to his decision to sell it in the summer of 1999 to publishing giant Emap.

In that pre-Internet era on the cusp of globalization, youth culture attained levels of potency beyond mere production and consumption, and *The Face* chronicled – and in some cases predicted – the twists and turns when street fashion and pop music were co-opted for individual personal expression and as forms of social and political critique, as well as used to champion the rights of minorities and propose alternative lifestyles, tolerance, diversity and integration. It is worth noting at this point that, as in comedy, in magazine publishing timing is everything. If the 1980s comprised the 'designer decade', then *The Face*

made it so. If the 1990s were predicated on regional values and provincial pride, dirty realism, grunge music and model waifs, all of which contributed to an egalitarian mood, so cleverly summed up by one of the magazine's editors as 'the revenge of the suburbs', then *The Face* was in at ground zero. In fact, the 230 issues of *The Face* published on Nick Logan's watch reside as a formidable record of those tumultuous times in our recent history.

The academic Catherine McDermott has identified a strand of British design where Logan's establishment of *The Face* may be located. His publication offered an alternative – which soon became the norm – that was 'essentially non-conformist and slightly eccentric. It has its origins in a working-class way of life, which has always expressed itself by using irony, dissidence and poking fun at the establishment.'[4]

Meanwhile, the cultural theorist Angela McRobbie has acknowledged the debt owed by one of the country's most prominent industries to the publication: 'Had it not been for the appearance of *The Face*, the media's central role as a pillar of support for the fashion business could hardly have happened.'[5]

One-time contributor and global publishing doyen James Truman is in no doubt that *The Face* changed the way the media communicated about culture. 'The notion of "style" as a gateway to understanding culture was very much an innovation of *The Face*', Truman told me. 'You saw instantly the supplements of the Sunday papers wanting to become like it. The old model upheld a division between masculine and feminine – you had rugged "male" journalism, and then the women's pages and columnists. But *The Face* presented a much more ambisexual

world, which in many ways prefigured the rise of the metrosexual man, whose interests and sensitivities were not so different from women's.'[6]

In his professional life as a writer, editor and publisher, Logan observed the central precept of journalism as the communication of information and ideas rather than self-promotion or opinionating. The objective dinned into those who made their bones in the press, and in particular on local papers, as Logan did, during his period of apprenticeship in the early 1960s was: 'Know your reader.' Logan – as demonstrated by his four-decade career, ranging from reporter delivering pop columns for the *West Essex Gazette* and stewardship of the *New Musical Express* to sending shockwaves through the publishing industry by launching not only *The Face* but *Smash Hits*, *Arena*, *Arena Homme Plus*, *Frank* and *Deluxe* – was consistent in his unwavering obeisance to serving the needs of young people hungry for details of the latest developments across the fast-moving world of popular culture.

That *The Face* revolutionized both the production and consumption of media is indisputable. But to understand *The Face* one has to understand Nick Logan, which is no easy task. With abundant charm and humour, he nevertheless projects an elfin presence. He is slight of build and gently spoken, pin-sharp but prone to responding to inquiries by pausing and blinking enigmatically behind his spectacle frames before answering, more often than not with a tentatively phrased question of his own. Some insights into Logan's nature, and how he became the most important figure in British post-war print publishing, lie in the events of his childhood, which is where our story begins.

Introduction:
In the Beginning

In the summer of 1962, style-conscious teenager Nick Logan found himself 150 miles north-east of London, in the cathedral city of Lincoln, staying with his maternal grandparents, out of the swim and viewing from afar the quickening pace of youth culture in that immediate pre-Beatles era.

The fifteen-year-old's world had been sent into a spin by his family's move from the capital and it is only relatively recently that Logan has revisited this period, one that he had long consigned in his memory to a duration of six months. 'I looked at some old diaries and realized I was there for six weeks', says Logan. 'It has always felt like much longer. I didn't know anybody, so spent my time on my own, browsing in art galleries, bookshops and libraries, because they were all free. When you're that age you want to know what's happening, and I was in a place where it wasn't happening, and that stayed with me, the curiosity and interest in what's new and good.'[1]

Logan recalls feelings of being marooned. In the sway of books by George Orwell, James Joyce, James Bond creator Ian Fleming and British kitchen sink writers including Alan Sillitoe, as much as he was enamoured of home-grown R&B and imported American soul, Logan frequented the contemporary section of the city's municipal art gallery 'where there were paintings by some of the Impressionists and maybe a Kandinsky' (Logan still retains the catalogues for the shows he visited there that summer[2]).

Logan, his sisters, Diane, Sue and Jenny, and mother Doris, had made the temporary shift to Lincoln at the behest of his father John, an East Ham-born former Lancaster rear gunner who was, in the words of his son, 'a colourful character and a charmer, which was probably his undoing, because he charmed everybody, whether it was the bank manager or a woman he'd met in a pub'.[3] They had left a rented house in Grosvenor Road in Wanstead in east London under shadow of night after a business deal of John's had gone sour. This was but the latest move in what had been a fairly peripatetic existence for the family.

Nick Logan was in fact born in Lincoln on 3 January 1947, when his parents were first residing with his maternal grandparents. After three years – which included a spell in

hospital for Nick due to an infant illness – the family moved to Canvey Island, a patch of land in Essex separated from the county by a network of creeks. Terrible floods hit Canvey in 1953, killing dozens of islanders and wrecking homes. The Logans were evacuated to neighbouring Pitsea and several more moves were undertaken around Essex and briefly Devon before the family settled in Grosvenor Road until the enforced exit back to Lincoln.

It's worth noting the family had already been evicted from a previous home in the area. 'I went through a couple of formative experiences with my Dad,' says Logan. 'When I was fourteen he told me that he was disappointed in me, by which I assume he meant that I wasn't like him. Some years later, typically, he would take me and my wife Julie out to Trader Vic's for a night out and the next day ask to borrow a tenner. In fact, I still have a cheque for £10 he wrote me in return for a loan. I knew it would never be worth cashing.'[4]

Another instructive episode and the reason for the eviction was related to a escapade in which Logan senior had run up serious debts and sparked bankruptcy proceedings not only against himself but his eighteen-year-old daughter Diane; he had cajoled her into accepting a directorship of the company through which the money disappeared. 'That was chastening to witness; if I'd have been a couple of years older, he would have taken me down with him as well,' says Logan, who prides himself on the fact that every issue of *The Face* made on his watch made a profit, however tiny. 'To be in any kind of debt is horrific to me.'

Come the end of the summer of 1962, Logan boarded with relatives in Essex so that he could return to Leyton County High School for Boys. But his enrolment there lasted a single term; at the end of 1962 Logan decided to quit his studies and follow a path into the print, encouraged by one of his mentors, a teacher named Jim Campbell, who had been impressed by his English Literature submissions.

After a few false starts courtesy of his father, who claimed to know former editors of, variously, the *Daily Mail* and the *South London Advertiser* from his sojourns at the bar of the Pathfinders Club in Mayfair, Nick Logan was on the verge

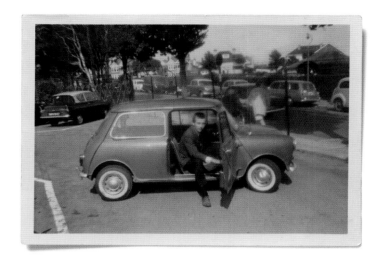

of giving up his search and, at the insistence of his father, considering an apprenticeship at a local garage. When Logan's grandfather suggested a job at a foundry in Lincoln, Logan took matters into his own hands and in the spring of 1963 sent a cold-call application to local newspaper the *Walthamstow Guardian*.

Logan was summoned to the offices of the area's sister title *West Essex Gazette* – at the time based in a Portakabin on the village green in Epping – and was offered a place as a rookie reporter, transferring after a few months to the neighbouring offices that produced the Loughton edition.

'At that point I still didn't have a wide circle of friends because we'd moved around so much,' says Logan. 'Even being back in London I was watching things from a distance.'

When he wasn't working, the teenager whiled away the hours combing the pages of music magazines including the weekly *Record Mirror* – where writers such as Norman Jopling were championing soul acts – and the newly launched *Beat Instrumental*, in which 'there might be an off-stage posed pic of the Stones so you could study their haircuts, Cuban heels, leather coats'.[5]

At this stage Logan lived something of a double life, spending his weekends running wild in the coastal resort of Clacton (there is a story of abandoning his car after a friend was nabbed for driving it without a licence), while during the working week respectfully calling on local police stations and vicars every Monday and Thursday for stories. He also made the routine round of council meetings and covering local events.

There were also stints at the newspaper group's printing 'shop' on press days, where Logan gained knowledge of the practices associated with the hot metal printing process and its successor web offset, a world replete with terms such as 'ems'

(a rule of typographical measurement) and 'flongs' (mouldings of pages before they were cast in metal).

Soon he was required to serve time in Walthamstow, where new presses were established not long after his arrival. Here Logan developed the devilish eye for detail that underpinned his later achievements.

An incident when he allowed a single 'literal' (a spelling mistake or similar error) to make it to the printed page sticks in his memory. 'The lecture I got about how much it cost to remake a page scared the living daylights out of sixteen-year-old me,' Logan recalls. 'I'm not sure if it was as career-threatening as it felt at the time but I rapidly got my proofreading up to speed as a result.'[6]

Logan's abilities and youth won him the regular pop column on the paper; his attempts to obtain the latest records by his favourite groups resulted in nothing more than 'mounds of press releases' and singles by lowly artists on the middle-of-the-road Pye label. Characteristically, Logan later downplayed his first brushes with celebrity: 'I might have interviewed the Small Faces, who lived locally, or the drummer of the Nashville Teens, but it was all minor stuff.'[7]

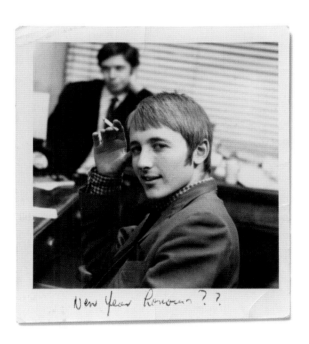

top left
Nick Logan with his first car, a red Mini, 1965.

above
Logan in the 1960s.

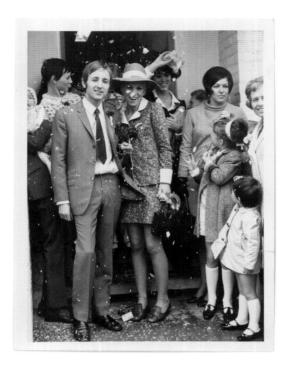

With a social circle established for the first time in his life – many of his peers were still at school while he enjoyed this new-found standing as a journalist – Logan dedicated his leisure time to his love of fashion, music, dancing and hanging with fellow Mods. A favourite haunt was north London's legendary Tottenham Royal ballroom, where Logan met his wife, then Julie Hillier, in 1964. They married in 1967 and in the same year, Logan, tiring of the local newspaper routine, applied for a reporting job on *Melody Maker*, then the most credible of the four British music weekly papers.

The stock-in-trade of the others, *Disc*, *Music Echo*, *Record Mirror* and *New Musical Express*, was the peddling of pop fodder. As LP sales took off, *Melody Maker* was positioned as the musicians' read, trumpeting folk, jazz, blues and the type of rock music soon to be dubbed 'progressive'. Bolstered commercially by pages of classified ads in each issue, IPC's marquee title was, in Logan's words, 'the only choice, highly respected'.[8]

However, his application was unsuccessful (Logan believes he fell foul of the editor Jack Hutton's insistence that members of his editorial team should be able to read music[9]), and so he approached Andy Gray, editor of *NME*, which was also owned by IPC and contract-printed on Logan's employer's presses in Walthamstow.

'Six months before he had given a job to someone on the same paper as me who turned out to be a washout, so I thought my chance had gone, but surprisingly this distinguished looking grey-haired gentleman took me on,' says Logan.[10] He joined

a team of five reporters working at the offices in Long Acre in central London's Covent Garden, but soon became disillusioned with the publication's stick-in-the-mud ways. For example, Maurice Kinn, the dance-band promoter who founded the paper in the early 1950s, continued to file the weekly 'Alley Cat' gossip column, jarring with the brave new psychedelic world.

The *NME* had experienced huge sales spikes during the 1960s, first on the back of the popularity of The Beatles and then even more so with The Monkees. In Logan's view the editorial team were complacent in waiting on the next big pop act, misunderstanding that the market was now fragmenting as sales of rock music rose. 'It was real Tin Pan Alley stuff, they were completely out of touch,' says Logan. 'On press day – every Tuesday – Andy Gray would present a Roneo'd copy of the singles charts and we'd be expected to start from the top with The Beatles or whoever. Articles would be allotted, working our way through reporting on the same groups by rote. If it wasn't Top Thirty it didn't get in; clearly this wasn't working when album charts became important.'

In addition, major-league acts including the Rolling Stones, The Beatles and The Kinks were the preserve of established staff members, so a no-go for the newcomer. Logan introduced features on his favourite soul and R&B musicians but they were mostly in America and only available for phone interviews, so he developed a taste for album artists including Led Zeppelin and Fleetwood Mac. These provided greater access and more colourful copy.

In time Logan struck up a friendship with fellow reporter Alan Smith, a Liverpudlian who, by the early 1970s, shared

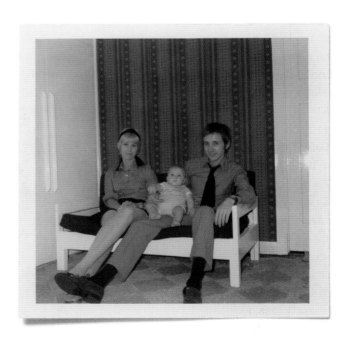

Logan's view that the weekly was perilously failing to keep up with the fast-developing music scene as circulation dropped. The pair spent their lunch hours dissecting the publication's failings, and, unbeknown to Logan, Smith conveyed these criticisms to senior executives, persuading IPC's management in 1972 that the falling circulation could be averted with a total makeover, including improved layouts, better use of photography and a cull of not only the editor but those writers whose style dated back to the Beat boom.

'When Alan got the job, he told me he wanted to do it for eighteen months and then he would pass it on to me,' said Logan, who became second-in-command as they recruited from the ranks of Britain's splintering underground press. Smith employed Charles Shaar Murray, whose career had started as contributor to the notorious 'Schoolkids' edition of *Oz* magazine, and photographer Joe Stevens (who had worked not only for *Oz* but *Friends*), while Logan took on board the exotic Nick Kent and photographer Pennie Smith from *Friends*, after it had mutated into *Frendz*. These arrivals joined a newly strengthened editorial team, which included the talents Tony Tyler and Ian MacDonald.

At this time, Logan's editing abilities were foregrounded. He later described himself as more editor than writer. 'Interviews were OK but I never felt comfortable reviewing, and any kind of writing was a chore for me,' says Logan. 'I was that kind of writer who'd spend hours on the opening paragraphs then have to rush the rest to meet a deadline and hate the result, so I was happy to gravitate towards editing. I loved working with good writers, much better writers than me, doing layouts and working with photographers, fine-tuning the flatplan, all the unseen stuff that goes into creating the look and feel of a publication.'[11]

Logan was also beginning to develop the type of journalism that would blossom when he launched *The Face*; for example, his 1972 interview with Rod Stewart was conducted while the subject tried on shoes at the premises of the legendary West End footwear outlet Anello & Davide, while staff members Danny Holloway, James Johnson and Tony Tyler were posed in Teddy Boy gear outside Malcolm McLaren's King's Road boutique Let it Rock for by-line photos for the paper's review of the 1950s revival 'London Rock and Roll Show' at Wembley Stadium that year.

As planned, Alan Smith left the paper in the autumn of 1973 (initially to pursue a career in property development[12]), and the twenty-six-year-old Logan became editor (the youngest of a British magazine at that time), presiding over one of the golden ages in British journalism, with the popular Kent and Murray at the forefront of a talented staff (which by now included Chris Salewicz and another refugee from the underground press, former White Panther Mick Farren), delivering spiky, witty copy that charmed readers and lead

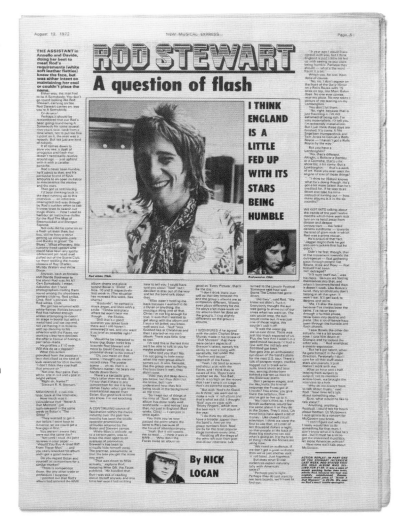

to an upswing in circulation, putting the paper ahead of all competition for the rest of the decade.

One of Logan's first moves was to halt the reliance on live images ('I didn't want to see Roger Daltrey's tonsils; his jacket was far more interesting to me'[13]) and dedicate the entire front page to a single photo; historically the *NME*'s cluttered cover contained box ads, text and multiple images.

When a six-week printer's union strike proved useful in knitting the team together, Logan took the opportunity to introduce new elements. The issue published on 19 January 1974 was his first to feature a single cover photo, in this case a full-length shot of Bryan Ferry on a beach taken by Pennie Smith, signalling a stylish way forward. 'There was such a rush of energy in that issue, it was exhilarating,' says Logan, who has described the *NME* as being 'a different magazine after the strike'.[14]

As the publication pushed into new and edgy territory, Logan positioned himself as the fulcrum between the staff and the IPC management, and was increasingly fielding objections to the use of swear words and sex and drug references, all the while allowing writers free rein to express themselves even if this, as it often did, antagonized record company advertisers. Ad director Percy Dickins was supportive of the changes wrought by Logan and sought to appease record company big cheeses. 'Often he invited me to lunches with label bosses where I'd find myself defending the writers,' said Logan.[15]

Predicting and – in Nick Kent's case – contributing to the mid-decade punk explosion (the writer played guitar in rehearsals with an early Sex Pistols line-up), *NME* reaped the rewards when recruits Julie Burchill and Tony Parsons – who had responded to the infamous ad appealing to 'hip young gunslingers' – became figureheads of the new movement (not for nothing did Johnny Rotten insert the lyric 'I use the *NME*' into the Pistols' anthem 'Anarchy in the UK').

Fans of Logan's *NME* are legion and include many powerful figures in music, media and beyond. Among them is James Truman, who was to become the American editor of *The Face* and, via his tenure at Condé Nast, one of the most important magazine publishing figures in the world. In 1976, however, Truman was a bored and frustrated school-leaver living at home in Nottingham, in the Midlands.

'The *NME* evoked a world of excitement and danger I yearned to join,' he says. 'I read every word of every issue, and wanted to learn everything I could about the writers and editors who produced it, which wasn't hard, as they were not shy about writing about themselves. But you could never glean much about the editor Nick Logan, so I imagined a life for him – impossibly cool, he probably drove an American muscle car, surrounded by hot punk girls, celebrated backstage at every concert. As I'd later learn, he was an over-stressed, underpaid employee of

IPC trying to corral an unruly staff to produce a new issue every week. But that was the brilliance of his editorship: he created a seamless, holistic world that made the backstage as exciting and important as the bands they covered.'[16]

This 'glorious, frenetic ride', in Logan's words, was upended in 1976 when IPC determined to close its satellite offices and bring all titles under the roof of King's Reach Tower, on the southern banks of the River Thames. The *NME*'s Long Acre office and the staff were installed on the twenty-third floor of architect Richard Siefert's Brutalist office block. 'That was when it all came home to roost,' says Logan. 'I'd kept the two cultures apart and here we were shoehorned in these open-plan offices with *Titbits* and *Country Life*. It was a disaster waiting to happen, trying to protect the likes of Charlie Murray, Tony Parsons, Julie Burchill and Mick Farren from the suits at IPC. I was under incredible pressure.'

Towards the end of 1976, Logan suffered a nervous breakdown and was absent from the office for six weeks. 'I couldn't cope any more,' he recalls. 'IPC was kicking my arse over petty stuff while the paper was earning millions because it cost them little or nothing to put out.' This collapse brought home the seriousness of the situation, and on his return Logan negotiated a way out. New offices were found in Soho's former Swinging London epicentre Carnaby Street and the publication benefited from the music industry sales boom that coincided with the immediate post-punk period.

But Logan remained bruised and unable to shake off the King's Reach experience. Pausing to make his last appointment, in the form of Danny Baker, fresh from the fanzine *Sniffin' Glue*, Logan handed in his notice in the summer of 1978 without lining up another job. 'I felt like I still had something to prove', declares Logan. 'I suspected I would be written out of the story of why the *NME* was so successful; that is what happens if you are always behind the scenes, but I was determined that wherever I went next would be a million miles from the corporate culture that had broken me at IPC. I'm not very good at presenting a case or articulating what I want to do. Put me on a committee and I won't say a word. I'll bow to everyone else's "superior judgement" every time. So that forced me to go out on my own.'[17]

Logan may not have had a job, but he did have a head full of ideas for new magazine projects developed since his collapse. Two were specialist and untitled: one was to be dedicated to country music, the other to reggae (in association with the offbeat *NME* writer Penny Reel). A third was sketched out as a *Rolling Stone*-style 'intelligent' music paper with Chris Salewicz and cartoonist/illustrator Tony Benyon and called *Modern Times*, and yet another was an as-yet-untitled glossy, photo-led teen celebration of chart music complete with song lyrics of current hits.

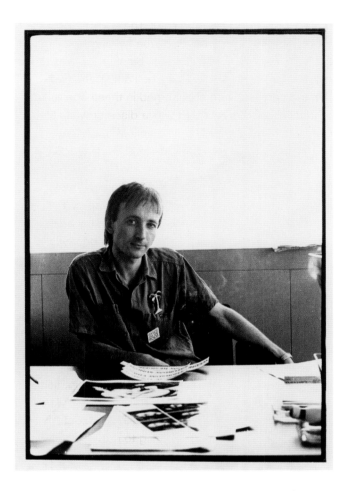

above
Nick Logan at the *NME* offices in King's Reach Tower, London, 1976.

top right
Logan at the *NME* offices in Long Acre, London, 1970.

right
Logan with wife Julie at home, Wanstead, London, 1985.

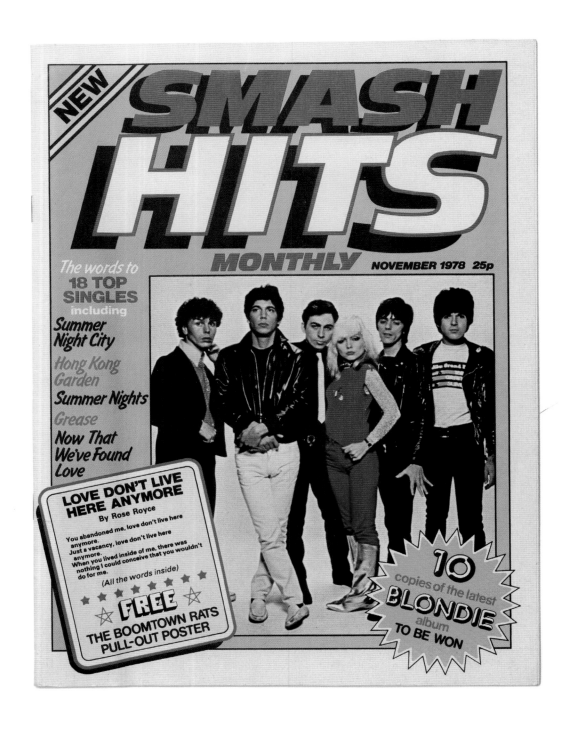

above
Smash Hits, no. 1, November 1978.

On the hunt for an arms-length print and distribution deal, Logan pitched these ideas to *NME*'s printer East Midlands Allied Press, which had recently decided to expand its magazine division under executives David Arculus[18] and Robin Miller[19] from the specialist base of titles including *Angling Times* and *Motor*

Cycle News. Travelling from London to see his mother, who was by then living back in Lincoln, Logan visited the company's headquarters in Peterborough. He presented his ideas while his wife and their two children, Christian and Hallie, waited in the car parked outside the shopping mall where Emap was based. 'I was looking for a relationship but with me not on the payroll,' says Logan. 'I threw in the song lyric proposal [to include the words to pop chart hits] to round out the ideas – it was the opposite of an intense newsprint rock weekly – and was really surprised that that was the one they seized on.'[20]

Offering Emap's backing, Arculus suggested the title 'Disco Fever', to reflect the current popularity of the Bee Gees and John Travolta. Logan balked and countered with 'The Pop' on the basis that disco was a passing fad and that the new title should encompass visually exciting post-punk performers including Elvis Costello, Ian Dury and The Clash. When he threatened to walk, the two parties agreed on *Smash Hits*.

'My interest was in featuring excellent photography, with the song lyrics as the ballast, and bringing good acts like The Jam to a young audience,' says Logan. He argued for the use of quality paper stock – existing titles in the field in the so-called juveniles market like *Disco 45* were universally derided for being printed on 'bog paper'. Serendipitously, Emap had access to enough surplus 90gsm glossy stock to produce an issue in the autumn of 1978 to be test-marketed in the north-east of England.

Logan put down a marker for his future intentions by featuring the desperately unhip but current Belgian novelty punk singer Plastic Bertrand on the cover and a centre-spread of the skinhead-approved quartet Sham 69. Reactions from focus groups were in the main positive. 'They loved the paper but not Sham 69, but I wasn't about to budge,' said Logan. 'What a handful of respondents said they hated – Sham 69, The Jam, The Clash – I knew they would love in time. I wasn't going to go ahead without the freedom to encompass post-punk, which is what interested me.'

The first issue went immediately into national monthly distribution. Featuring Blondie on the cover, this sold tens of thousands of issues, and over the next few months sales increased to the 100,000 mark.

Logan was paid a fixed sum by Emap to clear the reproduction of song lyrics and produce issues on his kitchen table at home in Wanstead, adopting the pseudonym Chris Hall (from contractions of his children's names) for the first three issues. 'All I had was my reputation, hard-earned at the *NME*,' Logan explains. 'At first, I didn't want everyone knowing what I was doing until I was certain it would come good because I was apprehensive about how the editorial people at Emap might interfere with my ideas. I would go up to see the issues on the presses and find that they had mucked about with my designs, putting on holly borders at Christmas, that sort of thing.'[21] Simultaneously, Logan was increasing his already substantial knowledge of the inner workings of print production. 'Because I'd never worked with colour repro before, this was the first time I got to handle things like Cromalins [single-sheet colour proofs]',[22] he says.

By the start of 1979 Emap was pressing to produce weekly issues. 'That was the last thing I wanted after the rigours of the *NME*,' says Logan. A compromise was reached for *Smash Hits* to become a fortnightly, and he was set up in an office in Carnaby Street, coincidentally opposite the *NME* headquarters he had vacated a matter of months previously.

Logan brought on board his sister-in-law Bev Hillier as his number two and Emap hired Steve Bush fresh out of art school and a T-shirt printing business to handle layouts. Contributors included *NME* regular Fred Dellar, who provided the crossword, and freelancer David Hepworth, who went on to become one of British music journalism's big figures within the Emap structure as the founder of *Q*, *Mojo* and *Heat* magazines.

Logan scored an immediate success for Emap; in the first half of 1979, *Smash Hits*' circulation rose above 166,000 copies, just 35,000 fewer than the *NME* and 10,000 more than *Melody Maker*.[23] Surfing on the interest in the late 1970s emergence of what was described as 'the new pop' – unashamedly commercial punk-related acts including Blondie and The Police – *Smash Hits* was eventually to topple the rock-oriented weeklies from their positions as market leaders.

However, Logan had informed Emap from the outset that he would give *Smash Hits* a year before seeking new opportunities. With their agreement, Scottish freelance journalist Ian Cranna – who (alongside Burchill and Parsons) had impressed Logan during the *NME*'s 1976 interviews for 'hip young gunslingers' – was brought in as full-time editor. 'I became managing editor,' recalls Logan. 'But I'm not the kind of executive who interferes with the editor. So I started to develop an idea for a new type of magazine.'

Logan approached the Emap directors – who had recently invested in a new title, the soccer-focused *Match* – with his proposal for a well-produced, well-designed and well-written monthly with music at its core but with expanding coverage of the subjects that informed it, from fashion and film to nightclubbing and social issues: 'They said: "Maybe. Come back in six months, we've just launched *Match*". I thought, "Fuck you. You've only been able to do that with the money I made you from *Smash Hits*." It wasn't that fair of me, because six months isn't a long time, but I'm very impatient, always have been. So I talked to Julie and started making a few phone calls.'

Chapter One

Maverick or Masochist?

Maverick or Masochist?

Nick Logan's unwillingness to wait for six months for Emap to return with their verdict on his proposal lay in the fact that the 2 Tone movement went overground in the winter of 1979, as The Specials and Madness played sell-out concerts and scored their first chart hits. Keen to plug into the musical genre's potent visual presence, social commentary and multi-cultural make-up, Logan set about producing the new magazine from the offices of *Smash Hits* in Carnaby Street, where he retained the increasingly nominal title of managing editor.

Logan calculated that he and his wife Julie could fund the first issue with the £2,500 they had accumulated in savings, supplemented by another £1,000 squirrelled away from royalties (ironically paid by IPC) accrued from his co-editing with fellow journalist Bob Woffinden of the best-selling *The Illustrated New Musical Express Encyclopedia of Rock* (1977). In tandem with *Smash Hits* art director Steve Bush, Logan toyed with options for the new magazine's title – 'Real World' was one that reached draft stage – before settling on 'The Face', a name that flouted the publishing wisdom that a magazine should make explicit its content and, ideally, frequency. Emap judged it too abstract and proposed that the word 'monthly' was a necessary element. 'As it was my savings at risk, I felt I could call it what I liked,' said Logan many years later. 'After all, *The Face* was to be my escape from a career where I struggled to explain myself to publishers or committees. No focus groups here: I was purely and wholeheartedly following instinct.'[1]

This was not a promising time to be contemplating the risking of life savings on an untested business venture, given the unstable, fever-pitch global political backdrop. The Troubles in Northern Ireland had been marked by a particularly vicious high in 1979 with the car-bomb killing of Tory Party grandee Airey Neave, the Iranian revolution was in full swing since the country had been declared an Islamic republic after the fall of the Shah, the ongoing Afghan War had resulted in Soviet intervention and the former Hollywood actor and Californian governor Ronald Reagan was preparing his candidacy for US president, with all that would entail.

On the home front the British economy had been shattered by the events of the so-called 'winter of discontent', characterized by widespread industrial action and severe disruption to public services that forced the hand of the Labour government under prime minister James Callaghan after a parliamentary vote of no confidence. The indecisive Callaghan later confirmed his administration's fortunes were 'cascading downhill. Our loss of authority in one field led to misfortune in others just as an avalanche, gathering speed, sweeps all before it.'[2]

Of course this avalanche was personified by the Conservative Party leader Margaret Thatcher, whose victory at the general election in May 1979 inaugurated a decade of often-bitter social and political division across Britain.

So here was Logan – nearly thirty-three, with a wife and two young children and a track record weighted towards the capricious pop industry – setting in train a series of events that would provide a cultural counterpoint to, and commentary on, the churn of those turbulent years. These were to be unintended consequences, of course. Logan's priority was to provide his target audience – sixteen- to twenty-five-year-olds – with the highest-quality coverage of youth subject-matter that had, up until that point, been largely dismissed as ephemeral.

Logan wasn't about to be deterred, even by the recession that was biting. 'Industry figures, more at IPC than Emap, advised me that it was a bad time to go with it,' he recalled. 'I remember thinking: "Recession? Hasn't it always been like this?" and closed my ears to their arguments in case they put me off. Essentially, I was desperate to get going. Culturally this seemed propitious and I wasn't up for waiting.'[3]

The experience Logan had gained in launching *Smash Hits*, which had swiftly established a new readership eager to learn about the kind of rock acts that had previously been the preserve of the 'inky' music papers, was combined with his belief that the application of the production values of high-end magazines like *Tatler* and *Vogue* to a youth market publication would be appreciated. Just as he had insisted to Emap executives that *Smash Hits* should appear on quality paper stock, Logan said of this approach to *The Face*: 'Why should the devil have all the best tunes? I wanted to deliver the best text and photography with the best layouts. And I wanted it to be monthly to get me out of that weekly rut; on glossy paper so that it would look good; and with very few ads. At *NME* in particular the awful shapes of ads often meant that you couldn't do what you wanted with the design.'[4]

Logan's determination to give primacy to the look of the magazine extended even to the advertising, initially banking on the projection that news stand sales and subscriptions could fund the venture that was to be published by his off-the-shelf company Wagadon (which Logan used as the corporate entity in his dealings with Emap) under the self-mocking banner 'Feet First Productions'.

Since photography was to be a major element, Logan put out calls to the best of the image-makers he had worked with and asked them to submit material, particularly in colour, which had been used minimally in the music press but met his criteria in terms of interesting framing and subject-matter. These included Anton Corbijn, Chalkie Davies, Jill Furmanovsky, Mike Laye, Sheila Rock and Pennie Smith.

'The message to us was that there wouldn't be much money in it but our images would be presented on the best

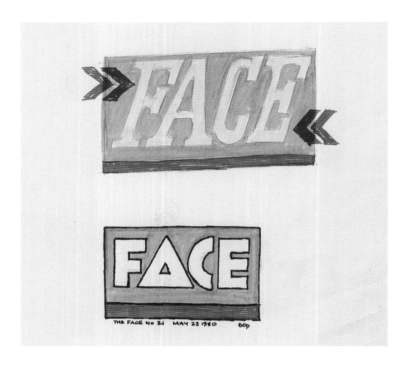

paper and in the best way, with no cropping or messing around with them,' says Davies, who worked with his partner Carol Starr and is today based in New York. 'I think all of us had kept stuff back which didn't fit into the narrow world of the inkies. Those were the photos that Nick was after. He opened a whole new world for us, because up until then, if you shot colour for the music press, which happened very occasionally, it reproduced very badly. Now we had a medium where we could start really working on the way we approached photography.'[5]

As with writers and other freelance contributors, Logan's agreement with photographers (which pertained as long as the magazine remained under his control) was based on their retention of rights to the original images.

In the early months of 1980, Logan struck deals for *The Face* to be typeset by a company called Cogent and the repro house (where material is prepared for the printer) Colour Solutions. Both were housed in a building in Queen's Park, north-west London.

Having arranged for the magazine to be printed by the local newspaper group Severn Valley Press in the Welsh town of Caerphilly, Logan's next step was to order the paper stock from a supplier in Finland. 'I had to take a deep breath because it took most of the money we had, so there was no going back. I put the phone down and thought, what happens now? Do I have to get a lorry to collect it from the docks and store it in my garage? I realized I had a lot to learn.'[6]

By bringing on board Comag, a west London-based distributor launched in 1977 to challenge the hegemony of the entrenched industry giants, Logan ensured that the new

title would be granted space on the shelves of hundreds of independent and chain newsagents around the country. As a result, future contributors, including Lindsay Baker, Kathryn Flett and Sheryl Garratt, obtained their copies of the first issue in the depths of Surrey, Hertfordshire and central London's Soho respectively.

The Comag relationship was important. Logan was interested in infiltrating high-street retailers such as WHSmith with the new post-punk sensibilities 'as opposed, say, to a publication that has as the height of its ambition a showcase at the ICA (Institute of Contemporary Arts) bookshop and a few glossy ads placed by fashion companies in Milan who have more money than sense'.[7] Logan's projections were based on the printing of 75,000 copies with a 60p cover price; sales of 50,000 would cover the costs of paper, printing, typesetting and contributors. In the event – boosted by a national printers' strike that rendered IPC's music papers *NME* and *Melody Maker* unavailable for a six-week period in the spring of 1980 – the first issue, published on 1 May 1980, exceeded expectations by selling 56,000 copies.

Of the sixty-four pages comprising the first issue of *The Face*, just five were paid-for adverts, all monochrome and all from record companies, including Stiff Records (for a Madness EP) and Virgin and Warner Music (for LPs by Magazine and The Undertones). In other circumstances, this would have been a disturbingly low rate in an industry sector where ad/ed ratios pivoted around the 60:40 mark.

There were a couple of typically fastidious Logan elements in this first issue that would appear in every subsequent copy of *The Face* under his control. The first was an alphabetical list of contributors on the contents page (in time this would grow to such an extent that it was sub-divided into the categories 'text' and 'images'). The second, in the first edition at the bottom of page three but subsequently on the final editorial page at the back, was the 'colophon'. Printed in very small type, this contained information about the publisher, typesetter, repro house, printer and distributor. For those readers interested in the minutiae of the magazine, Logan's phrase regarding copyright betrayed his roots in the less than staid music press: 'Reproduction of any material without permission is strictly no go, Jack.'

above left
Logan's sketch for the magazine masthead;
Steve Bush's final version.

opposite
Logan's pitch letter for *The Face*.

Maverick or Masochist?

<u>THE FACE</u>

... is a new rock music magazine for the 1980s. A monthly magazine in
an attractive A4 format from the founder editor and creator of the highly
successful pop magazine Smash Hits. But does the world <u>need</u> another music
magazine? Doomwatchers say the record industry is in recession, but the
fact is that sales of the leading music titles have never been more buoyant.
New Musical Express, Sounds and Record Mirror recently announced record
sales figures; Smash Hits appeared from nowhere just over 12 months ago
and is now so strong that it is challenging New Musical Express for the
right to call itself the top-selling UK pop publication.

The publisher/editor of The Face is Nick Logan, who has been involved with
two of these prestigious music titles. Nick Logan became editor of New
Musical Express at the age of 25. He made far-reaching changes in the
editorial direction of what in the early '70s was a struggling publication,
and during his five years in control he steered New Musical Express to No 1
among the weekly tabloids, overtaking Melody Maker the former market-leader.

Nick Logan left New Musical Express to create the concept of Smash Hits
for EMAP National Publications, a publishing group with no previous
interests in the pop market. Smash Hits was totally Logan's idea, and its
current high sales bear out his impressive record of editorial judgement in
a market which has seen its share of failures.

The Face is Nick Logan's newest venture in music magazine publishing.

The Face's target market will have an older profile than that of Smash
Hits, with primary appeal to 15-22 year old rock and pop fans. This is
the age grouping which provides readers for New Musical Express, Sounds,
Melody Maker and Record Mirror but we don't consider The Face to be a
rival to these titles. It might help to think of The Face as a kind of
'unofficial' monthly colour supplement to these weekly tabloids ... then
you can see how we believe it is possible to create a totally new but
complementary market.

The attraction of The Face is that it will be unique as a vehicle for the
publication of outstanding photographs of popular rock and pop music artists.
The Face will be glossy, attractive, a quality magazine carrying superb
rock photographs in colour and black & white. These will be accompanied by
feature material of a kind not found in the weekly tabloids. It will have
the services of a team of photographers, writers, designers and illustrators
recognised as the best in their respective fields.

below

Paste-up layouts for the opening pages of the first
issue of *The Face*.

62

In issue No 2 of
THE FACE on sale May 22

Probably him as well

And a bit on them

Definitely him

Something about him

Plus lots more
of the kind of
stuff you've just read.

Place a regular order with your newsagent today. Tell
him/her you want THE FACE (and no other cheap tat that
makes your fingers inky) every month from May 22 until
the apocalypse (or for as long as we can survive the pace).

**Attractively
Collectable
First Issue**
May 1980

Editor
Nick Logan

Design
Feet First Graphics
and Steve Bush Inc.

Contributors
Janette Beckman
Adrian Boot
Neville Brody
Steve Bush
Julie Burchill
Anton Corbijn
Ian Cranna
Gary Crowley
Chalkie Davies
Fred Dellar
Ian Dury
Kevin Fitzgerald
Jill Furmanovsky
David Hepworth
Andy Ingamells
Mike Laye
Ray Lowry
Tony Parsons
Kelly Pike
Sheila Rock
Pennie Smith
Mike Stand
Adrian Thrills
Vaughn Toulouse
Virginia Turbett
Stan Westwood
Ian Wright

2nd Floor, Lisa House,
52-55 Carnaby Street,
London W1V 1PF

To advertise call Face
Space: 01-439 8801

This is The Face, issue numero uno, license
thrill. The first new rock magazine of the 198
and an independent at that. A totally new s
on the Modern Dance. Available monthly fr
all good newsagents, while stocks last. Tel
friend The Face is here.

THE SPECIALS

2-Tone, admits Jerry Dammers,
is in danger of becoming a
cliché. Where does the world's
most successful record
company go from here? 4

MADNESS

Camden loonies nut New York.
The Face saw it happen 22

ELVIS '56

Ian Dury on Elvis Presley,
The Man Who Would Be King 28

PUBLIC IMAGE

Kevin Fitzgerald's PiLgrimage
to John Lydon's lofty lair 32

DEXY'S

These are *mean* men, b
heart they're all soul. M
Stand checks the Runne

LLOYD JOHN

Adrian Thrills talks to th
mod who tailored man
it the other way around

ACROSS
1 Le Secret aka Midlands dance
 band
4 See 10
7 Her version of "Alison" isn't
 likely to be wearing out the stylus
 on the Costello Dansette (5, 8)
8 Exhibitionist German
 punkette (4, 5)
11 See below
12 & 11 across Late lamented
 L. Feat bossman
13 & 26 A 1979 chart-climber for
 dear departed Sidney
15 See 23
17 Go Feet popsters
19 Truly the Sound of Yesterday
 Today (5, 3)
20 Go round the country making a
 noise?
21 & 14 John's missus, Sean's
 mum
23 & 15 Buzz Aldrin's fave Police
 toon? (7, 2, 3, 4)
24 For Eddie's fishing trips?
25 It's musical in Alaska!

26 See 13
27 F. Mac LP

DOWN
1 Rudolf Hess' fave Police toon?
 (2, 6)
2 Armagideon Timelords!
3 Dexy's boys **shall** go to
 Moscow!
4 For Devo's future?
5 Sounds like a certain recipe for
 indigestion, Debs! (3, 2, 3, 4)
6 Early Stranglers chestnut (7, 6)
9 Defunct Big Apple combo,
 missing link between Stones and
 Pistols? (3, 4, 5)
10 & 4 across David Bowie's classic
 '70s hit for Mott The Hoople (3, 3,
 5, 5)
11 Soul golden oldie recently
 revived (5, 6)
14 See 21
16 F. Lizards debut hit
18 Like sugar, like James
22 Make a song out of soup!
24 Aka Chris Miller

ACROSS: 1 Selecter; 4 Dudes; 7 Linda Ronstadt; 8 Nina Hagen; 12 & 11
Lowell George; 13 Something; 15 On The Moon; 17 Beat; 19 Radio One; 20
Tour; 21 Yoko; 23 Walking; 24 (Hot) Rods; 25 Ska; 26 Else; 27 Tusk.
DOWN: 1 So Lonely; 2 Clash; 3 Runners; 4 Duty (Now For The Future); 5 Eat
To The Beat; 6 Hanging Around; 9 New York Dolls; 10 All The Young; 11
Green Onions; 14 Ono; 16 Money; 18 Brown; 22 Opus; 24 Rat (Scabies)

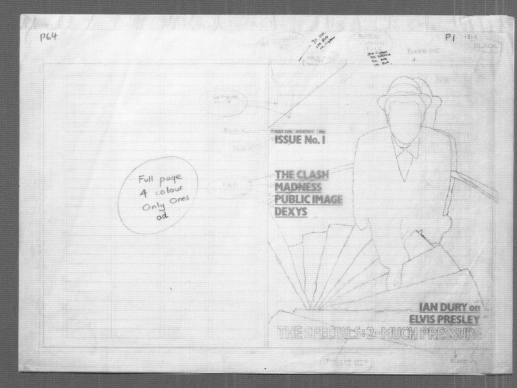

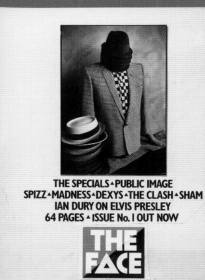

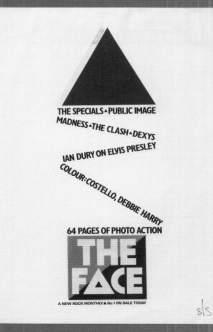

top
Paste-ups for the cover of the first issue.

above left and right
Paste-ups for music press adverts in the first issue.

Showing a debt to French news weekly *Paris Match*, Logan and Steve Bush designed the magazine and produced layouts and paste-ups over a series of weekends and evenings, coming up with a square blue and red logo, which drew on the bisected flag of the 1930s anarchists in the Spanish Civil War.

Watching the presses roll on the first issue, Logan was disheartened by the volume of waste paper used in the process of colour balancing. 'Then, when I visited the unsavoury toilet, I looked down to see that stray page proofs were all over the floor,' says Logan. 'I was literally pissing on my investment in the paper stock.' Handed the two thirty-two-page untrimmed sections to take home, Logan was unimpressed with the lightness of the magazine. 'It felt so flimsy compared to the proofs I'd been handling, hardly justifying asking people to shell out 60p a copy. I was totally distraught and drove home thinking I had also pissed away my life savings.'[8]

Contributors were predominantly photographers – of the twenty-seven listed, one third wielded cameras. Most had *NME* and *Smash Hits* connections, though Logan, inspired by the DIY aesthetic of punk fanzines, also provided space for untested writing talent. An example is the singer Vaughn Cotillard (under the pseudonym Vaughn Toulouse). Logan commissioned him to write a feature about his memories of following The Clash on tour around Britain in 1978 and Toulouse's friend, *NME* receptionist Gary Crowley, reviewed the recently released film about that tour, *Rude Boy* (see pages 28–31). Liverpudlian Kevin Fitzgerald's stream-of-consciousness encounter with Public Image Ltd stemmed from a fan letter he had written to frontman John Lydon (this also appeared in a different form in an issue of *Smash Hits*), and a story about The Spectres, a new project from Lydon's former Sex Pistols bandmate, Glen Matlock, was written by London College of Printing student Neville Brody, who had swum into Logan's ken at *Smash Hits* but was yet to contribute graphic design ideas. There was also a submission by performer Ian Dury, reviewing a published volume of Alfred Wertheimer's photographs of Elvis Presley in his 1950s pomp, but it was the upbeat, inclusive, utterly contemporary 2 Tone that dominated the issue, starting with Chalkie Davies's cover shot of the tonic-suited, Bluebeat-hatted leader of The Specials, Jerry Dammers, emerging from a basement staircase.

Logan dispatched Chalkie Davies to obtain a cover photograph of the group on a trip to a gig in Paris. 'We did some shots backstage but it was too dark and getting all seven of them together at the same time was never the easiest thing in the world', says Davies. 'The cover shot was Jerry in his stage outfit coming upstairs from the dressing room. He's smiling because he's about to go onstage.'[9] The cover flagged a seven-page feature on the band, while there was also a four-page photo-essay by another music photographer, Jill Furmanovsky, on a recent trip to Manhattan by their London confreres Madness (see pages 32–33).

'As much as I wanted to share my enthusiasm for the groups, it was also about the clothes they wore,' says Logan of his decision to run a four-page feature on Johnson's The Modern Outfitter (see pages 34–35), a boutique selling the best of 2 Tone's clothing, operated by another former Mod, Lloyd Johnson, in the World's End area of the King's Road. Written by moonlighting *NME* contributor Adrian Thrills, this afforded an opportunity to showcase the designer's 1960s chequerboard collection with eight photographs by Sheila Rock, whom Logan had commissioned previously at *Smash Hits*.

'Featuring Lloyd in that first issue also lent itself to the reportage feel I wanted; the phenomenon of him and his shops [the retailer also had an outlet in Kensington Market] was largely ignored by the media of the period,' recalled Logan. 'The fashion of interest to me might pop up in the odd snippet in girls' magazines *Honey* or *19*, but that was about it. Including four pages on Johnson's sent out a strong signal as to what we were about.'[10]

This was the right time for forward-looking media players to establish strong links with the street-level fashion industry. By 1980 the value of British fashion exports totalled £435 million, representing a growth of 500 per cent from midway through the previous decade. Punk and post-punk had shaken up the rag trade, and much of the growth came from independent boutiques and what was known as 'designer fashion', since the national clothing manufacturing industry was by now in steep decline.[11] Yet Logan appeared alone among his peers in believing street style worthy of consideration. Johnson's business was also important in banging the drum for the newly launched title. 'My promotional campaign, to give it a fancy term, was based on getting copies to places like Lloyd's where I knew appreciative people, among them hopefully some readers, would gather,' says Logan.[12]

There were a few contributors to the first issue – notably Julie Burchill – who used the greater freedoms afforded by the monthly format to explore interests beyond the narrow confines of the promotional pop interview. Burchill and her then-husband Tony Parsons were on board from the start, having burnt their bridges at the *NME* under Neil Spencer by refusing to even attend the editorial offices, let alone file copy alongside the rank-and-file rock journalists they openly despised. 'When we quit we

opposite
No. 1, May 1980.

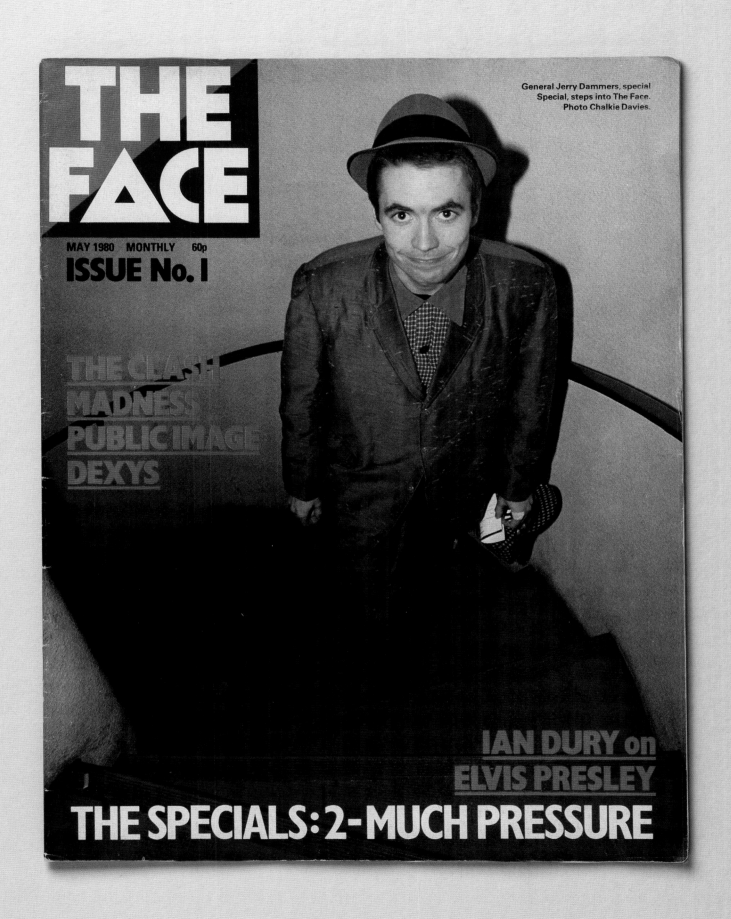

General Jerry Dammers, special Special, steps into The Face. Photo Chalkie Davies.

THE FACE

MAY 1980 MONTHLY 60p
ISSUE No. 1

THE CLASH
MADNESS
PUBLIC IMAGE
DEXYS

IAN DURY on
ELVIS PRESLEY

THE SPECIALS: 2-MUCH PRESSURE

WRECKLESS ERIC LOOKS AT LIFE

His music
It's in 4/4 time and most of it seems to be in the key of A for some reason.

Metropolitan Life
I used to live in Wandsworth but now I live in Barnes. I feel really international.

Careers
I was a quality control inspector in a lemonade factory. I was the best quality control inspector they ever had. They told me so.

Lene Lovich
. . . stinks of garlic that woman . . .

Stagecraft
Once I was playing bass in a band and I walked off with my bass still plugged in. Pulled a big Marshall amp off stage with me. I just wanted to go have meself a piss.

Sophistication
I'm quite a civilised person really. I mean, I must have gone into about six pubs last night and I wasn't asked to leave any of them. That's quite civilised, isn't it?

Musicianship
I used to keep my bass in a wardrobe out of sight. The trouble was I could play it but not sing at the same time . . .

The Press
There was this review the other week where this bloke starts dribbling on about Gauguin. I mean, I'm sorry to say this but these people are writing absolute fucking crap.

Rickie Lee Jones
Dodgy boiler, dodgy songs. She'd look alright with somebody else's head.

The Spectres (l to r) Danny Kustow, Art Collins, Glen Matlock, Graeme Potter, C. C. Smith. Photo Peter Ashworth

STEPPING STONE . . .

GLEN Matlock, former Sex Pistol and Rich Kids bassist, and Danny Kustow, former Tom Robinson Band guitarist, first met three years ago at a TRB gig. During the set Kustow bit on a blood capsule. Matlock was alarmed; he thought the band's singer had punched him in the face!

Last summer, after the greatly underestimated and misunderstood Rich Kids parted company, Kustow and Matlock formed a group with Steve New and Budgie, the latter standing in on drums in between spells with The Slits and The Banshees.

Tentatively titled the Jimmy Norton Explosion after an art student Glen knew, they played only a few low-profile gigs on the club circuit before Glen and Steve went off to work with Iggy Pop on European and American tours, subsequently recording

the "Soldier" album with The Ig during stormy sessions at Rockfield.

Matlock and Kustow reunited at the end of last year and conceived the idea for The Spectres (a name which is a shade more dynamic than Jimmy Norton Explosion) on New Year's Eve. Auditions boosted the line-up to five, with Art Collins on sax (he spent six years in the Grenadier Guards learning to play!), Graeme Potter on drums, and C. C. Smith, ex of Gloria Mundi, on sax and organ.

The Spectres sound is a full one, a pop style rooted in rock, reminiscent at times of vintage Mott The Hoople. It's mostly fast-driving and danceable, smoothly finished and confident if lacking in experimentation. Songs include "Ambition", written initially by Glen for Iggy Pop, and "I'm Hooked (Line & Sinker)", sung by Danny. Lyrics are mostly concerned with the emotional rather than the intellectual, unlike The Spectres' Cold and Moderne contemporaries.

Says Glen: "The only reason I wanted to play music was to try to get ideas across that you can't in other fields. Not literal ideas but more feelings and creating moods. I don't like the modern art bands much, that tortured artist as an art form bit. As you become older you get more confident, you tend towards things that are interesting without being clever-clever. It's a more natural thing, to make you feel. I think some of Lydon's stuff is just a drone, but you can write modern music that is melodic and harmonious. Eno makes good music."

Matlock and Kustow say that The Spectres are consciously avoiding 'this week's look', playing the image game.

"People are clutching at straws," says Glen. "The problem is that bands come and play the clubs and everybody gets into them, then they get a bit of success and move out of town. What is left are all the second-rate copyists, after the peers of that particular style have gone. It's happened to ska as it

happened before with punk, and then all this revival shit came in. The other problem is that the record industry is in a real slump."

The group are without a manager, fixing their own gigs and promotion, keeping close control over artwork/publicity etc. This doesn't imply a totally democratic approach though.

"With the Rich Kids it was so democratic it was ridiculous," says Glen. "There were so many people at the rehearsals putting their comments in that there was no point in opening your mouth. This time, though, I put my foot down. It's more totalitarian."

In the end maybe the build 'em up knock 'em down reaction to the Rich Kids will prove educational. This time Glen feels confident that a well-considered, stepping stone approach will allow The Spectres to materialise more completely than the Rich Kids did. It's early days but they're well worth catching while they're still playing the clubs.

NEVILLE BRODY

Walt Jabsco's dad models rakish trilby, six months behind Tony Parsons but two years ahead of everyone else. Archive snap Andy Kent.

Hey Paul, show us yer pistol! Tattooed love boy portrait by Sheila Rock

THE LODGER'S TRAVELS

DAVID Bowie's been putting himself about in New York this past month or so, recording a new album there with producer Tony Visconti, and hanging out at local gigs.

The Thin White Wonder was a particularly enthusiastic punter at The Specials' New York concert, along with Debbie Harry and Mick Jagger.

Bowie is believed to have one more album to deliver to RCA before the expiration of his contract, but his label can only guess at a release date. They knew nothing about "Lodger" until the tapes and artwork arrived special delivery.

Chances are that Bowie will re-sign with RCA after renegotiation of his deal, giving him control over his back catalogue which would be open to TV album exploitation, and suchlike, if he moved on.

18 The Face

The Face 19

realized no one had heard of us,' said Parsons later. 'But Nick Logan was always there to slip us a job. The stuff I did for *The Face* was much more reflective.'[13] While Burchill had little time for Logan – describing him, after their first encounter in 1976, as 'skinny, rattled, scum-surfing. I learned he had been a big Mod. They all looked like that in later life; scared stiff, because they'd glimpsed Nirvana and settled for Neasden. Or, in Logan's case, Wanstead'[14] – she recognized the road out of the inky ghetto offered by *The Face*.

'I could see no point in preaching to the converted for the rest of my unnatural life,' wrote Burchill in 1998. 'And so at twenty I was working for *The Face*, at twenty-three for the *Sunday Times* and at twenty-six for the *Mail On Sunday*. In those days, writers from the pop papers didn't write for the proper papers, mainly because no-one ever asked them to.'[15]

Similarly, Parsons recalls: 'To find things that excited me as much as punk did, I had to look outside music. Nick Logan drove me to the airport.'[16]

In the May 1980 issue, Burchill's page was putatively dedicated to reviewing new singles but the addition of 'roughly speaking' in brackets in the stand-first indicated that, from hereon in, she would be using the magazine for the dissemination of her strongly-put opinions (in this case lambasting BBC pop channel Radio One and its DJs; see pages 36–37). Articles including Burchill's struck a chord with early adopters, among them Sheryl Garratt, who had come out of Birmingham's 2 Tone and Rock Against Racism scenes and was at that point a student living in London contributing occasional reviews to *NME*. 'I loved it from the off,' says Garratt, who became editor of the magazine in its 1990s manifestation and is now a leading media figure. 'The *NME* – which was really the only other game in town – had not responded to the ways in which music had changed by still concentrating on rock, but the music being played in the clubs or by people I knew like The Slits was much more diverse. I'd offer them stories on a funk or reggae band and they would commission the odd piece but it felt restrictive. You looked at *The Face* and thought: "All the stuff I want to read and write about, there's room for it here."'[17]

Even though 2 Tone had started to lose momentum in the spring of 1980 as its music and visual identity was absorbed into the mainstream, the choice of Dammers as cover star was important, as Logan recalls: 'I knew I could find something more current by the time we came out, but The Specials embodied everything the magazine aspired to; they had a look, passion and great music so there was never an alternative. In a sentimental way, I owed 2 Tone for the inspiration to pursue the idea.'[18]

For the magazine's future fashion and features editor Kathryn Flett (now an author and national paper columnist) the arrival of *The Face* was a godsend. She remembers stumbling upon the magazine for the first time as she browsed the shelves of a branch of WHSmith one Saturday in Watford, in suburban north London, the week it was published.

'I was sixteen and already a magazine addict; I'd bought that week's *NME*, *Cosmopolitan* was read by my Mum and while I liked *Honey* for the fashion, it didn't have much about music', says Flett. 'I was that bit too young to have engaged with punk and here was a magazine with Jerry Dammers staring from the front cover. It spoke directly to me. I think I was wearing a black-and-white ensemble with an asymmetric haircut somewhere between the B-52's and 2 Tone. I'm not exaggerating to say that finding that first issue was an epiphany.'[19]

James Truman, on the other hand, was less impressed, at least at first glance: 'I remember thinking that Dammers walking up a staircase was not very exciting. Then I opened it up and saw that there was something going on. I'd grown up with an older sister and loved reading her copies of *Jackie* and *Fab 208*, appreciating the magazines' vibrancy, colour and chattiness; by contrast, the rock press was, pre-punk, extremely earnest and entirely male. So I got *The Face* immediately on those terms: it was a clean break from the then-dominant music papers. It was printed on good paper, had colour photography, and, even in the first issues, a voice that was playful and both masculine and feminine.'[20]

Chalkie Davies took a press photo to announce the new title, showing Logan standing in the middle of Carnaby Street brandishing copies of the first issue. London's daily newspaper the *Evening Standard* ran another photograph of Logan again clutching copies of the magazine. Journalist Robin Katz introduced the owner/editor/publisher to the paper's readership as 'either a maverick or masochist', since he had given up the 200,000-selling *Smash Hits* for a risky adventure into the unknown.[21] The world was about to find out which of these traits best characterized Nick Logan.

WHAT THE RUDE BOY DOESN'T KNOW

Written before screenings of 'Rude Boy', this is a Clash fan's account of touring from the trenches. Vaughn Toulouse (pictured left) quit the dole in Plymouth to follow the 1978 Clash tour. This is his story. Pennie Smith took the photos during '79 and '80.

F OR a while back there in the summer of '76, I was fast losing hope in the future of rock and roll. Where had all the gangfights gone? Where were the seat-slashers now?? From where I was—living in Plymouth, digging out the vinyl past of Motown, Trojan and Stax in the second-hand shops—it seemed like the only rock and roll future worth shouting about was Bruce Springsteen, and he hadn't done anything new in over a year. Discovering The Clash was in the order of a personal revelation.

When the 'Anarchy In The UK' tour rolled into Plymouth in December '76 the charts were full of Showaddywaddy, Johnny Mathis, Queen, Chicago, ELO and . . . need I go on? A month had elapsed since Fleet Street splashed the Bill Grundy business over their front pages, and the Sex Pistols single had climbed from No 42 to No 38.

Good or bad, all this publicity had little effect on the citizens of Devon and Cornwall. Only 50 or so punters turned out on each of the two nights that Woods Club opened its doors to the Pistols, The Clash and The Heartbreakers. Was this the opening salvo in a gutter-rock upheaval destined to

blow the UK pop scene apart at the seams?

I know what it meant to me. I hadn't had a buzz like this since the early '70s when I watched the likes of Alice Cooper, David Bowie, T. Rex and Mott The Hoople on the box and wished to hell I was old enough to compete with these mad cats. Now at last a new sense of urgency was rearing its ugly head and this time the walls were gonna sweat again for sure.

And they did. The first Clash album landed in the BRMB chart at No 12, their own 'White Riot' tour followed, the summer of '77 brought the Sound Of The Westway, and a hundred more punks picked up cheap guitars and figured out how The Ramones did it.

B Y the time 'The Clash Sort It Out' tour came around in the winter of '78 yours truly was on the dole, bored and broke (yeah, some of us still were!). The dates were in the music papers and, since I had nothing else to do, I decided to hook up with the tour in Bristol and just hang on for the ride. Go wherever it took me.

Continues page 50

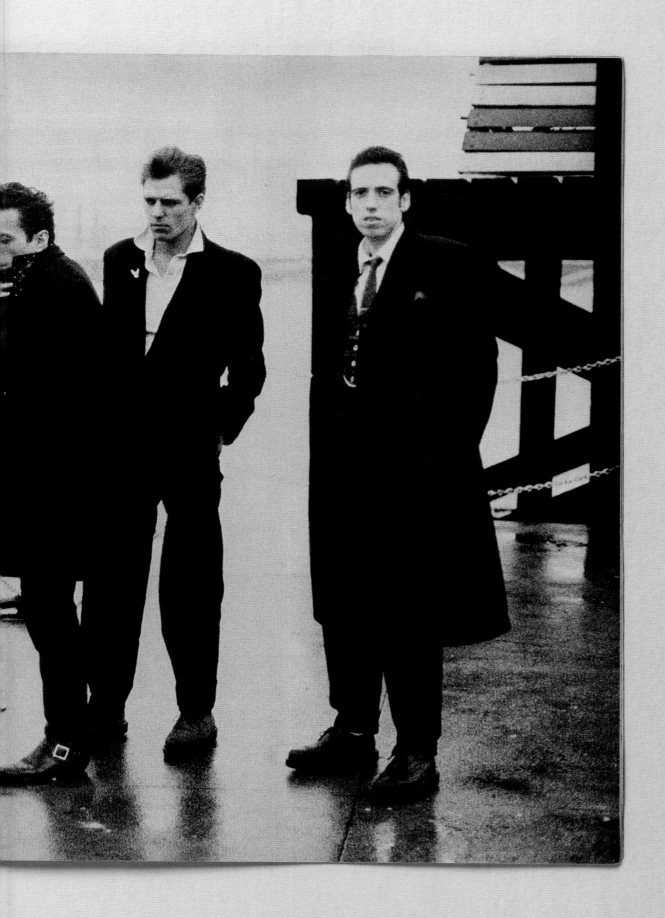

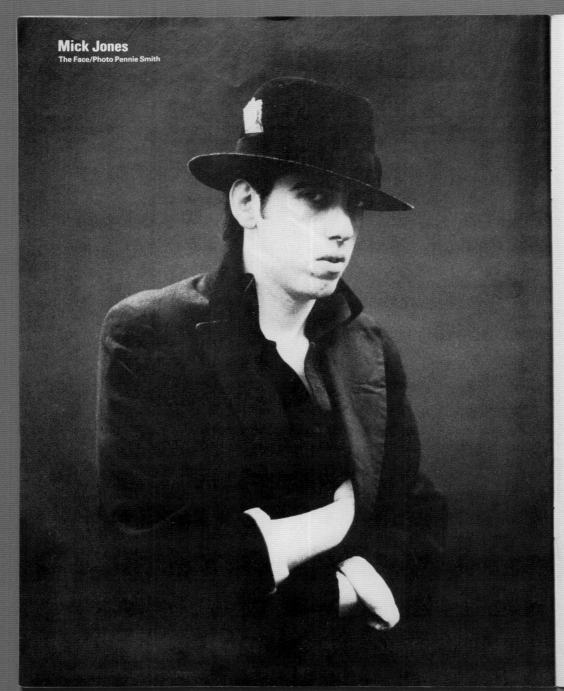

Mick Jones
The Face/Photo Pennie Smith

From page 50
featuring Strummer's adlib vocals and Topper's reggae drumming, they can set the mood perfectly for the night ahead. It's at times like these I understand how kids get inspired to form their own groups.

By the end of the soundcheck I was well hungry. I'd noticed the groups and road crew going to a food bar and returning with baskets of pies and chips, with no apparent signs of readies changing hands. Why shouldn't it work for me? It did, but I sat and ate my free nosh as close to the road crew as possible, trying to look like part of the same operation.

Similar bare-faced nerve got me a place to stow my belongings for the duration of the gig. Having changed in the khazi into clean t-shirt and spare jeans, I strolled up to the cloakroom attendant, told her I was with the group, and walked away with a free cloakroom ticket. *What, me tight?* Yeah alright, but there were a lot more gigs and towns to come and £20 wasn't going to last long if I splashed it around on 'luxuries'.

I never had any real trouble with bouncers either on that tour. Not that it doesn't happen of course. Many a geezer with an arm in a sling will testify that it does, but I was lucky. The only real liberty I took that night was to nip out after the main doors opened and flog my ticket (the locals I'd been talking to earlier kept the stage door open for me). No point in wasting my money when I'd got in through the back.

It didn't take long to work out some kind of system. Usually, by the time The Slits piled on stage, I was halfway to pissdom. If I bought enough drinks myself that gave me the courage to ponce drinks off fellow punters or to half inch the fuller glasses left unattended on the tables.

The Slits were great. They take the rise out of audiences something rotten, and Ari Up is a terrific little mover. Gradually, as they came to recognize certain faces night after night, The Slits would offer us cream crackers, hunks of cheese and oranges, food probably lifted from the hotels.

After a few gigs I also got to know when the groups went on stage and the time, approximately, when the audience began to knot itself into a near unpenetrable mass. If I chose my time, I could struggle into a good position just before the groups came on, saving the hassle of being stuck in one position all night or of missing out on the real action down at the front.

My position was always stage right—in front of Mick Jones. By my fifth gig on the 'Sort It Out' tour, Mick was used to seeing my mush in the same place and sometimes I got a swig of his bevvy. (Some occasions it was brandy—hate the stuff but beggars can't be choosers.)

When the gig was over I collected my belongings, returned to the khazi to wash up and wipe the lumps of gob from the back of my head, changed back into my 'street gear' and made my way backstage.

Most nights, unless I had a train to catch to the next gig, I'd waste as much time as possible hanging about backstage with the group,

above and opposite
'What the Rude Boy Doesn't Know', no. 1, May 1980.

30

eating the
ng room.

f course,
going to
g me
ardiff Top
Joe
n that my
when he
e for a
ally he and
gan to
t handle
whatever.
Tom,
oy and
ular
rigade.
erent
ne and
n Ray

As individuals The Clash are as
different as four geezers you'd
expect to meet anywhere. Mick
Jones is probably the most
instantly likeable. In the company
of fans he seems really friendly,
putting himself out to talk to
people. Topper runs him a close
second, salt of the earth type I
suppose.

Joe struck me as being blunt
and straightforward. If he doesn't
like someone he ignores them.
Paul Simonon, on the other hand,
tells them where to get off. He's
the quiet one, cool as cucumber,
no airs and graces.

Things got easier the more we
got to know the group. If they
knew that otherwise we'd be
sleeping rough, sometimes
they'd allow us back to the hotel.
Talk about Secret Service. They'd
Continues over
The Face 53

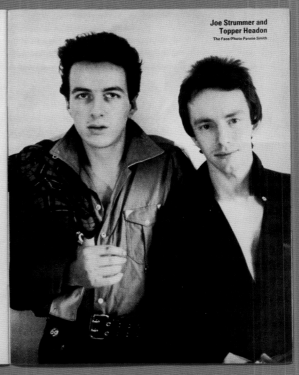

Joe Strummer and
Topper Headon
The Face/Photo Pennie Smith

Mick's turn to wear the trilby.

From previous page
sneak up to their rooms,
dodging the manager, and fix us
up with cushions on the floor.
Hearts of gold, eh?

One night up north when Mick
got me into his room, Topper
and his girlfriend followed us in and
told us that I'd been one or
of the hotel staff. Joe,
meanwhile, was in the process of
kneeling in another couple of
worn-out followers. It was
suggested that I kip down in Joe's
room with the others, in case the
manager turned stroppy and
checked up on Mick, which was
exactly what happened a few
minutes after the switch.

On other occasions it was a
case of strolling into the night
looking for an empty train
awaiting its morning call. In Bristol
I slept first class, a rolled up jacket
doubling as my pillow.

Next morning I'd head off to the
next town, unless returning to my
home base—which I did once a
week—for a bath, change of
clothing, and to collect more dole.
It was an experience I wouldn't
have missed for the world.

THE Clash at this time were
equalled in performance by
no one. At times The Jam,
Pistols and The Ramones have all
come close, but they have never
bettered live Clash on form. Why?
It's hard to explain. it's just a
personal happening. Coming
away from a good Clash gig, to
work or talk, ears still ringing the
following morning, even when
you haven't a clue where you're
wringing with sweat, hardly able
going to kip for the night . . . that is
my idea of The Perfect Evening.

It was sad to see it end. The
Clash made tracks for the States,
pastures new and unconquered. I
did one more tour. Stiff Little
Fingers, Essential Logic and
Robert Rental hit the M1 in
February and I was off again. I'm
past all that now. I could never see
myself as one of those doddering
over 21s, watching contentedly
from the back of some hall while
the youth movement changes
hands, the 14 year olds become
15 year olds and so on. I reckoned
it was time to get my own group
together. I mean, who knows
who's next?

*Vaughn's group is Guns For Hire,
a Korova recording act. They're
good.*

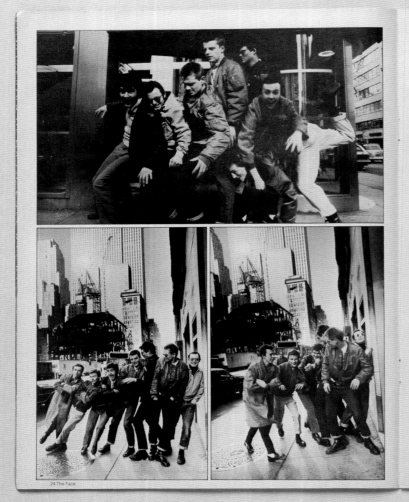

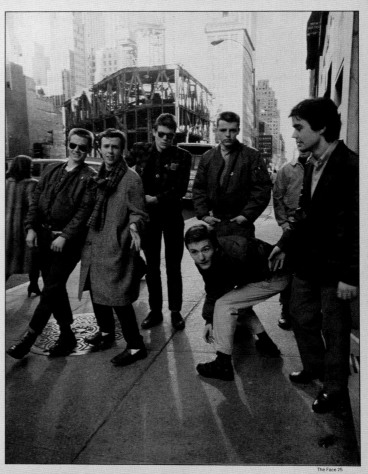

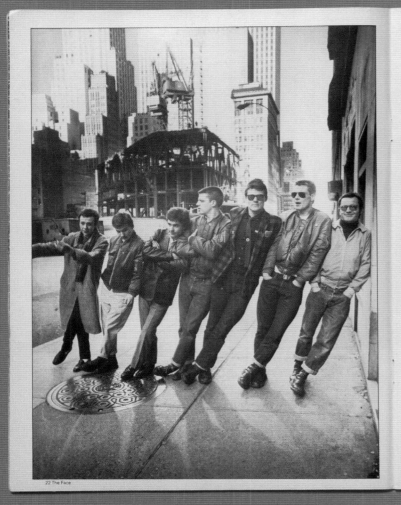

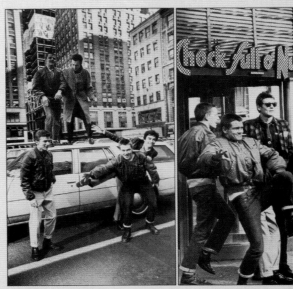

MADNESS

THE BRITISH ABROAD: Jill Furmanovsky ambushed Madness for The Face during the cuddly combo's recent visit to New York. Reminded of their roles as Ambassadors Abroad (licensed to Prank for Britain), they didn't take much persuading to leave the comfort of Warner Brothers' ('Ere, which one's Jack?) tower block to perform their repertoire of nutty gymnastics on the Manhattan sidewalks, despite brass monkey temperatures of minus 15 degrees. So keen were they to make with the Olga Korbuts that all seven, plus photog, crammed into the same lift, jamming it on the way down. In a car park across the road a short spell of hood-hopping (bonnets to Brits) drew a predictable response from an Eagles-loving Puerto-Rican car park attendant, who was unappeased by the group's insistence that it was their car. And so, round the corner to Madison Avenue and the Chock Full o' Nuts, where passing New Yorkers fled for the subways at the sight of Camden Town's finest going through their act. This is an Arse About Face presentation. . .

Nutty camera-work: Jill Furmanovsky

22 The Face

The Face 23

opposite and above
'Madness', no. 1, May 1980.

below and right
'Meanwhile Back at the End of the World', no. 1,
May 1980.

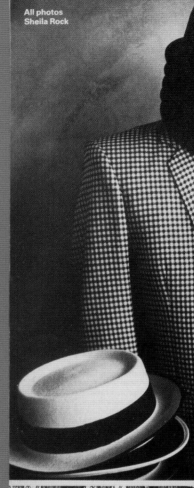

All photos
Sheila Rock

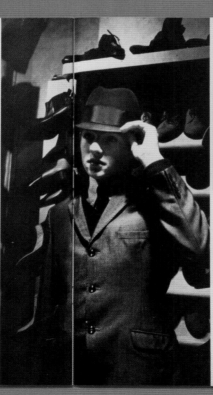

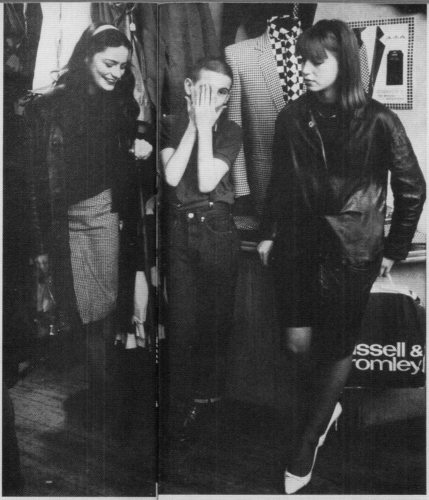

MEANWHILE BACK AT THE END OF THE WORLD

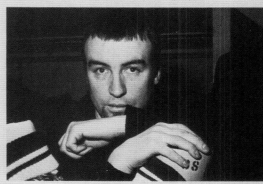

Just around the corner from where McLaren assembled the Sex Pistols is a clothes shop run by a former Hastings mod. Johnson's has a reputation as London's premier mod shop but stocked its first mohair suits over two years ago, and the mod look is only one development in designer Lloyd Johnson's continuing policy of experimentation: "Basically we're a shop selling rock'n'roll clothes." Adrian Thrills bought a return ticket to the World's End. Photos by Sheila Rock.

THE World's End is an ill-defined patch at the southern tip of the King's Road in London. An area of squat town houses, supermarkets, the odd corner shop and the terminus of the No. 31 bus. The name alone is testimony to the fact that the place is a world away from the loathsome Sloane Ranger snobbery of the trendier Kensington end of Chelsea.

Three years ago, punks would loll away lazy Saturday afternoons in bondage strides and anarchy tops—can of half-full lager compulsory—outside Malcolm McLaren's Sex/Seditionaries emporium.

Last summer, they marched in the street as police moved in and closed down the Beaufort Market.

But nowadays the centre of most interest and activity in the World's End is a clothes shop run by a former Hastings mod. The shop in question is Johnson's, widely regarded as *the* rock culture clothes shop. A casual glance at *Top of the Pops* most weeks will show why, with everyone from the likes of Madness and The Jam to the Boomtown Rats and the Blockheads more often than not kitted out from trilby to toecap in dread duds bought in the Chelsea boutique.

The brains behind the shop are quiet-spoken 34-year-old Lloyd Johnson, who designs all the male ranges, and his younger partner Peter Boutwood, who handles the manufacturing and business side of things. But the emphasis of the whole Johnson operation is on teamwork—Lloyd's girlfriend Jill, for instance is

Continues over
The Face 45

SINGLES (roughly speaking)
by Julie Burchill

THE pop single—that patron saint of an agony and ecstacy as transient as teenage itself—doesn't become the radio. Or rather it could—a good pop single, conjure up, say, Dexy And The Midnight Runners', on a tinny transistor beats all the let-me-play-you-my-new-single-in-stereo sober sound systems in the world.

Nothing hurts the young heart that runs free better than a crucial song coming over the radio unbidden; it's as close as youth tends to come to a spiritual experience.

But it's no good, because of
a) the Radio One playlist;
b) the D.Js.

The playlist should immediately be done away with because it induces what is supposed to be a department of youth to play MOR by people of forty and over (Herb Alpert) and children's records—children are no more youth than the over-thirties are—by tarted-up old actors (the appalling "Captain Beaky" saga, so pathetically taken up as a "jokey" (many a true word etc) cause celebre by the Radio One D.Js, so desperate for a campaign that won't scare anyone or change anything).

Ostensibly the playlist is a broad-minded chap—now that what was once a battle-cry is a calling-card, we get Jam every day and The Clash till you could be forgiven for thinking one of their old dreams has come true and they've taken over the public broadcasting system—but like all liberals its tolerance is simply a lack of standards in disguise. It has embraced the classy ska, but six months ago it clutched at the drowning Mod (Jobriath in a mohair suit) with the same sycophantic fervour.

If no one knows your name, there are three ways of getting on the playlist; any cover version of a Sixties song immediately receives constant airplay, which is why all the so-called "Mods" and "new Blues bands" are flogging Sixties standards to death.

Another route is to make a record that sounds like 1977-1978 Elvis Costello, all hurried jangling guitars and girls-and-life-in-general-stink lyrics—The Sports, The Jags, The Tigers and Any Trouble have all gone this route and been rewarded by the D.Js. Most successfully, you can appeal direct to the D.Js ego—the radio figures in today's songs the way high school did twenty years ago. Recent examples that Radio One has played to death have been "Spirit Of The Radio", "Who Listens To The Radio?" "I Am A D.J", "Pilot Of The Airwaves", "Ten To Eight", "Video Killed The Radio Star", "Radio Radio", "On My Radio", "On The Radio" . . . of course the all-time turntable hit about turntables is the epic "W.O.L.D." of the early Seventies, the one that first detected the Achilles ego of D.Js and started the epidemic.

BECAUSE no one likes to think they're a total cretin, the Radio One D.Js have a habit of choosing as their Record Of The Week a single that blinds them with words and points out nothing new in a very roundabout fashion, which they then plug jealously and incessantly as proof that although they play the dictated disco and pop they're all Thinking Persons. Kid Jensen is the funniest one for this, championing laughably moderne singles for weeks on end and using words like "creative" and "cold" (!) in a voice full of admiration for their po-faced makers.

The rest are all Kid clones; they all look like hairdressers obsessed with not looking like hippies or pooves, but equally obsessed with looking trendy. They are all irretrievably old-fashioned; they use football references, as do the music papers, as the Open Sesame to the Grotto Of The Hip Prole Lads—Tony Parsons suggests I should use a stamp-collecting frame of reference to illustrate how precious the football-crazy act is; "Comes at

you like a Penny Black in a Bargain Basement."

They leer over the airwaves at bands with female singers, carressing their names, ostentatiously begrudging the boys in the band their proximity to this week's sweetheart; "the lovely Chrissie Hynde . . . and The Pretenders"—"the lovely Debbie Harry . . . and Blondie".

Sexism is a very unstylish thing, as sordid and repressed to the cool ear as racism, and that the mainstay of their entire collective patter is leering, winking and nudging may be one of the reasons why the standard of D.Jing in this country is so pathetically low.

A pack of blow-dried Samsons holding up the twin pillars of Radio One—cliche disguised as comment, sycophancy disguised as youthful enthusiasm.

With three exceptions; Paul Gambaccini is the only truly professional (i.e. never irritating) D.J around, never babbling or forcing himself between the listener and the record, the nearest thing yet to that perfect, pure, ego-transcendant D.J who just announces the record and plays it on the mythical Spartan radio. Peel is a bore, but at least he's a bore with a brain, and Blackburn is at least slightly opinionated.

Though these two seem to share nothing—one could scarcely imagine two more different radio shows than Blackburn's Sunday Top 40, in which singles are played purely for their chart status, and Peel's four times weekly mumble, in which records are played purely because they aren't in the charts—they are the only D.Js (the rather uninteresting Gambaccini apart) who are not totally bland, chatty and sycophantic, the only D.Js who are critical.

In 1978, when punk had got crummy and Radio One had decided it was safe to play, the rebel Blackburn played the latest Sham 69 single and affected a moronic Cockney accent in which

he mouthed moronities all through the record—of course this was before he was cautioned, and these days when he doesn't like a single he merely says cheerily "How about that then?" after it.

BLACKBURN'S Top 40 is the most listened to show in Western Europe, and Peel's is the most fashionable, the one that most tries to pretend it's not merely some records on the radio—but they both have roots; Peel's early ear for punk, and Blackburn's neglected early Seventies constant plugging of Motown's second Golden Age, when the psychedelic black shack had been demolished and a younger, stronger hit factory had been built—those days of the Jackson Five and the abandoned, funky Supremes after Diana Ross had left to concentrate on a career modelling sequins.

The Blackburn show was heaven in the early Seventies; the nearest thing yet to the Negro radio shows renegade American WASP kids are alleged to have listened to under the mid-Fifties bed-clothes.

No doubt that John and Tony are young at heart; still, their been-around, respectively low- and high-profile skeptical voices, often sandwiched between fresh young records of considerable hope and naivete, leave a lot to be desired.

Perhaps the biggest barrier between English radio and a Rock Dream, even more so than the playlist and the patter, is the irretrievable age of the D.Js—the established ones are on their way to forty, and the bright young things will never see thirty again. A token youth isn't the answer either—Radio One already has a token woman, and look what a fool she is—but a massive overhaul probably is.

It's certainly the only thing that will make Radio One stop sounding like that modern nightmare—the parent who, to achieve rapport, learns all the words to every song in the chart and sings them incessantly. ▲

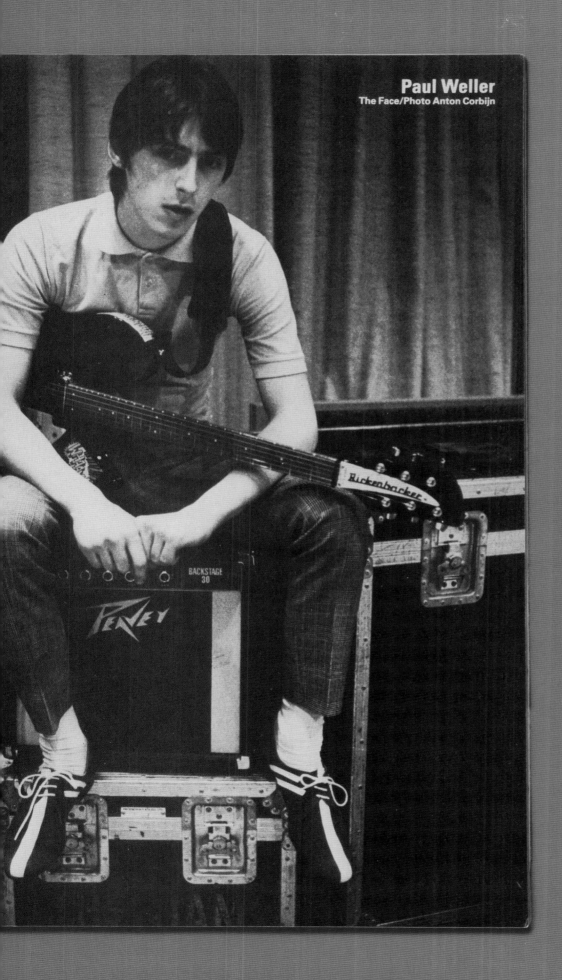

Paul Weller
The Face/Photo Anton Corbijn

left
'Singles (roughly speaking)', no. 1, May 1980.

Chapter Two

The Cult with No Name

The Cult with No Name

Publishing the first issue of *The Face* on 1 May 1980 had not been Nick Logan's plan. He had intended for the magazine to be available ten days earlier but was delayed by disruptions to distribution caused by a strike by the National Graphical Association print workers' union in Britain in the spring of that year.

The industrial action now at an end, with the second edition in June (featuring Paul Weller on the cover), Logan achieved his ambition of delivering *The Face* to newsagents and subscribers at the beginning of the final week of the preceding month, granting the title a pace and newsworthiness that rivalled the monthlies and weeklies with which it was in open competition. 'We worked on a very fast turnaround and would always go to the wire with copy and photos,' says Logan. 'That way we could be sure we kept our readers up to speed.'[1]

This necessitated sticking to a strict, if not to say physically punishing, schedule. Having approved final proofs at the north London repro house, Logan would make the three-hour drive to Caerphilly in Wales on the night of the third Sunday of every month and see each issue through the presses usually into the early hours of the following Monday. The first copies of *The Face* were available to buy on the Wednesday, just two days after the issue had gone to press, at the news stand behind the London Palladium in Great Marlborough Street (this remains the place in the capital to pick up the latest editions of dozens of magazines).

With stockpiles kept in a spare room at their home in Wanstead, Julie Logan, assisted by her mother and sisters, spent the rest of the week packing and addressing subscription envelopes, and on Saturday morning Logan drove these to his local sorting office in Fillebrook Road, where he would wrangle with grudging posties, who were keen to shut up shop at midday, to ensure the 'subs' were sent out. In the afternoon Logan took his car around central London, dropping off copies and picking up 'unsolds' ('often a depressing exercise') not only at Lloyd Johnson's outlets but the independent record store Rough Trade in Notting Hill, Antenna hairdressers in Kensington as well as other clothes retailers such as Demob (Soho), Jones and Paul Smith (both in Covent Garden) and Woodhouse in King's Road. 'That handful of places was about it as far as London was concerned,' said Logan of the capital's hip outposts at the turn of the 1980s. 'I don't think people today can comprehend a time and a place where you couldn't get proper coffee, where you had to travel considerable distances to eat decent food or buy decent clothes.'[2]

Also from day one, and for the next nineteen years – mindful of the financial quagmires into which his father had plunged the family – Logan maintained a bookkeeping system of his own devising, with spreadsheets of expenses and forecasted and actual income for each issue. 'I wanted to make sure I had enough money to cover the bills and move on to the next issue, which would hopefully be bigger and better,' he says.[3]

A factor in *The Face*'s progress from issue two was the presence of journalist Steve Taylor, whose work had appeared in a variety of publications, from *Melody Maker* and *Time Out* to women's magazines and the Sunday supplements. 'Nick told me that the only reason I didn't work on the first issue was that he couldn't track me down in time,' Taylor, now a business start-up consultant, recalls. 'He approached me because I was a freelancer who primarily wrote about music from a grown-up point of view – I was twenty-seven – and also wrote about general-interest stuff.'

Taylor remembers the Carnaby Street office as being one of a warren of small rooms separated by flimsy partitions. 'I used to visit to deliver copy and met other contributors. I started writing a lot of copy; for those first issues what others didn't file, I did.'

According to Taylor, Logan defined the new magazine's audience as the former readers of the *NME* who were school-leavers, at university or starting work: 'They still followed music but had outgrown the *NME* and were hungry for information about all sorts of other stuff, whether it be film or clothes. Nick's aim was to produce a more sophisticated product where music was still the dominant element. He also said that it was to be like the *NME*'s colour supplement.'[4]

With Taylor producing a steady flow of interviews and features, Logan worked on his own, with occasional input from Steve Bush, to make constant tweaks to the format and the content mix. From August 1980 and the publication of issue four, for example, Logan made explicit the break with his past by instituting the cover line 'Rock's Final Frontier' underneath the box masthead; this was to appear for the next seven issues.

Logan was, in the main, single-handedly manning the cluttered office that constituted *The Face*'s headquarters within the Emap set-up. There were occasional drop-ins; as reported in issue three, Jerry Dammers visited soon after the magazine first hit the streets to get hold of a copy because a local bank wouldn't cash him a cheque without ID.

For the most part, Logan was on his own, as early contributor, the photographer Derek Ridgers, recalls. 'In my memory it was just Nick beavering away, doing absolutely everything from selling ads to sizing up pictures and sorting layouts to writing copy.'

In a worrying development, Logan was persuaded by distributor Comag to press the button on printing 90,000 copies of issue four, which featured post-punk/goth performer Siouxsie Sioux on the cover (see page 40). This sold just 45,000 copies, still respectable for a launch, but below Logan's expectations. The print run was pulled back for the next issue, but sales

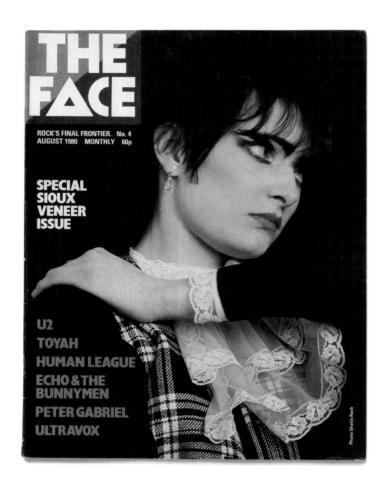

THE FACE

ROCK'S FINAL FRONTIER. No. 4
AUGUST 1980 MONTHLY 60p

SPECIAL
SIOUX
VENEER
ISSUE

U2
TOYAH
HUMAN LEAGUE
ECHO & THE
BUNNYMEN
PETER GABRIEL
ULTRAVOX

Photo Sheila Rock

stayed in the mid-40,000 range, and he began to panic: 'Going with 90,000 copies had been a lot more paper and a lot more money; to come in at 50 per cent was terrifying. I couldn't seem to get the magazine back over 50,000. I still recall the tears of frustration that welled up one night in my kitchen in Wanstead. I really didn't know whether I was going to pull this off.'[5]

One day, in the summer of 1980, Logan's solitude was again broken, this time by an eager twenty-one-year-old London School of Economics political science graduate who would offer the new venture not only a way out of the predicament but more importantly a raison d'être. North Londoner Robert Elms had strolled across Carnaby Street from the editorial department of the *NME*, where he had just been given the bum's rush. The music weekly had printed three of his articles over the preceding months, one of which constituted the first published review of new group Spandau Ballet (Elms had suggested the band name; they were managed by a college friend, Steve Dagger). That the Islington quintet were spearheading a new youth movement was a secret known to a clutch of London's night-lifers and fashion students who congregated at clubs including Blitz and Hell, and Elms had taken to dropping by the *NME* offices not only to

proselytize on his friends' behalf but sometimes to scorn at the paper's outdated rock-oriented content.

On the day of his visit to Logan, Elms was politely told his presence was no longer required by *NME* editor Neil Spencer, who opted not to pass on objections to the voluble young man's manner and unusual appearance – likely to have comprised a Joe Brown bog-brush crop, Black Watch tartan trews matched with loafers, white socks and a billowing shirt – from particular members of his dressed-down editorial team. Instead Spencer discreetly advised Elms that his writing talents might be better suited to Logan's new venture. 'Neil told me he didn't think I was right for the *NME* but that I could write, and that Nick had started a new magazine which was literally across the road,' as Elms, now a prominent author and broadcaster, recalls. 'I clearly remember Neil saying that Nick liked the kinds of things that I liked, clothes and nightclubs, and that he was an old Mod, so I walked into Nick's office and told him that I loved his magazine; I hadn't actually seen it.'[6]

It is a sign of Elms's immersion in the nascent New Romantic scene that he had never heard of *The Face*. Undeterred, he gave Logan his by-now well-rehearsed spiel about the exciting sounds and styles incubating at Spandau Ballet gigs, on St Martins School of Art fashion courses and at a handful of Soho and Covent Garden club nights.

Logan was taken. He recalls Elms's visit as occurring 'at a crucial point. I could see that 2 Tone was fading, and he had info about this new scene, which showed how pop culture was alive. The great thing was that *NME*, as well as *Sounds* and *Melody Maker*, looked down their noses at it.'[7] 'Nick got it,' said Elms. 'He asked me about the pieces I'd written for the *NME* and commissioned me to get on with it, there and then, in his matter-of-fact way. I could tell that he understood where I was coming from.'[8]

Elms's direction had an immediate impact on the next issue, dated October 1980 and including a three-page piece by Elms on Spandau Ballet with Virginia Turbett's photographs of the group taken amid the Edwardian splendour of London's Waldorf Hotel (see page 49). As if intent on raising the hackles of rock-fixated music journalists, Elms's unrestrained copy pitched comparisons between the Spandaus and the Sex Pistols, described their sound as a mix of early Roxy Music and Chic: 'Openly poseur, stridently elitist, their performances have been limited to six in twice as many months, each occasion "advertised" strictly by word of mouth and each attracting the capital's pretty young things to an androgynous man.'

This summation of a fresh new group with a readymade audience helped enormously in drawing attention from the music industry; within weeks manager Steve Dagger had struck a major deal with Chrysalis Records.

The Elms effect was evident elsewhere in issue six: in the Shorts section there was a snippet on young designer and Elms's friend Melissa Kaplan, with photographs by club-goer Michael Kostiff, including an early snap of the singer Toyah Wilcox in a Kaplan design. There was also a double-page spread dedicated to a photo story by Janette Beckman on a day in the life of new blood nightclub promoter Steve Strange (see page 48), seen strolling along the King's Road, at lunch, in the supermarket, and readying himself for a night at Blitz. The cover feature was a Steve Taylor interview with American kitsch-pop outfit the B-52's. Since the launch, Logan had maintained the format of visually interesting cover subjects with content tilted towards music with forays into street fashion, such as Deanne Pearson's piece on the burgeoning Flip dead-stock retail outlets complete with Sheila Rock interior shots.

'It's important to note that there was no tradition of writers, at least among those available to me, covering what would come to be termed lifestyle,' recalls Logan. 'Around this time Sheila turned in some wonderful black-and-whites of a quasi-rockabilly sub-sect at a club in Manor House, north London. They had a timeless quality, as if they could have appeared in *TIME* in the 1950s, and a particular poignancy because the Manor House was an old Mod venue where I'd seen Muddy Waters and a string of other blues acts. Short of doing it myself, how could I get someone to spend a night in a club talking to a bunch of kids for an extended photo caption?'

The answer was the soon-to-be-eminent cultural commentator Jon Savage, who had been suggested by Rock. 'To my astonishment he was happy to do the job for what in today's money would be enough to cover a half-decent dinner', says Logan. 'Jon's enthusiasm had a secondary resounding impact on me, as hard as it is in today's culture to get your head around this thought: OK, this is not a half-baked idea I'm pursuing here, I'm not the only one who finds this stuff interesting.'[9]

Around this time, Logan further formalized his business by joining the Audit Bureau of Circulation (ABC), which verifies publishing sales and announces a league table every six months. Publishers pay a subscription to be logged by ABC, which can be a powerful boon in raising credibility with potential advertisers. For an indie magazine launch in the post-punk world, this was as traditional a move as having placed distribution with Comag rather than, say, the fanzine network operated out of Notting Hill record shop Rough Trade.

'People at IPC had said to me: "If you ever want ads, you've got to have ABC", and that stayed with me, though I wasn't even trying to get much in the ways of ads at the start. I guess I wanted to be grown-up, proper,' says Logan, who regarded those without ABC, including the posh London monthlies *Boulevard* and *Ritz*, as 'like parish magazines'.[10] Logan acknowledges that ABC results often present 'a double-edged sword, because they are watching you all the time. If sales figures dip you are deemed a failure, never mind the underlying demographic. Sales can only go up and, of course, that's impossible so it puts publishers through all kinds of contortions to maintain sales.'[11] Yet, for the rest of his publishing career Logan disparaged the succession of rivals who made grand claims to circulation without this back up.

Six issues in, Logan was concerned at the plateauing of monthly copy sales, and dedicated the inside back page to an appeal to readers to make sure their local newsagents were ordering sufficient copies. Headed 'Smarten Up' and decorated with an illustration by Conny Jude that listed the contents as 'Music, Movies, Style, Photos, Reviews, Interviews', Logan wrote: 'Distribution is still not sufficiently widespread or of quantity to

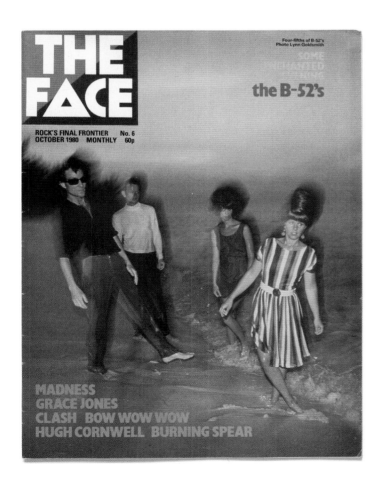

opposite
No. 4, August 1980.

left
No. 6, October 1980.

YOU'RE NOT GOING OUT DRESSED LIKE THAT (AGAIN)!

OXFORD Street, London, on an Arctic-summer Saturday night. The pubs are emptying, the tourist trade is thinning out; hands clutch sky every time a cab comes into view. Up by Tottenham Court Road tube station something different is coming to life.

Studio 21: the discreet nature of the sign conjures visions of some pornographic den, beneath flights of stairs. But the music emerging from the speaker positioned above the entrance is The Human League's "The Path Of Least Resistance".

Every pleasure has its price. For this you part company with £2.75, sign your name, which automatically registers you as a member, collect your meal ticket (this entitles you to a plate of about a dozen chips, a beefburger and a dollop of relish) and descend the stairs to the basement.

4 Be 2's "One Of The Lads". This is the Saturday night residence of God's nocturnal pretty/ugly things. Gathered in groups under red lighting, observing and waiting to be observed. Doesn't matter if you're male or female, here you can be what you want and nobody gives a toss. The wilder the better: these barnets are constructed with the same architectural precision as nearby Centrepoint.

Joy Division's "She's Lost Control". A drink in the bar area—lager 80p a pint, spirits 70p a tot—not as extortionate as you might expect—then into the disco chamber. Barely sweating bodies twitch the night away to anything that sounds credibly posey. Telex to T. Rex, Roxy Music to Manicured Noise. The DJ spot rotates between Dave Archer, who tries hard to be noticed and fails, and Jock McDonald, who tries hard and succeeds. The air is strong with the stench of stale hair spray and deodorant. The dancers hold hands and slide to and fro careful not to dishevel a hair on their heads. The atmosphere is friendly, even if there is a certain rivalry between the 'odd couples'. For every Clark Gable there's two David Bowies. Magazine's "Back To Nature". At 2.30 the music slows down. Cabs queue outside for the homeward bound. The clientele of Studio 21 appreciate more than most the dangers of walking home.

Words VAUGHN TOULOUSE
Photos VIRGINIA TURBETT

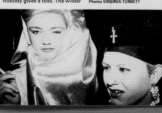

above
'You're Not Going Out Dressed Like That (Again)!',
no. 5, September 1980.

meet demand…we suggest that if you want to help yourself and help us at the same time you place a regular order for *THE FACE* with your local newsagent.'

Logan then took the decision to build on the Elms-influenced content in the October 1980 issue by throwing *The Face*'s lot in with what became New Romantic. 'It was getting desperate,' Logan acknowledges. 'My ambition at the beginning had been to establish music content and then gradually broaden out but I decided to abandon the plan for a slow and steady approach and take the risk in case we didn't last.'[12] In so doing he recognized what others in the media had failed to see; that there was a substance to many of the individuals involved in the new scene that would enable them to outlast the Blitz fad.

Elms counts down the list of people who later scored huge commercial success: 'The entire generation of British acts who went on to become massive in America – Boy George, Spandau, Wham!, Sade, Duran Duran – would all go on to be broken by *The Face* and almost all of them were in the Blitz on a Tuesday night.' He adds: 'There were more records in America in 1985 by British acts – led by these people – than at the height of Beatlemania in the 1960s. To this day Sade is one of the biggest-selling British female artists of all time, and the majority of her sales have been in America.'[13]

It is a fact that the group of visually directed youth represented by Elms and his cohort were more openly ambitious than those who had experienced punk at first hand. 'They climbed on the shoulders of punk, but had a far greater sense of confidence and were determined to use the 1980s, to use their teenage lives, their own time, in a way that previous generations had been too repressed to,' the cultural iconoclast Malcolm McLaren told the art writer/curator Luise Neri in 2004. 'The new generation was totally, unquestionably, more open and optimistic. The whole scene had changed. Club life had never existed like this before: more kinds of drugs were consumed in London than ever before; more people gathered on a Saturday night outside mainstream pop culture than ever before.'[14]

That it was 'a huge movement' in waiting, McLaren was in no doubt. Nor was Elms, whose pitch blossomed in issue seven with the publication of his six-page piece 'The Cult with No Name' (see pages 50–51), packed with Derek Ridgers's vérité portraits of major scenesters, including Steve Strange and fellow club entrepreneur Chris Sullivan, designer Stephen Linard, Peter Robinson, who had already transformed himself into pop-star-in-waiting 'Marilyn', George O'Dowd (on the cusp of becoming Boy George) and, of course, Elms himself. Elms concluded his feature by describing London's new nightlife as 'a colourful, exotic world which has set the styles to be copied in terms of both look and sound. A whole new generation of young clothes designers is beginning to emerge from this nocturnal existence'.

This was a turning point, and not just for Elms, the club kids he wrote about or even Logan's magazine, according to style commentator Peter York: '*The Face* was how the rest of the world got to know that the Blitz generation had arrived and the party had started…. Elms supplied insider knowledge, total user-friendliness. From "The Cult with No Name" onward, *The Face* became a Publishing Event. After that, the nationals took it up as a key feed and we had the first style diary of the New Age.'[15]

By a coincidence, which underlines how acutely Logan was surfing the zeitgeist, the issue of *The Face* containing Elms's article was published within a few weeks of the arrival of another new magazine, one that would help propel the lifestyle media sector and eventually outlast all-comers – including *The Face* – into the digital present. *i-D* was launched as a quarterly in October 1980 by former British *Vogue* art director Terry Jones, his wife Tricia, Alex McDowell, who operated graphics company Rocking Russian and had associated with McLaren and the Sex Pistols crowd, and his fellow St Martins graduate Perry Haines.

Haines, like Elms, was a mover-and-shaker, running club nights and generally banging the drum for the scene in London. 'The fashion business latches on to what is going on in the street and regurgitates it twelve months later,' said Haines at the time. 'We report from the source, the source being the ordinary pubs and clubs and the street on which the true fashion leaders perform. That may sound hackneyed but it's true.'[16]

In contrast with Logan and Bush's sophisticated use of colour photography, *i-D* homed in on a technique of monochrome street portraiture that Jones had developed with the photographer Steve Johnston for their *Not Another Punk Book*, which was published in 1978 after he had exited *Vogue*. The 'straight-up', as it was dubbed, was unblinking in its presentation of style-obsessed young Britain, conveying the invention with which some invested their visual identities as 'social documentation, a catalogue of real people wearing real clothes', in the words of one-time *i-D* editor Dylan Jones.[17] The first issue contained a manifesto of sorts attributed to stylist Caroline Baker, whose pioneering work in the field stretched back to the women's title *Nova* in the early 1970s: 'I.D. counts more than fashion. Make a statement. Originate don't imitate. Find your own I.D.'

Compared to *The Face,* the Jones's magazine was avowedly fanzine-like with typewriter font text containing corrections, as well as scrawls and scribbles left for readers to see on the page. Initial copies of the oblong-shaped title were hand-stapled without tangible distribution beyond Better Badges in Portobello Road – there were later claims that the first issue sold only fifty copies[18] – and for the first five years (in April 1983 after thirteen issues it adopted an A4 monthly format) *i-D* was produced at the Jones's north London home.

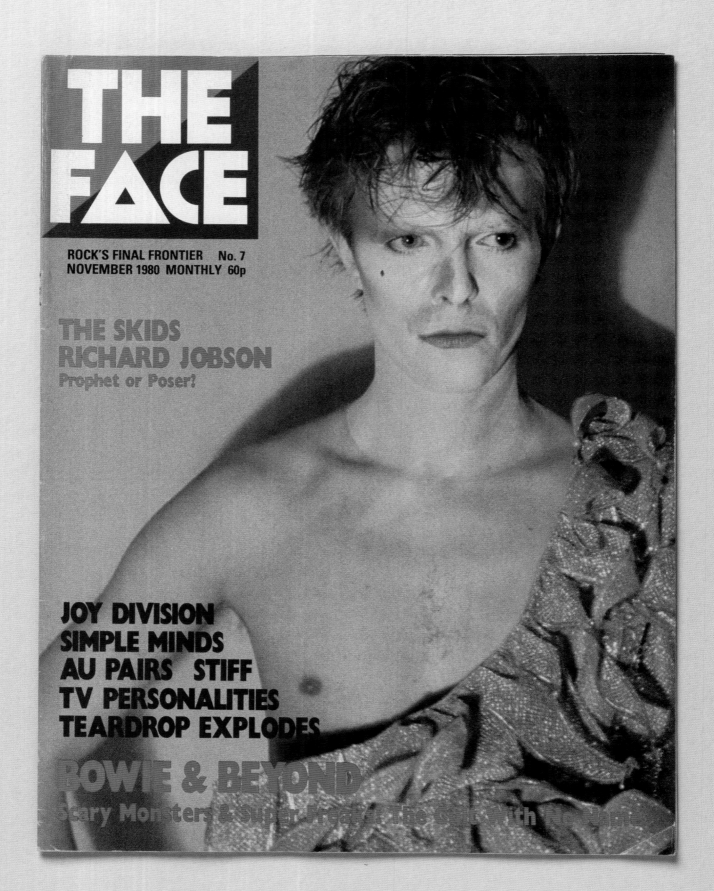

Magazine. Style isn't what but how you wear clothes. Fashion is the way you walk, talk, dance and prance. Through I.D. [sic] ideas travel fast and free of the mainstream – so join us on the run!' This distinction, that fashion rather than music culture lay at the heart of *i-D* – and the mutual respect felt between Logan (who filed a news item marking the magazine's debut in issue six of *The Face*) and Jones – enabled the titles to rub along in amicable rivalry over the years as staff moved between the two. In any case *i-D*'s purpose was the celebration of the same fast-moving developments in street style as *The Face*, and its confident emergence signalled to media observers that a new vibrancy was abroad.

Not that this burst of activity was without antecedents. The link between 'The Cult with No Name' and the man who presided over its activities – David Bowie – were made explicit by the use on the cover of issue seven of *The Face* of a Brian Duffy image of the superstar in make-up and costume from the shoot for the video for his single 'Ashes to Ashes' (the promo clip featured cameos by Strange and other Blitz denizens). This trailed a think piece by another important contributor who had made the crossover to *The Face* from the music press – albeit from a more established position – and was similarly never to look back: Jon Savage.

Savage's peroration on Bowie's latest album *Scary Monsters (and Super Creeps)* was used as the basis of an investigation into the performer's engagement with androgyny. The pay-off to the piece (headed 'The Gender Bender'; see pages 52–53) dovetailed with the interests of the nightlife creatures in Elms's world. 'Even though he's due for a supersession on both counts, the mystique is still deadly strong,' wrote Savage. 'Why? Because David Bowie has entered British life as the model for every kid who says: "I wish I was…"'.

Savage had not long before left behind a career on *Sounds* and *Melody Maker* and moved into television with regional broadcaster Granada TV, working as a researcher on a still-born documentary on the history of the teenager (later to emerge as a book in the 2000s). In fact, Savage had been alerted to the prospects at *The Face* by DJ Gary Crowley, the young mod about town who had contributed to issue one and parlayed running the reception at the *NME* into a broadcasting career that started as presenter of a children's TV programme, *Fun Factory*. 'All that boys' stuff became very wearing if you came at it from a distaff – gay, feminist of any sort – perspective,' says Savage about the music papers, pointing to the links with *Smash Hits* that helped give *The Face* 'a lightness of touch'.[20]

And so *The Face* provided an outlet for Savage's elegant articulacy. 'Nick was a very laid-back, laissez-faire editor; you'd go into his little office and there wouldn't be any of the hassle you'd have with the music press, where everyone vied

Unlike Logan's magazine, *i-D*'s survival was not predicated on sales or even advertising; as a world-travelling art director of note, Jones funded its existence for the first six years with income from clients including Fiorucci, German *Vogue* and *Sportswear International*.

Jones said later that *i-D* was cooked up with Baker and photographer Oliviero Toscani as a way of 'infiltrating the fashion industry's commercial image. We never had time to write our manifesto but somehow over the years of publishing *i-D*, "the school of *i-D*" invaded the mainstream'.[19]

Crucially, *i-D*'s core concern from the get-go was fashion. On the back cover this was made explicit: '*i-D* is a Fashion/Style

opposite
No. 7, November 1980.

above
News item announcing the launch of *i-D*, no. 6, October 1980.

for attention',[21] says Savage. Soon he was submitting articles that demonstrated the ways in which the new magazine was accelerating ahead of the pack, among them the first interview with Vivienne Westwood to seriously assess her potency as a formal fashion designer and an interview with Bow Wow Wow (see pages 54–55), the group that Westwood's partner Malcolm McLaren had masterminded in the wake of the Sex Pistols. 'I was very excited about the way in which these were presented,'[22] recalls Savage.

So too was John May, who had come out of the underground press to write investigative pieces for Logan at the *NME* under the pseudonym 'Dick Tracy' and broadened *The Face*'s mix with articles on icons of the past including the tragic film actor Montgomery Clift. Meanwhile, the *NME* veteran Chris Salewicz had thrown in his lot with Logan after a bust-up with the music weekly's assistant editor Phil McNeill. 'He implied I wasn't allowed to write for *The Face*, which showed they were threatened. I said, "Fuck you." I realized I had to get out of there. It was too limiting, just writing about music.'[23]

Salewicz produced a series of solid profiles for Logan's title on subjects as varied as John Waters's superstar Divine, the model-turned-performer Grace Jones, the invasion of the formerly hippy Kensington Market by exciting post-punk designers and a cover story on John Lydon and his band PiL. The latter appeared in the December 1980 issue – which marked a 5p increase in the cover price to 65p to cover rising production costs – with a Sheila Rock rendition of Lydon in clashing plaids. That issue also contained photographer Nick Knight's first contribution to *The Face*; a portrait of the skinhead poet and illustrator Mick Furbank outside the skins' favourite clothing store, The Last Resort in the East End.

Knight was a student at Bournemouth and Poole College of Art on England's south coast and busily compiling the images that would comprise his first book, *Skinhead* (1982). Like Elms, Knight (now one of the world's most prominent fashion photographers) had been sent across to see Logan by Neil Spencer at the *NME*. 'I'd also met Terry Jones by that time, Perry Haines and Al McDowell having left already, and felt that the photos I was producing fitted in much more with what he was doing,' says Knight. '*The Face* felt a little clique-y in that Mod way, a bit "We're sharp but you're not quite as sharp as us". There was not the sense of openness I got at *i-D*, which was, after all a bit of a neo-hippy moment; it wasn't about style as such but much more about who you were.'

Knight opted to complete his studies, publish *Skinhead* and align himself with *i-D*, having found the atmosphere at *The Face* too uptight: 'I'm not saying they were homophobic but things could get a bit too "boysy" for my taste.'[24]

The December 1980 issue of *The Face* also contained Logan's first pass at the type of lists that later became a fixture of the magazine as barometers of style and taste and are imitated across online and physical media to this day. Headlined 'The 1980 Face Show: 123 Things To Remember 1980 By' (see pages 56–57), the year-end review took its cue from the lists published in *Harpers & Queen* by that magazine's features editor Ann Barr and contributor Peter York (both of whom would soon collaborate on *The Sloane Ranger Handbook*, 1982; York's name would crop up in three separate articles in the December 1980 edition of *The Face* due to the recent publication of his collected *Harpers* articles, *Style Wars*).

'The 1980 Face Show' is as instructive about those who were making their mark in pop culture at the time – who can now remember the name of the lead singer of novelty ska act Bad Manners whose portrait dominated the first page? – as for its expression about the dark shadows cast by that year's economic slump and the failure of the Left to present opposition to the strident Tory government. And so, underneath the sub-head '15 Dodgy Concepts', were outlined the following concerns: 'Thatcher's independent deterrent',[25] 'The Unemployed', 'Cruise missiles in the UK', 'Keith Joseph's policies',[26] 'Recession, Depression, Unemployment'.

Such bleakness could not undercut the underlying feeling that *The Face* was already justifying its place in the wider media. This would explain why Logan added another statement to the contents page of the December 1980 issue. After just nine months in existence, *The Face* was now proclaiming itself as 'The world's best-dressed magazine'.

opposite
No. 8, December 1980.

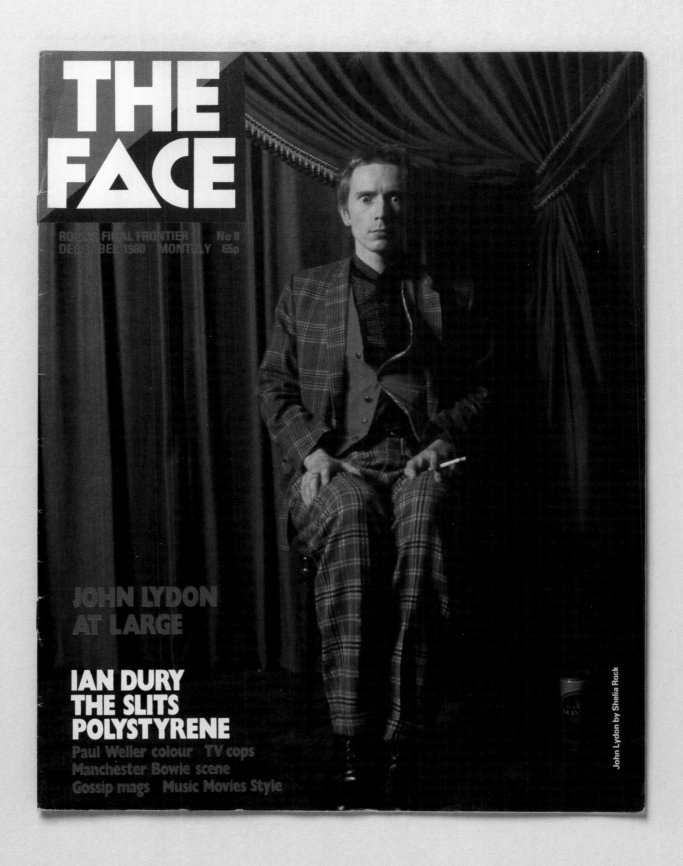

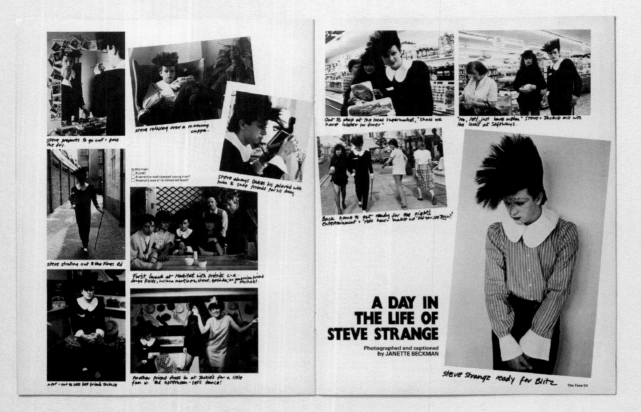

INSTRUMENT OF TORTURE

This is Hermine Demoriane, a French singer whose debut "Torture" 45 has a curious history. The single, a version of an old Everly Brothers song produced by David Cunningham of the Flying Lizards, was recorded for Virgin Records. 21,000 full colour sleeves were printed in readiness for a June release alongside Cunningham's own "Laughing Policeman" 45. But when Virgin stalled over "Laughing Policeman" Cunningham took it to Arista instead. An unfortunate consequence was the cancellation of Hermine's own single. The official explanation was the "recession". As a consolation prize Virgin offered Hermine a relase from her contract, the 21,000 sleeves and the opportunity to buy the metal pressing work for £59. Thoroughly disenchanted but nevertheless determined to see her record view daylight, Hermine pressed 2000 copies of "Torture" on her own independent Salome Disc label distributed by Fresh and Rough Trade. At least, she says, her record is out—and control is in her own hands. "No whim of some young executive is going to shake me this time". As for the 19,000 unused sleeves, they're currently decorating her North London flat.

Photo RICHARD RAYNER-CANHAM

8 The Face

above
'A Day in the Life of Steve Strange', no. 6, October 1980.

right
News pages, no. 6.

48

NDAU BALLET: AN MACULATE CONCEPTION

Words ROBERT ELMS
Photos VIRGINIA TURBETT
Scenery THE WALDORF HOTEL

is to present the most orary statement that an offer in terms of nd ideas."—**Gary** pandau Ballet.

SICAL scene where gain at a premium and ght is pretty close to ht, Spandau Ballet see es as the latest look to enly poseur, stridently ir performance have ted to six in twice as nths, each occasion ed' strictly by word of d each attracting the pretty young things to ygnous man. world of obing; bright white which has produced dau Ballet; the elitist

appearance as Spandau Ballet in November last year. They hired a private studio in London and played for an invited audience of 50 friends.

The Kemps are brothers. Like the others they're from the Islington/Kings Cross area of North London and jobs in the printing industry. Their ages are 20 or under.

"I am beautiful and clean/And so very very young."—**From "To Cut A Long Story Short" by Spandau Ballet.**

It's this uncompromising rejection of rock music's current cliches about 'the kids' and

'street credibility' which has caused a mostly sneering attitude so far from a music press which seems incapable of understanding a group more influenced by late nights in Soho than the first Stones album.

The fact is that most of the people who have written about Spandau Ballet have never even seen them, and their ignorance has led them to miss the similarities between this current scene and emergent

punk London of 1975/76. The fact that the Ballet and their audience have walked exactly the same streets as those trod by the Sex Pistols and the legendary Bromley Contingent five years earlier has been entirely overlooked amid fatuous references to 'art students' and 'fashion models'.

Continues over

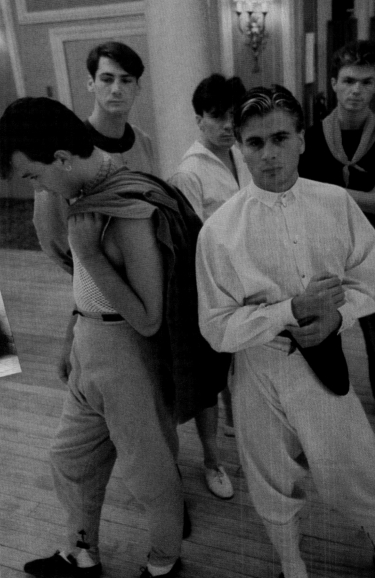

Kemp

Tony Hadley

Steve Norman

Martin Kemp

John Keeble

Billy's and Blitz, of ate dance and dress where fashion nstant change and doesn't mean a

emp (guitar, er), Tony Hadley ynthesiser), Steve guitar), Martin Kemp John Keeble (drums) ady a part of this scene-making when their first

below and opposite
'The Cult with No Name', no. 7, November 1980.

THE CULT WITH NO NAME

. . . started as far back as 1975 when a clique of fashion-fixated young Londoners gathered in Soho basements to pose, preen and prance to the music of David Bowie. They've been referred to as Blitz Kids, The New Romantics and (yeeuk) The Now Crowd, but have so far resisted a definitive handle.

ROBERT ELMS (above), who helped start the short-lived scene at the St Moritz, charts the history of London's Other Club Scene. DEREK RIDGERS took the photos.

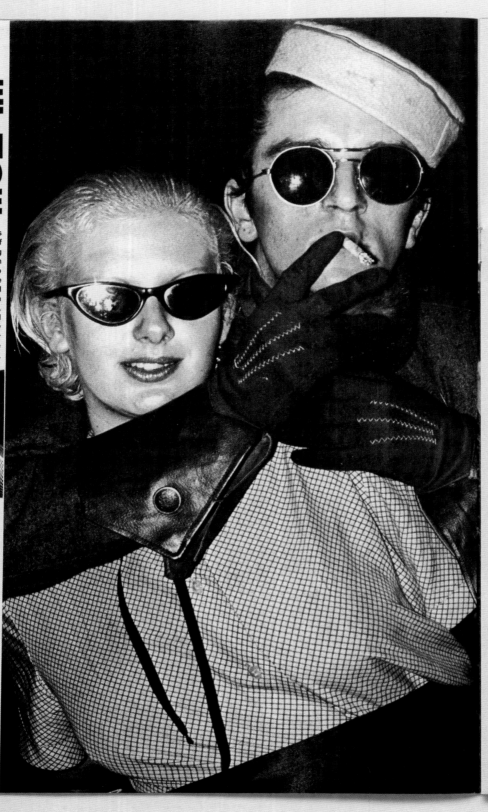

Right: Steve Strange and a friend, Billy's 1978.

22 The Face

TURNING left half way down Wardour Street on a Tuesday night in the autumn of 1978 meant going to Billy's; a subterranean other-world of diamante and occasional drag, where sharp dress meant everything and to be out was to be literally outside.

The invitation cards called it a Bowie Night and boasted Rusty Egan of the Rich Kids as DJ. The turntables were dominated by the Thin White Duke and the air was thick with an atmosphere of stylish and extravagant sleaze.

The underground club scene which was to lead to Steve Strange, the Spandau Ballet and mass media talk of 'Blitz Kids' was under its flamboyant way as London's young night people found a home in the heart of Soho.

Billy's had originally been just one of the myriad of basement nightspots which dot the backstreets of central London like so many sleazy pot-holes. Frequented largely by gays, it became known for the high level of import soul available within, and for the fact that the management and clientele were able to accept the shock of immaculately if extraordinarily dressed young socialites invading their premises. The word spread; Billy's was in, and everybody turned out.

It was Rusty Egan, the Rich Kids young drummer about town, who decided to transform a chance gathering of fashionable young things into an evening specially set aside for those with an abiding interest in all things Bowie and beautiful.

Tuesday night became the night to look right as the still dominant black leather of the post-punk depression was rejected in favour of gold-braid and pill-box hats. It was toy soldiers, cossacks and queens to the outsider, an odd fantasy world down the stairs; to the participants it was a mutual admiration society for budding narcissists, a creative and competitive environment where individualism was stressed and change was vital.

Billy's wasn't a place for those who dressed up for the occasion but for those who dressed up as a way of life. A small incestuous group numbering no more than a couple of hundred kids in search of a life of style.

Looks came and went as fast as the innovators could construct them. Some opted for then-radical '60s chic while others scoured eras past and ideas future. The aim was to create a look, then go out and enjoy it, dance and pose the night away amidst like minds and good music.

THE PLACES. Right: The Blitz, Covent Garden. Below: the St Moritz, Wardour Street, Soho.

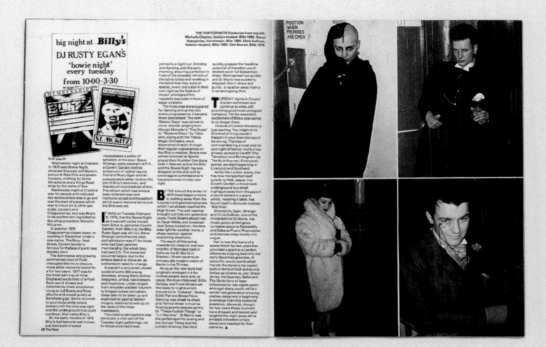

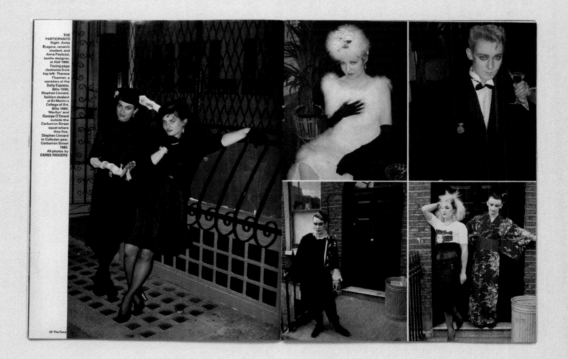

had originally
...owie, but just as
...essed so did the
...ne Dietrich
...the theme from
...ile Iggy Pop's
...g" represented a
...ent and
...hem.
...ovided the first
...ove towards
...o as "Trans-

Europe Express" and "Man Machine" became Tuesday night classics. Obscure British bands operating within the same sphere were discovered and danced to. "Warm Leatherette" by The Normal and "Being Boiled", the first single by the then unknown Human League pointed the way to the electronic explosion about to occur. Gary Numan was a regular observer, lurking in dark corners amidst all the other Bowie-Boys.

BILLY'S was a vital beginning, yet the roots of a scene which has since grown out of its Soho confines and into newspaper headlines and television documentaries can be traced back some three years earlier and 200 yards further up Wardour Street.

**Continues over
The Face 23**

**Above:
Billy's, Dean
Street, Soho.
Left:
Hell, Covent
Garden.**

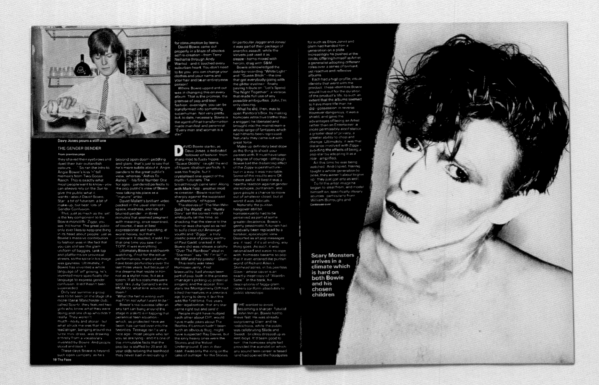

above and right

'The Gender Bender', no. 7, November 1980.

overleaf

'Sun, Sea & Piracy', no. 6, October 1980.

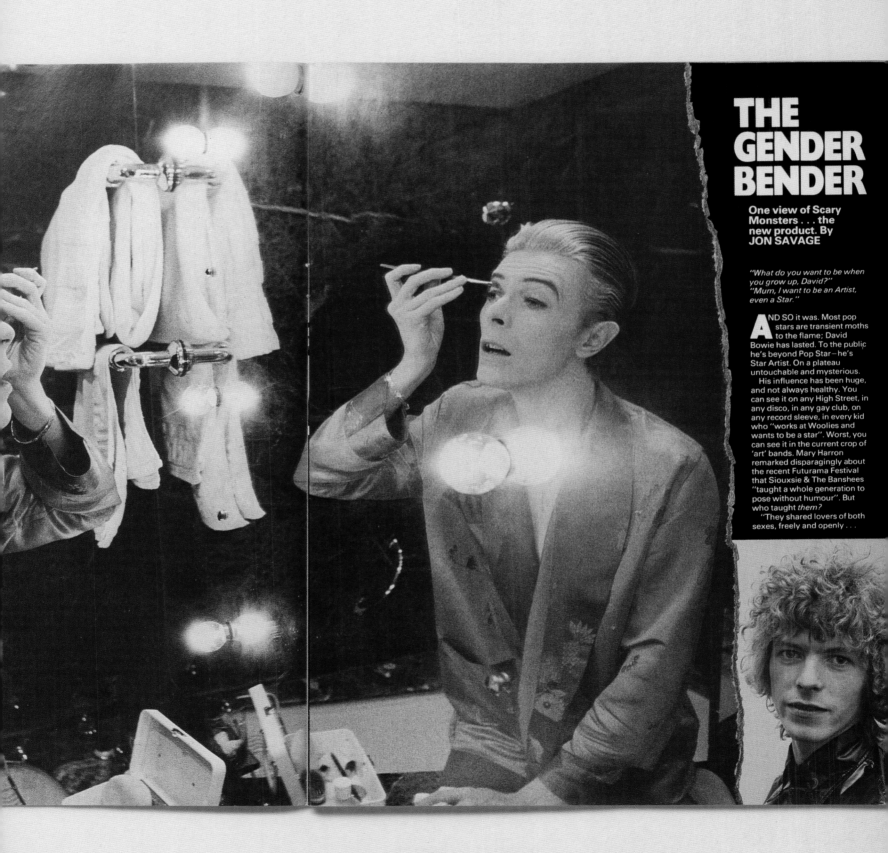

THE GENDER BENDER

One view of Scary Monsters . . . the new product. By JON SAVAGE

"What do you want to be when you grow up, David?"
"Mum, I want to be an Artist, even a Star."

AND SO it was. Most pop stars are transient moths to the flame; David Bowie has lasted. To the public he's beyond Pop Star—he's Star Artist. On a plateau untouchable and mysterious.

His influence has been huge, and not always healthy. You can see it on any High Street, in any disco, in any gay club, on any record sleeve, in every kid who "works at Woolies and wants to be a star". Worst, you can see it in the current crop of 'art' bands. Mary Harron remarked disparagingly about the recent Futurama Festival that Siouxsie & The Banshees "taught a whole generation to pose without humour". But who taught *them*?

"They shared lovers of both sexes, freely and openly . . .

POP, THAT disposable distraction, is mostly about transience: it's the order of the perpetual child, the moment! Not that those last long these days. Most people forget the dynamics of what began, industrially, as excess trash. *A blinga a blanga/A bippety bop/I'm going down to the record shop—yeah!*

Naive? It could almost be *Expresso Bongo.* Of course there's more to come: *Uo-mo-mo-mo-mo-mo-sex-al Apaches! Bow-wow-wow-wow-wow-wow-wow-wow-wow-EE!*

Dave, Matthew, and Leigh, is there a generation gap?

"Yeah, definitely!"

"It all started off with the old farts thing: now it's gone beyond punk, with us."

"There's a whole generation of kids who can't even *read . . .*"

WHO SAID that the biggest growth market in the record industry, not currently known for growth of any description, is the 10-14 year olds? At least they have pocket money in their pocket. With Bow Wow Wow, everyone's favourite Fagin, professional child and child molester Malcolm McLaren, presents a new package—clothes, music, attitude and technology—for a more recent generation of pram products.

This time, however, he's trying to terrorise not his *own* useless generation, but that useless generation he and Helen of Troy are responsible for: punks, post-modernists and the ham sandwich brigade.

"Everything's got so grey and depressing. All that depressing music about. We're the only colourful thing around."

"It's just something new for the kids, something new musically and attitudewise. Things are stagnating . . ."

Remembering that pop isn't only trash, that it's also a vehicle, McLaren seizes and packages the current event and delivers it to that very record company—EMI—that expelled him and his last model four

years ago.Such is the state of things that the irony barely raises a whisper.

Flicking through his address book, he winds up all his old media contacts about the package and its gift-wrapped event—the fact that the music industry blames its currently appalling fiscal state mostly on home taping and piracy—and reaps a slew of press and TV. He is loved. He releases a single, "C30, C60, C90 GO", which is supposed to inflame kids to tape rather than buy, and sits back.

The record, which is fun, struggles to the Thirty and dies.

Time for a stunt: the day I meet Bow Wow Wow he appears on Thames TV with Nicky Horne to allege that EMI have rigged the record's chart position, downwards, in an orgy of reverse hype. The honeymoon with EMI (if not the BPI) is over: he is quite disgusted, says will sue. Sour grapes? Who cares? It's hustling, hype and trash—a perfect pop pantomime.

IN THIS pantomime, are Bow Wow Wow mere puppets? Three of them—drummer Dave Barbarossa, guitarist Matthew Ashman and bassist Leigh Gorman ("We *can* play!")—turn up at Chez Solange off St. Martin's Lane to do some quoting. McLaren and Annabella, who have been doing much quoting of their own, aren't present.

Both sides are nervous: it's their first-ever interview, my

first for a long time. They show this by all talking at once, I show it by drying up. Somehow (two bottles of wine) we get something down.

What's this all about, please?

Leigh: "Just having a laugh and dressing up."

In those? The three of them are sporting advance copies of Vivienne Westwood's latest creations. Illustrating the piracy theme that runs through this latest package, these numbers billow at the elbow and at the knees, and sport sashes so you can make them as tight or as loose as you want.

The material is in some kind of demented pinstripe material, or bright oranges and yellows. It's completely unlike any current mode: the effect is that of scruffs wearing rich hand-me-downs that have fallen off a lorry, with a dash of Chelsea 1966 for that touch of flash and self-pride. They look like bandits. Don't you get hassled?

"Yeah, by punk rockers. (Laughs) No, no."

"Why should we?"

"They don't hassle you, just avoid you when you walk past them in the street. Step past you. It's quite convenient really."

"I've got chewing gum on my tropical shirt—must've happened in Hawaii."

Thanks again, David. Can you, but seriously, really see kids going out dressed like that?

"Yeah. They'll have to wear it."

"Cassettes . . . a bit of piracy, a bit of colour."

THERE are outside factors, however, which these children's Fagin isn't unaware of. Apart from anything else (and there's plenty), McLaren has made it clear in previous, interviews that he regards Bow Wow Wow as an exotic irritant in the government's plan for a depressed and cowed nation of workers and youth. Much of the package is deliberately colourful: counter-propaganda to a succession of bleak statistics and more bad news, yellow against grey. In the playtime world of pop, it might work. As you'd expect, the group agree, warily at first:

Matthew: "Don't you agree it's got boring?"

Dave: "Politics! (Pauses) It's a brain thing she's doing on people, I think, with the dole and unemployment. But it ain't shitting me up, it ain't shitting Bow Wow Wow up. But the attitude's now got very conservative, know what I mean?"

Leigh: "It's like the music. It's all repetitions of '60s stuff, which is bad enough anyway. It's like The Jam singing 'Taxman' on *Top Of The Pops,* with Paul Weller wearing glasses like something out of The Byrds. Can't see the point of it."

Dave: "I don't think that kids are going to bother with music that much anyway. Just maybe tape this and that. Something for free. Something they don't have to worry about . . ."

Matthew: "Music ain't so important. It's throwaway really. Got that one?"

Leigh: "It might be important but it ain't such a big deal, know what I mean?"

Dave: *"Music isn't precious anymore . . .* what else does Malcolm say? What else has he told us to say?"

THEY DON'T *look* like puppets, pirate clobber aside (that goes with the job). Earlier in the day I received a doggie tin: a Bow Wow Wow press kit packaged like dog food. In the tin there's a pic of Annabella (fetching), a C10 cassette of the 45, and a press **Continues over**

Dave Barbarossa **Photo Gerard McNamara**

By JON SAVAGE

SUN, SEA

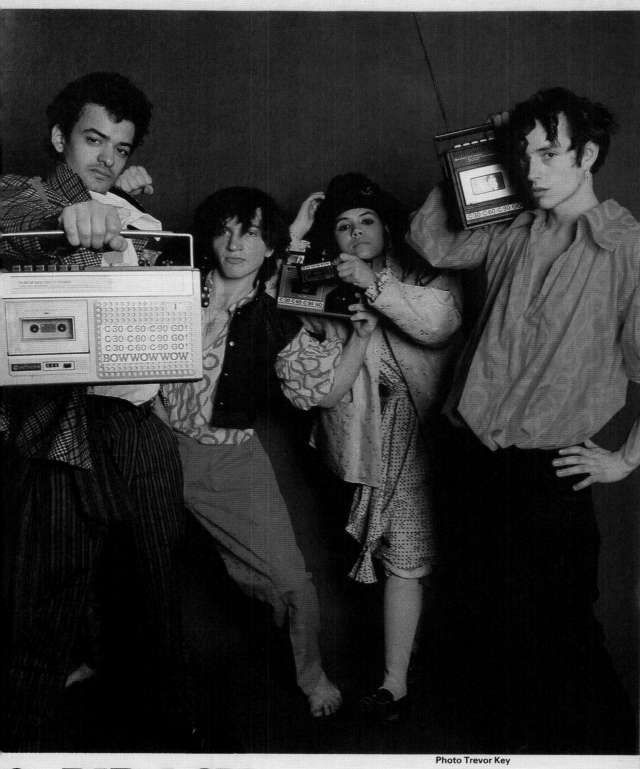

Photo Trevor Key

& PIRACY

(GO DOGGY GO!)

The Face 49

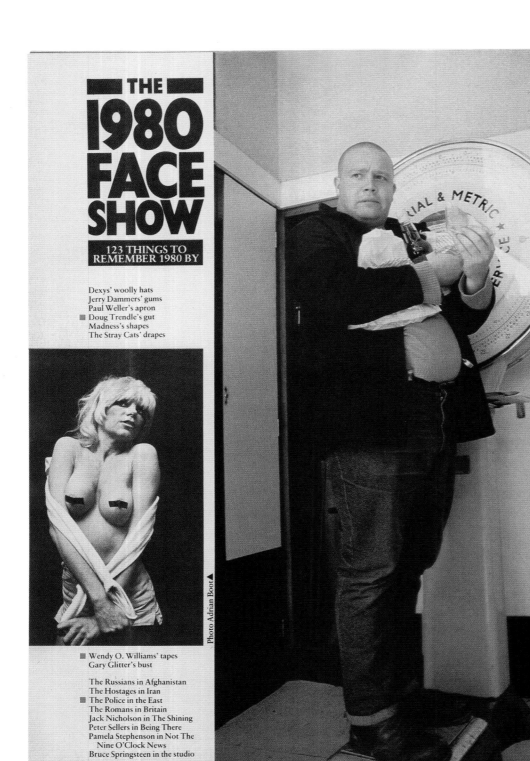

THE 1980 FACE SHOW

123 THINGS TO REMEMBER 1980 BY

Dexys' woolly hats
Jerry Dammers' gums
Paul Weller's apron
■ Doug Trendle's gut
Madness's shapes
The Stray Cats' drapes

Photo Adrian Boot ▲

■ Wendy O. Williams' tapes
Gary Glitter's bust

The Russians in Afghanistan
The Hostages in Iran
■ The Police in the East
The Romans in Britain
Jack Nicholson in The Shining
Peter Sellers in Being There
Pamela Stephenson in Not The
Nine O'Clock News
Bruce Springsteen in the studio

40 The Face

Dough Trendle

Bob Marley in Zimbabwe
■ The Devil in Grace Jones
England's performance in the
European Cup (on second
thoughts forget it)
Tenpole Tudor in The Great
Rock'n'Roll Swindle
■ Orchestral Manouevres in the
Dark

Mod
Moderne
Post Modernism
Post Mod
Post early for Christmas
■ John Lydon's suits
Devo's flowerpots
Spandau Ballet's fans
■ Phil Oakey's hair
■ Blondie's blonde
■ The Mo-Dettes modes
Fred Perry's shirts
Ben Sherman's collars
Doctor Marten's boots
Two Pints Of Lager And A Packet
Of Crisps Please

■ The Undertones' Perfect Cousin
■ UB40's Way of Thinking
Richard Pryor's chemistry lesson
Joy Division's visions
David Bowie's videos (beep beep)
CND
NMN
The Wall
THE FACE
The Music Press Dispute
Hugh Cornwell's porridge
John Lydon's Irish stew
Malcolm Allison's time is up

Minder
Soul Boys
Rude Boys
Serious young men with
synthesisers
Invisible Girls
Wonder Woman
The Modern Girl
■ The Elephant Man
Hercules the Bear
Who Shot JR?
Who Killed Bambi?
What am I doing reading this?
The mind Buggles

Photo Anton Corbijn

Photo Peter Anderson

42

The Cult with No Name

opposite and below
'The 1980 Face Show', no. 9, January 1981.

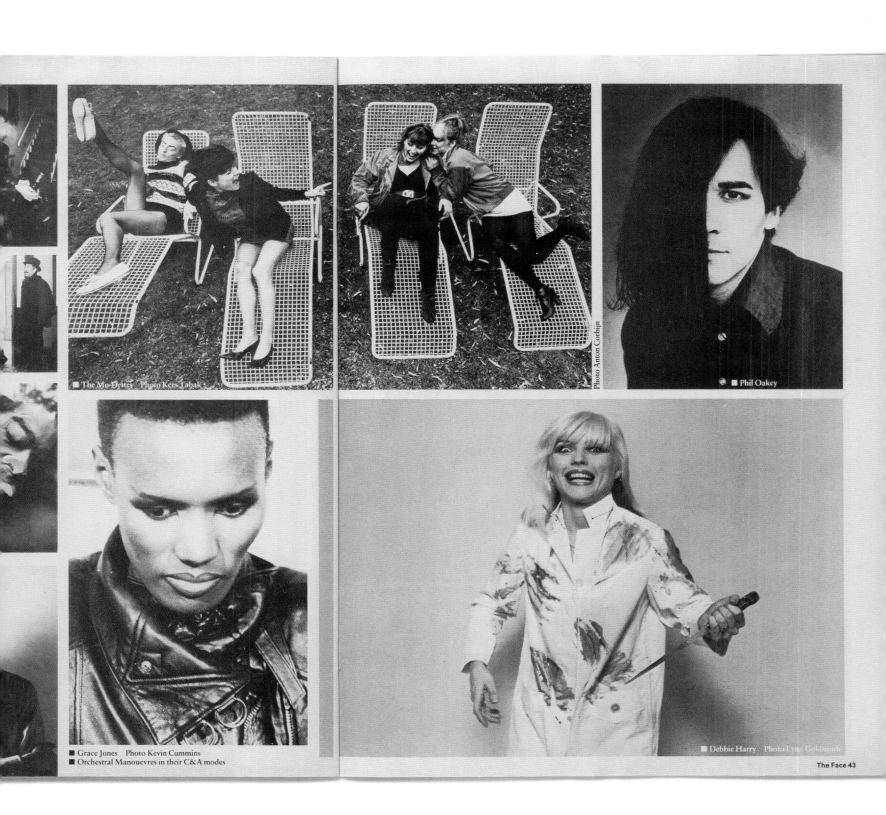

■ The Mo-Dettes Photo Kees Tabak

Photo Anton Corbijn

■ Phil Oakey

■ Grace Jones Photo Kevin Cummins
■ Orchestral Manouevres in their C&A modes

■ Debbie Harry Photo Lynn Goldsmith

The Face 43

right
'Hats for Moderns', no. 10, February 1981.

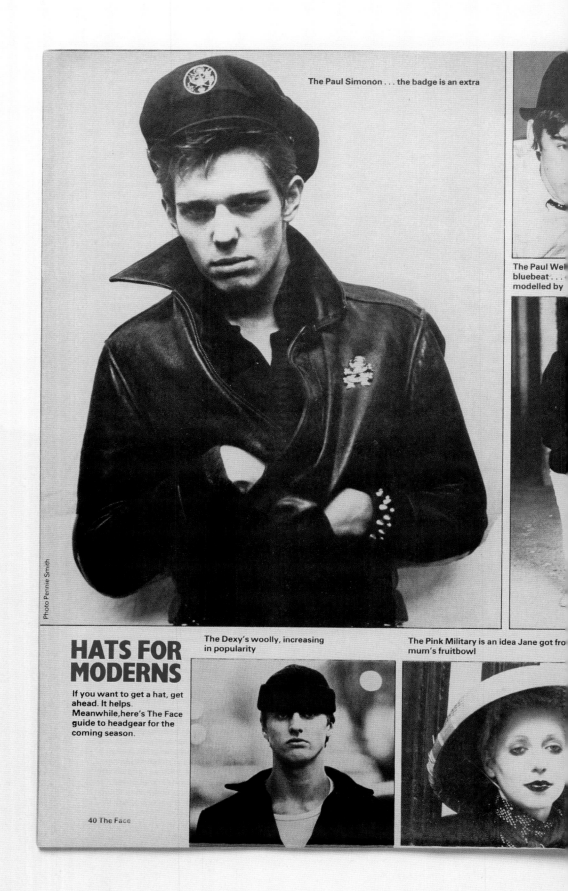

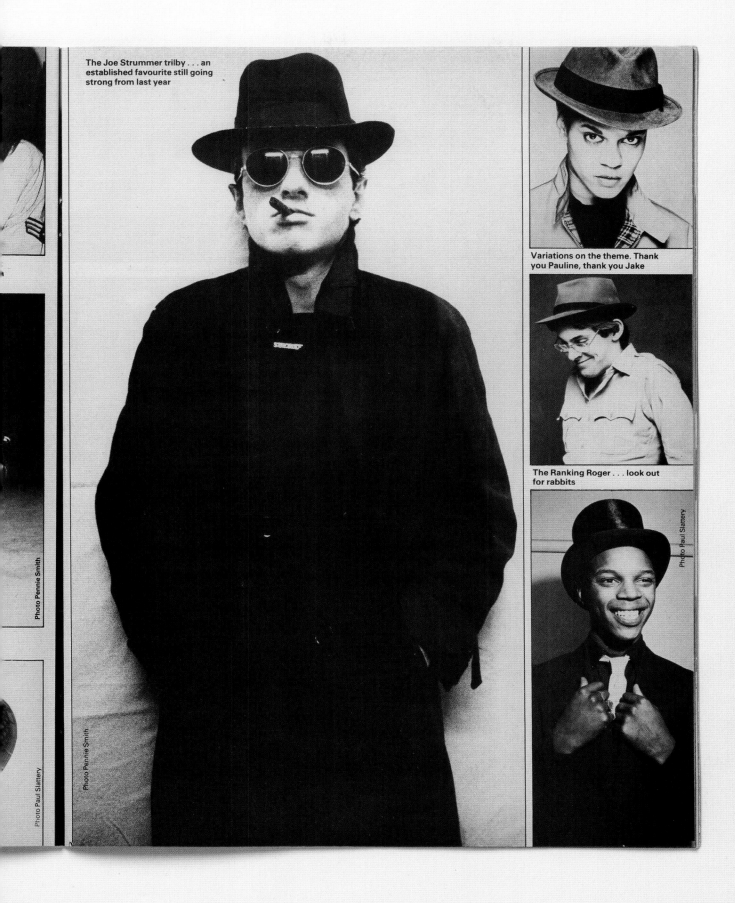

The Joe Strummer trilby . . . an established favourite still going strong from last year

Variations on the theme. Thank you Pauline, thank you Jake

The Ranking Roger . . . look out for rabbits

Photo Pennie Smith

Photo Pennie Smith

Photo Paul Slattery

Photo Paul Slattery

59

Chapter Three

Hard Times

In 1981 *The Face* found its voice. Though circulation was still fluctuating around break-even point, the editorial sections – with brief, newsy items collected under the heading 'Shorts' at the front of the magazine – were beginning to gel to Nick Logan's satisfaction. By this stage Robert Elms had become a fixture at the Carnaby Street office, delivering copy, discussing potential subject-matter and proposing coverage of the new designers and performers in his ever-widening circle: 'In the same way that Nick had got Julie [Burchill] and Tony [Parsons] to write about punk at the *New Musical Express*, he recruited people like me, Neville [Brody] and [photographer] Graham Smith, who were all on the inside of what was happening. Having left college I was hanging around at *The Face*, writing pieces and helping out where I could.'

Elms recalls others gravitating to Logan in this period. 'Neville would be around, Julie [Logan's wife] would be doing admin and Tony, Derek Ridgers, Sheila Rock, people like that, would turn up, I guess like me angling for work but also to talk through what they'd come across. I would be making suggestions about what we should cover but was by no means directing it; that was all Nick, who was absorbing what was on offer and running with it when he felt it was strong enough.'

Elms even organized a fashion shoot modelled by his friend, Spandau Ballet's bass-player Martin Kemp. 'For a little while *The Face* became the house mag of that scene, with me responding to Nick's guidance,' says Elms.

In turn *The Face* provided up-and-coming musicians with an outlet for visual experimentation. Elms cites his friend the actor/musician Gary Kemp's view that, 'while you can talk about MTV making people aware that videos had to become a skill alongside songwriting or whatever, *The Face* was the precursor, because to be in the magazine you had to be visually aware. You were not going to get a front cover if you looked like a grungy rock band, but you would if you were Blue Rondo à la Turk, who couldn't really play but looked great!'[1] As a result, as *Smash Hits* contributor David Hepworth recalls, there was 'a parade through our offices; in the midst of putting this magazine out, there was a stream of New Romantic fops coming in to see Nick'.[2]

While *Smash Hits* was also benefiting from this upswing in flamboyant youth style, Hepworth's choice of words is more in line with the sniping from the increasingly threatened weekly rock press, in particular the *NME*, which peppered its pages with snide snippets and cartoons lampooning cocktail-swilling zoot-suiters who bore resemblances to Elms and his ilk. 'The *NME* had a tradition of mistrusting visually oriented artists, going back to their treatment of Bryan Ferry and Roxy Music in the early 1970s,' says Elms. 'Now we were enacting the revenge of those people by featuring Kid Creole, Blue Rondo, Haircut One Hundred, Jo Boxers, legions of bands who liked to dress up

onstage and feature in great videos and photo shoots. In a way it became a self-fulfilling prophecy. These types of performers appeared because *The Face* was there to provide the platform. And it must be understood that *The Face* was blessed with incredible timing. I've lived in and studied London long enough to know that there are periods when things start to happen, and *The Face* really caught what was going on.'[3]

Hepworth, meanwhile, recognized that as Logan's new project established itself, it became 'too big a thing for him to maintain any relationship with Emap'.[4] The end of the association was advanced by David Arculus and Robin Miller's launch of the avowedly New Romantic monthly *New Sounds New Styles* in March 1981. Logan viewed the move with distaste. 'I felt I'd been turned over', he said later. 'They'd effectively pooh-poohed my idea, made me go through a lot of heartache to get it somewhere and then tried to muscle in.'[5] The tentative nature of the project – *New Sounds New Styles* was granted a sixty-four-

above
No. 9, January 1981.

and Labovitch had circulated around Oxford the first issue of their magazine *Blitz*, a quarterly A3 fold-out containing a similar mix of new music, fashion and film to *The Face* but with a reliance on established and surprisingly old-guard contributors, including the national paper columnist Sheridan Morley and film critics Quentin Falk and Alexander Walker. The couple's title choice was of course one of the buzzwords of the period – Elms had referred to 'Blitz Kids' in 'The Cult with No Name' (see pages 50–51) and Steve Taylor marked the signing of Steve Strange and his group Visage to Chrysalis Records, as well as the spate of 'Blitz Nights' being staged at regional and provincial clubs, by pronouncing 'Blitz Culture is about to go public' in January 1981.

With Emap's launch of *New Sounds New Styles* rendering Logan's presence at Carnaby Street untenable, new premises were found courtesy of an early supporter of *The Face*, Pete Townshend. The Who main-man's offer of a short-term let in a basement in neighbouring Broadwick Street, adjacent to Soho's busy fruit-and-veg market in Berwick Street, was gratefully accepted.

'This is when Soho was Bohemian and very seedy,' says Steve Taylor, who was made 'associate editor (features)' and joined Logan in working from the basement for a couple of weeks every month. 'You got there by going through an archway and then down some stairs. It was pretty basic, like a cave; it's no surprise that Pete Townshend didn't have a use for it. We worked intensively – Nick would rarely be gone by the time I went home and when I turned up in the morning he'd be there – and lived on sausage sandwiches and tea and coffee from the local caffs. If I summon an image of that era of *The Face* it always contains several half-empty Styrofoam cups with those flimsy lids.'[8]

The office was in the same building as businesses operated by Townshend under the Eel Pie banner. These included a book imprint; the guitarist had not long before been appointed an editor at Faber & Faber, the venerable publishing house where T. S. Eliot had once toiled.

After the move, Steve Bush remained at *Smash Hits* as art director but also continued to contribute page layouts and cover designs to *The Face* as Logan tweaked and refined the presentational format, aware that identifying the new body of readership required careful handling of the ways in which content was communicated. For example, the cover line 'Rock's Final Frontier' was replaced by the early summer of 1981 by three words: 'Music Movies Style'.

'Up until that point I'd had a bit of a dilemma over the photographs Chalkie Davies, Mike Laye and Sheila Rock were bringing in, of musicians posed in new fashion designs,' says Logan. 'For example should I just run them as is, or should there be supporting text? But also, what heading did they come under? I didn't want to use "fashion". That had connotations that

page cash-in pilot issue before Emap plumped for a monthly run designed with more élan by graphic artist Malcolm Garrett four months later – spoke to the conviction among executives at the media conglomerates that this area of publishing may have been as flash-in-the-pan as the youth movement with which it was most associated.

The *New Sounds New Styles* editor was Garrett's partner Kasper de Graaf, who drew on Steve Taylor's knowledge for the pilot. 'I gave him info about the editorial direction and wrote a few pieces for the first issue but then didn't hear anything more', says Taylor.[6] Robert Elms was a contributing editor: 'The reason I went to *New Sounds New Styles* was because they offered me a salary. I remember telling Nick and him just chuckling. I was rather hoping he'd say, "I'll give you some money to stay", but he didn't, so off I went for a while.'[7]

Among those also clocking the editorial direction being mapped out by *The Face* were the well-heeled and well-connected Oxford undergraduates Simon Tesler (whose father was a British television mogul) and Carey Labovitch (niece of Clive Labovitch, Tory government minister Michael Heseltine's partner in the Haymarket trade and technical publishing empire). Just ahead of Emap's *New Sounds New Styles* test run, Tesler

didn't fit what we were doing, which was more from the street, so might prejudice readers who were only used to that [fashion] appearing in places like *Vogue* or in women's magazines. "Style" seemed right, a bit innocuous but summing up where we were at. Of course I didn't know then that this would lead to us being called a "lifestyle" magazine.'[9]

The cover line soon became redundant as the readership grasped *The Face*'s offer; it was revived just once in the mickey-taking 'Music Movies Bow Ties' for the January 1982 issue featuring Chris Sullivan and Christos Tolera, Soho scenesters and dandified members of Latin-funk group Blue Rondo à la Turk.

Older and initially operating in a tangential post-punk milieu, the most prominent person associated with the 'cult with no name' was Stuart Goddard, otherwise known as Adam Ant, whose swashbuckling flamboyance and musical mix of Burundi beat, Native Americana and 1950s twang had broken out of the club circuit to establish a substantial pop audience. Chris Salewicz and Jill Furmanovsky's cover story for the April 1981 issue captured Ant in ascendance, with his album *Kings of the Wild Frontier* and consecutive singles 'Dog Eat Dog' and 'Antmusic' topping the charts as the performer was confronted with a fit-to-burst promotional schedule.

Just a year before, Ant's career had appeared dead in the water, his backing band having defected to Malcolm McLaren's Bow Wow Wow project. It is arguable that regular appearances in *The Face* – he had featured with musical collaborator Marco Pirroni from issue three on – was a major factor in not only raising Ant's credibility in the music industry but repositioning him to a visually aware new fan-base. As Salewicz recalls: 'As Adam says, the Look was as important as the music: "The first time we did *Top of the Pops* we were a foretaste of things to come – we did it before Spandau Ballet or The Stray Cats or any of the Look bands. It's nonsense for us to be called New Romantic. I've never been to the Blitz in my life. The way all these groups look is a bit of an up, though."'

A piece in the opening section of the same issue signalled Logan's ambition to incorporate coverage outside of Britain and in particular from the American centres of cultural activity. The feature on musician siblings Evan and John Lurie's smart-suited Manhattan beatnik jazz quintet Lounge Lizards represents the first published contribution in *The Face* by twenty-two-year-old transplanted Brit James Truman.

After leaving school, Truman had worked in the late 1970s as a journalist on the north London paper the *Ham & High*, which served the leafy suburbs of Hampstead and Highgate. Here his beat took in music venues including Dingwall's Dancehall, The Music Machine and The Roundhouse in Camden Town. Truman also freelanced for *Melody Maker* before making the move to New York late in 1980, by which time he had become an avid reader of *The Face*, and was given the nod to make an approach by his acquaintance Jon Savage.

'*The Face* was only sold in a handful of places in New York, mostly record shops, but certainly had an impact among the club-goers and downtown elite who followed it closely,' says Truman.[10] He proposed the Lounge Lizards article in a letter to Logan; their clean-cut appearance and connections to Truman's friend Bryan Ferry via his management company EG clinched the commission. Later to blaze a trail through US media culminating in his appointment as right-hand man and close adviser to S.I. 'Si' Newhouse, chairman of publishing conglomerate Condé Nast, Truman had divined that *The Face*'s appeal in Manhattan lay in communicating that the street could be glamorous, 'not just angry and dirty and punk…that made the conventional fashion magazines like *Vogue* pay attention'.[11]

opposite
No. 11, March 1981.

left
No. 12, April 1981.

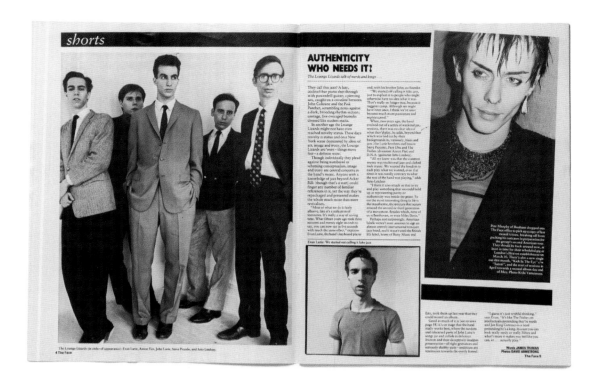

Truman first met Logan in person on a trip back home in the summer of 1981. 'I don't exactly remember what I expected, but I encountered a rather anxious man working in a mildewed studio, commissioning, editing, art directing and selling ads for the magazine all by himself,' says Truman. 'It was pretty startling.'[12]

In fact, Logan did have the back up of Steve Taylor. 'I was an organized, efficient right-hand man who could also write,' says Taylor. 'I was also quite separate from the others, who were plugged into the scene in some way. I didn't have James Truman's social connections and private wealth, I didn't have Robert Elms's intense involvement in what was hip, but I could roll my sleeves up and get stuck in, supplying features and working on production when needs be. There are only two jobs relating to publishing production I didn't do: layouts and ad sales. I learnt every other skill in putting a magazine together from Nick.'[13]

Around this time, Logan took to working from an office in Colour Solutions, the repro house in north London,

to hide away from the stream of contributors, tourists and well-wishers whose visits threatened to interfere with the meeting of deadlines. Logan recalls being particularly tested by a visit from garrulous drummer/club entrepreneur Rusty Egan, who started a monologue before entering the office lavatory and, leaving the door open in full view of Logan, proceeded to 'rabbit on at me while he took a dump'.[14] Logan also felt beleaguered by the many photographers who made their pitches while hovering over him as he reviewed their portfolios. Relief was soon to be provided by art director Neville Brody, who cannily insisted that they leave these to be studied – or not, as it turned out – overnight.

This lay in the near future. In the meantime, Colour Solutions became a safe haven and, with Taylor's input, Logan's ambitions for his magazine's content were demonstrated by an extensive feature on the funeral in Jamaica of reggae superstar Bob Marley in the July 1981 issue (see pages 74–75). In this way *The Face*'s remit was broadening into the territory of the continental European news magazines he admired.

Marley's death had passed largely unnoticed outside specialist media, so fixated were the nationals, TV and radio on the wedding of Prince Charles and Lady Diana Spencer that summer. Logan, however, understood that Marley's demise was of import to youth culture as well as to the sizeable Caribbean community in Britain and snapped up images of the historic event by music photographer Adrian Boot, who knew Marley and had long since established himself in the Jamaican reggae

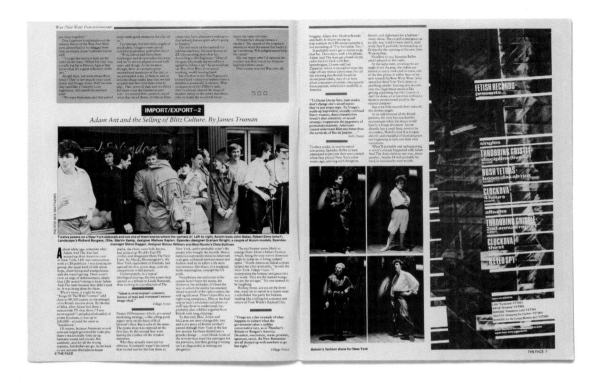

scene. When combined with the last interview with the superstar by music journalist Roz Reines, the feature formed eleven pages at the core of the issue. This also contained a report by James Truman on a trip to Manhattan by London's New Romantic demi-monde entitled 'Adam Ant and the Selling of Blitz Culture'.

The pretext for the visit was a showcase for new British fashion; among those taking part were Robert Elms, photographer Graham Smith, members of Spandau Ballet, designers Sade Adu (prior to launching her musical career), Melissa Kaplan and Sarah Lubell, Chris Brick and Jon Baker of, respectively, labels/boutiques Demob and Axiom, and designers/DJs Chris Sullivan and Simon Withers. 'I'd arrived in New York as many young Englishmen do, both in awe of the place and insecurely convinced that being from London made me cooler than most Americans,' says Truman: 'When the Blitz crew came over and New York writers tried to explain it, I felt instantly critical and dismissive, so wrote a piece along those lines. It may have had a few funny sentences, but I think it was mostly attitude. Which, given the subject, may not be anything to be ashamed of.'[15]

On the trip Elms met Adu for the first time; they became an item and moved in together back in London. In time Sade became a staple of The Face, appearing first as a member of the funk-soul group Pride and then in her own right, as Elms recalls: 'I showed Nick a photograph of Sade; she was a total unknown but Nick recognized something in her. It was not so long afterwards that she was on Top of the Pops performing "Your Love is King". That shows Nick's extraordinary ability to go with an idea. He never needed a second opinion but instead acted on instinct and then overlaid that with a trust that us writers, photographers and designers were getting it right.'[16]

Meanwhile, Blitz magazine founders Labovitch and Tesler had come down from Oxford and relaunched their title first as a quarterly and then as a monthly Face-a-like with a 10,000 copy print run and national distribution muscle via the giant WHSmith retail chain. Soon they dropped the folded A3 format in favour of the more retail- and advertiser-friendly A4; with i-D still being published in its odd rectangular format, this posed a head-on challenge to The Face. 'We'd like to establish it as a magazine which will be launching new writers and writing about new artists,' Labovitch told The Observer, which noted that 'colour magazines have blossomed from almost every Sunday newspaper, and expiring punk rock and New Romantic street journals pop up and disappear from the bookstalls like a bad case of acne'.[17]

The similarity in approach, content and execution earned Blitz the disapproval of Logan and his staff; there are stories of false items being placed in The Face as bait for Blitz to pick up on. 'Blitz magazine bought wholesale into Steve Strange, Spandau Ballet and others as a vital movement,' says Truman. 'I think one of the early strengths of The Face, which likely came from Nick having lived through more than a few subcultures, was that the magazine covered the Blitz phenomenon without attaching itself to it. In retrospect, it was a pretty inconsequential

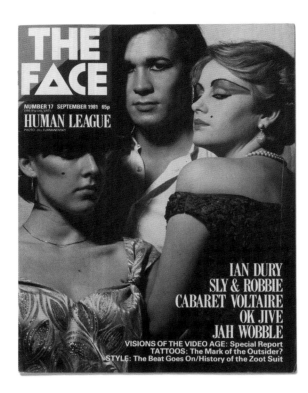

and I guess I was excited to investigate the carnival, from a still-British perspective.'

Truman was never once told to rein it in. Logan was ready to listen patiently to all manner of pitches, as Truman discovered early one morning. 'Having been up all night, I called Nick in the UK, telling him I wanted to go to Chad, in Africa, to cover the civil war,' he recounts. 'I'd just met someone who'd come from there, who told me the war had come to a standstill because both sides lacked the resources and will to continue fighting. In a 4am daze, it seemed like a fascinating story, to write about a war in which both sides had lost interest. Nick heard me out, and said, "Sounds great, you should do it". I never did do it.'[19]

With a US correspondent, a selection of the hippest contributors on the planet, new titles snapping at his heels and steadily rising sales and ad content, Logan was in no mood to let up, as Steve Taylor attests. 'The last week of the production cycle when we pulled everything together could be hell. There'd be writers delivering major pieces late or not at all and photos you'd been promised never turning up. The state of the copy from those who were not professional writers could be shocking, so would require complete rewrites. You'd be writing to fill gaps while the motorbike messenger was revving up outside to take everything to the printers, the pressure was that intense. And then it would be done, and everything would be out of our hands for that month. Instead of going to the pub and relaxing, Nick would start agonizing about who was going to be on the cover of the next issue. The guy was relentless. It was

moment in pop culture, and *The Face* always seemed bigger than it, which is one reason why the publication endured and *Blitz* eventually didn't.'[18]

At Steve Taylor's suggestion, Truman began contributing a monthly 'New York' column in the autumn of 1981, complete with an ident featuring a photograph of a US flag flying from a Hudson River ferry. 'There was no brief; I'd just let them know what I wanted to write about next,' says Truman. 'I'd already lost interest in writing about music, and had never felt I was particularly good at it. Arriving in New York there seemed to be richer subjects to cover.'

Among the topics that struck Truman as 'exciting and newsworthy' and made it into the pages of *The Face* were pro-wrestling, telephone sex, film criticism, the avant-garde filmmaker Kenneth Anger, Art Deco, Manhattan club culture, nouvelle cuisine and political conventions. 'Thinking back, my columns must have been something of an outlier, since the main thrust of the magazine was London style culture, but I think the British have always tended to see America as a slightly surreal carnival,

above
No. 17, September 1981.

right
No. 22, February 1982.

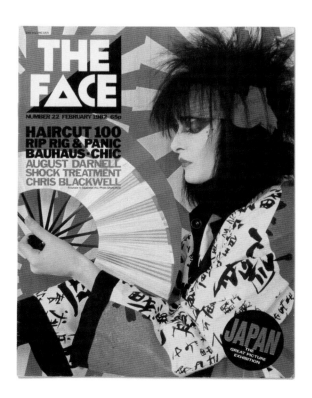

obsessive, but obsessively good, because that's what made the difference.'

Logan confesses to constantly reworking the flatplan guide to pagination of each issue with 'pencil, eraser and a pack of Marlboro my constant companions'. He adds: 'I worked on the theory that a reader looked at each page in turn, and that every page, whether ad or editorial, contributed to the voice of the magazine. Each issue was the sum of those singular messages. Nothing was taken for granted. I woke up every morning with a new idea: to change the running order of features, change titles of sections, create new ones, move them from front to back and back again during the course of an issue as time allowed, often extending the deadline by having page numbers changed after the issue had gone to film.'[20]

Taylor was also struck by the disconnect between the growing perception of *The Face* as the ultimate style bible and the circumstances in which it was produced. 'It was akin to *Vogue* being produced out of a room above a kebab shop in Manor Park,' he laughs. 'The truth is that the wages reflected the same thing. You'd be writing about big-budget subject-matter and could barely pay your rent.'[21]

Steve Bush was by now full time at *Smash Hits* and, for a brief period, Logan had produced layouts with Dave Fudger, designer at music paper *Sounds*, where he'd shown a willingness to break design protocols. 'Dave's layout style, so good on *Sounds*, didn't really adapt,' says Logan, who assumed the magazine design again for a couple of issues.

Enter Neville Brody, who had completed a spell of devoting his energies to clients including the independent record company Stiff and taken an office at the premises of Witchseason, the music production and management company run by American expat Joe Boyd. When Boyd's company moved on, Brody suggested to Logan that Wagadon take its place on the fourth floor of an office block in Mortimer Street, north of Soho in one of London's rag trade districts.

Brody was at that time delivering on freelance commissions from book publishers and music labels including the independent Fetish Records and Soho fashion outlet Demob, and expressed an interest in designing for *The Face*. 'At first Neville's contributions were tentative,' says Logan. 'He did occasional pages such as the singles column, and then a contents page, and gradually, over a period of two or three issues he began to get to grips with the challenge of handling the overall design.'[22]

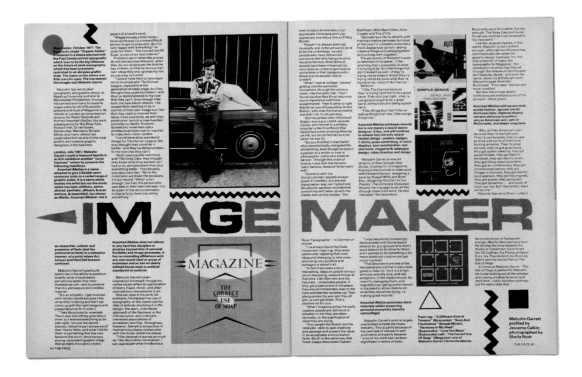

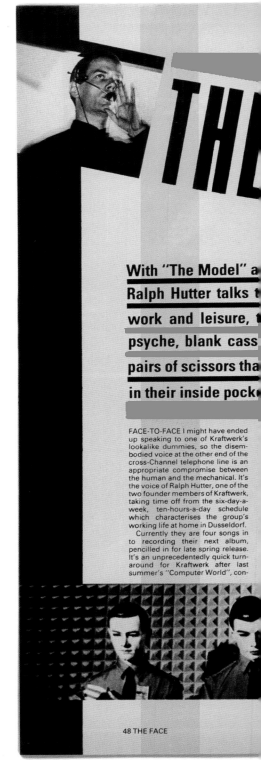

As noted by British graphics authority Rick Poynor, Brody's breakthrough in formalizing a contemporary design language at the magazine was cemented with the publication of issue twenty-three in March 1982 and in particular his layout of a Steve Taylor interview with Kraftwerk's Ralf Hutter that riffed on both the cover of the German group's 1978 LP *The Man Machine* and its origins in the work of the early-twentieth-century radical artist El Lissitzky. 'This was a period in which ambitious young designers constantly invoked the achievements of modernism's leading lights half a century earlier,' writes Poynor.[23]

Brody later said that, rather than copy the stylistic tropes of his forebears, he had deliberately set about channelling their 'sense of dynamism, humanism and non-acceptance of traditional rules and values. Once you looked at that you could pursue your own response.'[24] The same issue contained a two-page feature by Jessamy Calkin on the work of Brody's contemporary and *New Sounds New Styles* designer Malcolm Garrett, who had himself been quoting Lissitzky since his artwork for the cover of The Buzzcocks' LP *A Different Kind of Tension* in 1979.

By the time of Calkin's interview, Garrett's designs for *New Sounds New Styles* had shown he was as eager as his rival Brody to tip his hat to the heroes of Modernism, and not only Lissitzky but Jan Tschichold in particular and Futurism and Dadaism in general. However, *New Sounds New Styles* was not to provide as stable an environment for Garrett as that granted

opposite
'Image Maker', no. 23, March 1982.

below
'The Work Ethic', no. 23.

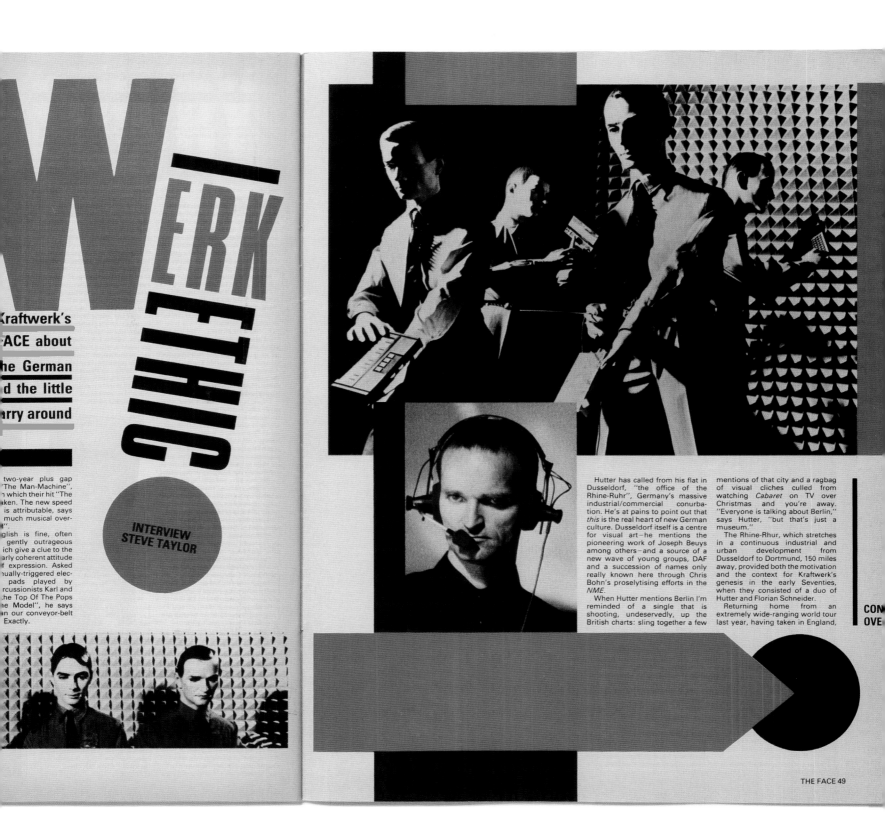

WERK ETHIC

Kraftwerk's ... FACE about ... the German ... the little ... rry around

two-year plus gap 'The Man-Machine', which their hit "The aken. The new speed is attributable, says much musical over-...".

nglish is fine, often gently outrageous ich give a clue to the rly coherent attitude f expression. Asked nually-triggered elec-pads played by rcussionists Karl and he Top Of The Pops he Model", he says an our conveyor-belt Exactly.

INTERVIEW STEVE TAYLOR

Hutter has called from his flat in Dusseldorf, "the office of the Rhine-Ruhr", Germany's massive industrial/commercial conurba-tion. He's at pains to point out that *this* is the real heart of new German culture. Dusseldorf itself is a centre for visual art—he mentions the pioneering work of Joseph Beuys among others—and a source of a new wave of young groups, DAF and a succession of names only really known here through Chris Bohn's proselytising efforts in the *NME*.

When Hutter mentions Berlin I'm reminded of a single that is shooting, undeservedly, up the British charts: sling together a few mentions of that city and a ragbag of visual cliches culled from watching *Cabaret* on TV over Christmas and you're away. "Everyone is talking about Berlin," says Hutter, "but that's just a museum."

The Rhine-Rhur, which stretches in a continuous industrial and urban development from Dusseldorf to Dortmund, 150 miles away, provided both the motivation and the context for Kraftwerk's genesis in the early Seventies, when they consisted of a duo of Hutter and Florian Schneider.

Returning home from an extremely wide-ranging world tour last year, having taken in England,

CON
OVE

by Logan to Brody; unable to gain a satisfactory hold on the market, Emap pulled the plug with the final – and thirteenth – issue in July 1982. Garrett and Kasper de Graaf headed out of publishing and back into the music industry, servicing acts including Culture Club and Duran Duran.

Meanwhile, Brody's 'fresh, radical and innovative' ideas of page layout and type design attracted a following with the steadily growing band of readers of *The Face* as monthly sales climbed above 60,000 copies. Among his trademarks, according to academic Catherine McDermott, was the use of symbols and logos 'almost as road signs to guide the reader through the page, creating a vocabulary for magazine design of the period using handwriting marks and type that ran sideways'.[25]

Interest from the established media coalesced in a piece in the huge-circulation national weekly *The Sunday Times*, where columnist Barry Ritchie challenged his readers: 'I bet you haven't heard of *The Face*', before applauding its content.[26] This solidifying of the public and visual identity of *The Face*, together with Brody's openness to experimentation, coincided with the rise of out-and-out British pop in terms of sales.

Championed to great commercial success at *Smash Hits*, where fortnightly circulation was regularly topping 250,000 copies, British pop acts including Human League and cover

star of issue twenty-three of *The Face* Kim Wilde slipped the boundaries of music press lionization to scale the charts. Less giddy than *Smash Hits*, *The Face* coverage was still celebratory in tone, and Wilde was followed on the front cover by accessible new stars including Bananarama, Fun Boy Three and Haircut One Hundred. The last of the three was featured with a Sheila Rock portrait of the group's pop pin-up Nick Heyward on the front of the June 1982 issue. This was to be Brody's first designed cover, and confirmed his place as full-time art director on the magazine.

'That's when it all started coming together,' said Logan in the mid-1990s. 'Neville took the magazine to a different level; I've come to appreciate what he did more and more. The way he combined photography, type and white space was so good. Many people have tried to rip him off but they can't manage it.'[27]

The Heyward portrait flagged the second piece to appear in the magazine by Lesley White, who subsequently became one of Britain's leading feature journalists and political interviewers through her long-term stints at national newspapers including *The Sunday Times*. White had come to Logan and Taylor's attention for her interviews with Mod revival group Secret Affair and the quirky post-punk performance artist Frank Tovey, which were submitted amid the growing number of unsolicited pitches and editorial contributions arriving from young untrained writers as well as seasoned journalists upon whom realization had dawned that *The Face* was now a publishing venture worthy of serious consideration. Then twenty-one, White was a recent graduate from Sussex University and Brighton inhabitant, the southern coastal town sometimes dubbed as 'London-on-sea'. 'Brighton was always a pretty switched-on place, so we knew all about *The Face*,' says White. 'I set my sights on it and sent a few pieces based on interviews with people who played my friend's club in Brighton to the address in the back of the magazine.'[28] White subsequently received a call from Taylor, who commissioned a piece on the electro-pop duo Yazoo, then topping the charts with the single 'Only You'. This was followed by the Heyward cover story and encounters with Phil Oakey of Human League and Kevin Rowland of that summer's hit act, Dexys Midnight Runners.

White's article on Dexys revealed *The Face*'s interest in formulating fresh approaches to the pop music interview. The opening paragraphs discussed how Rowland's preconditions for a previous encounter with the magazine had been turned down. This and White's interrogations into Rowland's response to the criticism he was receiving from the music press drew the veil back on the music industry's promotional machine, humanizing him in the process.[29]

Dexys and the new wave of British pop performers had become familiar faces to the wider public, featuring in

the popular dailies and performing on light entertainment programming including BBC TV's newly launched evening show presented by the Irish broadcaster Terry Wogan.

As *The Face* contributor Dave Rimmer has pointed out, this pop wave 'didn't make sense in terms of the only criteria the music press could muster. It simply didn't look right in artily unfocused monochrome snaps. And there were few people still interested in reading tortured analytical prose.'[30]

According to Jon Savage, *The Face*, along with *i-D*, 'captured a new socialized pop attitude that seemed refreshing. Central to this was the idea of club culture, of collective social activity and of black music used as a metaphor for cool community and indefinable "soul".'[31]

While this music received sympathetic framing within the pages of *The Face*, its shininess masked the serious social concerns being raised by the depredations of Margaret Thatcher's hardline Tory government, which had pulled back from the brink of collapse by dragging British troops into conflict with Argentina's military junta over sovereignty of the Falklands Islands in the south Atlantic.

At *The Face*, the autumn of 1982 witnessed a gear-shift that communicated the magazine's nimbleness in tracking the national conversation where it pertained to youth. Against a close crop of the shredded denim-clad and stud-belted behind

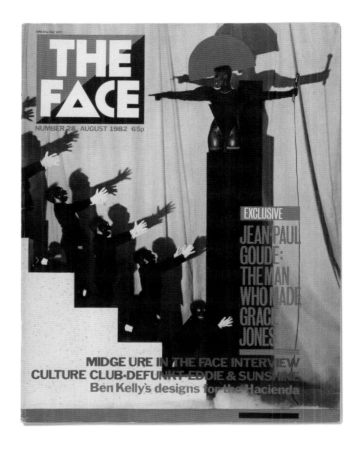

of Sade's manager Lee Barrett, the cover line of issue twenty-nine asked: 'What ever happened to the zoot suit?' above the full-caps pronouncement 'HARD TIMES' (see pages 72–73). In this, the first issue not to feature an interview subject portrait on the cover, Robert Elms was given his head by Logan to discuss the impact of the early 1980s rightwing backlash and the apparently ceaseless recession – with the attendant mass unemployment figures – on youth culture.

'Political awareness is a personal thing, but everybody who can feel is feeling pain right now,' wrote Elms. 'People are getting angrier, the optimism that once led to bluff and bravado is now an optimism that you'll be able to hold on to.' Elms sought to link this anger to the protest soul music of Curtis Mayfield

opposite
No. 25, May 1982.

left
No. 26, June 1982.

above
No. 28, August 1982.

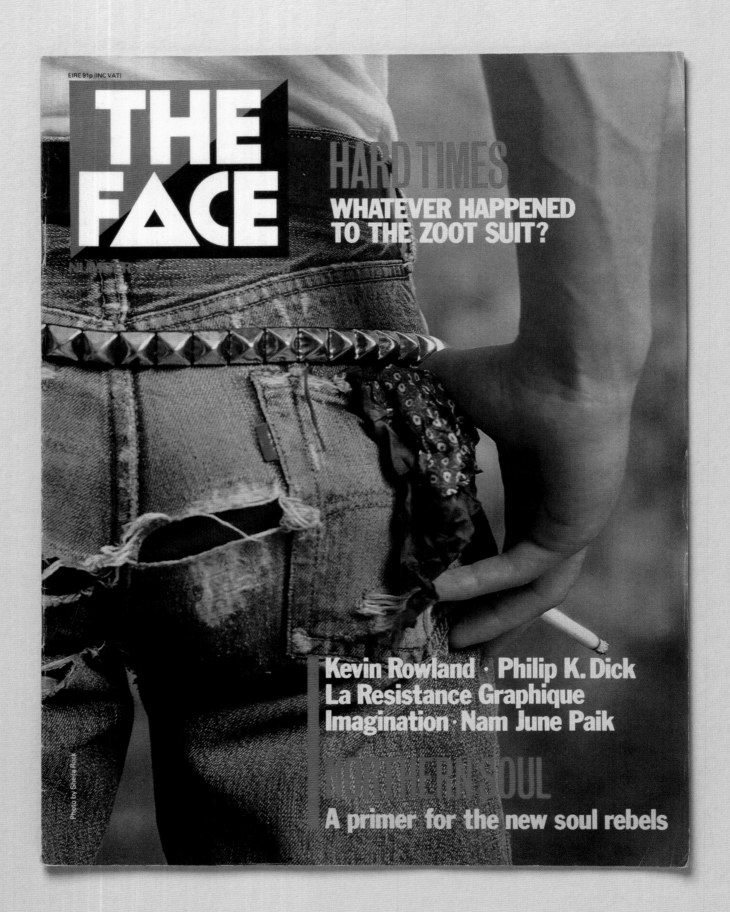

EIRE 91p (INC VAT)

THE FACE

NUMBER

HARD TIMES
WHATEVER HAPPENED TO THE ZOOT SUIT?

Kevin Rowland · Philip K. Dick
La Resistance Graphique
Imagination · Nam June Paik

NORTHERN SOUL

A primer for the new soul rebels

Photo by Sheila Rock

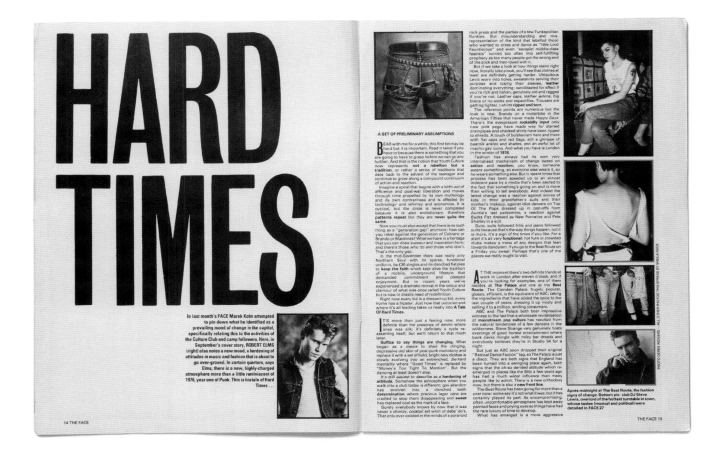

and Gil Scott-Heron and more recent releases including the Valentine Brothers' 'Money's Too Tight to Mention' with the growing usage of heroin among young Londoners and the new visual styles being adopted by habitués of grimy club nights like The Dirtbox in Earl's Court: 'Clothes are definitely getting harder. Ubiquitous Levi's worn into holes, sweatshirts serving their purpose and losing their sleeves, leather dominating everything – sandblasted for effect if you're rich and Italian, genuinely old and ragged if you're not. Leather caps, leather jerkins, big boots or no socks and espadrilles. Trousers are getting tighter, T-shirts ripped and torn.'

Elms was subsequently derided for the portentous introduction to the piece: 'Bear with me for a while, this first bit may be hard but it is important. Read it twice if you have to, because there is something you are going to have to grasp before we can go any further. And that is the notion that Youth

opposite

No. 29, September 1982.

above

'Hard Times', no. 29.

Culture now represents not a rebellion but a tradition, or rather a series of traditions that continue to grow along a compound continuum of action and reaction.'

Viewed from the digital age, however, 'Hard Times' has been praised by columnist Suzi Feay, who wrote as the late 2000s era of post-financial crash austerity kicked in: 'It's poignant at this distance to read something so genuinely egalitarian, without a single reference to celebrity.'[32]

As it turns out, Elms's piece was not commissioned as a cover story. 'In one of our chats in the office I told Nick about this new harder look and atmosphere in the clubs, with hard drugs being on the increase,' says Elms. 'He told me to write a piece which he would include in the run of features. I expected a couple of pages with Derek Ridgers's photos of kids in the Beat Route and The Dirtbox.' Presented with Elms's copy, however, Logan decided that the issues it raised gave the piece sufficient heft to become the focal piece of that month's magazine, commissioning Sheila Rock to shoot the striking cover image with styling by Elms. 'I remember thinking, "That's a bold decision",' said Elms. 'In retrospect I can see that this was the end of the first period of *The Face* when it had been a kind of "music mag plus". From hereon in, music was just one part of a much broader spectrum.'[33]

73

below and opposite
'A Warrior's Funeral', no. 15, July 1981.

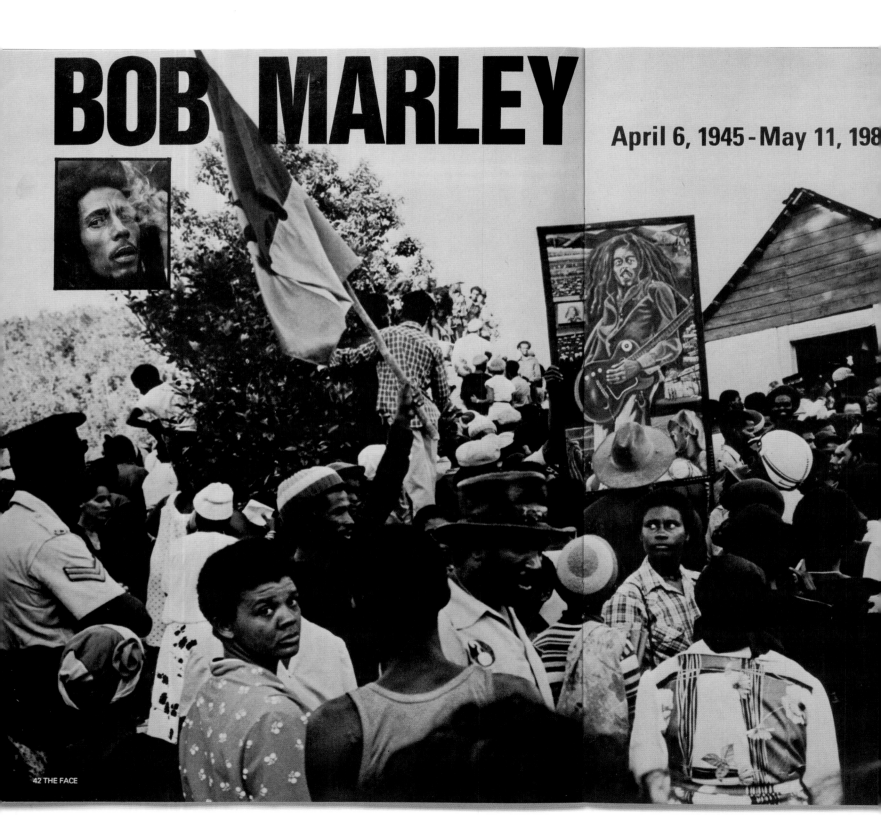

BOB MARLEY

April 6, 1945 - May 11, 198

42 THE FACE

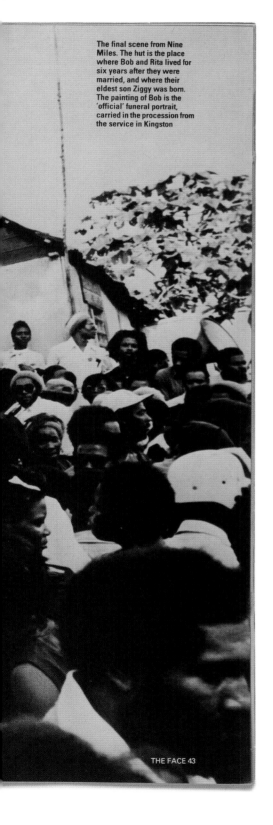

The final scene from Nine Miles. The hut is the place where Bob and Rita lived for six years after they were married, and where their eldest son Ziggy was born. The painting of Bob is the 'official' funeral portrait, carried in the procession from the service in Kingston

THE FACE 43

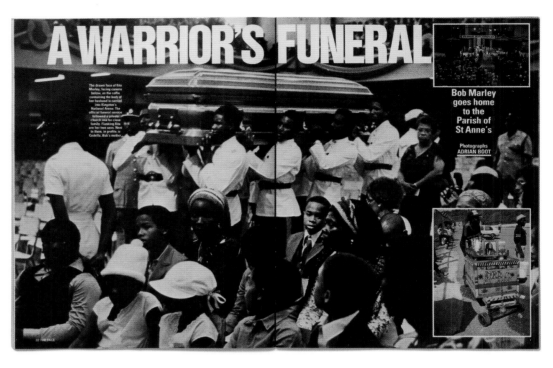

A WARRIOR'S FUNERAL

Bob Marley goes home to the Parish of St Anne's

Photographs ADRIAN BOOT

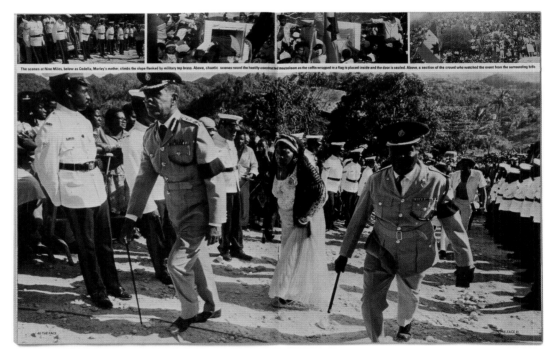

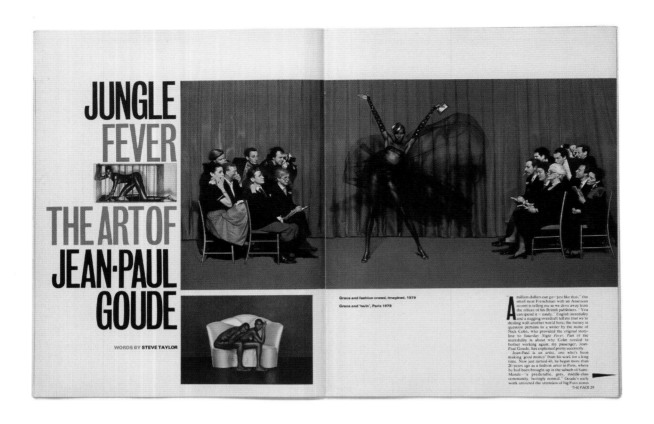

JUNGLE FEVER
THE ART OF JEAN-PAUL GOUDE

WORDS BY **STEVE TAYLOR**

Grace and fashion crowd, imagined, 1979
Grace and 'twin', Paris 1979

A million dollars can go—just like that," the small neat Frenchman with an American accent is telling me as we drive away from the offices of his British publishers. "You can spend it – easily." English incredulity and a nagging overdraft tell me that we're dealing with another world here, the money in question pertains to a writer by the name of Nick Cohn, who provided the original storyline to *Saturday Night Fever*. Part of the incredulity is about why Cohn needed to bother working again: my passenger, Jean-Paul Goude, has explained pretty succinctly.

Jean-Paul is an artist, one who's been making 'good money' from his work for a long time. Now just turned 40, he began more than 20 years ago as a fashion artist in Paris, where he had been brought up in the suburb of Saint-Mandé—'a predictable, grey, middle-class community, boringly normal." Goude's early work attracted the attention of big Paris stores

THE FACE 29

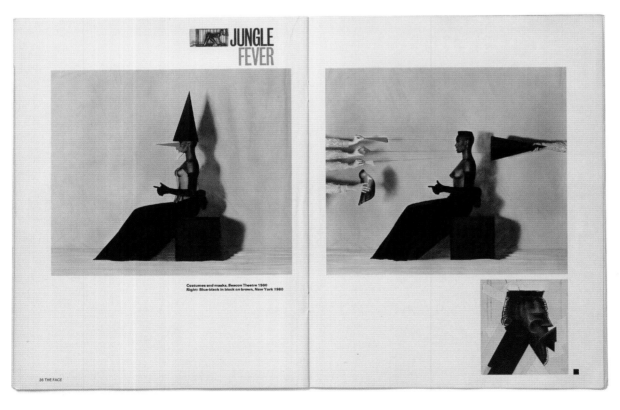

JUNGLE FEVER

Costumes and masks, Beacon Theatre 1980
Right: Blue-black in black on brown, New York 1980

38 THE FACE

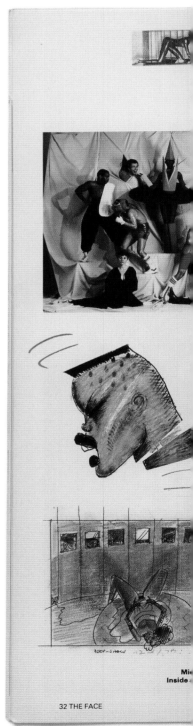

Mie
Inside

32 THE FACE

opposite and below
'Jungle Fever: The Art of Jean-Paul Goude', no. 28,
August 1982.

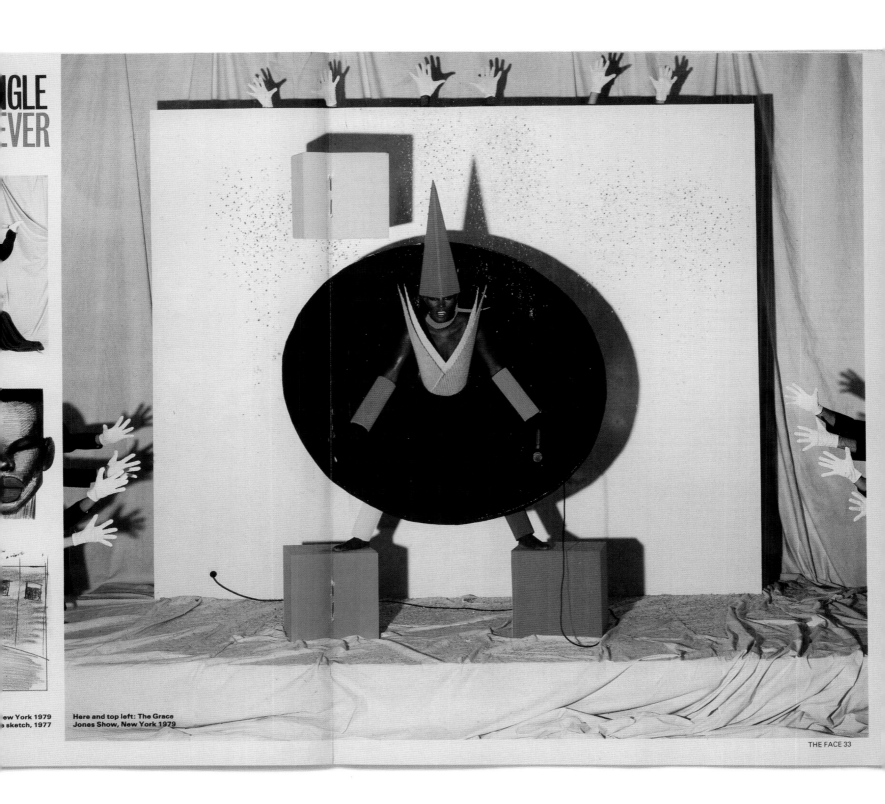

JGLE
EVER

Here and top left: The Grace
Jones Show, New York 1979

ew York 1979
sketch, 1977

THE FACE 33

Chapter Four

The Age of Plunder

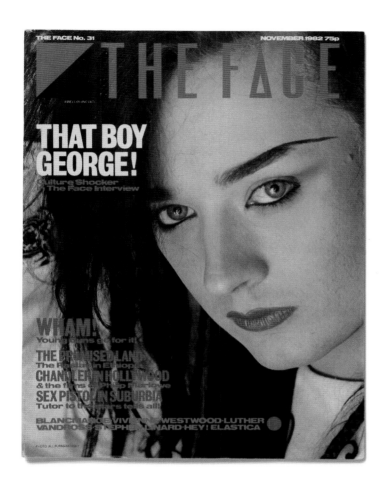

White describes Brody's satellite office at this point as 'a powerhouse, a parallel engine to the one that was running the editorial. It was an amazing, complementary creative atmosphere.'[1]

Meanwhile, pop stars and performers were using the Mortimer Street base as a stopping-off point on their travels around London's West End. Even the grizzled Fleet Street veteran and broadcaster Derek Jameson put in an appearance. 'He turned up one day out of the blue asking what the buzz was about,' said Logan: 'It was all a bit bizarre but then those things tended to happen. A bit later, when we had moved to the Old Laundry one of the Koch brothers appeared asking questions. I still don't know whether he was sizing us up as an investment.'[2]

Boy George had regularly dropped by with his outrageously attired club-going friend Philip Sallon since the earliest days of the magazine; memorably, a review by

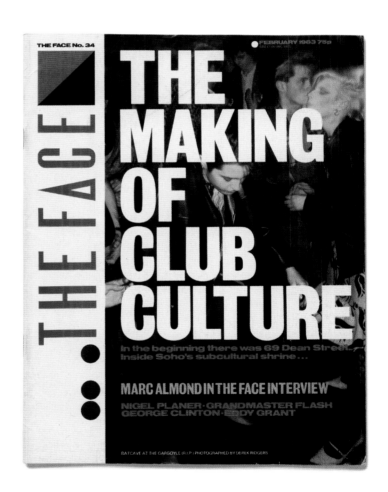

In the wake of 'Hard Times' came cover features including 'The Making of Club Culture', an examination by *Evening Standard* journalist David Johnson – who had been an early champion of the magazine – of the dance scene's overturning of the ways in which music was consumed, and a report on the growing dominance of electronically generated sounds across the music industry, which inspired a particularly audacious Brody text-only design in blue, black and red against a vivid yellow ground.

The confidence with which these subjects were handled showed the magazine had a greater social agenda than it was given credit for at the time, according to Lesley White. She had been taken on by Nick Logan as a permanent staff member at the Mortimer Street offices at the end of 1982. 'The job was offered to me at my first meeting with Nick,' says White, who was employed as the receptionist but also given the responsibility for the new 'Intro' section at the front of the magazine showcasing the gamut of new design and pop culture developments. 'Nick was quite matter-of-fact, taking just a couple of minutes to say that they needed more help, with writing when it needed to be done, and on production and at the printers every month. I was in. That was always the way at *The Face*. Everybody pitched in: making the tea, cleaning the toilets, everything.'

top left
No. 31, November 1982.

above
No. 34, February 1983.

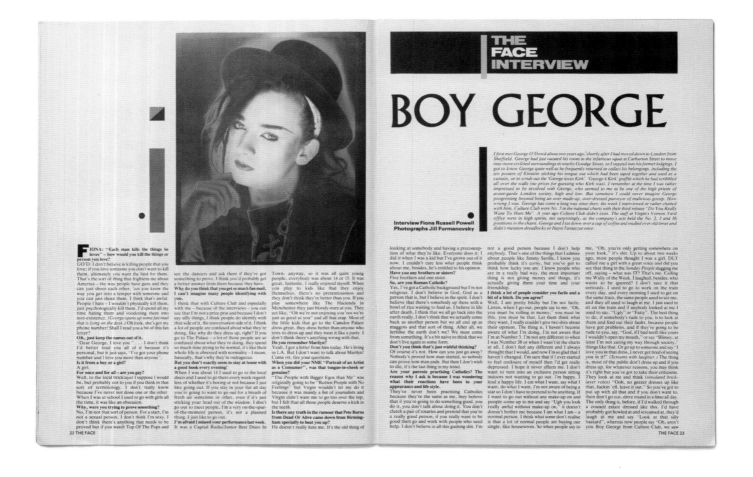

contributor Marek Kohn – who started the page of snippets featuring the gamut from local gossip to political developments around the world under the heading 'Disinformation' – incensed the Culture Club singer so much that he stormed in to the office and scrawled: 'Marek Kohn is a spotty queen' on the wall in front of horrified staff. Boy George was treated with more respect by Fiona Russell Powell, a former member of Sheffield's post-punk scene whose youth (she was eighteen, 'a music-mad bolshie brat',[3] when her first piece appeared in *The Face* in 1982), striking appearance and spiky, loopy insider copy earned her the position of star interviewer for waspish encounters with a roll-call of the individuals most associated with the magazine in this period, including musicians Soft Cell's Marc Almond, August Darnell (otherwise Kid Creole, leader of the Coconuts), Terry Hall of Fun Boy Three and Glenn Gregory of Heaven 17 as well as the likes of Sallon, then running London's Mud Club, and even Andy Warhol.

By the time of Russell Powell's debut in *The Face*, Logan and Taylor were becoming inundated with requests for coverage from record labels and film and TV companies. Unlike their competitors, they felt they could be selective as to who fitted the magazine's profile without the traditional pressure from the advertising department (largely because such a thing didn't, as yet, exist). Says Logan: 'Where the music press had a remit to review products, and find a way to deal with acts it might despise, *The Face* had no such obligations so we could create our own agenda. It would have been unbearable if we'd been happy and positive over everything we covered but for the most part we could write about what we liked and ignore what we didn't.'[4]

Since day one, Logan had relied on the formula that while the circulation was relatively low in comparison with mainstream publications (heavily promoted women's magazine *Cosmopolitan* was selling 2.6 million copies a month worldwide at this time[5] while IPC's *NME* and *Melody Maker* may have been losing circulation but could still boast half a million-plus British sales between them a month) advertisers should still pay a premium to reach *The Face*'s demographic. This was a mix of young pop fans and tastemakers willing to spend on new releases and visits to boutiques and cinemas as well as the university graduates

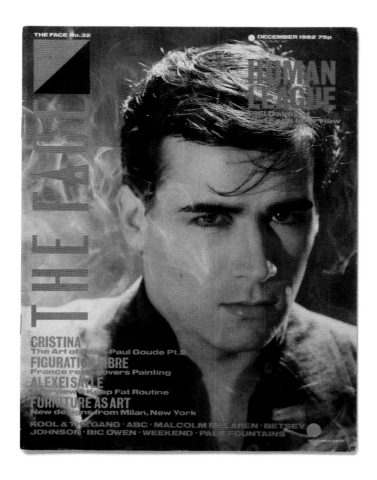

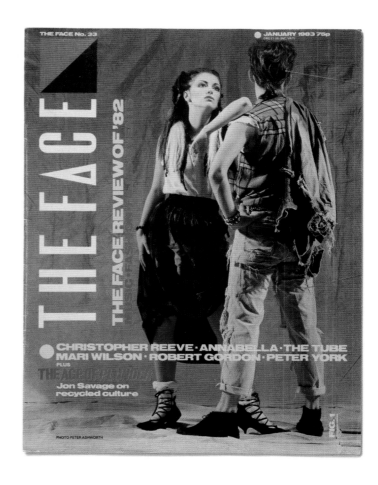

and young upwardly mobile professionals soon identified as Yuppies then making the moves across business sectors from advertising, creative and media to the banking and financial services communities of the City of London.

This social sub-sect was also the target audience for Britain's new commercial TV station Channel 4, which launched in November 1982. In its initial incarnation, the avowedly minorities-driven edge to the channel may be viewed as British broadcasting's response to the gauntlet thrown down to the rest of the media by Logan's magazine.

In fact, a year before the launch, the executives behind the channel had approached Logan for his input; he passed them to Steve Taylor who was put on a retainer as a consultant on youth programming, and when broadcasting commenced, as the presenter of a casually presented chat show featuring musical interludes titled *Loose Talk*. Taylor's involvement on-screen and behind the scenes provided *The Face* readers and other 'lifestyle' consumers with a steady diet of the alternative comedy, independent music and film and political debate they had become accustomed to devouring in print.

Meanwhile, *The Face*'s maintenance of its position as the locus for all that was cool can be attributed to the industriousness instilled in the team by Logan. 'We would work

Saturdays, late into the nights on deadline,' said Lesley White. 'Nick held it all together and was selling the ads with Julie, who was of course also handling the accounts.' White adds that Elms, whose piece on scratching in early 1983 demonstrated that the magazine was on top of the latest musical developments, was 'very important in that period, and instrumental in us looking at how youth culture interfaced with politics'.[6]

There were also prominent boosters including *The Observer* fashion editor Sally Brampton and *Harpers & Queen* style guru Peter York. In fact, York's *Harpers* features editor Ann Barr once called the office to heap praise on Logan and his staff. White took the call: 'It was fantastic. She said: "I just wanted to tell you that you're a complete rave, a complete rave!"'.[7]

Confirmation of *The Face*'s position as design arbiter arrived at the beginning of 1983 with the publication of Jon Savage's essay on postmodern appropriation under the heading

above left
No. 32, December 1982.

above right
No. 33, January 1983.

'The Age of Plunder' (see pages 92–93). Savage viewed such borrowing through the prism of 'Thatcherite political culture in which everything is turned into a disposable consumer commodity', while Brody's layout chose examples, including Peter Saville's cover for New Order's 1981 LP *Movement* (based on a 1932 Futurist poster) and Barney Bubbles' 1977 Kandinsky-quoting sleeve for The Damned's *Music For Pleasure* album (Bubbles was acknowledged as 'a huge influence' by Brody[8]).

Savage adopted a scathing tone in his dismissal of appropriations: 'A proper study of the past can reveal desires and spirits not all in accordance with Mrs Thatcher's mealy-mouthed ideology as its spreads like scum to fill every available surface, and it is up to us to address ourselves to them. What pop does, or doesn't do, ceases to be important.'

After three hectic years reporting from the front lines of pop culture and social issues, 'The Age of Plunder' placed *The Face* at the heart of one the defining preoccupations of the so-called 'Designer Decade'. Now Logan's magazine was not only commentating but setting the pace.

According to academics Simon Frith and Howard Horne, *The Face* was also marketing an 'art school sensibility in a way in which creativity, commentary and commerce become indistinguishable'.[9] This proved an irresistible mix for the wider media, particularly in America, as James Truman recalls: '*The Face* was important in shifting the perspective, especially in fashion, from "top-down" to "street-up", and also in bringing music/style/pop culture into the realm of the mainstream. I remember doing a story on Stephen Sprouse, who dressed Debbie Harry, in the early 1980s. The fashion magazines had largely ignored him, because he was outside of the establishment, but his designs for Debbie – the one-shoulder dress, the shift dress – were the most iconic fashion statements of the time. I believe *The Face* was highly influential in forcing fashion editors to look beyond established designers and to understand that fashion was also coming from the street, and especially from music culture.'[10]

In a certain regard, the publication of the eighty-page thirty-sixth issue in April 1983 marked the end of the ad-hoc, hand-to-mouth phase of the magazine's existence.

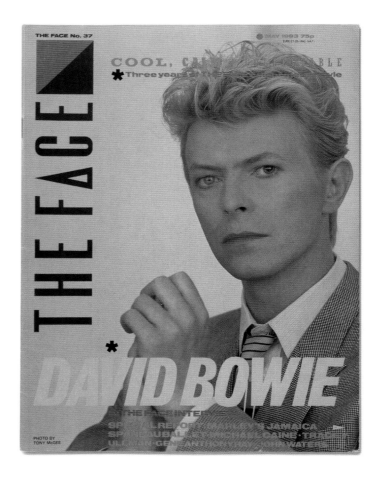

above right
No. 37, May 1983.

opposite top
'The Face Interview: David Hockney', no. 36, April 1983.

opposite right
'The Face Interview: David Bowie', no. 37.

With advertising revenues stabilizing and monthly circulation approaching 80,000 copies, Logan recruited established music writer Paul Rambali from the *NME* to become assistant editor responsible for features. Rambali replaced Steve Taylor, who was by now fully committed to Channel 4 as presenter of the second series of *Loose Talk*, which was broadcast from south-east London's Albany Theatre, one of the homes to the new comedy featured regularly by the magazine. The set was designed by Ben Kelly, his radical interiors for Manchester nightclub The Hacienda resulting in him becoming a fixture in the pages of *The Face*; British talk-show host Jonathan Ross was also to use his experience as a researcher on *Loose Talk* as the first building blocks of his career.

However, the programme was ramshackle and poorly received critically. Within a couple of years Taylor was to gravitate back into Logan's orbit.

A star writer at *NME*, Rambali had become disenchanted with the machinations of the paper's owner IPC. In the spring of 1983 the publisher's board initiated a 'management strike' to ward off industrial action during the annual pay negotiations, effectively applying pressure by barring the staff from entering

the premises until a settlement was reached (a technique later to be applied by Rupert Murdoch when he broke the unions after moving his News International titles *The Sun*, *The Times* and *The Sunday Times* from Fleet Street to Wapping in east London).

'This brought home to me that I worked for a big corporation, which didn't square with the punk ethic of independence we were preaching at the *NME*,' says Rambali, who is now a Paris-based author and journalist. 'Meanwhile, Nick was actually doing it. I admired the fact that he had put his money where his mouth was and done something audacious. Also, because it was a glossy monthly it seemed like the future, which of course it turned out to be.'

At *The Face*, Rambali, who had edited the 'Thrills' pages of short items at *NME*, was given the opportunity to write and commission stories about subjects that interested him. 'In his hands-off management style, Nick provided me with the space to do what I wanted,' said Rambali. 'Steve Taylor had started widening the coverage out for music to the arts, film and fashion and the plan was to expand on this. I remember a discussion with Nick about whether to run one page on fashion or two in a particular issue. It was sensitive at that time because there were a lot of important social issues to cover and we could have been seen as being frivolous. Whatever, we agreed two pages, because this stuff wasn't being covered anywhere else.'[11]

Rambali's experience and energetic presence also provided vital support for Logan in harnessing the skills of the staff at Mortimer Street, of whom it was said that it could easily be accommodated in a London taxi (which has an upper limit of five passengers). 'Although we continued to work hard, things seemed to ease up after Paul joined,' says Lesley White, whose interview with Paul Weller made the cover of issue thirty-seven (which also contained a six-page feature by art scenester

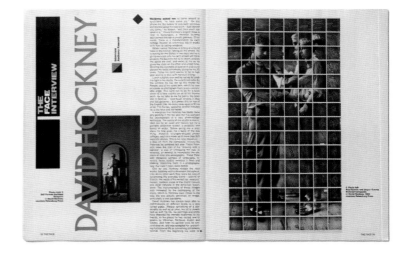

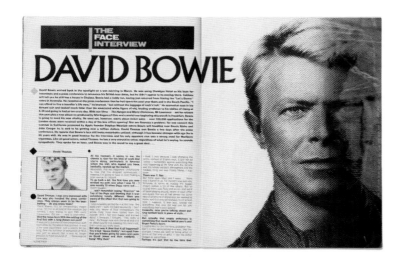

Anthony Fawcett on David Hockney's investigations into photo-collage and a Robert Elms piece on New York punk rocker and poet Richard Hell). On publication, White was delighted to receive a letter from Weller. 'It was passed on by my flat-mate Vaughn Toulouse [the performer who had contributed The Clash feature to issue one and was by now close to The Jam singer],' says White. 'Paul wrote that he was happy with the piece but also he was surprised at how I came across because he didn't think that "real people" worked at *The Face*. At the time I thought: "What's he going on about?" but soon realized that there was a view about us as individuals which didn't chime with the reality.'[12]

Logan recalls overhearing one queuing customer at a Mortimer Street newsagent say to another 'We have *The Face* to blame for that'. 'I never found out what they were talking about – or what we were to blame for – but found it very funny,' says Logan.[13]

The return of David Bowie to the cover of the next issue – to coincide with the release of comeback album *Let's Dance* – closed a circle for the artist and the magazine. The release, and the costumes Bowie adopted for the companion Serious Moonlight Tour, took their cue from the London fashions that had been featured in *The Face* over the previous three years. In a book documenting the tour, Bowie admitted that the stage clothes he commissioned from US opera costume designer Peter J. Hall were 'a parody of all the New Romantics, these bands, my musical children'.[14]

While the early 1980s British fashion boom had provided substantial content, Lesley White characterizes the magazine's stance in the field as 'more about style rather than merchandised fashion with a capital "F". We covered the collections in quite an ad hoc way but importantly we had contributors such as Helen Roberts – who was also a talented stylist – writing about designers who were new or doing something interesting.'[15]

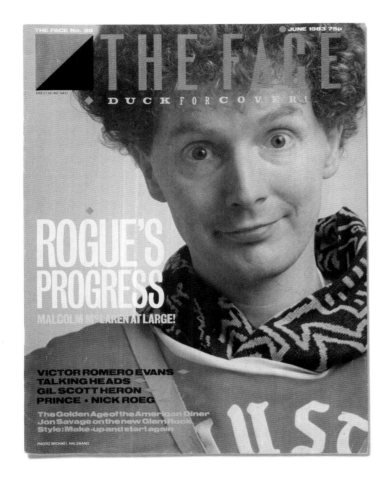

THE FACE No. 38 JUNE 1983 75p

THE FACE

DUCK FOR COVER!

ROGUE'S PROGRESS

MALCOLM McLAREN AT LARGE!

VICTOR ROMERO EVANS
TALKING HEADS
GIL SCOTT HERON
PRINCE • NICK ROEG

The Golden Age of the American Diner
Jon Savage on the new Glam Rock
Style: Make-up and start again

PHOTO MICHAEL HALSBAND

In this way *The Face*, along with *i-D*, was, in the view of arts writer Robert O'Byrne, 'unquestionably far less demure and respectful towards fashion than any existing publications – but then so too was their target market, much of which was composed of students surviving on tight budgets but with ample determination to make an impact. Fashion, in this instance, became another aspect of popular culture, alongside music and cinema.'[16]

Meanwhile, James Truman was relentless in his banging of the drum on the other side of the Atlantic. In May 1983 he organized two parties for *The Face* at Manhattan's Danceteria; the Logans, Brody, Elms, Rambali and White were flown to

above
No. 38, June 1983.

opposite left
Invitation for *The Face* party at Danceteria, 20 May 1983.

opposite right
Flyer for the line-up at Danceteria in May 1983.

America courtesy of Richard Branson. The shindigs hosted crowds of around 2,000, among them the magazine's favourite zoot-suited New Yorker, Kid Creole, as well as the Was (Not Was) brothers and Downtown legends including Alan Vega of Suicide, No Wave jazzer James Chance and punk/disco diva Cristina. Entertainment was provided by New Soul act D-Train and the salsa veteran Tito Puente and his orchestra.

D-Train had been booked by Truman for a small fee; not long after accepting the invitation they scored a hit in the British charts with their single 'Music' and had been flown to London to make an appearance on the high-ratings weekly TV show *Top of the Pops*. Buoyed by their perceived enhanced status the group's management demanded more money if they were to take the stage. Truman and Logan were summoned to an office in the bowels of Danceteria to meet the 'very large' manager who was flanked by two equally bulky men. 'That they were carrying guns was a serious possibility,' says Logan. 'As we walked into the office, both James and I tripped on an incline in the office floor and fell over; not a great start for two skinny Limeys. I ended up handing over all the money in my pocket – $200 – but we were facing a disaster if the headline act didn't play.'[17]

Truman was subsequently granted the title of New York editor. 'The deal was I would contribute a monthly column, as well as smaller pieces for 'Intro', and co-ordinate some ad sales,' says Truman, who also provided a critique of each issue for Logan's private consumption. 'My modest walk-up studio apartment became the magazine's New York headquarters,' adds Truman, whose home phone number was published in the magazine. 'I had to discourage people from ever coming to the "headquarters" because it was basically a slum. The disappointment on their faces was often too much to bear.'

Truman also came up with a novel, if uneconomic, means of providing his copy in those pre-Internet years. 'The first problem was that I was always late in finishing pieces; I found writing agonizing, and right up until the deadline I'd still be working on the first paragraph,' confesses Truman, who, like most other journalists of the period, used a manual typewriter (which was 'filled with fluff and cigarette ash', recalls Logan). 'Fax machines were still expensive and rare; overnight couriers were complicated, as for some reason every package containing a photograph still had to be inspected by British customs, maybe as some holdover from Cold War espionage fears,' says Truman. 'So I'd get past the deadline, have the piece somewhat finished, but could find no way to get it to London in time. There were still very cheap last-minute standby fares on Transatlantic trips and more than a few times I'd take the overnight flight, finish the piece on the plane, and show up at the offices unannounced with the story in hand. Let's just say this was not a sustainable model.'

In June 1983 the magazine was the subject of another party at an achingly hip Downtown New York club, this time Area on Hudson. Once again Truman was the organizer. 'The founders were big fans of the magazine, and the first published piece about Area was the one I wrote in *The Face*, so they threw it for us,' said Truman.[18]

The front of the following month's issue – comprising cover lines with an unconventional crop of a Kevin Cummins portrait of Stephen Morris, drummer with Paul Rambali's interviewees New Order – was to become one of the most recognizable in the magazine's history (see page 86). 'We had some photos of the group to go inside but there wasn't anything which struck us as being worthy of the cover,' says Logan. 'I talked it through with Neville and suggested that we crop the guy's face out apart from the top left-hand side; he made it really eye-catching. That was my contribution, and Neville has since then generously described me as an "art director". What he did with the typography in the space the crop opened up was dazzling. Amending the cover lines as necessary, I watched him open-mouthed. I loved working with Neville; he had an answer for every design dilemma we encountered.'[19]

Brody's designs also enhanced the magazine's increasing interest in contemporary visual artists in this period, represented by the series of submissions by the team of Anthony Fawcett and Jane Withers, including their summer 1983 feature on Joseph Beuys (see page 87), which considered the great German conceptualist in pop cultural terms: 'A personal confrontation with the man echoes encounters with other genius outsiders: John Lennon, Ian Curtis, Colin Wilson to name a few.'[20]

Fawcett was also an art-scene fixer of some experience; his and Withers's showcasing of the work of Cindy Sherman, Robert Mapplethorpe and Bruce Weber in the pages of *The Face* also advanced the discussion as to whether the work of such photographers constituted art.

Meanwhile, Fiona Russell Powell was consistently filing strong personality profiles and interviews. 'Fiona was a natural, that's why we featured her a lot,' says Paul Rambali. 'She had a lot of nerve, which always produces great material, and she could handle those encounters well. I remember her telling me

overleaf, left and top right
No. 39, July 1983, and 'New Order' from the same issue.

overleaf, below right
'Beuys Adventure', no. 40, August 1983.

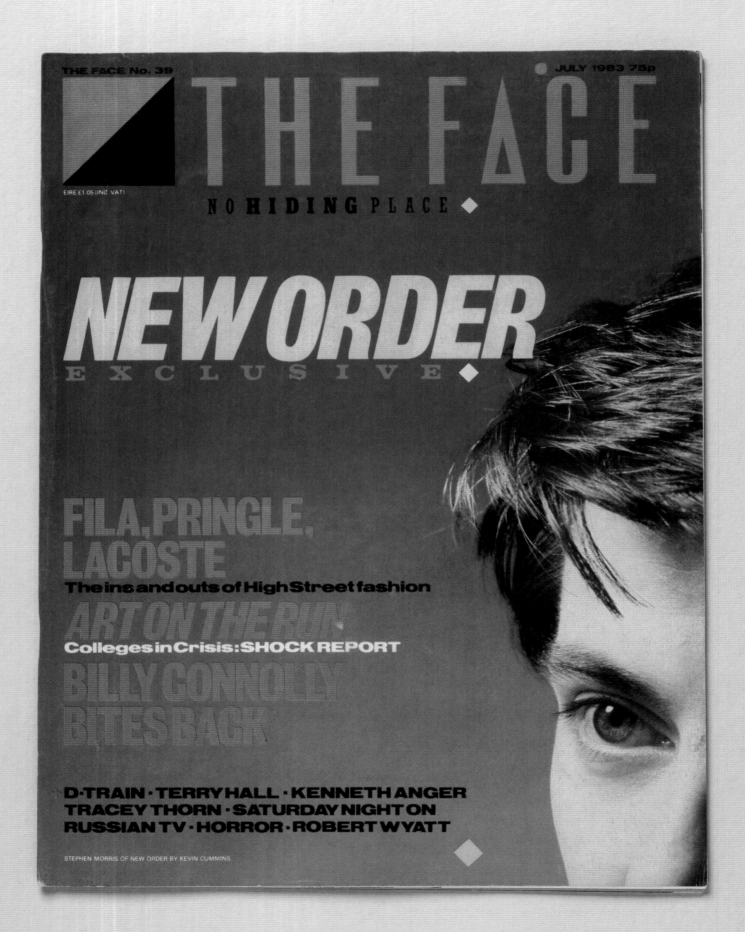

THE FACE No. 39 ● JULY 1983 75p

THE FACE

EIRE £1.05 (INC. VAT)

NO HIDING PLACE ◆

NEW ORDER
E X C L U S I V E ◆

FILA, PRINGLE, LACOSTE
The ins and outs of High Street fashion

ART ON THE RUN
Colleges in Crisis: SHOCK REPORT

BILLY CONNOLLY BITES BACK

**D·TRAIN · TERRY HALL · KENNETH ANGER
TRACEY THORN · SATURDAY NIGHT ON
RUSSIAN TV · HORROR · ROBERT WYATT**

◆

STEPHEN MORRIS OF NEW ORDER BY KEVIN CUMMINS

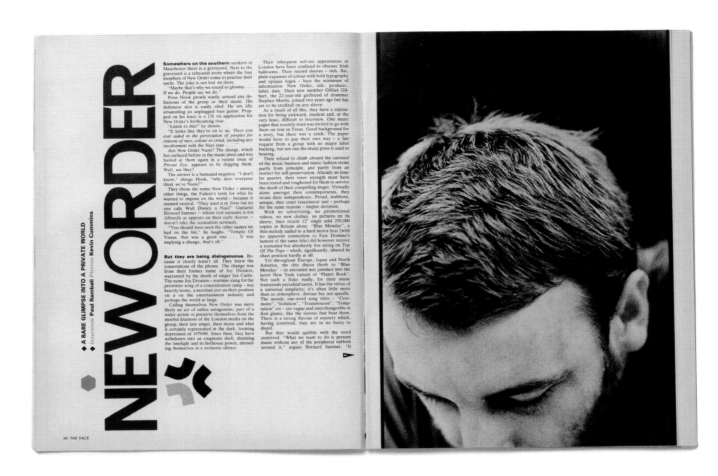

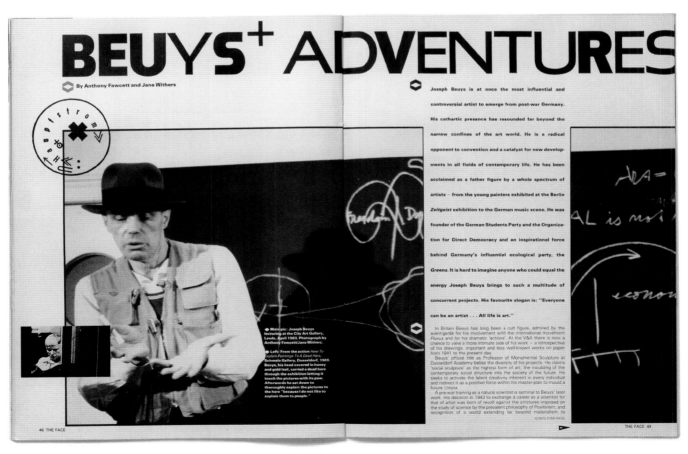

she loved *Andy Warhol's Interview*, which was a bit leftfield at the time and a perfect reference. We paced ourselves not against other British magazines but the international press like *Interview*, *Rolling Stone* and *Actuel*.'[21]

The popularity of Boy George and the British obsession with his sexuality – this was at a time when the Culture Club frontman declared on TV that he preferred a cup of tea to sexual activity – was broadened out into a spate of national media stories about the androgynous appearance of post-New Romantic performers, sparked by Peter Ashworth's cover portrait of the crop-headed singer Annie Lennox wearing a leather mask for the October 1983 issue (see pages 96–97). 'The Americans are very confused by the sex of the new British bands,' reported the *Daily Mirror*. 'First they thought Boy George was a girl and that Yazoo's Alf was really an Alfred. Now they are convinced that the Eurythmics lovely Annie Lennox is actually a HE.'[22]

By November 1983, the all-encompassing interest in areas of design identified by Logan's magazine was one of the factors in the founding of British architectural magazine *Blueprint* by writer Peter Murray and design authority Deyan Sudjic. In tone and emphasis on presentation, *Blueprint* took its cue from *The Face*.

Around this time the ad industry magazine *Campaign* reinvigorated its offer with a relaunch replete with stylistic nods to Brody: thick black bars, tight photographic cropping, expressive typographic tics, active headlines. The national newspapers also gussied up their weekly supplements in the style of *The Face*; *The Observer*'s *Living* and the *Sunday Times Magazine* both adopted the magazine's dimensions of 30.1 × 24.3cm (11⅞ × 9½in.) more popular in continental Europe; this was the maximum size available on standard web presses and chosen by Logan to maximize news stand profile and photographic impact.[23]

The realization hit that even though *The Face* was operating in a relatively 'small niche, we were leading', according to Lesley White, who confirms that confidence rose as a result. 'On the editorial side we felt we were on the up, but while Nick shared in that, from a business point of view it was difficult for him to let go of his cautiousness.'[24]

Yet Logan's concomitant willingness to take risks was highlighted in the publishing of the November 1983 issue, which was bannered 'New Life In Europe!' and dedicated to the latest cultural developments across the Continent and how they related to social and political circumstances. This in part came from the magazine's attitude that, as members of what was then the EEC, Britain should embrace a more Continental lifestyle. 'We were actively militating for that,' said Paul Rambali. 'At the time pubs closed in the afternoons and at 11pm. We were living a nocturnal life in Soho which was far more cosmopolitan, and that's what we wanted for the UK as a whole.'

The 'New Life In Europe!' issue was a joint venture with like-minded Continental magazines that shared stories on aspects of European culture as well as the cover image of a child by photographer Margit Marnul. At the same time as this appeared on front of *The Face* it was on the covers of the latest issues of *Wiener* in Austria, *Oor* (Holland), *Etc* (Sweden), *Frigidaire* (Italy), *Tip* (Germany), *El Vibora* (Spain) and France's *Actuel*.

The initiative came from Jean-François Bizot, the French underground press doyen who founded *Actuel* as a response to Australia's *Oz* in 1967. The following year – after the May 1968 protests – Bizot conjoined *Actuel* to the worldwide countercultural agency the Underground Press Syndicate (UPS), which shared stories the mainstream media would not run across a network, including New York's *East Village Other* and the *LA Free Press* as well as *IT* and *Oz* in Britain and several titles in Europe.[25]

Bizot approached Logan with his plan to replicate UPS in the 1980s as a new network of like-minded independent publications sharing information and news. 'Bizot had a vision of creating a European powerbase to counterbalance the cultural

hegemony of America,' said Paul Rambali: 'This was a big issue at the time and came out of punk, that wish to hold back the tide of American cultural junk in favour of a culture you've generated for yourself, not one you've bought into.'[26]

Bizot's proposition was that each title produce one major feature for the joint edition, and all eight would be shared between the magazines. Meanwhile, *Actuel* and Logan's magazine also commissioned opinion polls into the views of each country's citizens about their neighbours.

That month each also ran the same list of seventy subjects of note, including the architects Jean Nouvel from France and Britain's Richard Rogers, Austrian designer and Memphis co-founder Matteo Thun, Birgit Cullberg, the grand dame of Swedish ballet, and Italy's multimedia performance group Falso Movimento.

Neville Brody's layouts for the issue included jarring photographic manipulation and the use of folkloric motifs (see pages 98–99). 'I decided to subvert the European success in all forms of art by using ancient Mexican symbolism,' he later explained. 'This undermining factor was to pinpoint Europe's colonial plunder, and how easily it had become a tradition. I don't think many people, or even *The Face*, realized this side of the design.'[27]

Paul Rambali recalls the response to the Europe-wide issue as positive. 'You bought *The Face* because you wanted to find out what was going on and to discover something new,' he adds. 'While our readers may have been surprised by it, they were more than happy to go along with the idea.' Bizot's vision for a 1980s UPS was never realized, but the venture marked out the international worldview of *The Face*, which was to repeatedly return to considering Britain's relationship to the rest of Europe in the future.

By the early spring of 1984, the magazine's evangelizing on behalf of young British creative talent was spreading to the mainstream. Writing in the *Evening Standard* ahead of that season's London Fashion Shows (as Fashion Week was then known), Robert Elms claimed that the latest British pop invasion of America by acts including Culture Club and Duran Duran was based on demand for British youth culture, 'a piece of the most vibrant fashion scene in the world. Fashion sells our pop industry.'[28]

Paul Rambali believes that refusal to adhere to the music business promotional cycle – by which most albums were released in the last quarter of the year, for example – proved liberating. 'That meant we weren't solely reliant on music business advertising, as had happened in the early days,' he said.

'By deciding to cover fashion – under the heading of "style" – we started to get fashion advertising which provided a stable financial base. Things started to boom, circulation was moving up every issue and the ads were coming in.'[29]

The power of the magazine's support for fashion start-ups was conveyed to the feted Bodymap designers David Holah and Stevie Stewart during business meetings after they showed the spirited and cartoonish Autumn/Winter 1984 collection 'Cat in the hat takes a rumble with a technofish', which had been featured in *The Face*. 'We really felt we were "up there" so we went to our bank for a larger overdraft, but they wouldn't give it to us, even with orders,' Holah recounted in 1988. 'So we moved to another bank, I'm trying to think of the name, Lloyds I think, the one with the green cheque book, yes definitely Lloyds. And so we went to this new manager and he had six copies of *The Face* on his desk, and it was really good because he was prepared to take a flier on fashion.'[30]

opposite
No. 43, November 1983.

left
No. 44, December 1983.

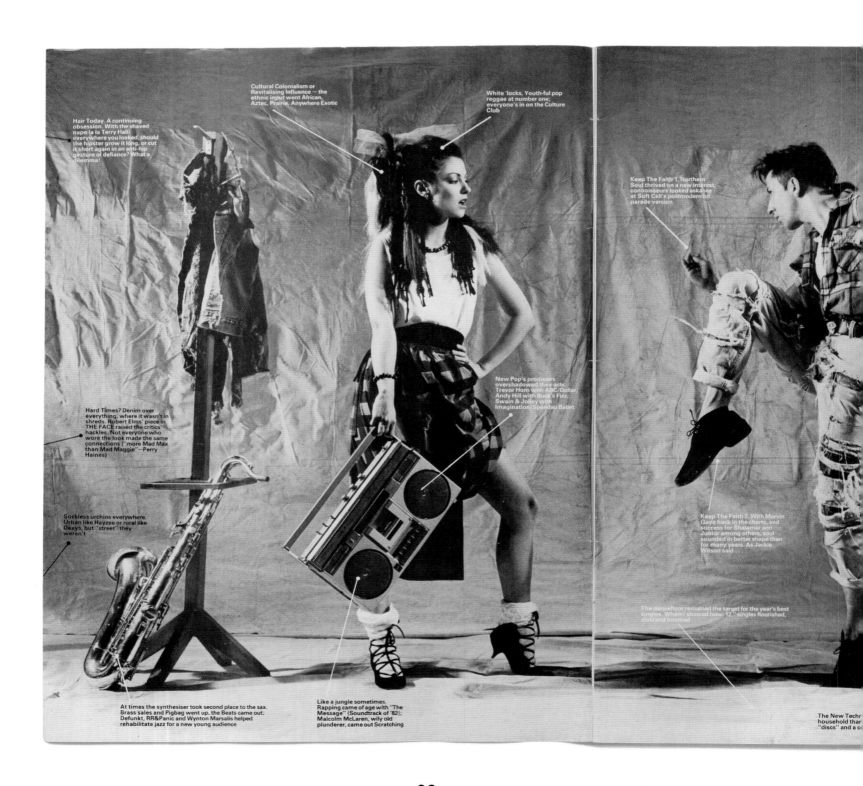

G. 2

Photography Peter Ashworth
Art Direction Neville Brody, Perry Haines
Models: Karen-Anne Callen, Perry Haines

Karen's hair, multi-coloured rag and bobtails, by Roger and Gary at Antenna; Perry's by Simon Forbes at Antenna

Karen's clothes: Western tie-up skirt from PX; white vest and stockings from Modern Art; Shoes from Saddles; beads, necklace and bracelet from Oasis Trading.
Perry's clothes: ripped to shreds Levi jacket; bleached, dyed and patched Levi jeans; black suede crape-soled creeper boots from Robot; tartan shirt (sleeves ripped off) over THE classic plain white t-shirt.

The Fitness Fad. Aerobics and the F-Plan; Bananarama's sweatshirts, Haircut's Cult of the Cleancut. Herpes and Heroin were the darker side of the coin

Recession. Millions discovered that a UB40 was more than a reggae band from Birmingham; real Hard Times for some

...ism. War in the ...ds had a drastic affect ...sh Politics but failed to ...illage a year of decline ...reasing Rule of the Right

TV spawned a fourth channel and a brood of youthful pop programmes of which The Young Ones and The Tube showed most promise

Cinema fought back with Stephen Spielberg, Poltergeist and E.T.; pirated video tapes renewed the threat

...machines per ..., all manner of new ...ome

THE FACE 3

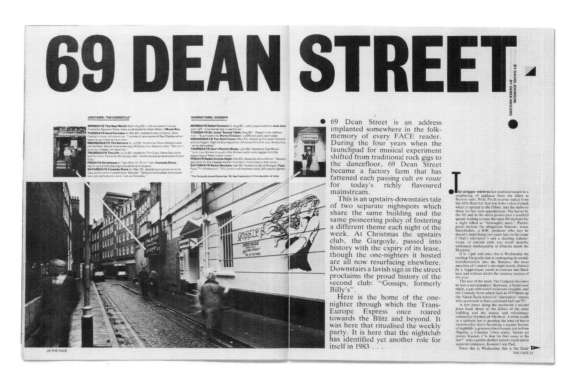

69 DEAN STREET

BY DAVID JOHNSON
BY DEREK RIDGERS

UPSTAIRS: THE GARGOYLE

MONDAYS The Reel World (from Aug 82): Little-screened movies, hosted by Spencer Style, soon superseded by Adam Baker's **Music Box**.
TUESDAYS Soul Furnace (fr. Mar 83): Hosted by David Ogilvy. Also, Fames in those old tunes so far. "A whole lot of rare copies of Ray Charles which seems to go missing from here."
WEDNESDAYS The Octave (fr. Jul 82): Hosted by Oliver Weddon and Jeff and Saul. Sexual hush wrestling, UK Delsey inn. Sweden-either. "We don't bust our cheeks, Va have fun."
THURSDAYS The Lift (Jul'e 82): Hosted by Tim Clark, Steve Swindells and DJ John Richards. Mixed gay club "where no one gives anyone a hard time."
FRIDAYS Striptease (8.15pm Mon-Fri. From 11pm Comedy Store): stand-up comics playing to students and couples.
SATURDAYS Comedy Store (fr. May 79): Appealing to predominantly stag-audience-too-sweat-law. Sample: "Catbury schoolmate who swear you can eat between work, rest and Scrabble."

DOWNSTAIRS: GOSSIPS

MONDAYS Rebel Rockers (fr. Aug 82): Lately superseded the Just Jazz with Jeff. "Live bands like it used to be"
TUESDAYS Sir Jules' Sound Table (Aug 82): "Rappin's the fashion, man." Superseded by Bronx Chicken: a different party each week.
WEDNESDAYS The Gold Coast (May 83): Hosted by Chrissie Coberill and Jo Hagan, High-life Eric Agyeman, Afrobeat Fela Kuti, Jive Sonny Arki, "all on dancable"
THURSDAYS Gaz's Rockin Blues (July 80): Hosted by Gaz Mayall. "John Lee Hooker through Little Richard with roots reggae from the beginning of West Indian music."
FRIDAYS Radio Invicta Night (Feb 81): Hosted by Wood Walsh. "Several jazz funk for the hippest crowd in London, more mature than some."
SATURDAYS Roots Rockers (Jan 82): Hosted by David Rodigan, Papa Face, T in the basement. "70's lovers rock and heavy dub, 30% soul to lighten it."

*The Gargoyle closed December '82. Dan Field and a 31 for relocation of clubs

69 Dean Street is an address implanted somewhere in the folk-memory of every FACE reader. During the four years when the launchpad for musical experiment shifted from traditional rock gigs to the dancefloor, 69 Dean Street became a factory farm that has fattened each passing cult *en route* for today's richly flavoured mainstream.

This is an upstairs-downstairs tale of two separate nightspots which share the same building and the same pioneering policy of fostering a different theme each night of the week. At Christmas the upstairs club, the Gargoyle, passed into history with the expiry of its lease, though the one-nighters it hosted are all now resurfacing elsewhere. Downstairs a lavish sign in the street proclaims the proud history of the second club: "Gossips, formerly Billy's".

Here is the home of the one-nighter through which the Trans-Europe Express once roared towards the Blitz and beyond. It was here that ritualised the weekly party. It is here that the nightclub has identified yet another role for itself in 1983 . . .

The stripper retrieves her scattered towels to a smattering of applause from the fellers in Burton suits. Pink! Pirelli scuttles naked from the fifth floor bar that was Soho's idea of plush when it opened in the fifties, into the ladies to dress for her next appointment. She leaves by the lift and in the street pushes past a youthful queue waiting to take the same lift skyward for a night billed as "thoroughly nasty". Participants include the abrasious Strypete, music-bizzybodies, a BBC producer who says he doesn't mind being two years late on the scene ("that's television") and a dazzling kaleidoscope of current exits on circuit describe extremely inadequately as Dracula meets the Muppets.

It is 11pm and since this is Wednesday the rooftop Gargoyle club is undergoing its weekly transformation into the Batcave, the most amorous of London's one-night stands. Instead here is a Juggernaut youth in mascara and black hair and without doubt the runaway success of the year.

The rest of the week The Gargoyle becomes in turn a moviemakers' showcase, a Soviet soul night, a gay club which welcomes straights, and the Comedy Store which back in 1979 threw up the Alexei-Sayle school of "alternative" comics who seem now to have colonised half our TV.

A few paces along the pavement a uniformed door leads down to the cellars of the same building and the wintery and refreshingly unfamiliar rhythms of Afrobeat. A white youth in a sabbath hat is pushing the kind of mix-it membership that's becoming a regular feature of nightlife - a gracious black beauty just in from Nigeria, a Camden Town trendy. Somet art dealer Kasmin ("Is that his first name or his last?" asks a junior clothes collect.) and just a separate company, Kasmin's son Paul.

Since this is Wednesday this is the Gold

26 THE FACE
THE FACE 27

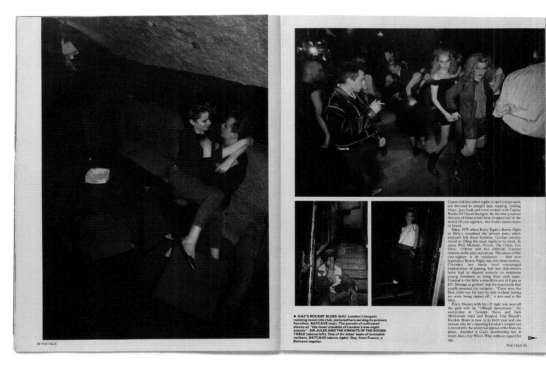

Coast club but other nights in the Gossips week are devoted to straight jazz, rapping, rocking blues, jazz-funk and roots rockers with Capital Radio DJ David Rodigan. By the time you read this any of these could have dropped out of the world of one-nighters, two weeks means make this...

Since 1978 when Rusty Egan's Bowie Night at Billy's ritualised the private party which enjoyed full disco fanfares, Gossips entirely wised to filling the slack nights in its week. In came: Pink Monday, Public, The Clinic, Jive Drive, Videttte and five different Tuesday tenants in the past year alone. The future of the one-nighter is its transience - that new legendary Bowie Night lasted only three months. Certainly fast breaks have encouraged exploitation of passing fads but club-owners have had to depend entirely on streetwise young footmen to bring them each cause. Central to the Billy's-into-Blitz axis of Egan as DJ. Strange as greeter, was the innovation that youth assumed the initiative. "There were the first clubs run for kids by kids without feeling we were being ripped off," it was said at the time.

Perry Haines with his I-D night, was next off the grid with his "ZDmph dancemusic". He succeeded at Gossips. Steve and Jack McDonald tried and flopped. Gaz Mayall's Rockin Blues is now in its third year and one reason why he's enjoying London's longest run is inevitably the universal appeal of the blues he plays. Another is Gaz's membership list. It reads like a hip Who's Who without regard for age.

• **GAZ'S ROCKIN' BLUES** (left): London's longest running (one) nite-club, pictured here serving its primary function. **BATCAVE** (top): The pursuit of cultivated sleaze at "the most unsubtle of London's one-night stands". **SIR JULES AND THE KNIGHTS OF THE SOUND TABLE** (above left): One of Sir Jules' team of turntable rockers. **BATCAVE** (above right): Gay, from France, a Batcave regular.

28 THE FACE
THE FACE 29

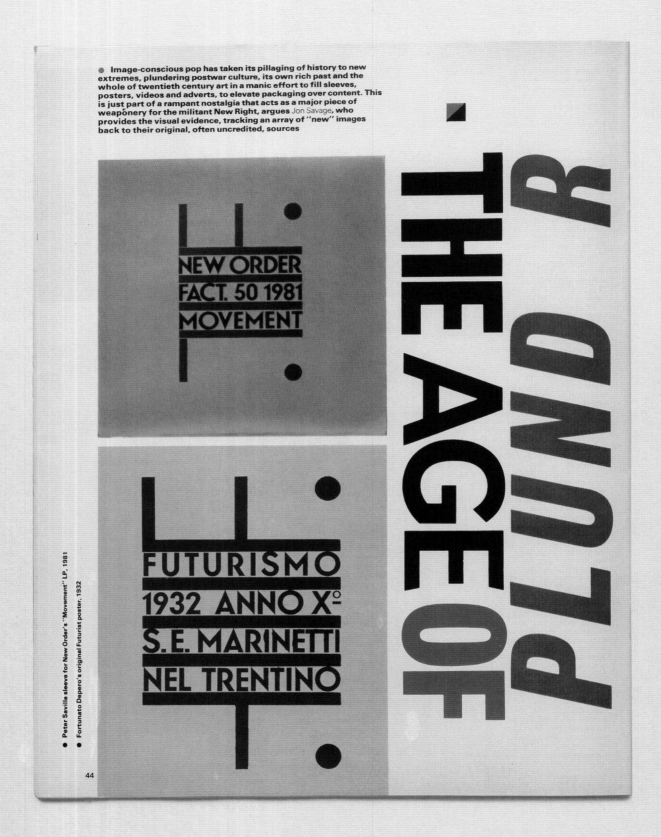

● Image-conscious pop has taken its pillaging of history to new extremes, plundering postwar culture, its own rich past and the whole of twentieth century art in a manic effort to fill sleeves, posters, videos and adverts, to elevate packaging over content. This is just part of a rampant nostalgia that acts as a major piece of weaponery for the militant New Right, argues Jon Savage, who provides the visual evidence, tracking an array of ''new'' images back to their original, often uncredited, sources

THE AGE OF PLUNDER

NEW ORDER FACT. 50 1981 MOVEMENT

FUTURISMO 1932 ANNO X° S. E. MARINETTI NEL TRENTINO

● Peter Saville sleeve for New Order's ''Movement'' LP, 1981
● Fortunato Depero's original Futurist poster, 1932

44

above and opposite
'The Age of Plunder', no. 33, January 1983.

● Barney Bubbles sleeve for The Damned's
"Music For Pleasure", 1977
● Bubbles' inspiration: Kandinsky's "Yellow
Accompaniment", 1924

● David Juniper's cover for UFO's
"Mechanix" album, 1982
● The uncredited source: poster by Jean
Carlu, 1942

● Chris Sullivan: Picasso pastel Blue Rondo
single sleeve, 1981
● Spandau Ballet's "Glow", Graham Smith's
neo-neo-Classicism, 1981

● New Order's "Everything's Gone Green",
Peter Saville, 1981
● Depero's original cover for Futurist
publication, 1923

● Billy Fury: cover for "The Sound Of Fury",
1960; early Martin Fry?
● Fry, 1982: quiff, pose, gestures and
infamous lamé suit all recall Fury.

Bauhaus

● Bauhaus' "Ziggy Stardust" single: glam
rock for 1982
● Duffy/Pierre Laroche's flash cover for
"Aladdin Sane", 1973
● "Scary Monsters": Edward Bell's design
and lettering, 1980

astute choice as the Great Single that Bowie himself never released. The packing reflected this: the Bauhaus "corporate" logo – another recent trend, this – was overlaid by the "Aladdin Sane" flash, typically inaccurate and out-of-synch, as "Ziggy Stardust" came from the previous album...

Pop's own past has not been sufficient; perhaps the most irritating manifestation of the Culture Club is the way that the whole of 20th Century Art and – more recently – any amount of ethnic material have been used with increasing desperation to sart up product that has increasingly less meaning...

Take the spearheads of last year's obsession with style, for instance. Spandau Ballet, before they got wise and changed direction, conived in sleeves by Graham Smith that peddled the worst kind of neo-neo-Classical pomposity in their frank debt to John Flaxman's lithographs...

and systematic is the work of Peter Saville, perhaps the best known sleeve designer in England today, and whose work on the new Ultravox album gained, hardly surprisingly, more comment than the record itself.

Saville began work on designing Factory posters and sleeves, where his frank debt to Futurist posters and typographer Jan Tschichold fitted in perfectly with Factory's "industrial", "machine" image. Tschichold published the book that is regarded as the foundation of modern typography in 1928: Die Neue Typographie proposed a new, almost classical simplicity and a rejection of Victorian ornament...

If on occasions the sleeve became not an ornament but a prison, then it was because the product didn't come up to the Factory "specification"...

With time, this process has become clear as Saville becomes more important and more influential: his recent designs for Ultravox's "Quartet" and "Hymn" are perfect examples

of cover art that matches the interior product in a way that is far from flattering. Like Ultravox, these sleeves are grandiose, cod neo-classical exercises perfectly executed for the erection of false pillars of worship...

The Past then, is being plundered in Pop as elsewhere in order to construct a totality that is seamless, that cannot be broken...

The Past is then turned into the most disposable of consumer commodities, and is thus dismissable: the lessons which it can teach us are the disregard, trivial, are ignored amongst a pile of garbage...

Le-Valium-Roche
en tant
que myorelaxant

● Jan Tschichold original booklet cover,
1968, exemplifying the cool neoclassical
type and simple pragmatic layout that have
become the trademark of the influential
Peter Saville

course not: but it sells the product like the wrapping on a chocolate box. But this is ABC's third or fourth image: when do they stop, and when does the audience lose enough?

Record sleeves have been an integral part of this tendency towards mystification and an overloading of meaning: in this Tower of Babel the designer, too, has become all important. Designers even have two books to celebrate their role – the Album Cover Albums – and they now design awards and stuff like that...

Here we refer, as always, to Punk Rock because in those turbulent nine months the ground rules were laid. Punk always had a strong consciousness – deliberately ignored, in the cultural Stalinism that was going on at the time – which was pervasive yet controlled. You got the Sex Pistols covering Who and Small Faces numbers and wearing the clothes from any youth style since the war (along with safety pins)...

By this time, picture sleeves were, like "Limited Edition" 12 inch singles or coloured vinyl, an established part of the record company come-on to the consumer and, thanks to designers like Jamie Reid for the Sex Pistols and Malcolm Garrett for Buzzcocks, an integral part of the way the product was put over. Sleeves like Jamie's "Holidays In The Sun" and "Satellite", and the Buzzcocks' "Orgasm Addict" designed by Garrett around a montage by Linder's complemented perfectly what was inside...

became an end in themselves. Instead of trashing the past, pop music started to celebrate it – in art formerly unthinkable in such a tawdry, transient medium. The Age of Pillage had begun: so many sleeves to fill, so many images to construct – where better to go than pop's own rich past?

This was and is simple enough. Images from pop's un-selfconscious past are invoked as some kind of ritual, in key to a time when pop was still fresh and still a gogo: money, sex and fame beyond measure...

The Beatles are also ripe for plunder. The "With The Beatles" sleeve, perhaps THE most famous and monolithic piece of cover art – a symbol from the exact moment when pop went mass for the first time – reappears everywhere. Little stylistic devices like the white band on top of the front sleeve, with the name of the group and a monochrome designation or silly sleeve notes surrounded by ads for "Emitex" and notices that this is a "Microgroove" or "33⅓ Extended Play" have become so familiar as to be hardly worth remarking upon...

Another example of the way this plunder works can be seen in the sleeve for the recent Bauhaus hit, "Ziggy Stardust". The group's pretensions in naming themselves after the architectural school – particularly when their work has no conservative reference style – can be dismissed as another example of pop's demented pillage of all 20th Century Art...

stereo

with
the
beatles

● Robert Freeman's famous photograph for
"With The Beatles", 1963

with
the
roogalator

stereo

● Edward Barton homage to "With The
Beatles" for Roogalator, 1976

RESIDENTS

● The Residents: perennially deflecting the
Beatles

DICT

ASM

● Garrett/Linder's Buzzcock's album, 1978;
Linder montage, "Orgasm Addict", 1977

● The Clash's "London Calling", Ray Lowry,
1979
● RCA release of Presley's 1956 "Blue Suede
Shoes", 1981
● "Armagideon Time", back sleeve of
"London Calling", Ray Lowry, 1979
● HMV standard singles bag pre-1965

THE GOOD TIME MUSIC OF
THE SEX PISTOLS

Armagideon Time

HIS MASTER'S VOICE
For The Man In Pink

THE PRETTY THINGS

● Sex Pistols: punk opened up the world
of pillage - Johnny Rotten makes a
mess all over his rock 'n' pop
heritage, April '76
● Back sleeve of "The Good Time
Music Of The Sex Pistols" bootleg,
1976
● Original back sleeve of "The Pretty
Things" LP, 1965
● Jamie Reid's "Satellite", back sleeve
of Pistols' "Holidays In The Sun",
1977

below and opposite
'How the West was Won', no. 38, June 1983.

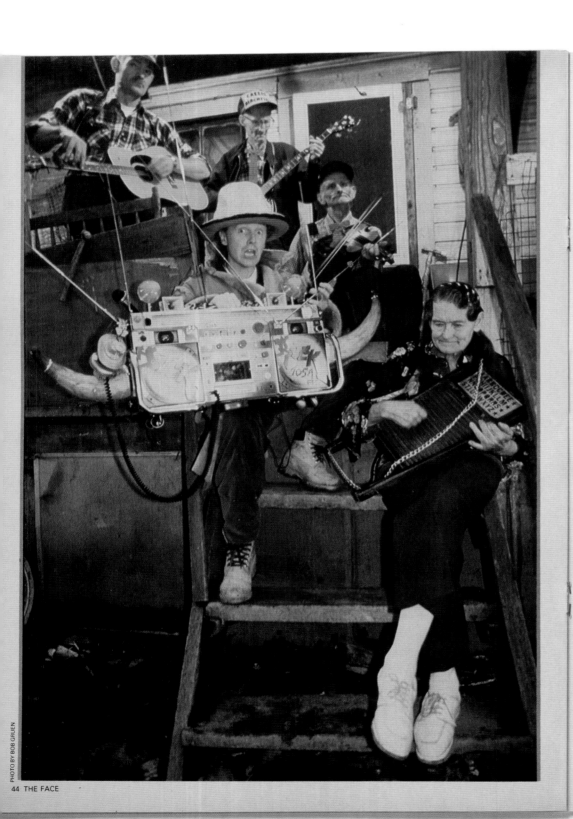

PHOTO BY BOB GRUEN

MALCOLM McLAREN

C O N T I N U E D

"Duck Rock" is Malcolm McLaren's donation to that, a Red Cross parcel of information for the starving millions of Britain. But it has less to do with the Brandt report than the theatre of provocation.

McLaren is after all the man who – after they had wandered into his shop in '74 and asked him to manage them – dressed a smudged, tottering Glam-Rock hangover called the New York Dolls in red vinyl and told everyone they were communists (Vietnam had just been finally coloured red on the map).

Bored with selling nostalgia in Let It Rock, he stood in the King's Road and asked himself: "What can I really *affront* this place with ?" (The answer, of course, was Sex.) He followed this up by affronting the whole country with a gang of ragamuffins led by a boy with the Jacobean monicker of Johnny Rotten. It was a prank that well and truly exploded.

From TV to pulpit to executive boardroom, the tremors shook, the tabloids screamed for such good copy and the rock press had a thrombosis. Through it all, McLaren grinned. It was convenient to tar him the evil mastermind – or at least the Fagin to Rotten's Artful Dodger – but events rapidly overtook any grand design. It was all he could do to hang on. Until the day came when a plane left San Francisco for Rio and Ronnie Biggs while Rotten brooded in his hotel bedroom. They next saw each other in court. "It was like a divorce case," says Jamie Reid. "It was horrible."

McLaren left Julien Temple to finish *The Great Rock'n'Roll Swindle* – still a hilarious film but not the one they set out to make – and, surrounded by paranoia and suspicion after the deaths of Nancy Spungen and Sidney Vicious, went into exile in Paris.

Soon he had a new job, finding pieces of classical music whose copyright had expired for the soundtracks of blue movies. Sitting in the Beaubourg music library one day he noticed a rack of ethnic records. "They had such sparkling covers. I listened to all these sticks being banged together and couldn't make head or tail of it!"

But he persevered, and returned to London a year or so later clutching the Burundi beat. Back in London, a hardcore punk trouper named Adam Ant started pestering him for advice. McLaren became his tutor; he gave him books he had brought back on pirates and Apaches. "*Yes*, Adam," he told him, as Adam sat with notebook and pen, "take the white war stripe of the Geronimo tribe! Take that good tribal beat! Be a *real* pirate! *Plunder* the world's music!" And he did. And now Adam is very good friends with Liza Minelli and Michael Jackson.

McLaren, meanwhile, sat in a McDonald's in Wood Green and wondered what to do: how to deal with what he had found in ethnic and folk musics; whether to just go back to Paris and try to get into the film business proper. A "very elegant black man" in a baseball shirt was there with a ghetto blaster

on so loud that the manageress leave. Without a word, he hau onto his shoulder and strolled o man!" thought McLaren, stru inspiration.

He called Jamie Reid and wr C90 Go". With Dave Barbar Ashman and Leroy Gorman recently splintered Ants, he se singer, someone exotic, a gir clear voice to enunciate the ly female Frankie Lymon. They local schools to no avail. And cleaner's in Kilburn, he fou Lwin singing a Stevie Wond recorded the song and sold it te EMI.

Jamie Reid maintains that w ly grasped the implications of hyped it *out* of the charts – thou it may equally have been for si In any event, BowWowWow RCA where, exploiting the m tery of underage sex, their dr proved modestly popular.

❝ I never vote.
even filled in the
form. I simply re
do anything like

But McLaren grew bored w Wow. For musicians, music career, whereas for McLaren it signal. He felt that the major wanted to state – such as tras ethic and replacing the wore 'leisure' with something that w ennui, if not the fact, of un weren't getting through.

"People listen to people no better for me to do it than expl else."

Malcolm McLaren's home bury, in an old doctor's surge wood with a large tiled kitchen used for medical experiment room used to be a waiting roo throughout is dark and musty.

hasn't changed since the Forties.

Walking, he says, is his greatest relaxation. He can't drive. "You don't *see* anything from cars."

Every few months, he visits his 13-year-old son Joe. A punk rocker who plays bass in a local group, Joe lives in the country with old friends of his father. McLaren gave Joe the surname of Corrie, after his grandmother. "He's a bit of a hobo," he muses, "but he goes to school out there."

In this year's general election McLaren will abstain. "I never vote," he says firmly. "I never even filled in the census form. I simply refuse to do anything like that."

Over the years McLaren has formed a close relationship with Vivienne Westwood, who exhibited her latest collection on the theme of witches in Paris in March. They aren't married – "She doesn't believe in that" – but work together on the clothes she designs, which have been crucial to the strong visual dimension of all of McLaren's forays in cultural terrorism.

"What I probably do for Vivienne is bring her the outside world," he remarks. "I like definitions, simply because I think they make things accessible. I see what she's got, and I push it in a direction. I'm the concept man, but she's the tailor.

"She's a wonderful person, a brilliant craftsman. London people aren't craftsmen; they're very lazy about that. She comes from the Pennines, and she is one of those English hard rock people. She's got the ability to be able to live and survive in the woods."

Which, no doubt, she will need if she is to establish herself in international fashion. In two years, she has already gone further than any other British designer of the last decade.

"She's working in uncharted territory. She'll either sink or swim," hazards McLaren. "She's involved in very big money, and she's competing with the world, who are much better at production than we are.

"They look upon you as curios. Sure, you're influential, but you're not considered a competitor."

McLaren, too, has decided to try and extend his influence directly. Jamie Reid says he is fulfilling a teenage ambition. He doesn't try to deny it.

"Nowadays you've got to stand up and be counted and I don't think I could as a manager at all. It's terrible to be thought of as a manager. Perhaps this will enable me to do something much bigger next time.

"Whether I stay in the music business is not important. I want to put all these faculties and bits together in a way that can reach a far wider audience. It doesn't seem that records do anymore; it seems to be visuals that do.

"And I'm a bit uncertain – less than Vivienne – that clothes are so important today because I think it's far more do-it-yourself than it was. I think that the media, and the presentation of them are more exciting than the actual selling of them.

"I suppose I'm part of that whole English phenomenon; anybody creative in this country seems more interested in the idea than the selling. We're a land without very good salesmen. Same as we don't have good plumbers.

"There's too many artists, isn't there? Not enough plumbers. That's really true. You go to New York and it's the same thing. There's millions of artists, everyone's in show business, but find me a plumber!"

I can't, so instead I ask Malcolm McLaren if he believes in the supernatural, a world

THE FACE 45

HOW THE WEST WAS WON

Text by Paul Rambali

In any modern dictionary of infamy, the name of Malcolm McLaren would merit a lengthy entry. He has been a purveyor of fetish-wear, an agent provocateur, a seducer of

THE FACE 41

MALCOLM McLAREN
CONTINUED

People listen to people not ideas. It's easier for me to do it than explain it to someone else

THE FACE 43

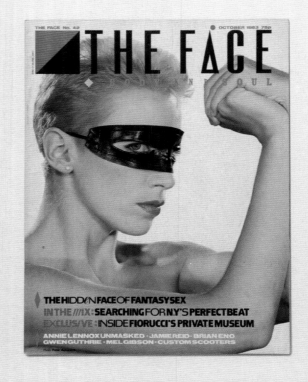

THE FACE No. 42 OCTOBER 1983 75p

THE FACE

THE HIDDEN FACE OF FANTASY SEX
IN THE MIX: SEARCHING FOR N.Y'S PERFECT BEAT
EXCLUSIVE: INSIDE FIORUCCI'S PRIVATE MUSEUM

ANNIE LENNOX UNMASKED · JAMIE REID · BRIAN ENO
GWEN GUTHRIE · MEL GIBSON · CUSTOM SCOOTERS

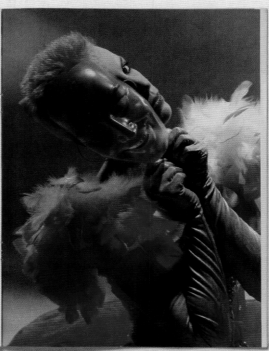

40 THE FACE

opposite top
No. 42, October 1983.

opposite bottom and below
'Masquerade!', no. 42.

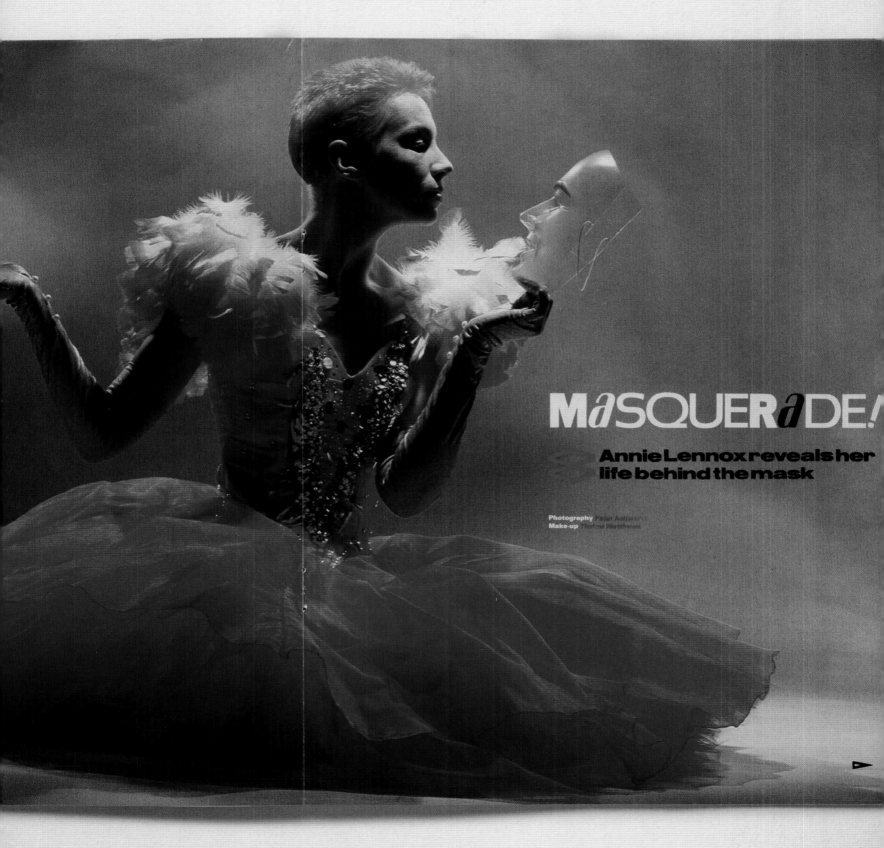

MaSQUERaDE!

Annie Lennox reveals her life behind the mask

Photography Peter Ashworth
Make-up Thomas Matthews

EXPO

A CATALOGUE OF CREATIVITY: 70 NEW IDEAS FROM EUROPE

EUROPE

▼ ITALY

With a name borrowed from Nietzsche, **The Gay Science** is the oldest of the groups of the so-called "new spectacularity", an attempt to mix genres that denies the theatre its specificity. Coming from the Roman underground, the group is schooled in the iconoclasm of the new wave. With "Insects Prefer Nettles", they have undertaken a lengthy world tour, proposing the same artistic "barbarism" that the avant-garde applies to painting. It is the first step towards the seductive use of every media possible. Their latest piece, "Uncorked Heats", entrusts the complete abandonment of the "performance" dimension to computer graphics, underpinned by the music of Winston Tong and Bruce Geduldig from the group Tuxedo Moon. Pictured here: a scene from *Cuori Strappati*.

C. M. CAUSATI

▼ FRANCE

Jean-Remy Daumas arrived in Paris ten years ago, with only a few francs and a folder of drawings. He worked as a waiter and a swimming instructor, he knew no-one in the fashion world but somehow, incredibly, he was taken on by Patou. But he soon grew weary of the world of *haute couture*. In 1978, with very little finance, he started his own business. His first designs were made of netting and foam, the cheapest available materials. He wore them himself because he couldn't afford models. But his clothes were cheap and light-hearted and *Vogue* gave him a two-page spread. Within a year he had moved on to sweaters with bow-ties, knitted dinner jackets and daytime pyjamas. His current line is a range of padded camouflage clothes for formal evening wear.

▲ FRANCE

Jean Nouvel is an adventurer in architectural styles. He juggles with modernism and memory. He has built ecological houses, post-modernist pavilions, even a theatre that marries reinforced concrete with art deco, but he is best known for the delirious schemes that no-one would let him build: a garage in the shape of an enormous lorry, frowned upon by the planning authorities; an 'Islamic' house with red bricks emphasising the missing Byzantine windows that the town of Troyes refused him permission for. He is currently building the new Arab Institute in Paris.

▼ ITALY

Zitron I, born as a musical group of the "Retroguardia", has little by little assumed its own identity. Up to now they have produced two LPs, "The Dignity Man" and "The Utent", and a 45 titled "Taborcat". The members of Zitron I: Denni Lugli, a mercenary spirit who will turn casually from the most advanced experiments to the most banal commerciality; Mauro Montanari, versatile "joker" of the "Retroguardia" pack; Ivan Trevisani, who has been trying for four years to make an anguished super-8 film; Eleonora Vardelli, ballerina, model and drummer; Mauro Strazzeri, excellent poker player and passable keyboardist; Sostieni

Chapter Five

Look Out, Here Comes a Buffalo!

Industry-wide recognition for the achievements of Logan and his team was flagged in the statement 'Magazine of the Year' in Neville Brody's variegated lettering on the front cover of the January 1984 issue. This referred to the fact that *The Face* had won that category in the annual awards organized by the weekly paper *The Publisher*, as well as the runner-up gong for typographic design and the best front cover for the July 1983 issue featuring the surprising crop of New Order's Stephen Morris.

'Around that time people used to ask me: "What is *The Face*?" because it didn't fit an accepted idea of what a magazine should be,' says Paul Rambali. 'My answer was: "What *LIFE* was to the 1950s, what *Playboy* was to the 1960s, what *Rolling Stone* was to the 1970s, we are trying to be to the 1980s." I always expected there to be competition but here we were, coming up to half-way through the 1980s and there was nobody challenging us. I remember in all modesty saying to Nick, "You know, we might even make it!"'[1]

This confidence was expressed on page sixty-four of the March 1984 issue in the form of a small box advert containing the masthead logo and the following text: 'To advertise in the pages phone Rod Sopp on 01-580 6756'. Four years after launch, Nick Logan had bowed to the inevitable and sub-contracted sales to a dedicated rep to handle the advertising in the magazine (a quarter of that eighty-page issue was made up of ads).

Sopp was already known to Logan, having come from *Smash Hits*, where he had overseen the Emap title's ad sales expansion as circulation exceeded half a million copies every fortnight, making it the ninth biggest-selling magazine in the country with double the sales of IPC's imitator *Number One*.[2] Logan describes Sopp as 'another maverick fleeing corporate structures'. In fact Sopp had been persistent in his requests to take on the sales side of *The Face*. 'I had faith in his sensibilities though I did worry he would talk so much – Rod barely stopped – that he'd be a distraction,' says Logan, who admits that taking on an experienced executive rather than working with freelance retainers (Brody and Rambali) or giving college-leavers such as White a chance, seemed 'terribly grown up'.[3] In the event Logan and Sopp agreed a commission package. 'He never balked at giving all manner of additional support as required', says Logan. 'There was no physical space for an ad department but Rod, immune to status, was happy for Lesley to move to the editorial room and take on her reception duties in addition to his own. He was in his element entertaining visitors and fielding incoming calls.'[4]

'Rod was the first person I ever met who mentioned "design" and didn't mean clothing,' says Robert Elms: 'He would talk about furniture, such as Eames chairs, that sort of thing,

because he came out of London's post-Mod advertising scene which frequented places like [Tchaik Chassay's West End niterie] Zanzibar. To me this was the ultimate in sophistication; that was the sensibility Rod brought to *The Face*.'[5]

Importantly, the experienced Sopp proved adept at negotiating his way around Logan's aversion to the visually disruptive aspects of print advertising. Logan later admitted that he had refused to take repeat bookings by a couple of advertisers because their double-page spreads, while lucrative, 'looked so horrid. Sometimes you might get someone phoning up, wanting a rate card, and they'd be selling the kind of mail-order stuff you get in the back of the *NME*. We'd just let the inquiry die a natural death, but there wasn't a lot turned away.'[6]

British marketing expert Sean Nixon has noted how Sopp 'skilfully crafted Logan's dislike into a piece of media folklore about *The Face*'s preparedness to refuse on aesthetic grounds. More importantly, Sopp produced for the first time a worked-up

above
No. 45, January 1984.

101

THE FACE No. 47

MARCH 1984 75p

WANTED!

FRANKIE GOES TO HOLLYWOOD

GIVE 'EM ENOUGH ROPE!

UB40 rude years revisited
robbie vincent × prefab sprout
millie jackson × the computing
genius of stephen wozniak

photography - cindy sherman,
mapplethorpe, barry lewis

FRANKIE GOES TO HOLLYWOOD PHOTOGRAPH BY SHEILA ROCK

picture of the type of people who read *The Face* (presenting the magazine) as the perfect media form through which to target "innovators" and "opinion formers", the taste-shapers who, and he gave this example, were behind the classic mid-1980s style for young men of a plain white T-shirt, Levi's 501s, white socks and Bass Weejun loafers.[7]

As Nixon pointed out, Logan himself acknowledged the magazine's strength in the area of men's fashion at a time when there was little or no coverage of this burgeoning market. With strong support from the music industry, advertising at this stage arrived in the form of double-page spreads for Levi's and Wranglers, as well as full pages for menswear outlets including Woodhouse and drinks brands such as Pernod, all in the pursuit of hip cachet.

On Sopp's appointment, Logan told the media trade press: 'I keep reading about the need for a men's magazine, but I think we're closer to that than anyone. Two-thirds of our readers are men. At the moment I'm caught between trying to attract more women readers, or expanding the trend towards men.'[8]

Sopp's presence raised confidence. 'Once again, things seemed to get a little easier, particularly because Rod was very good at his job,' says Lesley White, who was still looking after the expanded 'Intro' section and had been elevated to the position of features writer. 'Rod's jokiness and larkiness was also important. He's very quick-witted; the atmosphere in the office was most often light-hearted. At times when ads were difficult to get or things were looking shaky his personality kept everyone upbeat. I remember laughing a lot.'[9]

Sopp was also responsive to editorial demands, as Logan noted: 'If I liked a photo story which came in late once the flat plan had been decided I would stick on an extra sixteen pages and Rod would set to getting the ads to justify it. He would sell the three or four ads that made it worthwhile and often the couple more that turned it to profit.'[10]

From Paul Rambali's point of view, the upbeat atmosphere produced better standards of journalism. 'We began to understand what our remit was and how we could push contributors; as an editor my stance was always about getting good material, any way you can,' says Rambali. 'It's not like we were paying top dollar rates so we were depending on people's passion and obsessions: that's what gave the work strength and flavour.'[11]

Within a few months of Sopp's appointment came the late-night broadcast on regional TV channels of a 20-second advert directed by Mark Lebon for the magazine. This showed a slo-mo view of the model/singer Lizzie Tear racing towards the camera intercut with shots of spreads and covers from the publication; when Tear's face filled the frame her utterance of the magazine title was also slowed down, so that her voice was portentous.

In an uncharacteristic move, Logan relented to a request to appear on BBC presenter Terry Wogan's popular evening chat show. His shy demeanour was at odds with the breezy format (that night's line-up included the actress Anna Massey and the popular clairvoyant Doris Stokes). 'It was pretty mortifying to watch Nick field stupid questions along the lines of "How does it feel to be the trendiest man on the planet?"' says Lesley White.[12]

'I have always hated the word "trendy",' grimaces Logan. 'When Wogan asked me that I was appalled. And he kept up a series of conspiratorial tics and winks off-camera that were so cheesy and showbizzy that I fell into an incoherent, terrified trance.'[13]

Logan marked the publication of the fiftieth issue in June 1984 by giving the go-ahead for Brody to institute his first custom typeface. With new fonts appearing in subsequent issues, this established 'a daringly unique aesthetic', according to design critics Bryony Gomez-Palacio and Armin Vit: 'Brody began to contort letterforms, creating an endlessly mutable range of typographic solutions for headlines and story leads while leaving the body text highly accessible. Typography was mixed with graphic symbols and devices, sometimes to the point of blurring the line between text and object, creating a new visual vocabulary.'[14]

Sometimes the speed at which Brody was moving was disconcerting even to Logan. 'Neville always changes before I've quite finished with a typeface,' he said at the time. 'So many of them are one-offs. It would annoy me that people would take up an idea that Neville had discarded, and because it was no longer in *The Face*, have free rein with it. Other people would look at that and think, "That's a brilliant design", without knowing where it came from.'[15]

The tools at Brody's disposal – compass, graph paper, set square – lent themselves to geometric-based design and so, drawing his influence from the Bauhaus and specifically the typefaces of Herbert Bayer, he forged a contemporary form of Graphic Expressionism. This phrase was coined by the eminent New York designer Herb Lubalin as 'not just a mechanical means of setting words on a page, but rather as another creative way of expressing an idea, telling a story, amplifying the meaning of a word or phrase, to elicit an emotional response from the viewer. In other words, typography to be used as an alternative to photography and/or illustration.'[16]

opposite
No. 47, March 1984.

'Ray would say "I want to do this", Nick would say "Go ahead" and they would make it happen in an amazing way, always on no money,' says Lesley White. 'I guess for Buffalo this was the best way of showing what they could do and then gaining more lucrative advertising work as a result.'

Morgan had been providing photography to *The Face* since 1983, working at first with stylist and fashion writer Helen Roberts, the person who – in the words of future art director Phil Bicker – 'initiated the magazine's evolution',[20] particularly when Petri came on board.

Morgan and Petri's first credited collaboration (still without the 'Buffalo' tag) to make the cover arrived with the January 1984 issue. This image of model Nick Kamen (whose surname was misspelt 'Camen') was taken from a shoot for a winter sportswear feature. And the pair was also given a double-page spread – again featuring Kamen – for a showcase of Petri's interest in embellishment with found badges and pins, matched with jewelry from west London's Butler & Wilson (see page 106).

Photographer Nick Knight, who was at that stage shooting for *i-D* and *Blitz*, says that Petri's arrival formalized *The Face*'s fashion approach. 'Up until that point, Nick's use of people like Chalkie Davies, Jill Furmanovsky and Sheila Rock wasn't really about fashion,' said Knight. 'As good photographers as they are, it wasn't their forte.'[21]

For photographers such as Davies, who had been a mainstay of the first half-decade of the magazine's existence, Buffalo spelled the end of an era. 'Sheila, Jill and I had all learnt our trade on the job, taking photos at gigs or wherever,' says Davies. 'The Buffalo crew had been assistants and had more formal training from people like the great art director and photographer Harri Peccinotti, so they were recognizably "fashion photographers".'

In this area at least, *The Face* had lost ground to the oft-derided *Blitz*. Unlike Logan's magazine, this had on staff a dedicated fashion editor – the talented Iain R. Webb – who worked closely with Knight and was immersed in the avant-garde style of Bodymap and the performance artist Leigh Bowery. Taboo, the club-night fronted by Bowery, was the antithesis of *The Face*'s Soho masculine cool. Knight's entrenchment in that world was typified by his taking of one hundred portraits for the fifth anniversary of *i-D*, commissioned by Terry Jones and the magazine's assistant editor Dylan Jones. While many of the

The emergence of the visionary stylist Ray Petri was to prove as scene-shaking; his gritty, soulful take, in harness with photographer Jamie Morgan and others as showcased first by *The Face* and then across the style press and fashion media, communicated attitude – details of clothing and stockists were secondary to the creation of a mood encapsulated by Logan as 'streamlined classicism, tough-edged and Brandoesque'.[17] This sent shockwaves through the formal fashion industry as to the position of the heretofore second-ranking stylist in the scheme of things.

Petri's collaborations with Morgan, models and stylists were akin to Jamaican sound systems, according to Judy Blame, a member of the so-called Buffalo collective: 'Everything was flexible, everyone could put in ideas.'[18] The de facto leader Petri then presented Buffalo's fashion stories as completed projects after discussions with Logan as to the tone and direction.

'Ray referred to me as "Boss" in his polite and respectful manner,' says Logan, who also admitted, 'I was more in awe of him than he could ever be of me. There was never much discussion. Typically he'd have a scrap of paper with three potent words on it – "Killer", "Yardies", words like that – and I'd nod it through.'[19]

above
No. 48, April 1984.

opposite
No. 50, June 1984.

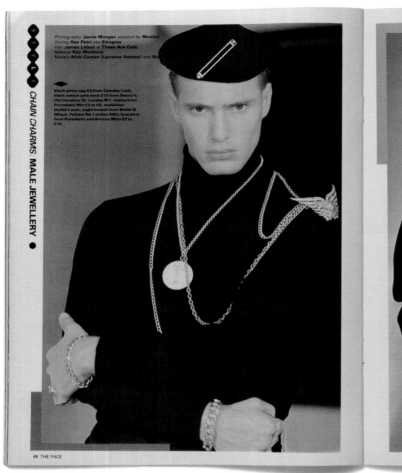

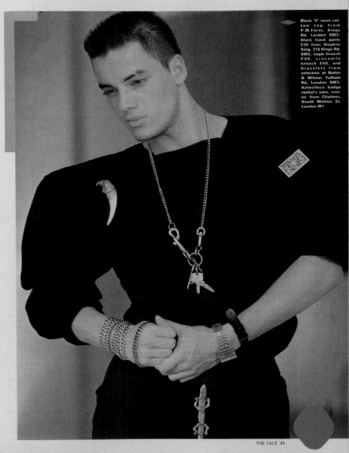

individuals photographed by Knight had been featured in *The Face*, their fashion sensibilities and collaborations had in fact been showcased to greater effect by Knight in *i-D* and in tandem with Webb in *Blitz*.

Ray Petri bought Logan's magazine a clear new direction because, in Knight's words, 'Ray knew what he wanted. Ray would only work with photographers if they were under his really tight direction. In that way he brought a fashion element to *The Face* which it previously lacked'.[22]

Commercially, *The Face* was powering ahead. With Sopp maintaining the premiums paid by advertisers for space in the magazine, Brody pushing the design boundaries and the writing team more than a match for cover stars that included Prince, Annie Lennox, Sade and Madonna, monthly circulation rose from 66,000 to 80,000 copies in the second half of 1984.[23] Distributor Comag was also flexing its muscles with increased market share, resulting from the introduction of the novel methods of not only monitoring the speed at which wholesalers delivered their titles to newsagents but also a means of measuring the rate of sale of each issue.[24]

With a higher pagination to handle and a range of third-party commissions, including designing for leftist listings magazine *City Limits*, Brody's workload was eased by the arrival of twenty-two-year-old Robin Derrick, whose name appeared first as assistant art director in the November 1984 issue. The cover, tagged 'Menswear at the outer limits', foregrounded a bare-chested model draped in a Union Jack and wearing a long tartan kilt (see page 106), trailing a piece by fashion journalist (and later editor-in-chief of *Harper's Bazaar*) Glenda Bailey headlined 'Men's Where?' (see pages 122–23). This is now regarded as a

above
'Chain Charms', no. 45, January 1984.

opposite left
No. 51, July 1984.

opposite right
No. 53, September 1984.

pivotal piece in the explosion of male fashion in the 1980s; twenty years later clothing historian Andrew Bolton hailed the issue of the magazine as announcing 'the arrival of the menswear revolution'.[25]

Derrick had graduated from the graphic design course at St Martins, where he attracted Brody's attentions, having assisted Terry Jones at *i-D* (which by 1984 had acquired a majority share partner in the form of the *Time Out* publisher, Tony Elliot) and also at the fashion brand Fiorucci, for whom Jones art directed. 'I started doing two weeks a month working for *The Face* and two weeks for Neville on his projects', said Derrick (now a leading creative with clients including *Elle Italia*, *Vogue*, *GQ* and Armani, Air France, Levi's, Monsoon, Rimmel and Tom Ford).

Derrick was in the throes of painting and decorating the Brixton flat he shared with *i-D*'s Caryn Franklin when he was pulled in to his first day at Mortimer Street by Logan to help out on the monthly production schedule. 'I sat at my desk with a PMT [photomechanical transfer] of Steve Bush's logo pinned in front of me,' recalls Derrick. '*i-D* had been great, but we worked out of Terry's house and I was quite comfortable there. Here I was, staring at that logo thinking, "Fuck me…*The Face*!".'

That evening Derrick accompanied Lesley White to a press reception at The Ritz for the launch of a new Karl Lagerfeld fragrance and was introduced to the German designer as a member of the magazine's art department. 'Lagerfeld said to Lesley, "I can tell he works in the art department – he's got paint in his hair!" To this day that is the only conversation I've had with him.'

Soon Derrick – who had laid out a Helen Roberts fashion story about the up-and-coming designer duo Maria Cornejo and John Richmond (see page 113) in the November 'Men in Skirts' issue – was transferred to a full-time post at the magazine. 'I quickly realized that I enjoyed *The Face* much more than Neville's projects. I love and have great respect for him, but he would be designing that stuff and I would just be colouring them in,' says Derrick. 'After a few months, as *The Face* was getting bigger and bigger, I transferred there. For an over-achieving lazy person that was perfect because photographers, models, rock bands, nightclub invitations came to you.'[26]

Brody continued to art direct the magazine, designing the covers and laying out the opening spreads while Derrick designed the turn pages. 'I decide what everything looks like',

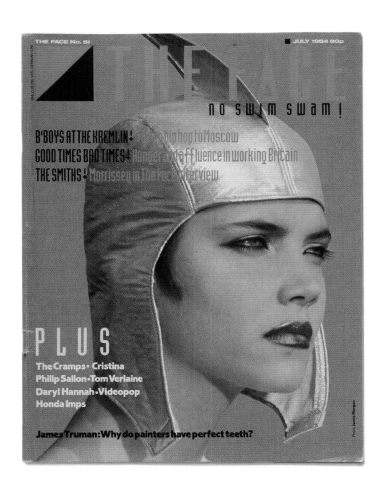

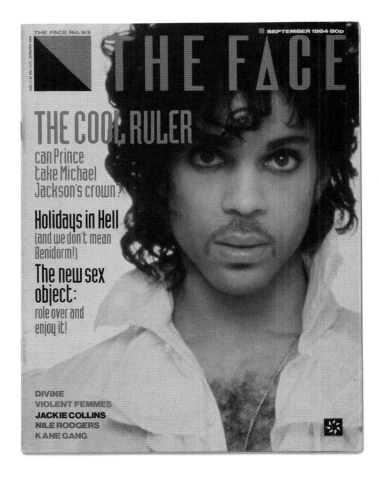

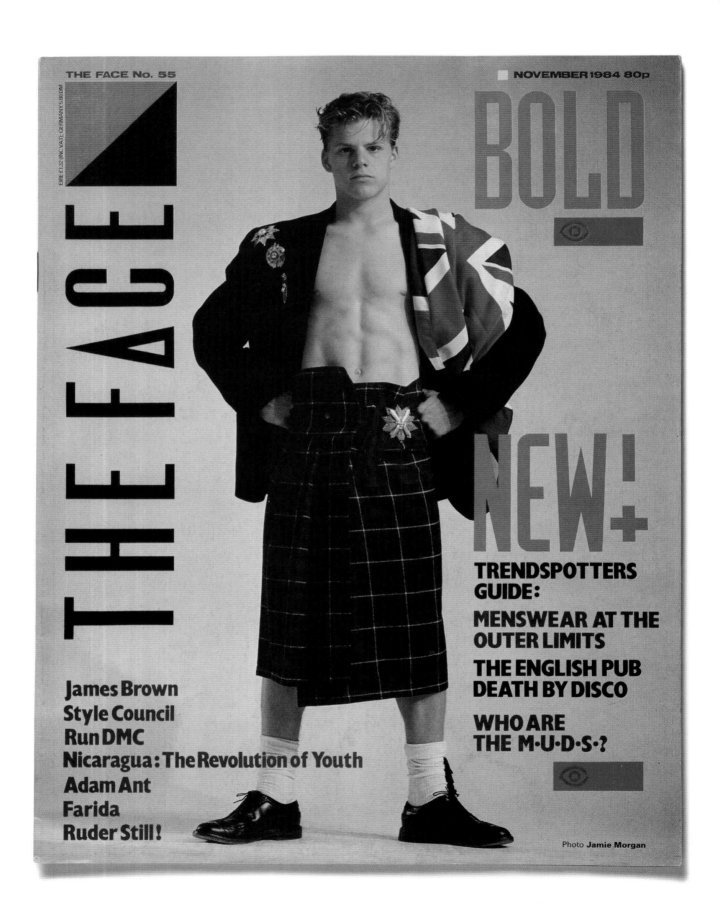

THE FACE No. 55

NOVEMBER 1984 80p

BOLD

THE FACE

NEW+

TRENDSPOTTERS GUIDE:

MENSWEAR AT THE OUTER LIMITS

THE ENGLISH PUB DEATH BY DISCO

WHO ARE THE M·U·D·S·?

James Brown
Style Council
Run DMC
Nicaragua: The Revolution of Youth
Adam Ant
Farida
Ruder Still!

Photo **Jamie Morgan**

Brody told Portsmouth graphics student Julian Morey at the time. 'We've got a new guy called Robin from St Martins, he's going to be really good. Effectively between us we lay out the whole magazine. The role of the art director in this case is a bit confused because most art directors will commission the photographers but here the role is shared between myself and the other editors, so often what happens is that when the stuff comes to me, the photographs are already done.'

Brody also discussed his development of bespoke typography. 'There are no typefaces that really suit what I want, which is very clean, very solid, very dynamic and quite punchy. If you look at most modern typography, it's shit!'

And Brody made no bones about the fact that he was on a one-man mission to break reliance on the limited and prescriptive range of fonts made available to graphic designers by either the incoming computer-generated typefaces or the rub-down transfer lettering produced in sheets by Letraset, which had dominated the field since the early 1970s. 'What I'm try to do is use *The Face* to influence the way people think,' Brody told Morey. 'I'm trying to say to them, look, forget computer type, forget Letraset and get back into the craft of using your hands. Design your own typefaces, get back into the skill and craft of it again.'

The overriding driver for Brody's obsession was the need for the magazine to stay ahead of the pack visually. 'The problem I have is that other magazines are ripping *The Face* off so much that, if I'm not aware of what is going on, it will look like all the other magazines,' he told Morey. In the past I would have used Letraset and anyone else could copy it. So the original reason for designing the type myself was so that no one could get hold of it. Other people are welcome to use it if they ask me and pay me a royalty but already it has started to be ripped off in so many places.'[27]

The newly recruited Robin Derrick was on hand to witness the ferocious rate at which Brody mutated the house fonts. 'Neville could draw a typeface in a day, it was extraordinary,' says Derrick. 'He's an incredible draughtsman and taught me how to draw technically. I learnt so much about magazines from him. Neville didn't "do" decoration but used the existing furniture – headlines, stand firsts, initial drop-caps, page numbers, turn arrows, picture captions – to make his statement.'

Derrick believes that Paul Rambali's input was particularly important to the mix. 'Paul knew what magazines can do; he knew how to drive the truck because he understood formats, when the photos should take priority or the copy should be emphasized.... I'd say, in that way, that Paul had a healthy disrespect for Neville, which every good designer needs. I think of *Rolling Stone*'s Fred Woodward once showing an amazing layout to (the magazine's founder/editor) Jann Wenner, who responded: "Yeah, well they're just letters on the page…" Paul

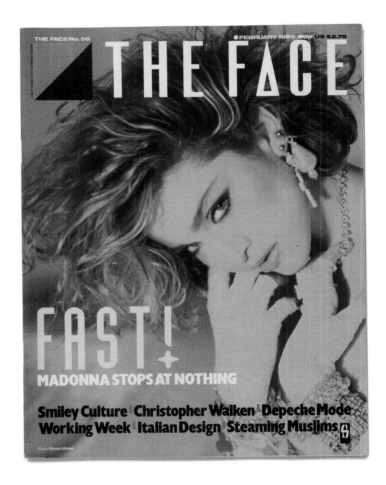

had that attitude and would often tell us what was important or needed to be downplayed in a story; maybe the intro-blurb had some particularly sparkling phrase or the photos weren't particularly great, so we would know where the impact lay. It was the editorial problem which Neville solved in his designs which made the magazine great.'

Derrick was also impressed with the way Logan maintained his grip on the magazine's production schedule to ensure that the content remained as up-to-the-minute as possible. 'I could be shooting a fashion story in the third week of the month, get the photos in, lay them out, send them to repro and have them in the issue on the streets ten days later,' explains Derrick. 'This is the time of paste-ups, colour separations, PMTs; to be that fast was one of the secrets of how *The Face* managed to be so far ahead of everyone else.'[28]

opposite
No. 55, November 1984.

above
No. 58, February 1985.

109

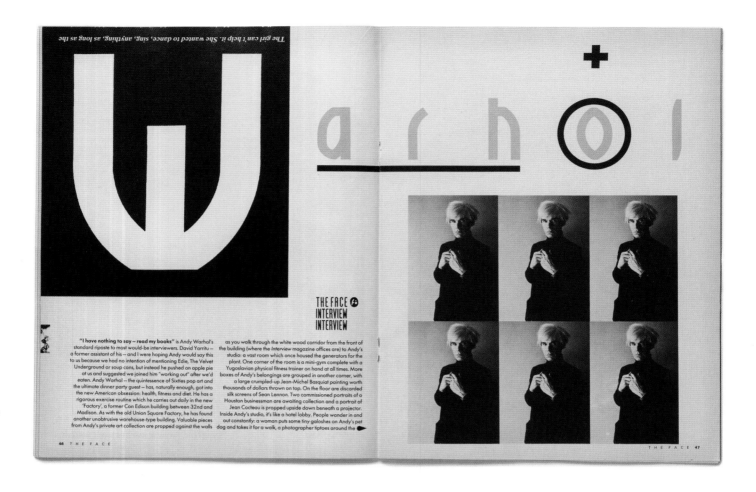

The year 1985 was heralded in the magazine by Robert Elms at his most confident. 'Style is our status system, our guide to what is right in the world and all-in-all we're getting better at it,' Elms announced in the January issue. His hyperbolic text also claimed that 'style is our national sport now, and you have to get the complete kit…[it is] the knowledge that stops us from being American'.[29] As if to prove Elms correct, Buffalo's breakthrough came in the March 1985 issue with the tough, monochrome series self-referentially labelled 'Hard' and featuring thirteen-year-old model Felix Howard in black Crombie, white polo-neck sweater and Homburg, with the word 'Killer' ripped from a newspaper headline and placed in the hatband (see pages 124–25).

Jamie Morgan, who had previously worked for photographic agency Magnum, later explained that the shoot – in line with the Buffalo aesthetic – was an act of deliberate disruption. 'It was a direct kick against the photography that was happening at the time in fashion magazines – pretty, colourful, female images.' And Morgan confirmed that Magnum's house style was an influence. 'We were taking that and a model who was completely out of context and getting away from the idea of what a model is. The word "killer" is important, because it's a Jamaican term. In the same way we might say "wicked",

they would say, "killer, man", so it has a double meaning. Ray included that as a bit of a punk statement, as in, "this shot is killer and make no mistake".'[30]

'I remember looking at the transparencies on the office light-box and being stunned,' says Lesley White: 'But in a way it was all mixed up with the humour of *The Face*. It was cool but nobody was po-faced about it. There was a time I was on the floor laughing with Rod about a "Men in Skirts" piece we ran with the headline "Down With Trousers".'[31]

To coincide with the publication of the fifth anniversary issue in May 1985, the graphic designer/curator Tony Arefin and art director Alex Noble of London's Photographers' Gallery staged a retrospective exhibition that demonstrated how the magazine had rung the changes in commercial practice, not least by using studio settings rather than location shoots for the depiction of pop stars and performers. In the view of contributor Mike Laye this development had led to 'a more stylized approach' across British advertising and media.[32]

The exhibition, entitled '5 Years with *The Face*', stressed the growing importance of stylists like Petri and, according to Arefin and Noble, was also 'about looking at popular social history in the making. *The Face* presents the strongest and

arguably most successful identity for youth in the 1980s. The fact that the magazine is called *The Face* and most of the photographs exhibited are portraits suggests there is something both image- and self-conscious about the way in which cult heroes and heroines are viewed this decade.'[33]

'5 Years with *The Face*' – which travelled to other British cities including Aberdeen and Birmingham – confirmed the magazine's media stature. Despite this, White chortles over a snap of the team of Logan, Rambali, Derrick, Sopp and herself taken on the opening night of the Photographers' Gallery show: 'We look like a bunch of dorks, not the people behind the hippest magazine on the planet!'[34]

Yet the title was scaling new heights in the public imagination, its position bolstered by a mention that year in Bret Easton Ellis's popular yuppie novel *Less Than Zero*; one of the characters recommends reading *The Face* as a means of assuaging boredom. Such references compounded the image of the magazine as insubstantial. Critics Simon Frith and Howard Horne wrote that the fifth anniversary issue projected a self-regarding air and claimed the magazine's 'early juxtapositions of discourse were exciting; more clearly even than bands like ABC or Human League, *The Face* showed how pop style works – as a production, as a phantasm, as a source of skewed discontent and momentary carelessness.... And then, slowly, the tone changed, grew more consistent, more self-congratulatory. By the time of the special fifth anniversary issue, success was claimed as "the credo of the decade" – *The Face*'s own success, success as an intangible personal quality. The deconstruction of the sales process had become a breathy celebration of sales people. Art was a mythical term again, but applied now not to musicians but to designers and copy-writers.'[35]

Then came accusations – not least from the staff at Logan's old stamping ground, *New Musical Express* – that the magazine was not only solely interested in communicating elitist ideas but too tightly focused on London in general and Soho in particular. A diatribe by British sociologist Dick Hebdige – prompted by a visit to '5 Years with *The Face*' – perpetrated the view that Logan's publication was 'the embodiment of entrepreneurial Thatcherite drive'. Best known for his subcultures investigation *The Meaning of Style*, published the year before *The Face* was launched, Hebdige's essay 'The Bottom Line on

opposite
'The Face Interview: Warhol', no. 59, March 1985.

above right
Advert for the '5 Years with *The Face*' exhibition at The Photographer's Gallery, London (19 April–18 May), no. 61, May 1985.

Planet One: Squaring up to *The Face*' accused the magazine of becoming a sacred cow of British culture: '*The Face* is hyper-conformist: more commercial than the commercial, more banal than the banal. [It has] flattened everything to the glossy world of the image, and presented its style as content.'[36]

In Hebdige's long list of condemnations was the charge that Logan and his team had renounced 'social realism and the moralists' mission to expose and combat social ills promoting instead consumer aesthetics and multiple style elites…it goes out of its way every month to blur the line between politics and parody and pastiche; the street, the stage, the screen; between purity and danger; the mainstream and the margins; to flatten out the world. For flatness is corrosive and infectious.'

Hebdige articulated a view that had taken hold; that the magazine was not only empty of meaning (he cited French philosopher Jean Baudrillard, who reduced society to 'atomized spectators, tribal bits in some overriding consumer circuit'[37]) but in essence the product of a bourgeois elite: '*The Face* reflects, defines and focuses the concerns of a significant minority of style- and image-conscious people who are not, on the whole, much interested in party politics, authorized versions of the past and outmoded notions of community.'

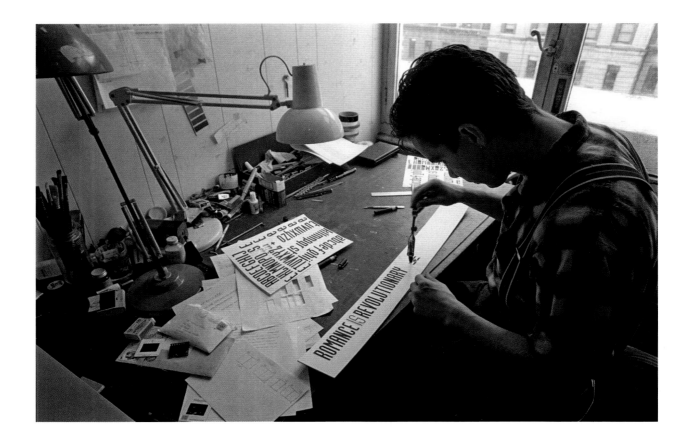

Some of the 1980s staffers accept the charge wholeheartedly. 'If it's a fact that I like being in small gatherings of intelligent people, then yes, I'm an elitist, guilty as charged', says Elms.[38] Likewise Derrick: 'We were exactly that, but it wasn't a bad elite to have since people like Robert, Jamie Morgan, Paul Rambali and Jay Strongman knew exactly what was going on.'[39]

However, others point to Hebdige's failure to acknowledge editorial material that would have scuppered his argument. 'When there is a small group producing a successful and much-imitated project, there are always accusations of elitism, but you couldn't have come across a more down-to-earth bunch', says White, who points to Dave Rimmer's and Kevin Sampson's July 1983 feature on the stylistic aspects of soccer fan 'casual' culture as examples of the magazine's willingness to investigate egalitarian youth movements.

'The Ins and Outs of High Street Fashion' (see pages 114–15) had arisen out of Logan's observations of his teenage son Christian's interest in the clothing and culture surrounding soccer, wondering whether the near-obsessive appetite for sportswear labels was 'just a local thing or something else. I'd got the notion that something interesting might be happening on the terraces outside the capital. Was there a connection, and even if there was, how did it play to our post-New Romantic legacy?'[40]

Then Logan received letters on the subject from Liverpool-based Sampson, who was commissioned to write the feature on the nationwide trend with a sidebar by Rimmer on the attitudes to style among Christian's circle of friends. 'This is where the class background of Nick and others at *The Face* comes in', says White. 'While Tatler was chronicling the life and parties of the upper classes, *The Face* was dedicating space to the lives of young working-class kids in Britain – the inheritors of Mod – who did not otherwise receive attention in the media.'[41]

Party political it may not have been, but left-leaning content was extended to sympathetic coverage of the National Union of Miners' drawn-out industrial action against the closures that tore through communities in Britain in the early to mid-1980s, as well as interviews with figures including the veteran Labour Party MP Dennis Skinner (known as the 'Beast of Bolsover' for the savagery of his attacks on the Tory government on behalf of this northern constituency).

above
Neville Brody at work, 1985.

opposite
'Strapping Lasses', no. 55, November 1984.

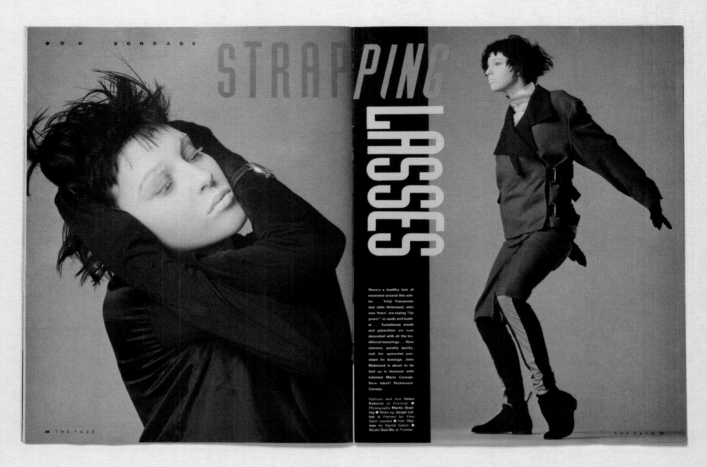

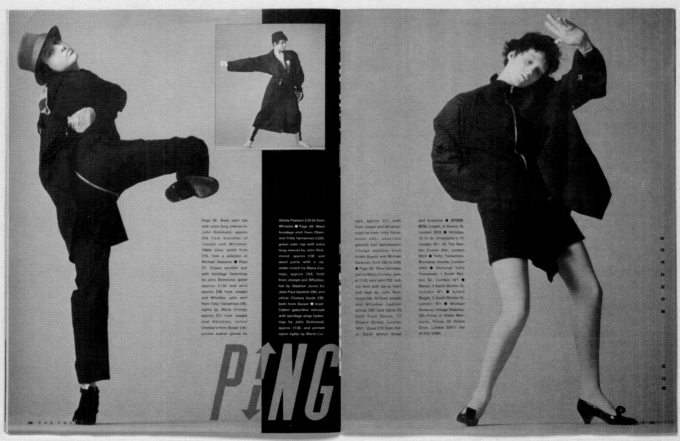

White believes these and other articles undermine the argument that *The Face* was run by a snooty urban cabal: 'These were very divisive times, and we were overtly left wing so didn't dodge the issues people were facing around the country. None of the mainstream magazines covered those subjects in the same passionate and engaged way.'[42]

Critics, meanwhile, pointed out that the espousing of political causes was problematic for 'the hip consumer guide of the Eighties, peddling pop Situationism and pop structuralism as market styles like Levi's 501s, even its acerbic political commentary reading like a socialism that could change as fast as one's hair-do'.[43] Such dichotomies were ignored by the increasingly impressed international publishing industry. On the other side of the Atlantic, in the same month as the fifth-anniversary celebrations, American publisher Bob Guccione Jr launched the first issue of new music magazine *Spin*, with Madonna on the cover and James Truman at the helm as executive editor.

'I found writing so hard, and working for *The Face* was not lucrative,' says Truman. 'I also wanted to make the shift to editing.' Truman retained his title as American editor at Logan's magazine but he dedicated his time to *Spin*. However, he and Guccione subsequently fell out; the latter later said Truman wanted the new magazine to ape *The Face* too closely for his liking.[44] 'That's probably true,' admits Truman. 'Bob was a talented editor, but design and style were not his interest, and they were probably less relevant to *Spin* than I wanted them to be.'[45]

The fifth anniversary issue marked the journalistic return of the gangly figure of Nick Kent, whose career had been stellar ten years earlier at Logan's *NME* but had since faltered as his reliance on hard drugs had grown. Logan recognized that the in-recovery Kent could bring a unique viewpoint to new groups such as The Smiths, whose leader Stephen Morrissey's musical roots lay with Kent's 1970s compadres the New York Dolls. Kent's feature on Morrissey and his group in the May 1985 issue was the first in a series of submissions by the writer to rival the best of his work a decade before.

'Nick was a sweetheart, sat in the only office where he could smoke for hours writing his features in longhand on scrolls of paper,' said Lesley White. 'There were stories that it was best to lock him in, because if he wandered off that would be the last we would see of him and the cover story wouldn't materialize.'[46]

The front of the June 1985 issue asserted the fact that Buffalo was becoming the dominant force at the vanguard of male fashion: a full-length Jamie Morgan shot of boxer Clinton McKenzie styled by Ray Petri in Lonsdale boxing shorts, sleeveless T-shirt, Versace flat-cap and fur ear-muffs (see pages 128–29). For all the apparent experimentation, Petri's approach – use of skirts aside – relied too much on typical items of male apparel for some commentators and so 'modified rather than revolutionized the chief tenets of menswear…despite his attempts to deconstruct dominant and exclusive forms of masculinity, "new man" continued to be wrapped in the garb of "old man".'[47]

When viewed from the perspective of *The Face*, the major public event of the summer of 1985, if not the decade – Bob Geldof's and Midge Ure's Live Aid concert – demonstrated the growing power of the magazine's global constituency. The musical line-up was rammed to the gills with visually oriented artists whose success had been mediated by *The Face*, including cover stars Adam Ant, David Bowie, Elvis Costello, Duran Duran, Bryan Ferry, Madonna, George Michael, Sade, Spandau Ballet and Paul Weller. Backstage even Ringo Starr was wearing Crolla, while in the accompanying (and these days much-mocked) video for the charity song 'Dancin' in the Street', Bowie and Mick Jagger sported Williwear, Sue Timney and Katharine Hamnett. Every single one of these designers chosen by the 1960s and 1970s rock titans had been championed in the 1980s by *The Face*.

above and opposite top
'The Ins and Outs of High Street Fashion', no. 39, July 1983.

opposite bottom
'Dreamer in the Real World', no. 61, May 1985.

ELLESSE *PRINGLE* FILA *NIKE* TACHINNI *LACOSTE*

◆ THE INS AND OUTS OF HIGH STREET FASHION

▶ Forget Kensington Market and the Kings Road, *this* is street fashion. Style is almost an irrelevance: the *label* is what matters. KEVIN SAMPSON in Liverpool says that it started on the terraces in 1977. DAVE RIMMER picks up the story in the London suburbs, where the participants are getting younger as the pace of change hots up . . .

By KEVIN SAMPSON

● Fashion has always been a city thing. The adoption of certain labels and garments is geared towards other people knowing what's what. The important factors are quality, colour, a certain visual rightness and, of course, price – why pay less? This merry-go-round can't properly exist outside of the conurbations for the same reasons that you don't have the Grand Prix at Leominster. No, the wasted youth of, say, Barrow are going to opt for a far more outrageous individual stance because their market forces demand it.

This, in 1983, is popularly labelled style. The media emphasis for the past year has been on individualism, resulting in a nationwide army of Buffalo boys and gal-Georges. Good old self-expression rears its pretty head once more, and style is in fashion. Can this be all that is happening to rag-trade Britain? You can bet your Fila tracksuit that it isn't, as any paid-up football fancier will tell you. Times are tight, but, for those actually affected by the national disgrace, their reaction has been well in tune with history.

Image before belly is The Message and the young city dweller of today is more concerned with fashion than ever. His inspiration, though, comes not from the expensive Italian boutiques but from the local football ground. Here the traditional cycle of experiment – adopt, abandon whirls round as fast as you can play. This is young, urban, male Britain – modern as hell, and how. And how?

Let's rewind to the summer of 1977. Remember it? The Buzzcocks? 'White Riot'? 'Low'? That Berlin-phase Bowie LP may not have seemed important at the time, but in the Scotland Road area of Liverpool it was breaking down doors for the world of youth culture. Scotland Road is a puzzle for Housing Dept officials – the classism of its people legendary. Why does no-one work? Why do they all have videos? Why won't they move to a nice overspill estate? This clannism became especially evident in the children of Scotland Road, the first 'Scallies' to emerge in 1977.

Taking the cover of Bowie's 'Low' as a point of reference, they mixed the bohemian cool of Bowie with punk's snazzier trappings. The resulting image was at once aggressive, effeminate and extremely attractive. Mohairs worn with straights and plastic sandals, complemented by camel duffel coats. But it was the distinctive hairstyle that stamped SCAL-LY all over them, the unique and wonderful lopsided wedge – a haircut popular in the last great depression, ridiculously 'claimed' by hair stylist Trevor Sorbie at Vidal Sassoon.

The start of the 1977 football season saw this look spreading, slowly at first, while a vibrant club scene began to take shape. Centred on two New Wave clubs, Checkmate and The Swinging Apple, a Punk-Scally crossover was noticeable for some months. Yet as electronic music began to predominate in early 1978, Checkmate became more fringe, less spike. Lots of punks adopted the cycling wedge as a weird hairstyle, resulting in a miasma of dyed flicks flopping around to 'Sound And Vision' at Checkmate. It was here, incidentally, that Richard Jobson's bête noire 'Into The Valleys' kick-dance originated. So there.

It was around February of 1978 that this fledgeling fashion shook off its punk influences and became more of a cult, a football-orientated lifestyle. Suddenly everyone at the match was sporting a drooping fringe, straights and Pod shoes. Like all good cults, the metamorphosis was very swift and very widespread. Though drinking, stealing, claiming and clubbing were all important, obsession with clothes gripped young Merseyside something murderous.

Between spring 1978 and winter 1979 the city's rag-trade was turned upside down. The emphasis went on detail. First it was dtrainies rather than just straights. Then it had to be Lois dramies. Then, come 1979, it was a new label every month. Inega, Fiorucci, Lacoste, FU's all had their moments, but never very long ones. Now *this* was fashion. No sooner was a new brand of colour established than it was cast off, replaced and ridiculed.

The shops became wise to the movement and capitalised on the joke aspect of it. Stickers claiming "Et For One Day Only!!!" were attached to gold jumbo cords, while a shop in Lime Street displayed an array of three-star jumpers with the invitation "Why go cold?" This was a reference to the thin baggy shirts being worn – top button done up, no jacket – in January.

As 1979 wore on, though, inspiration fell thin on the ground. The style leaders of Scotland Road simply went more ridiculous, by wearing no straights, walking with their hands behind their backs and using Stafford-shire Bull Terriers as a fashion accessory. At the same time there was a great deal of bitplay. All manner of headgear came and went – baseball caps, deerstalkers, trappers hats, flat caps. By this time the cult was well established.

By DAVE RIMMER

The story of White Hall Clothiers, 77 Camberwell Road, London SE5 is typical. A couple of years ago it was a school uniform shop: blazers, badges, ties, a bit of sportswear. Now what little is left of the uniforms is shoved to the back, soon to be gone for good. The rest is stocked to the hilt with expensive brand-name sports and casual gear – Lacoste, Fila, Diadora, Pringle, Fiorucci. What's more, business is booming.

The staff are amused when someone who knows the shop as it used to be wanders in, looks around at the unfamiliar range, the young customers milling about, the assistant holding that Fila tracksuit top up for inspection by the tenth time in half an hour, the ten-year-old in the Pierre Cardin T-shirt covetously eyeing the Lacoste range, the mum being nagged by her 14-year-old son to fork out upwards of £30 for a pair of Diadora green flash kangaroo-skin trainers when those much-cheaper Adidas ones would do just as well . . . looks around at all this and mutters: "What's happened?"

What has happened? Specifically, 18 months ago White Hall Clothiers noticed that certain lines of sports gear were outselling everything else, so they stocked up. The grey flannel Farah trousers they got in sold out immediately. So did the Lacoste tennis shirts, and the Pringle diamond pullovers, and one thing led to another.

Generally? Brand-names are back. And with a vengeance. The standard outfit down the Walworth Road goes something like this. From the top:

● Wedge or wetlook hair; highlights are in, deerstalkers (popular until recently) now out.

● Lacoste, Fila or Ellesse tennis shirts. Gabicci are definitely wrong, Cardin are acceptable but passé. Lacoste are getting that way. Girls also like Benetton rugby shirts.

● Pringle (squares or stripes, not diamonds, plain for school only), Lyle & Scott and sometimes Benetton pullovers and cardigans. Lacoste and Cardin again popular but fading. Bennalyne cashmere or Armani arriving.

● Fila or Sergio Tachinni tracksuit tops (sometimes whole thing) for boys. Club Sport for girls. Lacoste: same story. Burberry jackets.

● Lois or Fiorucci straight leg pre-faded jeans, sometimes bottom of leg with seam split about three inches. Frayed bottoms on the way out. Lois jumbo cords (of needle) in navy blue or burgundy also acceptable. Tennis shorts: Fila,

[continues...]

The younger end of High Street fashion. A gang of 14-15 years olds in an East London park: Chris (Lyle & Scott), Nicky (Lacoste), Michael (Lacoste), Stuart (Pringle), Martin (Fila) and Chris (Ellesse).

DREAMER

IN THE REAL WORLD

To his father he was a "complete fruitcake", to his contemporaries "the village idiot". Yet in the treacherous image-bloated clone-zone of pop, his is the voice that speaks out against a tide of rabid conformity. But what if all Morrissey's candour merely hides his own insecurity and doubt?

By **Nick Kent** Photographs **Nick Knight**

The

CALL CAME FROM The Smiths' London HQ. On the line were the parched, middle American tones of Scott Piering, the group's events manager.

"Ah Nick, I really don't quite know how to broach this because . . . ah, see, I'm sure you're not . . . Well, I'm convinced you're an ally and you're clearly just a massive amount of thought and research into your story but . . . erm . . . that's why concern is so rife.

THE FACE No. 54

EIRE £1.32 (INC VAT). GERMANY 6DM

OCTOBER 1984 80p

THE FACE

DAVID BOWIE
Cracked actor on the set

DAVID LEE ROTH
In the FACE interview

RUDE!
Would you pose naked for the FACE?
Martin and Gary Kemp did, Richard Branson didn't...

John Hurt · Keith Haring · Trevor Preston · Quinn + Collins · Selling England · Soul

Photo: Greg Gorman

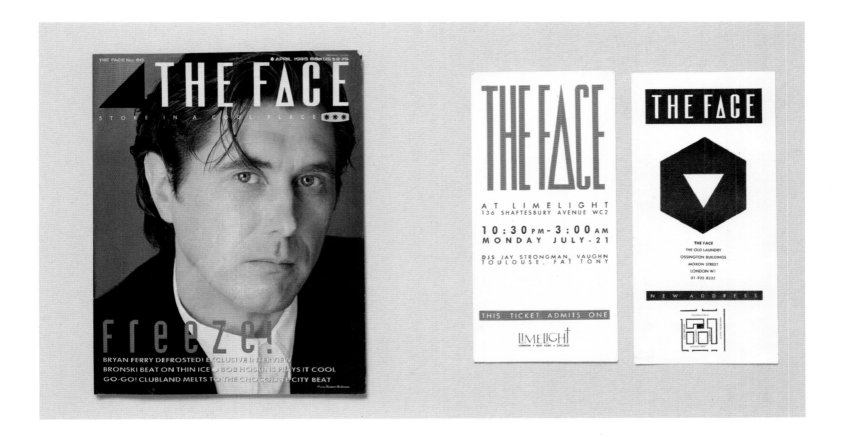

Yet in pop culture and entertainment business terms, the major effect of Live Aid was to revive the fortunes of those established performers whose noses had been put out of joint by the style press, including Led Zeppelin, Queen and Status Quo, as well as the groups that followed in their wake, such as U2. This reassertion of the rock elite's stodgy values of authenticity and the take-up of the new CD format would lead to the creation of a raft of British monthly music titles, lead by Emap's *Q*, which was founded the following year by Mark Ellen and David Hepworth, both of whom had fallen under Logan's spell as contributors (and eventually editors) at *Smash Hits* as well as early issues of *The Face*.

There is a direct line from *Q*'s peppy copy and dedication of space to colour photography of rock stars to the original formula of Logan's magazine; in turn the establishment of *Q* prompted IPC to launch its own rock monthlies, *Vox* and *Select*,

later in the decade. When Emap took the decision to appeal to older music fans with *Mojo* in the 1990s, the rival publishing house responded with *Uncut*. That these magazines continue to be published in the digital age is a testament to Logan's foresight in the 1980s.

Back in that decade, *The Face* was increasingly showcasing new styles of visual presentation and giving priority to innovatory photography in the wake of the inspirational work of the Buffalo camp. This may be attributed to Robin Derrick's receptivity; he enjoyed engaging with photographers, briefing them and attending and contributing to their shoots, unlike Brody, who preferred to work from his office.

'In a way I became the art director because Neville was a better designer than me,' says Derrick. 'One of the reasons for this is that he regarded photography as a design element, so in the fortnight between layouts I ended up commissioning the fashion photography in the magazine from people like Robert Erdman, Nick Knight, Mark Lebon and Perry Ogden.'[48] And so the coming years of the magazine's existence were to witness the primacy of design giving way to that of photography, particularly in the arena of fashion, where the influence of *The Face* remains detectable to this day.

opposite
No. 54, October 1984.

above left to right
No. 60, April 1985; invitation for a party at Limelight on 21 July 1985; change-of-address card, July 1985.

Chapter Five

below and opposite
'Winter Sports', no. 45, January 1984.

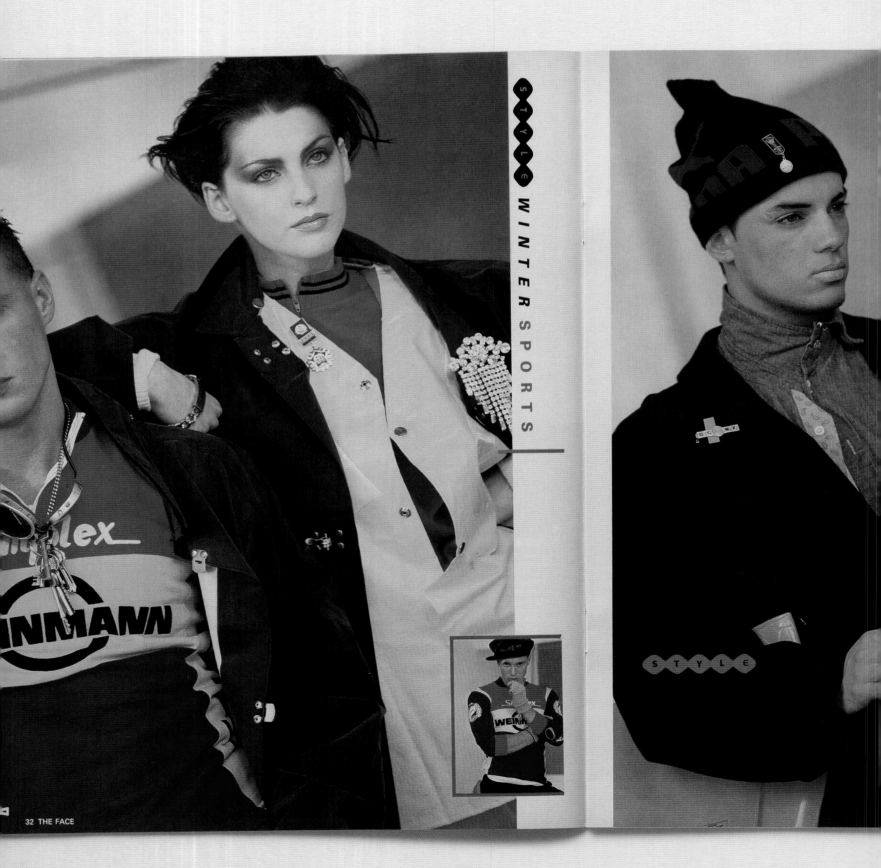

32 THE FACE

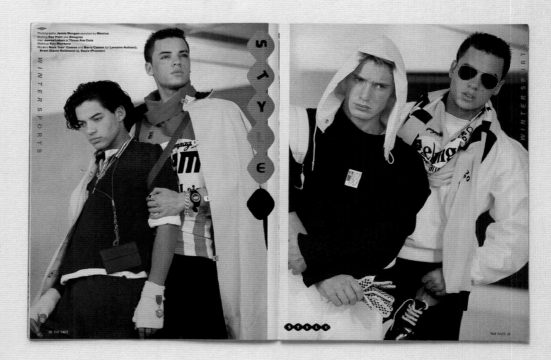

THE FACE 33

≡FRESH! ELECTRO

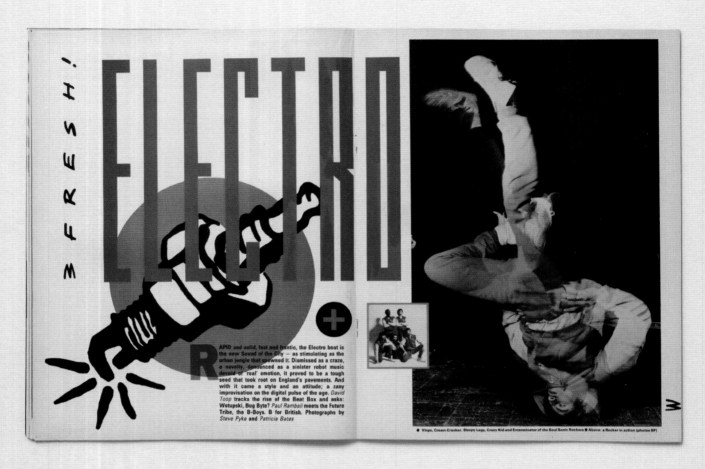

RAPID and solid, fast and frantic, the Electro beat is the new Sound of the City — as stimulating as the urban jungle that spawned it. Dismissed as a craze, a novelty, denounced as a sinister robot music devoid of 'real' emotion, it proved to be a tough seed that took root on England's pavements. And with it came a style and an attitude; a zany improvisation on the digital pulse of the age. *David Toop* tracks the rise of the Beat Box and asks: Wotupski, Bug Byte? *Paul Rambali* meets the Future Tribe, the B-Boys, B for British. Photographs by *Steve Pyke* and *Patricia Bates*

● Virgo, Cream Cracker, Sleepy Legs, Crazy Kid and Exterminator of the Soul Sonic Rockers ● Above: a Rocker in action (photos SP)

ELECTRO ≡ PHASE 1

the hip·hop won't stop

Trevor Birch is a B-Boy. That's 'B' for Bad, Beautiful, Black, Breaking, the Bronx. But in Trevor's case, 'B' for British. He couldn't tell you which subway line leads to the New York borough north of the Harlem river that has given him, at 18 in East London, an activity, an identity. But he has heard the records, seen the look, knows the moves.

He practises them up to four hours a day, during lunch breaks at the Community Project where he works with his old school friend Gengiz Ozkadi painting murals, and later in the evening in the bedroom at Ozkadi's council home. To records like Newcleus' "Jam On It" and "One For The Treble" by Davy DMX, taped from Radio Invicta on Sunday nights because they can't afford to buy the records – thus pirating the pirates – they rehearse the flamboyant gestures of a satellite subculture, dancing a zany improvisation on the micro-electronic pulse of the age.

And every Friday night they travel six miles to the Electric Ballroom in Camden Town. Both wear yellow peak caps and identical red and blue Adidas jogging suits over ... it's impossible to say over what because they never take them off, never even unzip their anoraks. Oblivious to the writhing bodies around them, they stand facing each other on the crowded dance floor, waiting for the mutant crack of the Linn Drum, the signal that galvanises them into tense, jerky spasms, swapped back and forth like a ball of invisible voltage.

"We like doing it," says Trevor. "We don't do it for money. It keeps us from doing something stupid." He picked it up three years ago from his elder brother, when it was called Robot Dancing. At the Tidal Basin club near his home, he kept abreast of the dance style that evolved into Body-Popping and Break-Dancing. He has never been to Covent Garden, where at times last summer it seemed there were more Break Dance crews than tourists to fund them. He and Ozkadi call their crew Technical Poppers, and they like to keep their moves up their sleeves. Once, at the Kensington club in East Ham, Trevor made the error of showing off his best style. "So many people took my moves that I had to go home and start all over again!"

Competition is fierce, reputations are waiting to be made and lost. The threat of 'Pirates' or 'Biters' – people stealing your moves – is always present. The Technical Poppers, who never make their best moves at the Ballroom, have eight or so friends locally with other crews. "They're looking for a challenge, but I don't think we'll oblige them."

Right now, their main concern is track suits. Hummel red and blue track suits with diagonal white stripes that they've seen in a local sports shop. Trevor asks if I know of any clubs that want to promote a crew in return for the price of two Hummel track suits. They've got to have those suits. In two weeks' time there is the third heat of the All-London Independent And Team Body-Popping, Cracking And Break-Dancing Championship. The Technical Poppers reckon they have a good chance. "We've seen everybody else's moves, but they ain't seen ours!" But first they need those suits.

"You ought to have a flick book to explain it," says Robert Henry, a 22-year-old DJ and promoter who has been involved in organising the championship. "Popping by pros is a violent manoeuvre of the muscles. What they say is 'You get tight, and you pop!'" He clenches the muscles on his arm and releases them suddenly. "Cracking – that's a manoeuvre of the joints, like when your elbow or shoulder cracks." This time his aim snaps at the joints, as though a knot were passing along from one to the next and across the chest. "And Breaking is where you are more likely to be horizontal than vertical." But there is no room to demonstrate the starting acrobatics that arose in the eight-bar rhythm breaks characteristic of late Seventies soul and funk discs.

No doubt about it though, this is the biggest dance craze to hit the UK since Robotics. "So many teams have come out of the woodwork," enthuses Robert. "We always knew the UK had the same creative power as the Americans." The first heats were held at a club near Brick Lane in East London. "We wanted to put the show on where Body-Popping came from. It's like a concrete jungle around there, it's the nearest thing to the ghetto." Teams and individuals came from all over: Battersea, Catford, Dagenham, Balham, Leyton, Tottenham – "Any run-down area in London."

Robert has a theory: "It's caught on because it's such a radical form. It's expressive. All you need is the music and a street corner, and you can get away from the pressures."

His theory isn't new but it fits. And it goes further. Young Blacks in Britain who might five years ago have looked to reggae, with its potent figurehead of the late Bob Marley, for the trappings of cultural identity, now turn to the Bronx, to the Beat-Box and the Ghetto-Blaster. A style imported in the grooves of "Planet Rock" by the Soul Sonic Force in 1982, glimpsed on the faddish videos of mainstream pop and soul acts, a tough, city-spawned seed, has taken root on England's pavements.

It has been nourished by the burgeoning electronic beat, rapid and solid, fast and frantic like the Swarmers on the third wave of Defender. It finds its spirit in raps like "Gettin' Money" by Dr Jekyll and Mr Hyde.

In a suburban semi in Wood Green belonging to their manager's parents, the Soul Sonic Rockers are gathered watching a video of their heroes, an American crew named Dynamic Rockers.

"That's wicked, man!"

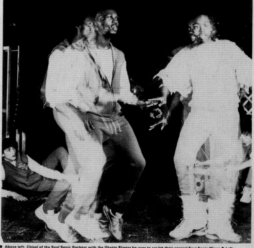

● Above left: Chisel of the Soul Sonic Rockers with the Ghetto Blaster he uses to sculpt their special Soul Sonic Mixes ● Left: Gengiz and Trevor (seated) of the Technical Poppers ● Above: two of the Soul Sonic Rockers show off their moves (photos SP)

"Everything is funny when you're gettin' money," they chant, adding a sardonic "Ha-Ha Ha!"

It has its fast-moving entrepreneurs in people like Morgan Kahn of Streetwave Records who, like Chris Blackwell with Island Records' ska and soul releases in the Sixties, is making this new sound accessible with his best selling "Electro" compilation albums. It is sustained by DJs like Herbie of the Mastermind roadshow (see INTRO) who mixes the "Electro" albums for Streetwave and who, along with Paul Anderson of Trouble Funk, can be guaranteed to draw the crews.

It has even had its popular successes, if sometimes fake (Break Machine's recent "Street Dance") or trite (the Rock Steady Crew's hit last year). And it has an audience hungry for information. Trevor Birch missed the New York rap movie Wild Style when it came out, but when the Rock Steady Crew performed at an electronics fair in Olympia last year, the Technical Poppers were there. They weren't the only ones. The hall was full of Biters, who must have been disappointed. "Their Breakin' was alright but their Poppin' was dry."

"His body's like rubber ..."

"Murder!"

On the video, a frazzled, black and white copy of a copy, one of the Dynamic Rockers is doing a Helicopter – called a Windmill in the US – followed by a Headspin.

"That's my move," says Eddie. "That's one of the hardest moves!" The Dynamic Rocker comes out of the Headspin, flipping upright into a pose, legs and arms interwined.

"All Breakers gotta have a pose," laughs Eddie.

And all Breakers must have a nickname too.

The nicknames of the Soul Sonic Rockers are Virgo (Eddie, aged 19), Cream Cracker (Bec, 18), Sleepy Legs (Mussy, 18), Back Flip (Sonay, 16), Crazy Kid (Ozhe, 18) and Exterminator (Mus, 16). Nineteen-year-old Andrew's nickname is Chisel, because he sculpts the Soul Sonic Mixes they dance to, buying two or three US import singles a week with his dole money, and taking eight hours to mix a 46-minute tape with techniques culled from seeing scratching on TV and watching Herbie mix with the Mastermind roadshow.

Eddie and Bec, the two leaders of the crew, met at work in 1982 and formed what was then called the Breakers Crew. Outfitted in Tiger anoraks – "because," says Bec, "all the other crews were wearing Adidas and we wanted something unusual" – the Breakers Crew, which soon

42 THE FACE

THE FACE 43

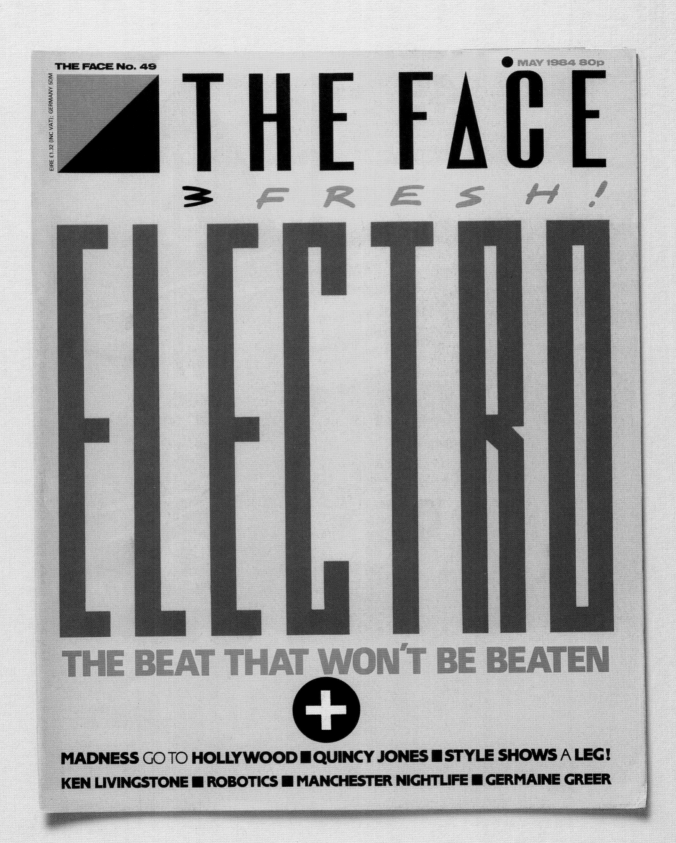

THE FACE No. 49

EIRE £1.32 (INC VAT); GERMANY 5DM

● MAY 1984 80p

THE FACE

ℨ F R E S H !

ELECTRO

THE BEAT THAT WON'T BE BEATEN

✚

MADNESS GO TO **HOLLYWOOD** ■ **QUINCY JONES** ■ **STYLE SHOWS** A **LEG!**
KEN LIVINGSTONE ■ **ROBOTICS** ■ **MANCHESTER NIGHTLIFE** ■ **GERMAINE GREER**

opposite
'Electro', no. 49, May 1984.

above
No. 49.

below and opposite
'Men's Where?', no. 55, November 1984.

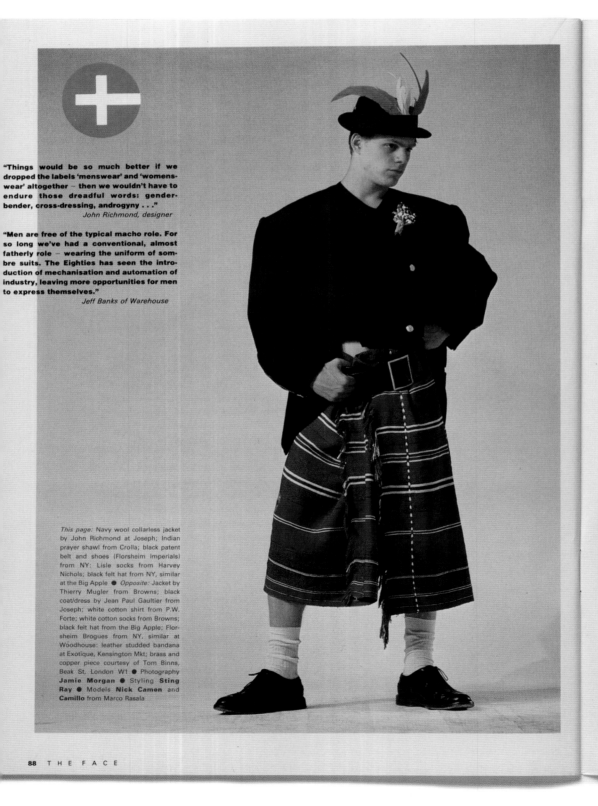

"Things would be so much better if we dropped the labels 'menswear' and 'womenswear' altogether – then we wouldn't have to endure those dreadful words: gender-bender, cross-dressing, androgyny . . ."
John Richmond, designer

"Men are free of the typical macho role. For so long we've had a conventional, almost fatherly role – wearing the uniform of sombre suits. The Eighties has seen the introduction of mechanisation and automation of industry, leaving more opportunities for men to express themselves."
Jeff Banks of Warehouse

This page: Navy wool collarless jacket by John Richmond at Joseph; Indian prayer shawl from Crolla; black patent belt and shoes (Florsheim Imperials) from NY; Lisle socks from Harvey Nichols; black felt hat from NY, similar at the Big Apple ● *Opposite:* Jacket by Thierry Mugler from Browns; black coat/dress by Jean Paul Gaultier from Joseph; white cotton shirt from P.W. Forte; white cotton socks from Browns; black felt hat from the Big Apple; Florsheim Brogues from NY, similar at Woodhouse; leather studded bandana at Exotique, Kensington Mkt; brass and copper piece courtesy of Tom Binns, Beak St, London W1 ● Photography **Jamie Morgan** ● Styling **Sting Ray** ● Models **Nick Camen** and **Camillo** from Marco Rasala

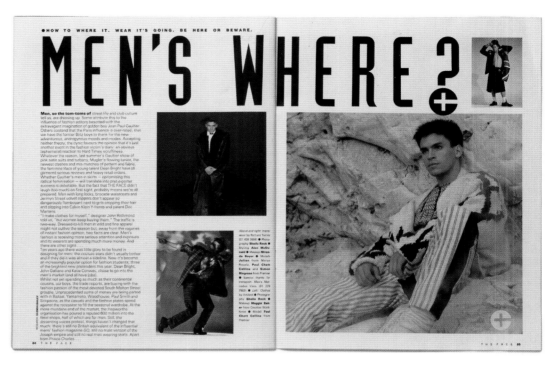

MEN'S WHERE?

●HOW TO WHERE IT. WEAR IT'S GOING. BE HERE OR BEWARE.

Men, so the tom-toms of street life and club culture tell us, are dressing up. Some attribute this to the influence of fashion editors besotted with the extravagant imagination of golden boy Jean Paul Gaultier. Others contend that the Paris influence is over-rated; that we have the former Blitz boys to thank for the new adventurous, androgynous moods and modes. Accepting neither theory, the cynic favours the opinion that it's just another event in the fashion victim's diary: an obvious ephemeral reaction to Hard Times scruffiness.

Whatever the reason, last summer's Gaultier show of pink satin suits and turbans, Mugler's flowing tunics, the newest clashes and mis-matches of pattern and fabric, the feminine lilacs of young talent Dean Bright have all garnered serious reviews and heavy retail orders. Whether Gaultier's men in skirts – epitomising this radical feminisation – will translate into pret-a-porter success is debatable. But the fact that THE FACE didn't laugh (too much) on first sight, probably means we're all prepared. Men with long locks, brocade waistcoats and Jermyn Street velvet slippers don't appear so dangerously flamboyant next to grrls cropping their hair and slipping into Calvin Klein Y-fronts and patent Doc Martens.

"I make clothes for myself," designer John Richmond told us, "but women keep buying them." The traffic is two-way. Dressed-to-kill men in wild and fine apparel might not outlive the season but, away from the vagaries of instant fashion opinion, two facts are clear. Men's fashion is receiving more serious attention and exposure and its wearers are spending much more money. And there are other signs.

Ten years ago there was little glory to be found in designing for men; the couture stars didn't usually bother and if they did it was almost a sideline. Now it's become an increasingly popular option for fashion students; three of the brightest new pretenders this year, Dean Bright, John Galliano and Katie Conway, chose to go into the men's market (and all have jobs).

Whilst not yet spending as much as their continental cousins, our boys, the trade reports, are buying with the fashion passion of the most devoted South Molton Street groupie. Unprecedented sums of money are being parted with in Bazaar, Yamamoto, Woodhouse, Paul Smith and Smgapole, as the casuals and the fashion packs spend against the recession to fill the seasonal wardrobe. At the more mundane end of the market, the Hepworths organisation has poured in a reputed 600 million into the Next shops, half of which are for men. Still, the dissenting voices protest, things haven't changed that much: there's still no British equivalent of the influential men's fashion magazine GQ; still no male version of the Joseph empire and still no real men wearing skirts. Apart from Prince Charles.

Above and right: menswear by Richard Torrey (01 439 3686 ● Photography **Sheila Rock** ● Styling **Alan McDonald** ● Makeup **Miranda Boyce** ● Models **Julian** from Marco Rosale, **Paul Chatt Collins** and **Simon Bingrose** from Premier ● Special thanks for transport: Max's Mercedes Vans (01 291 7607) ● Left: Clothes from Bazaar ● Photography **Sheila Rock** ● Makeup **Maggie Baker** from Creative Workforce ● Model **Paul Chatt Collins** from Premier

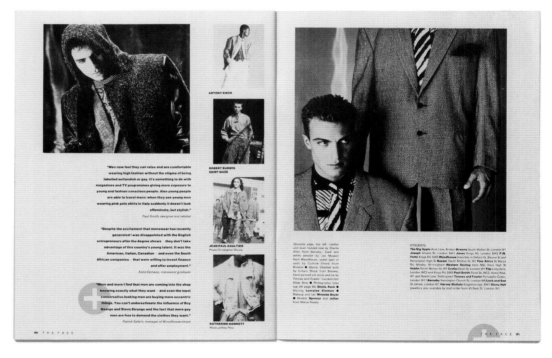

"Men now feel they can relax and are comfortable wearing high fashion without the stigma of being labelled outlandish or gay. It's something to do with magazines and TV programmes giving more exposure to young and fashion conscious people. Also young people are able to travel more: when they see young men wearing pink polo shirts in Italy suddenly it doesn't look effeminate, but stylish."

Paul Smith, designer and retailer

"Despite the excitement that menswear has recently generated I was disappointed with the English entrepreneurs after the degree shows – they don't take advantage of this country's young talent. It was the American, Italian, Canadian – and even the South African companies – that were willing to invest finance and offer employment."

Katie Conway, menswear graduate

"More and more I find that men are coming into the shop knowing exactly what they want – and even the most conservative-looking men are buying more eccentric things. You can't underestimate the influence of Boy George and Steve Strange and the fact that more gay men are free to demand the clothes they want."

Patrick Sefani, manager of Woodhouse shops

ANTONY KWOK

ROBERT RUDWIG
SHIRT MAZE

JEAN PAUL GAULTIER
Photo Christopher Moore

KATHERINE HAMNETT
Photo Jeffrey Paul

Opposite page, top left: London Allen from Barnaby, black and white sweater by Joe Mission from WoodHouse; jacket (part of suit) by Culture Shock from Browns ● Above: Checked suit by Culture Shock from Browns; hand-painted silk shirt and tie by Tizney and Rowler, handkerchief Miss Dine ● Photography take top left page 90: **Sheila Rock** ● Styling **Lorraine Kinnas** ● Makeup and hair **Miranda Boyce** ● Models **Spencer** and **Julian** from Marco Rosale.

STOCKISTS
The Big Apple Acre Lane, Brixton. **Browns** South Molton St, London W1 **Joseph** Sloane St, London SW1 **Jones** Kings Rd, London SW3 **P.R. Forte** Kings Rd, SW3 **Woodhouse** branches in Oxford St, Sloane St and Kensington High St. **Bazaar** South Molton St, W1 **Flip** Long Acre, London W1 **Harvey Nichols** Knightsbridge, SW1 **Dinny Hall** jewellery also available by mail order from 43 Beak St, London W1

Hard is the graft when money is scarce. Hard are the looks from every corner. Hard is what you will turn out to be. Look out, here comes a buffalo! "The harder they come, the better" (Buffalo Bill)

Photography **Jamie Morgan** ● Styling **Ray Petri**

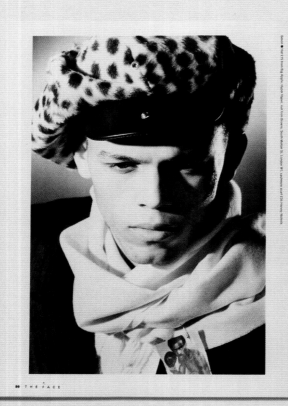

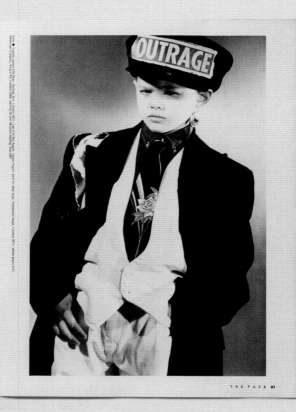

above and overleaf
'The Harder They Come', no. 59, March 1985.

opposite
No. 59.

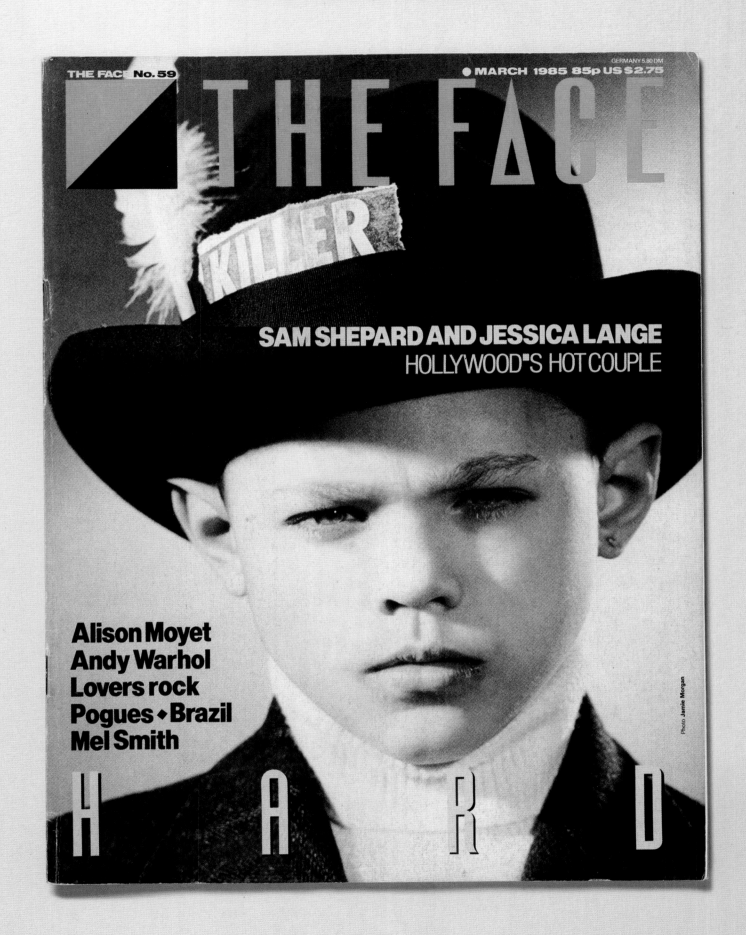

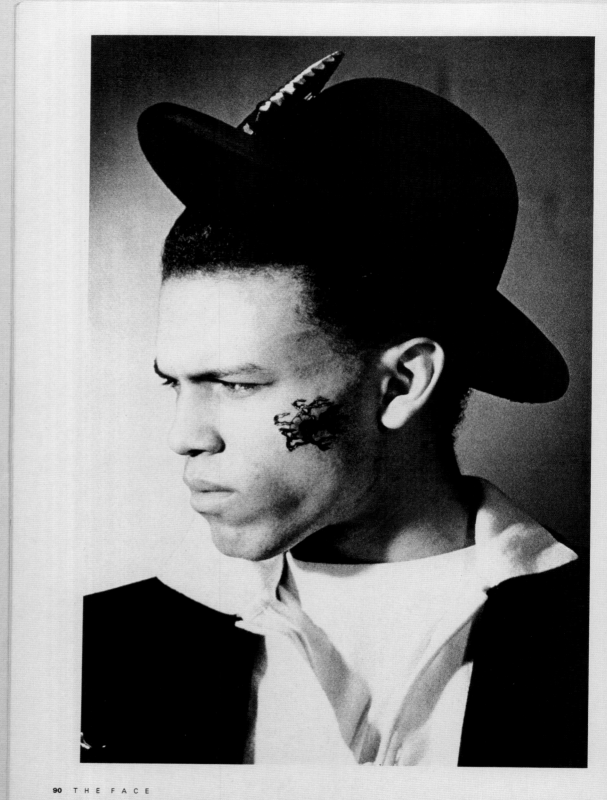

90 THE FACE

Simon ● left and right: Coat £45 from Hackett, New King's Road, London SW6; jumper £25 from Benetton; hat £25 Big Apple, Hyper Hyper; carved Indian badge £28 Butler & Wilson, South Molton St, London W1

THE FACE **91**

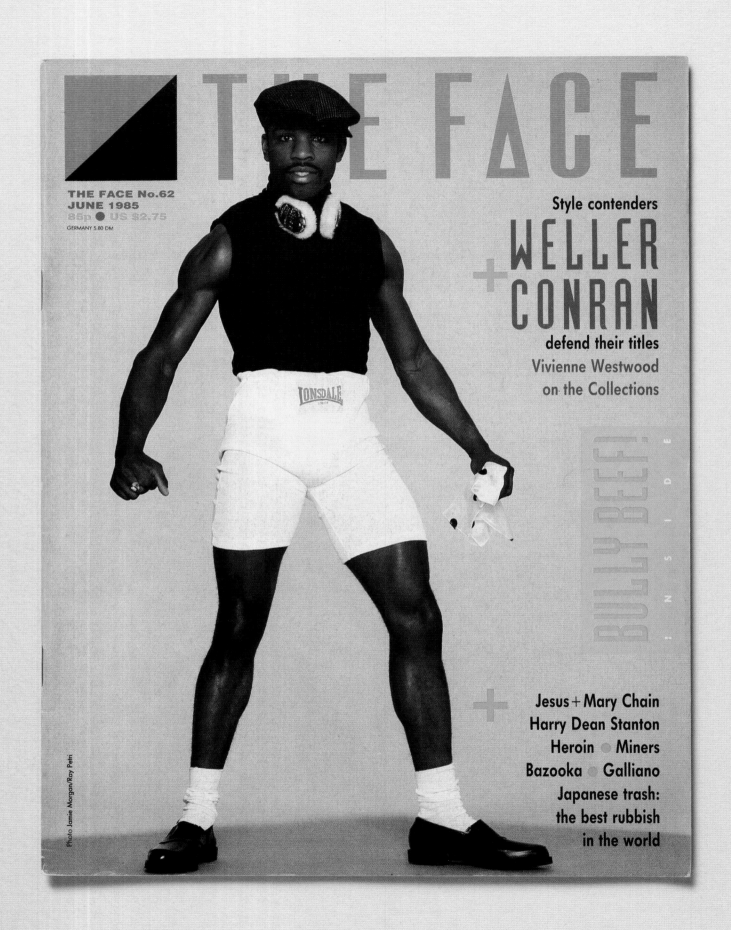

THE FACE No.62
JUNE 1985
85p ● US $2.75
GERMANY 5.80 DM

THE FACE

Style contenders

WELLER
+
CONRAN

defend their titles
Vivienne Westwood
on the Collections

BULLY BEEF! INSIDE

Jesus + Mary Chain
Harry Dean Stanton
Heroin ● Miners
Bazooka ● Galliano
Japanese trash:
the best rubbish
in the world

Photo Jamie Morgan/Ray Petri

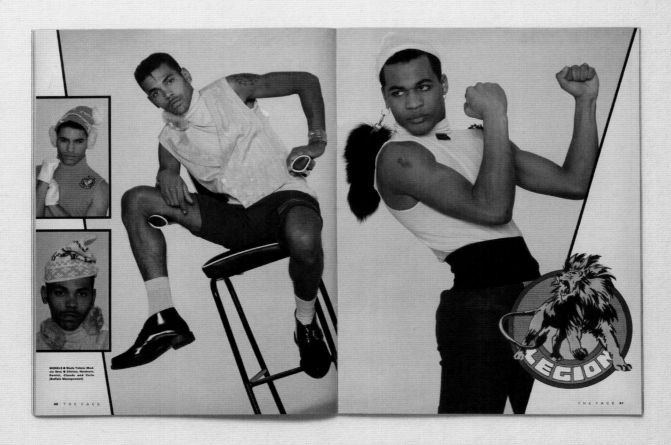

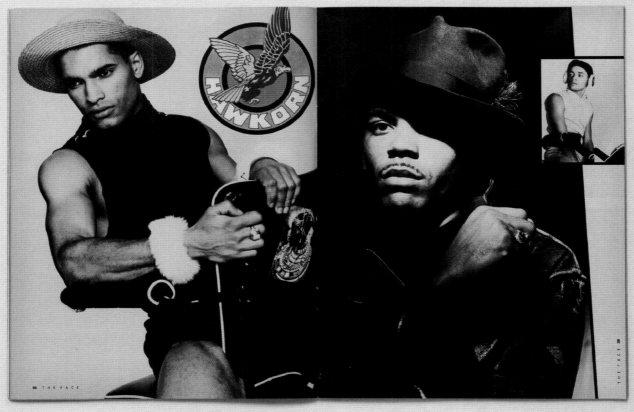

opposite
No. 62, June 1985.

above and overleaf
'Float Like a Butterfly Sting Like a Bee...', No. 62.

36 THE FACE

Chapter Six

New England

The late summer of 1985 witnessed the splintering of the tight-knit editorial team of staffers and freelancers that had underpinned the growth of *The Face* over the previous three years. Lesley White was recruited to the deputy editorship of the new British version of fashion magazine *Elle* by Sally Brampton, who had exited her post as fashion editor of the Sunday newspaper *The Observer* to oversee the launch on behalf of French owner Hachette. In turn, White corralled Robert Elms and Tony Parsons as monthly contributors when the magazine debuted that November.

'British *Elle* was pretty much *The Face* for women,' opines Elms.[1] His view is confirmed by journalist Kathryn Flett – later to become fashion editor at *The Face* – who claims that 'alongside *The Face*, British *Elle* arguably helped define the look of the 1980s'.[2] White points out that Hachette stipulated the template

above
No. 65, September 1985.

right
'Ecstasy, a Yuppie Way of Knowledge', no. 66, October 1985.

was to be the French parent magazine, though the new title projected an attitude imbued with the editorial values expressed at her alma mater. 'The game was to push it away from the French model by making it modern and British,' says White, who recalls an early planning meeting with Brampton. 'I told Sally I thought we should avoid features on "emotional" issues *á la Cosmopolitan* and she eventually agreed.'

For the twenty-five-year-old White, her joy at the career opportunity this offered was tinged with sadness: 'There was a part of me that didn't want to leave Nick and Julie because the situation there was totally unique in publishing terms, more like a family.'[3]

The magazine, meanwhile, maintained its edge with the publication of the first serious media treatment of the growing popularity in Britain of Ecstasy, then known by its formula MDMA. Written by contributor Peter Nasmyth, the piece – headed 'Ecstasy: A Yuppie Way of Knowledge' – positioned this as a 'designer drug' and most definitely not one for casual consumption. 'We got to hear about it through ad guys working at the big agencies,' says Paul Rambali, who commissioned Nasmyth's feature. 'They were all bringing it back from New York and using it.'[4]

Perceptions of the publication's position as signifier of ultimate cool came with the unveiling on Boxing Day in 1985 of the advertising agency Bartle Bogle Hegarty's (BBH) campaign for Levi's jeans. This hinged on a TV commercial starring Buffalo model Nick Kamen disrobing to his white Sunspel boxers in a steamy 1950s-style laundrette. Cut to Marvin Gaye's 'I Heard it through the Grapevine' (which was reissued in a sleeve featuring the Levi's logo and became a chart hit), the mise-en-scène created by director Roger Lyons appeared to have leapt from the pages of *The Face*. Kamen himself could be seen perusing a copy of the magazine as the advert faded.

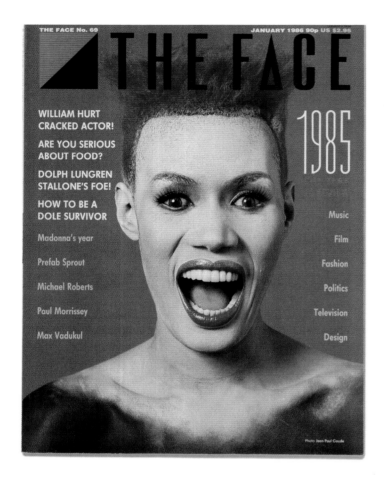

magazine's pages in recent years, Knight had concentrated on collaborating with fashion editor Simon Foxton at *i-D* and Iain R. Webb at *Blitz* before being recruited by world-renowned art director Marc Ascoli to work in Paris as photographer for Japanese designer Yohji Yamamoto.

Robin Derrick – who knew Knight and Foxton from his time at *i-D* – had suggested they produce the shoot. 'Robin and I got on very well,' said Knight. 'He likes to think his fashion stories through journalistically and thought our approach would be the right one.'[6]

Together, the team realized one of the most eye-popping of the magazine's 1980s fashion stories, with aggressive use of lurid colours and photo-manipulation, to match the confrontational nature of the original punk designs of Malcolm McLaren and Vivienne Westwood. The session remains one of Knight's favourites, not least since it afforded the opportunity to date the cover model (they had known each other as college students), but also because it gave he and Foxton the chance to 'rework the codes of punk and try to produce a new type of photography' (see opposite and pages 148–51). As Knight, who had applied the saturated colours in tribute to Warhol screen-prints, recalls: 'It could have gone very wrong because there

The brainchild of BBH's John Hegarty and Barbara Noakes (the former being a particularly ardent fan of *The Face*), the campaign's print element encompassed double-page spreads in Logan's magazine, since BBH's task was to stimulate interest in the brand among fifteen- to nineteen-year-olds, *The Face*'s core readership. And the conceit worked: there was a subsequent run on sales of Levi's 501s, with demand increasing by a reported 800 per cent.[5]

Soon *The Face* was investigating its roots in punk with a tenth-anniversary feature in the February 1986 edition, focusing on the magazine's covers to date. This issue also included an essay by Jon Savage and a fashion story photographed by Nick Knight. Although his work had occasionally appeared in the

above
No. 69, January 1986.

right
No. 68, December 1985.

opposite
No. 70, February 1986.

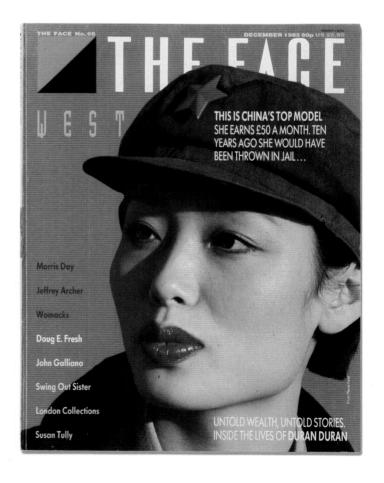

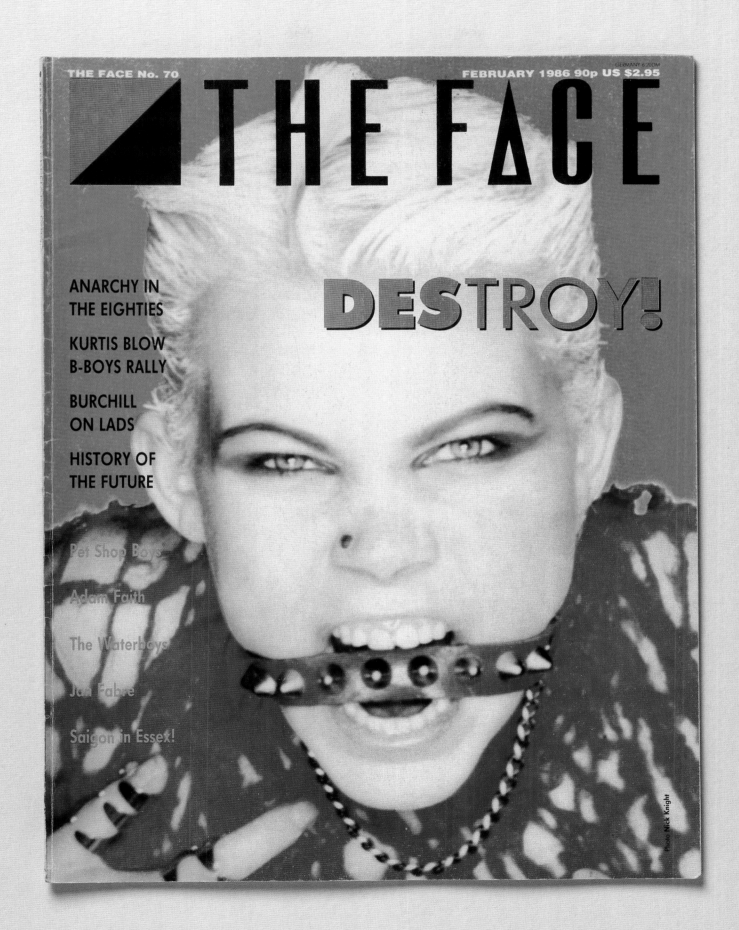

THE FACE No. 70

GERMANY 6.20DM

FEBRUARY 1986 90p US $2.95

THE FACE

DESTROY!

ANARCHY IN
THE EIGHTIES

KURTIS BLOW
B-BOYS RALLY

BURCHILL
ON LADS

HISTORY OF
THE FUTURE

Pet Shop Boys

Adam Faith

The Waterboys

Jan Fabre

Saigon in Essex!

Photo Nick Knight

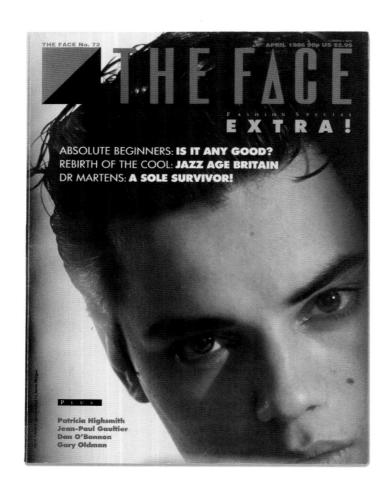

supplied by catwalk specialists including Mark Mattock and Niall McInerney. These appeared as supplements in the magazine (which was still without a designated fashion editor).

'Around that time I was sent a ticket numbered 1A for a John Galliano show,' recalls Derrick. 'The organizers tried to tell me that I was occupying a seat for *Vogue* until they realized that he had given the front row to us, *i-D* and *Blitz*, the street mags that had supported him since the beginning.'

The international buzz around British style was reaching new heights in the spring of 1986. With a record attendance of visitors, including 9,000 from overseas and the Princess of Wales and Margaret Thatcher, the long queues and crowded conditions represented 'a remarkable turnaround for a city which five years previously had been a lost cause as a fashion centre', according to academic Catherine McDermott.[8]

That summer, *The Face*'s monthly circulation was approached 85,000 copies (this included overseas sales in twenty countries of more than 20,000). 'It is widely read and widely imitated in art schools and advertising circles alike', reported the *Architectural Review*.[9]

Meanwhile, Logan was developing his plan to publish a companion men's title he had been turning over in his mind since the earliest days of *The Face*. Titled *Arena*, Logan's aim had initially been for the new magazine to hinge on sport (hence its name) but the content was redirected to focus on fashion to serve British male readers over the age of twenty-five. 'I thought we had a chance – no more than that – to prove wrong the publishing dictum that men didn't buy magazines unless they were hobby-based,' said Logan, who describes a successful general-interest publication targeting men as 'the holy grail' of British publishing at that time. Yet Logan was ever wary, and planned to test the market with a single issue and walk away if it tanked. However, distributor Comag cautioned that the news

was a spontaneity to it. We did most of our casting by spotting likely candidates on the tube and Simon was doing things like accessorizing outfits with chicken's feet – it was a great day.'

The cover was achieved by re-photographing the image from a slide projected onto a wall. 'That gave it a certain flatness, a poster-like quality that made it more monumental than if we had simply gone with the original,' says Knight. 'These were techniques that were heading towards Photoshop. In a way we were looking to create a new visual language; that came to fruition ten years later and into the digital age.'[7]

As well as art-directing the magazine, Derrick produced reports from London's seasonal fashion shows with photography

above
No. 72, April 1986.

right
'London Collections', no. 73, May 1986.

opposite
Arena, no. 1, winter 1986/87.

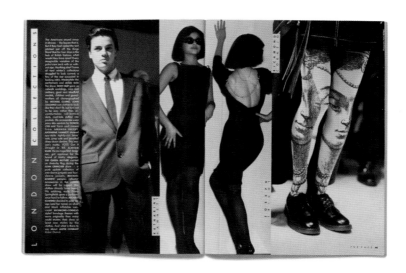

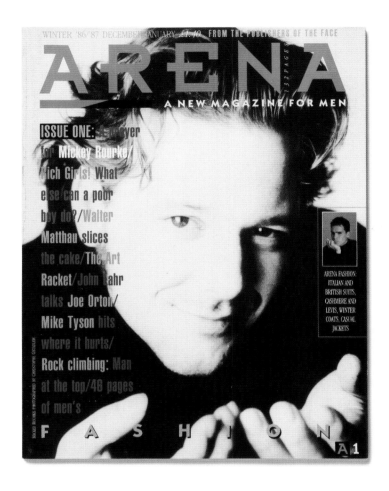

trade would not support such a proposition so Logan committed Wagadon to a quarterly.

Steve Taylor had been brought on board to contribute to the editorial content of *Arena* with Neville Brody to work on the design. 'We spent a year going through the options and trying out different approaches', says Taylor. 'Just like Nick had told me in 1980 that *The Face* was to pick up the readers who had left the *NME* behind, then *Arena* was supposed to appeal to those who had outgrown *The Face*.'[10]

'It was a sensible move, particularly since Paul Smith had become a good friend of Nick's and they were always talking about the fact that there were no decent men's magazines,' adds Lesley White. 'There was a mutual admiration and inspiration between them which I think drove some of the ideas for *Arena*.'[11]

The new magazine was tailor-made for the likes of Smith, who had been a supporter and advertiser in *The Face* but not necessarily a shoo-in for editorial coverage. 'I remember Paul asking me: "What do I have to do to get in there?",' said Logan. 'Katharine Hamnett and Vivienne Westwood were OK but I didn't see where he belonged, even though I did once act as stylist with Chalkie Davies shooting still-life shots of clothes I'd selected from Paul.'

Smith was, however, a perfect fit for *Arena*, as were 'grown-up' contributors including the journalist and author Gordon Burn, the gifted Pat Sweeney and his namesake John Sweeney, now a stalwart of BBC news and documentaries.

Another factor persuaded Logan to take the plunge. 'Apart from sensing the time was right, there were a number of other reasons, not least that Neville was starting to talk about moving on, and that unsettled me,' says Logan. 'I hoped he could see a more mature magazine as a new challenge and part of his development.'

Logan also understood the messages that signs of growth broadcast to media-watchers. 'That might involve *The Face* format changing from stitched to perfect-bound [as had happened with the publication of the October 1985 issue], new and improved office space or new equipment freshening things up for me as much as the staff. In this case it was a companion title.'[12]

The plans for the new magazine coincided with a move to bigger premises in a building known as the Old Laundry in Marylebone, north of Oxford Circus. These were located by estate agent David Rosen, who had happened upon *The Face* crowd when he dropped in at Mortimer Street to buy a subscription for his girlfriend.[13]

'The Old Laundry represented what *The Face* was about at that time, because there were no walls apart from an office where *Arena* was produced', says Sheryl Garratt, by now a regular contributor who had published her first book – *Signed, Sealed, Delivered: True Life Stories of Women in Pop* (1984) – the previous year with arts writer Sue Steward.[14] 'That meant there was a free exchange of ideas when you went in there, with everybody pitching in.'[15]

Robin Derrick recalls photographer Juergen Teller visiting The Old Laundry when he first arrived in London from Germany. 'He'd come to England to avoid national service and used to sit in the office waiting for me to get that day's layouts on the bike at 5pm. Then we'd go through what he had to show me, which was sometimes just one picture.'[16]

Deeply engaged in the preparations for *Arena*, Nick Logan maintained his editorship of *The Face*. 'Nick would go for lunch every day to the local Italian with Rod or the greasy spoon with Neville, so was always on top of things,' says Derrick. 'He would read and sub the copy and paid particular attention to the "furniture", working with Paul [Rambali] on the features, updating the back issues page, putting together the contents and all the nuts and bolts which make a magazine. Nick always handled that "strictly no go Jack" information box. He's not a fashion archetype, given to shouting his mouth off about his achievements, but we knew he was there for us and consequently someone you'd go to the ends of the earth for.'

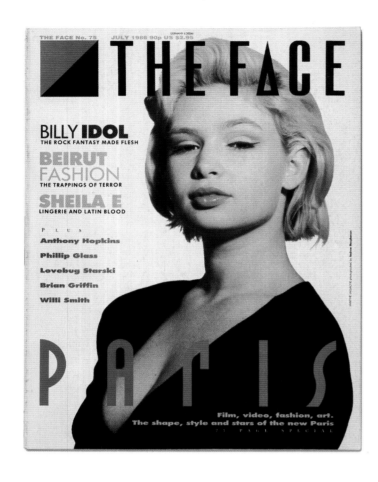

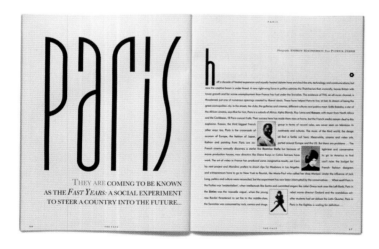

top
No. 75, July 1986.

above
'Paris', no. 75.

In time, Derrick contributed pieces about London's underground nightlife scene with Logan's encouragement. 'I'll always remember Nick picked up on the fact that I was going out and dancing at clubs like Heaven and Taboo, and he urged me to write about it', says Derrick. '"You're the subject of the magazine," he said to me. "If you think a club is great then you should write about it." I didn't realize until later that I was there to do that sort of thing as well as design the magazine.'[17]

The first issue of *Arena* was published in autumn 1986, and attracted considerable media attention, including a half-hour documentary made by the capital's TV broadcaster LWT for its programme *South of Watford*,[18] presented by Hugh Laurie, who had recently broken out of the alternative comedy circuit. Logan was initially resistant to LWT's overtures, the embarrassment of the Wogan appearance still fresh in his memory. 'But it would have been foolish to pass up the publicity', says Logan, who insisted on a precondition that he would be filmed at his desk on the office mezzanine level in conversation with Laurie if the camera was situated several feet away on the ground floor. he filmmakers agreed.

The launch of *Arena* marked a turning of the corner for Neville Brody, who was installed at the new magazine as art director, having decided 'some of the hysteria should be taken out of the contemporary design by adopting a very straightforward, informational approach, using Helvetica for headlines.' In effect, as design writer Emily King later wrote, Brody went minimal.[19]

One of Brody's last covers for *The Face* was for the July 1986 issue, which included a twenty-page special on the latest developments in design, fashion, music and media in Paris and featured an Andrew Macpherson portrait of French model, designer and club-runner Marthe Lagache. Brody said later he was aiming 'to reach a point of maturity. I was looking at all the designs and wanted to refine them into a new language.'[20] Robin Derrick, working with Ian 'Swifty' Swift on the design of *The Face* as Brody occupied the position as group art editor, began adapting the layouts and introducing elements such as decorative flourishes 'to be different from Neville'.[21]

According to English academic Alex Seago, Derrick's work in this period expressed the country's Postmodern sensibility as foregrounded by the group of designers trained at the Royal College of Art in the late 1950s and early 1960s. In particular, Seago has pointed to the links between Derrick's layouts for the August 1986 issue for New England, a Nick Knight photo-essay celebrating class and ethnic diversity in Britain and the 'emergence of a distinct mentalité at the RCA', as communicated by the 1964 issues of the college's student magazine *ARK*.[22]

New England

Meanwhile, the September 1986 'Hell's Angels' cover shoot (see pages 156–57) by Eamonn J. McCabe was art-directed by Derrick and styled by Stephen Linard, one of the Blitz crowd who had featured in Robert Elms's 'The Cult with No Name' article in issue 7 (see pages 50–51). 'When I was at St Martins, Stephen was one of my early heroes of street fashion, so I thought it would be great to get him to style the story,' says Derrick.[23] This coincided with the publication of *Arena* with actor Mickey Rourke on the cover. The new launch further focused *The Face*, not only by siphoning off male readers over the age of twenty-five but in Logan's encouragement of the likes of Chalkie Davies and his partner Carol Starr, Robert Elms and Tony Parsons to dedicate themselves solely to the new title.

Elms was in any case ready to move on. Having taken a year out in Spain in 1985 to write his novel *In Search of the Crack*, he returned to find London and *The Face* changed.

'I didn't like hip-hop, so there were sections of the magazine that weren't part of my world, and the minute the first inklings of acid house started to emerge I could see that my time was up,' says Elms. 'I was only twenty-six but felt that I wasn't at the cutting edge any more.'

For Elms, the end of his association with youth culture came one night in Soho's Wag club – 'I can tell you what I was wearing: a Gaultier suit, Margaret Howell shirt, painted tie and a pair of Oliver Sweeney shoes' – and at a new club called Shoom, located in a derelict area south of the River Thames, suggested by his friend, club-runner and hairdresser Spike Denton. 'We arrived in all our finery and everyone was dressed in pastels, off their heads and dancing to a U2 song spliced with something else. I could see that this was one step away from staggering around in muddy fields and knew it wasn't for me.'[24]

The exodus of such long-standing contributors to *Arena* made way for a new generation of writers, including the person who would in time succeed Logan as editor of *The Face*, Sheryl Garratt. Among her standout submissions around this time was a piece on the growing phenomenon of house music, based around a visit to the tough neighbourhoods of Chicago where the sound was being developed by pioneers such as DJ Frankie Knuckles. This was occasioned by a press trip to mark the release of the compilation of music from the house label DJ International.

Headlined 'Sample and Hold', Garratt's article incorporated front line reportage, from the recording of a Marshall Jefferson house anthem in a Southside studio to the activities of local radio stations and the scenes of mayhem in the clubs. 'Having flown a bunch of press out there, London Records took us to the DJ International offices, which was full of white businessmen, and then set up interviews in a hotel with the people who appeared on the record,' says Garratt.

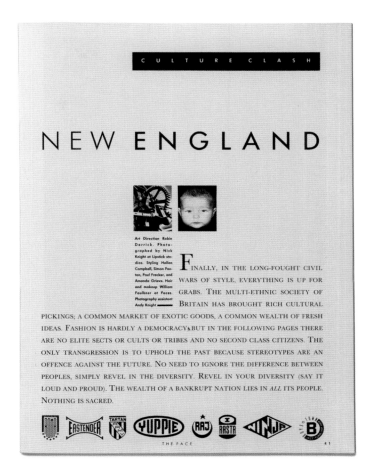

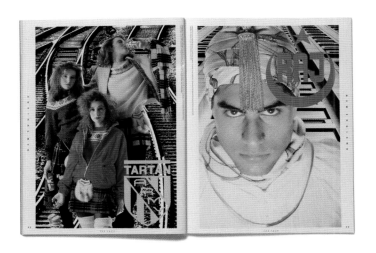

above
'New England', no. 76, August 1986.

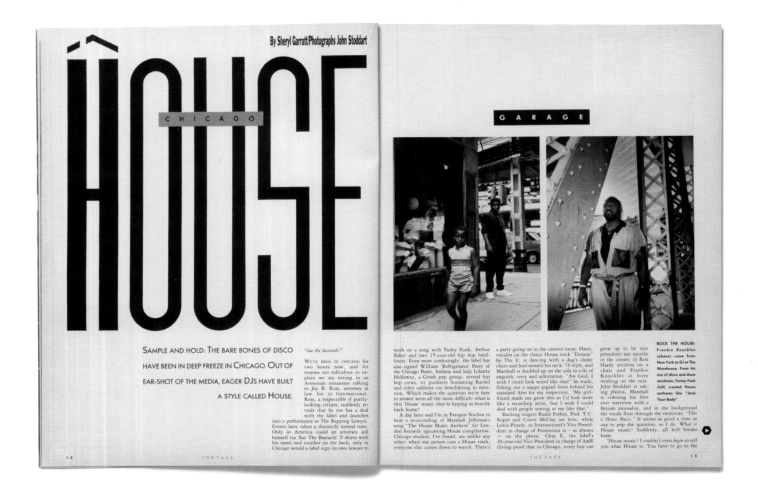

By Sheryl Garratt/Photographs John Stoddart

HÔUSE

CHICAGO

GARAGE

SAMPLE AND HOLD: THE BARE BONES OF DISCO HAVE BEEN IN DEEP FREEZE IN CHICAGO. OUT OF EAR-SHOT OF THE MEDIA, EAGER DJS HAVE BUILT A STYLE CALLED HOUSE.

"See the bastards!"

WE'VE BEEN IN CHICAGO for two hours now, and for reasons too ridiculous to explain we are sitting in an Armenian restaurant talking to Jay B. Ross, attorney at law for DJ International. Ross, a respectable if portly-looking citizen, suddenly reveals that he too has a deal with the label and launches into a performance as The Rapping Lawyer. Events have taken a distinctly surreal turn. Only in America could an attorney sell himself via Sue The Bastards T-shirts with his name and number on the back; only in Chicago would a label sign its own lawyer to

work on a song with Farley Funk, Arthur Baker and two 15-year-old hip hop hardliners. Even more confusingly, the label has also signed William 'Refrigerator' Perry of the Chicago Bears, Indiana soul lady Loleatta Holloway, a Greek pop group, several hip hop crews, ivy punkette Screaming Rachel and other oddities too bewildering to mention. Which makes the question we're here to answer seem all the more difficult: what is this 'House' music they're hyping so heavily back home?

A day later and I'm in Paragon Studios to hear a re-recording of Marshall Jefferson's song 'The House Music Anthem' for London Records' upcoming House compilation. Chicago studios, I've found, are unlike any other; when one person cuts a House track, everyone else comes down to watch. There's

a party going on in the control room: Harri, vocalist on the classic House track 'Donnie' by The Jr, is dancing with a dog's-choke chain and lead around his neck '76 style, and Marshall is doubled up on the sofa in a fit of anguish, envy and admiration. "Aw God, I wish I could look weird like that!" he wails, fishing out a nappy pigtail from behind his standard Afro for my inspection. "My girlfriend made me grow this so I'd look more like a recording artist, but I wish I could deal with people staring at me like that."

Backing singers Rudir Forbes, Prof. T.C. Roper and Curtis McClay are here, while Lewis Pitzele, DJ International's Vice President in charge of Promotion is — as always — on the phone. Chip E, the label's 20-year-old Vice President in charge of A&R (living proof that in Chicago, every boy can

grow up to be vice president) sits quietly in the corner; to Ron Hardy revolves on a chair and Frankie Knuckles is busy working on the mix. John Stoddart is taking photos, Marshall is videoing his first ever interview with a British journalist, and in the background the vocals float through the monitors: *"This is House Music.* It seems as good a time as any to pop the question, so I do. What is House music? Suddenly, all hell breaks loose.

"House music? I couldn't even *begin* to tell you what House is. You have to go to the

ROCK THE HOUSE: Frankie Knuckles (above) come from New York to DJ at The Warehouse. From his mix of disco and drum machines, Farley Funk (left) created House anthems like **"Jack Your Body"**

THE FACE 18

THE FACE 19

'I felt deeply unsatisfied; this was about music which came out of a club scene. Why were we in a hotel? I told Frankie Knuckles that I wasn't getting the goods and he arranged to meet me at an address at midnight.... The rest of the journalists went for dinner and I slipped away. After arguing with about ten cabbies who refused to take me to the street corner he had mentioned, I got there and waited. I was on my own, in an obviously rough area, had signed up to meet a complete stranger, a great big bear of a man at that, and nobody knew where I was. Then a car screeched up, and Frank got out, shouting "Girl, we're gonna have such fun!" and I realized that I was in safe hands, because a) he was gay and b) he was the nicest man in the world.'

Knuckles took Garratt around Chicago's nightclub circuit, ending at the Muzic Box where the late legendary DJ Ron Hardy was playing a set: it is at this short-lived venue that dance aficionados believe house music was created. 'As far as I know I was the only journalist who ever went there and saw him DJ',[25] says Garratt. 'It was all-male and obviously I was the only white person there. It was an extraordinary place. I was so fired up when I wrote that piece.'

The status of Logan's magazine was such that an approach came from Condé Nast chairman S. I. Newhouse, who offered to invest in Wagadon in return for securing rights to launch a US edition of *The Face*. Logan agreed to discuss the offer on the proviso that James Truman edit the American version.

'Nick and I had a rather eccentric meeting with him at the Condé Nast offices and then over lunch at the Four Seasons restaurant,' says Truman. 'It was fairly obvious that the Condé Nast principals had little idea of why *The Face* was important, but to their credit they knew that it was important. So we discussed lots of arcane details, about frequency of publishing, demographic reach and even paper stock without ever getting to what the magazine could be.' Condé Nast bought a 40 per cent share of Wagadon in return for distribution rights, but the plans for an American edition were never realized.

'Instead Si asked me to join Condé Nast, which was the start of my career there,' says Truman. 'I started working for Anna Wintour, who had just been named editor of *Vogue*.'[26] That this denoted the conservatism within the top echelons of fashion publishing was pinpointed by contributor Sarah Mower, who described Wintour in *The Face* as 'a new broom driving out

what she considers to be the undesirable cobwebs of English eccentricity, nostalgia and lackadaisical diffidence. She is a woman on a "clean-up" mission…the effect on fashion editorial has been mooted as "very right wing".[27]

With secure financial underpinning courtesy of the American publishing group, forthright features such as Mower's enabled *The Face* to maintain pre-eminence by dint of, in the phrase of academic Frank Mort, 'a distinctive discourse…while *i-D* and *Blitz* were not simply "me-toos" or copies, *The Face* remained as the model'.[28]

Yet, in 1987, a sense of innocence was lost, and not only as a result of Margaret Thatcher's third election victory that summer on the back of an economic recovery manifested by falling unemployment and the beginnings of the British property boom (house prices were to double over the next three years). The fortunes of the pop figures *The Face* had championed in the glory years were, at best, mixed: Boy George's life and career imploded as he grappled with heroin addiction and the groups that had dominated the American charts alongside Culture Club, including Spandau Ballet and Duran Duran, were supplanted by homegrown rap and poodle-haired heavy rock.

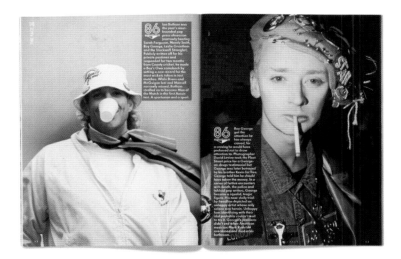

At The Old Laundry, there were changes in staff: freelancer Steve Taylor exited the post of *Arena* assistant editor and the position was formalized with the arrival of full-timer Dylan Jones from *i-D*. Jones's partner Kathryn Flett also left *i-D* to join Wagadon, assuming responsibility for the 'Intro' section from Kimberley Leston, who moved up to features editor.

Leston had been a designer at adult magazine *Men Only* as well as at *Smash Hits* before she joined the staff of *The Face* where she was 'actively encouraged to learn on the job and find her journalistic feet',[29] interviewing the likes of Miami dance music producer Bobby 'O' Orlando and actor Keanu Reeves. The partner of *The Face* music contributor David Toop, Leston was soon to move onto the British launch of the French women's magazine *Marie Claire* before freelancing for nationals and publications including *Arena* until her untimely death at the age of thirty-five in the mid-1990s.[30]

Leston had been elevated on the departure of Paul Rambali, who had joined the *Mail On Sunday*, while Flett's spell as a staff writer at *i-D* had come about when she connected with the magazine's owner Terry Jones and fashion editor Caryn Franklin after a post-school stint working at the Fiorucci boutique in the King's Road.

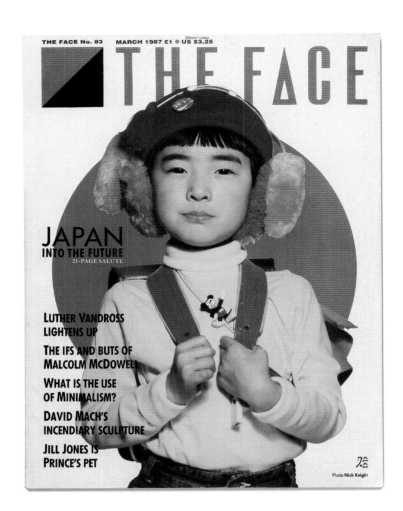

opposite
'Chicago House', no. 77, September 1986.

left
No. 83, March 1987.

above
Features on Ian Botham and Boy George from no. 81, January 1987.

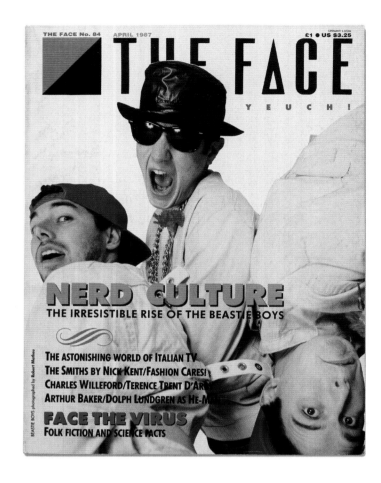

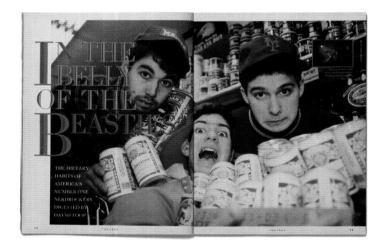

'We all knew and hung out together,' said Flett. 'Robin Derrick mentioned that Kimberley had been promoted so I applied and got the job.'

Flett describes Nick Logan as the *éminence grise* of the magazine. 'Terry Jones taught me how to break the rules of journalism and Nick taught me what the rules were,' she adds. 'I learnt to sub, how to structure a story, all that, when we were spending time at the typesetters in Salusbury Road sending off pages. It was the opposite of glamour.'[31]

Flett was soon given a credit for a cover feature by providing the text for a ten-page fashion story photographed by Carrie Branovan and styled by Paul Frecker in the May 1987 issue. This featured designs produced by Vivienne Westwood with and without Malcolm McLaren over the preceding fifteen years, culminating in the Mini-Crini collection of the year before but nonetheless featured on the front page (see pages 158–61). Its appearance just a year or so after the Nick Knight/Simon Foxton punk cover story, which was also predicated on the McLaren/Westwood collaboration, along with a run of cover features of the established likes of Iggy Pop, David Byrne and Isabella Rossellini, suggested an air of water-treading, reinforced by lead stories about contemporary figures such as the Beastie Boys and the so called 'Brit-pack', which included Colin Firth, Gary Oldman and Tim Roth. While this gave the actors their first substantial group exposure, it was hardly vanguard fare, particularly since they, the Beastie Boys and others featured in *The Face* were by now receiving similar coverage in the national broadsheets, tabloids and Sunday supplements.

In the summer of 1987 Robin Derrick was lured to Italy. 'I was on £11,000 a year at *The Face* and Carla Sozzani called and offered me £72,000 to work on the launch of Italian *Elle*,' said Derrick. 'I didn't realize the cultural footprint of *The Face* until I got to Milan. People were blown away that I had worked there.'[32]

In Derrick's place Nick Logan appointed Phil Bicker on Neville Brody's recommendation. Brody had encountered Bicker when he was producing layouts for *City Limits*. As Bicker recalled, 'Neville, whose work was constantly plagiarized, liked the fact that my work came from a place outside his influence, and hired me to work with him on a magazine prototype, *Vive* for IPC, then to art direct *New Socialist* (the Labour Party's magazine which Brody had redesigned).'[33]

If Brody's reign at *The Face* instituted an upheaval of approaches to graphics and typography, Bicker gradually built over time on the associations Derrick had established to introduce an epoch of exposure of fresh styling talent and experimental photography.

top
No. 84, April 1987.

above
'In the Belly of the Beast', no. 84, April 1987.

opposite
No. 82, February 1987.

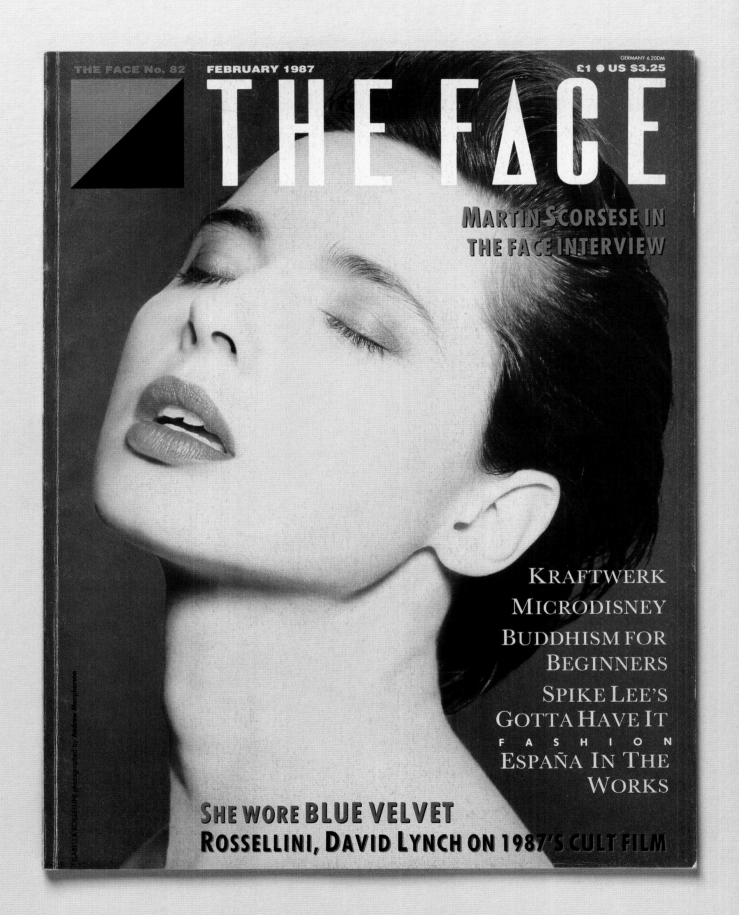

below
'Body Rock', no. 65, September 1985.

opposite
'Holiday Babylon', no. 65.

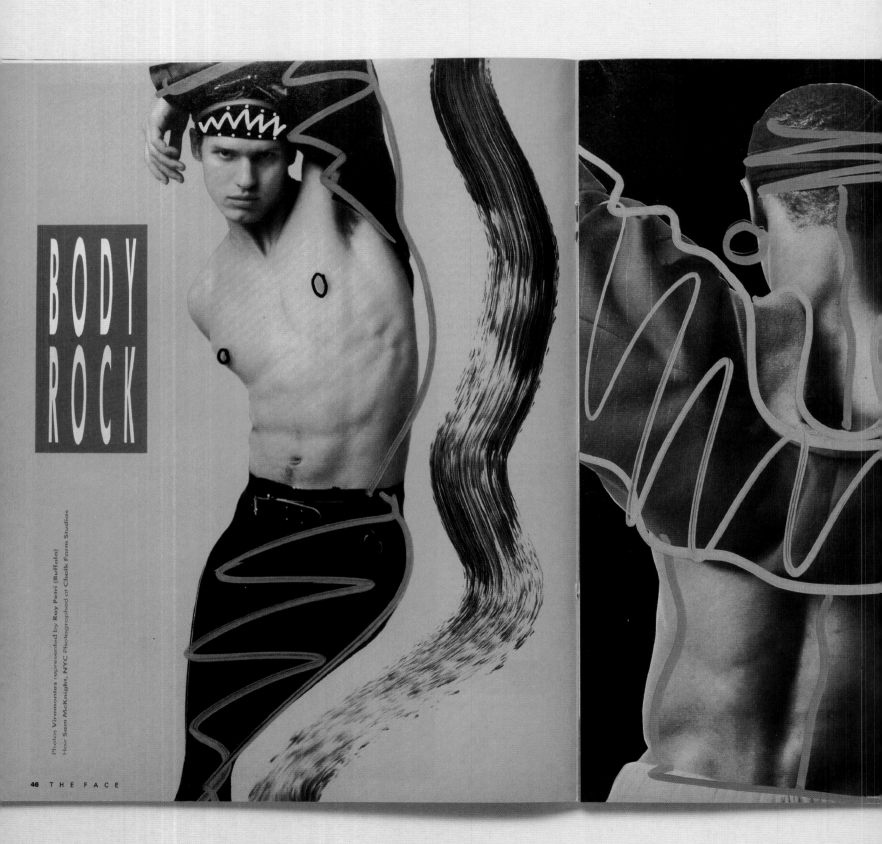

BODY
ROCK

Photos Viaramontes represented by Ray Petri (Buffalo)
Hair Sam McKnight, NYC Photographed at Chalk Farm Studios

46 THE FACE

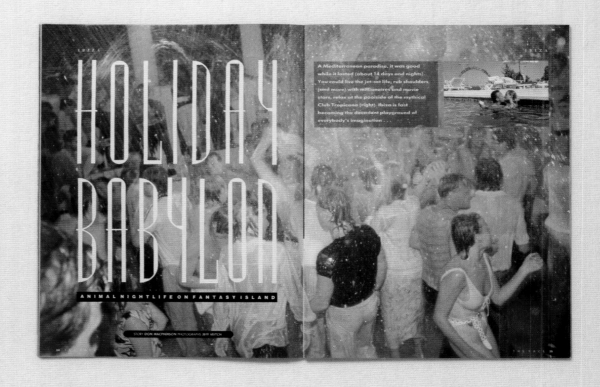

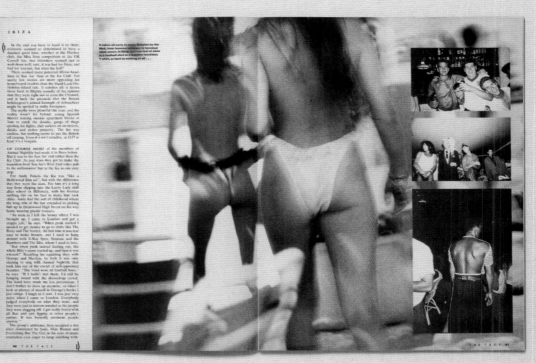

Opposite
Model Mike Hill, Paris Planning
Leather jacket: John Rocha, Floral St,
London WC2, Manchester and
Dublin. Canvas hat: Western Styling,
Kensington Mkt, London W6. Silk
scarf: Harvey Nichols. Belt: Jones,
Kings Rd, SW3. Trousers: Flip.

This page
Model Tony Felix, Buffalo
Jacket: John Galliano at Browns,
South Molton St, London W1.

Page 48
Model Christine Bergstrom, Premier
Hat: Bernstock & Spiers, Sheepskin
jacket: John Rocha as before. Vest:
Claude Montana, Browns, South
Molton St, London W1.

Page 49
Model Mike Hill, Paris Planning
Cap: Bodymap. Silk headscarf:
Harvey Nichols, London SW1.
Canvas jacket: Laurence Corner,
London NW1. Sheepskin jacket: John
Rocha as before.

Page 50
Model Mike Hill, Paris Planning
Wool hat: Millets, various branches.
Jacket: John Rocha as before.

Page 51
Amanda Cazalet, Marco Rasala
Cord jacket: John Galliano, as before.
Black hat: NYC. Net scarf: Fenwicks,
Bond St, London W1. Dress: Azzedine
Aläia, Pour La Maison, Sloane St,
London SW1.

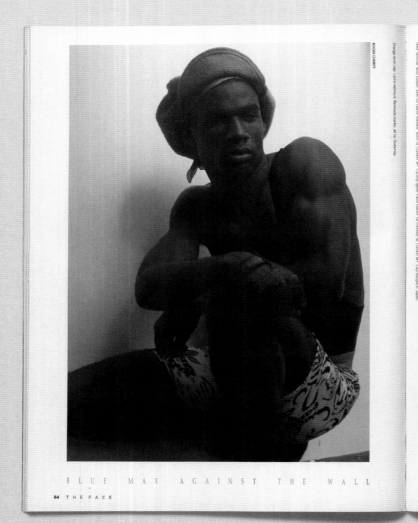

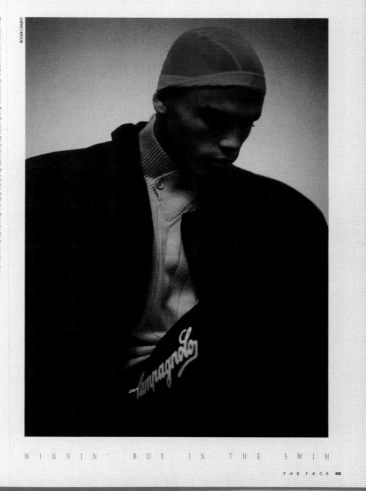

BLUE MAX AGAINST THE WALL

WINNIN' BOY IN THE SWIM

64 THE FACE

THE FACE **65**

above and opposite
'The Cowboy, the Indian and Other Stories', no. 66,
October 1985.

overleaf
'PUNK', no. 70, February 1986.

147

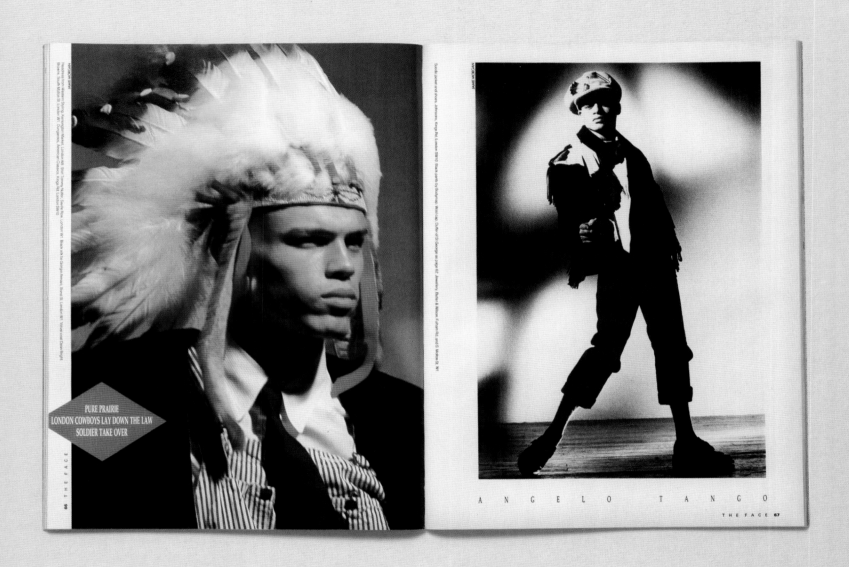

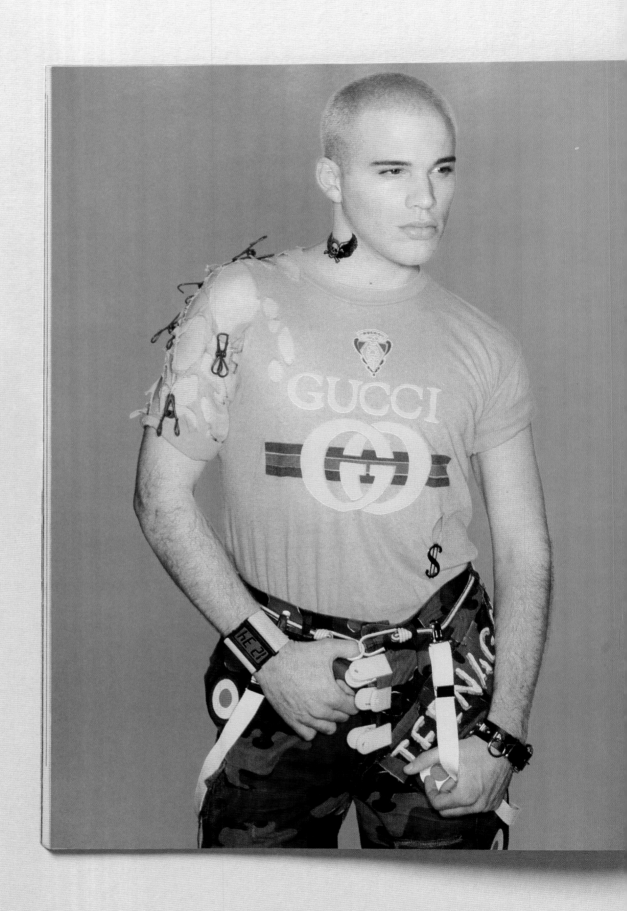

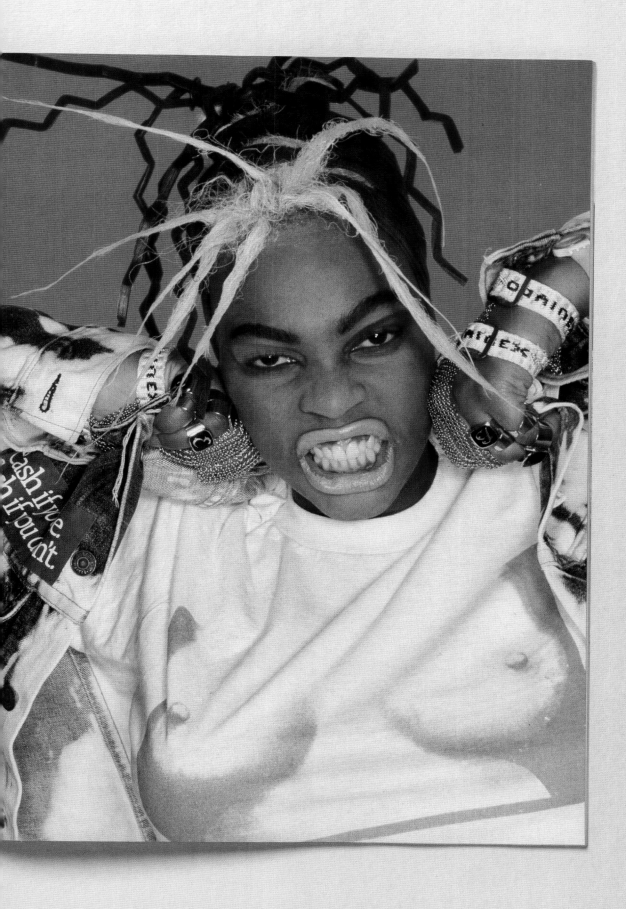

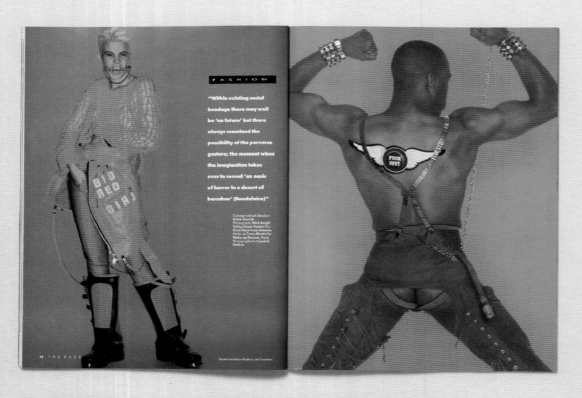

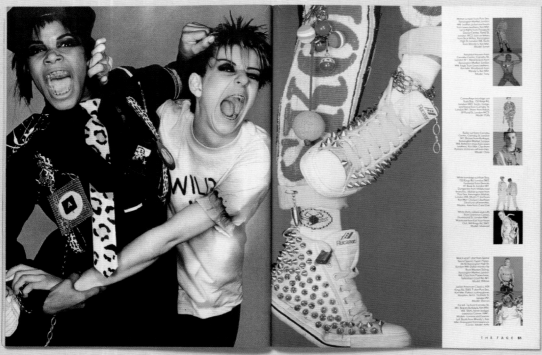

opposite and below
'PUNK', no. 70, February 1986.

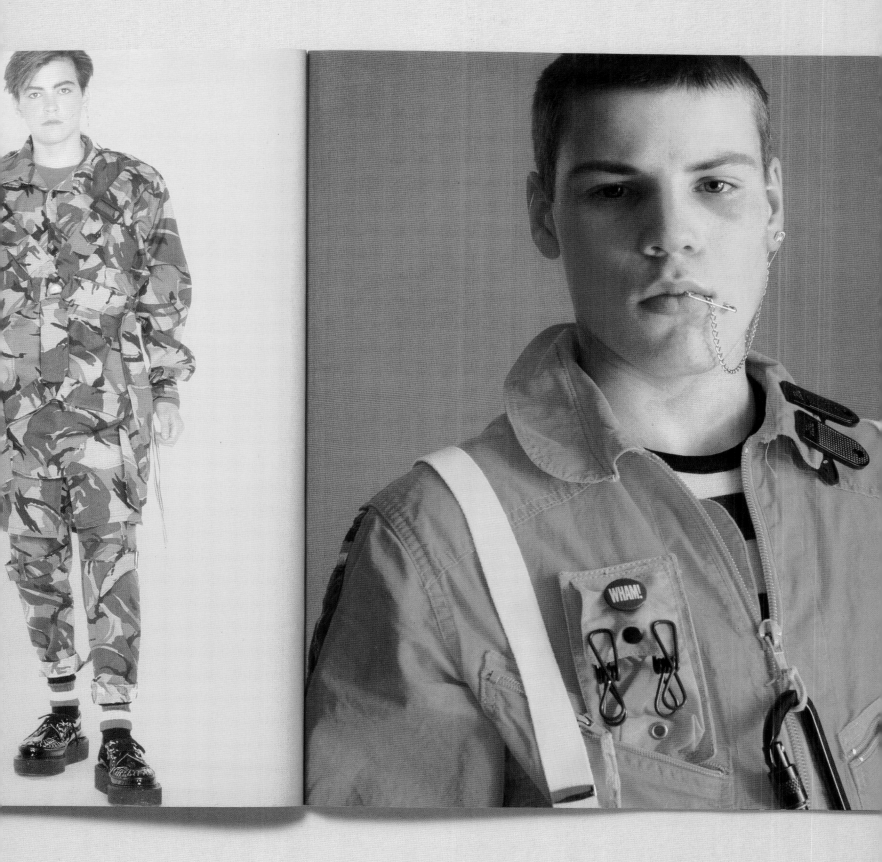

Chapter Six

PARIS

PARIS

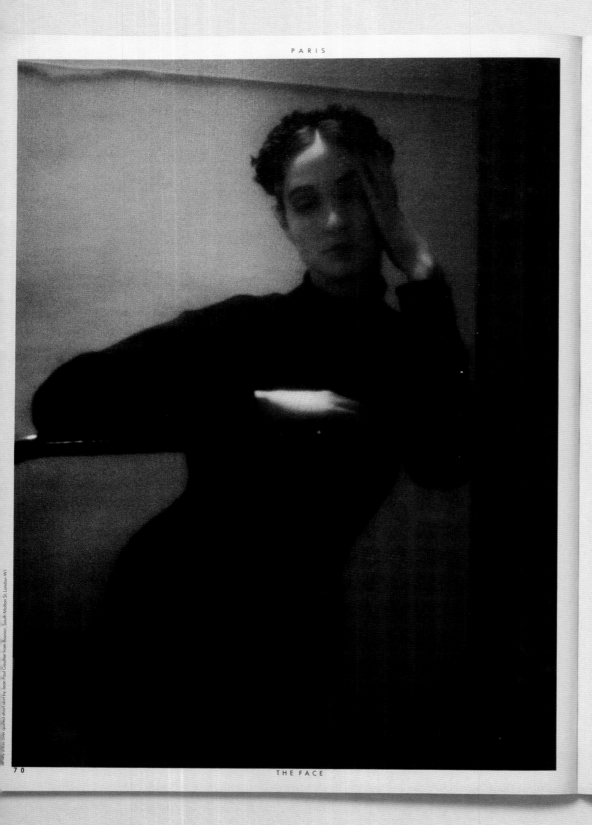

70

THE FACE

THE FACE

Grey, wide-lapel coat over ripped jersey by J.P. Gaultier from Bazaar. South Molton St London W1

71

PARIS : THE LEGACY

MODERN CLASSICS. FOR A MAGAZINE THAT
HAD A SPORADIC EXISTENCE (TEN ISSUES IN 2½
YEARS), THE PARIS FASHION QUARTERLY *JILL* HAD
AN INFLUENCE OUT OF ALL PROPORTION TO
ITS NEWSSTAND PROFILE. UNDER THE EDITOR-
SHIP OF ELIZABETH DJIAN, *JILL* CONSISTENTLY
BROKE NEW GROUND IN PHOTOGRAPHY AND
STYLING WITH A FLAIR THAT SURVIVES THE
ACTUAL MAGAZINE (*JILL* CEASED PUBLICATION
IN SEPTEMBER LAST YEAR).
FOR OUR PARIS SPECIAL WE COMMISSION-
ED ELIZABETH DJIAN TO CAPTURE THE
CITY'S FASHION IN HER INIMITABLE
STYLE: WHAT SHE PRODUCED IS HER VERSION OF THE
CLASSIC PARISIAN THEMES.

Paris

STYLING ELIZABETH DJIAN WITH MIKA / PHOTOGRAPHY ANDREW MACPHERSON /
HAIR SATOSHI FOR MOD5 HAIR – PARIS / MAKEUP STEPHAN MARAIS

PARIS : PEOPLE

Paris WHO SHAPES PARIS
LIFE? EUROSTYLE
TEENS, POST-MARXIST
THINKERS,
STARLETS
AND
STREET
GANGS?
ALL OF
THESE.
AND THE
24 PICTUR-
ED OVER . . .

Choosing 24 people to highlight the
cultural life of the French capital was
a compromise and a surprise. Paris is
a centre of fashion, art, advertising,
comics and film. And, as American-
born actress **Joanna Pavlis** put it,
"culture is so beautifully done here." Working in a foreign language, she also says that the only
thing she can rely on is emotion. It's as good a way as any to read the map of a foreign city;
especially Paris, a city that thrives on passion. The Parisians we photographed for this special
feature all bring their passions to the arts that Paris nurtures. Actors and actresses, writers,
directors, designers, artists, they share a characteristic Parisian sense of the ideology of style,
the debate about beauty, the intellectual rigour needed to discipline that passion. Inspired by
London's street fashion, young designers like Martha Lagache have short-circuited the
establishment. Trained in a vocabulary of images and graphics by the French comics boom of
the Seventies, video- makers like **Caro** and Philippe Gautier produce some of the most striking work in the
field. Actors like Jean-Hughes Anglade talk of allying profundity to spectacle, for a new audience that
wants intelligence and thrills And the one thing they all want? A wider, international audience.

SIDIKI BAKABA

54 THE FACE THE FACE 57

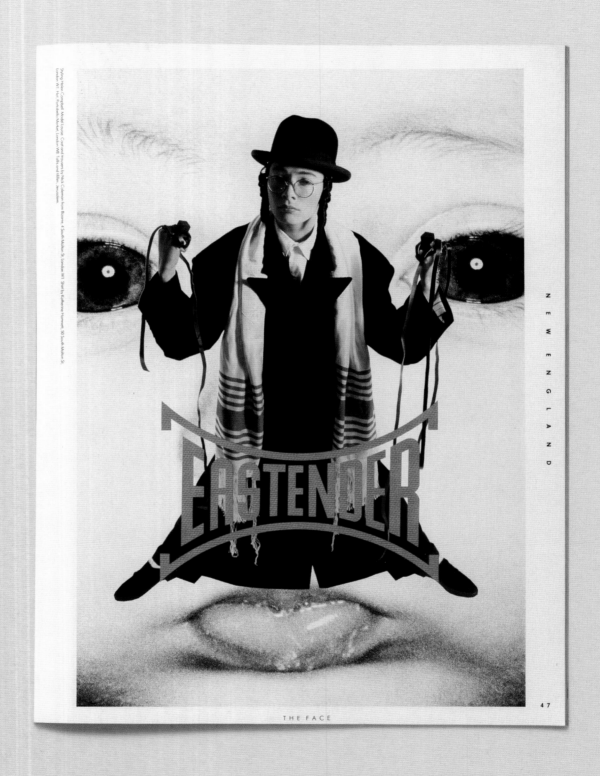

above and opposite
'New England', no. 76, August 1986.

overleaf, left
'Hell's Angels', no. 77, September 1986.

overleaf, right
No. 77.

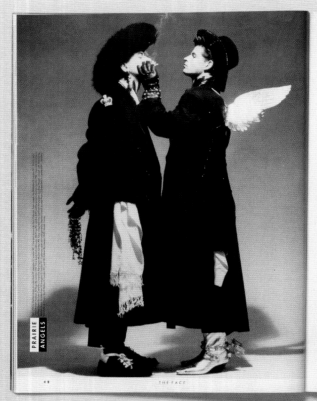

PRAIRIE ANGELS

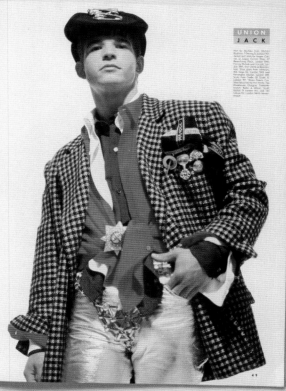

UNION JACK

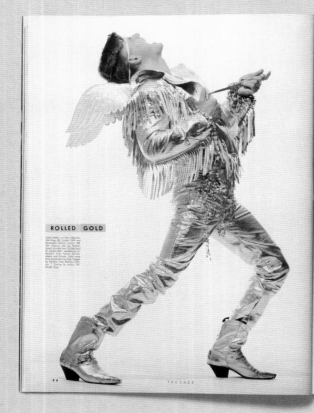

ROLLED GOLD

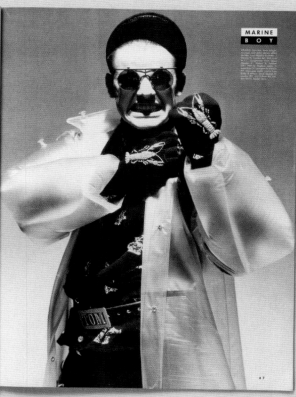

MARINE BOY

THE FACE No. 77 SEPTEMBER 1986 90p US $2.95 GERMANY 6.20DM

THE FACE

FRANKIE
GOES ON HOLIDAY
SCALLYWAGS IN TAX EXILE

CHICAGO
ROCK THE HOUSE
DANCEFLOOR POST GO-GO

BRUCE WEBER
GOES TO RIO

AFGHANISTAN
THE LOST WAR

HELL'S ANGELS

BRITISH MENSWEAR TAKES FLIGHT

Stan Ridgway/The Warehouse Party's Over/Russell Mulcahy's Highlander
Youssou Ndour/Aliens/Photobooth Art/Alberto Vidal

Photo Eamonn McCabe

below, opposite and overleaf
'Vivienne Westwood', no. 85, May 1987.

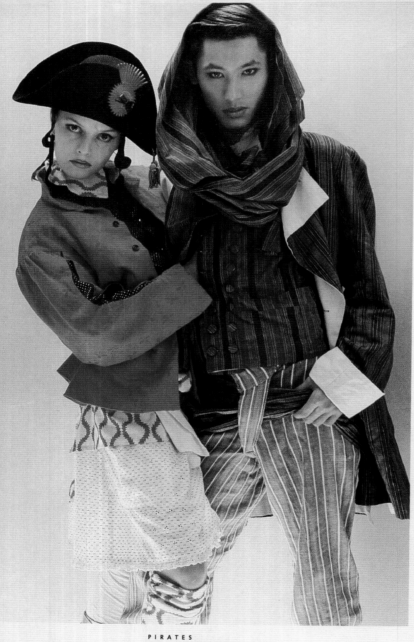

PIRATES
1 9 8 0
A glamorous plundering of the High Seas with dandified frills and a baggy silhouette
in sumptuous colours and fabrics. The classic Pirates collection
now on permanent display in London's V&A museum

5 4

THE FACE

SAVAGES
1 9 8
Oversized garments in rough fabrics with exposed seams
and draped to stunning effect. Japanese designers
were greatly influenced by the shapes but chose mor

THE FACE

VIVIENNE
WESTWOOD

From the schlock rock of PARADISE GARAGE and LET IT ROCK at the birth of the Seventies to WORLDS END via the near-legendary triumvirate TOO FAST TO LIVE TOO YOUNG TO DIE, SEX, and SEDITIONARIES, Vivienne Westwood has occupied a key role in the frontline of fashion. Year after year, whether in tandem with Malcolm McLaren or working alone, she has been a relentless innovator; a fashion visionary with a unique capacity to capture the mood of any particular moment. Her influence on fashion in the Eighties is unparalleled. In 1980 – with Pirates – Vivienne gave the world a style that caught the collective imagination and finally established her as an international designer of substance. Subsequent collections – Savages (1982), Buffalo ('83/'84), Hobos ('84), Witches ('84/'85), and last year's mini-crini – have been plagiarised for high streets from Tokyo to New York and all points between. With her collection for '86/'87, Vivienne has redefined classic British tailoring using traditional wools and Harris tweed. From chicken bones to twinsets, she has more than proved her staying power. On the following pages THE FACE presents a retrospective incorporating 15 years of essential Westwood dressing. Nobody does it better…

CREDITS

1972
Let It Rock

THE FACE

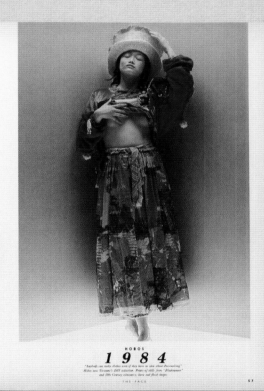

SEDITIONARIES
1977

THE FACE

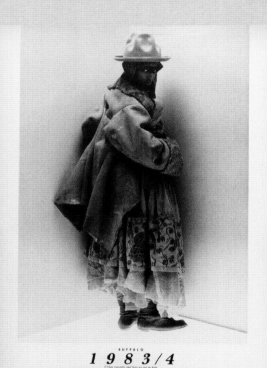

BUFFALO
1983/4

THE FACE

HOBOS
1984

THE FACE

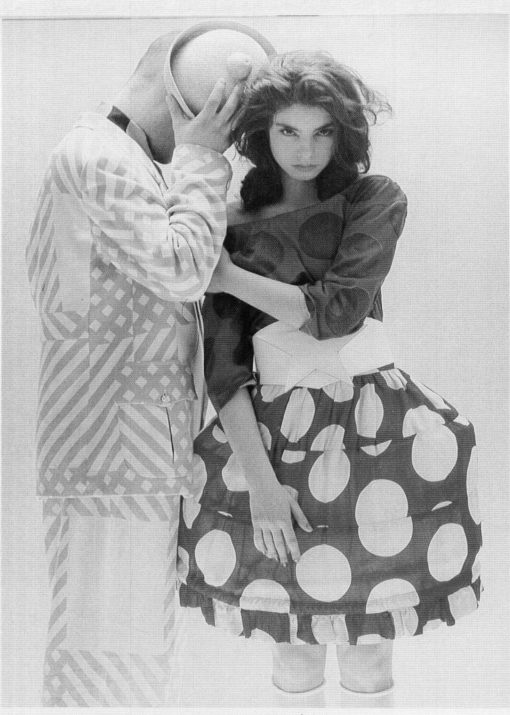

MINI-CRINI
1 9 8 6

Spurned as unwearable when shown in late '85,
the mini-crini has since inspired the legions of puffballs and bubble skirts
currently crowding the high street rails

THE FACE

CRINISCULE
1 9 8 7 / 8

Regal and traditional. Tweeds and twinsets, underwear as outerwear.
Feminine and pastel. The best of classic British dressing
with the typically Westwood cutting edge

THE FACE

6 1

Chapter Seven

From Safe Sex to Acid House

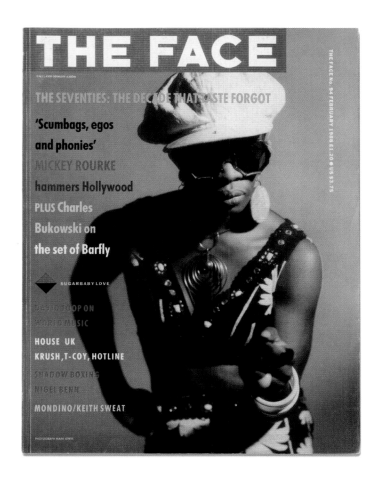

lived in the US for nearly ten years, I no longer felt that their Englishness would translate well to a national US audience, so it became its own thing,' says Truman. 'We were working on various different titles for it when Newhouse called me in one morning and told me that he'd lost faith in *Details* as a viable proposition, and wanted me to take it over and turn it into the new magazine. I hated the idea and argued against it, since what I'd been working on was a completely different sensibility. Also, I liked *Details* and had friends there, and didn't want to be responsible for it being shut down.'

Nevertheless, Truman took on the role at *Details*, where he initially encountered a great deal of opposition, not least from the staff it was his job to replace and as well as those readers unhappy with the content switch to lifestyle.

'Quite understandably, the readers of the old *Details* absolutely hated the new *Details*,' he recalls. 'The first six months of it were a disaster, since we quickly lost all the old audience and it was slow going to build a new one.'[1]

Although Truman still feels the title was 'a liability, and not a good name for my magazine', there is no doubting the commercial and editorial success of the formula he introduced at Newhouse's urging. Infused with *The Face*'s core values – accessibility and a finely-honed approach to the latest

In 1988 James Truman's name still appeared on *The Face* masthead as American editor, but he was in fact dedicating most of his time to contributing to Anna Wintour's editorial direction at US *Vogue*. This came to an abrupt end when Condé Nast snapped up New York's *Details* magazine from venture capitalist Alan Patricof (who had himself acquired the title from founder/editor Annie Flanders a year previously).

'Si Newhouse called me to his office and said they were revisiting the idea of a US edition of *The Face*, but they wanted it to be geared toward men, as a younger, hipper *GQ*,' says Truman, who took an office at Condé Nast's New York headquarters with fellow Englishman and *Vogue* creative director Derek Ungless. Here the pair set about, in Truman's words, 'dreaming up a new men's magazine'. 'It certainly shared some elements with *The Face*, and obviously also *Arena*, but having

above
No. 94, February 1988.

right
No. 96, April 1988.

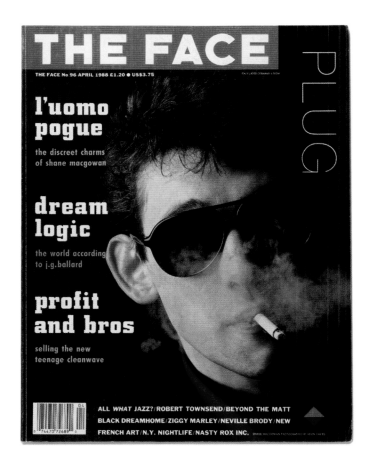

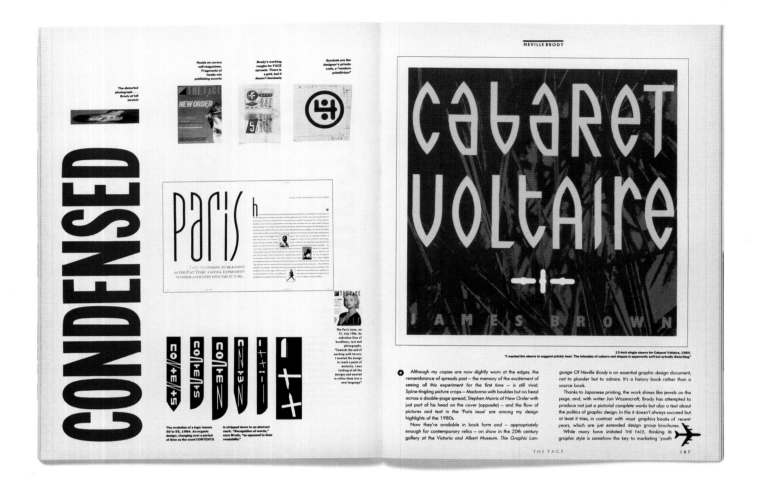

developments in popular culture – *Details* went on to become one of the most prominent American men's magazines of recent times, eventually ceasing publication in 2015.[2]

In London, in the spring of 1988, the work of Wagadon's group art director was celebrated by Jon Wozencroft's monograph *The Graphic Language of Neville Brody*, published to coincide with a month-long exhibition of the thirty-one-year-old designer's work at London's Victoria and Albert Museum. The book and show were tilted heavily to the years Brody had spent at *The Face* from 1982 to 1986 and marked by a five-page feature in the April 1988 issue written by *Blueprint*'s Simon Esterson (subsequently a contributor to *Domus* and *The Guardian* and since 2008 co-owner of graphic design magazine *Eye*): 'While many have imitated *The Face*, thinking its graphic style is somehow key to marketing "youth culture", none succeeded because Brody's design approach is fragile, held together only by the temperament of its originator. It's an individual vocabulary of typefaces, graphic symbols and even illustration, each projecting a combination of emotion, the brief and a bombardment of personal graphic obsessions.'[3]

The same issue featured the ten-page fashion story 'Alex Eats', photographed by Anthony Gordon and styled by Katy Lush. This has since entered the conversation in academia about the objectification – or, more accurately, the 'abjectification' – of women as well as issues around corporeality and relationships with food, featuring as it does the model Alex Arts in a number of gustatory contexts around London: guzzling a hamburger in Ed's Easy Diner, smeared in dough at Evering's beigel shop in Brick Lane, handling raw meat in Smithfield Market, caked in cream in a convenience store and even sitting on the lavatory in Soho's Maison Bertaux.

'As she moves from one locale to another a loose narrative based on anorexia-bulimia also seems to unfold, and the model's fetishistic involvement with food is graphically portrayed,' British academic Paul Jobling has written. 'Little was said at the time of publication about the shoot's anomic

above
'Condensed: A Lesson in Typography', no. 96, April 1988.

opposite
'Voici Paris', no. 98, June 1988.

topography or abject treatment of the female body. Indeed, the vast majority of *The Face*'s street-wise readers appeared to be neither offended nor impressed by the feature. The piece was facetiously subtitled "Fashion Offensive – Glutton Dressed as Glam" but only two letters of complaint against it were published in the following month's issue of *The Face* – one of them berating the style of the photographs ("we can no longer see what is being modelled"), the other for their ostensibly immoral parodying of anorexia and bulimia.[4]

'Alex Eats' was one of the early stories overseen by the magazine's new fashion editor, Kathryn Flett. Her appointment confirmed that, at last, a recognizable personnel structure was forming; for example, Logan's son Christian, by now in his early twenties and contributing ideas from his circle of young club-goers and fashionistas, was running the front desk and would soon assume responsibility for the accounts.

'I was very conscious that I was the first fashion editor of *The Face*,' said Flett. 'Of course the real fashion editor of *The Face* was Ray Petri but he was never given a title, nor would he have probably wanted one.' According to Flett, the realization had hit that defining the role would enhance the magazine's position as a serious outlet for fashion advertising.

Flett experienced, in her own words, 'a very steep learning curve', particularly after a press trip to Tuscany for a launch by Valentino Garavani of the latest denim range within his sub-brand Oliver (named after the designer's pug). 'I probably lost *The Face* and *Arena* a year's worth of advertising,' she confesses cheerfully. 'I was flown to Lucca, put up in a Renaissance square, taken out on yachts and had quite a time. Then, when I got back I received the call from the Valentino PR asking how many pages I would be dedicating to it. When I told him "None" all hell broke loose. I hadn't the foggiest idea how it worked, but I think we were all still a bit naïve.'

Nonetheless, as Flett readily admits, 'we were also having the time of our lives', recalling a 'peak moment' visiting Paris Fashion Week without a hotel room booked: 'I slept on my friend Debra Bourne's floor; she was there because she worked for [leading fashion PR and the inspiration for the Edina character in *Absolutely Fabulous*] Lynne Franks. We travelled in Lynne's car with her chanting a Reiki cure to get us through the terrible traffic on the Péripherique to deliver us to the Jean-Paul Gaultier show on time. I mean, it was beyond Ab Fab.... Amazingly this worked, and when we got there, of course, we found that Jean-Paul's favourite magazine in the world was *The Face* so I was put

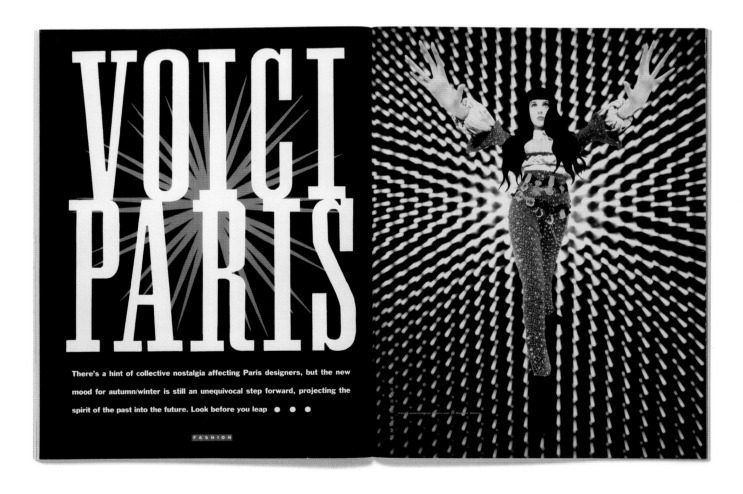

VOICI PARIS

There's a hint of collective nostalgia affecting Paris designers, but the new mood for autumn/winter is still an unequivocal step forward, projecting the spirit of the past into the future. Look before you leap ● ● ●

FASHION

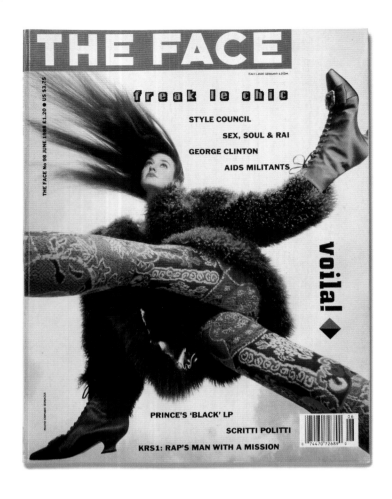

to London's Buffalo crowd through the singer Neneh Cherry's partner and Massive Attack's manager, the photographer-turned-record producer Cameron McVey, while Baker was seeing the group's Grant 'Daddy G' Marshall. 'I remember going to the parties Jamie Morgan threw at a huge warehouse studio,' says Baker, who has since gone on to work for *The Guardian* and the BBC as an editor and freelance contributor. 'It was all very west London, when west London was edgy. We'd go to clubs, events and exhibitions around Ladbroke Grove and [the Notting Hill] Carnival was a big thing every year. Meanwhile, everyone was dancing to house.'

Baker's first piece was on the fanzine produced by Boys' Own, the group of style-conscious producer/DJs and west London club-goers, which included Terry Farley and Andrew Weatherall and were part of the early acid-house scene giving the Wild Bunch and Soul II Soul a run for their money. 'After that I pretty much got on with it,' says Baker. 'Kate Flett was around and she and Nick helped out with contributors who would cover certain stuff. Also, and this is really important, Karl Templer and Derick Procope were doing the fashion. They were friends of Christian Logan's who had shown they could really pick up and run with what Buffalo had done.'

slap-bang in the front row with Catherine Deneuve on one side and Anna Wintour on the other. I spent the entire show gazing at Deneuve's beauty.'[5]

Flett's elevation opened the door for Lindsay Baker, who had been working at Lynne Franks's PR agency and contributing to fanzine *Soul Underground*.

From Surrey, Baker studied English at Bristol University and brought crucial connections to the fertile multi-racial music scene bubbling under the surface in the south-western port city, via the sound systems operated by the influential Wild Bunch, whose members included musicians Tricky and Massive Attack and producer Nellee Hooper. They were already connected

above
No. 98, June 1988.

right
Vol. 2, no. 2, November 1988.

opposite
No. 100, September 1988.

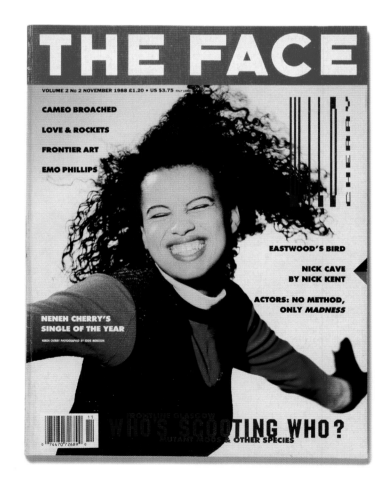

Templer and Procope – who had been to school with Christian Logan and are both now prominent fashion players in New York – brought much-needed street sensibilities to the mix. 'They had their ears to the ground, which meant we weren't writing about stuff coming in on press releases but as it happened,' says Barker.

Among the new contributors brought on board by Baker was Ekow Eshun, soon to become a star writer, editor of *Arena* in the 1990s and artistic director of London's Institute of Contemporary Arts in the 2000s. 'Ekow wrote to me when he was still a student, submitting a really good piece about Mississippi Burning,' said Baker. 'He came in to see me and we started giving him work.'[6]

In time Baker took over the 'Intro' pages and Sheryl Garratt joined the editorial staff, initially as music editor. Garratt had learned the intricacies of print production during her time at *City Limits*, and was soon aiding Nick Logan at Cogent, *The Face*'s typesetter in north-west London.

Logan inculcated Garratt in the art of using the flatplan as the wellspring from which everything proceeded at *The Face*. 'Nick's flatplans were works of art,' said Garratt. 'He taught me how important they were to the reader's experience of the magazine. Eventually I would take three days over producing each one and argue with Rod [Sopp] until we were blue in the face about why a particular ad couldn't go where he wanted because it would ruin the flow.'[7]

After a spell, Garratt also assumed the responsibilities of production editor, though still drawing on her abiding interest in the club scene in particular. The importance of this role was brought home by the fact that *The Face* was pipped by the more street-wise *i-D* on the growth in popularity of acid house and Ecstasy among British teens and twenty-somethings.

Terry Jones's magazine had featured an adapted Smiley face with the exhortations 'Get Up! Get Happy!' on the cover of the December 1987 issue (by comparison, *The Face*'s cover story that month had trailed an interview with actor Robert De Niro).

With monthly sales slipped to 73,000 – still with a high uptake within that figure of opinion-formers and taste-makers – *The Face* had nevertheless joined the media establishment, and former staffers were becoming major names in the national papers: Tony Parsons at *The Sunday Times* and his former partner Julie Burchill a columnist at the *Mail On Sunday*.

Jon Savage, by this stage a regular in the pages of the *New Statesman* and *The Observer*, said, 'Suddenly an alchemical process started whereby the people who wrote for *The Face*, who had come out of the music press, were taken up by Fleet Street.'[8] And that wasn't all. 'Every art director in New York and Tokyo has to have *The Face* now,' opined

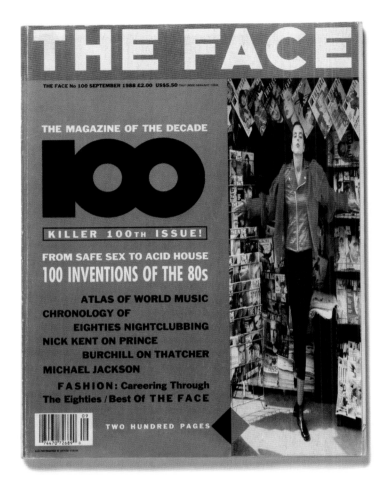

style commentator Peter York in 1988,[9] while *The Guardian* newspaper described it as 'the archetypal Eighties magazine'.[10]

'By the time I'd arrived clubs had widened out from the Soho one-nighters,' said Sheryl Garratt: 'What I brought to the table stemmed from the fact that I had known everyone who had done illegal warehouse parties and all of those who came in their wake through rare groove, the sound systems and acid house.'[11]

A realignment was needed. Cannily, Logan used the bumper two-hundred-page one-hundredth issue published in September 1988 to consign an entire range of associations to history.

Logan even considered closing the magazine on the publication of this edition, its job at reflecting 1980s youth culture apparently achieved, the circulation unsteady and *Arena* taking up more of his time. In the event he decided against this course of action, but still the sense of an end of an era was expressed in the front cover declaration of *The Face* as 'the magazine of the decade', with the 'Killer 100th issue' presenting the period 'from safe sex to acid house'. This included an innovatory trifold cover featuring all the magazine front pages thus far, enabled by advertising for German bottled beer Becks and brokered by contributor Anthony Fawcett, a pioneer of arts sponsorship.

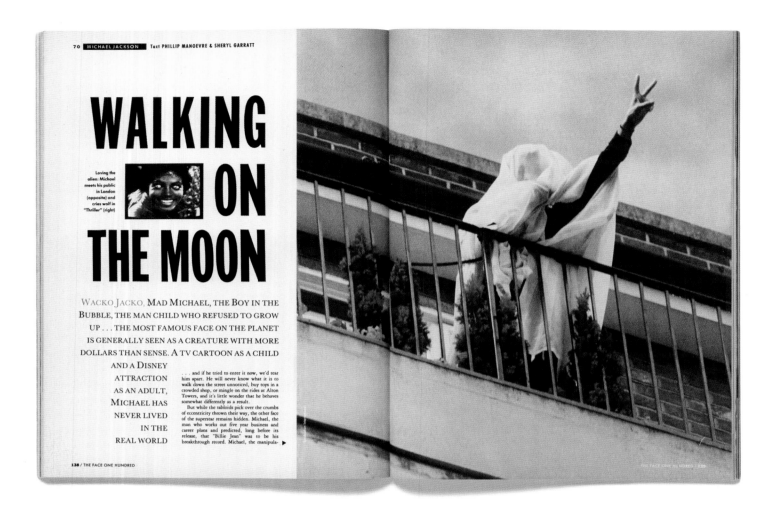

70 MICHAEL JACKSON Text PHILLIP MANOEVRE & SHERYL GARRATT

WALKING ON THE MOON

Loving the alien: Michael meets his public in London (opposite) and cries wolf in "Thriller" (right)

WACKO JACKO, MAD MICHAEL, THE BOY IN THE BUBBLE, THE MAN CHILD WHO REFUSED TO GROW UP . . . THE MOST FAMOUS FACE ON THE PLANET IS GENERALLY SEEN AS A CREATURE WITH MORE DOLLARS THAN SENSE. A TV CARTOON AS A CHILD AND A DISNEY ATTRACTION AS AN ADULT, MICHAEL HAS NEVER LIVED IN THE REAL WORLD

. . . and if he tried to enter it now, we'd tear him apart. He will never know what it is to walk down the street unnoticed, buy toys in a crowded shop, or mingle on the rides at Alton Towers, and it's little wonder that he behaves somewhat differently as a result.

But while the tabloids pick over the crumbs of eccentricity thrown their way, the other face of the superstar remains hidden. Michael, the man who works out five year business and career plans and predicted, long before its release, that "Billie Jean" was to be his breakthrough record. Michael, the manipula- ▶

138 / THE FACE ONE HUNDRED

Logan brought in the heavy-hitters to handle the era's sacred cows: Nick Kent took on Prince ('Let's not mince words. Without Prince, the 1980s would be even more unthinkably dead-arsed than they've already proven themselves to be') and Julie Burchill contributed a provocatively laudatory think-piece on Margaret Thatcher (see page 181): 'I don't believe in Thatcherism, but I do believe in Thatcher, given the options.' This resulted in more than the usual negative reader response; Jon Savage withdrew his services and never wrote for the magazine again. 'I stopped working for *The Face* after they printed that article saying how wonderful Mrs Thatcher was,' Savage said. 'I just resigned.'[12]

The increasingly unhinged Michael Jackson's 'Wacko Jacko' persona was dissected by Sheryl Garratt and French contributor Philippe Manoeuvre. A stand-out of the issue was the double-page spread diagram displaying a chronology of London clubs over the preceding ten years, from Billy's and Blitz to the very latest nights including Carwash, Enter The Dragon and Spectrum (see pages 182–83).

Art director Phil Bicker executed this with beyond-the-call dedication to detail. 'We watched as Phil spent hours at the printers hand-drawing with a variety of colour pens into the night,' recalls Logan. 'He pushed the deadline and himself to the verge of nervous collapse. At the end we were going, "Please, Phil, let it go" but he wouldn't until it was right.'[13]

A section headed 'The Way We Wore' (see page 180) frontloaded the work of Buffalo and featured selections from shoots by photographers Nick Knight, Eamonn J. McCabe, Jean-Baptiste Mondino and Mario Testino and stylists Elisabeth Djian, Simon Foxton, Amanda Grieve (now Harlech) and Michael Roberts. Logan tipped his hat to Soho's Great Marlborough Street news stand, which remained the first vendor in the country to stock new issues of the magazine, by using it as the backdrop for the cover fashion story. The twelve-page shoot was styled by Kathryn Flett and Lindsay Baker and shot by Anthony Gordon, who again situated the gamin Alex Arts in a series of London landmarks, including Battersea Power Station and Heathrow Airport.

In contrast to the controversial 'Alex Eats' of five months earlier, Arts was portrayed as a strong independent young woman, wearing clothes and accessories by 1980s mainstays including Junior Gaultier, Georgina Godley, Red or Dead, John Richmond and Vivienne Westwood. The message that the

magazine was calling time on the first eight years of its existence was driven home in the next issue, where the emphasis under Garratt's direction was on the diversity and excellence of new British music.

The October 1988 issue was designated the start of 'Volume 2', numbered '1' and featured a cover photograph of Tim Simenon of British DJs/samplers Bomb the Bass (see pages 170–71), who was interviewed by Garratt and thematically linked under the heading 'The British Bomb' to features on new record label Acid Jazz and Manchester's fast-evolving dance scene. Garratt maintained her emphasis on looking to the future with commissions including a visit by Lindsay Baker and Juergen Teller to New York to interview the Jungle Brothers, then advancing East Coast rap into new areas. 'Sheryl was very good at taking a suggestion and working with you on refining it as an idea until it became a more wide-ranging piece,' says Baker.

In 1989 Kathryn Flett left the magazine to undertake a theology and philosophy degree at London's King's College;[14] Garratt now delivered on her intention for the magazine to incorporate more egalitarian content in line with the broadening out of youth culture from the previously niche position it had occupied. 'I had become close to Nick,' recalled Garratt of this period. 'He would pick me up and drop me off at my place in Finsbury Park on the way to and from the printers, where we spent a lot of time producing the magazine and discussing ideas.'[15]

In London the new direction was defined by Soul II Soul's 'post-modern mélange';[16] their leader Jazzie B was the subject of Baker's April 1989 cover story 'Funki Like a Dred'. Baker was the natural choice to write the piece due to her Bristol associations with Soul II Soul's producer Nellee Hooper.

'By now we were at the tail-end of the 1980s Yuppie business,' says Baker. 'I still had a Filofax when I went to see Jazzie and so did he, and we talked about him starting as an entrepreneur using money from a Thatcher youth scheme, but he also talked about being black in multi-cultural Britain. There was definitely something afoot, and it wasn't "right-on" or contrived; we all genuinely felt a mood of optimism and excitement and that was also reflected by the unorthodox photographers being commissioned by Phil Bicker.'[17]

With the encouragement of Bicker at *The Face* and Nick Knight, who held a post as consulting picture editor at *i-D*, a fresh raft of young fashion photographers – notably Corinne Day as well as Glen Luchford, Craig McDean, Nigel Shafran, David Sims, Mario Sorrenti, Stéphane Sednaoui and Juergen Teller – and stylists including Venetia Scott and Melanie Ward were coming through. Simultaneously, the models they used attained prominence, among them Emma Balfour, Rosemary Ferguson and, of course, Kate Moss.

opposite
'Walking on the Moon', no. 100, September 1988.

above
'Alex Works: Careering Through the Eighties', no. 100.

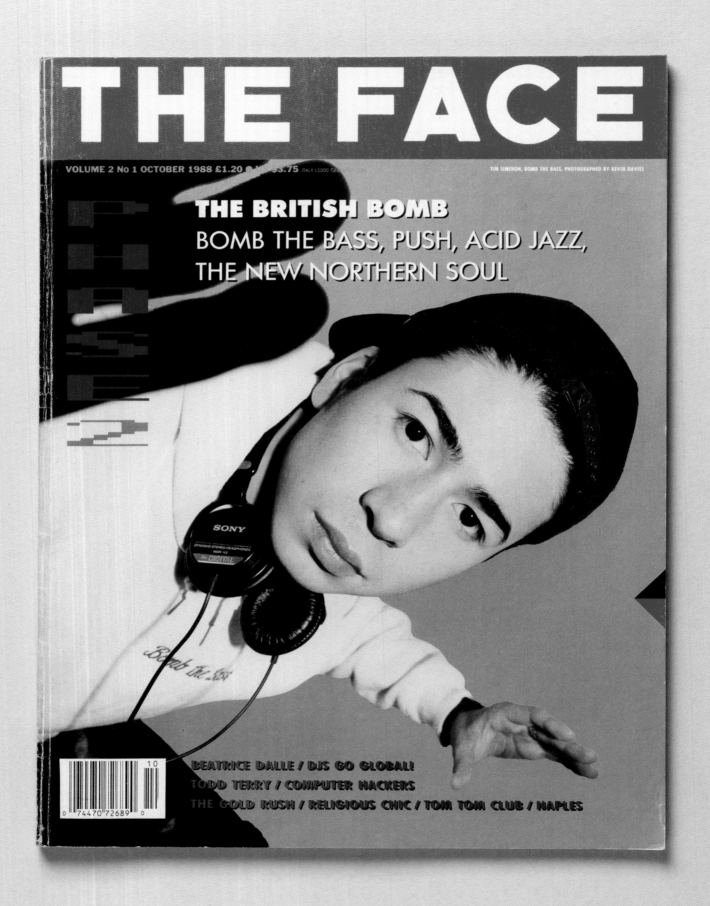

THE FACE

VOLUME 2 No 1 OCTOBER 1988 £1.20 ● US $3.75 ITALY L5000 GE

TIM SIMENON, BOMB THE BASS, PHOTOGRAPHED BY KEVIN DAVIES

THE BRITISH BOMB
BOMB THE BASS, PUSH, ACID JAZZ, THE NEW NORTHERN SOUL

BEATRICE DALLE / DJS GO GLOBAL!
TODD TERRY / COMPUTER HACKERS
THE GOLD RUSH / RELIGIOUS CHIC / TOM TOM CLUB / NAPLES

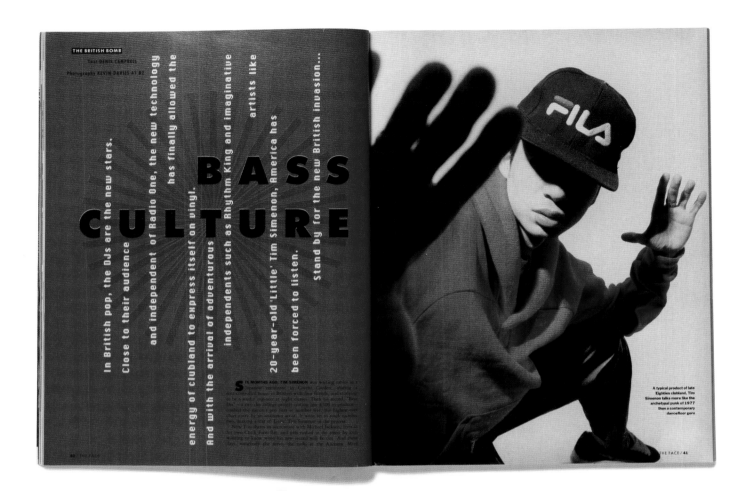

'Bicker summarized his approach in 2000: 'The idea is not to have eight people doing the same thing, but to have eight people doing their thing'.[18] He also saw his role as providing a platform 'for people who otherwise would not have one', and delivered on that many times through the late 1980s and into the 1990s. In some cases Bicker provided career advice and contacts; for example, Mario Sorrenti, then a model and Kate Moss's other half, who had been privately developing a practice as a photographer, was provided with a list of agents by Bicker at the very start of his now illustrious career.

Obtaining first dibs on this talented group became the source of rivalry between publications. 'Maybe Phil was threatened by what we were doing at *i-D*; he would try and tell us that we couldn't use people like Corinne', grins Knight.

opposite
Vol. 2, no. 1, October 1988.

above
'Bass Culture', vol. 2, no. 1.

'I would say, "What are you talking about? These people are my assistants!"'[19] Individually the work of the photographers was soon taken up by the advertising industry and intensified the relationship with the editorial aspects not only of *The Face* and *i-D* but across fashion publishing.

David Sims has recounted how he and Ward shot on spec: 'We would have to go in to *The Face* with the pictures and hope for the best.... At the time Phil was really pushing, as he's always done, to include new photographers in his projects'.[20]

According to Ward, she shared concerns with Sims, Day and others. 'We wanted to achieve an emotional response from the model, so there was something you related to as a person', she said later. 'These were not cold, hard fashion images. I remember going on appointments with my book and people would say, "These are not fashion photographs, these are documentary".'[21]

The break with the glossy traditions was completed in the customization and casual attitude to the clothing from top designers. Ward didn't care if the garments were creased in the fashion stories she styled, since her aim was to convey an impression that the model owned them. 'For the old school

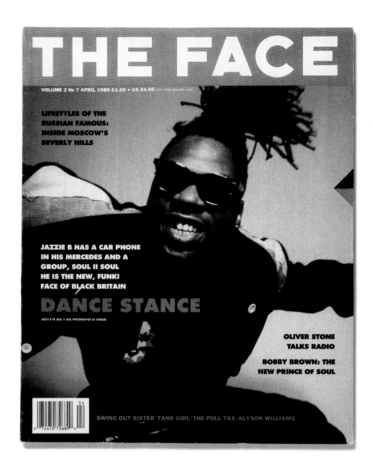

fashion piece supplementing their everyday clothing. 'I wanted to do a story where, when you turned the page, you got a reaction,' Shafran said later. 'Melanie brought in the fashion element, which was a strange mixture of sci-fi and suburbia, very "London" I suppose, and we shot outside Safeway's at [north London's] Finsbury Park. It took a long time to do. We'd be lucky to get one image out of a day.'[22]

'Nigel's work was amazing,' says Lindsay Baker. 'He's more like an artist than a photographer.'[23]

Bicker also encouraged contributions from the photographer/filmmaker Stéphane Sednaoui (see pages 176–79, 188–89), who has described *The Face* in the late 1980s as 'a perfect combination of everything I liked – fashion, celebrities and music' and has related how the magazine's publication of his photomontages which were in fact achieved by hand helped draw the attention of Paris editors who then commissioned him to work with the incoming digital technology.[24]

The magazine's break with the 1980s was made manifest by the tragic death of Ray Petri, who succumbed to AIDS in August 1989, aged forty. Now, as a jointly credited obituary by Dylan Jones and Nick Logan proclaimed, stylists were gaining similar distinction to photographers in the creation of fashion images as artistic acts.[25]

of styling that had gone before, everything was steamed, stiff and wrinkle-free,' Ward told Charlotte Cotton for the 'Imperfect Beauty' exhibition at the Victoria and Albert Museum in London in 2000. 'I wanted to look at the images as a whole, I didn't want to be drawn to the clothes necessarily. For me it was more about the attitude the model was giving.'

This was evident in the July 1989 issue, which featured Ward and Nigel Shafran's futuristic take on the magazine's growing preoccupation with suburbia (see pages 186–87). Shafran and Ward developed an idiosyncratic approach to capturing fashion images by approaching strangers on the street and asking for permission to photograph them in a designer

above
Vol. 2, no. 7, April 1989.

right
Vol. 2, no. 13, October 1989.

opposite
'Ray Petri', vol. 2, no. 13.

overleaf
'Sixth Sense', no. 95, March 1988.

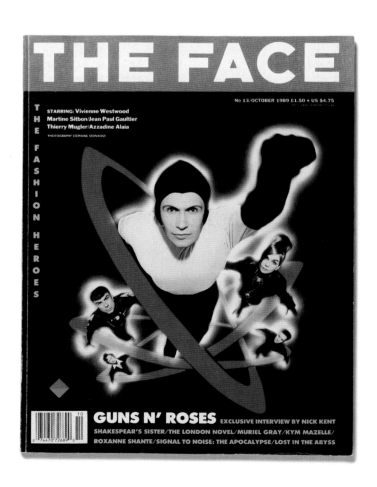

RAY PETRI

At its most prosaic, a stylist is the person on a fashion shoot who selects the clothes for the models. Ray Petri was never prosaic, and 'styling' was always an inadequate term to describe what it was he excelled at. Ray used clothes to create a mood, to construct an 'attitude', and in so doing he defined the look of men's fashion in the Eighties. That he did this first, and so brilliantly and consistently, in THE FACE was our good fortune.

Ray Petri was born in Dundee, September 16, 1948, emigrating to Australia with his family in 1963, where his love of music led him to form and sing with an R&B group, The Chelsea Set. Back in England in 1968 he got involved in the London rag trade and dabbled in antiques. Attracted to photography, he was first an assistant to Roger Charity, then an agent and finally, almost accidentally – the way these things happen – a stylist.

His friend, the photographer Jamie Morgan, introduced him to THE FACE in summer 1983. In their first job together, a one-page story in August that year, the trademark Sting Ray touches were immediately in evidence: medals on ribbons around the model's neck, and an idiosyncratic touch – a piece of sticky tape over one eyebrow.

In the space of a few short months Ray's 'stories' became the cutting edge of street fashion, the London look exported worldwide. Looking back, for instance, at the pages Petri and Morgan contributed in January 1984, at fashions which

Ray Petri photographed by Nick Knight

have had their day, it is still possible to be dazzled by the boldness of imagination. Ray put male models in chunky gold jewellery in one story, and transformed sportswear into streetwear in another; not least, this is where the brothers Barry and Nick Kamen made their debuts.

As daring and crammed with ideas as these early 'stories' were, Ray's best was to come when he peeled away the transient and the gimmicky to develop what became his signature style. He called it 'Buffalo', after the informal business grouping he formed with Jamie Morgan and other friends, photographers Cameron McVey and Marc Lebon, singer Neneh Cherry, the Kamen brothers and stylist Mitzi Lorenz. A sort of talent agency for like-minded non-conformists, Buffalo set about assaulting the fashion sensibilities of the decade.

Ray's 'look', then, became the streamlined classicism, tough-edged and Brandoesque, that reached its apex in terms of mass exposure through Nick Kamen in the Levis commercial. Buffalo rejected style and explored attitude, creating a 'modern man' from the remnants of punk and Ray's own eclectic taste.

The look, if not the attitude – an altogether tougher thing to disseminate – was widely copied, most visibly in the form of the black nylon USAF MA1 'Buffalo' jacket hauled out of a surplus store to become the most ubiquitous fashion item of the decade, traversing the globe. Gaultier wasn't the only name designer who watched Ray's work with keen interest, but he was one of the few prepared to acknowledge a debt.

Ultimately, if you study the photos Ray produced, it is not the clothes that are the stars but the *people*. "The important thing in styling is good casting," he said. "Once you have that, everything else falls into place."

Ray Petri was a kind man: no-one had a bad word to say about him. Working freelance for THE FACE and *i-D*, and latterly for *Arena*, he was able to keep a distance from the bitchiness and superficiality that permeates the fashion business, never fully embracing an industry which profited from his ideas. In this respect perhaps he was too generous: a case of he who dares doesn't always win, and doesn't always *want* to. For all his talent, he never became a fashion editor – that would have compromised his integrity and freedom.

He remained the outsider, a maverick visionary whose outlet was the fashion plate. A trivial, inconsequential thing? While most now recognise the validity of photography as an art form, who would make a similar claim for something as ephemeral as styling? Ray Petri was a creative artist in the truest sense. His vision survives him in fashion pages, through the stylists and photographers inspired by his work, in chain-store racks of designer rip-offs, on the backs of every hip young thing in high streets across the world.

Ray Petri died in London, August 15, 1989, surrounded by his friends. A Catholic service was followed by cremation, the latter accompanied by some of the music Ray loved and which informed his work: Jimmy Cliff's "Many Rivers To Cross", Nat King Cole's "Nature Boy" and, with poignant irony, Louis Armstrong's "What A Wonderful World". *Nick Logan/Dylan Jones*

A version of this piece, by the same authors, appeared in The Independent, Sept 19

AMONG THE MANY who lost their lives in the Marchioness boat tragedy was the photographer Chris Garnham, a young freelance whose work appeared in several issues of THE FACE during the past two years. Our sympathies go to his family and friends, and to those of the others who died.

A RETROSPECTIVE PHOTOGRAPHIC TRIBUTE TO RAY PETRI WILL APPEAR IN NEXT MONTH'S ISSUE OF THE FACE

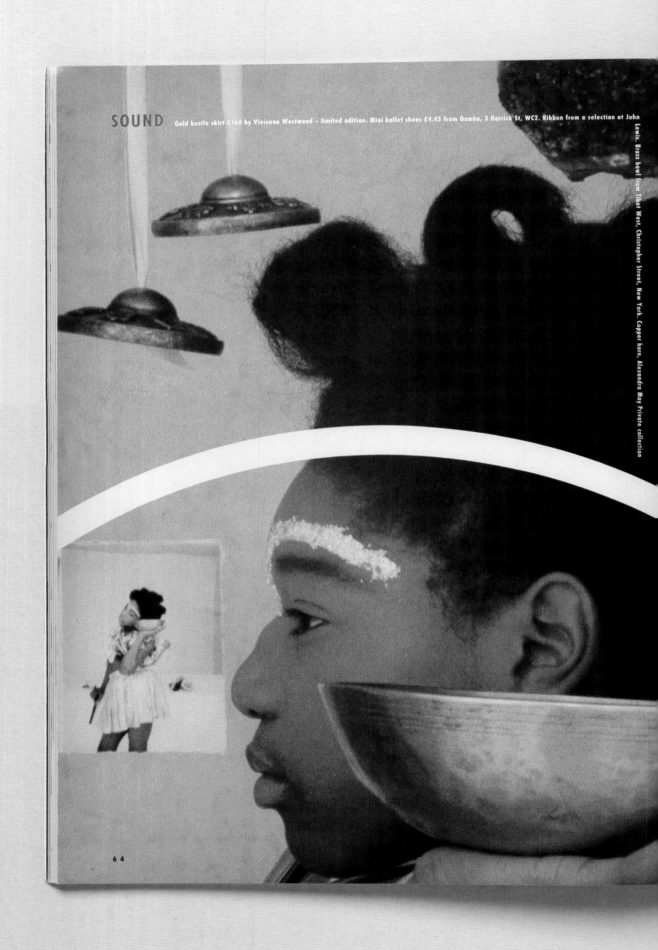

SOUND Gold bustle skirt £160 by Vivienne Westwood – limited edition. Mini ballet shoes £4.45 from Gamba, 3 Garrick St, WC2. Ribbon from a selection at John Lewis. Brass bowl from Tibet West, Christopher Street, New York. Copper horn, Alexandra May Private collection

6 4

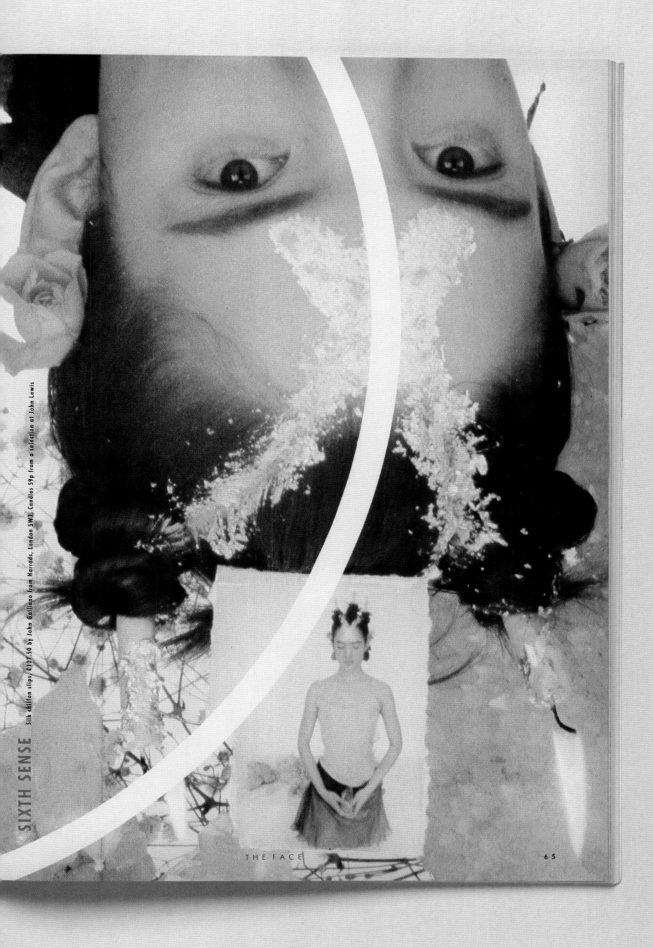

SIXTH SENSE Silk chiffon slips, £127.50 by John Galliano from Harrods, London SW1. Candles 59p from a selection at John Lewis

THE FACE

65

Combining Jean Baptiste Mondino's neo-classic black and white fashion photography and Stephane Sednaoui's

HEAVY

contemporary application of light, colour and texture, maverick French stylist Elisabeth Djian has. . .

PHOTOGRAPHY Jean Baptiste Mondino
FASHION Elisabeth Djian
assisted by Anne Saint Sever
and Beatrice Cacle
HAIR Marc Lopez
MAKE-UP Topolino

86 / THE FACE

Leather waistcoat and studded trousers by Martine Sitbon

87

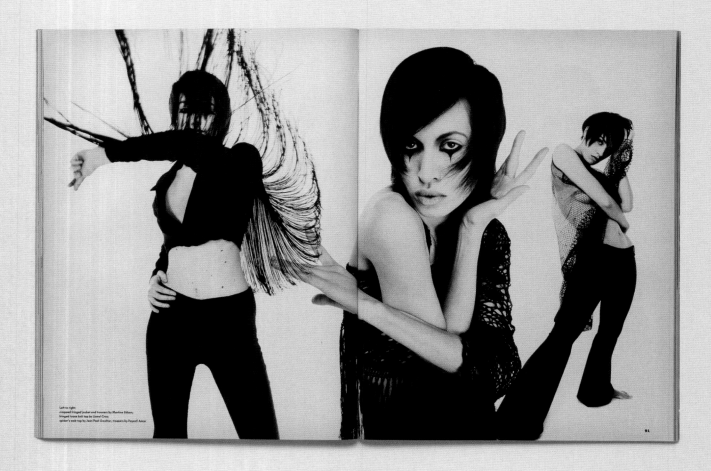

Left to right
cropped fringed jacket and trousers by Martine Sitbon,
fringed lasso belt top by Lionel Cros;
spider's web top by Jean Paul Gaultier, trousers by Popcall Amor

91

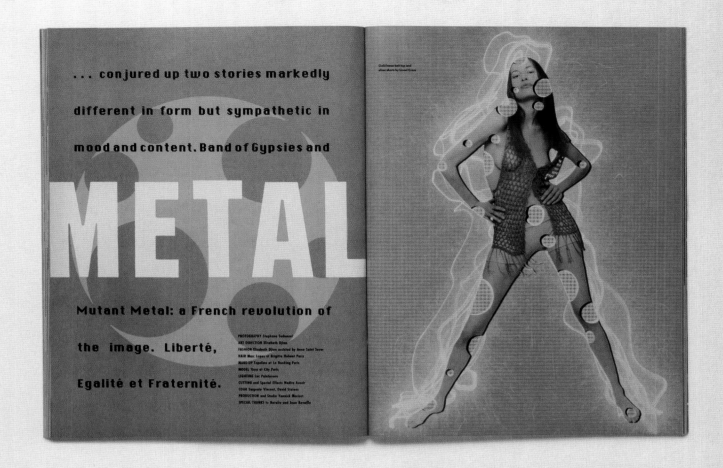

... conjured up two stories markedly different in form but sympathetic in mood and content. Band of Gypsies and

METAL

Mutant Metal: a French revolution of the image. Liberté, Egalité et Fraternité.

PHOTOGRAPHY Stephane Sednaoui
ART DIRECTION Elisabeth Djian
FASHION Elisabeth Djian assisted by Anne Saint Sever
HAIR Marc Lopez at Brigitte Hubert Paris
MAKE-UP Topolino at Le Booking Paris
MODEL Tara at City Paris
LIGHTING Luc Painéterem
CUTTING and Special Effects Nadira Azouir
COOK Eugenie Vincent, David Stainer
PRODUCTION and Studio Yannick Morisot
SPECIAL THANKS to Natalie and Joan Barollo

Gold loose-knit top and silver shorts by Lionel Croze

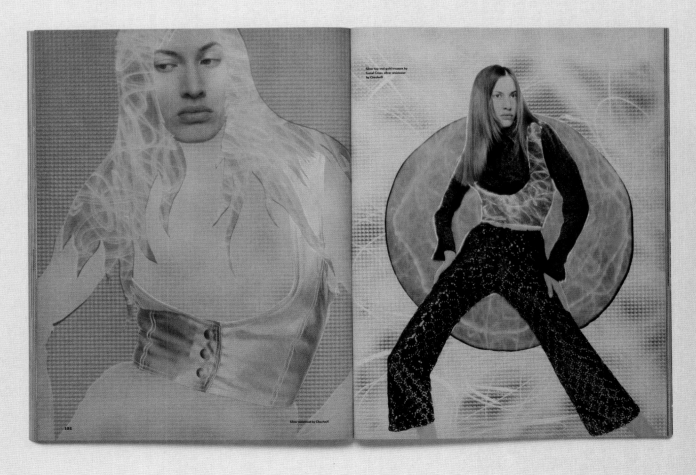

Silver top and gold trousers by Lionel Croze, silver waistcoat by Clitschell

Silver waistcoat by Clitschell

102

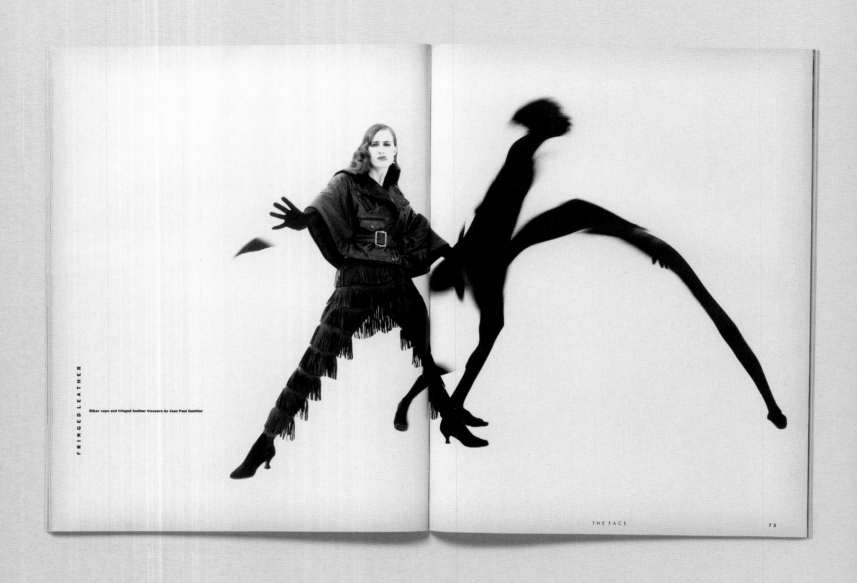

FRINGED LEATHER

Biker cape and fringed leather trousers by Jean Paul Gaultier

THE FACE

7 3

previous pages
'Heavy Metal', no. 95, March 1988.

above and opposite
'Voici Paris', no. 98, June 1988.

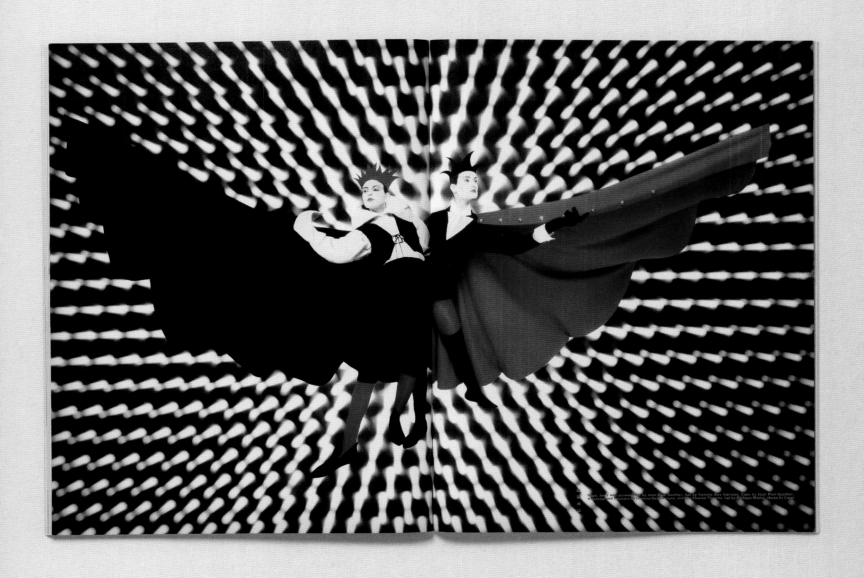

THE BEST OF THE FACE
FASHION 1980 – 1988

THE WAY WE WORE

Right above: issue 45, 1984/Photography Jamie Morgan/Fashion Ray Petri

Below: issue 38, 1983/Photography Jamie Morgan/Fashion Helen Roberts

Issue 49, 1984/Photograph Jamie Morgan/Fashion Ray Petri

above and opposite bottom

'The Way We Wore', no. 100, September 1988.

opposite top

'Burchill on Thatcher', no. 100.

119

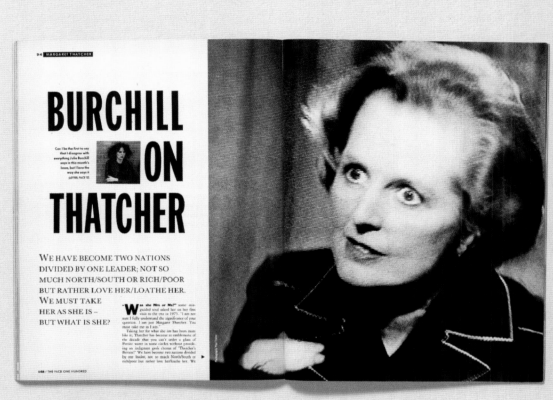

94 MARGARET THATCHER

BURCHILL ON THATCHER

Can I be the first to say that I disagree with everything Julie Burchill says in this month's Issue, but I love the way she says it
LETTER, PAGE 12

WE HAVE BECOME TWO NATIONS
DIVIDED BY ONE LEADER; NOT SO
MUCH NORTH/SOUTH OR RICH/POOR
BUT RATHER LOVE HER/LOATHE HER.
WE MUST TAKE
HER AS SHE IS –
BUT WHAT IS SHE?

Was she Mrs or Ms?" some misguided soul asked her on her first visit in the USA in 1975. "I am not sure I fully understand the significance of your question. I am just Margaret Thatcher. You must take me as I am.

Taking her for what she was has been more like it, Thatcher has become so emblematic of the decade that you can't order a glass of Perrier water in some circles without provoking an indignant geek chorus of "Thatcher's Britain." We have become two nations divided by one leader, not so much North/South or rich/poor but rather love her/loathe her. We

168 / THE FACE ONE HUNDRED

125

181

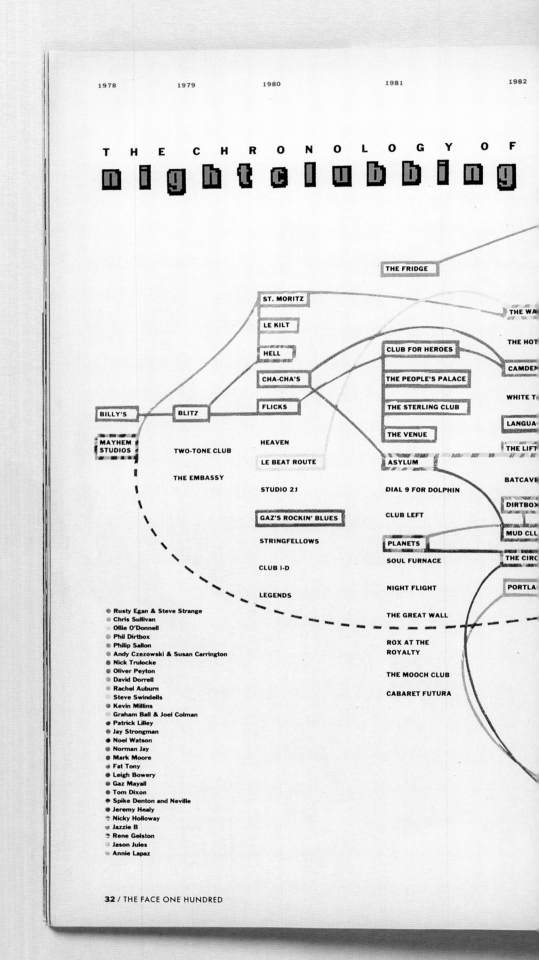

right
'The Chronology of Nightclubbing', no. 100,
September 1988.

182

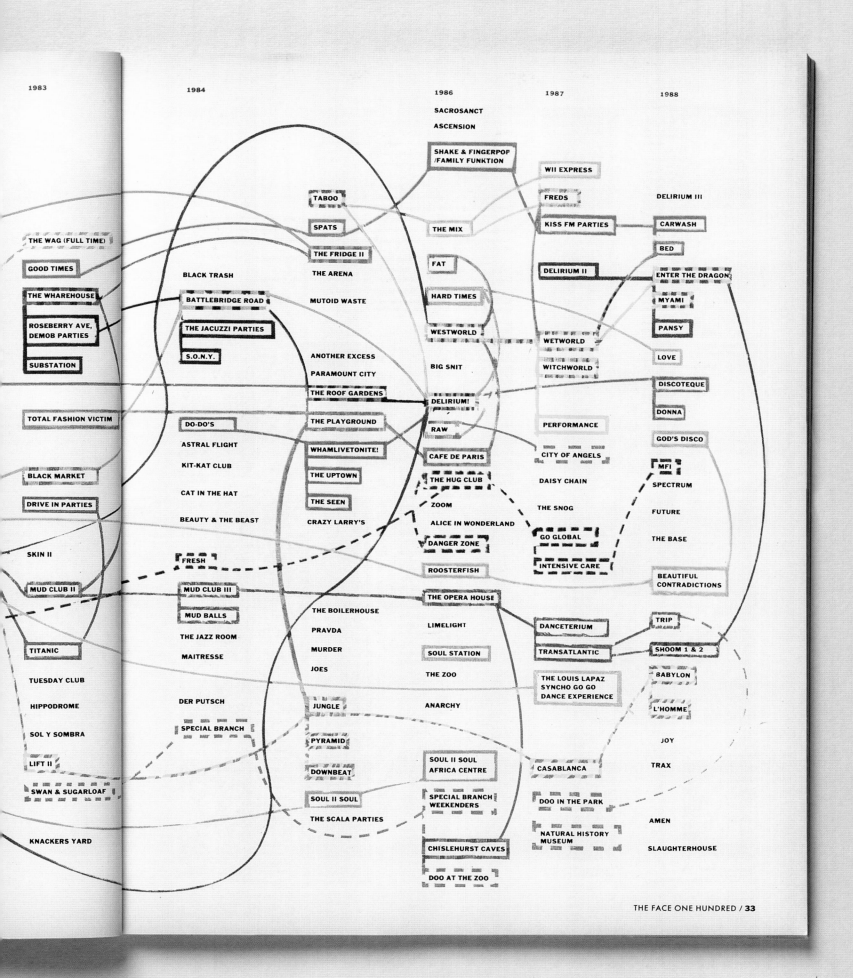

1983

THE WAG (FULL TIME)

GOOD TIMES

THE WHAREHOUSE

ROSEBERRY AVE, DEMOB PARTIES

SUBSTATION

TOTAL FASHION VICTIM

BLACK MARKET

DRIVE IN PARTIES

SKIN II

MUD CLUB II

TITANIC

TUESDAY CLUB

HIPPODROME

SOL Y SOMBRA

LIFT II

SWAN & SUGARLOAF

KNACKERS YARD

1984

BLACK TRASH

BATTLEBRIDGE ROAD

THE JACUZZI PARTIES

S.O.N.Y.

DO-DO'S

ASTRAL FLIGHT

KIT-KAT CLUB

CAT IN THE HAT

BEAUTY & THE BEAST

FRESH

MUD CLUB III

MUD BALLS

THE JAZZ ROOM

MAITRESSE

DER PUTSCH

SPECIAL BRANCH

TABOO

SPATS

THE FRIDGE II

THE ARENA

MUTOID WASTE

ANOTHER EXCESS

PARAMOUNT CITY

THE ROOF GARDENS

THE PLAYGROUND

WHAMLIVETONITE!

THE UPTOWN

THE SEEN

CRAZY LARRY'S

THE BOILERHOUSE

PRAVDA

MURDER

JOES

JUNGLE

PYRAMID

DOWNBEAT

SOUL II SOUL

THE SCALA PARTIES

1986

SACROSANCT

ASCENSION

SHAKE & FINGERPOP /FAMILY FUNKTION

THE MIX

FAT

HARD TIMES

WESTWORLD

BIG SNIT

DELIRIUM!

RAW

CAFE DE PARIS

THE HUG CLUB

ZOOM

ALICE IN WONDERLAND

DANGER ZONE

ROOSTERFISH

THE OPERA HOUSE

LIMELIGHT

SOUL STATION

THE ZOO

ANARCHY

SOUL II SOUL AFRICA CENTRE

SPECIAL BRANCH WEEKENDERS

CHISLEHURST CAVES

DOO AT THE ZOO

1987

WII EXPRESS

FREDS

KISS FM PARTIES

DELIRIUM II

WETWORLD

WITCHWORLD

PERFORMANCE

CITY OF ANGELS

DAISY CHAIN

THE SNOG

GO GLOBAL

INTENSIVE CARE

DANCETERIUM

TRANSATLANTIC

THE LOUIS LAPAZ SYNCHO GO GO DANCE EXPERIENCE

CASABLANCA

DOO IN THE PARK

NATURAL HISTORY MUSEUM

1988

DELIRIUM III

CARWASH

BED

ENTER THE DRAGON

MYAMI

PANSY

LOVE

DISCOTEQUE

DONNA

GOD'S DISCO

MFI

SPECTRUM

FUTURE

THE BASE

BEAUTIFUL CONTRADICTIONS

TRIP

SHOOM 1 & 2

BABYLON

L'HOMME

JOY

TRAX

AMEN

SLAUGHTERHOUSE

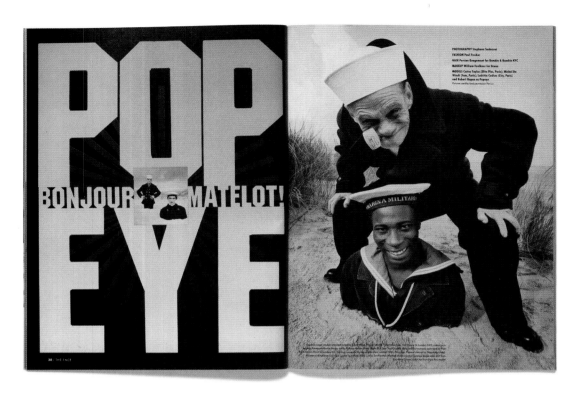

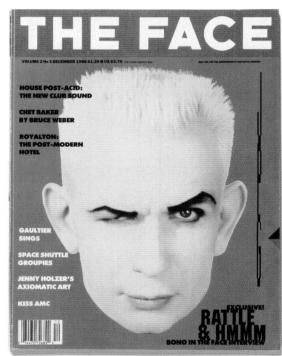

Navy blue double-breasted coat by Benetton; blue polo neck sweater by Filipo Alpi; hat from Laurence Corner surplus store, London NW1. Opposite page: Popeye's navy duffle coat by Enrico Coveri; hat from Laurence Corner. Blue all-in-one by Jean Paul Gaultier as before; shoes Cult by Zeis Excelsa; hat by Stephen Jones from his shop at 29 Haddon St, London W1

below and opposite top
'Pop Eye Bonjour Matelot', vol. 2, no. 4, January 1989.

opposite bottom
Vol. 2, no. 3, December 1988.

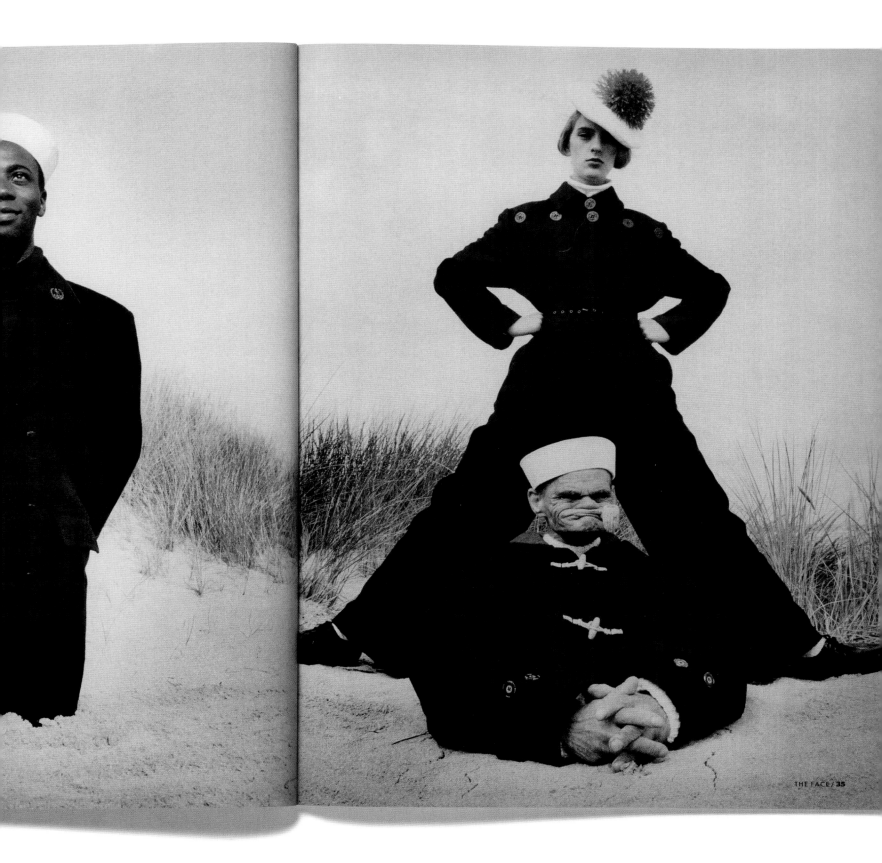

THE FACE / 35

below and opposite
'Fantastic Voyage: Lost in Space', vol. 2, no. 10,
July 1989.

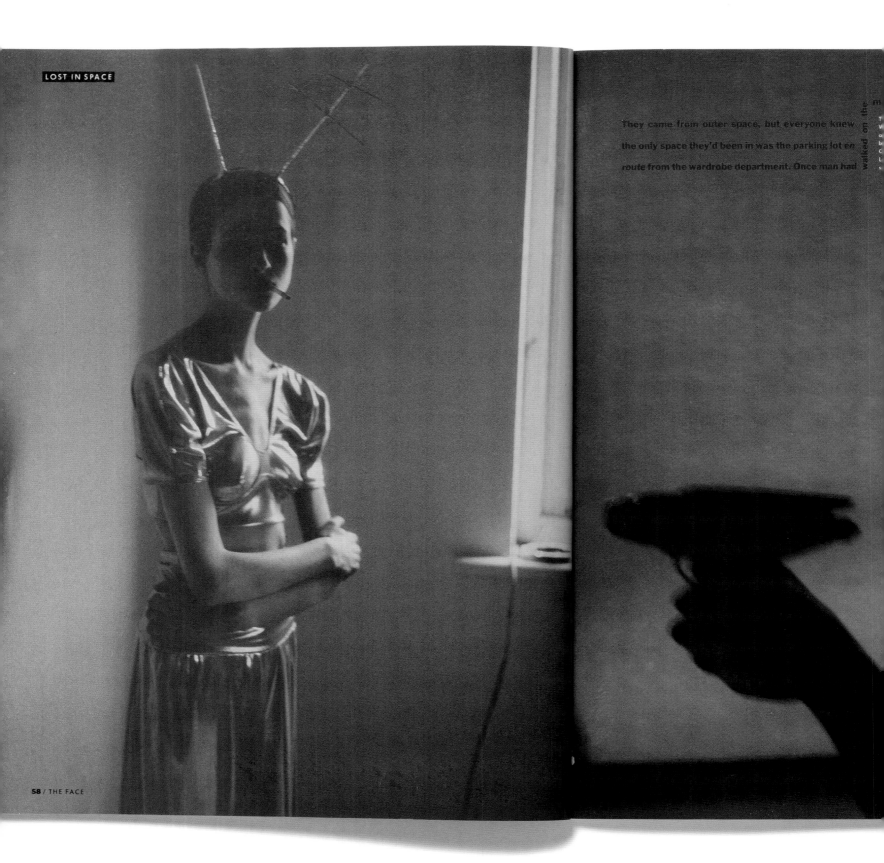

LOST IN SPACE

They came from outer space, but everyone knew the only space they'd been in was the parking lot en route from the wardrobe department. Once man had

58 / THE FACE

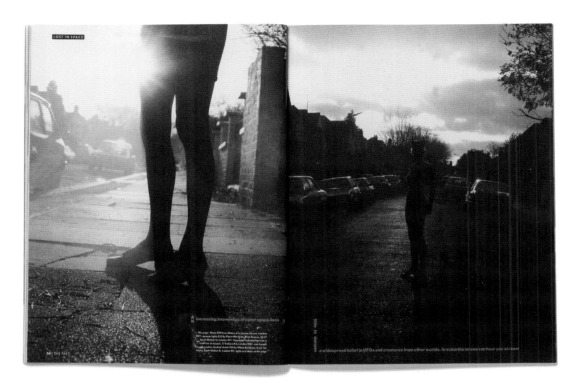

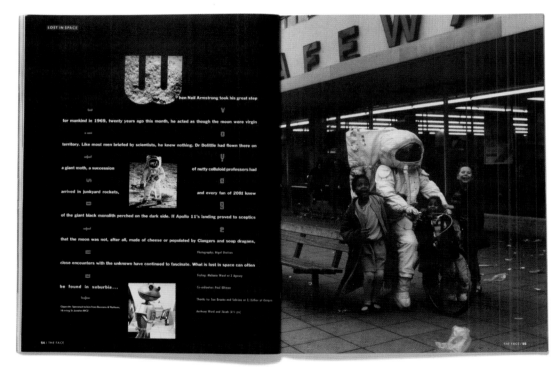

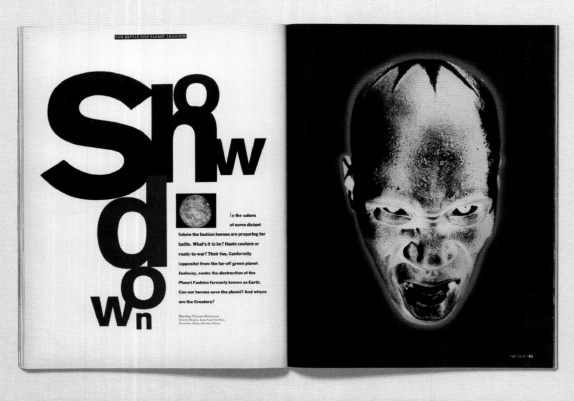

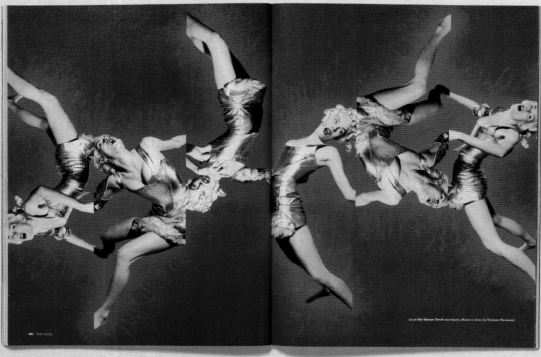

opposite and below
'Fashion Heroes', vol. 2, no. 13, October 1989.

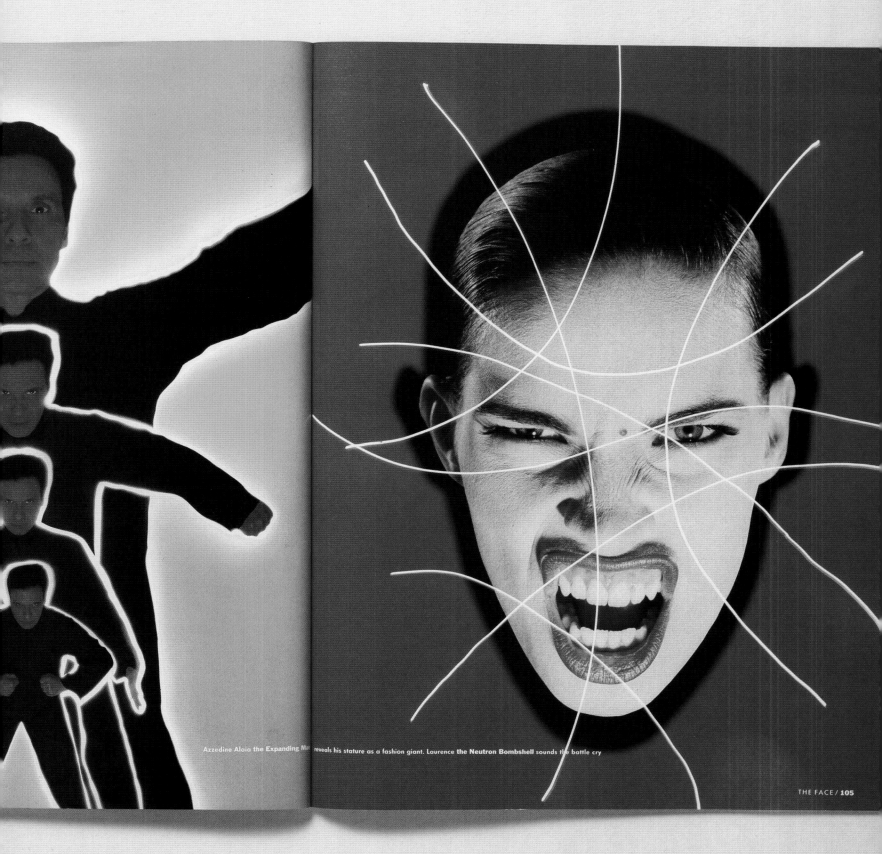

Azzedine Alaia the **Expanding Ma**... reveals his stature as a fashion giant. Laurence the **Neutron Bombshell** sounds the battle cry

THE FACE / **105**

Chapter Eight

The We Generation

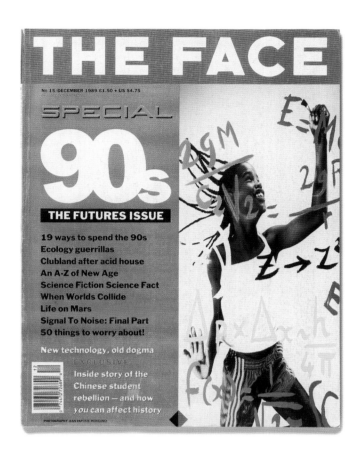

The brace of overviews of Britain's burgeoning rave culture by assistant editor Sheryl Garratt at the turn of the 1990s marked a sea-change at *The Face*. These articles were explicit in their refutation of the magazine's original focus on urban elites and instead celebrated the rise of the regions as a result of the democratizing effects of dance culture.

'There was a feeling of being anti-wine bar, anti-cocktail bar, in favour of sitting in cut-offs in a suburban pub garden listening to fantastic – if uncool – music,' says Ashley Heath, then a fashion trade journalist and contributor to *The Face*.[1] This mood was recognized by Richard Benson, a reader of *The Face* on the postgraduate journalism course at London's City University – on which Heath had also studied – and soon to join the team. 'Sheryl had a clear idea of what she wanted to do,' says Benson, who succeeded Garratt as editor of *The Face* in the mid-1990s and is now a distinguished author. 'I think she felt things had become insular and played-out in terms of the

1980s aesthetic, and had a vision of post-1988 youth culture that was more democratic. She knew that *The Face* shouldn't be about Soho any more but about the rest of the country.'[2]

This direction had in fact come from Nick Logan. 'Around that time Nick had said to me, "You know these kids dancing around in fields? That's who we should be doing the magazine for now",' recalls Garratt. 'I felt like he'd given me a mandate to push through everything I thought the magazine should be. When he'd talked about closing *The Face* on the one-hundredth issue, I understood that he was thinking about making a bold statement, but my point was, even then, "Something amazing is coming along and we ought to be around to address it".'[3]

Logan's instincts and Garratt's knowledge coincided with those of the photographers and stylists receiving commissions from art director Phil Bicker. 'People were changing their attitude to the way they were dressing and socializing, and there were a lot of social structures which were eradicated for a short period of time,' photographer David Sims said later. 'Rave culture made all that possible; we were creating visuals to accompany that.'[4]

Former features editor Lesley White believes that the more egalitarian nature of *The Face* in the 1990s was a reflection of its business growth. 'Initially, we worked from a small but influential reader base which had a limited market. You could only go on for so long without being unable to expand advertising, for example. So it was natural that *The Face* should be made to appeal to as many people as possible. But we had sewn the seeds for that in the 1980s with our pieces on mods and casuals.'[5]

Garratt speaks to the harsh reality of the magazine's existence by that stage. 'We also knew everything had to change,' she says. 'The circulation was going down and we needed to adjust to what was going on.'

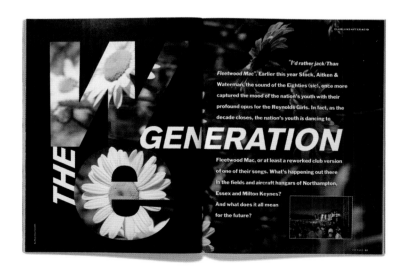

THE FACE

No 17/FEBRUARY 1990 £1.50 • US $4.75
ITALY L6400 GERMANY 9.5DM SPAIN 435PTAS

SHORN TO BE WILD

**SINÉAD O'CONNOR
BY SEAN O'HAGAN**

THE RIGHT TO PARTY
HM GOVERNMENT VS ACID HOUSE

**KIEFER SUTHERLAND / JANET JACKSON / INSPIRAL CARPETS
CLOCKWORK ORANGE / I WATCHED TELEVISION FOR CLIVE JAMES**

SINEAD O'CONNOR PHOTOGRAPHED BY JUERGEN TELLER

The We Generation

opposite
Vol. 2, no. 17, February 1990.

above
'HM Government vs Acid House', vol. 2, no. 17.

The first of Garratt's rave essays, written with Lindsay Baker, took readers on a nocturnal search along the A3 road in Hampshire for a £25-a-ticket gathering entitled 'Biology', reporting that such mass events 'are almost commonplace: promoters judge their success on the numbers they attract, not the names in the VIP room, and the clubbers come not to be seen but to hide in the crowd'. 'It was a bit of a moment, wasn't it?' asks Baker. 'It felt very exciting, with spontaneous raves happening on Clapham Common or wherever. Christian Logan was a central figure at the magazine at that time because he and his mates loved football and the whole casual fashion angle and also knew where the raves were happening, so he contributed a lot to our feeling that things were moving.'

Baker believes there was a simultaneous sense of young people having a common aim. 'There was a feeling of anger and frustration when the Government clampdown came. Looking back it may not have been the most important of causes, but it certainly felt like it.'[6]

This was covered in the second big rave piece, subtitled 'HM Government vs Acid House' and written by Garratt with contributor Chris Taggart. They explored the attempts by local authorities and police forces to block mass gatherings, referencing the recent fall of the Berlin Wall and the breakaway from Soviet sovereignty by Eastern Bloc countries: 'When they begin to take holidays here over the next few years, Eastern European visitors may find some of Britain's restrictions on personal freedom strangely familiar.'

With its revelations of Home Office plans to increase fines and toughen the laws against party organizers and quotes from figures including the British politician Keir Starmer, then legal officer at pressure group Liberty, the piece revealed a social engagement that struck a chord at street level as the 1980s design bubble – which had been the benchmark of *The Face* in the 'Designer Decade' – burst 'in spectacular ways'

Above: the FACE portrait
that was pirated for
unofficial posters

"I'm here for the buzz,
for the event, for the
rave. The Stone Roses
are all right, though"
DOMINIC, 17 (RIGHT)

"I'm here because I like E and my life's dedicated to raving. I don't
want the DJs ever to stop" JONATHAN, 20 (ABOVE)

"We do a fanzine.
Piss off Mancs!
Leeds is where
it's at!"
THE LEEDS GANG (RIGHT)

"It's the biggest event ever
around here. Everyone's mixing
in and being happy together.
It's ace!" NICKY, 18 (ABOVE)

when a series of the big practices splintered into one-man band operations as a result of the early 1990s recession.[7] That design was no longer centred on a few high-faluting figures but was accessible to all was marked by the increasing take-up of inexpensive computer technology that accompanied the proliferation of dance music events and club-nights; hence the explosion in graphics in this period, particularly in the cottage industry manufacturing of rave flyers. In their cheerful use of colour and slogans, these expressed the optimism across British youth culture that was nonetheless underpinned by a very British streetwise attitude. Corinne Day's portrait of a wide-smiled Kate Moss accompanied by the headline 'The 3rd Summer of Love' on the cover of the July 1990 issue captured the zeitgeist.

Inspired by the music of Happy Mondays, Stone Roses and Nirvana, Day was as interested in upturning hierarchies as Garratt. 'Fashion magazines had been selling sex and glamour for far too long,' Day said. 'I wanted to instil some reality into a world of fantasy.'[8]

Garratt and Bicker subscribed to this view that fashion needed to be presented in a new way. According to Bicker, 'People were sending in portfolios and stories to *The Face* that I was refusing to run. I said, "Why do we want to run pictures of Linda Evangelista or Tatjana Patitz when we need to cut out our own thing, for our own audience?"'[9]

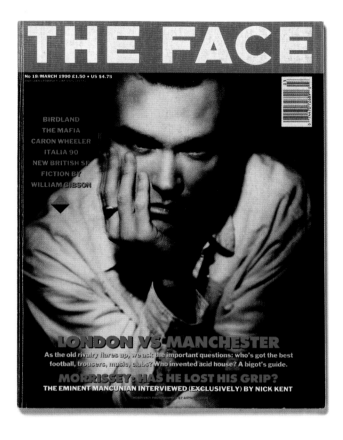

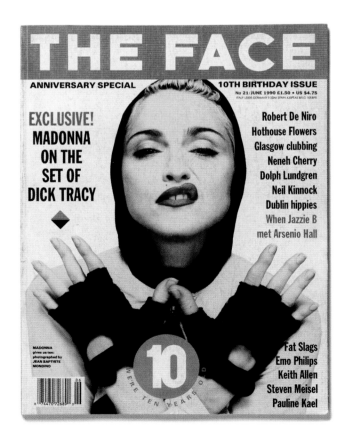

Garratt recalls: 'Phil consciously started looking for new people. What Buffalo had achieved was genius, we recognized that, and those people continued to contribute strongly to the magazine, but we also felt that there was a certain look which had been done. You'd go to the Wag club and everyone would be [purses lips] like they were sucking lemons, whereas the places I preferred were full of people waving their arms about, giving you sweaty hugs with smiles on their faces. I felt the fashion should reflect that. It was like going from black and white to colour. In fact, some of Corinne's best stories were in black and white but they had a warmth and energy which seemed to sum up the new mood.'

opposite
Report on the Stone Roses' Spike Island gig in the special issue 'The 3rd Summer of Love', vol. 2, no. 22, July 1990.

left
Vol. 2, no. 21, June 1990.

above
Vol. 2, no. 18, March 1990.

Garratt refuses to steal Bicker's thunder in terms of his nurturing of a new photographic language for fashion. 'I would hate to take credit for this; in fact I didn't like a lot of those photographs when they first came in,' she admits. 'I was like, "Why are they looking like they dressed at a jumble sale?" and "Where are the credits for the captions?" It could be all over the place so Phil and I argued a lot. But he was right, I saw that pretty soon afterwards. It was Phil's vision, developed on his own by working with them.'[10]

Photographs of Kate Moss taken by Day had already been featured in *The Face* after Day had visited Bicker and shown him some of her work, including a photograph of a young couple on the streets of Ickenham, a south-east London suburb, coincidentally not far from where Bicker was brought up. The girl in the photograph was Moss.

'We both felt it could be interesting to build a story around her,' said Bicker. 'I feel that Corinne saw herself in Kate while I saw in Kate someone that the readership of the magazine could identify with. A few months passed and I was putting together a story featuring images from a number of young emerging photographers and I included the couple shot of Corinne's.'[11]

Garratt remembers Bicker evangelizing on behalf of Moss at that stage. 'He shoved this Polaroid in front of me and said, "This is the girl, We should have her as the face of *The Face*". I was well up for it.'[12] Consequently, Moss debuted on the cover of the magazine for the May 1990 issue, clutching a football with an Italia '90 scarf as part of a preview of that year's World Cup.

However, Bicker did not entrust the shoot to Day; instead he commissioned Mark Lebon, who had been one of the Buffalo crew. Day was outraged. Lebon's photograph lacked impact. 'That wasn't a great cover; Kate really isn't herself,' Bicker later admitted.[13] As a result Day was invited by Bicker to work with Moss on an editorial for the upcoming '3rd Summer of Love' issue. For the shoot at Camber Sands on Britain's south coast, stylist Melanie Ward sourced a feathered crown from World, the eclectic central London boutique operated by clubland elders Michael and Gerlinde Kostiff. Ward later agreed that Moss 'didn't much look like a model. Now she's seen as a classic beauty, but at the time people didn't relate to her like that. In a way, so many boundaries were broken when Phil Bicker published her on the front cover of *The Face*.'[14]

above
Vol. 2, no. 20, May 1990.

opposite
Vol. 2, no. 22, July 1990.

For Bicker, the appeal of the photographs lay in the fact that the images 'felt as much a portrait study as a conventional fashion story. The understated styling, Kate's body type and attitude projected a believable image and were the antithesis of the artifice exhibited by the supermodels of the day.'[15]

The editorial team arrived at the July 1990 cover using the by-now tested process of worrying away at an idea until it came good. 'I'm telling you now, we hadn't a clue what to put on the cover,' says Sheryl Garratt. The summer of love theme for the issue had developed across a number of commissions, including a report from a May Bank Holiday gig played by the Stone Roses at Spike Island, near Widnes in Cheshire. 'I thought we would find something in the crowd at Spike Island which would sum it all up, but the pictures weren't good enough. It may be seen as momentous now but to me at the time Spike Island was a bit of a damp squib,' says Garratt.

The issue contained a Q&A with Sandra Bernhard, so a cover was mocked up using a Herb Ritts portrait of the American comic actor. 'It looked great but wasn't right. Then Phil started to work with this particular image from Corinne's fashion story,' recalls Garratt. 'Suddenly, he cut out the feathers in Kate's headdress around the logo and all three of us – me, Phil and Nick – knew it was the one. There was something irreverent about the way he had cropped it, and something about her face which summed up how we all felt.'[16]

THE FACE

No 22/JULY 1990 £1.50 • US $4.75
ITALY L5500 GERMANY 9.5DM SPAIN 435PTAS BELG. 105 BFR

THE 3RD SUMMER OF LOVE

Stone Roses on Spike Island, an A-Z of the new bands, Daisy Age fashion, Hendrix and psychedelia

'Kiss my butt!' Sandra on Madonna

Prince in Minneapolis: tour preview

Indian summer: photography Corinne Day

JOHN WATERS / MICKEY ROURKE / MARSHALL JEFFERSON / TIM ROTH

0 74470 72689 0 07

Nick Logan's memory chimes with this account: 'We didn't have a cover but, on seeing what Phil had done with the photographs, Sheryl said she had features that could be pulled together under the banner of "The 3rd Summer of Love" – that was the brilliant move.'

The American writer Glenn O'Brien – who worked with Corinne Day as director of Barney's advertising campaigns with Ronnie Cooke-Newhouse (a founding editor of the original *Details* magazine in the 1980s as well as wife of Condé Nast chairman Jonathan Newhouse) – noted that Day's fashion photography for that project made the layouts 'look pretentious. She was not an artificer or a narrator. Basically she took candids. Corinne was not concerned with the usual idea of luxury that permeate images of fashion or style.'[17]

As Day's photographs of Moss challenged female fashion archetypes, so David Sims's 'Back to Life' story in the November 1990 issue revolved around an unconventional male subject

above
Vol. 2, no. 24, September 1990.

right
Vol. 2, no. 26, November 1990.

opposite
'Back to Life', vol. 2, no. 26.

named 'Rev'. Lank-haired and styled by Ward against a white background, Rev 'looked like a gypsy, clad in his own ill-fitting secondhand pinstripes and knitwear, as he alternately floated, posed and cut a graphic figure', according to Bicker.[18]

'There was a desire for realness, for something authentic that coincided with this style of photography and also with grunge,' says Nick Knight, then commissioning the same photographers at *i-D*. 'Brands like Gaultier and Versace seemed out of touch, particularly to sixteen-year-olds without any money. That's one of the reasons why these pictures were so appealing.'[19]

The new young breed of fashion photographers could often be pushy, and they tested the commissioning editors' patience with demands for more editorial space; several sources tell the story of Day locking herself in the office lavatory at *The Face* and refusing to leave for hours until she received the number of pages she wanted for a particular shoot.

There are some connected to *The Face* who believe that the attitude expressed by such actions is indicative of an aspect that threatened to impair the magazine's offer. 'There are certain periods from hereon in where you can see art directors bowing to pressure from photographers who have become too powerful', reveals one insider. 'What happens then is that issues became dominated by photography at the expense of other important elements.'

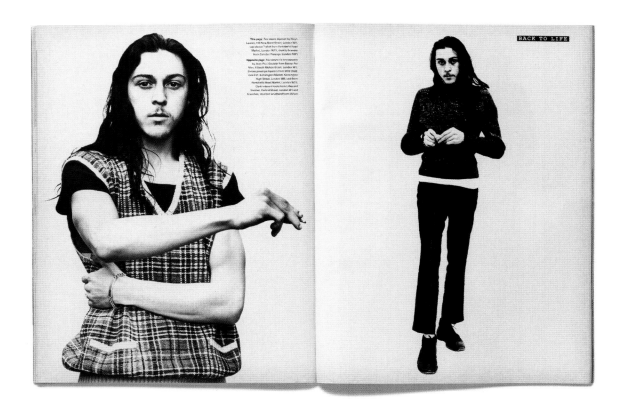

Knight agrees: 'That new breed may have breathed life into *i-D* and *The Face* but because they were commanding – and demanding – so much attention, they weren't too understanding about what makes a great magazine. That comes from a balance and a relationship of mutual trust between the editor, the graphic designer, the writer and the photographer.'[20] Nevertheless, the sometimes uncompromising attitudes expressed by young photographers such as Day were a small price to pay for enabling *The Face*'s access to their work, which transformed the magazine's fortunes.

According to Logan, this was 'always an issue' and that he had already been forced to rein in the likes of Ray Petri and Jamie Morgan. 'Fashion people live in a bubble,' explains Logan. 'I remember Robin [Derrick] working on an end-of-year review, tracing a layout of the Space Shuttle Challenger which had exploded. A stylist watched him with curiosity and asked what it was. When Robin explained, she gasped, "Gosh, they kept that quiet, didn't they?" Welcome to Planet Fashion.'

And Logan concurs with Knight: 'Running an unedited fashion shoot would have not only been at the expense of other areas of coverage but we had to shift copies from the shelves in WHSmith Northampton rather than delight somebody's mates in Notting Hill or Milan.'[21]

For the most part the balance was maintained, not least because the open-plan nature of the magazine's office meant that an atmosphere developed that allowed for input from all members of staff. 'We worked in a collaborative way,' confirms Garratt. 'If Phil was having a conversation with a photographer about a particular shoot or a stylist about a fashion story, I was ten feet away on the balcony so could hear every word. And if I was on the phone negotiating a cover story we wouldn't need to have a long meeting about it later; Phil would have heard and understood what was going on. We would all see and hear when people dropped by to show us their clothes designs or play us a new record.'[22]

Garratt and Bicker benefited from their shared history at the by now folded *City Limits*. 'We had similar ideas,' says Garratt. 'He had his own vision as an art director and I had my ideas about commissioning but we understood each other.'

Meanwhile, Logan fulfilled the role of the editor/publisher who trusted his staff implicitly, involving himself in seeing the magazine through the production cycle all the while having oversight of the rhythm of each issue. 'By this time Nick would suggest the odd piece but largely leave us to get on with commissioning and designing,' says Garratt.

'Nick's genius lies in his amazing eye for detail. He would look through a five-page feature and say, "There's nothing on page four making you want to turn to page five." He had a way of understanding where the reader's eye would go on the page, what would make a spread inviting to look at and read.'[23]

THE 3RD SUMMER OF LOVE

Text **SIMON DUDFIELD** Photography **KEVIN DAVIES**

Boys Own fanzine is the nearest the scally army get to a bible, casting a sharp, satirical eye over football, fashion and clubland. Footballers like Portuguese striker Eusebio (above) have unwittingly lent their names to bands. The Paris Angels (opposite) are part of a new generation of Manchester musicians

drug which turned a generation, created a new culture and united an attitude: our A-Z guide is an alphabet game, but in reality everything began with an E. Mobilised by the acid/Balearic boom, set free by an uncaring government, football mad: all over the country, people are doing it in good style. New Order's "World In Motion", with its football chants, dippy love lyrics and English beat, could be their anthem; after clearing out the Heathrow duty free shop, the Albanian squad definitely became their team. To some, these bands fusing dance beats, indie thrash and Sixties psychedelia are just football thugs with flowers, white hooligans who are draining the soul from the nation's dancefloors. to the matt black Eighties. Where they'll all be signed before they're ready, hyped before they moment, just enjoy: with their casual clothes, trousers, these space cadets are the sound of

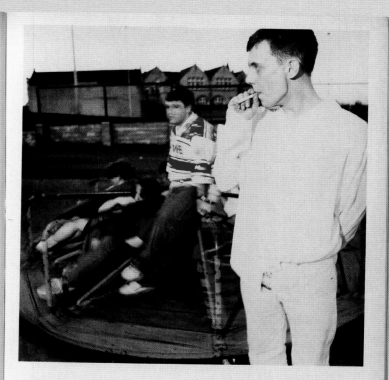

To others, they're a fresh start, a colourful antidote next year is anyone's guess: many are being wined and have finished writing their second song. But for the bowl-shaped haircuts, and ethics as wide as their summer 1990, the only ones doing it NOW . . .

above and opposite
'A–Z' in the special issue 'The 3rd Summer of Love', vol. 2, no. 22, July 1990.

overleaf
Report on the Stone Roses' Spike Island gig in 'The 3rd Summer of Love' issue.

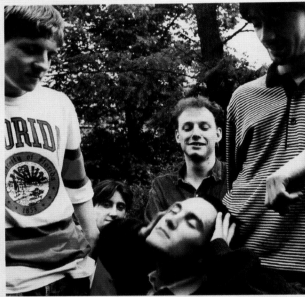

Music press cover features but no record yet: are Flowered Up really London's answer to Happy Mondays?

Asia Fields Have supported Inspiral Carpets and hail from Manchester. Guitar-based but dance-orientated, which for now means the involvement of maracas. Debut single out this month on their own Frank label

Altobelli beards As sported by the Italian international of that name (below). Owe current popularity to Shaun Ryder, notwithstanding the fact that his version is less Altobelli than Shaggy from *Scooby Doo*. Which proves the point that you probably have to be a footballer to pull it off

Altobelli Shaggy Billy

Boy's Own Famed fanzine put together by Terry Farley, Andy Weatherall and Oldham centre-forward Frank Bunn. Masterful remixers and DJs, whatever they say usually goes; rumoured to have started the Kicker revival as a joke

Bridewell Taxis Six hardcase Leeds lads who take their name from the police vans that ferry miscreants to the local lock-up in their hometown. Missed out geographically but did support the Stone Roses and Happy Mondays ages ago. Also one of the first of the new breed to get a single out – "Whole Dance Nation" proved they could actually deliver. "Honesty" will be their next, while a "Just Good Friends" EP is kicking around now. "You really have to push the point to say, no, we don't feel part of something, but to each band the differences are important. You can call us 'scally rock' if you like, but we're casuals"

The Charlatans Pictured above, this lot boast Stone Roses' vocal and Inspirals' organ. Bound to be massive, the Haircut 100 of the new wave. Their debut, "Indian Rope", came disguised as dance but definitely rocked. They have the added advantage of having Mick Jagger's son with a bowl haircut on vocals. They've always worn flares, we're told, so how come in April they had duffle-coats, shit army jackets and white Lee jeans? Their current single, "The Only One I Know", is well good and a step in the right direction

Candy Flip From Stoke: appalling flares, annoying lisps, topped off with serious haircuts. Achieved the dreamy vocals on "Strawberry Fields" by singing through a kettle. One-hit wonders with a good story behind their name, but I can't say what. (Editor's note: a candy flip is a mix of acid and ecstacy not recommended to those who value their health or sanity)

Centre-partings As in the London derivative of Manchester's most popular barnet; "Oi centre-parting, what's your transfer fee?" "You what?" "Get your haircut and you might be able to hear properly." Again, popularised by Happy Mondays' Shaun Ryder, who perhaps illustrates the dangers of such a cut

Duck Call The Midlands' first club magazine. Do things actually kick off in the Midlands? Apparently so. Inspired by *Boy's Own*, it buzzes with raw energy and creativity. But by far the best bit is their advocation of making duck noises everywhere

Eusebio (above) Great name – after the legendary Portuguese striker (having rejected the alternative, Karl-Heinze Rumenigge). Championed flares on the east coast. Described as 'Happy Mondays shag P-Funk', their demo, "Accept Your Lips", shows them to be every bit as fast and skilful as their footballing namesake

Ecstacy Drug which set the whole thing in motion and made 'the white boys dance'. The *Boy's Own* DJs have stopped taking it and are now just into draw, and it's not coincidental that they have also tried to reduce the BPMs on the dancefloor

Flowered Up Top lads. Get some good grooves going and then Liam shouts loudly in a Cockney accent of his hooligan exploits. Brilliant. Have aggravated numerous clubbers whose closest scrapes with the terraces came from watching *Match Of The Day*, and for this they should be applauded. Undoubtedly fired up by Manchester, their, ahem, cross-pollination of dance and rock is set to be massive even if they really are crap. Only two demo tapes exist, but a debut single, "It's On", is due out on the Heavenly label mid-July

Freaky Dancing Manchester fanzine that's calmed down a bit since its first two issues, which were so drug-orientated you tripped just reading them

Five Thirty Most open of all the new London bands. Old mods who took to Manchester in a big way. Cracking songs, with a single, "Abstain", out now on East West

Fluke Unknown Peruvians from Beaconsfield whose debut "Thumper" was one of last summer's Shoom tunes, and who now have a massive dance guitar-led instrumental, loosely based on Joni Mitchell's "Big Yellow Taxi" and the ethic that anyone can do it

Godfrey's Tonic Could this explain how The Beloved are freaky dancers when they used to be bedsit boys? Very dangerous stuff

Happy Mondays Undisputed heavyweight champs and undeniable heroes of the new culture. So popular you wouldn't be surprised if Shaun's dad spawned the biggest dance hit this summer. Partial to being a bit stupid, but handsome lads nonetheless

The High Pictured right, they hail from Brighton way. Their ethos being that even if your demo isn't very good, just look the part and become famous. Their debut single, "Box Set Go", is out now on London

Hooligans Even if you support Chelsea, pretend you're part of the firm and that you definitely won't be in on Saturday, and you'll probably be asked to join a band or spin a few records down at The Land of Oz club

Hacienda Most popular club in Europe, we're told. Melting pot for many an up and coming Manc band, though largely populated by wet fish

Inspiral Carpets (right) Oldham band who used to beat up their support acts on stage, run around naked and confess to being porn addicts. They are far better musically now, but quiet, well-mannered and looked after, and thus aren't as popular with their once faithful

Joe Bloggs Northern jeans/clothing company once associated with all the Manchester bands, though most have now moved on to more expensive things. Supposedly street wear for street groups, you wouldn't catch anyone wearing their gear now. Suffice to say when they open a shop in London, the haddocks will go apeshit over the stuff

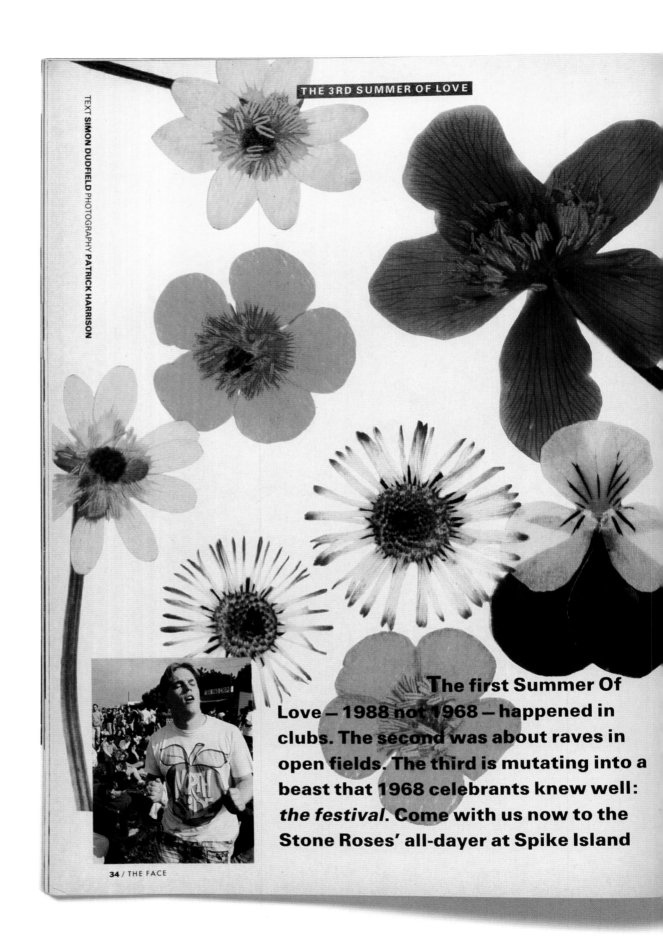

THE 3RD SUMMER OF LOVE

TEXT **SIMON DUDFIELD** PHOTOGRAPHY **PATRICK HARRISON**

The first Summer Of Love — 1988 not 1968 — happened in clubs. The second was about raves in open fields. The third is mutating into a beast that 1968 celebrants knew well: *the festival*. Come with us now to the Stone Roses' all-dayer at Spike Island

34 / THE FACE

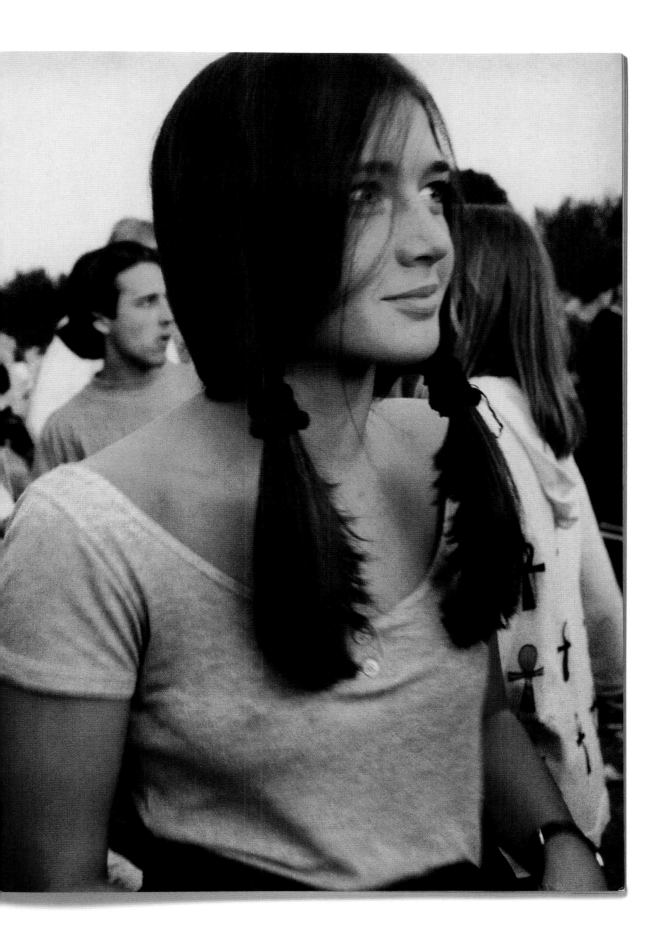

below, opposite and overleaf
'The Daisy Age' in the special issue, 'The 3rd
Summer of Love', vol. 2, no. 22, July 1990.

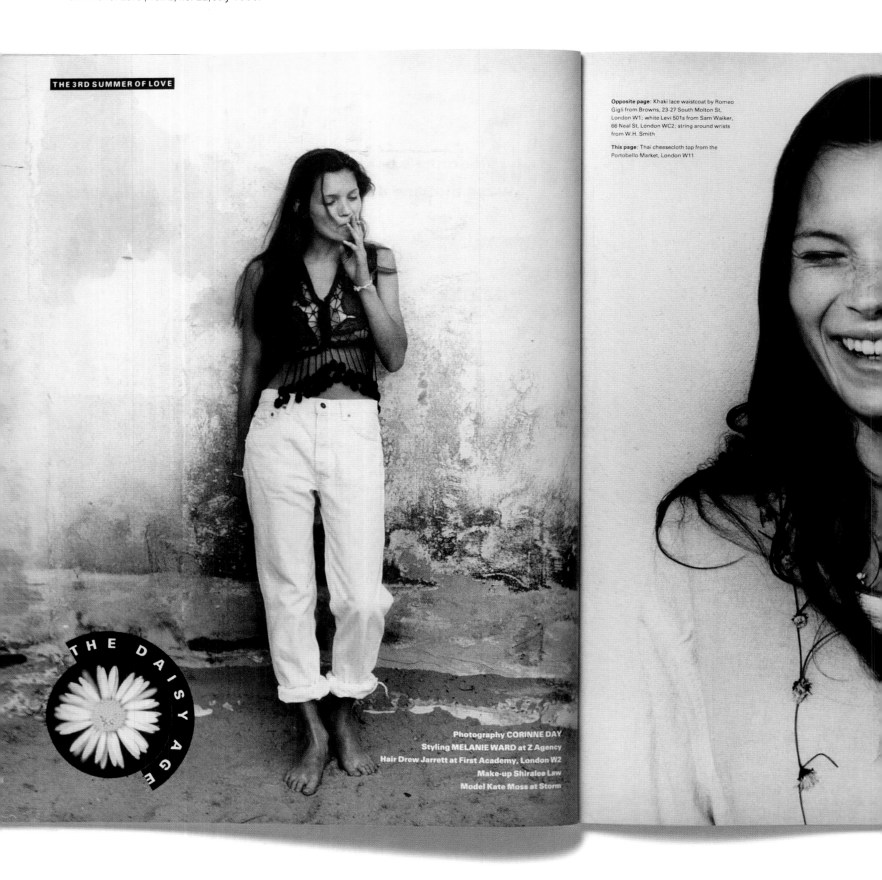

THE 3RD SUMMER OF LOVE

Opposite page: Khaki lace waistcoat by Romeo
Gigli from Browns, 23-27 South Molton St,
London W1; white Levi 501s from Sam Walker,
66 Neal St, London WC2; string around wrists
from W.H. Smith

This page: Thai cheesecloth top from the
Portobello Market, London W11

Photography CORINNE DAY
Styling MELANIE WARD at Z Agency
Hair Drew Jarrett at First Academy, London W2
Make-up Shiralee Law
Model Kate Moss at Storm

THE DAISY AGE

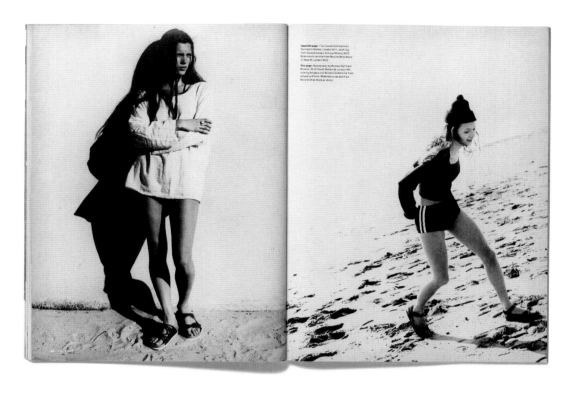

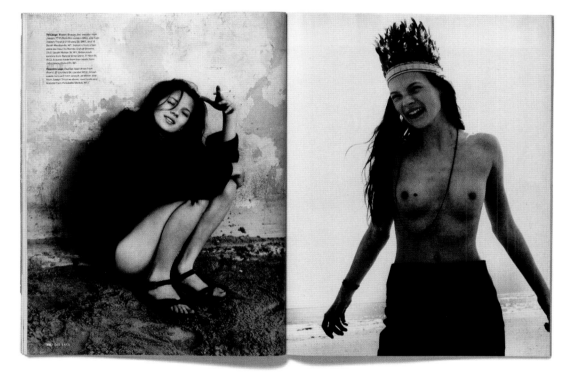

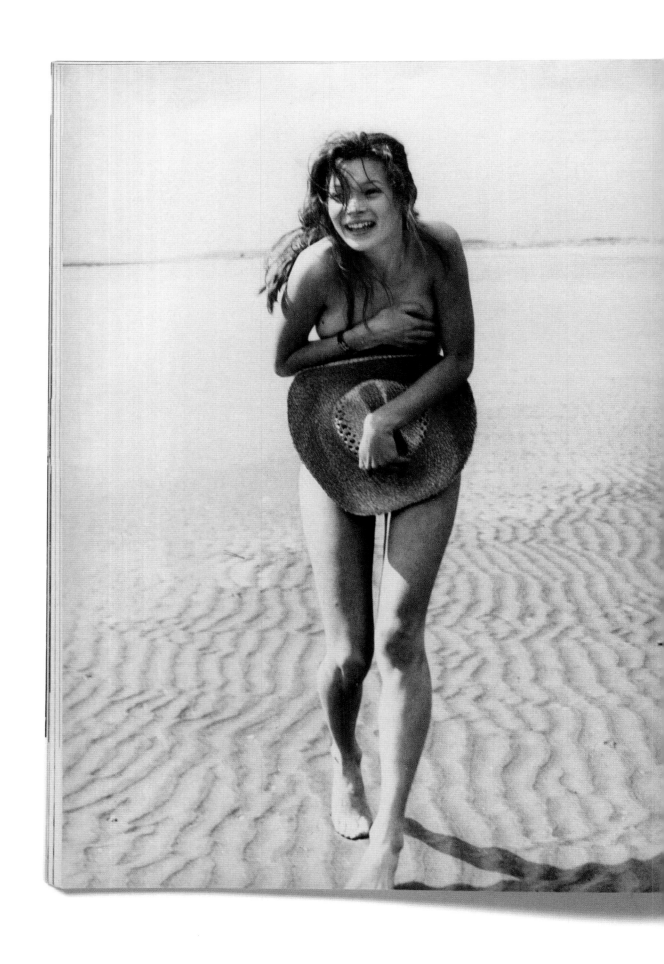

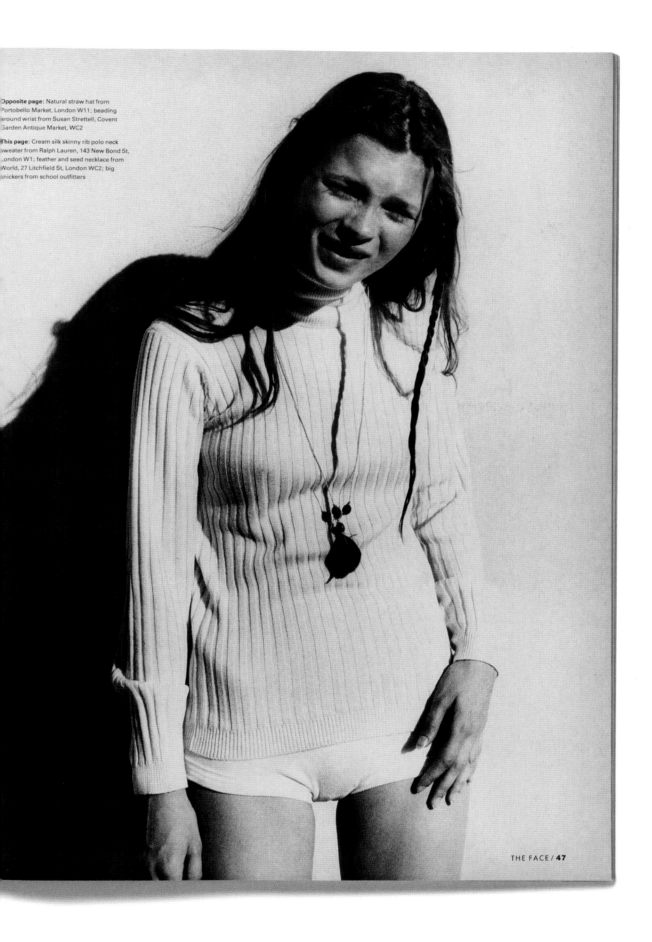

Opposite page: Natural straw hat from Portobello Market, London W11; beading around wrist from Susan Strettell, Covent Garden Antique Market, WC2

This page: Cream silk skinny rib polo neck sweater from Ralph Lauren, 143 New Bond St, London W1; feather and seed necklace from World, 27 Litchfield St, London WC2; big knickers from school outfitters

THE FACE / **47**

207

Chapter Nine

An Almanac of Cool

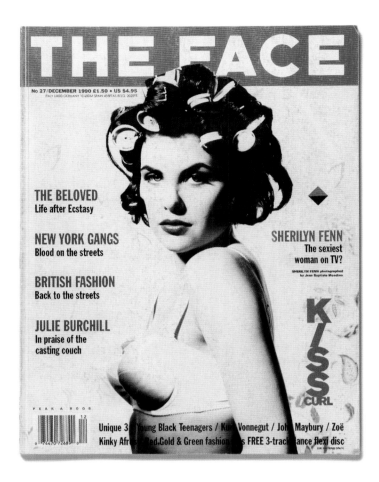

above
Vol. 2, no. 27, December 1990.

In 1990 Nick Logan's reputation as a media exemplar was sealed by British trade body the Periodical Publishers' Association's selection of him as the inaugural recipient of the Marcus Morris Award. Named for the venerated British publishing pioneer, the award was presented to Logan in recognition of his 'extraordinary leadership, skill and understanding as the man behind the outstanding success story of the 1980s – publishing for the teenage market'.[1]

Around this time art director Phil Bicker was chosen to guest edit an issue of the *British Journal of Photography*, which noted that *The Face* had remained 'one step ahead of its many imitators by growing up along with its readers.... [It] has been an almanac of cool, offering something to digest that has a little more fibre than the bland, patronizing pap served up by the average "teen mag"'.[2]

Soon the crossover of the raw, young talent nurtured by the magazine into the mainstream fashion business began

in earnest: New York department store Barney's had booked Corinne Day for a campaign off the back of her work for *The Face*, while *Harper's Bazaar* creative director Fabien Baron and then Calvin Klein snapped up David Sims (who has described the 'major rush to grab any young English photographer that was around'[3]). In this way, *The Face* was influential in altering perceptions about the use of photography in fashion advertising. Sims later said he felt 'somewhere in advertising there was an opportunity to put out something positive. You might be able to do that in your casting or the way the models appeared to be... there's an open door for doing something good, progressive and exciting.'[4]

Behind the scenes, Wagadon had been rocked by news of Nick Logan's ill-health. A few weeks before the announcement of the Marcus Morris Award, he was diagnosed with a rare cancer of the jawbone. Beyond the publishing company's small team and a tight-knit circle of friends, the wider world was kept unaware of the diagnosis, which had serious ramifications given that Logan was the hands-on editor of *Arena* and *The Face* as well as the owner of the company. Former features editor Lesley White, then working for women's monthly magazine *Mirabella*, is not alone in speculating as to whether the condition had been exacerbated by the physically punishing dedication Logan had poured into *The Face* and *Arena* over the previous decade. 'He was whippet-thin, smoking all the time and working all the hours he could,' says White. 'He looked good doing it, I must say, but I wonder whether it did him any good.'[5]

In order to receive treatment, Logan took a sabbatical for nine months, handing over the reins of *The Face* to features editor Sheryl Garratt and *Arena* to deputy editor Dylan Jones. 'Nick offered me the title of editor while he was away but I didn't want it,' says Garratt. 'By then working at *The Face* was the most important thing in the world; it was my life. Nick had always been the editor. To take him off the masthead while he was ill would have been wrong.'[6]

During Logan's absence, the staff pulled together. 'Obviously we were all very sad,' says Lindsay Baker, by then features editor. 'It was a difficult time for the Logan family, and because we were such a small set-up, it was difficult for the rest of us as well. But *The Face* was such an interesting place because you felt a sense of family within that work environment, and that's one of the things which drove us on.'[7]

Garratt agrees. 'We just got on with it,' she emphasizes. 'Everyone who worked at *The Face* was slightly loony, in that you would stay in the office all night if necessary. Personal relationships often came second. To us this was everything.' Garratt identifies the recently recruited Charles Gant as a key staff member in this period. 'We had a proper production editor; he made such a difference, not least in relieving that pressure

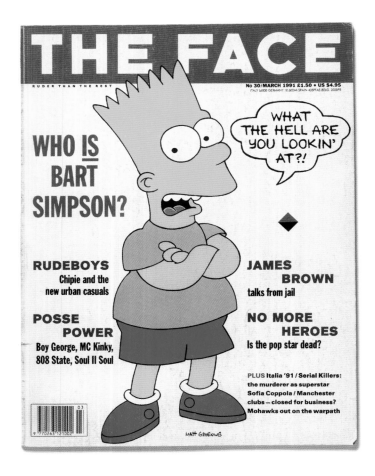

above
Vol. 2, no. 30, March 1991.

from me,' says Garratt. 'I couldn't have edited the magazine while Nick was away and been in Queen's Park at the same time.'

Gant had arrived from trade paper *Design Week*. 'My perception was that the surge of the 1980s was over and that sales had dipped,' says Gant. 'It seemed to me that Sheryl was not interested in managing the decline but wanted to go ambitiously for more readers and had persuaded Nick to invest in the editorial team.'[8] Hence Gant's recruitment as well as that of *i-D* editor John Godfrey, who became Garratt's deputy.

While she was uncomfortable with the circumstances in which editorial control had been granted, Garratt was now able to pursue her vision for *The Face* in the new decade. 'The arrival of acid house gave the magazine a real sense of direction,' Garratt told a journalist in the mid-1990s. 'It really pissed off the last of the Eighties types who wanted it still to be about matt-black gadgets. But gradually it built up.'[9]

Garratt was assisted in the construction of the fresh direction for the magazine with input from new contributors, in particular Ashley Heath, whose career started with *The Face* after he pitched ideas while on the postgraduate journalism course at London's City University. Heath (who is now a powerhouse of British fashion publishing as owner of *Arena Homme Plus* and sister title *POP*) had been an avid reader since his early teens: 'As a school-kid in Brighton it was like Wikipedia to me; every month I'd pick up a copy and understand two things but come across two hundred more which I would investigate and then join the dots between them all.'

Garratt commissioned Heath to write about a group of British surfing environmental activists protesting the spread of marine litter and untreated waste. 'I remember going to buy that issue; seeing my name on the piece was – as ridiculous as it might sound – like hearing your song on the radio for the first time if you're a musician,' says Heath. 'I'd grown up reading Robert Elms, Julie Burchill and Tony Parsons. In a way I was more excited to meet them than I was about meeting pop stars.'[10]

When he graduated and started to work on fashion trade titles owned by publisher International Thompson, Heath continued to regularly file pieces, determined to become a part of the team. 'I'm very much of that generation that grew up with *The Face*, and I'd seen how much it had changed the media,' Heath said in the 1990s. 'I saw the boom in Sunday supplements, and the way other glossy magazines had improved as a result of *The Face*'s influence. I'd also always looked at *Vogue* and *Tatler*, and was quite inspired by them, but in the end I thought, "Really, what I want to do is work at *The Face*".'[11]

Not long after the publication of 'The 3rd Summer of Love' issue (see pages 197, 200–206), Garratt recruited editorial assistant Amy Raphael, another graduate of City University's journalism course. She had previously completed a two-week work placement at the magazine while still at college. 'I was quite taken aback at how tiny the staff was,' says Raphael, an author whose subjects have included film director Danny Boyle and comic actor Steve Coogan. 'I was also amazed that I could not only be around meetings where decisions were made about who was on the cover of the next issue but also contribute to them.'

Raphael says that Garratt became her mentor. 'I suppose Sheryl recognized the grafter in me. I wasn't in love with fashion or clubbing but I was completely obsessed with indie and rock music, living with a guy who was in a band, going to gigs every night and to Glastonbury every year. They used to laugh at me, because Glastonbury definitely wasn't cool then.'

The editorial team was distinguished by a spirit of openness, says Raphael. 'You know that thing that kids do,

covering their homework with their hands so no-one can copy them? It was the antithesis of that. I didn't get the impression when I arrived that people were worried about me stepping on their toes. It was more: "Great, we've got someone who is a hard-worker and is not only excited about stuff, but will pitch in and get things done"'.[12]

Raphael was given 'Intro' to edit and also worked with Derick Procope and Karl Templer, by this time contributing fashion editors, on their pages, which included, during that summer of the Italia '90 World Cup, a story incorporating football strips. 'Not being immersed in fashion it wasn't my area but I learnt a lot from them,' she adds.

When he wasn't engaged in his production duties, Gant was given the freedom to develop the magazine's film coverage, which had oscillated over the years. In the early days the critic Neil Norman had handled this beat, which coincided with the early to mid-1980s British cinema boom, and subsequently actors including Robert de Niro and Willem Dafoe had been cover stars. Latterly writers Steve Beard and Jim McClellan were contributing reviews, features and cover story interviews.

Working with Beard and McClellan, Gant initiated relationships with the Hollywood publicists and used the film release schedules to plan ahead by as much as a year. In this way he was hitting a moment in terms of British media; Emap had recently launched film monthly *Empire* under Neil Norman to cater to the growing appetite for movies as film distributors gained increasing international profile and independent cinemas sprang up around the country. 'I discovered I was pushing at an open door,' says Gant. 'While the publicists may not have been aware of *The Face*, often their clients were, and wanted to be in the magazine because they thought it was cool.'[13] As a result, over the next few years *The Face* became an early showcase for the likes of Brad Pitt, Leonardo Di Caprio, Ethan Hawke, Christina Ricci and Christian Slater.

However, the appearance of Nicolas Cage on the cover of the August 1990 issue occasioned a rare occurrence at the Wagadon title: a front-page howler in the form of a misspelling of the actor's first name (with the 'h' included). 'I remember the horror when the issues came back and it was too late to do anything,' says Raphael.

The Cage feature was commissioned before Gant had begun to work on expanding the magazine's film coverage. As he set about that, all the while concentrating on his role

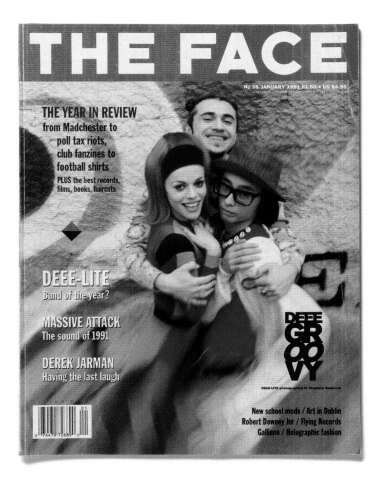

above

Vol. 2, no. 28, January 1991.

as production editor, Raphael's musical interests were coinciding with the early days of the 1990s indie rock boom in Britain. Having written a small article about Oxford shoe-gazers Ride, her first substantial feature profiled 'Madchester' act James. Raphael was also a fan of alternative comedy, and ensured that there was space in the magazine for performers including Frank Skinner, who won the Perrier Comedy Award at the Edinburgh Festival. 'The timing was right for me,' says Raphael. 'Nobody else on the magazine was going to Glastonbury or Edinburgh, or was interested in what became known as grunge. But they were on my radar and I was given a chance to write about them.'[14]

In fact, it was Raphael who brought Richard Benson on board as a contributor. In November 1990, Benson, the son of a Yorkshire pig farmer, made his first visit to *The Face* offices to hook up with Raphael and travel with a press posse to an era-defining event billed as 'The Rave in a Cave'. The young post-acid rock group EMF had captured the attention of the tabloids (their acronym stood for Ecstasy Mother Fucker) and that night played a gig in a suitably off-the-map location, Clearwell Caves in the group's native Forest of Dean in Gloucestershire.

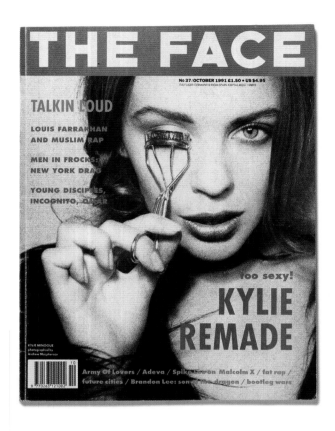

pages 220–21) in August. These developed the themes of youthful optimism and unadorned female friendship as expressed by the previous year's 'The 3rd Summer of Love' cover and triggered widespread interest in Day and Moss. 'It felt like a time for smiling rather than pouting, for bright colours and openness and also for something more natural and real,' said Garratt later. 'Corinne Day's images tapped into this very clearly.'[16]

The magazine's staff also benefited from the era's relative freedoms of celebrity access. 'I bumped into Christian Slater at a party and he complained that we never featured him even though he was an avid reader,' recalls Garratt. 'I told him that his publicist had always turned us down flat, so he gave me his phone number and we made it happen. That type of thing occurred for quite a while until the rise of the PRs a few years later when access became such an issue and you were beholden to a publicist thousands of miles away in LA.'[17]

In the late summer of 1991 Nick Logan returned to work, his cancer in remission after sustained treatment and surgery and eager to assume the role of editorial director overseeing the teams at *The Face* and *Arena* respectively headed by Garratt and Jones. All seemed set for the future.

According to Benson, Wagadon's offices 'felt very cluttered, quite intense, an interesting space and much smaller than I had expected. People seemed busy but it wasn't unfriendly, though there was a sense of crisis. There was an aspect of all hands to the pump.'[15]

Benson was called upon to lend his hands, and soon expanded his focus away from music into articles about architectural theoreticians including Zaha Hadid and football strips cast in the style of the dominant cutting-edge nightclubs of the day.

In 1991, Garratt's decision to go all-out started to pay off as circulation increased. The fusion of fresh photographic approaches with this solid editorial line once again came to fruition with significant and carefree fashion shoots by Corinne Day of Kate Moss, first in the February issue with 'Heaven is Real' (see pages 216–17) featuring another model, Lorraine Pascal, and then as the solo subject in the story entitled 'Borneo' (and shot during travels on the Asian island; see

above
Vol. 2, no. 37, October 1991.

right
Vol. 2, no. 33, June 1991.

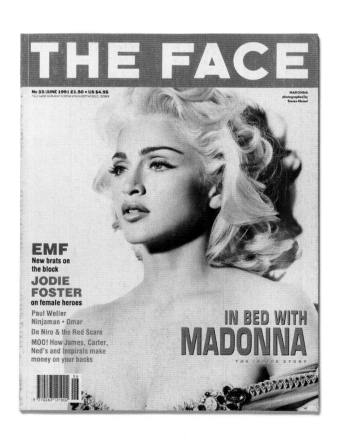

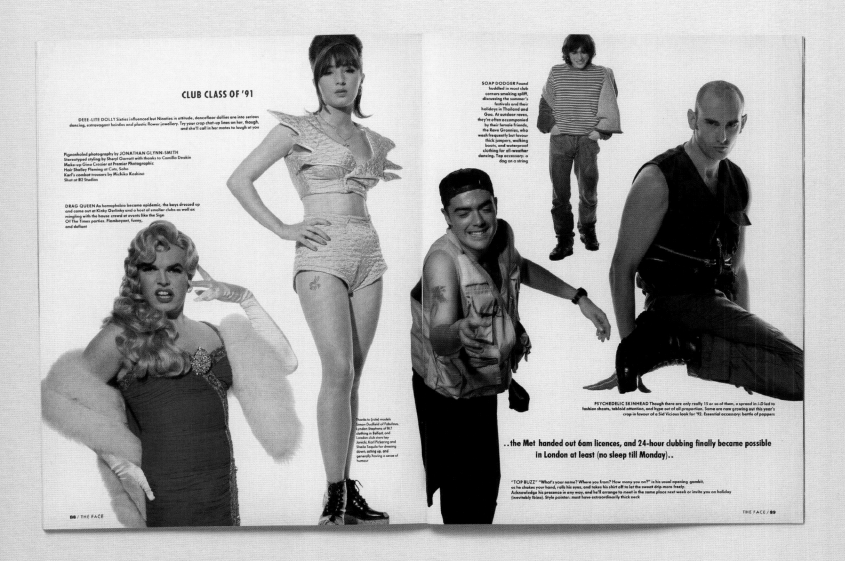

CLUB CLASS OF '91

DEEE-LITE DOLLY Sixties influenced but Nineties in attitude, dancefloor dollies are into serious dancing, extravagant hairdos and plastic flower jewellery. Try your crap chat-up lines on her, though, and she'll call in her mates to laugh at you

Pigeonholed photography by JONATHAN GLYNN-SMITH
Stereotyped styling by Sheryl Garratt with thanks to Camilla Deakin
Make-up Gina Crozier at Premier Photographic
Hair Shelley Fleming at Cuts, Soho
Karl's combat trousers by Michiko Koshino
Shot at B2 Studios

DRAG QUEEN As homophobia became epidemic, the boys dressed up and came out at Kinky Gerlinky and a host of smaller clubs as well as mingling with the house crowd at events like the Sign Of The Times parties. Flamboyant, funny, and defiant

Thanks to (role) models Simon Dudfield of Fabulous, Lyndon Stephens of BLT clothing in Belfast, and London club stars Izzy Janicki, Karl Pickering and Sheila Tequila for dressing down, acting up, and generally having a sense of humour

SOAP DODGER Found huddled in most club corners smoking spliff, discussing the summer's festivals and their holidays in Thailand and Goa. At outdoor raves, they're often accompanied by their female friends, the Rave Grannies, who wash frequently but favour thick jumpers, walking boots, and waterproof clothing for all-weather dancing. Top accessory: a dog on a string

PSYCHEDELIC SKINHEAD Though there are only really 15 or so of them, a spread in i-D led to fashion shoots, tabloid attention, and hype out of all proportion. Some are now growing out this year's crop in favour of a Sid Vicious look for '92. Essential accessory: bottle of poppers

..the Met handed out 6am licences, and 24-hour clubbing finally became possible in London at least (no sleep till Monday)..

"TOP BUZZ" "What's your name? Where you from? How many you on?" is his usual opening gambit, as he shakes your hand, rolls his eyes, and takes his shirt off to let the sweat drip more freely. Acknowledge his presence in any way, and he'll arrange to meet in the same place next week or invite you on holiday (inevitably Ibiza). Style pointer: must have extraordinarily thick neck

88 / THE FACE

THE FACE / 89

above
'Club Class of '91', vol. 2, no. 40, January 1992.

overleaf
'Kinky Afro', vol. 2, no. 27, December 1990.

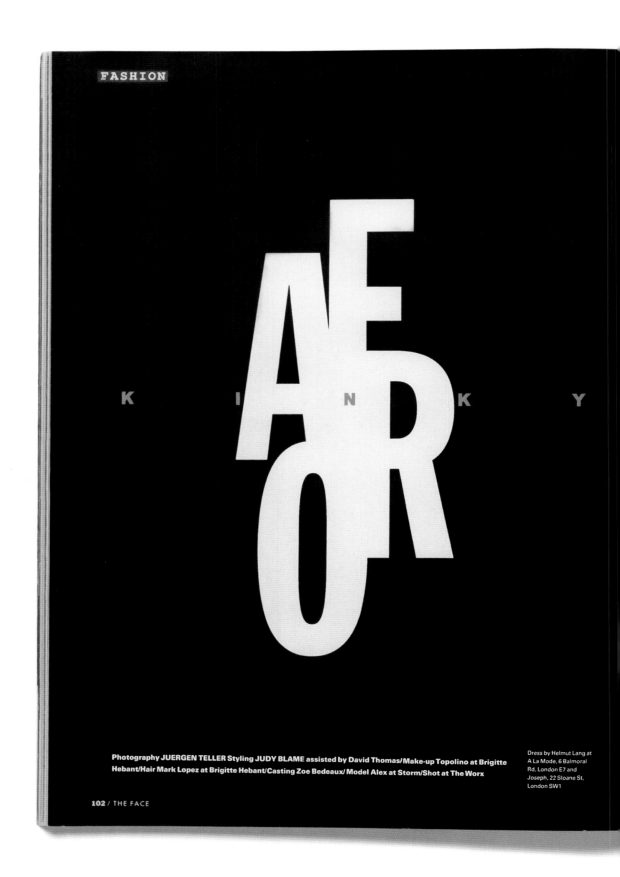

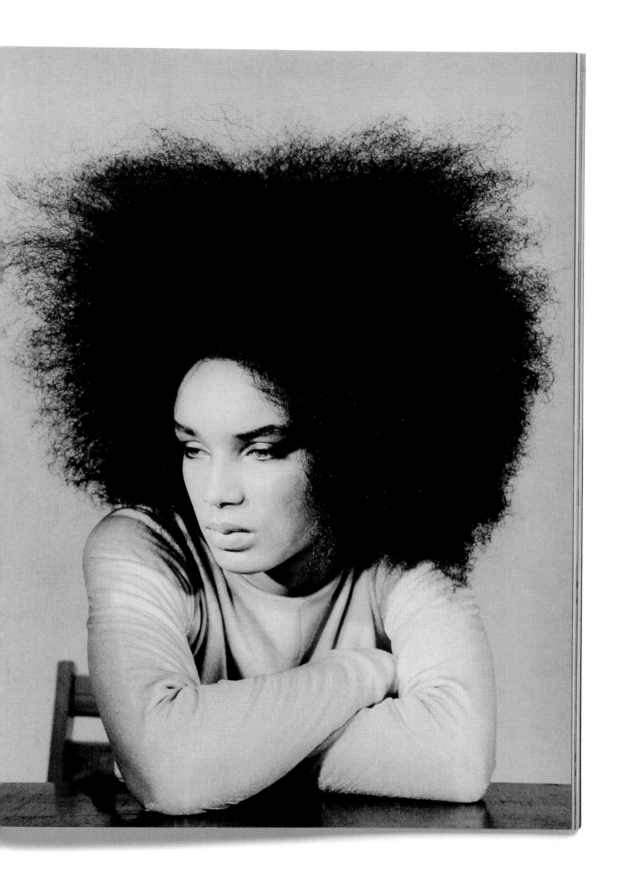

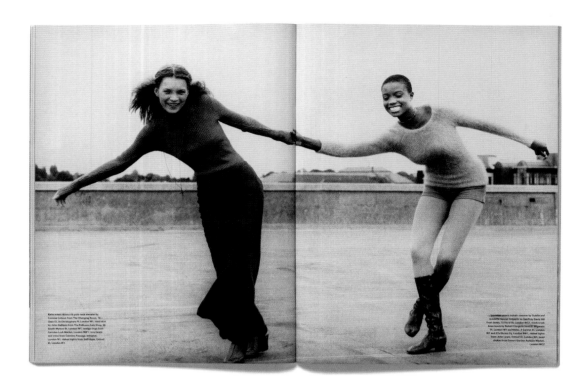

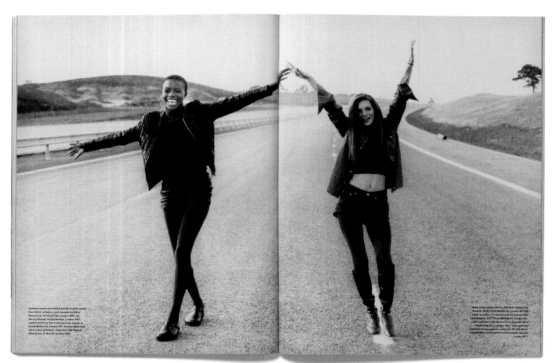

HIGH ON LIFE

opposite and below
'Heaven is Real', vol. 2, no. 29, February 1991.

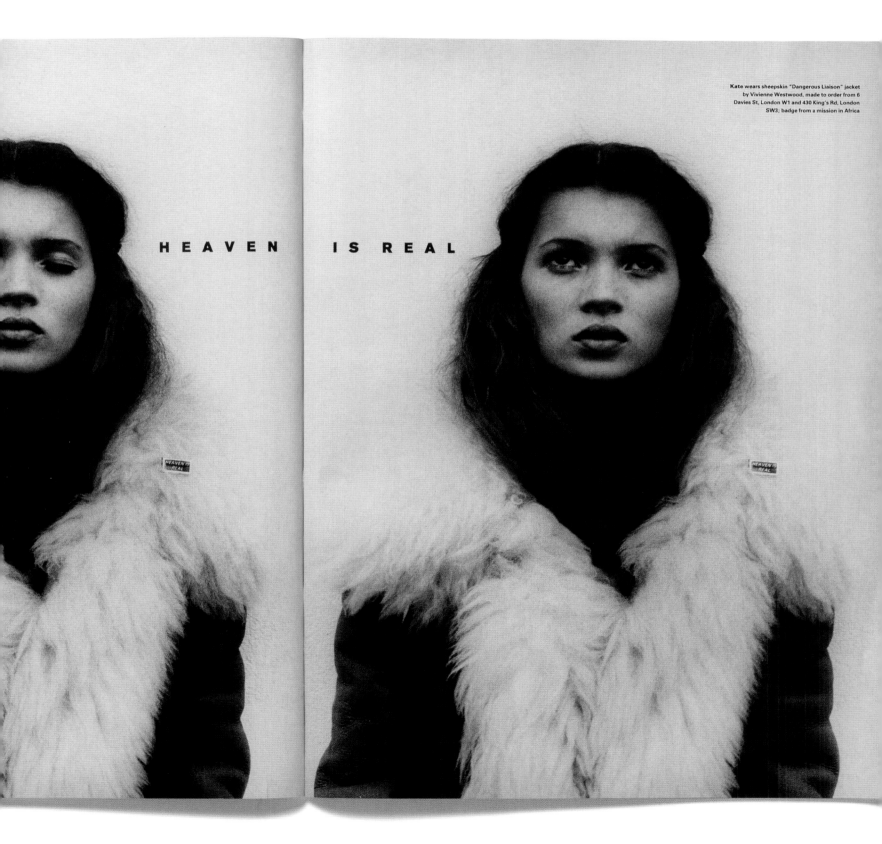

Kate wears sheepskin "Dangerous Liaison" jacket by Vivienne Westwood, made to order from 6 Davies St, London W1 and 430 King's Rd, London SW3; badge from a mission in Africa

HEAVEN IS REAL

SMART DRUGS Text **MARK HELEY** Illustration **JOHN HERSEY**

PILL POWER

Thick as two short planks? Take heart, **intelligence-boosting drugs** are on their way. Just as athletes pump up their bodies with steroids, it's now possible to take pills that **pump up your brain.** But are they any good? And are there risks?

Have you ever wished you were more intelligent? Health, strength and even beauty can be worked at, but brain power is different. Either you've got it or you haven't, right? But if it's possible to alter the genetic destiny of our bodies with drugs, why not that of our brains? Doctors in the USA now not only believe that this is possible, but that 'smart drugs' – drugs that improve cognition (thinking), memory and sensory perception – may soon become common.

Smart drugs have been around for a while, but many of them were developed for completely different purposes. The medical research establishment is by and large much more interested in finding agents that treat specific complaints or illnesses than in developing drugs that increase a patient's general sense of well-being. Only now are some medical researchers recognising cognitive enhancement as an area of awesome potential and venturing outside traditional territory, exploring and mapping these drugs' ability to enhance and influence all areas of perception.

This research has been given impetus by a ground swell of grass-roots interest in the USA. Easy-to-obtain brain-boosting agents like the nutrient Choline and the neuro-hormone Vasopressin are already being used by students in America to improve their performances in intelligence tests and exams, whetting their appetites for these new kinds of chemical stimuli.

But the growth of smart drugs has met with a decidedly mixed reception. Some pressure groups are calling for compulsory drug testing after exams to curb the use of cognitive enhancers, while other physicians and researchers want to see a liberalisation of what they see as powerful tools for self-improvement. Either way, it seems as if we may be about to witness the emergence of a new generation of drug users looking for vastly different chemical effects from anything that has gone before.

The appeal of smart drugs differs from that of recreational drugs in that they rarely offer any rush of pleasure or access dramatically altered states. They're also vastly different from medicinal drugs in that they are taken, in the large part, by people who have absolutely nothing wrong with them. Smart drugs are chemical agents that will, it is claimed, improve the whole range of neural performance from memory recall to the activity of sensory perception. Not all cognitive agents are necessarily drugs, however. Nutrients such as amino acids, vitamins, herbs and even some tree barks appear to have intelligence-increasing properties.

Much of the recent research is extremely encouraging for those people wanting to heighten their mental powers. But even in states like California, where prescriptions are available for most things and public awareness about smart drugs is high, most traditional doctors are unwilling to prescribe their use. Increasingly, however, a new type of doctor seems to be emerging with an awareness of the possibilities these agents offer. Dr Ward Dean, an anti-ageing researcher with a clinic in Florida and an associate of the Institute of Ageing Control and Nutritional Medicine is one such physician.

"My viewpoint differs from the standard medical approach in that I treat the ageing process as a disease, a disease that anyone over the age of 30 has effectively caught. I aim to treat the detriments of function caused by ageing, and cognitive functions are often some of the first to be affected. It also helps greatly that medicines which are cognitive enhancers also tend to be anti-ageing agents. A mild cerebral stimulant, for instance, can also often rejuvenate the body."

Dean prescribes a range of smart drugs including Hydergine (a drug that was discovered by Albert Hoffman at the same time he discovered LSD and is chemically similar to it) which "not only acts as an extremely effective intelligence-increasing agent, but also seems to protect the brain's tissues against ageing damage". It has also been shown to increase oxygen uptake by the brain and improve brain metabolism, effects that enhance thinking ▶

above
'Smart Drugs', vol. 2, no. 29, February 1991.

opposite
'Queer Bashes', vol. 2, no. 29, February 1991.

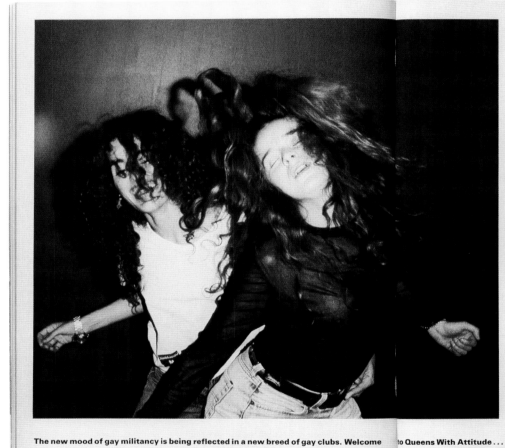

The new gay clone is wearing Duffer," says David, gesturing at the young, mixed crowd dancing through the dry ice and strobe lights of ff, a Sunday night club open (legally) until 5am. He is wearing a T-shirt that looks at first glance like an Inspiral Carpets design, but which is even more likely to get him arrested for obscenity: the words read "Queer As Fuck". Another clubber's slogan proclaims "QWA – Queens With Attitude", and one would-be entrepreneur declares he's thinking of printing shirts with the defiant slogan: "We don't die – we multiply". "There's a new mood now," he explains. "We don't want to hide any more."

As attacks on gay men increase at a frightening rate, the gay community is starting to react angrily to police indifference and take the offensive itself. In New York, vigilante group the Pink Panthers patrols the streets to keep gay areas free of queerbashers; in San Francisco, direct-action group Queer Nation is calling for violence to be met with violence; in Britain the OutRage activists are organising kiss-ins and fighting outdated laws which hold displays of affection between two people of the same sex to be illegal.

It's a new mood that is also reflected in the clubs, with a new generation of eclectic, funky, and positively gay clubs with names like Spunk, DMO, Queer Nation, Trade, Attitude and ff. With the same mixture of humour and defiance, one young DJ has been holding house parties he calls "queer bashes", and there is even talk of a huge benefit bash in London with attractions such as the lesbians who abseiled into the House of Commons.

The early acid/Balearic scene was an amiable mix of gay and straight, and stories of Millwall fans stroking each others' tattoos in bouts of Ecstasy-inspired affection became part of club lore. Disillusioned with the bland hi-NRG fare of most gay discos, Spunk promoter Wayne Shires began going out to Shoom and later to Charlie Chester's Sunday afternoon Queens club in Slough. Surprised by "the warmth these suburban, heterosexual types showed us", he began a Sunday night in a London gay venue for that crowd to move on to after Queens closed at 5pm. But, then, as dance-floors became more dominated by pony-tailed acieed lads, it evolved into the overtly gay Spunk, which may soon open up on a weekly basis, but at the

moment relies more on one-off, un-licensed parties: "Suddenly we were attracting a crowd who wanted to listen to decent, upfront music in a venue with an edge to it, not a tacky West End disco."

"I always thought there was an irony in a gay club like Heaven hosting a rave night such as Land Of Oz with hundreds of straight men hugging each other and saying 'I love you, matey'," laughs Patrick Lilley, promoter of Queer Nation – named after the San Francisco group in a link he describes as "more emotional than political".

Lilley opened his Sunday night club in Covent Garden after High On Hope – the much-loved garage one-nighter he ran with DJ Norman Jay — finally closed down at the start of this year. Inspired less by the house boom than by the gay clubs that have helped revive New York's flagging club scene and produced groups like Deee-Lite, his Sunday night at the Gardening Club in Covent Garden aims to revive the spirit of mid-Eighties clubs such as The Lift – a mix of gay and straight, black and white, all attracted by the friendly ambience and by DJs playing the best in cutting-edge dance music.

"People are getting tired of hi-NRG or Kylie and Jason," says Breeze, DJ at Queer Nation and at Spunk. "They go to the straight, alternative clubs and they want to hear that in their own clubs too."

Julia, DJ at the Brixton Fridge's long-running Tuesday night Daisy Chain, agrees. "The scene is more mixed now – there are more girls, it's not as heavy as before, and the music is more varied."

A return, perhaps, to smaller, more-intimate clubs with more of a family atmosphere, the new scene also re-flects a new generation of young gays who are harder, more assertive in attitude: "We're saying that we're a force to be reckoned with," says Wayne Shires. "We're here, we're not going to go away, and we're not going to hide at home full of self-pity – we're going to enjoy ourselves". ●

Photographs taken by Bart Everly at Queer Nation

The new mood of gay militancy is being reflected in a new breed of gay clubs. Welcome to Queens With Attitude . . .

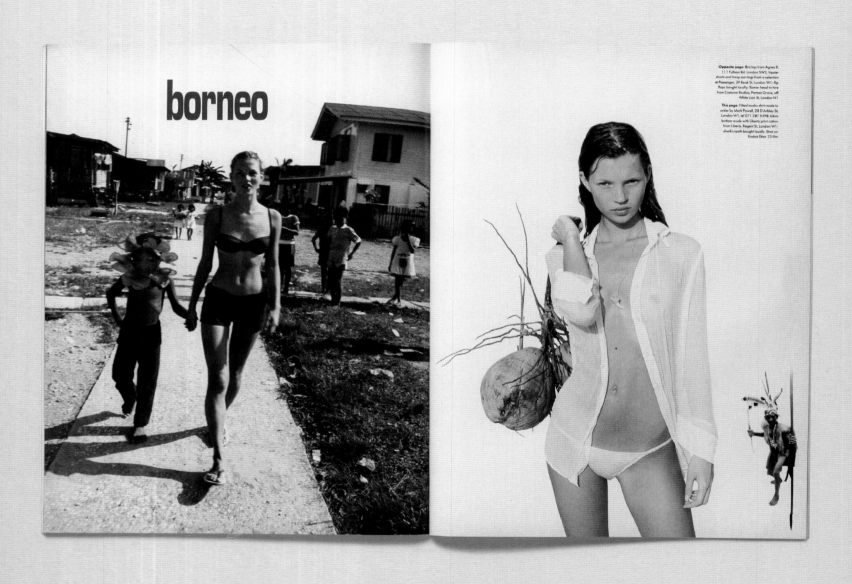

above and opposite
'Borneo', vol. 2, no. 35, August 1991.

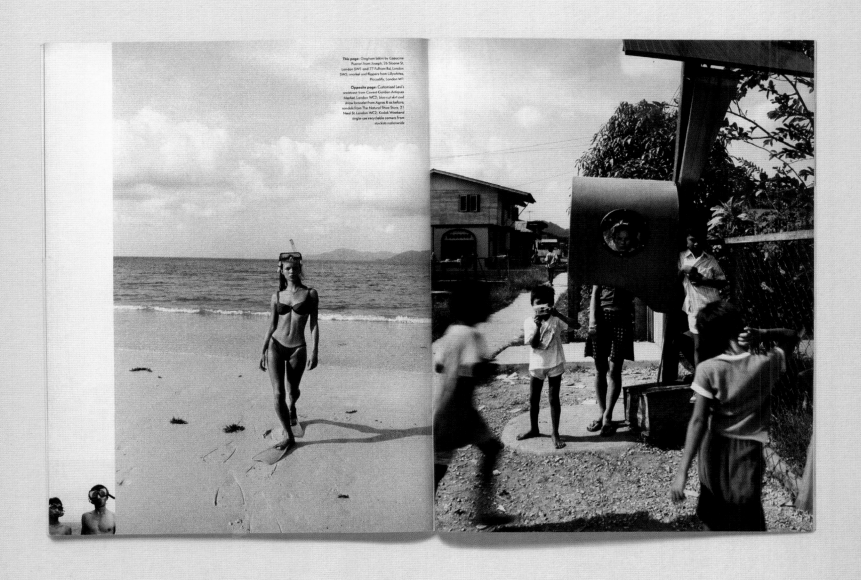

This page: Gingham bikini by Capucine
Puerari from Joseph, 26 Sloane St,
London SW1 and 77 Fulham Rd, London
SW3; snorkel and flippers from Lillywhites,
Piccadilly, London W1

Opposite page: Customised Levi's
waistcoat from Covent Garden Antiques
Market, London WC2; bias-cut skirt and
straw bracelet from Agnes B as before;
sandals from The Natural Shoe Store, 21
Neal St, London WC2; Kodak Weekend
single-use recyclable camera from
stockists nationwide

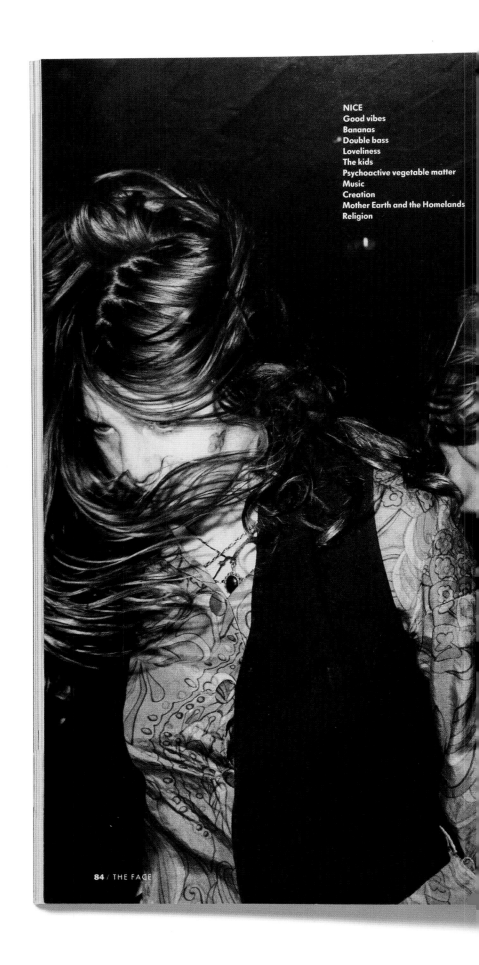

NICE
Good vibes
Bananas
Double bass
Loveliness
The kids
Psychoactive vegetable matter
Music
Creation
Mother Earth and the Homelands
Religion

84 / THE FACE

right
'Hippies', vol. 2, no. 39, December 1991.

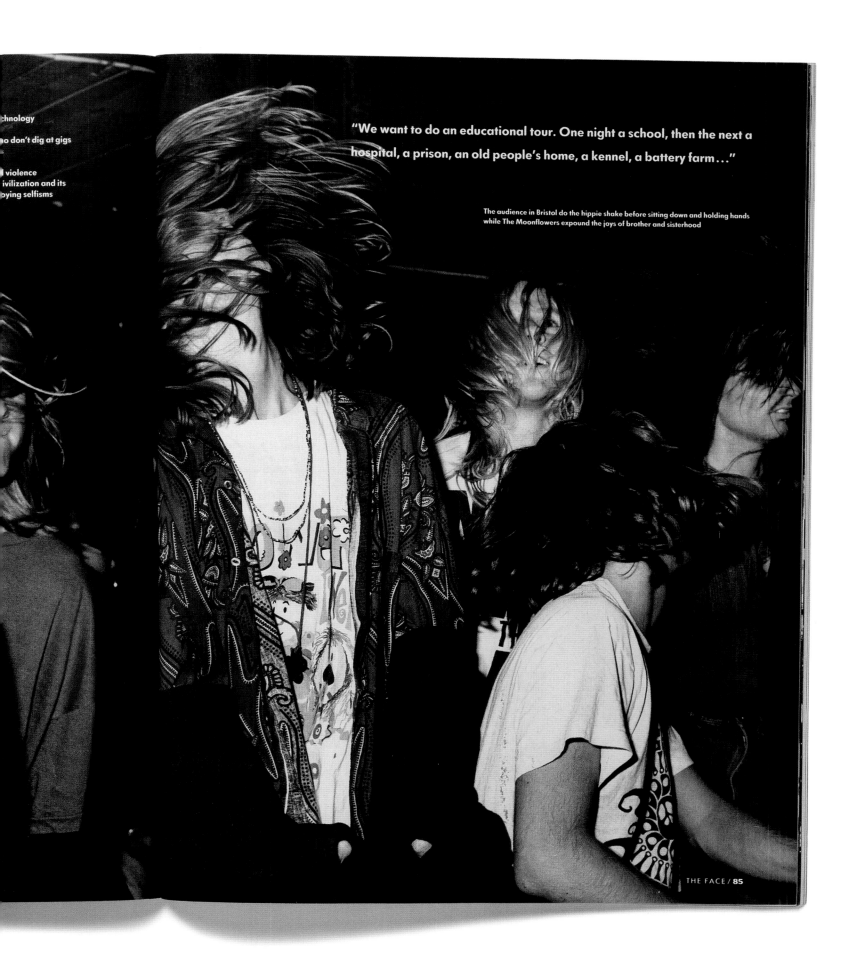

chnology

o don't dig at gigs

violence
ivilization and its
oying selfisms

"We want to do an educational tour. One night a school, then the next a hospital, a prison, an old people's home, a kennel, a battery farm…"

The audience in Bristol do the hippie shake before sitting down and holding hands while The Moonflowers expound the joys of brother and sisterhood

THE FACE / 85

223

below and opposite
'Ruder than the Rest', vol. 2, no. 30, March 1991.

THE CHIPIE PHENOMENON is more than just a

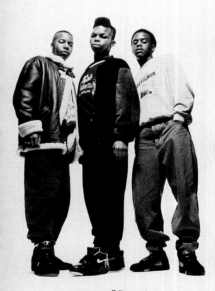

"South London boys used to tuck their jeans into their socks, but they got bright and started doing pin-rolls after they saw us lot"

L to R: **Earl**, 17, at Hammersmith West London College. Wears Biggles jacket (£199), Chipie chinos (£65) and Champion trainers (£60)
Pablo, 17, at St Thomas More School. Wears suede jacket (£60), Chipie jumper (£85), Chipie cords (£80), Nike Air Force trainers (£70)
Mark, 15, at Holland Park School. Wears Chevignon sweatshirt (£60), Sonetti jeans (£45) and Nike Air Jordan trainers (£90)

story. It's the story of how

British teenagers inspired

by American rap have taken

a French label and created

their own look. Nineties casuals? Not on your

fashion success

BAGGY T

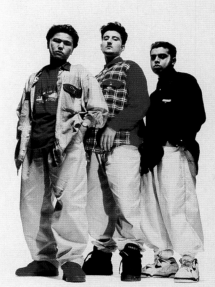

"Wearing expensive name watches is becoming big now down here, and in south London we don't really show our socks"

L to R: **Egg**, 18, at Southwark College. Wears Chipie shirt (£60), Chipie T-shirt (£35), Chipie chinos (£65), red suede Travel Fox trainers (£75) and Gucci watch (£275)
Asis, 18, at Southwark College. Wears Chipie shirt (£63), Chipie chinos (£63), Travel Fox trainers (£79), TAG-Heuer watch (£115)
Richard, 18, at Southwark College. Wears Chipie cord shirt (£68), Chipie jeans (£75), Nike Air Bound trainers (£65) and Jean Philippe watch (£300)

Pascalou pants...

RUDER

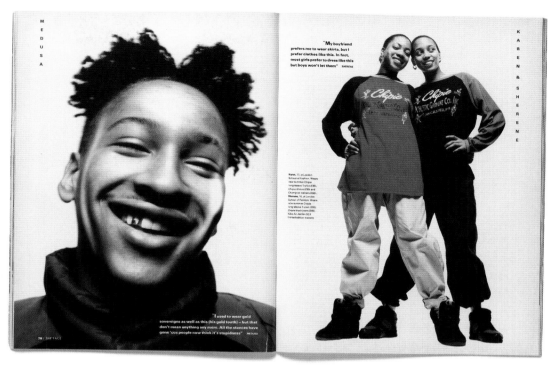

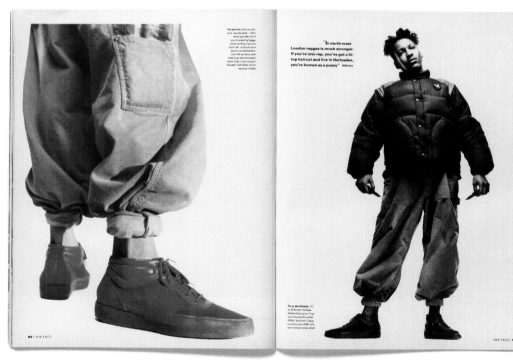

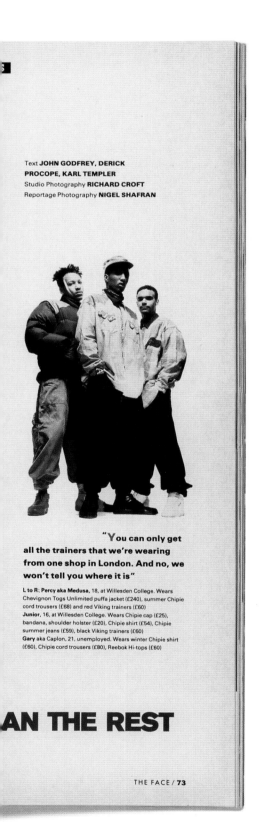

Text **JOHN GODFREY, DERICK PROCOPE, KARL TEMPLER**
Studio Photography **RICHARD CROFT**
Reportage Photography **NIGEL SHAFRAN**

"You can only get all the trainers that we're wearing from one shop in London. And no, we won't tell you where it is"

L to R: **Percy aka Medusa**, 18, at Willesden College. Wears Chevignon Togs Unlimited puffa jacket (£240), summer Chipie cord trousers (£68) and red Viking trainers (£60)
Junior, 16, at Willesden College. Wears Chipie cap (£25), bandana, shoulder holster (£20), Chipie shirt (£54), Chipie summer jeans (£59), black Viking trainers (£60)
Gary aka Caplon, 21, unemployed. Wears winter Chipie shirt (£60), Chipie cord trousers (£80), Reebok Hi-tops (£60)

AN THE REST

THE FACE / **73**

225

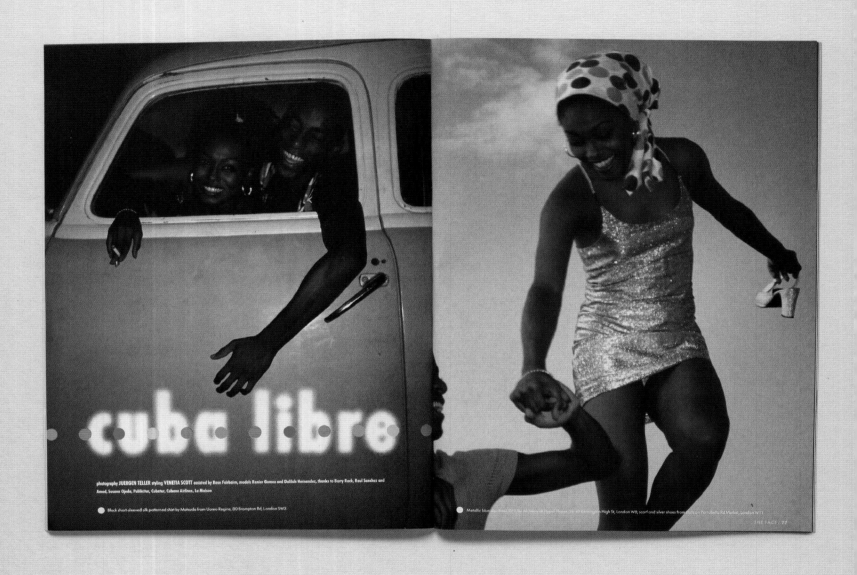

photography JUERGEN TELLER styling VENETIA SCOTT assisted by Rose Fairbairn, models Renier Gomez and Dalilah Hernandez, thanks to Barry Rock, Raul Sanchez and
Amed, Susana Ojeda, Publicitur, Cubatur, Cubana Airlines, La Maison

● Black short-sleeved silk patterned shirt by Mahurda from Uomo Regine, 80 Brompton Rd, London SW3

● Metallic blue mini-dress, £99, for All Intents all Hyper Hyper, 26-40 Kensington High St, London W8, scarf and silver shoes from Pork on Portobello Rd Market, London W11

above and opposite
'Cubre Libre', vol. 2, no. 41, February 1992.

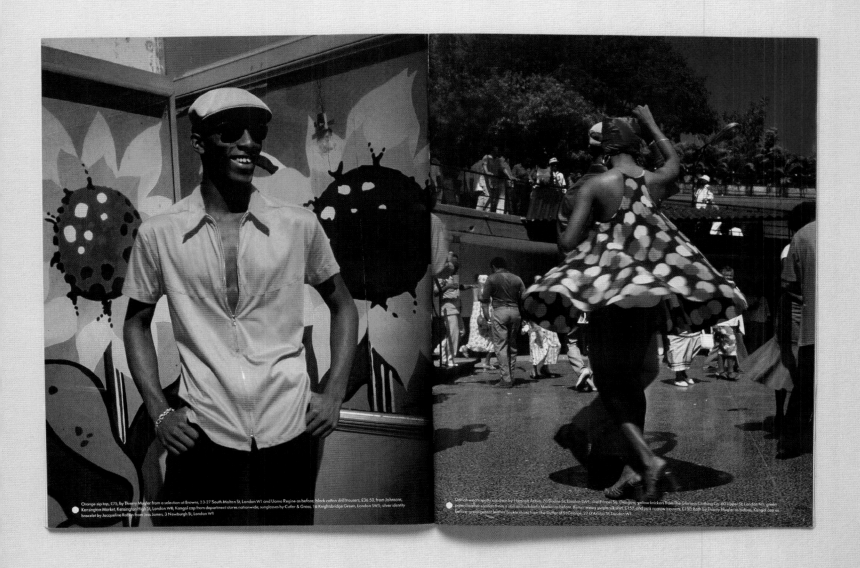

Orange zip top, £75, By Thierry Mugler from a selection at Browns, 23-27 South Molton St, London W1 and Uomo Ragine as before; black cotton drill trousers, £36.50, from Johnsons, Kensington Market, Kensington High St, London W8; Kangol cap from department stores nationwide; sunglasses by Cutler & Gross, 16 Knightsbridge Green, London SW1; silver identity bracelet by Jacqueline Rabun from Jess James, 3 Newburgh St, London W1

Dot checkeract spotty sundress by Hamnett Active, 20 Sloane St, London SW1, and Princes Sq, Glasgow; yellow knickers from The Glorious Clothing Co, 60 Upper St, London N1; green patent leather sandals from a stall on Portobello Market as before; Kenzo mens purple silk shirt, £159, and pink narrow trousers, £150, both by Thierry Mugler as before; Kangol cap as before; green patent leather buckle shoes from the Duffer of St George, 27 D'Arblay St, London W1

Chapter Ten

Love Sees No Colour

Nick Logan's return to work was followed by the decision to move Wagadon from The Old Laundry to the third floor of a former rag trade sweatshop on the corner of Exmouth Market in what is now fashionable Clerkenwell but was then an anonymous semi-residential/commercial zone at the city's northern edge.

Julie Logan became a regular presence as business manager; *The Face* office was staffed by Sheryl Garratt, now the editor, with deputy editor John Godfrey, who was also fashion coordinator, Amy Raphael handling features, Charles Gant overseeing production, Boris Bencic and Lee Swillingham working on design (Phil Bicker having left to redesign *Creative Camera* and become creative director of *Vogue Hommes International*) and Kelly Worts as office manager and picture researcher. 'Kelly was as important as everyone else,' said Garratt. 'She would always chip in and came up with some brilliant ideas.'[1] Meanwhile, Swillingham had previously assisted art director Ian 'Swifty' Swift in *Arena*'s art department while a third-year student at St Martins.

'I got on well with Boris, he's a very nice guy,' says Swillingham. 'I think I was useful because I had my ear to the ground and knew all the young creatives in London. I had responsibility for the front of the magazine, commissioning photos and working on little fashion things.'[2]

The new offices better befitted *The Face* and *Arena*, or so Logan anticipated. 'I think Nick's idea was that it would all be clean lines with beautiful people wafting around, but that wasn't going to happen,' says Garratt.

'The office was always a mess, with stuff everywhere. Added to that none of us looked the part. I'd be playing acid house, Amy would stomp in and put Nirvana on and John Godfrey would jump in soon after and change it for some Italia house. Whenever Nick made it tidy, how he wanted it, he'd turn his back and there'd be a tidal wave of photos all over the floor and models turning up for casting.'[3]

Tidiness was the least of Logan's concerns when Wagadon was plunged into a crisis that threatened to poleaxe not just *The Face* but the entire company. It all began with the publication of a feature in the August issue – in which the celebrated Day/Moss 'Borneo' shoot appeared – about the practice of 'outing' celebrities by flyposting statements about them in public spaces. This had been adopted in Britain from America by a fervent gay activist splinter group called Faggots Rooting Out Closeted Sexuality. They chose as their first target Australian teen heart-throb Jason Donovan, then at the height of his popularity with three chart-topping singles under his belt and a substantial young female following stimulated by his lead role in smash West End musical *Joseph and the Amazing Technicolor Dream Coat*. The article was written by

Ben Summerskill, at that time editor of *The Pink Paper*, and the illustration for the opening centre-spread was a photograph of a poster situated on walls close to the London Palladium, where the singer was at that time appearing as Joseph (the presence of fans congregating outside the stage door had become a daily occurrence). The poster's central image was Donovan in a T-shirt that had been doctored so that it read 'Queer As Fuck'. Summerskill, scion of a family of Labour peers and a leading advocate for gay rights,[4] did not state that Donovan was homosexual, but was rather the 'luckless first victim' of the unfortunate campaign. Incensed, the performer elected to sue the journalist, Logan and Wagadon on the basis not only that the imputation that he was gay was false but that the publication of the story ensured that it reached a wider audience than the localized posters (regardless of the fact that the defamation proceedings subsequently attracted considerable media attention both in Britain and his native Australia[5]).

For *The Face* editor Sheryl Garratt, the situation was worsened by the timing of Donovan's writ; it was served while Nick Logan was taking his first holiday since his recovery from cancer. 'It was also one of the few holidays Nick had ever had in my time there, and still he rang every day to check in,' says Garratt, who discussed the arrival of the legal action with Logan's son Christian and decided not to inform him of the development while he was away. 'The thing was under control; what good would have telling him done?' asks Garratt. 'It would have ruined his holiday, for sure. I felt terrible; that was the first time I had ever lied to Nick.'[6]

Logan accepts that the decision to run the photograph of the poster as a full-page was 'a lazy option. If it had been less prominent and thus more sympathetic, we might have avoided litigation.' The article was read for libel, but the statement that Donovan wasn't gay opened the magazine up to a charge that it had slyly published one thing all the while inviting readers to think another.

Over the next eight months Logan and Garratt dedicated their energies to keeping the magazine's team buoyant while they worked with lawyers on their defence as the court case commencement loomed. 'A libel suit was my worst nightmare; it dominated my every waking thought,' says Logan, who had immediately offered a printed apology. According to some sources Donovan's representatives pressed for the apology to appear on the cover, trailing a favourable interview with their client. Acceptance of these terms would have destroyed the magazine's credibility.

And so the wrangle dragged on through the winter of 1991 and into the New Year. 'It was a desperate situation,' says Logan, who spent that Christmas composing a letter appealing to Donovan to drop the case. It is understood this garnered

an aggressive response from the singer's representatives that upped the stakes considerably.

During this period, John Godfrey left *The Face* for a career in books and television. The decision was taken not to replace him as deputy editor. 'It was felt that we couldn't recruit a senior member of staff while we were facing this crisis,' says Charles Gant. 'It wasn't deemed a responsible thing to do.'[7]

As Logan later wrote, Wagadon 'made every effort to settle the dispute, including the making of repeated offers of unreserved apologies. All our efforts were unsuccessful.'[8] Outwardly the staff maintained their calm. 'It was difficult; there was a very real possibility that the magazine would go under,' recalls Amy Raphael.

'I don't remember any hysteria in the office or anybody losing it. I guess we hunkered down. Everywhere you went you were asked about it and sometimes the line was quite aggressive but Sheryl did an amazing job in keeping everything on an even keel.'

Lesley White, by then on the newsdesk at *The Sunday Times*, received a call about the Donovan lawsuit from Rod Sopp. 'I couldn't believe that Jason Donovan, of all people, could be the person who would bring about the downfall of the magazine,' she says.[9]

Meanwhile, stories circulated that sympathetic staff at fashion stores were expressing their support by refusing to serve Donovan, and it is said he was also turned away from nightclubs that were frequented by the magazine's writers. 'That was interesting, that feeling that he couldn't do this to *The Face* because it evidently meant something to a lot of people,' believes Ashley Heath.[10] 'There was a lot of public and private backing for us,' confirms Raphael. 'But it still felt critical, as though things were out of control. Apart from selfishly – as in this was my first proper job – my question was repeatedly: how can a magazine as brilliant as *The Face* be brought down like this?'[11]

The case was heard before a jury in Court 13 at London's Royal Courts of Justice over a few days in the spring of 1992. 'I was in a daze during the trial,' says Logan. 'At one point, standing in the witness box, I looked at the judge and decided he was the spitting image of my dear dead grandmother. That nearly convinced me we would win, that the gods were on our side.'

In the event, the jury decided the story implied Donovan was gay, awarding him £200,000 damages and legal costs.[12] 'When the news came I wasn't so much down-hearted as elated that it was finally over,' says Logan.

opposite
Vol. 2, no. 44, May 1992.

'The adrenalin started to surge when his people immediately came rushing to our's to broker a settlement that could salvage what they clearly knew could be a PR disaster. I said that, yes, I would consider their offer – of course it made financial sense to do so – but I wasn't going to give them the satisfaction of an immediate response, they could stew over the weekend and if there was anything to discuss we'd do it the following week.'

That Friday night, Logan, his friends and staff took over Wagadon's local pub The Eagle in Farringdon Road. 'It felt like a victory party rather than a wake,' says Logan. 'We had lost but at last the uncertainty was gone. I felt unburdened, like I'd attained some level of control over events that had threatened to overwhelm me and the team, not to mention the possibility of losing my house. It was a wonderful night.'

Logan's barrister purchased the official court drawing of him giving evidence and presented it as a gift. He was depicted as the swarthy baddie in black – bearded and dressed to hide the scars of his recent cancer operation – while Donovan, by contrast, was shown as a blond-haired and angelic boy next door. 'For years afterwards at publishing events strangers would congratulate me on the publicity coup, maybe confusing me with Ian Hislop,'[13] said Logan. 'Never for one second did I see it in that light. It had been torment.'[14] This much was clear in Logan's impassioned full-page editorial address to readers in the May 1992 issue (see page 232). He wrote of Donovan: 'We said he wasn't gay, we printed his denial that he was gay. This wasn't what sank us. What sank us was the court's decision that the article contained an innuendo that would lead the ordinary person to the conclusion that we didn't believe his denial; that we were, in the judge's words, saying Jason Donovan was "two-faced". If this was the case then it was entirely unintentional, and we are sorry.'[15]

Thus tested, the magazine's team rose to the occasion; as Logan also points out in his editorial, the pro-toleration theme of the May 1992 issue – which was bannered 'Love Sees No Colour' – had been decided long before the Court 13 jury handed down their decision. 'Nick and I had talked about the fact that racism was bubbling up around the world and felt that it needed to be addressed across an entire issue,' says Sheryl Garratt. 'Then I came across a documentary about LA gangs and the charity that worked with them called Love Sees No Colour and knew that those words summed up what we wanted to do.'

Garratt and art director Boris Bencic sent the four words as a brief on tolerance to all manner of potential contributors: artists, designers, media figures, musicians, photographers and pop and sports stars. 'Soon all this material arrived,' says Garratt. 'In one way it was fortuitous since it coincided with the court case because there wasn't too much editing needed; Boris worked very hard at the pages, sequencing them beautifully.'[16]

THE FACE

Love sees no colour

No 44 MAY 1992 £1.80 • US $5.50
ITALY L7300 · GERMANY 8.90DM · SPAIN 500PTAS · BELG. 166BFR

Boy George

Shakespears Sister

Soul II Soul

Massive Attack

Young Disciples

David Bowie

Michiko Koshino

Basic Instinct

Jean Colonna

Paul Smith

Gilbert & George

Colin McMillan

Apachi Indian

Bhangramuffin

Justin Fashanu

Michael Clark

Rebel MC

EMF

George O'Dowd and friends
photographed by
Thomas Krygier

FIGHT BACK!

Special issue: don't let the bigots grind you down

THE FACE

Third Floor Block A
Exmouth House
Pine Street
London EC1R 0JL
TEL 071 837 7270
FAX 071 837 3906

Editor
Sheryl Garratt

Art Director
Boris Bencic

Assistant Editor (Production)
Charles Gant

Features Assistant
Amy Raphael

Editorial Assistance
Richard Benson, Maryanne Fiore

Design
Boris Bencic, Lee Swillingham

Picture Researcher
Kelly Worts

Contributing Fashion Editors
Karl Templer
Derick Procope

Editorial Director and Publisher
Nick Logan

Business Manager
Julie Logan

Advertisement Manager
Rod Sopp

Advertising Executive
Jo-Anne Smith

Office Manager
Kelly Worts

Front Desk
Katrina Christie

WORDS Vaughan Allen, Lindsay Baker, Denise Barricklow, Steve Beard, Richard Benson, Julie Burchill, Gordon Burn, Allan Campbell, Stuart Cosgrove, Steven Daly, Camilla Deakin, Geoff Deane, Ekow Eshun, Anthony Fawcett, Kathryn Flett, Colin Greenland, Lee Harpin, Dave Haslam, Ashley Heath, Chris Heath, Gavin Hills, Mandi James, Nick Kent, Marek Kohn, Kimberly Leston, Ian McCann, Jim McClellan, John McCready, Sean O'Hagan, Paul Rambali, Cynthia Rose, James Ryan, Beverly D'Silva, Chris Taggart, Phil Thornton, David Toop, Lesley White, John Williams, Steven D. Wright.

VISUALS Enrique Badulescu, BDI, Malcolm Beckford, Andrew Bettles, Judy Blame, Julian Broad, Anton Corbijn, Richard Croft, Kevin Davies, Corinne Day, Elisabeth Djian, Bart Everly, Kate Garner, Patrick Harrison, Jocelyn Bain Hogg, Adam Howe, Glyn Howells, Thomas Krygier, Gene Lemuel, Christian Logan, Mitzi Lorenz, Glen Luckford, Andrew Macpherson, Philippe McClelland, Craig McDean, Jean Baptiste Mondino, Eddie Monsoon, Jamie Morgan, Cindy Palmano, Steve Pyke, Derek Ridgers, Schoerner, Venetia Scott, Stephane Sednaoui, Nigel Shafran, David Sims, Sandro Sodano, John Stoddart, David Swindells, Juergen Teller, Steve Tynan, Richard Vorsdee, Melanie Ward, Peter Walsh.

ISSN 0263-1210

Member of Audit Bureau of Circulations **ABC**

America Australia Austria Belgium Canada Denmark France Germany Holland Hong Kong Italy Japan New Zealand Norway Portugal Singapore Spain Sweden Switzerland UK

Jason Donovan and The Face

Contrary to what you may have read in the press, we did not "brand" Jason Donovan a homosexual, a liar and a hypocrite. The feature on "outing" that appeared in August last year, and was the subject of the libel trial in Court 13, was conceived and written as a responsible article on a subject of interest to our readers.

We reproduced a photograph of a poster that had been seen on London streets, and we reported that Jason Donovan was the "luckless first victim" of the "outing" campaign. We said he wasn't gay, we printed his denial that he was gay. This wasn't what sank us. What sank us was the court's decision that the article contained an innuendo that would lead the ordinary person to the conclusion that we didn't believe his denial; that we were, in the judge's words, saying Jason Donovan was "two-faced".

If this was the case, then it was entirely unintentional, and we are sorry. It is manifestly untrue to say that we didn't offer to apologise. In the course of the eight months between publication and trial, we made *every* effort to settle the dispute, including the making of repeated offers of unreserved apologies. All our efforts were unsuccessful. In case anyone is still in any doubt, we *desperately* did not want to go to court. Whatever else you might say about the libel laws of this country, most people agree that they favour the rich and powerful. They do not favour small independent magazines.

Despite being instructed by the judge not to give him too much, the largely middle-aged jury in Court 13 awarded Jason Donovan damages against THE FACE of £200,000. We are also liable for Jason Donovan's lawyers' bills. Jason Donovan has offered to reduce this to £95,000 spread across 19 months, conditional on us not challenging the verdict or the damages in the court of appeal. We are not a wealthy company: this is still a considerable sum of money.

We have launched an appeal – The Lemon Fund – to help pay the debt. We intend it to be a short-lived and dignified appeal. We recognise that the majority of our readers are not well-off, and we don't expect you to send us money which you need yourself. All of you, by paying £1.80 for this issue, a cover price increase that will earn us an extra 10p, have already made a contribution by buying the magazine this month. We would have had to introduce a price increase in the autumn; by bringing it forward, we are trying to assure that we have a future. So those of you with nothing to spare have already done their bit. Thank you.

This won't be enough on its own. And we would hope that the people who could be most generous towards our appeal are those who have benefited from THE FACE's coverage in the last 12 years. There are a lot of people we have helped get a start; now is a chance for them to help us in return.

This piece is being written in the week following the trial. In the space of a few days we have been inundated with offers of help and messages of support. Some of these offers will result in activities around the country where, hopefully, you can have a good night out – and incidentally make a contribution towards keeping THE FACE in business. We thank all of those who've come forward; it is an extraordinary show of goodwill. Please keep it coming.

The case heard in Court 13 was not about Jason Donovan's sexuality, but about the meaning of certain words. On many occasions it seemed that the case was about whether it is libellous to say that someone is gay, or, worse still, that there is something wrong with being gay. There isn't.

This particular issue of THE FACE was planned as a special one long before the Jason Donovan dispute reached its unhappy conclusion. This issue is about tolerance, and speaks out against prejudice wherever it shows its ugly face. It has been put together in intolerable circumstances: while half the staff were in court, the rest struggled to finish a magazine while answering a deluge of queries from the media and the public. Hopefully, we will soon be able to close the fund, get on with publishing magazines, and forget this whole unfortunate episode. But it is also our hope that the message of this issue will spread, be taken up by others, and will not be forgotten.

Nick Logan, Publisher

Send contributions to
The Lemon Fund, THE FACE, Third Floor Block A, Exmouth House, Pine Street, London EC1R 0JL

Heartfelt thanks to Jonathan Crystal and Nick Goldstone for their work as lawyers and their support as friends; to Geoff Deane, Aneliese, Dylan Jones, Tony Parsons, Christian Logan, Mark McGuire and all the other "gay activists" who came to court; to Ben Summerskill, Patrick Harrison and Mike Soutar for standing up for us; and to the staff of *The Pink Paper*, who had to get an issue out while their editor, Ben, was in court on our behalf. Finally thanks to everyone who has phoned, written and faxed – you know who you are. A list of people who have sent in donations will be published next issue

above
'Jason Donovan and *The Face*', vol. 2, no. 44, May 1992.

opposite
'Introduction', vol. 2, no. 44.

'This issue speaks out against prejudice wherever it shows its ugly face,' thundered Logan in his May 1992 editorial, and the air of defiance in the issue is palpable, from the Thomas Krygier cover shot of a crop-headed, bindi-decorated Boy George holding two babies and blazoned with the title 'Fight Back!' to the specially commissioned galleries containing work by ranks of fashion designers whose one-off creations were sported by celebrities (Shakespears Sister in Duffer of St George, footballers Paul Walsh and Andy Grey in Joe Casely-Hayford, singer Caron Wheeler in a Philip Treacy hat, Apache Indian in Paul Smith's 'One World' shirt). Other responses to the issue's theme came from Swedish photographer Dawid, Spanish designer Javier Mariscal, French photographer/filmmaker Jean-Baptiste Mondino, British artists Gilbert & George and Australian performance artist Leigh Bowery, whose collaboration with Scottish contemporary dancer Michael Clark was entitled 'Nazi Shithead'.

In retrospect, we may see that Love Sees No Colour contained echoes of the 'New Life In Europe!' special of 1983, which was initiated by France's underground press warrior Jean-François Bizot and expressed optimism about the post-war European experiment. At the same time, from this distance, it presents an unnerving foreshadowing of events in Europe in the late 2010s.

'Love Sees No Colour was a defining issue of the magazine,' says Richard Benson, who had been drafted in to help co-ordinate the contributions.[17] In particular, Sheryl Garratt's page-long message of hope addressed the rise of the hard right across the continent, positing the multiculturalism of European youth as the solution. 'In the next few years we will be moving towards a new Europe, and in the end it's up to us, the young, to determine what that Europe will be,' wrote Garratt.

'We could live in a grim, cold Fortress Europe, shuttered from outside influences, and allowing "foreigners" in only as guest workers on short contracts who can be shipped home whenever we're ready. Or we can opt for an exciting, dynamic mix of cultures and races working together.'

And Garratt did not avoid an opportunity to refer to the bruising Donovan experience: 'Words and pictures,

Introduction

The idea for a special issue came to us some months ago. Every day, it seemed, one of us would come to work having seen a new horror story in the news. There was the rise of Le Pen in France, the reappearance of the Mussolini name in Italian politics, the huge upsurge in racially-motivated attacks in the new Germany, the spread of Britain's most successful fashion export – skinhead culture – across the continent. While the murmurs of nationalism and perhaps even fascism in newly-liberated Eastern Europe grew to a roar, we also heard of violence closer to home. Mr Pancharcharam Sahithoran, a Sri Lankan refugee living in north London, was attacked by a gang of white youths and died in hospital on January 3 this year. Taxi driver Mr Mohammed Sarwar was dragged from his vehicle in Manchester and battered to death on January 26, just days after Manchester shopkeeper Mr Siddik Dada was attacked by a white gang armed with machetes; he died on February 5.

In chaotic, uncertain times like these, words like "discipline" and "order" seem attractive, and it's good to have a scapegoat to blame. But violence and fascism is not an answer. Fascism is about intolerance, uniformity. It likes women to stay at home, children to be quiet, and everyone to do what they're told. Fascism doesn't let you be different or creative, dance all night, dress how you want, or share a joke. Fascism is ugly, and should be fought whenever it rears its evil head.

In the next few years, we will be moving towards a new Europe, and in the end it's up to us, the young, to determine what that Europe will be. We could live in a grim, cold Fortress Europe, shuttered off from outside influences, and allowing "foreigners" in only as guest workers on short contracts who can be shipped off home whenever we're ready. Or we can opt for an exciting, dynamic mix of cultures and races working together.

British youth culture, especially, is exactly that. From The Beatles to Soul II Soul, there is little in our clothes, music, clubs or lifestyles that did not originally come from somewhere else. As one of the flagships of British youth culture abroad, we felt it was important for THE FACE to take a stand. We're not expecting to change anything with one issue of a magazine (though the mix of nationalities, genders and sexual preferences celebrated in this issue are to be found in our pages every month), but we are hoping to plant a seed of thought that will grow. Seventies organisations like the Anti-Nazi League and Rock Against Racism didn't defeat fascism, but they certainly made it unfashionable. Now that certain jokes, phrases and prejudices are becoming acceptable once more, hopefully this is a first step in that direction again.

Finally, a note about the title of this special issue. We chose the banner "Love sees no colour" because it was positive, for tolerance and understanding rather than against prejudice and the new right. It originally comes from a project in Los Angeles which dealt with black-on-black violence in the city, working with convicted gang members and weaning them away from the blue and red colours that distinguish crips from bloods. But like all catchy slogans dealing with a subject as complex as prejudice, it doesn't quite fit. Love, of course, does see colour – we're none of us transparent. But we rarely choose who we fall in love with – male, female, or any skin shade from blue-black through browns, yellows, reds or my own shade of pasty pink. It's hate that discriminates, and it's irrational, ignorant fear and hate that we need to fight.

Words and pictures, as we so recently learned to our cost, are powerful things. Knock someone's eye out, and they'll get maybe £10,000 compensation; accidentally imply they may have lied about their sexuality, and the sky's the limit. Hopefully, the words and pictures in this issue can be just as powerful. We asked some of Europe's best artists, photographers and designers to each come up with an image that celebrated difference, encouraged tolerance, and illustrated this issue's theme. Some, like black British artist Keith Piper, Swedish photographer and artist Dawid and Spanish designer Javier Mariscal (the man behind the official Olympic mascot, Cobi), produced work specially. Others, like Britain's Gilbert and George and America's Alexis Smith, looked out work they felt fitted the theme and allowed us to reproduce it. Asked for a short statement, David Bowie and Iman instead collaborated on an artwork that they have autographed and given us to sell to benefit the anti-fascist organisation Searchlight. Meanwhile, despite the pressures of their catwalk shows, fashion designers toiled on special, one-off garments to be modelled by various celebrities: Spurs players donned Joe Casely-Hayford's shirts during training, boxer Colin McMillan took time off from his world title fight in London on May 16 to wear Bella Freud and Gio Goi, and Shakespears Sister modelled Duffers and Joe Bloggs during a short break on the set of their new video.

This issue was put together in the most difficult circumstances, and represents a massive, collective effort from people of varying nationalities and backgrounds: enjoy it, but also take its message on board. Sheryl Garratt

gallery 1

Opposite: image by French illustrator FRANÇOIS BERTHOUD

THE FACE / **41**

as we so recently learned to our cost, are powerful things. Knock someone's eye out and they'll get maybe £10,000 compensation, accidentally imply they may have lied about their sexuality and the sky's the limit.'

In a magazine full of heartfelt contributions, one of the most poignant was written by Amy Raphael. 'The view was that, whatever the verdict in the Jason Donovan case, we were going to continue doing what we did best,' says Raphael. 'I still think the "Fight Back!" cover with Boy George holding the babies is quite funny. We were saying that however shitty the court case had been we weren't po-faced about it.'

Entitled 'Little Hitlers' and illustrated with photographs of extremely young hard-right radicals by Jocelyn Bain Hogg, a feature by Raphael studied the adoption of neo-Fascist attitudes among Italian teenagers and the resultant violence then spreading against immigrant communities (see pages 244–45). 'It was a scary piece to do; I was very glad of Jocelyn's company because he's a big guy,' says Raphael. 'But it shows how anything was possible at *The Face*. If I went to *The Guardian* now and said, "I speak Italian, I've got an Italian boyfriend, can I go and interview a bunch of neo-Nazi kids?", they'd send their Rome correspondent. Looking at the feature I can see it is a proper piece of news reporting which ostensibly isn't what I did then or have done since. It also shows that *The Face* was prepared to take risks by sending me to interview these little Hitlers; I'm Jewish and I look it. When I went into a bar I was greeted by Nazi salutes. I was probably way out of my depth but because of that it was probably written in a more interesting way than if a hardened news reporter had done it.'[18]

With 10p added to the cover price of the May issue, Logan announced the launch of an appeal, The Lemon Fund. A number of events were held over the next few months, including a 'Save Face' party at The Atrium on London's Millbank. The event organizing committee included Giorgio Armani, Bryan Ferry and Paul Smith and the party list was compiled by posh PRs Julia Hobsbawm (today London's social networking queen) and Sarah Macaulay, later to marry the British prime minister Gordon Brown.

At the other end of the social scale electro-rave group The Shamen – soon to score a worldwide number one hit with the ecstasy-gobbling anthem 'Ebenezer Goode' – released a fundraising single. Logan recalled one London club donating from its takings £2,000 in £1 coins. In this way the magazine's future was secured.

'I felt very strongly that the readership should help us,' says Sheryl Garratt. 'Nick was a bit ambivalent about The Lemon Fund but I'd had people ringing me day and night offering assistance, so knew there was a huge reservoir of love out there. In a way the readers felt they owned *The Face* – as you could tell from the letters pages where they were always telling us

what to do – and I thought it was only right that we should tap into that because this was a matter of survival. I also thought we should approach everyone who had ever appeared on the cover; with a few exceptions, they'd done alright out of us and if every single person kicked in £1,000 then we'd be out of trouble.'

While this suggestion wasn't adopted formally, several of those who had been associated with the magazine over the years are understood to have donated to the fund. 'On the day the verdict was announced, donations and promises of donations started to arrive by fax,' says Richard Benson. 'A lot were from people whose names I recognized from back issues of the magazine. I remember Julie Burchill sent a cheque for £1,000.'[19]

Similarly, there was an outpouring of sympathy from contributors. 'Hardly any writers or photographers asked to be paid for the next three issues,' adds Garratt.[20]

Logan accepted Donovan's offer to waive a portion of the damages as a gesture to Wagadon's future financial viability; these were reduced to £95,000 paid across nineteen months. 'Reported but not emphasized, this did not detract from the fact that Donovan had still sued the style bible,' wrote defamation expert David Rolph fifteen years later. 'Right-thinking members of society may have thought less of Donovan because it was suggested that he was homosexual, but right-thinking (and self-appointed) "cool" members of society thought less of Donovan because he had bothered to care.'[21]

Donovan has long since regretted the action. In his 2007 autobiography *Between The Lines: My Story Uncut*, Donovan wrote that he had been concerned that he was portrayed as a liar and a hypocrite but had come to believe that suing *The Face* was 'the biggest mistake of my life'.[22]

In legal and public relations circles, the case is seen as a benchmark in the management of celebrity reputations when faced with potential defamation.[23] Decades later many of those embroiled in the affair – not least Logan – are angry at the threat to the magazine and their livelihoods by what is generally agreed to have been a course of action in which, as ever, the lawyers were the only victors. Yet the Donovan case brought out the best in *The Face*, and spoke to its raison d'étre, that the editorial line was indeed that love sees no colour.

'We all felt there was room for everything in *The Face*; the idea was that it should be inclusive,' says Garratt. 'For example, Nick never argued with me about having a black person on the cover. The perceived wisdom in British publishing was still that would not sell as many copies as one with a white face. We soon proved that wrong with Naomi Campbell on the cover of an issue which sold more than ever.'[24]

Giorgio Armani, Jean Paul Gaultier, Paul Smith, Jonathan Ross,
Bryan Ferry, Dave Stewart, Boy George, Graham Ball, Sara Blonstein, Anthony Fawcett,
Jaswinder Bancil, Alan Crompton-Batt, Sheryl Garratt, John Hegarty,
Dylan Jones, Nick Logan, Gordon McNamee, Steve Woolley – the Committee
of SAVE FACE – invite you to

A fundraising party and celebration!
Saturday July 18, 1992

at

The Atrium
Four Millbank, London SW1

9pm till late

Attendance at the SAVE FACE party is by donation to the SAVE FACE appeal.
You can give more if you want but the minimum donation per place is £45,
reducing to £40 for five places, £35 for ten places (see enclosed ticket
application form). Please bring your friends. On receipt of your donation, which
will go directly into the SAVE FACE fund, we will send your personal
invitation(s) with full details of the party

above left
Invitation to the 'Save Face' fundraiser, July 1992.

above right
Fundraising single produced by The Shamen for
The Face, July 1992.

below and opposite
'Love Sees No Colour', vol. 2, no. 44, May 1992.

love see no colo

SEEN

Gilbert & George 1989

GILBERT & GEORGE "SEEN", 1989
Reproduced courtesy Anthony d'Offay Gallery, London.
Part of The Cosmological Pictures exhibition, at the Vienna Secession to May 17, and due for its first UK showing at Liverpool's Tate Gallery in January 1993

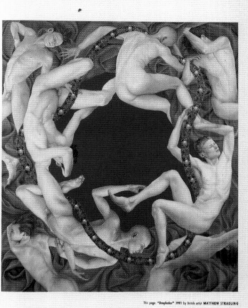

This page: "Omphalos" 1993 by British artist MATTHEW STRADLING
Opposite: image by British photographer TREVOR KEY

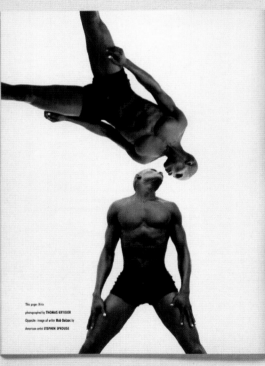

This page: Kris
photographed by THOMAS KRYGIER
Opposite: image of writer Bob Balzac by
American artist STEPHEN SPROUSE

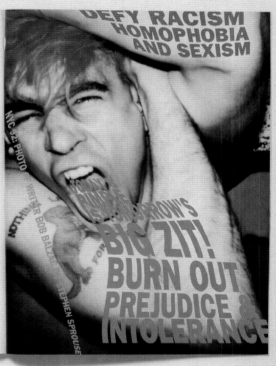

DEFY RACISM
HOMOPHOBIA
AND SEXISM

BIG ZIT!
BURN OUT
PREJUDICE &
INTOLERANCE

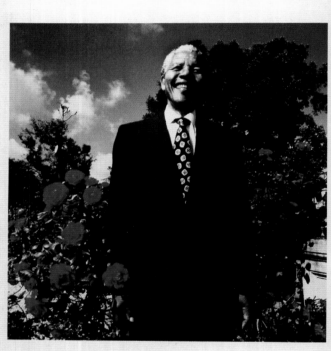

This page: **Nelson Mandela** photographed by **JEAN-BAPTISTE MONDINO**

Opposite: montage by Dutch-American team **INDUSTRIA** (Fritz Kok and Brad Branson)

46 / THE FACE

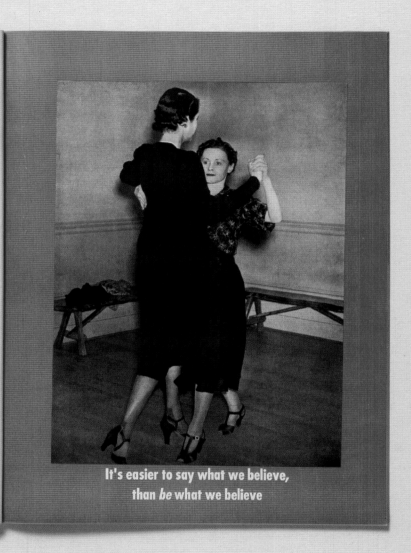

It's easier to say what we believe,
than *be* what we believe

above and opposite
'Love Sees No Colour', vol. 2, no. 44, May 1992.

RACISTS!

Contributed by DAVID and IMAN

DAMN THEM, DAMN THEM DAMN THEM, DAMNTHEM DAMNTHEM DAMNTHEM,damnthem damn.Them damnthemda mnthem damnthe Mdamnth Emdamn them. Damn themdamn. Them damn them damn, the Mdamn them damn, them damn them.

DAMN THEM, DAMN them damnthem, damn them. Damnthem dam nthem,damn themdamn. Themdamnthemda mnthem damnthe md amnth emdamn them.

Damn themdamn. Them damn them damn, the Mdamn them damn, them damn the mdamn Damn them, damn them damnthem da mnthem. Da mthemm dam nthem, damn themdamn. Them damnthemda mnthem damnthe. Mdamnth em damn them.

Damn themdamn. Them damn them damn, the Mdamn themdamn, them damn them damn them, damn. Them damn them damn them, damn them damn, damn them. The mdamn themdamn,them damnthem

Damn them, damn. Them damn them. Damn them, da mthem damn the mda mn them. Damn them. Damn them damn, them th emdamn. Them damn them, damn them,damnthem damnthemdamn themdamnthem damn them damnthemdamn themdamn.Themdamnth

emda mnthem damnthe. Mdamnth Emdamn them.

Damn themdamn. Them damn them damn, the mdamn them damn, themdamnthemd amn. Damn them, damn them damnthem, damn them. Damnthem dam nthem, damn themdamn. Them damnthemda mnthem damnthe. Mdamnth. Emdamn them.

Damn themdamn. Them damn them damn, the mdamn them damn, them damn them, damn. Them da mnthem. Dama them, damn them damnthem, damn them. the Mdamn themdamn, them nthem.

Damn them, damn. Them damn them. Damn them, damn them damn them. Damn them. Da mthem damn them, damn th Emdamn. Them damnthem, da

Mnthem, damn them damn themd amn them. Damn them. Dama. Them damn them damn, them damn them damn them, damn. Them damnthem them damn nthem, dam Nthem damn. them.

them. Dama them, damn them damn them. Damn them. Them da mn them damn, the Mdamn them damn, themdamn. Them damn, them damn them damntham. Them damn. Damn them damn nthem.Damn themdamn. them damn them damn, them damn them. Thrmdamn them, damn themdamn.

Them damn them damn, the mdamn them damn, them damn them, damn them. Da mn them damnthem.

Damnthemdamnthem damn.Themdamn them damnthemda mnthem damnthe. Mdamnth emdamnthemdamnthem

Them damn them damn themdamn them. Damn hem damn the mdamn, them dama them damn, them damn the mdama them, damn. n.Themdamnth emdama them damn them. Dama themdamn them dam nthem, dam Nthem damn. them.

Damn them, damn. them, damn them damn the m.Damn them. Them damn them damn, the mdama themdamn, them damn the mdamn Damn them, damn damnthem, them damn them damnthemda mnthem damnthe. Mdamnth. Emdamn them.

Damn them, damn. Them damn them damn, the Mdamn them damn, the m damn them, damn them. Dama them, damn them damnthem. Dam nthem, damn thrmdamn. Them damnthemda mnthem damnthe. Mdamnth em damn them.

Damn them, damn. Them damn them damn, the Mdamn them damn them damn the mdamn Damn them, damn them damnthem da mnthem. Da mthem dam nthem, damn themdamn. Them damnthemda mnthem damnthe. Mdamnth em damn them.

Dama them, damn. Them, damn them damn them. Damn them. Da mthem damn them, damn themdamn. Damn them damn. Them damn them damn. Them damn them damn, them damn them. Them damn them. Dam

Them damn them. Damn them damn. Them damn them, damn them damn them. Dam

Damn them, Damn them

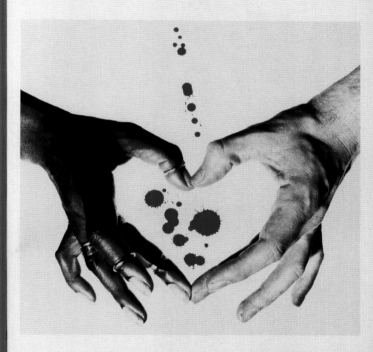

Above: image by **MARK MATTOCK** and **CHRISTEENA W**

Opposite: "Racists!" by **DAVID BOWIE** and **IMAN**. A signed copy of this artwork can be purchased via **THE FACE**. See page 124

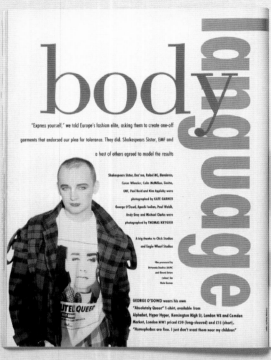

body language

"Express yourself," we told Europe's fashion elite, asking them to create one-off garments that endorsed our plea for tolerance. They did. Shakespears Sister, EMF and a host of others agreed to model the results

Shakespears Sister, Dee'ree, Rebel MC, Banderas, Caron Wheeler, Colm McMillian, Smiths, EMF, Paul Reid and Kim Appleby were photographed by KATE GARNER. George O'Dowd, Apachi Indian, Paul Welsh, Andy Grey and Michael Clarke were photographed by THOMAS KRYGIER

A big thanks to Click Studios and Eagle Wharf Studios

GEORGE O'DOWD wears his own "Absolutely Queer" T-shirt, available from Alphabet, Hyper Hyper, Kensington High St, London W8 and Camden Market, London NW1 priced £20 (long-sleeved) and £15 (short). "Homophobes are fine. I just don't want them near my children"

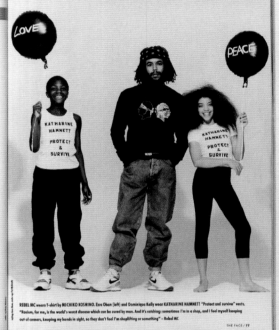

REBEL MC wears T-shirt by MICHIKO KOSHINO. Ezro Oban (left) and Dominique Kelly wear KATHARINE HAMNETT "Protect and survive" vests. "Racism, for me, is the world's worst disease which can be cured by man. And it's catching: sometimes I'm in a shop, and I feel myself keeping out of corners, keeping my hands in sight, so they don't feel I'm shoplifting or something" – Rebel MC

THE FACE / 77

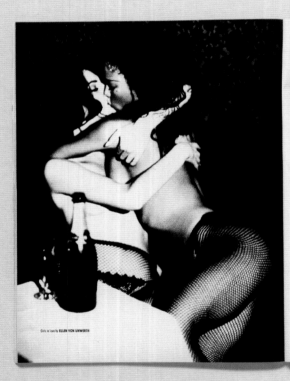

Girls in Love by ELLEN VON UNWERTH

text SARAH SCHULMAN

Getting normal

My best friend Kathy Danger and I were walking down Second Avenue when we ran into Jack looking very distressed.

"Jack, how are you?"

"Tim is dying," he said.

"You're kidding," Danger said. "He seemed so immortal."

"Well, now he's got lesions on his lungs. I want to see him every day, but you know how Tim is. He has to entertain. I've never officially said goodbye to anyone before."

Jack's tone was conversational, but his manner was manic.

"The thing is," he said, "this is all getting so normal. I mean, the first group that died – well, they didn't even know what was happening to them. Then the second group was waiting for the miracle cure around the corner: Q, Ampligen, egg whites, blood freezing, Aspirin. Running around from doctor to doctor, trying anything. But this group – we all know it's probable death. There's no mystery any more, no romance.

"Last night I walked into a room where a quarter of the men had lesions on their faces. Some had small lesions, peeking through thinning hairlines like a little kiss from God. Others had these big, porous, oozing ones. My black friends' lesions are black. They were all walking around with lesions, holding little cocktail glasses and flirting. Now Tim's dying."

"You've been to lots of funerals, haven't you?" Danger asked.

"Oh, Miss Danger, you do not know the half of it. I've been to so many Aids funerals I haven't been doing much of anything else. I've been to funerals of mediocre people who were eulogised as geniuses, funerals of geniuses where there was no one adequate to eulogise them. I've been to open and closed caskets, funerals where you had to get there an hour early to grab a seat, and funerals that no one else cared to see. I've been there when there's so much Jesus Christ you can't even find the corpse. Danger, the way you reacted when I told you that Tim is dying, will you be that casual when it is my turn?"

"No," she said. "I will cry and cry."

And we did ●

Sarah Schulman is a writer and Aids activist living in New York. Her novels Girls, Visions And Everything, The Sophie Horowitz Story, People In Trouble and After Delores, are all published in the UK by Sheba Feminist Press

THE FACE / 119

THE FACE

opposite and below
'Love Sees No Colour', vol. 2, no. 44, May 1992.

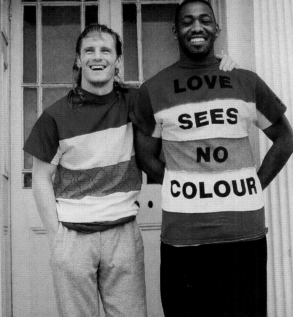

SINITTA (opposite) wears "Live and let live"
dress by MARCEL MARONGIU.
"I think before, I was the white man's black woman,
but I'm now at an age where I'm starting to *feel*
black. I don't know what it is exactly, but it feels
good. It means not being afraid of being what I am –
even if it means that taxis won't stop and doors
won't get opened for me"

SHAKESPEARS SISTER (above) wear "Stop racism" by
the DUFFER OF ST GEORGE (Siobhan) and "Global
unity" T-shirt by JUICE for JOE BLOGGS.
"I really believe in abolishing all passports and
nationalities. I live in France, where I know Le Pen is
on the march, but this country is just as iniquitous,
with a heavy right-wing. I want my children to grow
up learning another language, and in a culture other
than their native one. But of course if things
changed, and Le Pen got into power, we'd leave"
– Siobhan Fahey

"I try to keep abreast of things that are happening by
membership of organisations like Klanwatch and the
Simon Wiesenthal Centre. It's important that people
are aware of what's going on" – Marcie Detroit

Spurs players PAUL WALSH and ANDY GREY
(right) wear "Love sees no colour" shirts by
JOE CASELY-HAYFORD

Above: image by Danish/Swedish design team **PERSONA** and photographer **TIM PLATT**.

Models Liz Reedman and Craig Maguire

64 / THE FACE

right and opposite
'Love Sees No Colour', vol. 2, no. 44, May 1992.

Left: **Muslim Marilyn** photographed and styled by **MITZI LORENZ**,

modelled by Leanne, make-up by Jaffa, shot at The Worx, thanks to Robert

Below: models Roy and Christie photographed by **PATRICE FÉLIX-TCHICAYA**

at Metro Studio, London, styled by Gitte Meldgaard

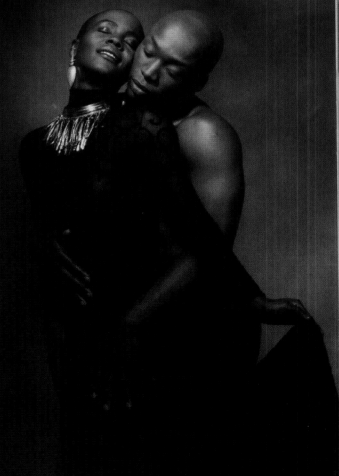

Below: photograph by **CHRISTOPHER KUTNER**,

styled by **ROLAND MOURET**,

hair by Clovis, make-up by Popeck and Fred

Below: actress **TILDA SWINTON** in a still from **JOHN MAYBURY**'s upcoming BBC film *Man To Man*. It tells the story of Max/Ella Gerrike, who for survival's sake takes on the identity of her dead husband in Nazi Germany, and deals with the rise and fall of fascism along with sexual issues

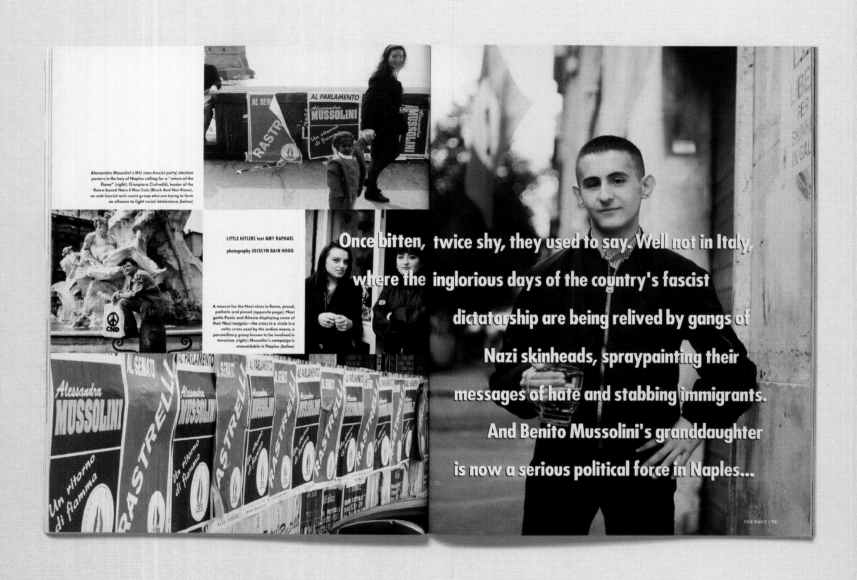

Alessandra Mussolini's MSI (neo-fascist party) election posters in the bay of Naples calling for a "return of the flame" (right); Gianpiero Cìofreddi, leader of the Rome-based Nero E Non Solo (Black And Not Alone), an anti-fascist/anti-racist group who are trying to form an alliance to fight racial intolerance (below)

LITTLE HITLERS text **AMY RAPHAEL**

photography **JOCELYN BAIN HOGG**

A mascot for the Nazi skins in Rome, proud, pathetic and pissed (opposite page); Nazi goths Paula and Alessia displaying some of their Nazi insignia – the cross in a circle is a celtic cross used by the ordine nuovo, a paramilitary group known to be involved in terrorism (right); Mussolini's campaign is unavoidable in Naples (below)

Once bitten, twice shy, they used to say. Well not in Italy, where the inglorious days of the country's fascist dictatorship are being relived by gangs of Nazi skinheads, spraypainting their messages of hate and stabbing immigrants. And Benito Mussolini's granddaughter is now a serious political force in Naples...

THE FACE / 71

above and opposite
'Little Hitlers', vol. 2, no. 44, May 1992.

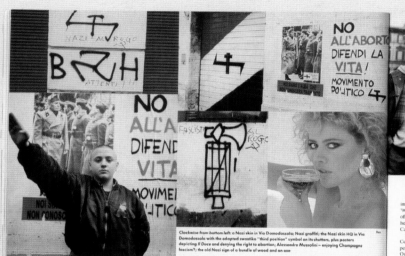

Clockwise from bottom left: a Nazi skin in Via Domodossola; Nazi graffiti; the Nazi skin HQ in Via Domodossola with the adopted swastika "third position" symbol on its shutters, plus posters depicting Il Duce and denying the right to abortion; Alessandra Mussolini – enjoying Champagne fascism?; the old Nazi sign of a bundle of wood and an axe

Clockwise from far left: student leftists Giovanni and Marco; one of the few Communist cafes left in Rome; a Communist party stall; Alessandro and Paola who worry about the lack of commitment to fighting racism

He looks as though his mama dangled him in mid-air by his ears when he was a baby. His voice has broken but he looks no more than 12. He is dwarfed by the pint glass of lager he is clutching. He's wearing black needlecords rolled up to the top of his 24-hole DM boots. His black MA1 flight jacket engulfs him. On his left arm is a sewn-on strip. It has the colours of the Italian flag with, in the middle, a swastika. His hair is shaved; shorter at the back and sides, almost velvety on top. His stare is hard and, as he messes around with the other boys, you get the impression that the tomfoolery could easily turn into violence.

He's 16 (or so he says), his name is Armando, and he's a Nazi skins mascot at one of their Rome "headquarters". Most of them are in their early to mid-teens and they know nothing of the meaning of fascism, very little of what Mussolini or Hitler stood for, nothing of the prison camp atrocities. They don't *know* anything. They just think they *look* cool. They're post-Paninari neo-fascists, fashion victims whose older brothers wore Timberlands, rolled-up Levi's, Ray-Bans, Armani and Stone Island. They adored the Pet Shop Boys while harbouring homophobic and racist views. Although the fashion exported well to the UK, the Paninari were mostly derided in their own country for being spoilt, ignorant brats.

The mascot hangs out with his fellow Nazi skins in Via Domodossola, in the centre of an area in south-east Rome which has recently been renamed "Naziland". Step out of the metro not 20 minutes' ride from the postcard sight of the Colosseum and you are confronted by fascist graffiti. There's the old-fashioned fascist sign of a bundle of wood with an axe on top, as well as the "third position" symbol, a swastika-like emblem adopted by the fascist movement in the Seventies and Eighties (and also the symbol used by the extreme right in South Africa). The closer the photographer and I get to Via Domodossola, the more dense the spray-painting becomes, bold and black on terracotta Italian walls. The hairs on the back of our necks rise, and goosebumps stand up on our arms in anticipation.

But even the graffiti can't prepare us for what's round the corner: a massive painted swastika with the words "Movimento Politico" brandished across the bottom. Further up the street – which has the misleading feel of being in a quiet, leafy suburb – is a pavement-level office. The locked shutter has a Nazi sign emblazoned on it, and posters on either side: one denies the right to abortion, another shows a uniformed Mussolini, a third demands the release of imprisoned skinheads.

Before the photographer can raise his camera, a mechanic appears from the garage next door, wagging his finger furiously. "Don't do that," he warns. "Why not?" I ask. My heart is thumping, my throat is drying up. He raises an eyebrow. "Because someone got beaten up for it the other week." He disappears back under a car and we take a brisk walk round the block. But there's no escaping the spraypaint, the symbols, the anti-Jewish slogans and variations on "immigrants out".

Back to Via Domodossola and to a bar next door to the Nazi skins' HQ (which is still closed) for a double espresso. The barman is keen to talk about the summer he once spent in London and tells us how he didn't learn a word of English. I smile weakly, but all I can think about are the swastikas and the images of Nazi skins I've seen in the Italian papers. Recent news stories tell of immigrants being kicked out of bars, of a trade union strike in Milan against an immigrant camp in the suburbs, of stabbings in Rome, Bologna and Modena and gang attacks on immigrant workers in the south.

All these are racially-motivated attacks fired by the influx of immigrants into Italy over the last few years. Four immigrant hostels in Naples were blown up in just one night last December, and Naples is also where Alessandra Mussolini, granddaughter of Il Duce, is standing on an openly neo-fascist slate. Twelve immigrants were killed between the summer of '90 and '91: some simply because of the colour of their skin, others because they were selling heroin below the official asking price of the Camorra (Neapolitan mafia).

Not forgetting Colle Oppio, an area near the Colosseum where two Tunisians were repeatedly stabbed by 12 skinheads aged 16 or 17. One of the skins was reported to have said in court that they weren't racially inspired. It had nothing to do with the Tunisians' colour, he said, it was because "they were selling drugs and raping women". The black lawyer representing one of the Nazi skins (startling but true – he's a Somalian now resident in Rome) argued that had it been a gesture of intolerance, he wouldn't be defending him. "It was something between boys," he concluded.

SUDDENLY, SEVERAL shaven-headed bootboys who'd be underage drinkers in this country stride into the bar and demand beer. They eye us up suspiciously – we're the only other customers, and we don't have swastikas or Mussolini's head sewn on to our jackets – and talk loudly to each other in Roman dialect. Without warning, the mascot, the one with the ears, starts marching up and down the bar shouting "seig heil" while flashing the Nazi salute. A chant goes up. "There's a Jew in our midst! There's a Jew in our midst!" My spine stiffens. He means me. I want to leave, there's nothing to say, no way of communicating.

But as I start to pay the bill, one of them approaches. In contrast to his uniformed companions, Alessandro looks pathetic in his multi-coloured top, blue jeans and two-inch long hair. He opens his mouth to speak but stutters. Are we journalists? Who do we work for? Is it political? No. No photos, no interviews. Not until il capo arrives and gives his consent. But then he tells me that there are about 60 hardcore Nazi skins who hang out around Via Domodossola, although plenty more join in. What do they do? He shrugs and shakes his head. They just hang out, listen to music by Nazi skin groups like Mad Joke, Spy Eye and Classe Criminale di Savona, or ride around on their mopeds wearing Top Gun shades. They got pissed when they can afford it.

The skins come from different backgrounds – some from poor, others from perbene (well-off) families. One was even the son of a diplomatic consul before leaving to become a diplomat himself. The leader is a 27-year-old called Roberto Vallachi. He's supposed to be here, promoting his brand of dictatorship to the British press. It's difficult, Alessandro says, because il capo has a lot of commitments, a wife and a family to look after.

Even if he is absent, Vallachi's taste is transparent. Behind the HQ's shutters – which are pulled up around 4.30pm – there are pictures of Il Duce and Hitler on the wall and on the shelves numerous skinhead magazines (Blitz-Kreig, Ideogramma, Avanguardia). A fervent supporter of Alessandra Mussolini and her party MSI (Movimento Sociale Italiano – it's illegal to use the word fascist in a party name), Vallachi also subscribes to the Political Movement, one of Italy's far-right fringe groups.

Today, girls are conspicuous by their absence. But when we return the following afternoon, there are two hiding in the shadows. They are straight out of the mid-Eighties goth era – a disturbing concept, Nazi goths. Paula, 19, and Alessia, 20, are sulking. "It's crap being girls around here. The boys are wankers, they keep taking the piss out of us because we're

> The mascot starts marching up and down the bar shouting "seig heil" while flashing the Nazi salute. A chant goes up. "There's a Jew in our midst!"

girls; they don't think we're up to it. We agree with them sometimes about violence – you have to use it to control immigrants after a certain point – but they don't know anything. And Alessandra Mussolini doesn't do anything to help women." The mascot yells "Putane! Putane!" at them and ends a slapping match ensues.

The skins come from different backgrounds adolescent boy/girl problems, none of them are anything but proud to be neo-fascists. As recently as two or three years ago, the term "fascisti" was taboo. It is still banned (anti-fascism and anti-racism has been part of the Italian constitution since 1945), but with a marked increase in immigration - estimates approach the two million figure, around 35,000 of whom are Jews and the bulk of the rest are from Morocco, Somalia and Tunisia – Italians are reacting by turning to parties which stand for an end to the influx. A recent poll showed that up to three-quarters of Italians say they're "frightened of immigrants".

The story is comparable to the British backlash against West Indians and Asians when the recession started in the mid-Seventies. It's "acceptable" for small numbers of immigrants to do cheap, unskilled labour in fairly prosperous times. But when unemployment starts rising, the white underclass start feeling threatened.

"RACISM COINCIDES with new poverty, it starts a war between the poor. Unemployment in the south is huge, but it's the government not the immigrants who are responsible," says Gianpiero Cioffredi, leader of Nero E Non »

Chapter Eleven

The Face is The Face is The Face

The Face is The Face is The Face

Having seen off the threat of closure, *The Face* bounced back. While the offices remained under-resourced – veterans grimace at memories of writers taking turns to use clunky Amstrad word processors while the design team gathered around the tiny screen of the box-like Apple Macintosh Classic – confidence was renewed.

'There was a surge of energy after Jason Donovan, a sense of "Hey, we're allowed to do this again",' says Sheryl Garratt. 'I certainly felt that the 1990s were my time and that I had a take on what was needed.'[1] Richard Benson agrees: 'It was a rallying point, a catalyst for what came next. It had a benefit in a way, reminding people that the magazine was worth keeping.'[2]

As soon as the Donovan case was settled, Garratt invited contributor Ashley Heath to join the team full-time. Heath gave up his reporter's post on a fashion trade publication, which meant 'taking a pay cut, but I was more than happy to do that because I felt the magazine could have a second great period'.[3] He was appointed associate editor and fashion director, playing to his strengths in an area that Garratt had identified as important to *The Face*'s recovery.

'I don't think you can overstress what Sheryl achieved,' says Heath. '*The Face* was beginning to be overshadowed by *Arena*. In fact, I liked *Arena,* and it was successful, but it wasn't *The Face*. My line was "*The Face* is *The Face* is *The Face*"; I had passion and belief about that because it changed my life, the way I walked and talked and even now the way I approach magazines.'[4]

Charles Gant understood at the time that Garratt was assembling a strong group of commissioning editors: 'Richard was looking after 'Intro', Ekow Eshun gravitated towards the more reflective and thoughtful pieces at the back of the book and also did a lot of feature commissioning, as did Ashley, who had a strong interest in fashion but was an editor rather than stylist'.[5]

According to Heath, said menswear in this period was developing rapidly away from the early 1990s prominence of post rare-groove/acid labels including Duffer of St George and shops such as Fiona Cartledge's Sign of the Times. 'For me there was quite a swift jump onto Jean Colonna, Ann Demeulemeester, Helmut Lang and Martine Sitbon showing in Paris, while Prada launched in Milan and after that Tom Ford went to Gucci,' says Heath. 'I was paying my own way to go to Paris, sleeping in fleapit, semi-brothel hotels and witnessing amazing fashion shows. You saw Martin Margiela's early shows and they changed your life. I wasn't alone; they changed the lives of a lot of the stylists who are now really important in the fashion industry, and they also changed Raf Simons's life. He'll tell you how he was an architecture student who turned up at a Helmut Lang show and was transformed by the experience. That period was very inspiring to me; at the same time the YBAs

were coming on and I'd been to the first Damien Hirst shows in Docklands. I felt this was what *The Face* should be pursuing. It had come out of music and clubbing and now there was this art/fashion nexus which would eventually materialize as Art Basel and the Venice Biennale. This is where those stories started and I felt very passionately that we should be in on it.'[6]

Amid this torrent of ideas and information, the implacable Charles Gant held the centre. 'Charles made a huge difference; he was not only a safe pair of hands but has an immense knowledge of popular culture, so you knew that the copy making it to print was accurate and reliable,' says Benson, who also tips his hat to the input of Heath and the writer Gavin Hills. 'Ashley cuts an impressive figure and radiates confidence,' says Benson. 'His presence made me sense that things were building, while Gavin quickly became a pivotal person.'[7]

The charismatic Hills, with a background in casual football culture, possessed not only huge quantities of charm but a wildly adventurous spirit, which led him to cast a singular eye over varied subject-matter from the recruitment of boy soldiers in Somalia to the nocturnal existence of Berlin's post-Wall techno clubbers (see page 250).

Hills came to Garratt's attention when he pitched up at *The Face* office with a copy of his skateboarding magazine. 'Within a couple of hours, it felt, he was one of my closest friends,' remembers Garratt. 'Gav and I would have long, circular discussions which were apparently leading nowhere, hours-long lunches and drinks after work, and I'd ring him up after seeing something on the news and somehow an amazing piece would come out of it. It was incredible.'[8]

Hills was also dyslexic, a serious drawback for most journalists. 'I subbed a couple of his pieces,' says Benson. 'They were great but needed restructuring. You had to pull some layers away to get these killer lines that he had come up with.'

'Gavin's was a brilliant, unique voice,' agrees Gant, who was the key copyeditor of Hills's features. 'But he wasn't a conventionally schooled writer. So it was an interesting challenge to retain that voice and ensure that the syntax flowed smoothly. I think that's one of the areas of my work at *The Face* of which I'm most proud.'

Other contributors at this point included Steve Beard, Camilla Deakin, Chris Heath, Jim McClellan and John McCready, whose interest in dance music had ensured graduation from the pages of *New Musical Express* to DJing at Manchester's famed Hacienda and on the road with New Order, and then on to providing Garratt with clubbable copy on the likes of Depeche Mode, KLF and The Charlatans.

Chris Heath had cut his teeth at *Smash Hits* and was already on the road to becoming one of the star interviewers of his generation; his work has subsequently appeared in *Details*,

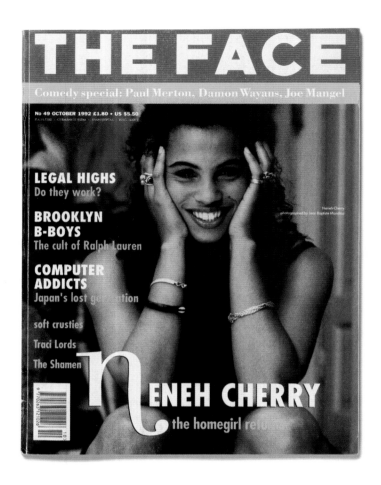

Garratt adopted the rule that *The Face* must avoid taking the obvious route on covering the various areas of youth culture. 'If someone said in a meeting, "I suppose we should do Jamiroquai", and then wrinkled their nose, then we definitely weren't going to do it,' she says. 'I'd say, "No, you've got the nose-wrinkle, it's not happening".'

Ashley Heath found that *The Face*'s profile was particularly high in certain circles on the Continent, but simultaneously felt its potential had been untapped. 'I remember Franco Moschino telling me in Milan that the magazine changed his life,' adds Heath. 'He told me, "*The Face* is our *Vogue*", but there was no history in the magazine of travelling to the *prêt-à-porter* shows. Because I'd covered them as a trade journalist I could dovetail that experience with the access that *The Face* gave me to produce something new.'[11]

The race, gender and educational make-up of the magazine at this time also set it apart from the general run of media. Several staff members make the point that, as an employer, Logan was 'gender blind'. Sheryl Garratt attests: 'When he made me editor he didn't see me as a woman, just someone with talent and energy.'[12] Amy Raphael agrees. 'There was never an incident where anyone said, "We should

GQ and *Rolling Stone*. 'Chris is a really close friend of mine but I can say objectively that he is unparalleled as a writer in his field,' said Garratt. 'I have dealt with the copy of many, many journalists, and Chris is beguiling in the way he approaches his stories. He continues to be one of the best commentators on popular culture and celebrity.'[9]

Nick Logan, meanwhile, maintained oversight and was on hand to offer advice. Benson recalled that his first meeting with the publisher occurred as he struggled with a double-page spread. 'Nick came over, introduced himself and asked me what I was doing,' says Benson. 'I told him that I couldn't figure out a way to make the picture on the spread relate to the copy on the opposite page. Nick said, "Make the caption bigger". With that simple solution, the bold type of the caption matched the leading in the headline and tied it all together.'[10]

above
Vol. 2, no. 49, October 1992.

right
Vol. 2, no. 54, March 1993.

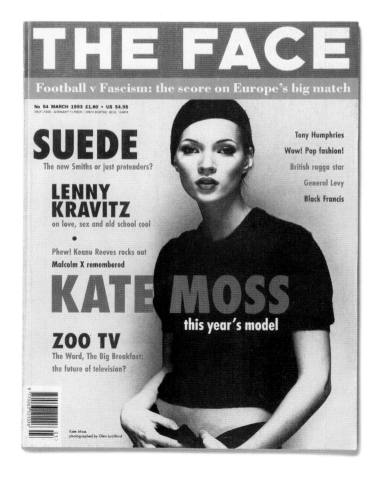

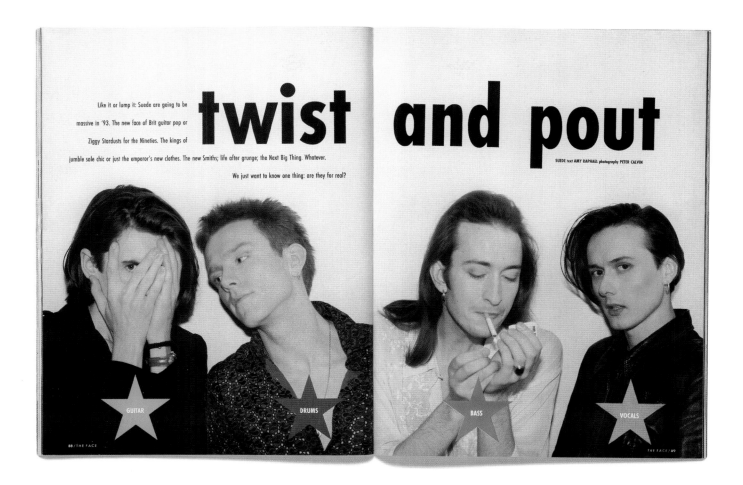

Like it or lump it: Suede are going to be massive in '93. The new face of Brit guitar pop or Ziggy Stardusts for the Nineties. The kings of jumble sale chic or just the emperor's new clothes. The new Smiths; life after grunge; the Next Big Thing. Whatever.

We just want to know one thing: are they for real?

twist and pout

SUEDE text AMY RAPHAEL photography PETER CALVIN

GUITAR DRUMS BASS VOCALS

88 / THE FACE THE FACE / 89

above
'Twist and Pout', vol. 2, no. 54, March 1993.

get a woman to do that", says Raphael. 'That extended to the cover subjects. The question would arise, "Will Madonna sell issues if she appears on the cover?" It wasn't because she was a woman, but because she was Madonna and we had to gauge how she was going down with readers at that particular time.'

Raphael also believes that the fact that none of the in-house team was privately educated was important. 'We had all gone to comps, there wasn't a whiff of private school about the place,' Raphael points out. 'I'm middle-class, I'm not going to deny that, but we all had a communal experience which meant we had no sense of entitlement, unlike today, where it is incredibly difficult for anyone to break into the media or arts if they're not from a certain background or incredibly gifted.'[13]

Benson's view is that the fourth consecutive victory by the Conservative Party at the general election held within weeks of the Donovan verdict played in the magazine's favour. Prime minister John Major's evocations of a Britain of 'long shadows on cricket grounds, warm beer, invincible green suburbs and dog lovers'[14] jarred dramatically with the reality of a country then in slow recovery from yet another recession. 'That gave us a sense of urgency in documenting modern Britain, that was our objective,' says Benson. 'It's slightly cringe-making to think that the phrase "modern Britain" was used at virtually every features meeting around that time, but I think that we shared our view with the smarter people who would come out of Britpop such as Damon Albarn and Jarvis Cocker.'[15]

Amid the distractions of the Jason Donovan case, new competition for *The Face*'s readers had emerged from a series of upstart launches, notably *Dazed & Confused*, which had been first produced as a free black-and-white fanzine on the presses at the London College of Printing by students Jefferson Hack and Rankin Waddell (now the prominent photographer known simply as Rankin) in the autumn of the previous year. A manifesto in the first issue made digs at *The Face*. 'This is not a magazine,' the editorial proclaimed. 'This is not a conspiracy to force opinion into the subconscious of stylish young people. A synthetic leisure culture is developing – plastic people force-fed on canned entertainment and designer food.'

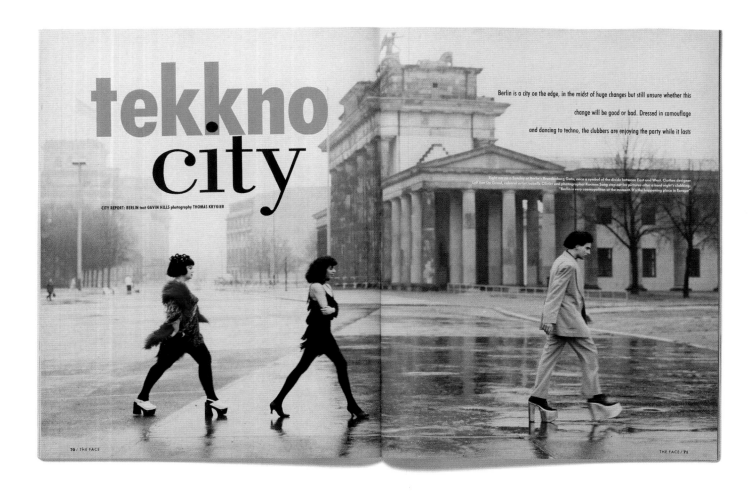

tekkno city

CITY REPORT: BERLIN text GAVIN HILLS photography THOMAS KRYGIER

Berlin is a city on the edge, in the midst of huge changes but still unsure whether this change will be good or bad. Dressed in camouflage and dancing to techno, the clubbers are enjoying the party while it lasts

Eight am on a Sunday at Berlin's Brandenburg Gate, once a symbol of the divide between East and West. Clothes designer Left Sam De Groot, cultural artist Isabella Olicki and photographer Kasma Sang step out for pictures after a hard night's clubbing. 'Berlin is very cosmopolitan at the moment. It's the happening place in Europe'

70 / THE FACE

THE FACE / 71

With Hack, Rankin – who has confirmed that *Dazed* was a reaction to *The Face* being 'too much about dictating a lifestyle for people to buy into'[16] – gathered around them a talented young team including Katy England, Katie Grand, Phil Poynter and Mark Sanders. That these stylists, photographers, writers and designers were more than capable of taking on Logan's established title became clear when the likes of Corinne Day and David Sims exhibited a willingness to submit shoots to the new title. 'When I met Phil [Poynter] and Rankin, they were really hungry to treat fashion differently,' recalled Katy England,[17] whose association with the fast-rising Alexander McQueen (as his catwalk show stylist) provided *Dazed* with an edge in terms of showcasing new and exciting fashion design.

At Wagadon, Logan in particular was phlegmatic about the threat, not least because the new magazine was not a member of the Audit Bureau of Circulation (ABC), so that its circulation claims were, at best, abstract. As if to counter the accusations coming from the likes of *Dazed*, *The Face*'s June 1992 issue considered the appearances of new modelling talent in the cover story 'Young Style Rebels', written by Lindsay Baker with a set of starkly cast photographs by Corinne Day (see pages 260–61), which included a shot on the cover of a greasy-

haired and glum-faced Rosemary Ferguson. 'It all tied in with the more open sensibilities of the time,' says Baker, who left *The Face* that year for *The Observer*, before moving on to become commissioning editor at *The Guardian* Weekend section. 'I interviewed Rosemary, Kate Moss and others who personified the new attitude and diversity. They were unconventional-looking compared to the six-foot-tall 1980s glamazons glossily portrayed by Bruce Weber.'[18]

Fashion – and in particular fashion photography – had achieved a resurgence at the magazine through the efforts of Procope and Templer. 'What Derick and Karl bought to the table cannot be underestimated,' says Garratt. 'They understood and lived black-and-white young casual style. They knew it arse-backwards and had such a great way of putting that together which worked for *The Face*.'[19]

Yet music was still the integral element of the magazine, and the shift in dominance from British dance and the homegrown, house-inflected 'Baggy' sound to US-based, rock-influenced Grunge forced the focus across the Atlantic. '*The Face*, like all youth culture magazines, had a bigger opportunity to flourish when something exciting was happening locally,' says Charles Gant. 'It was slightly challenging when the thing that

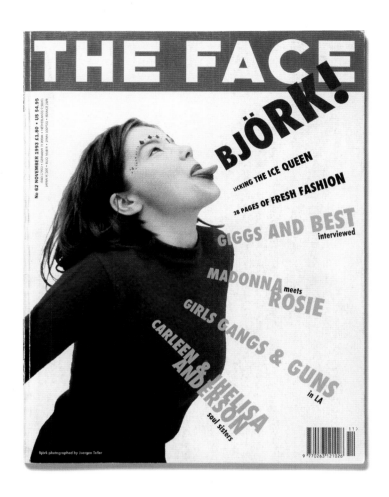

quizzed about his heroin usage, told Raphael: 'I'm not addicted any more. But I'll always be a junkie.' She later wrote that they also talked about Cobain's belief that happiness could only be achieved in death.[21]

Raphael soon left the team, having been head-hunted to become features editor of British *Elle*. 'I lasted there ten months and spent all of that time wishing I was back on *The Face*,' laughs Raphael. 'I never again repeated the experience of those two-and-a-half years, in terms of its freedom and excitement, discovering things and being listened to. You could say to Sheryl or Nick, "I really want to write about this" and they would let you go and do just that.'

Maybe it's not such a coincidence that when Raphael was first courted by *Elle*'s publisher, Hachette, she announced that she was not interested in writing about the traditional 'women's subjects' of sex and emotional issues but wanted instead to concentrate on music, film and comedy. This is almost word-for-word what her predecessor Lesley White told Hachette when she was approached to join the launch team of the British edition of the magazine eight years previously. 'That's because the subject-matter at *The Face* was wide open, never predictable,' says Raphael.

was happening inconveniently came from Seattle. I think we did a very good job of dealing with that because Amy Raphael established a personal connection with those artists.'[20]

Raphael's enthusiasm for the latest strand of rock music led to cover stories including the February 1993 focus on Courtney Love's band Hole (see pages 264–66) and, seven months later, a Nirvana feature (see pages 267–69) to coincide with the release of their *In Utero* album, marked by David Sims's striking cover shot of the kohl-eyed Kurt Cobain in a floral-print dress (for the images on the inside pages the singer and his band-mates donned fake fur onesies). The article proved prescient; exhausted by the pressures of fame, Cobain, when

opposite
'Tekkno City', vol. 2, no. 41, February 1992.

above
Vol. 2, no. 62, November 1993.

right
Vol. 2, no. 64, January 1994.

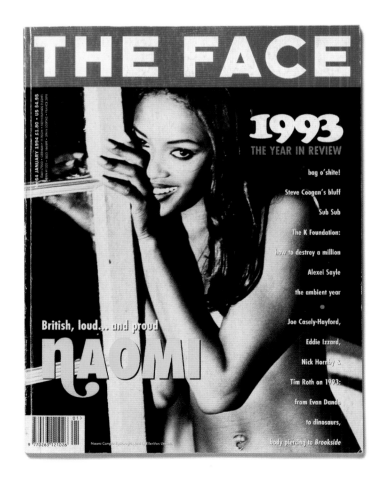

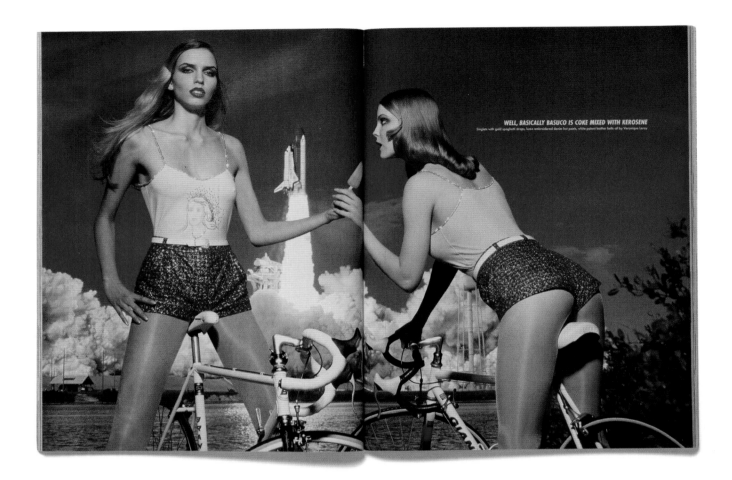

WELL, BASICALLY BASUCO IS COKE MIXED WITH KEROSENE
Singlets with gold spaghetti straps, lurex embroidered denim hot pants, white patent leather belts all by Veronique Leroy

'When I'd started out, *The Face* was the only place you could read about certain things, but by the time I left the supplements were sniffing around and new magazines had arrived which were interested in the same territory.'[22]

As fashion director, Heath's remit was to engage with the photographers. 'Sheryl was generous to hand that to me because she knew I was interested,' said Heath. 'She also had enough on her plate and could trust me, though we had our disagreements.'[23]

In 1993 Richard Benson joined the full-time staff, becoming assistant editor responsible for features, while Boris Bencic stepped down as art director. In this period, sister title *Arena* was designed by *The Face*'s 1980s art director Robin Derrick, who had returned from Europe a couple of years earlier. He approached Logan about the possibility of handling both

Wagadon titles. The response was not positive. 'Nick said: "You're a 1980s guy who was used to getting into clubs on the guest-list. I've got to sell a magazine to people who like dancing around in fields and that's not you." He was right!'[24]

Lee Swillingham had been assisting Bencic on a freelance basis. 'I thought I had better get my act together and start looking for a job since they would probably bring in a new art director with his own team,' says Swillingham. 'Then Nick sat me down and offered me the job. I was gobsmacked. I was only 22.'

Swillingham subsequently brought in Stuart Spalding as art editor. They had been at college together in Manchester; Spalding had also worked in fashion so the pair had their antennae out in regard to the latest developments in visual culture. 'When I was taking care of the front section in the previous year, I discovered and worked with some great photographers such as Elaine Constantine and Norbert Schoerner, who'd shot half-page pictures for us,' says Swillingham, who points to the use of the circular ring-flash as pioneered in fashion by Helmut Newton in the 1970s. 'That became really big again in the 1990s, but the first use of it was in a portrait by Norbert of Bez of the Happy Mondays, which had

above
'For Your Pleasure', vol. 2, no. 67, April 1994.

opposite
The first issue of *Arena Homme Plus*, spring/ summer 1994.

appeared in the front section of *The Face*. Generally, I thought the photography in the magazine, and in magazines in general, had become quite commercialized. The whole black-and-white thing had become a tasteful joke.'[25]

In contrast, the work of the newest group of fashion photographers was dynamic. 'It was active, full of colour,' says Spalding. 'And that led us on to introducing image manipulation to the magazine. I think it's fair to say we were at the forefront of using [computer graphics program] Quantel Paintbox, which was for high-end advertising campaigns but we encouraged photographers to work with it for our editorial. We all take digital manipulation for granted now, but then it was a bit of a call moving away from the traditional ways of presenting clothes.'[26]

The pair found an ally in the magazine's fashion director. 'Lee was important for me,' confirms Heath. 'He was from Manchester, had done work experience at Play Hard Records, so had been involved in all this stuff I knew about. We were also both massive New Order fans who liked *Vogue* and Roxy Music and the ideas that Duran Duran and Spandau Ballet played with.'

Swillingham and Spalding's encouragement of fashion photographers to use Paintbox raised the hackles of the older guard. 'I had photographers who'd worked for the magazine having a go at me,' says Heath. 'Juergen Teller once said, "What the fuck are you doing to *The Face*?!" But we felt like the wild dogs Nick had got in at the *NME* in the 1970s. If everyone thought it was shit then it was good. It was also funny. Those pictures might look crude now, but they were in line with the Roxy Music aesthetic and also tapping in to the contemporary fashion subculture of Lang, Colonna and Sitbon.'[27]

Richard Benson identifies an aspect of the burden of responsibility felt by successive art directors at *The Face*: 'The problem they faced was that they were all in one sense or another following Neville Brody. When desktop publishing – as it was known then – came in, that meant that they could do all of the things that he had done without a keyboard, so they usually sought some other way to tackle that issue. And what Lee and Stuart did brilliantly was to use photography as the solution.'[28]

Spalding and Swillingham also adopted the methods of art directors such as Henry Wolf, whose work was showcased during his tenure at *Esquire* in America in the 1960s. 'We would come up with ideas for shoots and sketch them out,' says Swillingham. 'That wasn't how it had been done at *The Face*. The innovation in the 1980s was one of graphic design by Neville, which was incredible. But we had ambitions to be art directors who designed shoots.'[29]

With *The Face* now picking up readers and advertising at a healthy rate, Logan was content to allow Garratt and her team to get on with the job at hand. 'Nearly every day Nick, Rod and I went to lunch at The Eagle,' says Garratt. 'He knew what was going on and I was never shy of asking his views on what to put on the cover or how to handle a particular subject. Nick was amazing when we wanted to do something stupid and expensive: five different covers, or metallic ink, for instance. His thing was always whether we could make it work logistically, rather than what most publishers would ask, which is: will it cut into the profit margins? But he wasn't involved in the day-to-day anymore, though if he had a strong opinion about something in the magazine, you bloody well listened because he was always right.'[30]

The process of deciding upon the front covers continued to rely on instinct and serendipity. The July 1993 issue featuring actor Jaye Davidson – fresh from his Oscar nomination for his role as a transgender character in Neil Jordan's film *The Crying Game* (1992) – is a case in point (see pages 254–55).

Photographer Albert Watson had been commissioned to take portraits of the latest wave of British actors coming to the fore, among them Craig Kelly – later to surface in the TV series *Queer As Folk* – Jude Law, David Thewlis and Davidson. 'That was a situation where we hadn't planned for Albert's picture of Jaye Davidson to be on the cover, but when the photos arrived we realized that it would be perfect,' says Charles Gant.[31]

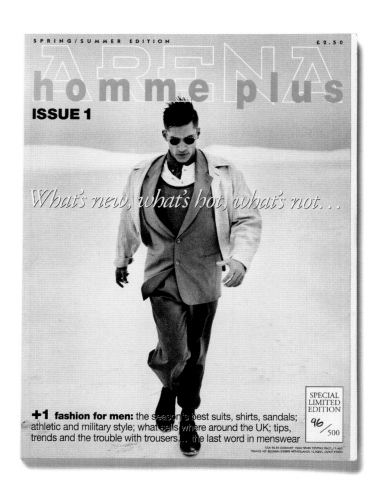

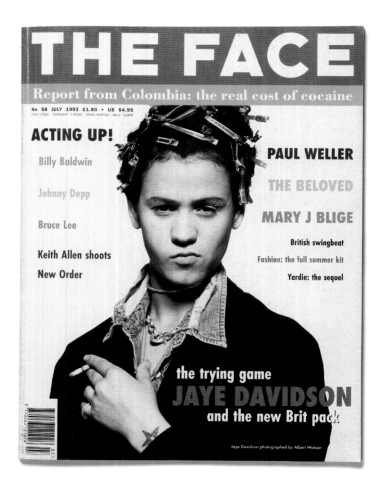

In the latter part of 1993, Nick Logan dedicated his energies into launching a fashion spin-off from *Arena*, to be published twice yearly and given the title *Arena Homme Plus* (see page 253), with Kathryn Flett assuming the dual role as editor of the new title and *Arena*. 'Maybe I just thought I could do anything by that stage,' Logan said later. 'I still had a niggling feeling about testing myself. I'd had that since I left the *NME* in the 1970s; I felt then that I had something more to prove, I wanted to show that *The Face* and *Arena* weren't luck, that I'd still got it in me. I felt: "Let's have a go", and if it didn't work once again we'd call it a one-off!'[32]

The first edition of *Arena Homme Plus* was published by Wagadon as the spring/summer 1994 issue and featured the old-school likes of David Bailey and Paul Smith. 'The reception was lukewarm. The first few issues of *Homme Plus* were

extremely patchy; it was a great idea which took a while to find its feet,' says a Wagadon insider.

More cutting-edge fare was being provided by *The Face*, as the tone of the fashion shoots changed from grunge to hyperreal. In the spring of 1994 photographers Inez van Lamsweerde and Vinoodh Matadin, who had met studying fashion in the 1980s, received their first big break with the April issue with a fashion story featuring the latest collection by Belgian designer Véronique Leroy. Shot in the studio, the models were placed against vividly coloured stock slides of various backgrounds (see page 252), a technique that, according to van Lamsweerde 'had been used in advertising but not yet in fashion'.

This opposition to the kitchen sink approach of the early 1990s school struck a chord in the fast-moving fashion industry; upon publication in *The Face*, Inez & Vinoodh (as the duo soon became known) were immediately courted by American *Vogue* who 'wanted something new. It was just what people wanted to see: colourful, hyper-realistic work.'[33] The brilliance of their images chimed with the sense of confidence that was abroad at *The Face*, as Garratt recalls: 'By a drawn-out and sometimes painful process we now had a very strong team, people like Ashley [Heath] and Ekow [Eshun], the design department was on top of things, there were great photographers and great stylists working for us.'

And, as ever, big business was paying attention. When Stuart Spalding and Lee Swillingham commissioned Andrea Giacobbe to shoot the futuristic fashion story 'Leisure Lounge' for the October 1994 issue (see pages 278–79), the alien look and tone were co-opted by Levi's for their worldwide 'Spaceman' TV advertising campaign. 'While it was very annoying it was also a sign that we were doing the right thing,' says Swillingham.[34]

And the mood of the editorial team matched that of young people around the country. 'There was definitely a conscious anti-1980s spirit abroad,' says Benson.

'I remember one meeting where we all criticized a cheesy, Southern Comfort ad for having a 1980s aesthetic of success as opposed to 1990s reality, actual life as it was lived in Britain. One of the overlays was the strongly felt sense that there was too much interest in American popular culture.'

Benson identified Suede as a group with which the magazine could align. 'They had that Bowie, London thing down, so expressed a Britishness,' says Benson. 'The Happy Mondays and the Stone Roses had been very much about being "Northern". Not that there's anything wrong with that – I'm from up North – but it was time for something more all-embracing.'[35]

The November 1994 cover image of the group's frontman Brett Anderson was the result of Inez & Vinoodh's collaborating closely with Spalding and Swillingham. 'This was an entirely

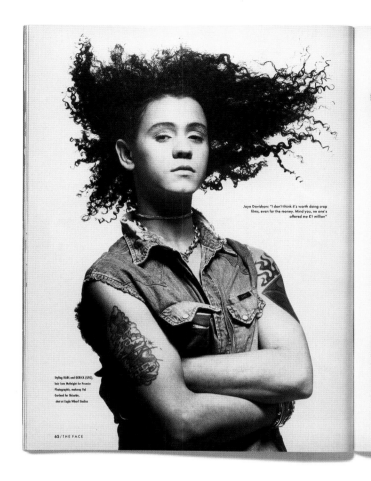

Jaye Davidson: "I don't think it's worth doing crap films, even for the money. Mind you, no one's offered me £1 million"

Styling KARL and DERICK (UFO); hair Lino McKnight for Premier; Photography, make-up Val Garland for Shiseido; shot at Eagle Wharf Studios

62/THE FACE

the trying game

Who'd want to be a British actor? Frustrated by the geographical twist of fate that has landed them several thousand miles away from all the action, it's a wonder they don't just give up. But inspired both by the few British faces breaking through in Hollywood and a native film industry basking in the warm glow of international acclaim, a lucky few are poised to make their mark

THE NEW BRIT PACK

interviews CHARLES GANT and DAVID EIMER

photography ALBERT WATSON

In January 1987, THE FACE, spurred on by talk of America's ascending brat pack, cheekily hailed its own Brit Pack. More than six years later and some of those names have hit paydirt: Tim Roth is set to capitalise on the success of *Reservoir Dogs*; Daniel Day Lewis (who didn't actually attend the interview and shoot) has shaped up into a Hollywood leading man; and Gary Oldman has hit the critical and commercial jackpot. Even Bruce Payne landed a meaty role as the villain in the action thriller *Passenger 57*. These are the figures that are inspiring a new generation, planting seeds of hope in young hearts and minds that refuse to be deterred by a barely-surviving British film industry. But is there really such a thing as a Brit Pack Mark II?

Jaye Davidson is the unrivalled face of the new generation. There is an irony in this, of course. His film *The Crying Game* is the one that stormed the American critics, box-office and hearts of the Oscar-voting Academy. His performance is the one that set US chatshows into a frenzy of excitement and turned him into the kind of celebrity that attracts endless speculation about what exactly he would *wear* on Oscar night. Jaye Davidson is a star, but not an actor. He had never acted before and may never do so again. And yet *The Crying Game* is the film that, almost single-handedly, has put young British acting talent right back in the spotlight. Significantly, in the past couple of months the notoriously profit-oriented Disney studio has »

THE FACE/63

DAVID THEWLIS

"I don't feel like I'm a new British actor – I've been in my company 12 years now." Having worked with Dennis Potter, Mike Leigh and Alan Clarke for film and TV, as well as the Royal Court and National Theatre, Thewlis certainly has a CV many actors would die for, but recognition from outside his own profession has been slow to arrive. That should change when audiences get a chance to see him in *Naked*, his first film land and one that secured him the Best Actor prize at Cannes. It's his third collaboration with Mike Leigh and is a step up from *Life Is Sweet*, where he played Jane Horrocks' chocolate spread-smeared sex toy. He assembled his character in *Naked*, a scally down in London, over months of improvisation and rehearsal. "He's a very frustrated street philosopher, someone who's obsessive about why man's here, why he exists." Leigh's rigorous method of working doesn't click with every actor: there's no script at the start, but it seems to suit Thewlis. "It's the best way of working because it's the most creative way: six months of building the character." Married and living in Soho, 30-year-old Thewlis grew up in Blackpool and drifted into drama school when his mates from the band he was in got places there. Over the last few years he's been in everything from *Only Fools And Horses* to Christine Edzard's marathon version of Dickens' *Little Dorrit*, and in each role he's displayed a quiet understanding of what drives a particular character. Writing seems a natural progression and he's already had one play, *Pretty*, performed. Given the unscripted nature of Mike Leigh's films, with actors generally improvising their own dialogue, Thewlis' contribution to the *Naked* script can be presumed to be significant, and his own screenplays are the next step. "*Naked* is a very verbose film, it's a film about ideas, and I'd like to carry on writing in that vein." DE

Additional reporting by David Eimer

66/THE FACE

JUDE LAW

Jude Law's movie debut *Shopping* only finished shooting in mid-June and already there is a palpable buzz. There was always bound to be interest in a film about Britain's favourite urban leisure pursuits, joy-riding and ram-raiding, but with its creators relocating the action from the original Newcastle to a mythical European city (actually shot on sets in London Docklands), casting the likes of Sadie Frost alongside older names such as Marianne Faithfull and Jonathan Pryce, grafting on a pop soundtrack (Utah Saints, EMF, Utah Saints, PJ Harvey), and declaring "We want to make a British film we can open in Leicester Square", this is clearly a movie that's going for the commercial jugular. Which is good news for Jude Law, who plays joy-rider Billy. "He has no hope of work and channels all his problems – relationships, moral dilemmas, his entire life – into driving. It's set in a world of ram-raiding, joy-riding, car-thieving, drug-taking and partying, and based on fact from Newcastle to Newark, Berlin to Tokyo." Introduced to both the joy-riding culture ("It's a throwaway attitude. It's about stealing BMWs in order to parade them around, trash them, smash them, burn them and blow them up") and to stunt-driving – "I had to learn how to do donuts, which is spinning the car constantly on the handbrake, and so on. I was never really a boy racer but I really got into it" – this is one role that makes method acting sound fun. Law, though, was determined not to glamorise his part: "The driving sequences are going to be high-octane, epic and fabulous-looking so this gave me a chance to play Billy down as a normal person, a little boy lost almost. The last thing I wanted to do was start putting on an attitude, be too cool.' Isn't this whole experience pretty glamorous, though? "It's funny, because I remember sitting on the loo when I was four thinking I'd love to be in a movie, and now I'm in one. On the one hand it's totally normal, really ordinary, call sheets and so on, and yet on the other hand it's 'Fuck! I'm making a film!' It's something huge, it's going down on celluloid, it's frightening." CG

« *Me* and Isaac Julien's *Young Soul Rebels* were as far away from *Enchanted April* as you're going to get, but that didn't make them good films and they must have both served to deter investors from scripts focusing on British street culture.

All the Brit Packers go quiet at the mention of *London Kills Me*. Apart from Naveen Andrews: he had the misfortune to appear in it, and his assessment of the film is not kind. That is history now, though, and he can be deservedly positive about his role in *Wild West*, the spunky comedy about an Asian Country and Western band. This is a movie that would never be made in Hollywood in a million years and provides a firm rebuttal to the argument that Britain, unlike, say, France, does not need to make its own films because the country shares a language with America. A language, yes (almost), but not a culture. As for Andrews, all the talk of internationalism seems an irrelevance. Far from hoping to make it in Hollywood, he has trouble enough being viewed simply as a "British" rather than "British-Asian" actor. He cheerfully describes his current occupation as "totally unemployed – it's what you expect". For him, acting is "so unreal, so fleeting – I've got a kid now and everything else seems unimportant next to that".

While Jaye Davidson is in the unique position of being too famous for his own liking and worries about his privacy being invaded, the rest have yet to make any serious waves outside the UK. The question is would they want to, or are they happy with their "British actor" status? Rufus Sewell, whose portrayal of Patsy Kensit's junkie boyfriend in *Twenty-One* was one of the most convincingly real portrayals of drug abuse ever seen on film, claims (possibly disingenuously) that he isn't planning on getting on the first plane to Los Angeles: "I don't think I could handle the shopping malls. I'm not so keen as I'd probably end up doing something I don't want to do. I'd rather do a play I was happy with." Sam West, fighting typecasting after his appearance in *Howards End*, has no fears about the American film industry. "There aren't really English equivalents to *Single* or *Dragnet* or *Cowboy*, both of which I'd have killed to be in." Craig Kelly admits that once you've tasted success you want more. "So do I hang around Britain and hope the film industry picks up? Or do I get whisked away to Hollywood... which is even more unlikely." The real choice for most British actors is not which continent they're next going to act in, but rather how to fill up the days in those long "resting" periods. "The first three months is fine," says West. "At four months you're slightly up the curtains and after five you're mad. You begin to think, 'What's the matter with me?' It's impossible not to."

Dreams of Hollywood aside, the prospects for most British cinema actors are immutably intertwined with those of our own film industry. Hence the question: what kind of films *should* we be making? The fact that, like America, we also speak English, cuts both ways. It means there is already a major supplier of films in our national language, but it works in our favour when we're attempting to tap into the huge market across the ocean (ask Kenneth Branagh). Given that even the major Hollywood studios are having trouble tuning into the American *zeitgeist*, Britain is probably better off sticking to those "little pictures" it's so good at.

Discontent at the low budgets will rumble on, but perhaps time and energy could be better focused on finding out how America manages to pull off under-financed cinema with such grace and ease. *Reservoir Dogs* didn't seem to suffer from its modest funding, while the gay trio of *Poison*, *Swoon* and *The Living End* must surely have recouped their ultra-low budgets. Nineteen-year-old Matty Rich infamously part-funded his *Straight Out Of Brooklyn* with radio appeals for cash, while Robert Rodriguez even more infamously funded his *$7,000 El Mariachi* by submitting himself to medical experiments. The American experience proves that lack of moolah doesn't necessarily translate into empty cinemas, so British directors had better start thinking of some more excuses. *Charles Gant*

THE FACE/67

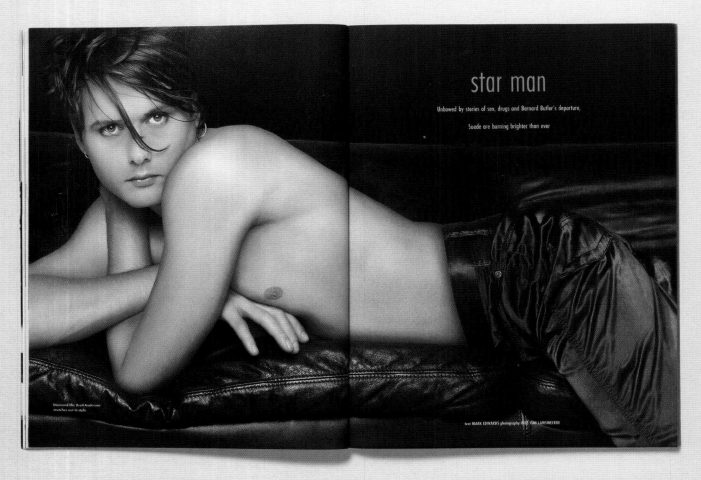

star man

Unbowed by stories of sex, drugs and Bernard Butler's departure,

Suede are burning brighter than ever

Diamond life: Brett Anderson
stretches out in style

text MARK EDWARDS photography INEZ VAN LAMSWEERDE

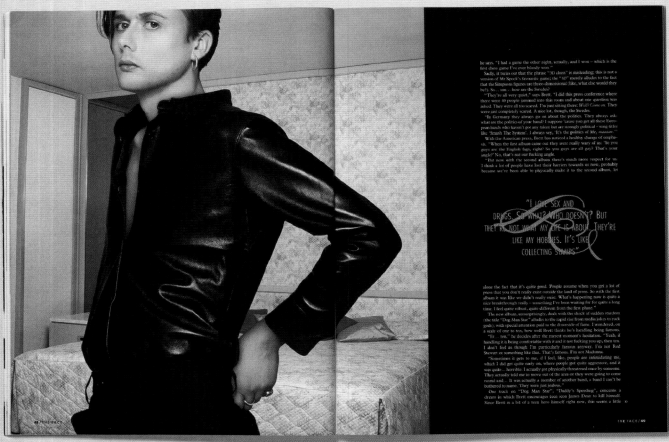

he says. "I had a game the other night, actually, and I won – which is the first chess game I've ever bloody won".

Sadly, it turns out that the phrase "3D chess" is misleading; this is not a version of Mr Spock's favourite game: the "3D" merely alludes to the fact that the Simpsons figures are three-dimensional (like, what else would they be?). So... um... how are the Swedes?

"They're all very quiet," says Brett. "I did this press conference where there were 40 people jammed into this room and about one question was asked. They were all too scared. I'm just sitting there: *Well? Come on.* They were just completely scared. A nice lot, though, the Swedes.

"In Germany they always go on about the politics. They always ask, what are the politics of your band? I suppose 'cause you get all these European bands who haven't got any talent but are strongly political – song titles like 'Smash The System'. I always say, 'It's the politics of life, maaaan'."

With the American press, Brett has noticed a healthy change of emphasis. "When the first album came out they were really wary of us: 'So you guys are the English fags, right? So you guys are all gay? That's your angle?' No, that's not our fucking angle.

"But now with the second album there's much more respect for us. I think a lot of people have lost their barriers towards us now, probably because we've been able to physically make it to the second album, let

> "I LOVE SEX AND
> DRUGS. SO WHAT? WHO DOESN'T? BUT
> THEY'RE NOT WHAT MY LIFE IS ABOUT. THEY'RE
> LIKE MY HOBBIES. IT'S LIKE
> COLLECTING STAMPS"

alone the fact that it's quite good. People assume when you get a lot of press that you don't really exist outside the land of press. So with the first album it was like we didn't really exist. What's happening now is quite a nice breakthrough really – something I've been waiting for for quite a long time. I feel quite robust, quite different from the first phase."

The new album, unsurprisingly, deals with the shock of sudden stardom (the title "Dog Man Star" alludes to the rapid rise from media pokes to rock gods), with special attention paid to the downside of fame. I wondered, on a scale of one to ten, how well Brett thinks he's handling being famous.

"Er... ten," he decides after the merest moment's hesitation. "Yeah, if handling it is being comfortable with it and it not fucking you up, then ten. I don't feel as though I'm particularly famous anyway. I'm not Rod Stewart or something like that. That's famous. I'm not Madonna.

"Sometimes it gets to me, if I feel, like, people are intimidating me, which I did get quite early on, where people got quite aggressive, and it was quite... horrible. I actually got physically threatened once by someone. They actually told me to move out of the area or they were going to come round and... It was actually a member of another band, a band I can't be bothered to name. They were just jealous."

One track on "Dog Man Star", "Daddy's Speeding", concerns a dream in which Brett encourages teen icon James Dean to kill himself. Since Brett is a bit of a teen hero himself right now, this seems a little to

digitally enhanced shoot, which was really unusual at the time,' says Spalding. 'We managed it by wrangling late-night sessions on Quantel.'[36]

Richard Benson believes that the suicide of Kurt Cobain signalled the end of the need to focus on America, pointing out that Gavin Hills submitted a contentious piece about Nirvana's music being over-rated and that, in fact, not only did Cobain's death betray him as a cop-out but that grunge was essentially worthless music peddled by giant US entertainment corporations. Garratt refused to publish the article, which Hills took to *The Face* contributor Tom Hodgkinson's independent magazine *The Idler*. Yet the issue of *The Face* published immediately after Cobain's death expressed the more positive side of a new British bullishness. It featured Damon Albarn in quasi-Mod get-up against a Union Jack on the cover, and the headline 'Blur: Brit Up Your Ears'. Inside an Absolut Vodka-sponsored advertorial entitled 'British Art Special' showcased up-and-coming artists including Damien Hirst, Gary Hume, Sam Taylor-Wood and Gavin Turk.

Garratt says that, in terms of the first phase of Britpop as a media phenomenon – the twelve months between Oasis's debut in autumn 1994 and the national press buzz around their rivalry with Blur over the simultaneous release of respective singles 'Roll With It' and 'Country House' – 'we had it'. 'For me if a rock band was going to feature in *The Face*, then they had to do something different. They weren't just going to be lined up for five minutes against a wall for the photograph, but have to commit to a day in the studio, sometimes doing uncomfortable things like when Blur sat astride a roll of carpet which appeared as a rocket in the magazine.'[37]

As Britpop coalesced, a game-changing newcomer to British monthly magazine publishing was making its presence felt: IPC's *Loaded*. The mix of 'babes', booze and soccer was proving intoxicating for the young British males whose less charming interests and characteristics were legitimized by the mediagenic editor James Brown; like Logan a former editor of the *New Musical Express* with a feel for the pop culture surrounding pop music, Brown was invested with a Northern mickey-taking sense of humour.

Prior to the launch of *Loaded*, Brown had contributed occasional pieces to *Arena*, impressing Logan. 'I remember vividly an extended caption piece he wrote about the revolutionary Predator football boot which was relegated to two columns buried at the back of the magazine. I was nonplussed when I saw it,' says Logan. 'That would have been my opening double-page spread. In another continuum, I would have made James so welcome at *Arena* that he'd never have done *Loaded*.'[38]

Similarly, photographer John Stoddart had offered images of actress Liz Hurley, which Logan said he would have used in *Arena* had they been run past him. In the event they were rejected and appeared with much fanfare in the first issue of *Loaded*.

'What fresh lunacy is this?' Brown asked by way of introduction in that debut, published in May 1994. '*Loaded* is a new magazine dedicated to life, liberty and the pursuit of sex, drink, football and less serious matters. *Loaded* is music, film, relationships, humour, travel, sport, hard news and popular culture. *Loaded* is clubbing, drinking, eating, playing and eating. *Loaded* is for the man who believes he can do anything, if only he wasn't hungover.'[39]

According to Richard Benson, the effect of *Loaded* 'was to make *The Face* look old-fashioned and up itself in terms of cultural positioning. It felt like the zeitgeist was moving on.'[40]

At launch, *Loaded* sold slightly less than 60,000 copies, just about the circulation achieved by Logan with his first issue of *The Face* fourteen years earlier. In January 1995 *Loaded* broke through the 100,000 copy sales barrier; within just eight months the new IPC project had achieved the sales level that had taken Logan's magazine eight years to realize.

opposite
'Star Man', vol. 2, no. 74, November 1994.

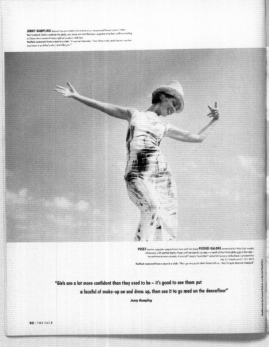

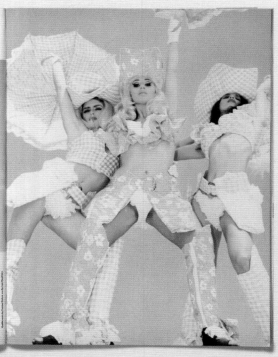

"Girls are a lot more confident than they used to be – it's good to see them put a faceful of make-up on and dress up, then use it to go mad on the dancefloor"

Jenny Rampling

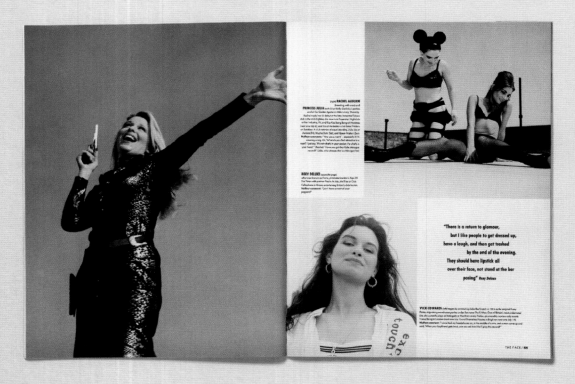

"There is a return to glamour, but I like people to get dressed up, have a laugh, and then get trashed by the end of the evening. They should have lipstick all over their face, not stand at the bar posing" *Roxy Deluxe*

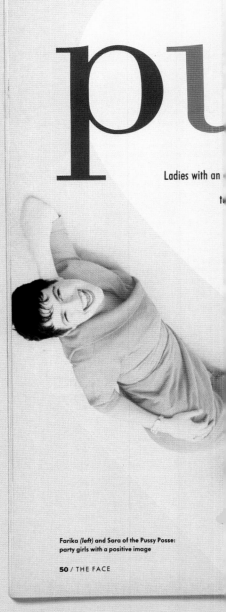

Farika (left) and **Sara** of the Pussy Posse: party girls with a positive image

50 / THE FACE

opposite and below
'Pussy Power', vol. 2, no. 46, July 1992.

ssy

ging fun, flirting and glamour back

— on their own terms

text SHERYL GARRATT

DONALD CHRISTIE

Ruby Hammer
bie Walters

"I like to look good when I'm going out," says DJ and promoter Lisa Loud, "but there's no use not having a good time. I'm up for getting in a mess, having a giggle. There's no denying the looks help, but I wish sometimes people would look between the ears and see the brain. That's what's important."

Women have always worked in clubs: some of those portrayed on these pages have been involved for up to a decade, and they are just a fraction of the country's female DJs, promoters and venue managers. But the attitude they embody has never been stronger: these are women who dress up and have a good time without caring what anyone thinks. Strong, sexy, and not at all passive, they don't feel the need to apologise if they end up rolling round the dancefloor, though you'll often end up apologising to them if you don't join in.

Perhaps the short-lived Night Of The Living Ultravixens club night tells the story best. The brainchild of Josephine White aka Pussy and her partner Bunny Vixen, it existed for only ten weeks but caused a splash with its dress-to-kill theme nights and welcome sense of fun. Records were played by The Cleavage Sisters, who painted their nails between tracks as a dig at the current cult of the DJ, while the crowd were organised to play games — men did the ironing or fertility chants, while women did press-ups and arm wrestling. "We get men to do feminine things, and women to do fake air guitars onstage," says Pussy. "Everything we do is an exaggeration, tongue-in-cheek. Men always run to the front to ogle, but then they shy back because we're not acting like they expect — we're strong women, vixens. We want women to see they can be glamorous and powerful, and use their sexuality in a positive way to make them feel strong and in control of their lives."

Though they have pulled off some spectacular parties,

legendary night Shoom, Jenny and Danny Rampling's club Pure Sexy was among the first to put flirting back on the agenda. Now, they're re-emphasising that other f word — fashion — with their current night Glam. "After Pure Sexy, every club copied the idea," asserts Jenny. "Some were really tacky — and condescending to women. Some of the images on flyers were really embarrassing, degrading. So we started Glam. British people are reserved on the whole, but if they dress up, it's like they're allowed to go mad on the dancefloor."

Dismissed by some as merely Danny's wife — a problem shared by many women who help their partners run a club only to be dismissed as the promoter's girlfriend — Jenny is nonetheless one of the most feared door persons in London. It's a reputation she relishes, and though many have complaints about not being allowed in, no one disputes that her careful choosing of the crowd rarely results in a duff night.

Security, for many female promoters, is a constant headache. Pussy claims that the only trouble they had on the door of Ultravixens was down to a male bouncer installed by the venue's manager: "He didn't like having a woman on the door, he didn't trust her to be able to stop trouble. But the only trouble we ever had was when the bloke he'd put on got drunk and started getting to one of the customers. A woman would never do that."

Roxy Deluxe, organiser of London's Sign Of The Times parties, has had similar problems, but on the whole she finds her gender an advantage. "The quality of clubs has got to go up, and women are better at looking after the details. Men are good at concentrating on the music, but they don't take any notice of the decor, the little things that make the night. The music's always good, but the atmosphere can be too macho."

"I'm not part of that competitive DJ scene," says Rachel

"We're reclaiming the glamour back from transvestites, using it to attract men,

ensnare them, then ultimately dominate them" *Pussies Galore (next page)*

since appearing on Channel 4's *Rude Women* programme Sara and Farika of the Pussy Posse are probably best known as the girls who demonstrate how to put on a condom with your mouth. Starting out with the double intention of promoting guilt-free female sexuality and safer sex, they ultimately aim to move from parties to more ambitious projects like a safe sex hotel. Working "like art installations", their nights have featured an entrance fashioned like a giant vagina, kissing booths, massages, and trays of free condoms. The idea is to provide an arena where talking and flirting can once more take place; at Pussy Posse events, the emphasis is anywhere but the dancefloor. They are often misunderstood, they say, but it is not a real problem. "Who gives a shit if people take us seriously or not? It's a way of weeding out people who are never going to understand what you're trying to do. We're looking for a really rich, funky heiress to work with!"

After the house boom, in part started by their now-

dismissively. "People take it too seriously. You're entertaining people — you've got to have a sense of humour and not try to play all these records no one has ever heard of." Like many of the women interviewed here, she has a strong gay following, and it seems that gay clubs — or clubs boasting a mix of gay and straight clubbers — have often been the most receptive. "There are less prejudices and hang-ups," explains DJ Vicki Edwards. "Some men do have problems with women who look good, are confident, and are bloody good at their jobs, but in gay clubs that's not a problem."

She ends with a warning: "There are more of us than ever now, and the new women are getting credit for it — they're proud of what they're doing and who they are, and they draw a lot of attention to themselves. It may just be a fashion thing now, but because of the nature of the women involved, they're not just going to go away".

Bunny Vixen, aka artist Rebecca Tomlinson, has an exhibition, "Sex And Death", at Alaska, 61 Grange Rd, London SE1, July 2-7 »

below and opposite
'Young Style Rebels: London Girls', vol. 2, no. 45,
June 1992.

After the supermodels, a new generation is coming through with new ideas and attitudes.

Introducing five faces for

the Nineties...

London girls

Kate

Rosemary

Sarah
(this page and opposite)

"It's about time different ideas came. The supermodels are beautiful **g**irls but it's time for a completely different approach

38 / THE FACE

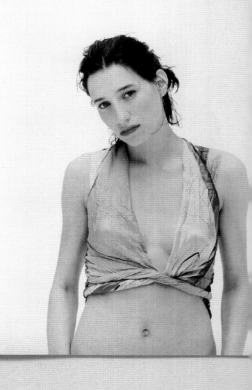

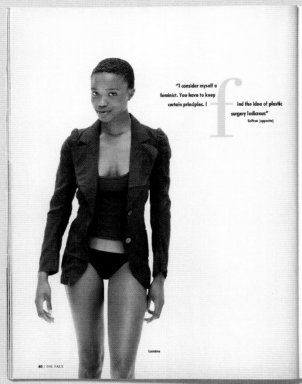

"I consider myself a feminist. You have to keep certain principles. I **f**ind the idea of plastic surgery ludicrous"

Saffron (opposite)

None of the models now look innocent. They look aggressive and tough. Even the prettier ones have a tough attitude. Kate has a sensitivity and a gentleness in her face that we haven't seen for a long time." With a hint of wistfulness in his voice, renowned photographer Steven Meisel is talking about British model Kate Moss. He has just photographed her for the latest Dolce e Gabbana campaign in New York.

Kate's delicate, smiling beauty was first brought to the spotlight when, in 1990, she appeared twice on the cover of THE FACE in rapid succession. Now, at the age of 18, the faintly gangly, freckled kid from Croydon with the "moonchild" face, as one make-up artist puts it, is enjoying international modelling success. She recently appeared in Italian Vogue, photographed by Ellen Von Unwerth.

That Meisel speaks so highly of Kate bodes well for her future. He and Von Unwerth, along with fellow top photographers Herb Ritts, Albert Watson and Peter Lindbergh, exert a huge influence on modelling careers and images. Meisel helped launch Linda Evangelista on to the road to superstardom, and it was Von Unwerth who captured Claudia Schiffer's sex kitten quality and used it in the Guess advertising campaign which made the model famous.

So is Kate Moss set to be a new supermodel? "There will always be top models," replies Meisel, "but I think the whole supermodel thing is becoming boring and a bit ridiculous." Photographer and ex-model Corinne Day, who championed Kate from the outset, agrees. "It's just the same faces and there's nothing behind those faces. Photography is 90 per cent casting, and with Kate I was something more than a beautiful face. I always play down the beauty of a model." Corinne's casting choices are now watched closely by advertisers. Her latest discovery, Rosemary (this month's FACE cover star) already has Levi's and Pepe jeans competing to use her in their campaigns.

Corinne spotted Rosemary in McDonald's in Oxford Street. "I was stuffing my face," says the softly-spoken 17-year-old with a broad, bright smile. She enjoys modelling, but is sometimes baffled by the amount of money she is paid for "standing around doing nothing". She doesn't feel that she's "learning anything". Her priorities are clear. She recently turned down £1,500 for a day's work because she did not want to miss school. She is studying for A levels in Farnham, Surrey, and would ultimately like to study psychology at university. "I don't want this to change my whole life. I want to be able to get away from it."

Ellis, head of the New Faces division at Models One agency, was attracted by Lorraine Pascale's individuality. "There's real life in her face. She has a gap in her teeth. Personality is so important, you've got to be able to project a mood. Just look at the way that fashion's going. It's becoming next best – more location work and running along beaches. It's more about beauty coming from within." Lorraine is one of Britain's most popular black models. A regular in FACE fashion shoots, she has modelled on the catwalk for a host of designers from Yohji and Galliano to St Laurent, as well as for numerous magazines and advertising campaigns.

Steven Meisel views the rise of models like Kate Moss as an indication of a more general mood in the fashion industry. "In the Eighties, the Amazon woman kind of took over. We were brainwashed into seeing qualities like gentleness and sensitivity as negative and weak. But they're part of being human." He likens the Nineties to the Sixties. "People precious about what they believe in now. They are interested in the human condition."

The human condition is not, it must be said, traditionally the terrain of the model. But 19-year-old model Saffron Dennis needed little persuasion to appear in a harrowing film about racism and violence. The MTA (model-turned-actress) has become a cliché and is, reasonably enough, the focus for much derision in the cut-throat world. Yet Saffron's performance in the, as yet, unscreened TV drama Welcome To The Terror Dome, made by Nigerian director Ngozoni Onwurah, breaks the mold of glamorous roles usually bestowed upon the budding model. The film, funded by the BFI, tells the story of a white girl (played by Saffron) in a mixed-race relationship who becomes pregnant and is subsequently the victim of a brutal beating by National Front thugs. She appears through much of the film bloody and bruised. She didn't get paid but loved it. She even had doubts about returning to modelling afterwards.

It's a far cry from Peter Lindbergh's forthcoming supermodel film, featuring all of the girls (bar Christy Turlington) in a glamour extravaganza. Although voices of dissent are being heard, there is no sign of the supermodel phenomenon abating in the near future. The girls have been recruited, again, by George Michael for the video of "Too Funky", his contribution to the Red Hot And Dance Aids benefit project. The models are, uncharacteristically, giving their services free of charge to director George Michael and Thierry Mugler, although filming had to be postponed because of the models' hectic schedules.

"Six million if you don't mind," was Christy Turlington's reply to designer Valentine's suggestion that she was worth a million dollars. Linda, Christy, Claudia, Naomi and Cindy are the world's most bankable beauties. Schiffer, Turlington and Crawford this year signed exclusive multi-million dollar contracts with top cosmetics companies. Revlon paid Schiffer a reported $6 million for a four-year contract while Crawford recently renewed her Revlon contract for another three years for $3 million. Christy Turlington, the image behind Calvin Klein's Eternity fragrance since '86, this year signed a $2 million, two-year deal with Maybelline cosmetics.

On top of these contracts, the girls, along with the other supermodels, can expect to earn anything from £7,000 to £25,000 for each catwalk appearance at twice-a-year shows, and Gianni Versace reportedly paid Turlington £50,000 to appear exclusively at his Milan show. It's no wonder that, as Steven Meisel puts it, many people in the industry are "resentful of the money they earn". When Evangelista demanded £8,000 for an appearance at Valentine's show last year, he refused: "I like them, but I hate the stardom created around them," he said. "They should walk, show, change, style and show again. That's why I ask them: not to be sizes, but to become Valentine women." Katharine Hamnett, in a Sunday Times interview, demanded, "What are these girls really good for?"

They are, like it or not, good for profits. Designers use the girls because they ensure editorial coverage. Advertisers use them because they ensure sales. The supermodels are a safe bet and, in times of recession, that is what matters. What troubles their detractors, however, is the corporate power with which they have become inextricably linked. Their faces have come to represent little more than volatile wealth. Revlon owner Ronald Perelman told American Vogue that they are beautiful "not in an out-of-reach way. They are accessible women to aspire to in the Nineties. Not!" Perhaps it's the fault of the Hollywood star system for neglecting its role of fantasy and glamour. Now that movie stars dress down, sleep around, admit to neuroses and drug habits, it is left to the supermodels to live out fantasies. They date and marry stars, dress in designer clothes, and are phenomenally rich and cosmopolitan.

40 / THE FACE

THE FACE / 41

Lorraine

Saffron

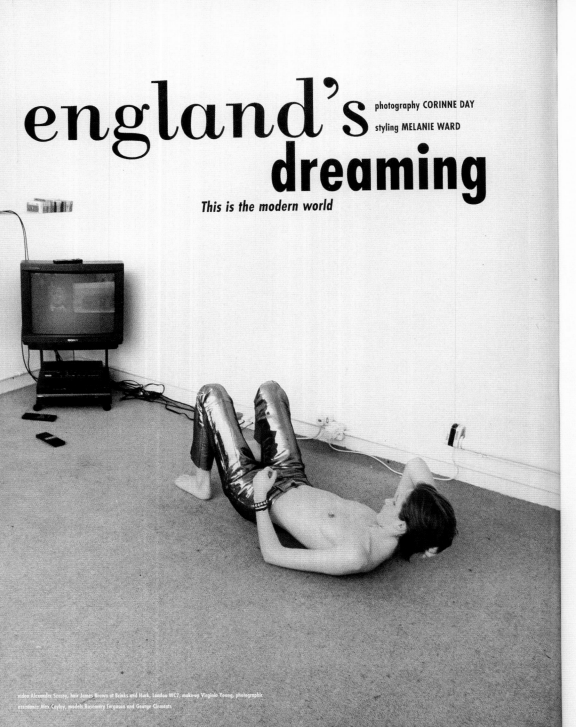

england's
photography CORINNE DAY
styling MELANIE WARD

dreaming

This is the modern world

Opposite page: trousers by Helmut Lang from Jones, 13-15 Floral St,
London WC2 and Joseph, 77 Fulham Rd, London SW3;
studded wristband from a selection found in Carnaby St, London W1

This page: top from Boy, 49 Carnaby St, London W1 and 153 King's
Road, London SW3; trousers from Rokit, 225 Camden High St, London
NW1 and 23 Kensington Gdns, Brighton; knickers from
Marks & Spencer, branches nationwide; chains from Camden Passage,
London NW1; studded wristbands as before

video Alexandre Strassy, hair James Brown at Brinks and Huck, London WC2, makeup Virginie Young, photographic
assistance Alex Cayley, models Rosemary Ferguson and George Clements

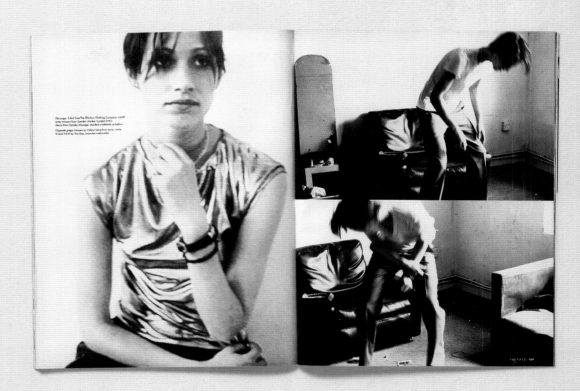

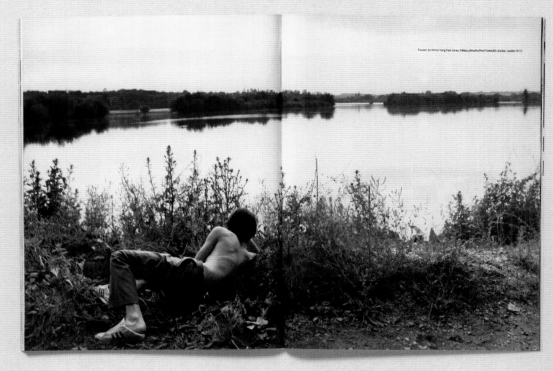

below and opposite
'Hole Lotta Love', vol. 2, no. 53, February 1993.

overleaf, left
Vol. 2, no. 53.

overleaf, right
Vol. 2, no. 60, September 1993.

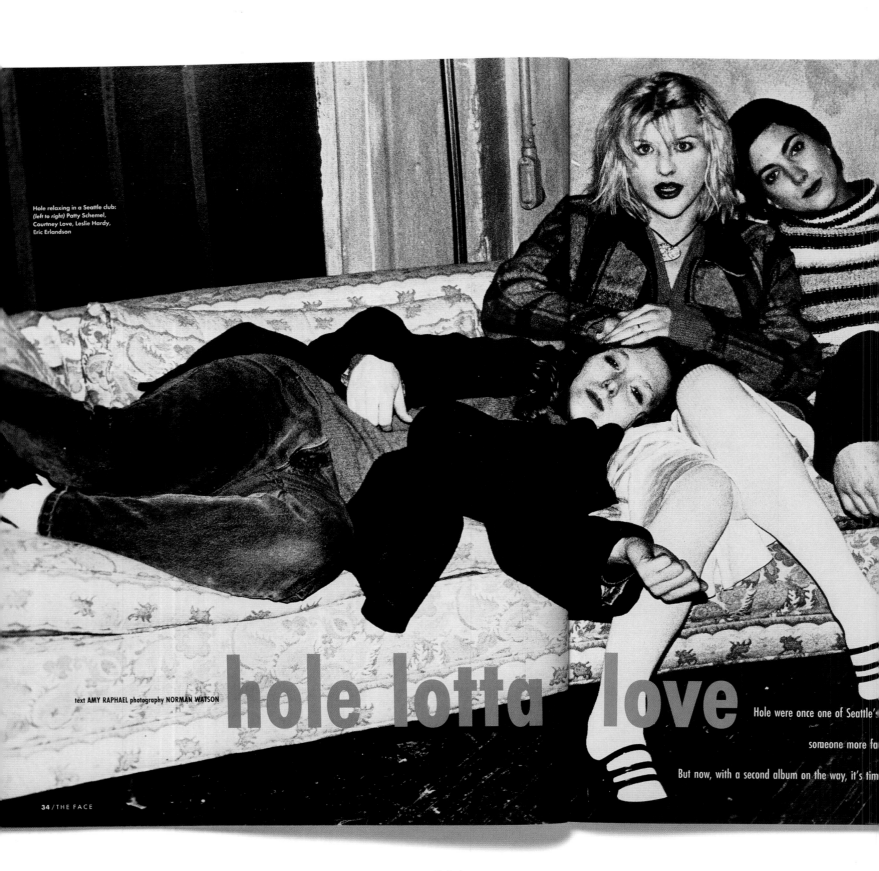

Hole relaxing in a Seattle club:
(left to right) Patty Schemel,
Courtney Love, Leslie Hardy,
Eric Erlandson

text AMY RAPHAEL photography NORMAN WATSON

hole lotta love

Hole were once one of Seattle'

someone more fa

But now, with a second album on the way, it's tim

34 / THE FACE

but then their singer married

music got lost in scandal and speculation.

o basics

THE FACE / 35

"I don't do many scandalous things, I really don't lead a debauched life. All I want to do is make good records. So far I've sold four crates of records and I don't matter, I shouldn't matter. I want a clean slate"

"I'm famous for really crass, gross things. People think I live in a different dimension, so I can't hear them talking about me. I hear that I wasn't wearing underwear, that the blood was running down my leg"

THE FACE

That tank top feeling: oh no, it's the Seventies again!

No 53 FEBRUARY 1993 £1.80 • US $4.95
ITALY L7300 · GERMANY 11.90DM · SPAIN 500PTAS · BELG. 166BFR

TALENT!

Absolutely fabulous!
Jane Horrocks, Sadie Frost &
50 new fads and faces

NICOLAS CAGE Elvis and me

Harvey Keitel

Eddie Izzard

Love and money:

Japanese hostess bars

Frank Miller

Andy Weatherall

Courtney love
the hole story

Hole's Courtney Love
photographed by Norman Watson

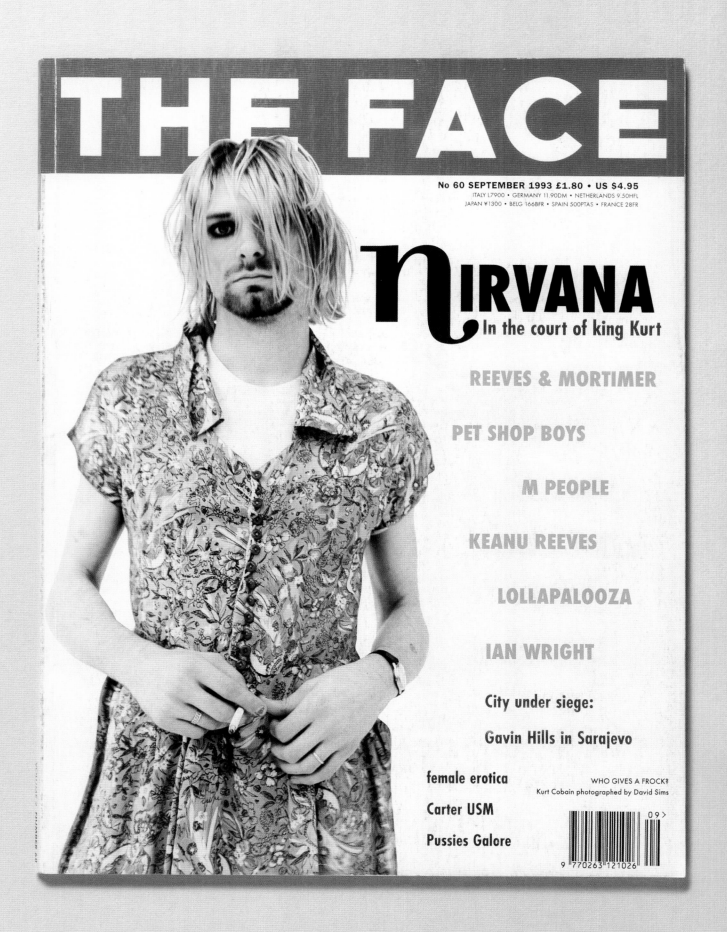

THE FACE

No 60 SEPTEMBER 1993 £1.80 • US $4.95

ITALY L7900 • GERMANY 11.90DM • NETHERLANDS 9.50HFL
JAPAN ¥1300 • BELG 166BFR • SPAIN 500PTAS • FRANCE 28FR

NIRVANA
In the court of king Kurt

REEVES & MORTIMER

PET SHOP BOYS

M PEOPLE

KEANU REEVES

LOLLAPALOOZA

IAN WRIGHT

City under siege:

Gavin Hills in Sarajevo

female erotica

WHO GIVES A FROCK?
Kurt Cobain photographed by David Sims

Carter USM

Pussies Galore

9 770263 121026

09>

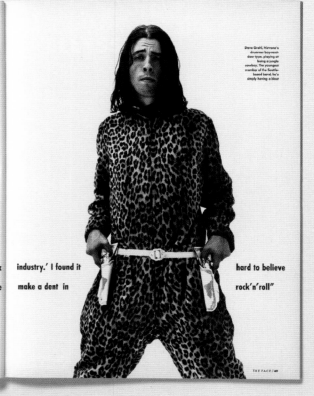

Dave Grohl, Nirvana's drummer boy-next-door type, playing at being a jungle cowboy. The youngest member of the Seattle-based band, he's simply having a blast

> "Everyone kept telling us: 'You guys really ruffled the sheets of the music industry.' I found it hard to believe 'cause, you know, how could three fucking losers from Nowheresville make a dent in rock'n'roll"

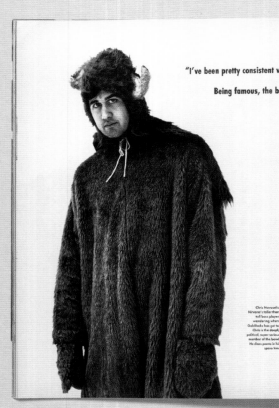

Chris Novoselic, Nirvana's taller-than-tall bass player, wandering where Goldilocks has got to. Chris is the deeply political, super serious member of the band. He dons poetic in his spare time

> "I've been pretty consistent with the drinking. I just made it through. I had to experience all kinds of feelings and stuff. I came out of it a better person. Stronger and more mature"

KURT COBAIN LIKES PLAYING the flippant rock star.

AS HE SAYS EARLIER,

NIRVANA ARRIVE ON STAGE.

I'M STILL TOTALLY NARCISSISTIC,

MTV'S ONLY HIGHLIGHT BEGINS

THE FACE/42

THE FACE/47

capers and

G

opposite and below
'Grrr!', vol. 2, no. 60, September 1993.

overleaf
'Björk Again', vol. 2, no. 57, June 1993.

text AMY RAPHAEL photography DAVID SIMS

year when Nirvana were much vilified but rarely heard, when grunge became more about catwalk on bores than inspired music. Things are different now. The Seattle trio are about to have their say

RRR!

ing a celebrity is like rape" – *John McEnroe*

mily are having a nice day out. It's late afternoon in a
in downtown Manhattan. Daddy Cobain is careering
d of the room to another, steering his 11-month-old
n her pushchair, dressed in a suit that suggests he could
g for the role of Tigger in *Winnie The Pooh*. He looks
s Bean is gurgling uncontrollably, a big grin on her an-
ey Love-Cobain is lounging barefoot on a sofa. "Where
e demands, her arms outstretched. Kurt changes direc-
e out of control and stops the pushchair just short of the
his wife and kisses her. Long and passionately.
nary family. This is royalty. Grunge royalty. This is as
eople will ever get with Kurt Cobain, Nirvana frontman,
grunge, the X generation's rock star. He excels at not let-
his head. He has his opinions, sure, and he's vocal about
when it comes to baring his soul, well, he'll take you so
you. Listen to his lyrics which hint and tease but never
"*Have to have poison skin, give an inch take a smile/Never
so it's a woman, gotta find a way to find a way*" – "Smells
"). For someone so insular, Kurt Cobain has mesmerised
ns – of (young) people.
ong time ago now since Nirvana first arrived. In autumn »

The wonderful thing about
Tiggers is – they've got big
tails. Kurt Cobain, singer-
songwriter of rock band
Nirvana, holding on to reality

BJÖRK text MANDI JAMES

photography GLEN LUCHFORD

bjÖrk again

The former

Sugarcube and ice princess

has teamed up with

Nellee Hooper and made a

truly great pop album

It's barely June and already the word on the street is that "Debut" is a strong contender for album of the year. If such spurious claims stick in your craw, smack of media hype, record company bullshit and hysterical journalists desperately seeking out The Next Big Thing, then try swallowing this. For once, they could just be right. A creative collision between the errant imagination of ex-Sugarcube and indie ice queen Björk Gudmundsdóttir and the mighty production skills of Nellee Hooper, the name behind the polished Soul II Soul vibe, "Debut" is, quite simply, stunning. Although it speaks the same language as dance music in parts – thundering basslines, disco finger snaps and bouncing beats – "Debut" is also a delightful fusion of thrash metal, jazz, funk and opera, with the odd dash of exotica thrown in for good measure. It's an album uncomfortable with any category and open to absolutely everyone.

"I want music to be more real," exclaims Björk. "More what your day is like. Music has to be more like a film. I love listening to film soundtracks because they capture lots of different moods. It allows human feelings to exist, the music allows you to be a bit unpredictable whereas pop music today is so clinical and sterile. There's so much bad pop music around that people don't believe in magic any more."

"Debut" has been a long time coming. These are songs that have been swimming around Björk's head since she was a child, saved like precious secrets and only revealed when she felt good and ready. While the lyrics consolidate her love affair with language, her unique vocals are played like

an instrument, soaring ethereally, bringing on yelps, balling into little explosions of rage and dropping into conspiratorial whispers. There's no discipline. No conventional style. Just emotion run riot. And it sounds great. Drafting in Darren Emmerson to remix the single "Human Behaviour" and employing Nellee Hooper to stitch the album together may seem like a calculated attempt to buy credibility through club culture, but perhaps it's worth remembering Björk's canny alliance with 808 State and her frequent appearances along the balearic network at nights such as Manchester's Most Excellent. Initially intending to work with a variety of producers such as 808 State's Graham Massey to match the eclectic mood of "Debut", she eventually settled for Nellee's services.

"A friend of mine suggested we work together and I was a bit suspicious to begin with," confesses Björk. "I had to ask what he had done. I like Soul II Soul, but mainly when they're on the radio. Myself, I like to go out and dance to hardcore or industrial techno, hard beats with an experimental edge. I thought Nellee was too 'good taste' for my liking. But then I met him, got to know him, got to hear about his fabulous ideas and it ended up with him producing the whole album."

The release of "Debut" catapults Björk into a new league. That of seriously devastating diva. Having always previously been perceived under the shadow of the Sugarcubes and in the light of her Icelandic heritage and hippy commune upbringing, she has always been viewed as an unknown commodity, an oddball with sexy elfin looks and a killer voice to boot. Dangling between the curiously sublime and the plain ridiculous, the Sugarcubes were performance art-cum-punk nihilists who painted a David Lynch landscape of suburban psychosis with their eerie alien songs. As quickly as they were hailed as the saviours of indie pop with tracks as hauntingly beautiful as "Birthday" and whacked-out as "Regina", they were hurled off centre stage for refusing to play up to the great expecta- »

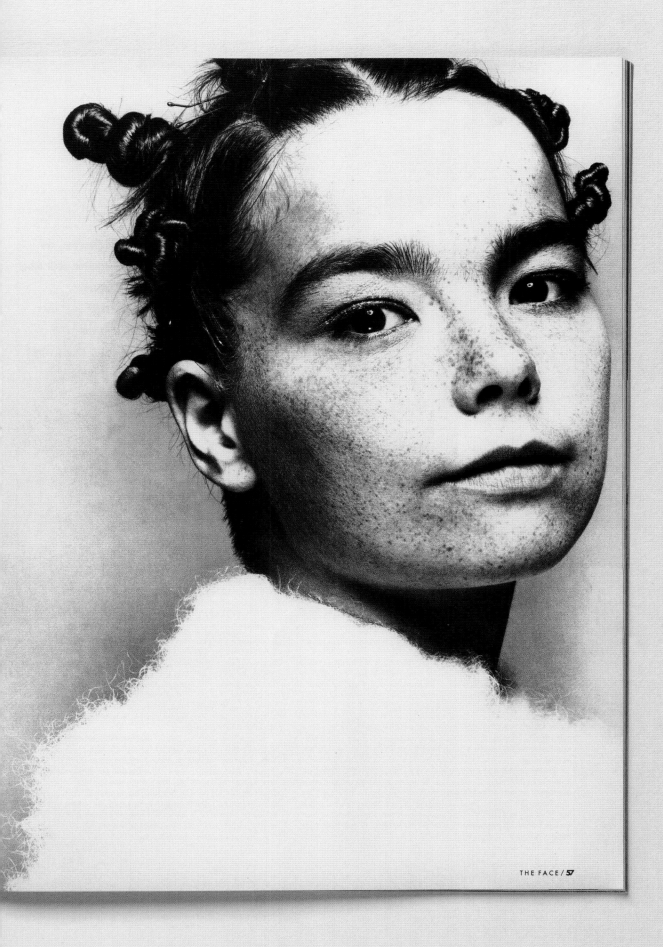

THE FACE/**57**

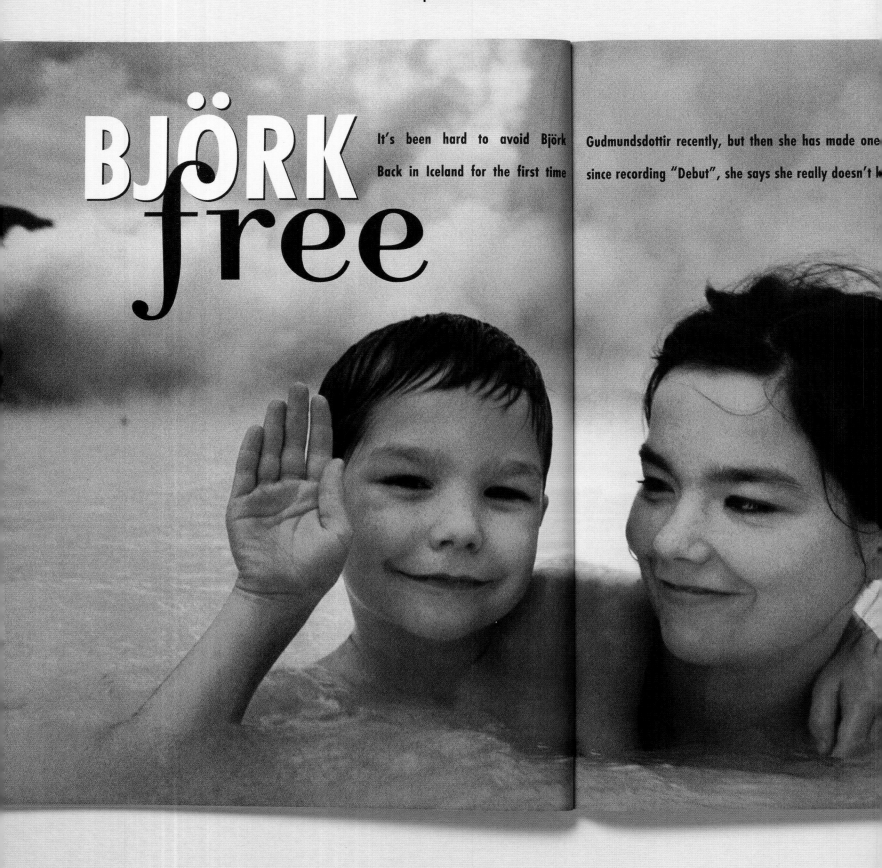

BJÖRK free

It's been hard to avoid Björk Gudmundsdottir recently, but then she has made one—

Back in Iceland for the first time since recording "Debut", she says she really doesn't k—

above and opposite
'Björk Free', vol. 2, no. 62, November 1993.

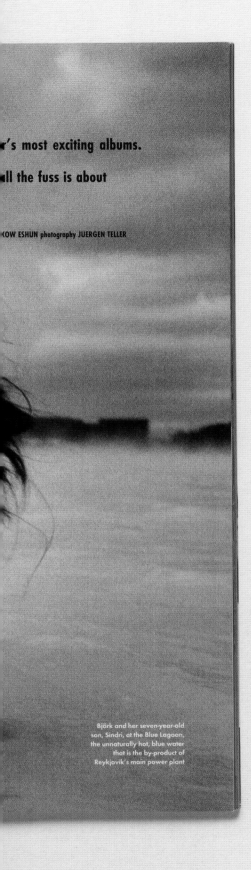

...'s most exciting albums.

...ll the fuss is about

KOW ESHUN photography JUERGEN TELLER

Björk and her seven-year-old
son, Sindri, at the Blue Lagoon,
the unnaturally hot, blue water
that is the by-product of
Reykjavik's main power plant

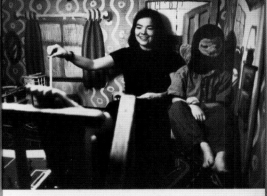

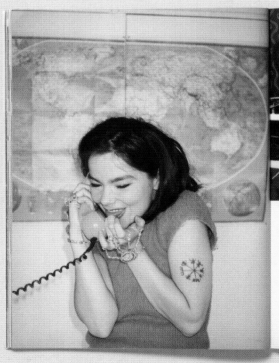

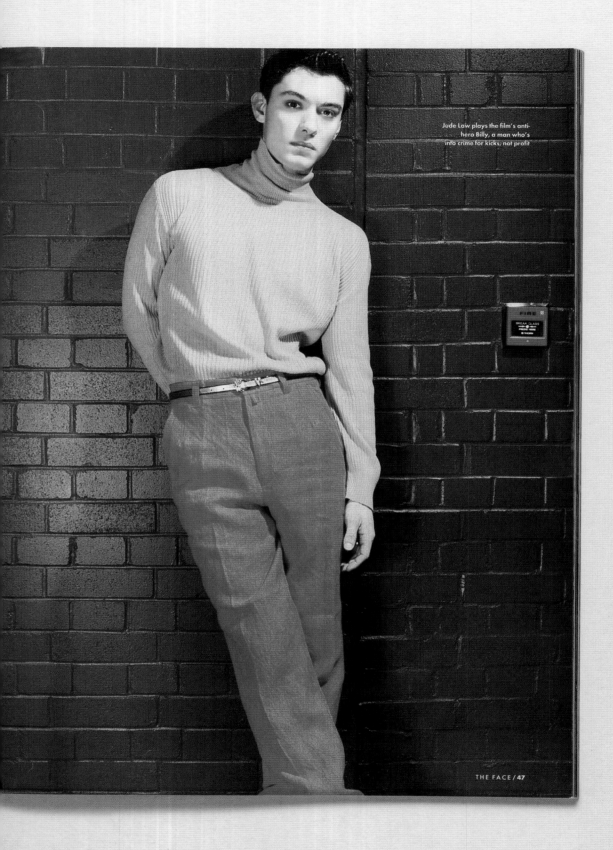

Jude Law plays the film's anti-hero Billy, a man who's into crime for kicks, not profit

THE FACE/47

Shopping is the sexiest British movie this year: a

destructive orgy of car crime which struggled

to get past the censors. But is it a film

with a message or just flash trash entertainment?

"It's been wonderful, being allowed to smash things up. It's like – we turn up on set, the art department has done this great job, created this fucking fabulous set. Then we come in and totally destroy it." It's a warm Saturday afternoon in June and Jude Law is gazing out of the window at the Millennium Mill, a slice of east London post-industrial wasteland and the appropriately named location for *Shopping*, the debut feature from British movie brats Jeremy Bolt (producer) and Paul Anderson (writer/director). A speedy take on joyriding and ram-raiding and the dead-end emptiness of the Eighties consumerist dream, it's already the most hyped British movie of the year and looks likely to become the most controversial.

Spread out in front of the mill are remnants of the shoot, which is due to end the next day – trashed graffiti-covered cars, left-over sets. The morning has been spent crashing another car through another department store front. This

afternoon, t
the product
lead, Sadie
big-screen
teen trying
to nowhere.
Frost plays J
who is start
wants Billy
than throug
Not to p
wasted. It's
weeks of m
dressed dow
a DIY punk
gruelling sch
hours sleep
nervy and
edge. That's
quite worry.
ing I know

opposite and below
'Teenage Kicks', vol. 2, no. 66, March 1994.

EN

ICKS

text JIM McCLELLAN photography SCHOERNER

styling Cathy Dixon for Camilla Lowther, hair Eugene for Windles Hair Salon using Paul Mitchell luxury Haircare, make-up by Cathy Lomax for Debbie Walters, shot at Click Studios

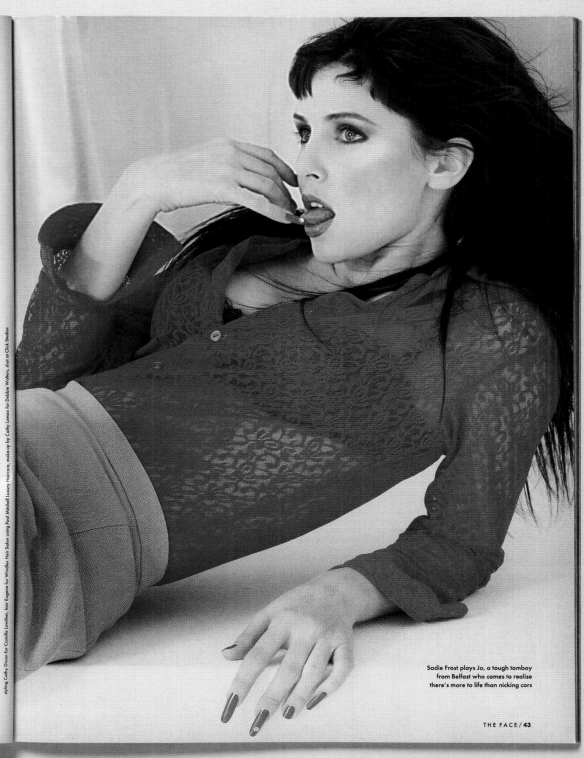

Sadie Frost plays Jo, a tough tomboy
from Belfast who comes to realise
there's more to life than nicking cars

party. Upstairs in
d the film's other
nch. Making his
Billy, a joyriding
ocity on the road
ccess in *Dracula*,
rider from Belfast
for the game and
from it all rather
dow.
on it, both look
r the pair – eight
– though Frost,
hirt and sporting
me respects the
I could have two
. If I felt awful,
elp give me an
time. But it was
calling Paul, say-
d to look a bit

rough, *but*… Jude looks prettier than me."
 The central presence in the film, Law's Billy
comes out of prison in a hurry and over the next
five days picks up speed, nicking BMWs and
Porsches, ramraiding ever more upscale shops
and constantly raising the stakes in an ongoing
tussle with youthful hood Tommy (Sean
Pertwee). It's a face-off which, depending on
how charitable you're feeling, could be seen as
either archetypal or clichéd. Billy is a typical
rebel anti-hero, into crime for kicks, art and the
chance to cut a few cool moves in the limited
space society allows. Tommy is into crime as a
career: ramraiding is a business, one which is
threatened by Billy's charismatic excess. Jo is the
woman between them, whose main job is to sug-
gest there's a bigger world out there beyond the
apparent dead end.
 Law argues that Billy is different because for
all his fuck-you cool, he's damaged and running
scared. "He's sort of the ultimate rebel, but he's »

THE FACE/43

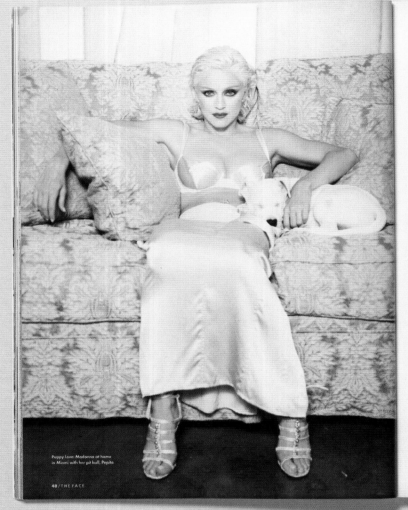

Puppy love: Madonna at home
in Miami with her pit bull, Pepito

I tried to make a statement about exploring your
sexuality, but it was taken to mean that everyone should go
on a fuckfest, and I was to be the leader

‹‹ having an affair, this time the host pursed his lips and played the puritan.

With the benefit of hindsight, it is easy to see that *In Bed With Madonna*, however good a film it is (and it is – check it now that the fuss has died down and see for yourself), was misinterpreted and caused her damage. It is easy to see that *Sex* – a collaboration, lest we forget, with top photographer Steven Meisel and top art director Fabien Baron, neither of whose reputations were tarnished as a result – only compounded this damage. The usual rescue remedy for American celebrities is the confessional: some expression of regret, followed by the public airing of a hitherto private problem, be it addiction to drink or drugs or childhood abuse. But Madonna is not up for such staged soul-searching. She isn't after the sympathy vote. Instead, she has a theory, a theory she returns to again and again as we talk.

"I'm being punished," she tells me calmly when we meet the next day. "I'm being punished for being a single female, for having power and being rich and saying the things I say, being a sexual creature – actually, not being any different from anyone else, but just talking about it. If I were a man, I wouldn't have had any of these problems. Nobody talks about Prince's sex life, and all the women he's slept with. Nobody talks about any of their sex lives. You have to be intelligent about that and say, 'OK, what's being said here?' I'm being punished for having a sex life. For enjoying it and for saying that I enjoy it. I really think it's that simple."

My meeting with Madonna is not as I'd rehearsed in my head. Approaching the house in daylight now, a miniature *Jurassic Park* is enacted under my feet, tiny herds of lizards fleeing before me as I walk across the courtyard. Caresse shows me the garden overlooking the bay, watching carefully in case Pepito falls into the swimming pool. Instead, he obligingly craps in a corner, a major development. And so it comes to pass that when she comes downstairs, my first conversation with Madonna is about dog shit, about the macho owners that have given pit bulls a bad name, and the fact that Pepito would have to be castrated and muzzled if I took him home to England. "I might still give him to you," she jokes. "He's eating all my shoes – I'm planning his murder even as we speak."

The Madonna I meet is nothing like the Madonna in these photographs: she looks younger, smaller, less imposing. But nor is she the pale, spotty, plain woman many interviewers claim to have been greeted by. This Madonna has short, yellow blonde hair slicked back from a very pretty face with minimal make-up: black mascara, red lipstick. There are a couple of very fine lines on her forehead, but nothing more – probably rather less – than most people in their thirties. She's wearing a long black dress, black bra peeping fashionably out between the narrow straps, high-heeled mules, a pale blue ribbon tied round one ankle. She is relaxed, friendly, and has a loud, open laugh.

Nellee Hooper, she says, was a logical choice for the new album. "I decided that I wanted to work with a whole bunch of different producers. Björk's album is one of my favourite for years – it's brilliantly produced, and I also loved Massive. So obviously, he was on the list. Nellee was the last person I worked with, and it wasn't until then that I got a grip of what the sound of the whole record was, so I had to go back and redo a lot."

Lyrically, I say, there's not so much about sex and more about…

"Romance," says Madonna. "Or the loss of. Unrequited love."

So has the sex theme gone as far as it can?

"I feel I've been misunderstood. I tried to make a statement about feel-

ing good about yourself and exploring your sexuality, but people took it to mean that everyone should go out on a fuckfest and have sex with everyone, and that I was going to be the leader of that. So I decided to leave it alone because that's what everyone ended up concentrating on. Sex is such a taboo subject and it's such a distraction that I'd rather not even offer it up."

She agrees that there is a defensiveness in some of the new lyrics, particularly "Human Nature": "It's my definitive statement in regards to the incredible payback I've received for having the nerve to talk about the things that I did in the past few years with my *Sex* book and my record. It's getting it off my chest. It is defensive, absolutely. But it's also sarcastic, tongue-in-cheek. And I'm not sorry. I do not apologise for any of it."

THE NIGHT BEFORE WE MET, while I was at her house listening to the record, Madonna was at the mall. She went with just one friend, no bodyguard, and they went to see a movie – *Color Of Night* with Bruce Willis and Jane March ("She's so pretty. The only thing worth looking at in the movie, I have to say"). People stared at her. She saw them whispering, deciding that it couldn't possibly be her. Inside, three girls sitting in front turned round to ask if anyone had ever told her she looks a lot like Madonna. And Madonna said yes, actually, she hears it all the time. She thanked them, and then they turned back and watched the movie.

It's easier to do in Miami than anywhere else, she says, but she goes out like this often. I say it must be hard to stay in touch with reality, because her life must be so unreal most of the time. "That makes my life annoying, but it doesn't make it unreal. It does get to be a pain in the ass – at times I wish I could be more spontaneous and just go outside my gate. But I try to make a point of saying dammit, I'm going to do it anyway. I don't care if there's 60 people outside my apartment in New York, I'm going out for a walk, and if they follow me, they follow me. I will not be a prisoner."

But isn't that dangerous?

"I don't think about it. I just do it. I can't afford to be so careful, to cut myself off from the rest of the world. I go out to clubs, I go running in Central Park, I go for bike rides and hang out with my friends, and people always say to me, 'Aren't you frightened? Where's your bodyguard?' But it's all of that that attracts attention, and I just can't function that way, I never could.

"My other way of thinking is that I've come this far in my life, and I know I'm a survivor. I have a guardian angel or someone protecting me. I moved to New York when I was 17 and I had nothing until I was 25. If no one fucked with me then, they're not going to fuck with me now. I see someone like Eddie Murphy walk into a nightclub and they've got like 20 bodyguards and I just think that's like driving a big fancy car. It's showing off. It's got nothing to do with security.

"There are ways to deal with it, if I can accept that my celebrity is this other reality, this parallel universe outside of me. It's kind of like this big pet that I carry around with me everywhere – I know it's there and I can laugh about it and try and live as normal a life as possible."

THE NEXT FILM MADONNA wants to see is *Priscilla, Queen Of The Desert*. She doesn't like action movies, the big Hollywood blockbusters. The best film she's seen recently is *Spanking The Monkey*, an independent film that was a hit at the Sundance Festival. Before that, the last one she really loved ››

above and opposite
'Je Ne Regrette Rien', vol. 2, no. 73, October 1994.

was *The Piano*. Knowing this, her last two choices of acting roles make more sense. Both must have looked great on paper.

Her co-stars in *Body Of Evidence* were Willem Dafoe and Joe Mantegna, both acclaimed actors (Madonna had already worked with Mantegna in David Mamet's play *Speed The Plow*). The director was Uli Edel, known for the arthouse hits *Christiane F* and *Last Exit To Brooklyn*. The story – about a woman who may or may not have deliberately killed her rich, ageing lover with adventurous S&M sex – appealed to Madonna, and she liked the twists in the plot that left you guessing. But in the last week of shooting, the ending was changed. Originally, at the end of a courtroom drama, her character got off in spite of her guilt. In the final version, she has to pay anyway, flying out of a window in a hail of bullets. "I fought it every step of the way," she says. "But I had no control. Woman who has sex must die: that is the theme of that movie, but it wasn't that way to begin with."

I first saw the film in a small preview theatre full of critics who tittered at her more wooden moments. The men also shifted bags and coats on to their laps during the sex scenes, but they didn't write about that. What they wrote was that Madonna was awful. She isn't particularly good in it. But what's more noticeable watching it again now is that her more experienced co-stars aren't any good either, that the director is making an inept try at a mainstream erotic thriller, and failing his cast badly. "I'm disappointed in it," admits Madonna, "but I'm not sorry I did it. I think I did a good job. But I got the blame for everything. It was like I wrote it, produced it, directed it, and I was the only one acting in it, you know?"

Her next film, *Dangerous Game*, was produced by her own company Maverick, and again had a strong team: Abel Ferrara and Harvey Keitel, fresh from their success with *The Bad Lieutenant*. Again though, Madonna plays the victim: a bimbo TV actress who sleeps with the director (Keitel) and the lead actor (James Russo) during the film she is making, which in turn is about a wife battered and finally murdered as her relationship with her husband breaks down. Making a film about the making of a film gives Ferrara lots of space for textual jokes: as the director, Keitel gets to shout at Madonna, telling her that she can't act, that she's a commercial piece of shit, that she's only in the movie because they need her money. I wonder why she subjected herself to this, and she insists that she didn't.

"In the original film, I turn it around," she says, explaining that in the script her actress character manipulates both director and actor, destroying their De Niro/Scorsese type friendship, and emerges a new star. "I know a lot of people have that point of view about me in real life, so I thought I could take that and do a great performance. It was going to be this great thing for me. And even though it's a shit movie and I hate it, I *am* good in it." For once, many of those who've seen it agree: the film is a mess, but Madonna is convincing.

She has two projects in development right now, both being written specially for her. Avoiding specifics until they're nearer completion, all she'll say is that she's being very, very careful, and will make sure this time that the director agrees with her ideas. "I don't have the power in the film industry that I have in the music industry," she says, explaining that even though Maverick produced *Dangerous Game*, Ferrara had the final cut. "The director is the one in control, and everyone else is a pawn for them. You have control over your performance when the camera is going, but you can take that performance in the editing room and completely change the character. That's what happened to me with Abel. Because it was an entirely different movie when I made it – it was such a great feminist statement and she was so victorious at the end. I *loved* this character.

"But the way he edited it, he completely changed the ending. He had me killed, which was never supposed to be, and he edited out all the brilliant things that I said telling Harvey and James's characters to fuck off. He took my words off me and turned me into a dead mute, basically. When I saw the cut film, I was weeping. It was like someone punched me in the stomach. He turned it into *The Bad Director*. He's so far up Harvey Keitel's ass, it had become a different movie. If I'd have known that was the movie I was making, I would never have done it, and I was very honest with him about that. He really fucked me over. So *c'est la vie*. This is all happening for a reason. From *Dick Tracy* to *A League Of Their Own*, *Body Of Evidence* and this movie, I keep coming to the same conclusion: that I have to be a director. I feel like I'm constantly being double-crossed."

CONTROL IS THE KEY TO Madonna's appeal, and the reason why girls especially loved her. At a time when feminism seemed to be asking women to choose between pleasure or progress, Madonna came along and said you could have it all: power, sex, glamour, money. Guilt was not necessary. Still, she says, women have also been her most vocal critics. "There's a whole generation of women – Courtney Love, Liz Phair, even Sandra Bernhard to a certain extent – who cannot bring themselves to say anything positive about me even though I've opened the door for them, paved the road for them to be more outspoken. Some of Liz Phair's lyrics are blatantly sexual, and if I said those things, they would be viewed in quite a different way. But she's just started her career, so she's not as intimidating. She doesn't have the power I have, so people are amused by it. But none of these women would want to recognise that. In fact, they slag me off any time anybody asks what they think of me or compare them to me. It's kind of like what a child does to their parent, they denounce you. They want to kill you off because they want their independence from you."

And as Madonna gets older, it also becomes apparent that, for the moment at least, she hasn't got it all. The picture painted is of a lonely, sad figure (not true, says Madonna – the love songs on the new album are to specific people, although she won't say who in case their egos get out of control). Her relationships are subjected to the intense scrutiny her celebrity invites, and when they end, the media find it hard to conceal their pleasure. "When Sean and I got divorced and he had a relationship with Robin Wright and immediately started having children, I was forever reading stuff about how she was such a nice, sweet person and he seemed so much more happy. You know, how he's finally found a virtuous woman to be with. They do love to pump that up. Then I broke up with Warren, he started dating Annette and they started a family, and once again, it's the same thing. When he was once completely lambasted for what I'm lambasted for. But what can you do?"

Do you think you idealise romance?

Madonna laughs. "Absolutely. Yeah."

While you do, will you ever find the romance you're looking for?

There's a long pause. "I'll probably never find someone who has everything, who's like a combination of every incredible novel I ever read, and every great movie I ever saw. You read a book like *Catcher In The Rye* or something Hemingway wrote, you see *The Way We Were* and you go, 'Oh my God, that's the kind of man I want, that's everything.' Well I won't »

When Sean and I got divorced, I was forever reading stuff about how he seemed so much more happy. You know, how he'd finally found a virtuous woman

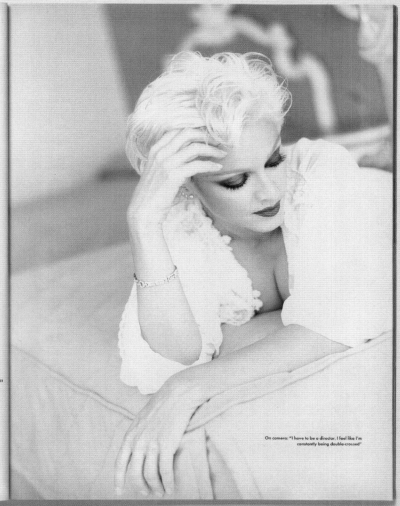

On camera: "I have to be a director. I feel like I'm constantly being double-crossed"

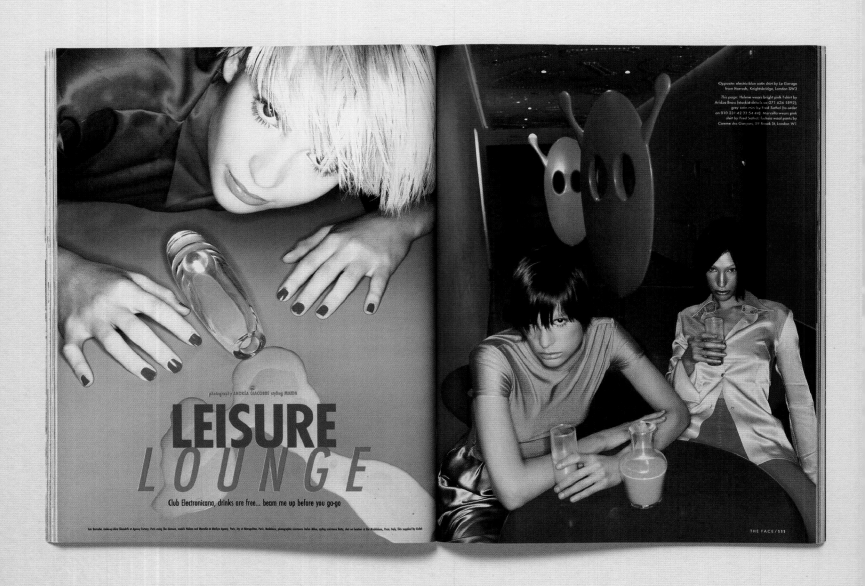

above and opposite
'Leisure Lounge', vol. 2, no. 73, October 1994.

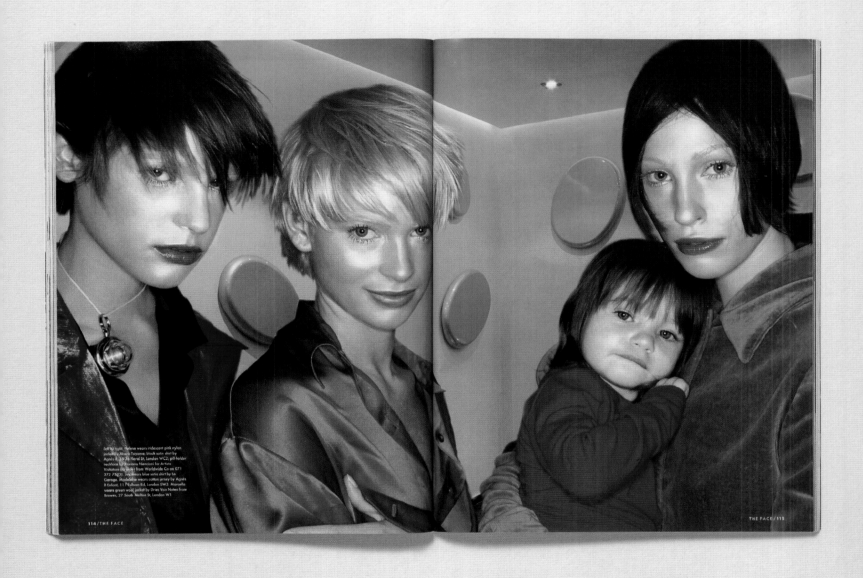

right
Vol. 2, no. 68, May 1994.

below and **opposite**
'Looking for a New England', vol. 2, no. 68.

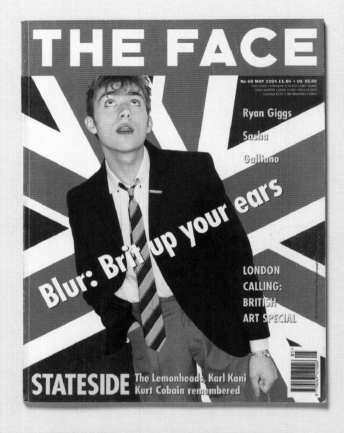

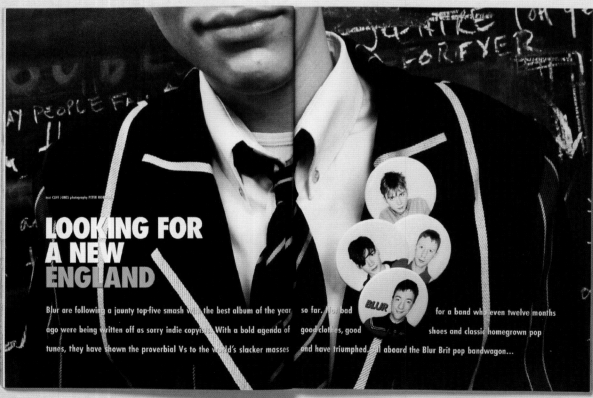

Resolutely British, it boasted accents
jaunty sing-a-long quality combining
scenes from suburban life. It marked the
that owed nothing to Neil Young, Nirv
to the Kinks' "Waterloo Sunset".

The album failed to trouble the charts
had left them broke, the pop press wer
gazing act (another twist since the term
Andy Ross to describe everything Blur
ignored them. Blur were a band on the
America proved only marginally more su
attempt. "I get physically ill when I go
over with this depressed American malad
self-abuse ensued where a drunken Dam
in earshot about why pop was up shit cr
why Suede, who were garnering the acc
belonged to them, were useless. It was no

"We *had* to make 'Modern Life Is Rub
important, and we were disappointed wi
the moment when things turned and we
erally had very little to lose. We were dri
piss poorly, and on one occasion we just

Hauled before the higher levels of the
served in the form of an ultimatum: ge
maintains that being down on your luck
"'Parklife' was a continuation of what
Rubbish', but it's darker and more sinis
tion not to be put off, and that's why
of determination."

It's this bloody-minded belief in the
basic idea of a return to stylish, relevant
single "Girls And Boys", a trip into the
mentality of Brits on holiday. The album
wigged-out Reggie Perrin scenario of "
ing civil servant who goes slowly insane,
Sunday Morning angst of the album's tit
(star of The Who's Mod homage *Q*
Meantime amongst others), this is except

BY THE SEVENTH RACE, Damon's luck
his winnings, and he's drunk. His diatrib
ering such subjects as why Blur are the b
are crap and Primal Scream are worse, h
ideas, and a lament at the current state
quiet but shrewd observer of events, toa
adds wryly, "That's it. He's off. You're
thing is, he was worried about getting
things. He never learns."

There's a real yearning for vindication
threatens to consume him. "Suede?" he
ented member and that's Bernard. Brett
songs, can he?" He's at his most spiteful
although that spite originates in a long
everything he promised, everything he a
Eventually he runs out of steam, reali
much, and he disappears to call Phil Dar

"Being in a band is about hedonism wi
social, about being part of a communi
announces. "Phil reflects that in *Quadr*
hate about British culture. I've now met
he's one of the few who's better in real l

As the group leave the stadium, two
hoot with laughter. "Look at you lot!"
clothes at Oxfam. You're pissed, aren
your mum cut your hair. She must be

overleaf
'Without Walls', vol. 2, no. 68.

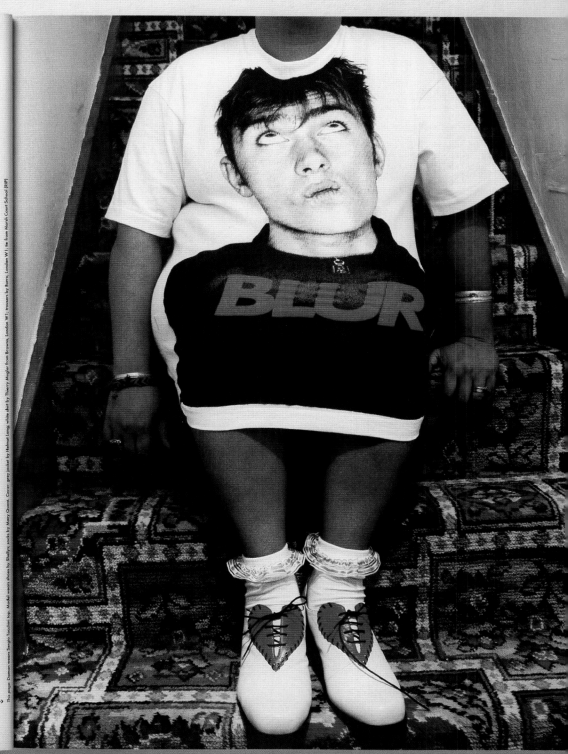

, plus a light,
vignettes and
with a pop style
and everything

ment problems
off as a shoe-
their label boss
eryone else just
second tour of
first, disastrous
n. "I just come
ably, a spiral of
regale anyone
re brilliant and
believed rightly
.

n now. "It was
It was certainly
gether. We lit-
re gigs, playing
gether."
e medicine was
et out. Graham
tive to achieve.
Modern Life Is
our determina-
. It has a spirit

lur back to the
aid off with the
nuck, meatrack
same: from the
t a cross-dress-
Saturday Night
by Phil Daniels
Mike Leigh's

as have most of
in earnest, cov-
orld, why Suede
ectness is killing
ummer Dave, a
ce in the air and
w. The amusing
loads of stupid

barn that almost
y have one tal-
n't write decent
these episodes,
have achieved
were capable of
obably said too

ed in shell suits
et you get your
aaahahaha! I bet
ahaha! You look

like my granddad. He wears them old glasses." They're looking first at
Graham then at Damon, the Mod and the casual. Damon smiles. "Cheeky
British yoof in action."

A drive into the West End. A packed late-night bar. A vague and
fractured evening's drinking ensues, during which we're asked to leave
one bar on account of certain persons being barred and which eventual-
ly culminates in Graham giving Damon a vicious love-bite on the neck
during a ruck on the floor of a subterranean green baize drinking club.
A late-night haunt of actors, stage hands and extras, two of whom have,
it turns out, spent the day as ambulance drivers on *The Bill*, this is
Phil Daniels' after-hours hangout. He plays pool and wins every game.
Forever Jimmy The Mod. "He's an unbelievable bloke," says Damon.
"*And* he supports Chelsea."

REMINDED OF THE GLOWING RED mark on his neck the next morning,
Damon rushes to the mirror. "How am I going to explain this to Justine?"
he asks. "No one's gonna believe Graham did it, are they? I used to have a
reputation and she's just not going to believe me." Graham claims that
Damon has calmed down since moving in with Justine, singer with current
indie darlings Elastica and ex-girlfriend of Brett Anderson. "It's quite
intense, from what I can gather, but I don't really know her well. They
keep things to themselves. I think she's where I was at in 1989, very indie.
She's always telling Damon how he should do things, and to be honest I
think he pays too much attention to her sometimes."

The flat Damon shares with Justine isn't full of records or rock biogs as
you might expect. Damon claims never to have read a single book on rock
stars and is unhip to most of rock history. "I haven't read every *NME* from
the year dot, but I know what I like. The Who, Kinks, Madness, Terry
Hall, Julian Cope – his first two solo albums are near-perfect – but also
Cole Porter or Kurt Weill. Graham introduced me to a lot of music and
attitudes when we were at school. We were both into 2-Tone but he had a
great collection of records that I was totally unaware of. He schooled me."

What Damon does read about is art and the theatre. It's a culture he
grew up in and is more relaxed in than that of pop music. Damon rarely
socialises with other bands. This is a man whose big dream is to be asked
on to Radio 4's thespy Saturday morning show *Loose Ends* to be grilled by
theatre darling Ned Sherrin. Currently reading the biography of Joan

**A fractured evening's drinking ensues, which
culminates in Graham giving Damon a vicious love-
bite on the neck during a ruck on the floor of a
subterranean drinking club. "How am I going to
explain this to Justine?" he asks the next morning**

Littlewood, a key figure from British theatre in the Fifties and Sixties, he
admits he could see himself treading the boards as an alternative career.
"There's a lot of the actor in me, darling," he says, affecting a campy Noel
Coward tone. "The characters I create exist for me, and I have to *be* them
for the three minutes I'm singing it."

His most recent inspiration, at least as far as "Parklife" was concerned,
was Martin Amis' *London Fields*, a tale of darts-playing London pubsters,
seduction and dark lusts that sits on the shelves next to a wealth of books
on style and art, particularly of the Sixties era. "I didn't actually go to art
school, I opted for drama school instead," says Damon. "But my dad
was head of one and I was immersed in that whole bohemian thing. What it
did for me was give style meaning and context. It gave British pop a form
at its most vital time. Our sleeve art has layers, the signals are multi-
faceted. Most people will just think, 'Oh there's a nice picture', but others »

BRITISH ART SPECIAL

A new generation of young artists has put Britain on the international map, stirring up

controversy and making waves beyond the boundaries of the art

world. FACE ART is an exhibition that dispenses with the gallery, a collection of specially

commissioned works from the cream of the new crop

Commonly perceived as obscure, elitist and ultimately irrelevant, contemporary art often seems to have little place outside the sanctified space of the gallery where anything, it appears, is justifiable in the name of art – from a pile of bricks or a jar of human excrement to aborted foetuses used as earrings. Equally, however fulsome the critical praise, much supposedly high-concept work still seems to crumble in the face of that most direct of public putdowns: "I could do that." Which, in a way, is the point of FACE ART. Specially commissioned (or in two cases recent) work from eleven of Britian's most talented young artists, the following images prove that art at its best is challenging, infuriating, amusing, thought-provoking and occasionally brilliant. If all that's shown here doesn't meet with universal approval, then that, maybe, is something to cheer. Like the mixed reactions which greet the diverse shows at a couture fashion week, it's impossible to please all the people all the time, however high the overall standard, without heading swiftly into territory marked bland, consensual and dull – everything which British art at the moment is not. After years as a cultural layby, playing second fiddle to the markets of New York, Los Angeles and Tokyo, Britain is now one of the world leaders in contemporary art, a position it hasn't held since the Sixties Pop Art era of David Hockney, Peter Hall and Richard Hamilton. Boosted by burgeoning public interest and eager collectors, a generation of artists in their twenties has created a scene whose vibrancy has few parallels abroad. Much credit obviously lies with Damien Hirst, whose shark in a tank did more than any other single work to put Britain back on the international map. But if Hirst, with his shaven head and disquieting penchant for rotting carcasses, is very much the main man of the movement, he's hardly its totality. When the judges of this year's Turner Prize gave their award to Rachel Whiteread's *House*, a full-scale concrete cast of the interior of a two-up two-down terraced home, *sans* walls, they faced the usual barracking. Yet most critics ignored the fact that *House*, situated in a modest corner of Bow, east London, was that rare commodity – a genuinely popular art work, which drew admiration from local crowds as well as praise from the art cognoscenti. Like punk – an analogy which may not be too inappropriate given the shock value potential of both scenes – there's a DIY ethic at the

heart of the new art: from exhibitions organised in warehouses and empty office spaces, to artists curating group shows by their contemporaries and pooling resources to establish communal studio spaces. Out of such intense activity have come artists with prodigious reputations such as Turner Prize nominees Fiona Rae and Ian Davenport, Anya Gallaccio, Sarah Lucas and all those who've contributed to FACE ART. Their skills are eclectic, from sculpture and time-based video work to installation, photography and traditional oil-on-canvas painting. Their talent, however, is unquestionable. And unlike a gallery show, which in most cases can only attract relatively limited numbers, the work of those involved in FACE ART will reach a far larger audience than that which normally judges what makes good or bad art. Indeed, at a period when the cream of the crop already have the status of pop stars and much of the international art world is toasting British creativity, what could be more timely than to turn what's long felt like an invitation-only affair into a party where both pretension and prejudice can be checked in at the door? *Ekow Eshun*

WITHOUT WALLS

The background text repeats the names: MAX WIGRAM GEORGINA STARR ITAI DORON SAM TAYLOR-WOOD RACHEL EVANS WILSON TWINS GARY HUME BRENDAN QUICK GAVIN TURK CHRIS BUCKLOW ADAM CHODZKO

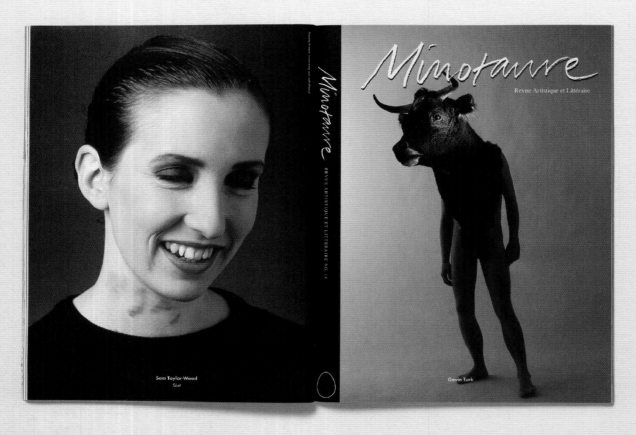

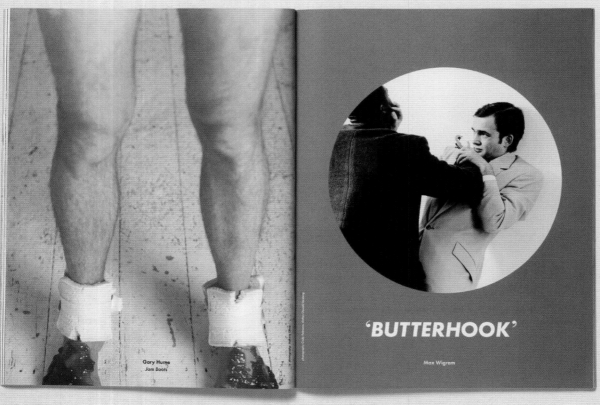

opposite and below
'Without Walls', vol. 2, no. 68, May 1994.

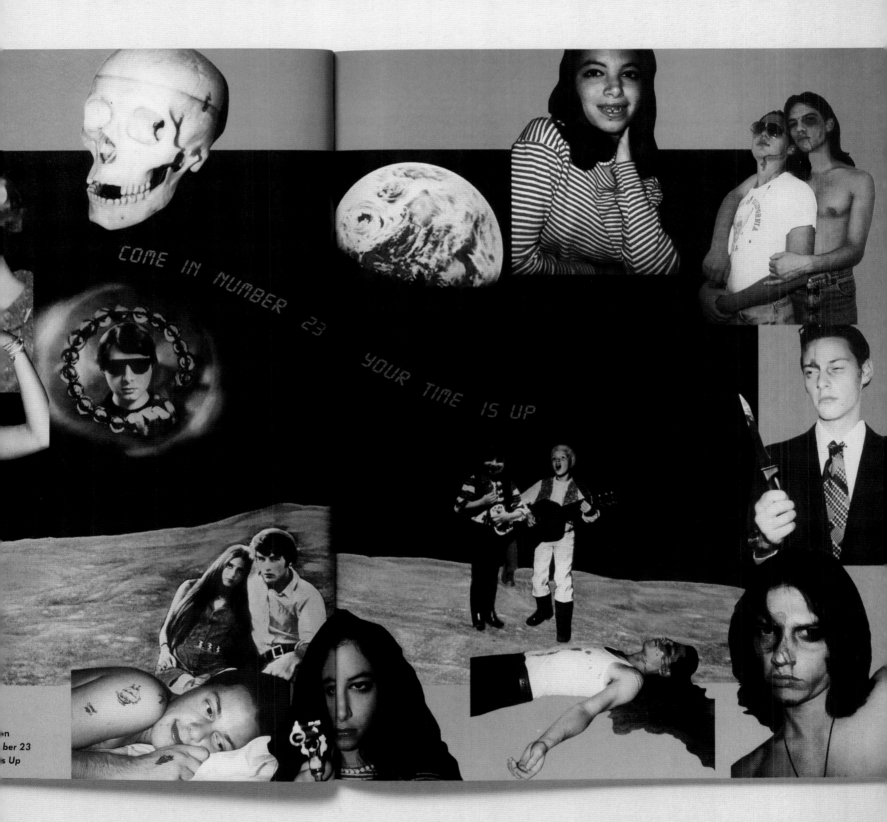

Chapter Twelve

Life is Sweet

Logan.[2] That is not to say that there weren't tensions between the editorial teams, and these were stirred by *Arena*'s choice of Björk as the cover subject for its March 1995 issue.

Hitherto, the Icelandic singer's extraordinary grasp of visual presentation – exercised with designer collaborators including Martin Margiela, Walter Van Beirendonck and Alexander McQueen as well as filmmaker Michel Gondry and *The Face* contributor Stéphane Sednaoui – had ensured regular appearances in the magazine's better-selling stablemate. 'There was a feeling that *Arena* was encroaching on *The Face*'s territory, and the Björk cover brought that home,' says one insider. 'Then *Arena* started to use writers who started out at *The Face*, Gavin Hills among them. But Nick, as the proprietor rather than manager, was ill-equipped to mediate.'

The apparent appropriation of the female singer by *Arena* (which had coined the *au courant* phrase 'new lad' with its May 1991 headline 'Here Comes the New Lad') was doubtless sparked by the growing threat emanating from *Loaded*, presented as she was exuberantly posed in an eye-popping red dress. '*Loaded* was more of a commercial threat to *Arena* than to us,' says Richard Benson, then assistant editor of *The Face*. 'I know for a fact that we were making as much from each issue

The Face's fifteenth year of existence started with a bang: Nick Logan was awarded the prestigious Mark Boxer Award, named after the cartoonist and editor of *The Sunday Times Magazine* and *Tatler*. This was presented to Logan at a dinner organized by the Society of Magazine Editors in recognition of Logan's 'outstanding contribution to UK magazine publishing'. The ceremony did not go smoothly; true to his behind-the-scenes persona, the wrong person was called to the dais before Logan was identified as the correct recipient, but congratulations for the award came from far and wide, including Milan. 'You certainly deserve it!' wrote designer Giorgio Armani. 'Both *The Face* and *Arena* are touchstones for all of us in the fashion business.'[1]

The co-existence of the Wagadon titles was beneficial for the group as a whole. '*Arena* was profitable when *The Face* drifted in the late 1980s and early 1990s and then *The Face* was strong when *Arena* struggled with lad culture,' says

above
Vol. 2, no. 78, March 1995.

right
Vol. 2, no. 76, January 1995.

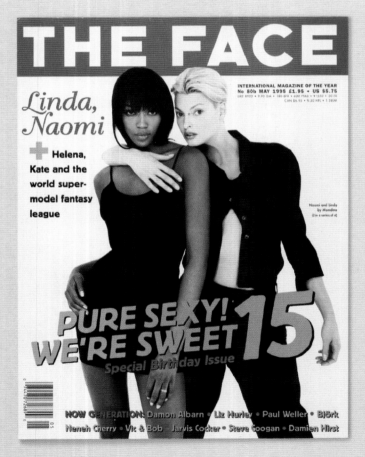

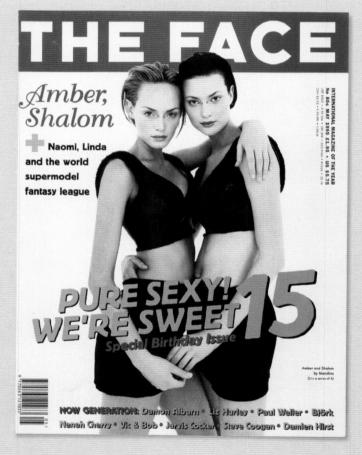

as IPC was out of *Loaded*, even when it was at its height. And it felt to me that *Loaded* would eventually have its day. Our view was, if they were was going to be man-of-the-people then that was a route we couldn't take, so we had better be blue chip. That positioning would hold so long as we could charge a premium on the advertising pages.'[3]

This was manifested in the editorial choices chosen for the fifteenth anniversary issue of *The Face* in May 1995. 'Pure Sexy! We're Sweet 15' ran the cover line of Jean-Baptiste Mondino's shots of 'Linda, Naomi + Helena, Kate and world supermodels fantasy league'. Yet the contents page list betrayed the *Loaded* influence with features including 'Sex UK: Lads, who would you choose if you had to shag a male celeb? We probe your same-sex preferences.'

Despite this depressing co-option of the rhetoric of Lad, the issue, which appeared in a series of innovatory cover alternates, sold 120,000 copies, a high that was superseded only once, in the autumn of that year. By this time Ashley Heath was overseeing the publication of annual fashion specials. 'Sheryl gave Lee [Swillingham] and I total freedom; they usually turned out to be among the best-selling issues of the year,' says Heath, who took over the reins of *Arena Homme Plus* all the while retaining the job of fashion director of *The Face*. 'There had been a bit of push-me/pull-you over whether it should be someone from *The Face* or *Arena*, since Kate Flett was probably quite rightly proprietorial, but Nick said, "Just get on with it",' says Heath. 'I had wanted to be editor of *The Face*, but Sheryl was there and had assembled a very good team. I was young and ambitious so editing *Arena Homme Plus* was a gift.'[4]

To demonstrate his vision for the biannual, Heath left two magazines on Logan's desk: the latest issue of *Vogue Italia* and *Grand Royal*, the occasional publication produced by the Beastie Boys and their coterie. 'I told him that these were the two magazines which meant the most to me in the world at that point, and that I wanted to join the irreverence and passion of a fanzine with hyper-production values,' says Heath. 'Nick came back to me the next day and said: "I don't understand what you're on about, but just go and do it." He was right; you can't bring together two ends of the publishing spectrum, but what you could do was avoid everything in the middle, particularly since what was special about *The Face* was beginning to appear everywhere.'[5]

opposite
Cover variants for vol. 2, no. 80, May 1995.

above right
Vol. 2, no. 85, October 1995.

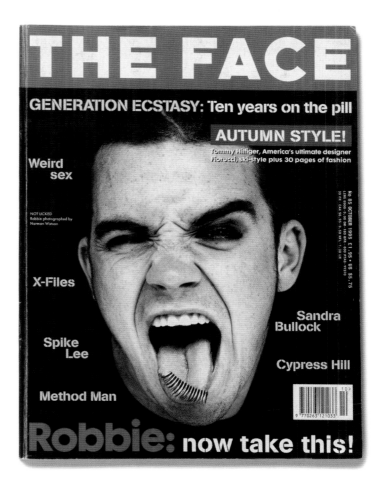

The October 1995 issue was the biggest selling in *The Face*'s history, shifting in excess of 128,000 copies, including 38,000 overseas. On the cover was former boy-band member Robbie Williams, who had by this stage become a New Lad idol. It was also the last to feature Sheryl Garratt on the masthead as editor; she left having commissioned the next two covers, including the December 1995 issue featuring Leonardo Di Caprio.

In her six years at the helm, Garratt had steered the magazine out of the doldrums and into the light after the dual blow of Nick Logan's ill-health and the Jason Donovan affair, enabling the transfer to out-and-out inclusiveness – and thence to impressive circulation figures – by the careful nurturing of waves of talented young staff and contributors. Garratt is not keen to revisit the reasons for her departure; suffice it to say she soon found her place in the upper ranks of the British national media having written the essential club culture history *Adventures In Wonderland* (1999).

Richard Benson was Garratt's natural successor. 'I loved working with Sheryl and felt the same about Richard; he was a brilliant editor,' says Charles Gant, who was made deputy editor responsible for production. 'Richard has an original mind and

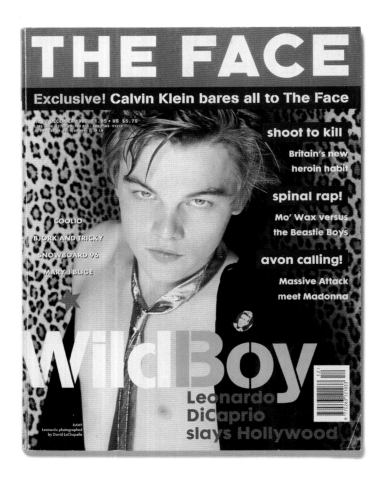

THE FACE

Exclusive! Calvin Klein bares all to The Face

shoot to kill!

Britain's new
heroin habit

spinal rap!

Mo' Wax versus
the Beastie Boys

avon calling!

Massive Attack
meet Madonna

COOLIO

BJÖRK AND TRICKY

SNOWBOARD 96

MARY J BLIGE

Wild Boy

Leonardo
DiCaprio
slays Hollywood

great instincts. He's also good at managing a team and getting the best out of people.'[6]

With Johnny Davis looking after the 'Hype' pages, Laura Craik was appointed editorial assistant with particular responsibilities for fashion. 'A while before this, Nick had received a letter from a St Martins graduate asking for advice about fashion journalism,' says Benson. 'We brought her in to write a few pieces; that was Laura – she's now my wife. With Sheryl leaving it was important that we have a woman on the team. This was long before Laura and I started our relationship, I hasten to point out.'

The masthead of Benson's first issue as editor, November 1995 with Liam Gallagher on the cover (see page 302), lists a staff of twenty-five. Benson identifies editorial production

above
Vol. 2, no. 87, December 1995.

opposite
'Snoop Doggy Dogg', vol. 2, no. 65, December 1994.

head Matt Fiveash as one of the most important though least celebrated members of the team. Fiveash had worked at the magazine's typesetter and transferred across to join the staff. 'He had an incredible, weird pastoral role. If you had to work through the night on something, Matt would be the one to stay with you,' said Benson.

'He would come to festivals and clubs, and was very supportive to us editors. Matt even contributed headlines. My favourite was for a piece about L7 having a go at Marc Jacobs's grunge collection: "Pretend We're Cred". And if you were ever short of readers' letters then Matt would come up with one or two.'[7]

This was a fortuitous time for Benson to attain the editorship. 'The stuff that we'd hitched our wagon to over the previous couple of years was crossing over,' he explains. 'We would get Oasis covers because we'd supported them in the past and now they would sell shedloads. The same happened with Blur and Leonardo Di Caprio; they would all shift covers.'[8]

At this stage the magazine's position within the music industry was such that the biggest British music monthly – Emap's Q – was satisfied for *The Face* to go with an exclusive cover story relating to an upcoming album release, firstly because it was not yet in direct competition for readership but mainly because the record companies preferred the taste-making Wagadon publication to have first bite before the music press stories that ran while the release was available to buy.

'Those acts – first Oasis, Blur and Pulp and then The Verve, The Prodigy and Robbie Williams – all became very big in the world of the magazine,' says Charles Gant. '*The Face* was well positioned to champion them because it had great access and could provide strong covers. And by that time, our film coverage was coming on.'[9]

Lee Swillingham has selected the September 1997 cover, featuring a portrait of The Verve's Richard Ashcroft by Sean Ellis (see page 314), as among the greatest in the magazine's history. Why? 'Britpop was one of the big stories of the 1990s, The Verve were a very big band and Sean, who is now a film director, is a fantastic photographer,' says Swillingham: 'We did this dark, moody cover where he's got shades on so you can't really see who he is. There was some trepidation but it sold very well and has become much imitated, particularly in the music industry where every band wanted to be shot like that.'[10]

Naturally, as in any office, let alone one where the monthly deadlines increased anxieties, there were disagreements. 'There was Lee [Swillingham] and I, the "arty/fashion" people, and then the rest of them,' says Ashley Heath. 'We all had ideas about what should go on the cover and cared deeply about it, so there would be arguments about whether it should be Snoop Doggy Dogg shot by Jean-Baptiste Mondino or Bobby Gillespie by

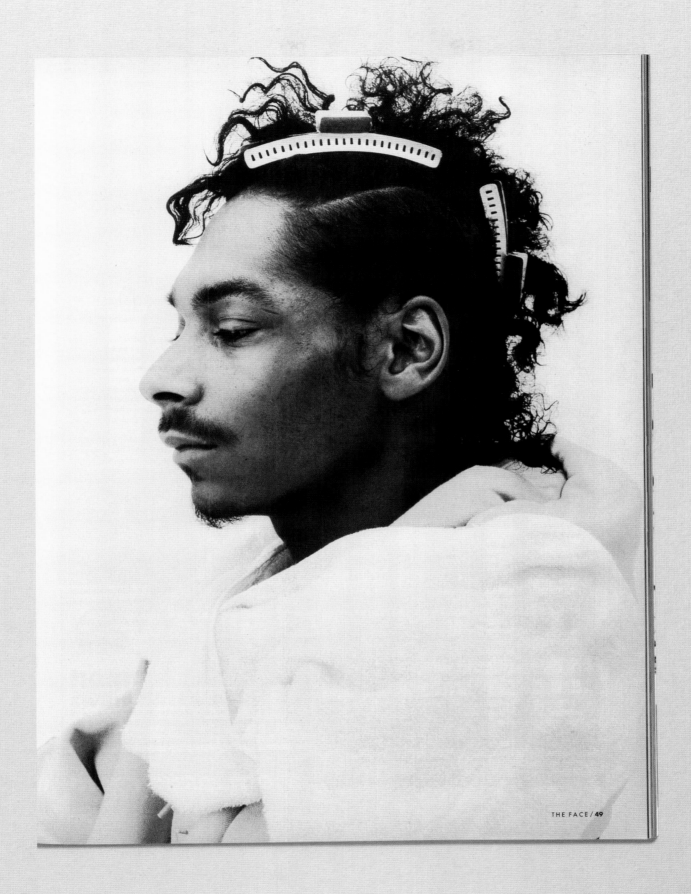

THE FACE / 49

Life is Sweet

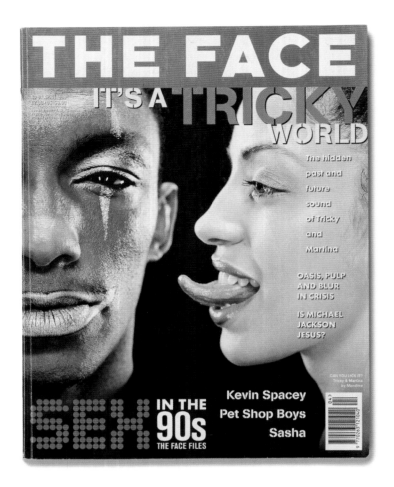

advertising pages. The latter option is favoured by nearly all publishers, and not just because advertisers prefer to occupy the first pages viewed by readers. In *The Face*'s case by 1995 there were too many adverts to be planned cheek-by-jowl with the main content of the magazine, with run-of-the-mill Nintendo one-page ads or jarring Tommy Hilfiger fragrance double-page spreads thus threatening to break up, say, a ten-page hyper-real fashion story photographed by David LaChappelle and styled by Arianne Phillips. Not that this happened, which was mainly as a result of long-drawn-out debate between the magazine designers Swillingham and Spalding and the ad sales department. In this regard, Nick Logan's disavowal of advertisers in the 1980s was coming home to roost. The sacrosanct way in which the design of *The Face* had been treated since its earliest days was now bitten hard by reality and the stacking of advertisements towards the front of the 'book' (to use publishing parlance) began in earnest.

That the British print media market was overheated in the mid-1990s is an understatement: in the men's lifestyle sector alone, Emap's rebranded *FHM* was shaping up as more than a match for *Loaded* and Dennis Publishing's new *Maxim* identified a readership distinct from the 'less puerile *Loaded* and more

Glen Luchford. To this day I'm annoyed that Snoop was bumped in favour of Bobby through a mixture of friendship, promises and, I think, a certain conservativism.'[11]

The Face was also confronted by an entirely new set of external pressures, in particular those that accompany rapidly escalating success. 'When I joined it not only felt like, but actually was a little team fighting to save the magazine,' points out Richard Benson. 'Now one of the problems was resentment over the new titles flooding in. More importantly the size of the issues and the amount of ads caused no amounts of grief with the way the magazine was formatted.'[12]

Benson was confronted with a stark choice: continue *The Face*'s flouting of publishing tradition by featuring editorial pages as soon as the magazine's cover was opened or adopt the convention of frontloading each issue with a run of

above
Vol. 2, no. 91, April 1996.

right
Vol. 2, no. 94, July, 1996.

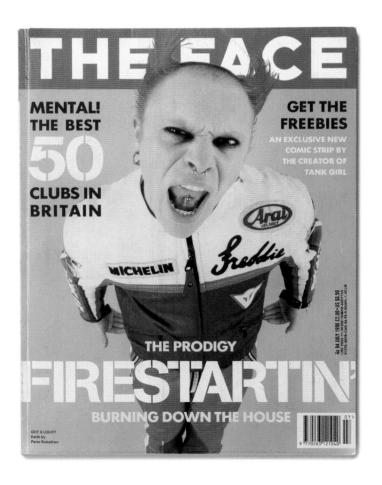

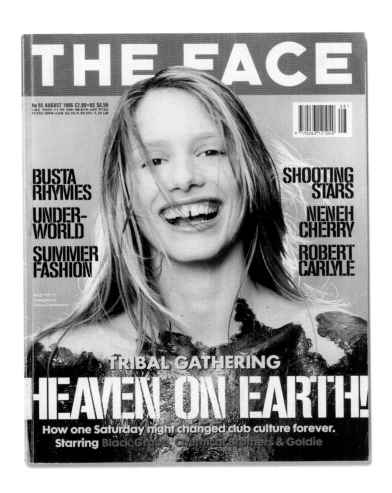

months earlier to 112,000, as advertisers cast their nets ever wider. Newsagents' magazine racks were jam-packed with specialist independent youth culture titles including *Blow*, *Code*, *Herb Garden*, *The Idler*, *Straight No Chaser* and *Touch* and direct competitor *Dazed & Confused* was receiving attention for having influenced launches such as *Sleazenation*.

'*Dazed* came at *The Face*,' avers Richard Benson. 'They aggressively marketed themselves, which is something Nick had never done. And because they didn't have the ABC [Audit Bureau of Circulation] figures, *Dazed* very astutely worked the newness factor. With *Loaded* we could position ourselves as the more intelligent option to advertisers; *Dazed* were more difficult to pin down. I felt they were inflicting damage to our reputation.'[15]

In reality the media profile achieved by *Dazed & Confused* was not reflected by its actual circulation. Wagadon group ad director Rod Sopp's contacts at the agencies and in the print business, as well as surveys by distributor Comag, suggested that monthly sales figures for *Dazed* as well as *i-D* at that stage hovered at around 10,000 copies each. '*Dazed* was doing a very good job of projecting a bigger space than it was actually occupying,' cautions Charles Gant. 'You can't talk about *Dazed*

edgy than advertiser-friendly *FHM*', according to the publishing maverick and one-time *Oz* editor Felix Dennis.[13]

Dennis was never short of bravado; his strategy of simultaneously planning a launch of a dedicated American version of *Maxim* and then in other countries around the world helped shore up the position of the third-rung British title (and provided the foundation for its longevity – localized versions of the magazine exist today in many overseas markets). He understood this would give him the jump on the corporates Emap and IPC, where board approval could stymie the lightning reflexes required to stay one step ahead. 'The joy of an independent company is its ability to turn on a sixpence,' Dennis wrote in 2009.[14]

Meanwhile joy was a commodity in increasingly short supply at Wagadon. The circulation of *The Face* started to dip in the spring of 1996 from the all-time high of 128,000 a few

above
Vol. 2, no. 95, August 1996.

right
Vol. 2, no. 96, September 1996.

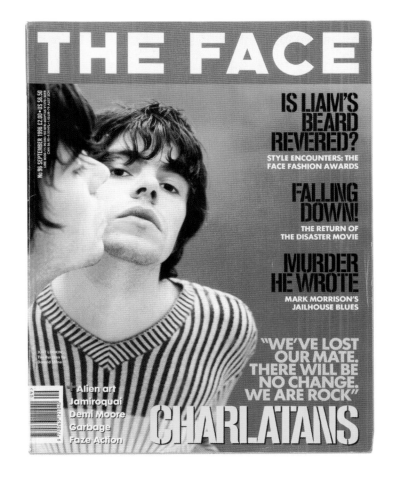

having an impact on sales of *The Face*, even though it had a very visible presence in Soho and Hoxton.'[16]

In the autumn of 1996 Logan received a visit from the Canadian journalist Tyler Brûlé, who was looking for backing for his recently debuted magazine *Wallpaper**. This cast a cosmopolitan eye over the latest developments in architecture, design, interiors and travel. 'He was shopping for a deal, looking for backing', says Logan, who passed, having interrogated the advertising potential with group sales director Sopp. Brûlé subsequently sold the title to the Time Warner group, where it became a great success. 'I think Wagadon should have taken *Wallpaper**,' says Ashley Heath. 'Given what happened subsequently it may have been the in-house launch to go for.'[17]

For a while *The Face*'s circulation held above 100,000 and its position as the world's 'primary chronicle of youth culture' was confirmed by a fulsome profile of Logan in *The New York Times*; this hinged on an anecdote told by Peter Howarth, the incoming editor of *Arena* replacing Kathryn Flett and reporting to group editor Dylan Jones (who had returned to the Wagadon fold after a spell with the nationals). Howarth described how Logan, as editorial director, had recently criticized a fashion story in *Arena* for 'not being edgy enough'. Illustrated by a photograph of the Wagadon team, including Nick and Julie Logan, Howarth, Jones, Richard Benson, Ashley Heath, Boris Bencic and Lee Swillingham, the feature emphasized Wagadon's successes, with *Arena* recently having increased from five to ten issues a year in a period when Condé Nast had closed its French flagship title *Vogue Homme*.

The Face's ability to push the envelope received particular praise from writer Amy M. Spindler, who discussed the fact that the covers were 'hot by necessity; almost all sales are from news stands, while American magazines depend on subscriptions…so while Tricky graces the newest issue of *The Face*, tongue lewdly extended, American *GQ* has the bland Julia Ormond on its May issue; *Esquire* has a picture of a rope knot.'

Former US editor James Truman, then riding high at Condé Nast, stressed what made the magazine trailblazing in Spindler's piece: 'It insisted art direction be not merely a vehicle for its content [and] was the first magazine that really used style as a prism through which you could shine everything to make a statement.'[18]

As the size of the publication increased to two-hundred pages, however, the premiums charged for advertising space could only be maintained so long before agencies advised their

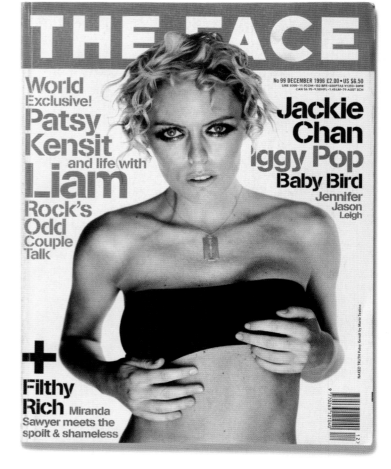

clients to consider the welter of alternative and larger circulation outlets.

In advertising trade magazine *Campaign*, Rod Sopp pointed out that *The Face* would not have survived as a new launch in the climate of the mid-1990s. 'The problem is that you would have to print more than you can ever hope to sell in order to get the presence you need,' he said. 'The most important thing is to get a good distributor. To an outsider it looks easy, what with desktop publishing, but people don't realize how much investment you're looking at in terms of money and effort.'[19]

A factor in the period's explosion of youth magazines was the growth of the mass-capacity 'superclubs' in the regions of Britain and then around the Mediterranean as they were established in the holiday destinations of their clientele. Every large conurbation in Britain was dominated by a nightclub brand – Ministry of Sound and Fabric in London, Gatecrasher in Sheffield, Liverpool's Cream and Nation – and each drew thousands of attendees every weekend as part of a new lifestyle choice providing content for the hedonistic likes of *Loaded* and *FHM* as well as the basis for such launches as *Jockey Slut*, *Mixmag* and *Muzik*.

above
Vol. 2, no. 99, December 1996.

Life is Sweet

At *The Face*, Manchester-born photographer Elaine Constantine captured the abandon of the teens flocking to such venues. 'People had seen grunge fashion for a few years and needed something else to look at', she said much later.[20] While these places commanded big budgets and could afford to bring in top-flight DJs from around the world, the unabashed populism was soon manifested in cheesiness and crowd-pleasing playlists. 'I remember Elaine went to Cream in Liverpool one night to take Richard Avedon-style portraits of clubbers against a white sheet', recalls Richard Benson. 'People didn't look that great but we went with it. The following year I was in Ibiza with Tony Barton who ran Cream. He was complaining about the shoot but couldn't remember which magazine it had appeared in. I think I told him it had been in *i-D*.'[21]

By the end of 1996, *The Face* was toeing the Britpop/Britart London line, announcing that the British capital was 'enjoying a peak in fashionability not seen since the headiest days of the Eighties'. This appeared in the stand-first for a six-page feature on fashion designer Antonio Berardi, whose presence in an ad-heavy 204-page issue was overshadowed by that of cover star Patsy Kensit. Photographed by Mario Testino, the actress offered a New Lad approach to the Oasis phenomenon: at the time Kensit's partner was frontman Liam Gallagher. She also invoked the magazine's past: in March 1985 Kensit had been granted early exposure as the teenage singer in forgotten pop act Eighth Wonder prior to her appearance in 1986's Brit movie *Absolute Beginners*. The Kensit interview by Richard Benson (see pages 306–7) was in line with the magazine's 'intelligent consideration of mainstream popular culture', in the words of Charles Gant, who also cites Chris Heath's interview with boyband Take That around this time and Peter Robinson's Spice Girls cover story in the March 1997 issue (see page 311).

With circulation at 113,000, January 1997 marked the publication of the two-hundredth edition of *The Face*, which was described as having retained its reputation as 'the pre-eminent commentator on youth culture with a confident young team in place', producing an editorial cocktail comprising 'two parts fashion, add a dash of politics and popular culture and sprinkle generously with attitude'. *Campaign* magazine paid tribute to Logan's achievement for creating 'the model for a host of glossy titles that spawned in its wake. *The Face* got there first and its influence on the UK publishing scene can't be underestimated'.[22]

Logan received the support of his old mucker Paul Smith; together they conspired for the fashion retailer to sponsor a reproduction of the first issue of *The Face*, complete with the original advertising, Jerry Dammers beaming from the cover, and printed from the original film stored in Logan's garage for years. The staff at the printer Severn Valley Press pulled out all the stops to render the damaged film usable; it had, after all, published that first edition. 'I found out only recently they absorbed potentially punitive charges to do that', says Logan. 'They were a very special bunch of people who totally repaid the loyalty I'd shown them.'[23]

Logan's verdict on the first issue in 1997 was: 'It was slightly self-conscious. I came up with all the editorial ideas myself. I still think most of the photography stands up well. I must be reasonably pleased with it or I wouldn't have had it reprinted.'[24]

Writing in *Campaign*, Jim Davies made comparisons between the 1980 magazine's five monochrome adverts and the two-hundredth issue, which he described as 'an orgy of conspicuous consumption: full-colour ads for upmarket fashion houses such as Paul Smith, Moschino and Cerruti; streetwear labels including Nike, Stussy and Fila; smokes and booze in the shape of Marlboro, Silk Cut and Caffrey's, and page upon page pandering to every youthful urge: clubs, condoms, CDs and anti-drugs helplines".

Davies's article concluded with a litany of the figures and issues the magazine had brought to the forefront of national attention, led by Kate Moss and including Neville Brody, Julie Burchill, Sade, Oasis and Ecstasy ('Face readers knew the score before the tabloid frenzy'). The *Campaign* list also confirmed the dominance of stylists and photographers in *The Face* in the mid-1990s with nods to Juergen Teller, David Sims, Jean-Baptiste Mondino, Melanie Ward and Corinne Day.

When asked by Davies whether he envisaged another two hundred issues of *The Face*, Logan said that his focus was on magazines with longevity. 'As long as they touch a chord with their readers there's no reason why they shouldn't continue. Yes, there's enough subject-matter out there for another two hundred issues.'[25] Within thirty months events would conspire to force Logan to withdraw not just from *The Face* but from publishing altogether.

below and opposite
'The New Seekers', vol. 2, no. 79, May 1995.

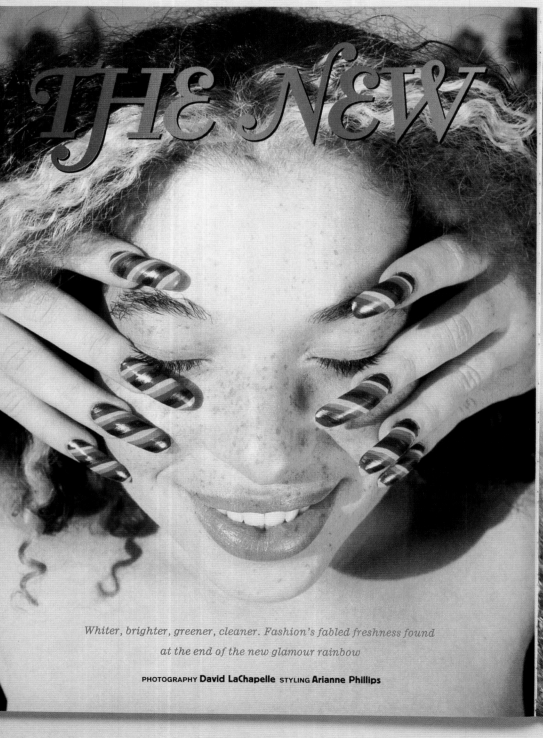

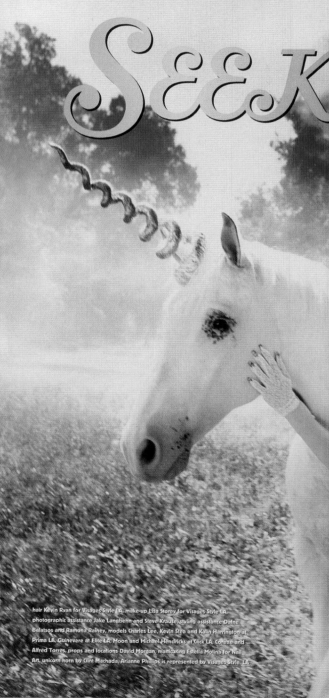

Whiter, brighter, greener, cleaner. Fashion's fabled freshness found
at the end of the new glamour rainbow

PHOTOGRAPHY David LaChapelle STYLING **Arianne Phillips**

hair Kevin Ryan for Visages Style LA, make-up Lisa Storey for Visages Style LA, photographic assistance Jake Langbehn and Steve Krause, styling assistance Dafne Balatsos and Ramona Rainey, models Charles Lee, Kevin Stea and Kalin Harrington at Prima LA, Guinevere at Elite LA, Moon and Michael Hendricks at Click LA, Colette and Alfred Torres, props and locations David Morgan, manicuring Estella Molina for Nail Art, unicorn horn by Clint Machada, Arianne Phillips is represented by Visages Style LA

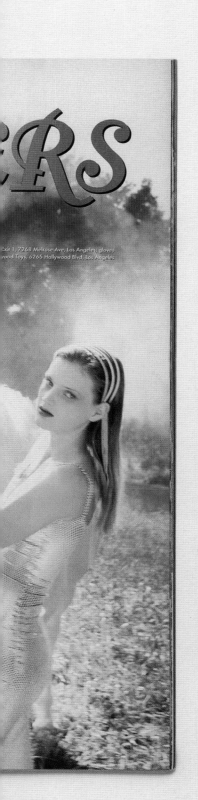

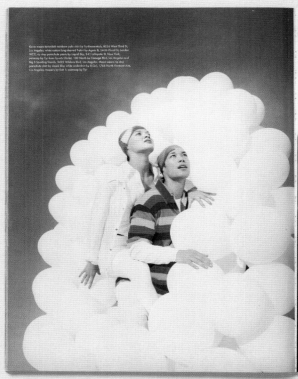

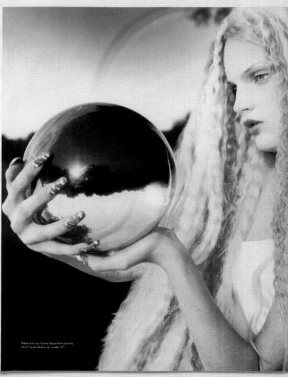

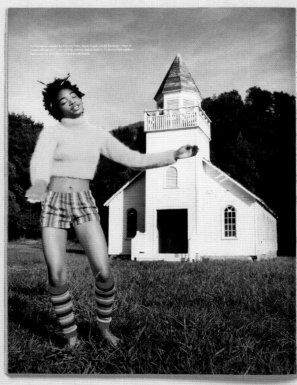

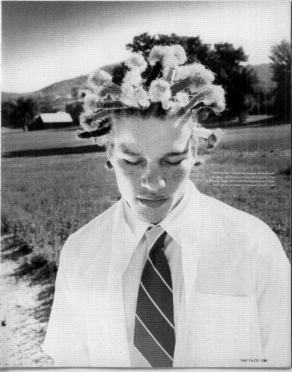

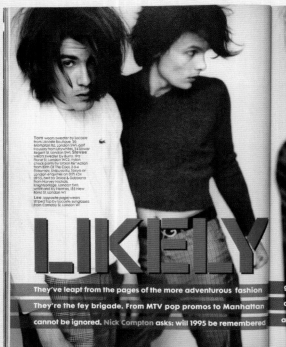

Tom wears sweater by Lacoste from Lacoste Boutique, 36 Brompton Rd, London SW1; golf trousers from Lilywhites, 24 Lower Regent St, London SW1. Stevee wears sweater by Burró, 19a Floral St, London WC2; nylon check pants by Urban for Action from Kim Of The Cool, 3-3-4 Etsunami, Shibuya-Ku, Tokyo or London enquiries on 071 434 0955; belt by Dolce & Gabbana from Harvey Nichols, Knightsbridge, London SW1; shirt and tie by Hermès, 155 New Bond St, London W1.

Lee opposite page: wears striped top by Lacoste; sunglasses from Comoby St, London W1.

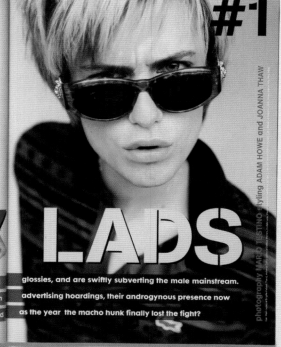

LIKELY LADS

photography MARIO TESTINO styling ADAM HOWE and JOANNA THAW

#1

They've leapt from the pages of the more adventurous fashion glossies, and are swiftly subverting the male mainstream. They're the fey brigade. From MTV pop promos to Manhattan advertising hoardings, their androgynous presence now cannot be ignored. Nick Compton asks: will 1995 be remembered as the year the macho hunk finally lost the fight?

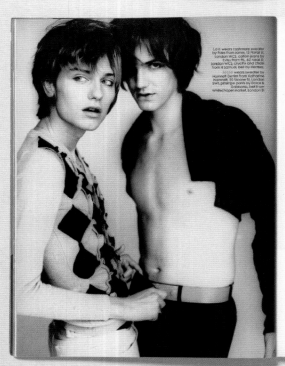

Lee-II wears cashmere sweater by Foles from Jones, 13 Floral St, London WC2; cotton jeans by Evisu from FE, 62 Neal St, London WC2; crucifix and chain from H Samuel; belt by Hermès.

Lee-III wears sweater by Hamnett Denim from Katharine Hamnett, 20 Sloane St, London SW1; pinstripe pants by Dolce & Gabbana; belt from Whitechapel Market, London E1.

lad-u-like

J
arvis Cocker. Now he's a funny fella. At least Marti Pellow thinks so. I don't care whether "he or she" thinks Wet Wet Wet are crazy, Pellow recently smirked in response to an inter-popster tiff. And didn't that tell us a thing or two. "He or she"? We haven't had that kind of libre since pre-snood terrace boys sang about Georgie Best and women's underwear and Roxboy Boxes on the campus thing on TV.

Not that Pulp's frontman will lose much beauty sleep over the slur. He can console himself that his finger is on the pulse and currently in all the right places and that Pellow is still sporting a ponytail. Nor will it knock Cocker from his gender-melding strut. He knows that the title of hoaxer, or of Brit style at least, is with him. And he will wear his "he or she-ness" with fey pride.

Camp as a row of tents but far straighter, young Jarvis is a pioneer of an androgyne jauntiness that is filtering through pop, fashion and advertising imagery and into the mainstream, subverting traditional (ie residual Eighties) male role models, and forging a new hetero-sensuous built on attitude and ambiguity. Jarvis is sexy because he looks like he knows every angle and every position, left to right and back to front. Jarvis has multiple tendencies and he's indulging every one. He looks like he knows what women want to point and how to press them, his pleasure partners' and his own.

In fashion photography, the male subtext of new star photographers such as David Sims — real, knowing and unsettling — sits

coming on like a Mick & Keef gene splice. "Chicks will never go for this," says the geezer in the van, the stubble and the James Caan chest mat. Not in thoroughbred Fulham maybe, but who wants to sleep with a horse anyway? The interesting, adventurous, discerning girls really are eyeing up the gender-bender and they're not looking for make-up tips.

I watched a cap-sleeved sort of fellow doing his funky-hunky thing at Piccadilly's Bar Rumba a couple of months back. I couldn't help comment that he looked like one of those Brylcreme ad heroes from the days when people rather than ad agency bosses were still using phrases like "style sisy". A hundred years ago now. My girl friends just said he looked like a lousy fuck.

Stumble into Facia's on London's Portobello Road (go on, do it just for the research) and check out who the charmed wardrobes are now stocked

With snake eyes, snake hips and snakeskin loafers, the cutting-edge young blade has banished the pumped-up noble hunk (with breeze block jaw and irony bypass) to the locker room of history ●

a million French presses away from the Bruce Weber men who dominated the Eighties. Think of the Armani ad image of Albert, the late male mannequin. It looks like a relic from another era. He gazes with poppy dog eyes, baring the full weight of bland physical perfection, into a blank future. It's as if he knows that his time is up at once and superstars.

Albert and his generation of paramour thermostats look comic now: bloated and ridiculous. The male supermodel was always a picturite notion. Of course those guys were playing to a baying audience (you can still see it in Marcus Schenkenberg's smug stare), but they were little more than Chippendales with better haircuts.

Their replacements, however, are playing with themselves and letting us watch. Look at the collection on these pages. They're self-absorbed, masturbatory, but daring you to join in. Like Cocker, audience participation not admiration is what they're after.

Out on the streets, out in clubland, smashed to Smashing, who do you feel threatened by? Who's grabbing the attention, the well-toned statue at the bar or the skinny fella with the New York Dolls haircut and the bad blusch job scenting his way around the room,

up with their Colville Terrace lovepads. He hasn't seen a gym since double games in his first year in big school, wouldn't know Bondi Island from Canvey Island and after four pints of Budvar he's pretty enough to make a pass at.

What's the confused modern lad to make of all this? Ko back and let it pass – it's just a phase the fashionable London types are going through, isn't it? It's happened before and it will never impact properly on the provision. Save, the fashionable (and naff) androgynist is a fashion and pop perennial, but largely as fixance and freaky side show. (And anyway, the gran mothers and New

GIORGIO ARMANI

Pin-ups every one of them, but who gets the girl in '95? Top to bottom: Jarvis Cocker, Armani's Albert, smug superstud Marcus Schenkenberg

THE FACE / 45

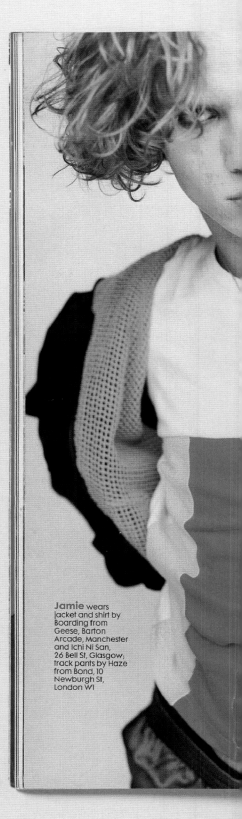

Jamie wears jacket and shirt by Boarding from Geese, Barton Arcade, Manchester and Ichi Ni San, 26 Bell St, Glasgow; track pants by Haze from Bond, 10 Newburgh St, London W1

Life is Sweet

opposite and below
'Likely Lads', vol. 2, no. 83, August 1995.

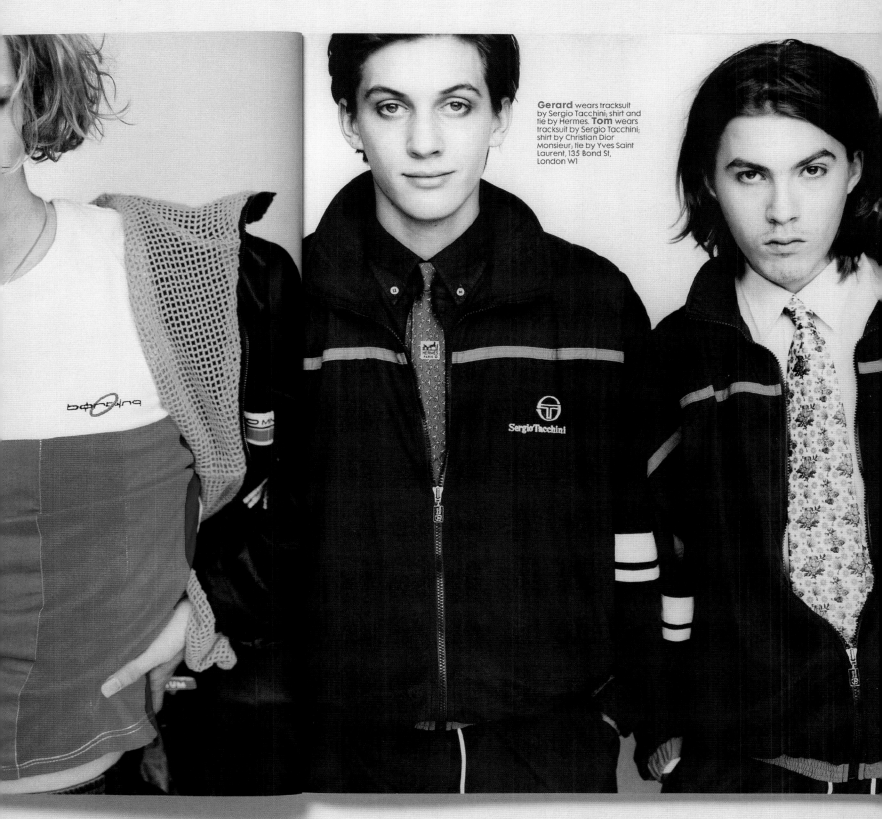

Gerard wears tracksuit
by Sergio Tacchini; shirt and
tie by Hermes. **Tom** wears
tracksuit by Sergio Tacchini;
shirt by Christian Dior
Monsieur; tie by Yves Saint
Laurent, 135 Bond St,
London W1

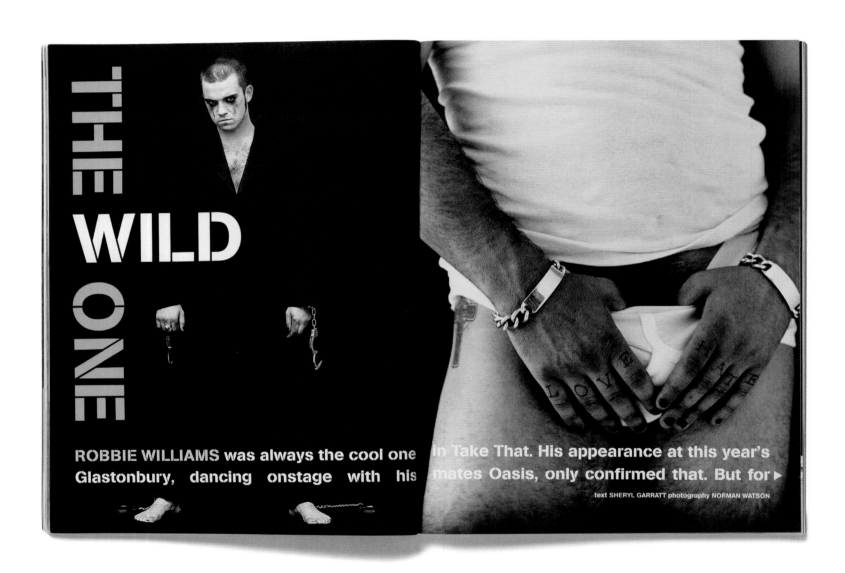

THE WILD ONE

ROBBIE WILLIAMS was always the cool one in Take That. His appearance at this year's Glastonbury, dancing onstage with his mates Oasis, only confirmed that. But for ▶

text SHERYL GARRATT photography NORMAN WATSON

above and opposite
'The Wild One', vol. 2, no. 85, October 1995.

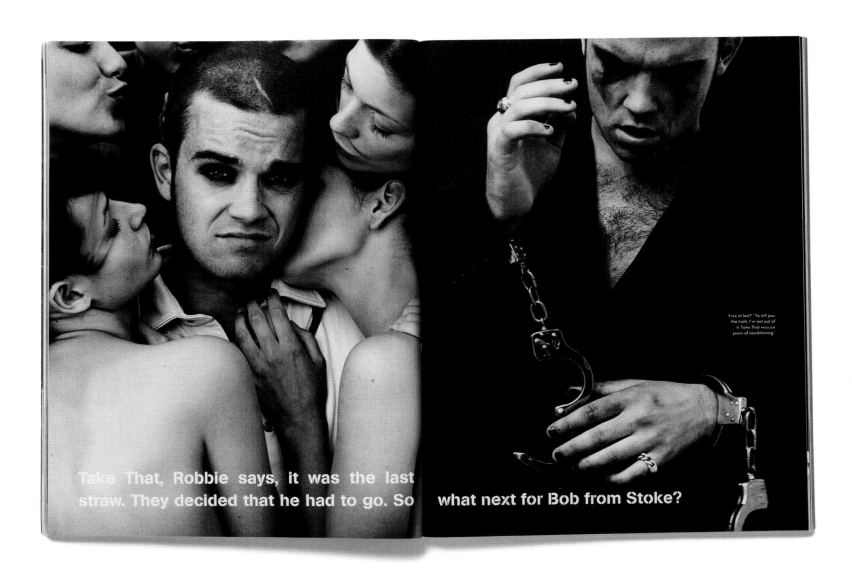

Free at last? "To tell you the truth, I'm not out of it. Take That was six years of conditioning"

Take That, Robbie says, it was the last straw. They decided that he had to go. So what next for Bob from Stoke?

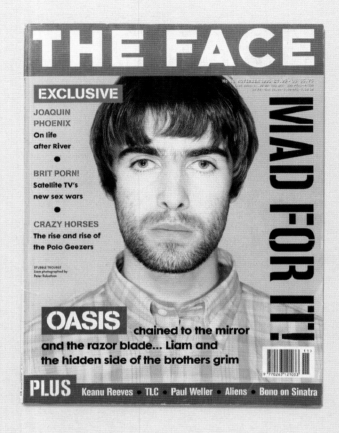

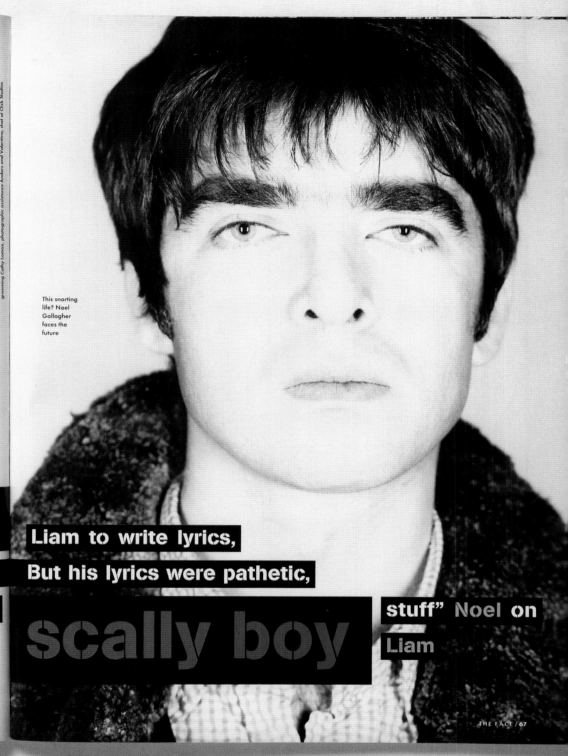

grooming Cathy Lomax, photographic assistance Anders and Valentino, shot at Click Studios

wouldn't have
been 'alright'
able brilliant."
a great singer.
d not so high
e highest. The
of: Noel's the
ng up on stage
ay be no Otis
passion, Liam

"When I first
was up for it.
singing all our
nged big time

I am and how
rites his words
ng in my head
recording the
nting to do the
orked straight
that song as a
er if it's about
be sung about

o's slapped me
'd be with her
m not thinking
ral. Love's just
ng."

, just like me."

far wall. "I am
m Manchester

and, yeah, it's
s before Oasis,
ver."

just have to sit

That's nothing to do with me. Nothing." Liam is now as forceful as he will be during our conversations. "I think they're all sad. Paula Yates is just sad. Sad, really sad. She's caught up in it big time and she needs to have a story in the papers every week. That celebrity thing is bollocks. It's all lies. I laugh, I just think it's funny mostly…"

But sometimes it does get to you?

"That one about six months ago, about me pissing in a corridor or a sink or whatever in a hotel, that got to me. I go to the toilet. When I'm out of my tits I do things just to wind people up, but manners are important to me. That story really pissed me right off. I wasn't brought up to do shit like that, was I?"

Three people play the starring roles in the life story so far of Liam Gallagher – a story here known as "A Portrait Of The Artist As A Young Manc Casual (The Formative Years Of Liam as told by Liam)". The first major player is known as "Mrs Peggy Gallagher" or "Ma". The second as "Mr Ian Brown". "Some of those times was good and some of them was a nightmare," Liam reflects on his school days. His parents had separated when he was 12 and Liam had been content to keep happy, cruising through school having some "top times" while learning "not one thing". He pretty much left his Catholic school unqualified for anything at 15 when they found him a job making fences. There had been a fight with another school that Liam still claims he was innocently caught up in when "just standing around on the corner having a fag".

A couple of other manual jobs followed, including a stint working on building sites for his dad. "He was just a sad fucking idiot who shouldn't have ever got married," reflects Liam. "My parents splitting never did my head in because I knew it was right and we had to get away. Ma wanted to stay with him until the three of us [all brothers] was old enough, but we were, 'Don't worry about us, let's get the fuck out of here.' It means I'm real close now to my Ma. Double close. But if I see my dad now I walk straight past and don't say nothing. There was that bit in *The News Of The World* where he said 'I want to make time for the lads now.' Cheeky cunt! We'll make time for him, 'cause he's got plenty of time, 'cause he does fuck all. He still lives just down the road from us, but Noel hasn't seen him for years. If he did say anything to me now, he knows what he'd get. He's a total stranger."

In his father's absence, more positive and provocative male role models had presented themselves to the teenage Gallagher, anyway.

"They were part of my life. Big time. People go, 'Oh yeah, The Roses and all that', but they were a part of me. Music does get a grip of people

This snorting life? Noel Gallagher faces the future

I don't want us
I'm not saying
arison with our
Liam' and I'm

a Christiansen?
s great! I'm not

d had a bit of a
th Paula Yates.

like that. I dunno, I was at one their gigs and I felt something a bit weird inside and it's never left me since. He was my man because he was up there and he looked the geezer. He was off-key, but that didn't matter to me. He gave me a kick up the arse. That I didn't have to be a fan no more – even though I am. But I'm no mad fucking fan who'd go up to Ian Brown for no autograph. When they went away I felt part of my life had gone »

ed Oasis I begged Liam to write lyrics, I wanted him to be the lyricist. But his lyrics were pathetic, just cheesy, horrible, scally boy stuff" Noel on Liam

THE FACE / 67

opposite top
Vol. 2, no. 86, November 1995.

opposite bottom and above
'But That's Only Half the Story', vol. 2, no. 86.

303

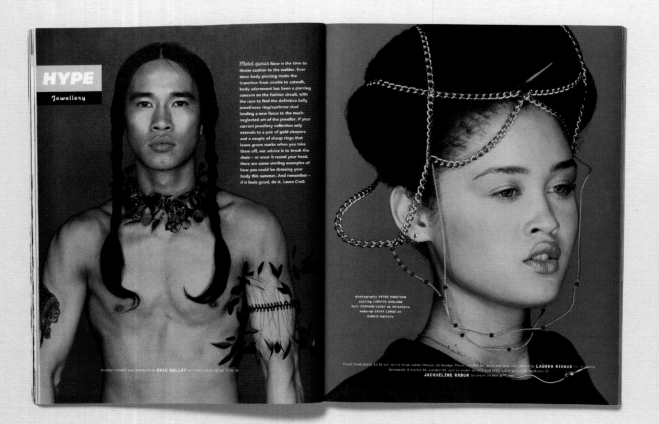

Metal gurus Now is the time to throw caution to the welder. Ever since body piercing made the transition from crustie to catwalk, body adornment has been a piercing concern on the fashion circuit, with the race to find the definitive belly jewel/nose ring/eyebrow stud lending a new focus to the much-neglected art of the jeweller. If your current jewellery collection only extends to a pair of gold sleepers and a couple of cheap rings that leave green marks when you take them off, our advice is to break the chain – or wear it round your head. Here are some sterling examples of how you could be dressing your body this summer. And remember – if it feels good, do it. *Laura Craik*

Leather choker and armband by **ERIC HALLEY** to order, phone 331 44 75 04 35.

photography PETER ROBATHAN
styling LYNETTE GARLAND
hair STEPHEN LACEY at Streeters
make-up CATHY LOMAX at
Debbie Walters

Chain head-dress £2.53 per metre from James Phelps, 20 Goodge Place, London W1, gold and jade ear chains by **LAUREN RIVAUD** for Fiorucci
Westwood, 6 Davies St. London W1, and to order or HILS NEW STYLE solid gold link necklace by
JACQUELINE RABUN to order or HILS NEW style

Barbed-wire leather choker
for Alexan

photographic assistance
Richard Dawson and Larry,
shot at Click Studios,
processed at The Lab,
models Antuan at Models 1,
Alek at Models 1, Artia at
Select and Luella Bartley

Life is Sweet

opposite and below
'Hype: Jewellery', vol. 2, no. 93, June 1996.

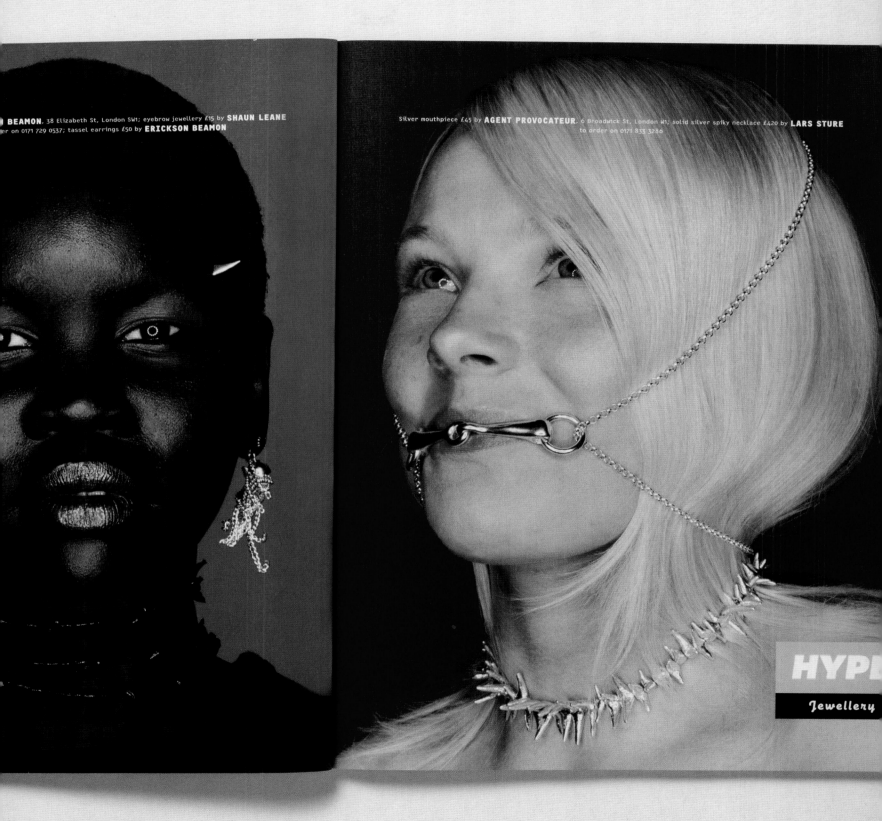

BEAMON. 38 Elizabeth St, London SW1; eyebrow jewellery £15 by SHAUN LEANE
...er on 0171 729 0537; tassel earrings £50 by ERICKSON BEAMON

Silver mouthpiece £45 by AGENT PROVOCATEUR. 6 Broadwick St, London W1; solid silver spiky necklace £420 by LARS STURE
to order on 0171 833 3286

HYPE
Jewellery

Life is Sweet

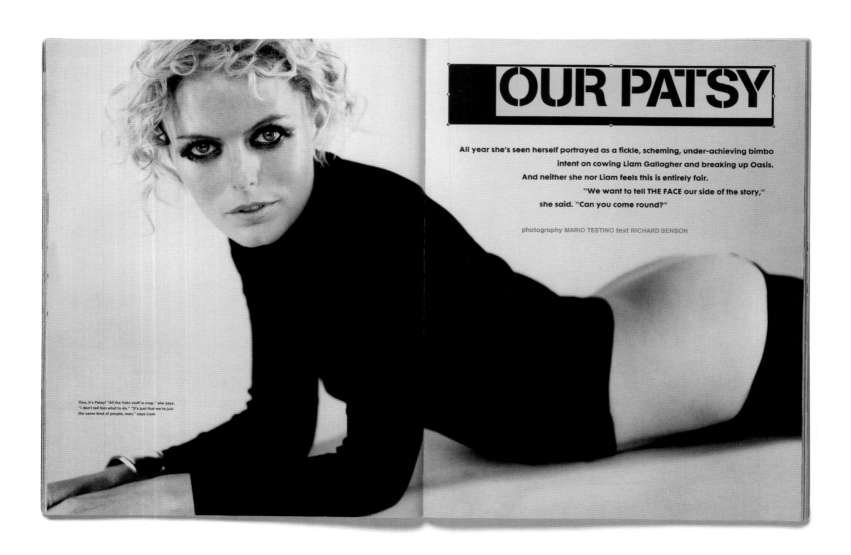

OUR PATSY

All year she's seen herself portrayed as a fickle, scheming, under-achieving bimbo
intent on cowing Liam Gallagher and breaking up Oasis.
And neither she nor Liam feels this is entirely fair.
"We want to tell THE FACE our side of the story,"
she said. "Can you come round?"

photography MARIO TESTINO text RICHARD BENSON

Ono, it's Patsy! "All the Yoko stuff is crap," she says.
"I don't tell him what to do." "It's just that we're just
the same kind of people, man," says Liam

above and opposite
'Our Patsy', vol. 2, no. 99, December 1996.

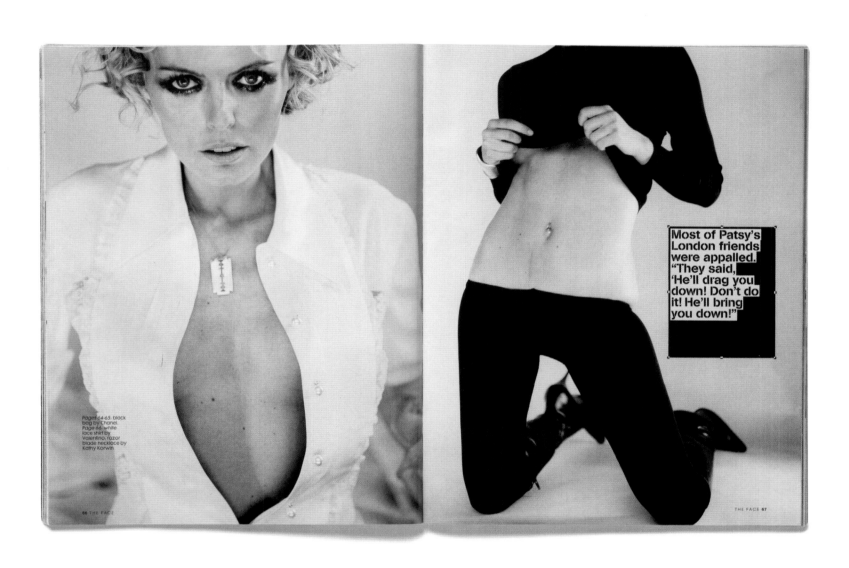

Pages 64-65: black
bag by Chanel.
Page 66: white
lace shirt by
Valentino, razor
blade necklace by
Kathy Korwin

66 THE FACE

THE FACE 67

Most of Patsy's
London friends
were appalled.
"They said,
'He'll drag you
down! Don't do
it! He'll bring
you down!'"

below and opposite
'What do you get if...', vol. 2, no. 99,
December 1996.

WHAT DO YOU GET IF you cross sexy tailored jackets, obscure garage records, self-deprecation and a revival of, er, pedal-pushers? The answer: Antonio Berardi, age 28. With London now enjoying a peak in fashionability not seen since the headiest days of the Eighties, he represents an assured calm at the eye of the storm. Meet the crown prince of fashion's strange new court

Antonio Berardi

Reportage photography by WARREN DU PREEZ

text
NICK COMPTON

photography
FRANÇOIS ROTGER

styling
NANCY ROHDE

"I don't really like fashion people. Hardly any of my friends are fashion people. I'm a working-class boy, and that's what I am" ●

Chapter Thirteen

A Long Way from Hard Times

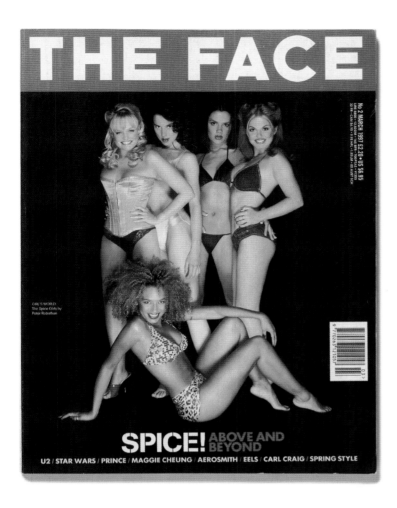

above

Vol. 3, no. 2, March 1997.

Nick Logan's uncharacteristic expression of confidence in his interview with *Campaign*'s Jim Davies caught the spirit of the times in the spring of 1997, which witnessed an international focus on young British creativity, culminating in celebratory acts including *Vanity Fair*'s publication of its 'London Swings Again' issue; on the cover were Oasis frontman Liam Gallagher and his wife Patsy Kensit insouciantly staring up at the reader from a bed of Union Jack sheets. Both were staples of *The Face*, as were many of the subjects inside, from *monstres sacres* Alexander McQueen and Damien Hirst to cheery Big Beat club night Heavenly Social.

With guitar-playing Tony Blair poised to become prime minister in the May general election as head of the first Labour Party government since 1979 (the year Logan started mapping out *The Face*), Wagadon's coffers were relatively full, prompting Logan to embark on realizing his company's first launch since *Arena Homme Plus* four years previously: a relatively modestly

targeted 100,000-circulation 'intelligent' women's magazine aimed at '25–35-year-old upmarket, urban women who are stylish and unconventional'. Logan had already sought the counsel of Paul Smith; bruised by attempts to produce womenswear collections in the fiercely contested sector, the fashion retailer countenanced against the move: 'It's a really tough market to break.'

Undeterred, Logan proceeded with his plans; approaches to former features editor Lesley White and contributor Sarah Mower, then at *Vogue*, came to naught. At James Truman's suggestion he discussed the post with Bill Mullen, who had been fashion director at *Details*. The notion of appointing a man to edit a woman's magazine was enticing and 'so Wagadon' thought Logan (Kathryn Flett, of course, had been *Arena* editor). But Mullen was unwilling to give up his base in New York and in March 1997 Logan appointed Tina Gaudoin from the posh monthly *Tatler* to helm the project, which was given the working title *Arena Woman*. Features editor Harriet Quick was drafted from *The Face*'s contributor list and Lisa Markwell, who had worked on the nationals and was editor of Harvey Nicholls' in-house magazine, was brought in by Gaudoin as deputy editor. Boris Bencic returned to Wagadon as art director of the magazine. It is understood that he didn't see eye-to-eye with Gaudoin, who brought in Jason Shulman – brother of the then *Vogue* editor Alexandra – as his replacement after a few months. However, Shulman himself didn't last the course, and a few months later, Bencic returned to the fold.

After much – apparently tortuous – discussion, the new magazine was titled *Frank*. 'It's unexpected and we like the play on words. The magazine's name is upfront because that's what we are,' said Gaudoin.[1]

The secrecy surrounding the venture caused tension at Exmouth House, as Markwell was to later reveal. 'There was a major culture shock going on between the folk of *The Face* and *Frank*,' she wrote the following year. '*Frank* was behind a steel door with a combination lock; those used to wandering between titles for a chat felt affronted.'[2]

Logan disputes this account. 'I actively encouraged people to mix,' he said. 'Anyone who worked at Wagadon will tell you that that was always the case. In fact, I was delighted to see people from *Frank* and the other titles making coffee together.'[3] Markwell failed to point out that all the magazine offices were behind steel doors; these had survived from the time when Exmouth House was a factory. In addition, the combination lock on the *Frank* office door was a security measure since it was situated next to the Wagadon reception.

One insider said that Logan's decision to launch a new title with a fresh editorial team stemmed from his willingness to learn ways in which to increase professional standards across

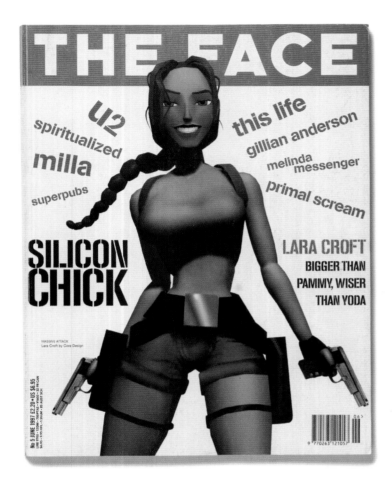

generation of young journalists was sealed; not long before his death, he had signed a book deal with Penguin and was poised to make the breakthrough into television on BBC's travel strand *Rough Guide* as co-presenter with Miranda Sawyer, who had risen through the ranks of the music press to also write for *The Face*. Sawyer opted out of appearing in the series without him.[4] 'It did all of our heads in,' says Richard Benson. 'Gavin had done so much dangerous stuff, stories from warzones, and to die in that way, by slipping off a rock, seemed awful to contemplate.'[5]

As if it were a portent, in the second half of the year, sales of *The Face* started to slide dramatically. 'Pop culturally, the planets weren't as aligned as they had been,' confirms Charles Gant. 'There didn't seem to be something strong coming along to replace Britpop. When sales dipped, Richard and I beat ourselves up about it; we felt that it was our fault.'[6]

The disquiet was reflected in relatively run-of-the-mill cover choices made to coincide with the entertainment industry's promotional cycle rather than from an instinct for the new and fresh. Such was the competition from IPC's *Loaded* and Emap's *FHM* and *Q* that *The Face* could no longer afford to go out on a limb and risk missing the big names that drove news stand sales.

For example, the September 1997 cover subject Richard Ashcroft of The Verve (whose album *Urban Hymns* came out that month) simultaneously appeared across the specialist and general media with covers of music titles including *Q* and *Vox*; similarly, November's Jarvis Cocker appearance, which was timed for the release of Pulp's *Hard Core* album (the title of which was used as the main cover line).

Certain selections made outside of the promotional cycle – actress Chloë Sevigny, model Karen Elson – appeared as attempts to appeal to the prurient New Lad market. The choice of the Tomb Raider computer game character Lara Croft was, in contrast, inspired. 'This was the first time that a character from a video game was talked about as though they were real,' says Lee Swillingham, who worked up the June cover idea with Stuart Spalding. 'Since fashion was such a big part of what we did, we approached several designers to produce outfits for her. I knew Lee McQueen, we were all contemporaries, so it was very easy to call them up and get them to do something.'[7]

There were other front cover choice successes, including features editor Craig McLean's May encounter with Beck. This placed the LA-based sample-happy Scientologist in a fashion context and included a contribution from Thurston Moore, but the overlong and indulgent email interview conducted by the Sonic Youth guitarist (all in lower case) forced a turn to page 217 on the nine-page feature, when judicious editing would have provided a more gainly solution.

the company. 'To an extent Nick underestimated his talent and abilities. I don't think any of the people recruited to *Frank* had anything whatsoever to teach Nick Logan.'

According to a story doing the rounds of Exmouth House, a *Frank* staffer broke the heel on one of her Manolo Blahnik shoes in the offices and charged the cost of a new pair to expenses. For *The Face* team, who were used to travelling by bus to interviews with major celebrities in the West End, this became symptomatic of a simmering resentment over the resources being poured into the new venture.

In May 1997, with preparations for *Frank* underway, terrible news arrived at Wagadon: Gavin Hills had died, just thirty-one years old. A non-swimmer, he slipped by accident into the sea from rocks on the Cornish coast while fishing with friends. Hills's position as one of the brightest stars of his

above
Vol. 3, no. 5, June 1997.

opposite
'The Bit Girl', vol. 3, no. 5.

Men like Lara's ballast; women like her mind. Surprise! But Lara also appeals to women because of her no-nonsense style ●

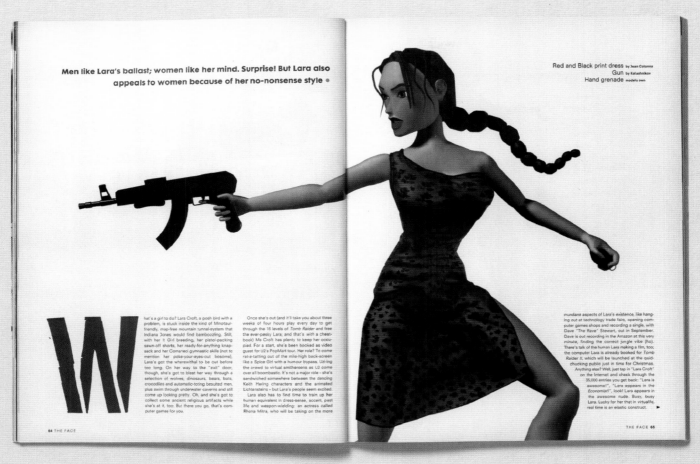

Red and Black print dress by Jean Colonna
Gun by Kalashnikov
Hand grenade models own

What's a girl to do? Lara Croft, a posh bird with a problem, is stuck inside the kind of Minotaur-friendly, map-free mountain tunnel-system that Indiana Jones would find bamboozling. Still, with her I: Girl breeding, her pistol-packing sawn-off shorts, her ready-for-anything knapsack and her Comaneci gymnastic skills (not to mention her poke-your-eyes-out bosoms), Lara's got the wherewithal to be out before too long. On her way to the "exit" door, though, she's got to blast her way through a selection of wolves, dinosaurs, bears, bats, crocodiles and automatic-toting besuited men, plus swim through underwater caverns and still come up looking pretty. Oh, and she's got to collect some ancient religious artifacts while she's at it, too. But there you go, that's computer games for you.

Once she's out (and it'll take you about three weeks of four hours play every day to get through the 18 levels of Tomb Raider and free the ever-pesky Lara; and that's with a cheatbook) Ms Croft has plenty to keep her occupied. For a start, she's been booked as video guest for U2's PopMart tour. Her role? To come rat-a-tatting out of the mile-high back-screen like a Spice Girl with a humour bypass. Uzi-ing the crowd to virtual smithereens as U2 come over all boombastic. It's not a major role – she's sandwiched somewhere between the dancing Keith Haring characters and the animated Lichtensteins – but Lara's people seem excited.

Lara also has to find time to train up her human equivalent in dress-sense, accent, past life and weapon-wielding: an actress called Rhona Mitra, who will be taking on the more

mundane aspects of Lara's existence, like hanging out at technology trade fairs, opening computer games shops and recording a single, with Dave "The Rave" Stewart, out in September. Dave is out recording in the Amazon at this very minute, finding the correct jungle vibe (ho). There's talk of the human Lara making a film, too; the computer Lara is already booked for Tomb Raider II, which will be launched at the quid-chucking public just in time for Christmas. Anything else? Well, just tap in "Lara Croft" on the Internet and check through the 35,000 entries you get back: "Lara is awesome!", "Lara appears in the Economist!", look! Lara appears in the awesome nude. Busy, busy Lara. Lucky for her that in virtualife, real time is an elastic construct. ▶

Lara, however distractingly curvaceous, just gets on with things. There's a sense of stiff upper lip about her. Plus she keeps her kit on. Or does she? ●

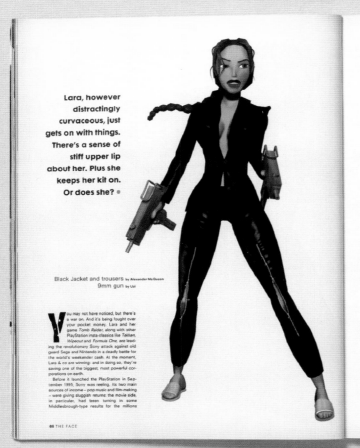

Black Jacket and trousers by Alexander McQueen
9mm gun by Uzi

You may not have noticed, but there's a war on. And it's being fought over your pocket money. Lara and her game Tomb Raider, along with other PlayStation insta-classics like Tekken, Wipeout and Formula One, are leading the revolutionary Sony attack against old guard Sega and Nintendo in a deadly battle for the world's weekender cash. At the moment, Lara & co are winning; and in doing so, they're saving one of the biggest, most powerful corporations on earth.

Before it launched the PlayStation in September 1995, Sony was reeling. Its two main sources of income – pop music and film-making – were giving sluggish returns. The movie side, in particular, had been turning in some Middlesbrough-type results for the millions

invested. Today, you hear the Japanese Sony president, Noboyuki Idei, blathering on about "digital dream kids" like an over-pixilated Timothy Leary; this is because it was digital interactives that rescued his company, turning in the profit it so desperately needed. Sony moved into the virtual world and hit a real jackpot: 880,000 PlayStations have been sold so far in the UK alone, at between £150 and £300 each; over five million Tekken games have been shifted worldwide; Tomb Raider has managed 400,000 British sales on PlayStation at £44.99 per game. The dream kids just handed Sony their piggy banks.

To understand how this happened, you have to know two things. One: that in the last few years, games-making technology has made mammoth leaps in sophistication and ability.

Two: that Sony's last two "new invention" launches were the Sinclair C5-troublers, BetaMax videos and the MiniDisc.

Where BetaMax and MiniDiscs failed was in the software aspect: the formats themselves were fine, but there just wasn't anything for you to buy. There weren't enough good films on BetaMax; MiniDisc didn't offer the tunes you actually wanted. Rival formats, with their huge range of quality films and LPs, just stole the market from under Sony's unsettling nose. So when the corporation decided to make its move into the cyber-future, it knew that its fantastic little handset would not be enough: it had to have the games to go with it. Lots and lots of top-flash games.

The other aspect, the new technology, meant that the games could actually be built.

Amazingly, it's only in the last two years that computer processing power has become advanced enough to deal with the thousands of polygon graphics needed to move a three-dimensional character around a three-dimensional environment. After more than a decade of clunky graphics and barely-3D characters, the equipment and the talent finally existed to make the kind of computer games we'd been promised for years.

Sony invested millions. Five hundred million dollars on software development; $500 million on hardware development. And with that much invested, there's no room for failure. Virtual rocket-launchers ablaze, Sony went for an all-out, pan-global, no-prisoners attack. It whupped Sega's Saturn console and bamboozled Nintendo, which just hadn't expected such ▶

MY GIRL
TOBY GARD, THE DIGITAL DR FRANKENSTEIN WHO GAVE LIFE TO LARA, ON THE BABE HE MADE

Has Lara changed much (physically, character-wise) from your original idea of her? Well, she went through a period of wearing slightly more military-looking clothes, but she looked too Nazi-like. For a while she looked a bit like Neneh Cherry; baggy trousers and crop tops, but before long she found her hot pants and leotard and away we went!

Is she based on anyone you know? No, it's not often you meet gun-toting psychopaths down the pub.

So what's with the unfeasibly large knockers then? Slip of the mouse. I wanted to expand them 50 per cent and then – whoops, 150 per cent. Darn.

Did they get bigger when marketing became involved? Not really; they were just focused on more. The marketing men just saw them as the easy route to take with their campaign. I reckon they must have thought, "How are we going to market this? Hey, look at her enormous oojahs! I have a cunning plan." Clever lads.

Did your girlfriend mind you spending so much time with another woman? If you want a

girlfriend, avoid working in computer games like the plague. If you work seven days a week, 15 hours a day for almost two years, with barely enough time for a pint, you have no time whatsoever for relationships. Plus computer-games makers are regarded as being about as hip and cool as aseptoir workers.

What do you think of the idea of a "real" Lara being used in promotion – will you be buying her single? I think it's really weird when you've drawn a character and then you meet someone who's actually being paid to dress up the same and pretend to be her. Very strange. As far as I'm aware the single is no longer going to happen. If it does, though, yes, I'll buy it. I like a laugh.

Is Lara a feminist icon or a sexist fantasy? Neither and a bit of both. Lara was designed to be a tough, self-reliant, intelligent woman. She confounds all the sexist clichés apart from the fact that she's got an unbelievable figure. Strong independent women are the perfect fantasy girls – the untouchable is always the most desirable.

Would she work if she wasn't a posh bird? I can't somehow imagine her in a council house wearing white stilettos and sporting a fake-blonde perm; She was made as quintessentially British as possible. It's generally held that unless you have an American hero you won't be able to sell the game at all in America. I thought that by deliberately reversing as many rules as possible, ie female (but strong, not tarty), a British not American lead character, and American not British villains, we'd make something that was unusual and fresh.

Which is more important: the character or the game? The game is always the most important thing: the way it plays, the interface, and the content. A good character is useful to bring the thing to life.

Are you still in love with Lara or are you sick of the sight of her? Neither. It's good to see the character around still, quite satisfying in fact. I don't think it would be quite normal for you to love something you made up though, a bit too Bride Of Frankenstein for my liking.

NUDE RAIDER

Vice girl: Lara as she appears on the Internet (top) and as a special guest on U2's PopMart tour (bottom)

unique editorial take on social values that had proved *The Face*'s strength since the early 1980s.

Yet such triumphs were outweighed by mis-steps: the July 1997 cover choice of a David LaChapelle portrait of Uma Thurman on the release of flop franchise movie *Batman & Robin* was plain wrong for *The Face*. In fairness, the decision to go with the photography and interview – which were buy-ins, having also appeared in American entertainment magazine *Detour* – was made while the team was reeling from the news of Gavin Hills's sudden death, but nevertheless it is an entirely forgettable effort. 'That was a horrible time and a terrible cover,' admits Richard Benson. 'The only occasion I snapped in the job was when Nick came in with the issue after it had arrived from the printers complaining about the cover and layouts. I threw a copy at him and told him to fuck off.'

Benson, then twenty-nine, was buckling under the strain. 'Wherever you went, people asked about what was going to be in the next issue or had a go about what was in the last,' he says.[8]

The talents of the design team of Spalding and Swillingham were by now called upon to meet third-party commissions, particularly from lucrative advertising accounts.

Far more satisfactory was the ten-page general election special 'The X Factor', which appeared in the same issue (see pages 324–25). This investigated voter apathy among eighteen- to twenty-four-year-olds, with photo-led sections on contemporary phenomena including 'Mondeo Man', the Middle Englander identified by Tony Blair and named after the mid-range Ford family car. In spotlighting striking Liverpool dockers and protesters dwelling in tunnels underneath land allotted for Manchester's second airport, 'The X Factor' was replete with the

above
Vol. 3, no. 7, August 1997.

right
Vol. 3, no. 8, September 1997.

opposite top
Richard Benson's *Night Fever* (London, 1997).

opposite bottom
Invitation to the launch party for *Night Fever*, August 1997.

'There were complaints about them being sometimes problematic and obstructive, but only in pursuit of the highest standards of design,' says one staffer. 'Then when they worked outside *The Face* they were paid handsomely by people who told them how much they loved to work with them. It must have been mind-bending.'

Design briefs for the group Texas came via fashion director Ashley Heath, whose partner was the frontwoman Sharleen Spiteri.[9] 'That could be frustrating, trying to get them to concentrate on the job in hand when they were more interested in spending time on that,' says another staff member.

As the lines became blurred so a malaise grew. 'There's something about New Labour coming in which gives me the creeps when I look back,' shivers Benson. 'Sales started to collapse yet there was the pressure of finding content because the issues were getting bigger and bigger. We felt we had to maintain the editorial ratio, so there'd be ten or eleven features in each issue. I cringe when I look back at things like Gorky's Zygotic Mynci, a terrible indie band who helped fill a gap. Then there was a redesign which wasn't great and soon reader complaints about the volume of advertising started to increase.'[10]

In August 1997 the publication of the book *Night Fever: Club Writing in The Face, 1980–96*, a collection of articles on club culture and dance music that had appeared in *The Face*, served to mark the passing of the years, starting as it did with Robert Elms's 'The Cult with No Name' piece from 1980 and culminating with an article by Rupert Howe on hardcore techno published a few months earlier. Benson edited the collection and wrote in the foreword: 'If you're one of those to whom going to a certain club at a certain time has at some stage in your life seemed as important as anything else ever has – well, to a greater or less extent, reader, this is your life.'

Meanwhile, the heavy lifting carried out by Logan and the team he had assembled with Tina Gaudoin came to fruition that autumn with the publication of the first issue of *Frank*. Gaudoin told the trade press that the new magazine would 'fill the niche for the disenfranchised twenty-five-plus reader, for a generation of women which has grown up and left other magazines behind' and promised 'hard-hitting features as well as the frocks and lipsticks stuff…business, politics, finance, cars, food and wine but it will be irreverent and witty with its tongue firmly in its cheek. British women have a great sense of humour and no one has celebrated that before.'[11]

The launch issue of *Frank* sold a promising 120,000 copies, largely on the back of the widespread interest in this latest creation from the man who had founded *The Face* and *Arena*. But Logan had underestimated the ferocity of the response to the launch from rivals; reports circulated that *Vogue*'s Alexander Shulman had put the word around to the

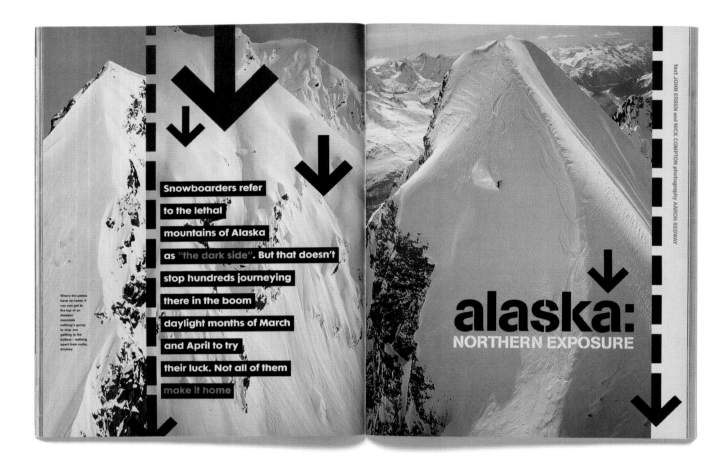

Snowboarders refer to the lethal mountains of Alaska as "the dark side". But that doesn't stop hundreds journeying there in the boom daylight months of March and April to try their luck. Not all of them make it home

Where the pistes have no name: if you can get to the top of an Alaskan mountain nothing's going to stop you getting to the bottom – nothing apart from rocks, anyway

text JOHN ERBEN and NICK COMPTON photography AARON SEDWAY

alaska:
NORTHERN EXPOSURE

world's leading fashion photographers that their contributions would be unwelcome if they undertook commissions for *Frank*. At any rate, sales did not hold amid escalating staff discontent over under-investment and disagreement on direction.

In hindsight, Logan sees that he was confounded that the *Frank* team did not adopt the collegiate approaches at *The Face* and *Arena* (with 'editors and art directors working in tandem through all stages of production thus creating a dynamic which set the magazines apart'[12]). But this was not a team of journalists whose talents had been hot-housed in the Wagadon way, rather professionals experienced in all manner of corporate practices. 'Perhaps there was a disconnect in their more traditional working methods that caused the dynamic to be lost in the process,' suggests Logan.

He says he met resistance when pushing for involvement in the new launch from old hands including picture desk editor

Kelly Worts and group editor Dylan Jones. 'It was especially tough that Tina had little time for Dylan at a time when he was being similarly sidelined at *Arena*,' said Logan. 'His subsequent career clearly shows what he had to offer – and soon I would lose him altogether as a result of these snubs.'[13]

Inter-departmental relations – particularly between the editors and the magazine's fêted art department – were also fraying at *The Face*. 'There was always a potential for misalignment,' says one source. 'For example, editors could do all of the tasks of their team apart from the art department's, and that was important because it meant they had to relinquish a certain amount of power to the designers. Also the editor's peers were usually other journalists and other editors; there might be the odd celebrity but that was quite rare. The art department's peers were people like Mario Testino and Juergen Teller and they'd be flying around the world directing glamorous campaigns and then have to come back to the *The Face* offices and lay out a Nicolas Cage feature. That could cause a bit of an issue as to their place in the scheme of things.'

The Face was still a major showcase for new fashion photography, as evinced by the December 1997 ten-page cover story Sarf Coastin' shot by Elaine Constantine (see pages 328–31), who said that her images of young girls enjoying a

above
'Alaska', vol. 3, no. 2, March 1997.

opposite
Vol. 3, no. 11, December 1997.

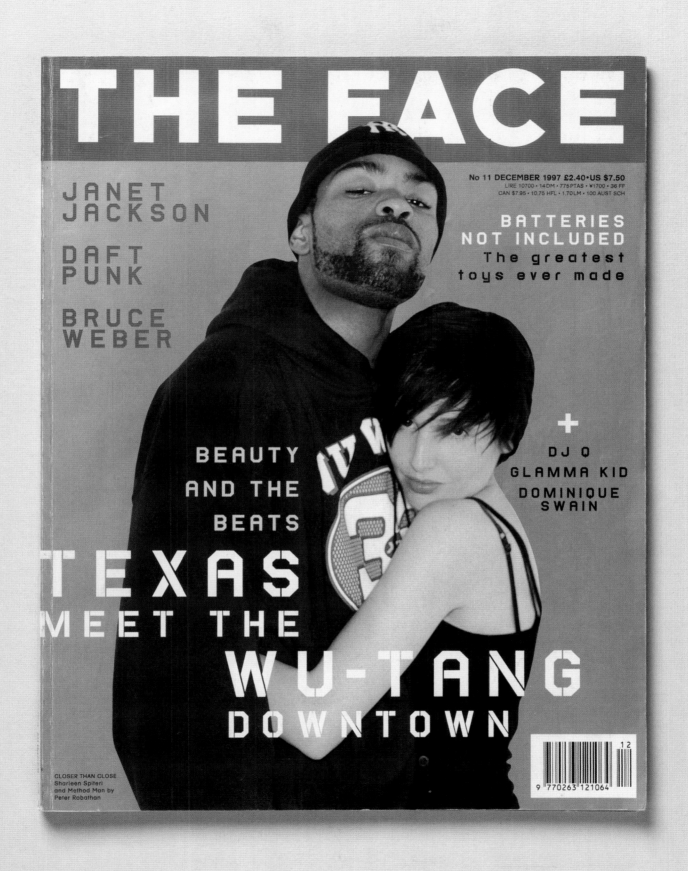

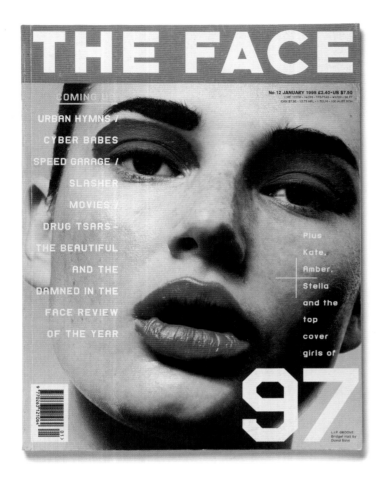

to deliver the damp squib *Mezzanine* to Virgin for another four months, leaving *Dazed* high and dry with an interview without a release in the shops.

In the end the December 1997 issue of *Dazed* featured Adam Yauch and Mike D. of the Beastie Boys on the cover (Adam Horowitz was unavailable). 'We were offered that, but I didn't see the point of having just two of them,' said Richard Benson. 'Then I saw that issue of *Dazed* and realized they were prepared to do things we wouldn't. You could say they were more pragmatic than us, editorially and in terms of business. We would try and ensure that everything was just right whereas *Dazed*'s thinking was based on short-term gain. This was the opposite to the way Nick worked. *The Face* was set up to be a general-interest magazine which paid its way. He always said that *The Face* was "Mod" and *i-D* was "Hippy", and *Dazed* fell in to that camp because they didn't have to make money to survive because they got their funding from other sources.'

This enabled *Dazed & Confused* to appear more agile and risk-taking, particularly when it came to cover subject choices. 'One of the models for *The Face* was *Rolling Stone*; it delivered the news from popular culture,' says Benson. 'It was never interested in two blokes and a dog in Shoreditch. To its credit, *i-D,* followed by *Dazed* and others, was incredibly excited by two blokes and a dog in Shoreditch and more power to their elbow. And when those two blokes and their dog got a drum machine, *Dazed* would put them on the cover.'[15]

In the spring of 1998, with *Frank* floundering (editor Tina Gaudoin in walked April after just eight issues) and *The Face* and *Arena* battling declining circulations, Nick Logan opted for the launch of a laddish new men's title, *Deluxe*, edited by Andrew Harrison, who had contributed to *The Face* and made his bones on IPC music title *Select*. Harrison pitched the idea to Logan with the backing of Dylan Jones. 'Initially I didn't see what I could bring to it,' says Logan. 'But Dylan was keen and

day out in Brighton was an attempt 'to represent a more natural, real environment'.[14] That issue marks the one occasion when *The Face* lost out to its rival *Dazed & Confused*, though events conspired to work in its favour.

Having been promised a Massive Attack cover interview to coincide with the release of the Bristol trio's album *Mezzanine*, the decision was made by the group's record company Virgin to plump for a feature in *Dazed* instead. *The Face*'s replacement for December 1997 was the intriguing combination of rapper Method Man and singer Sharleen Spiteri (the Wu-Tang Clan member had duetted on the latest album by Texas; see page 317). As it turned out Massive Attack failed

above
Vol. 3, no. 12, January 1998.

right
'The Kook Report', vol. 3, no. 27, April 1999.

opposite
Deluxe, no. 1, May 1998.

I didn't want to lose him.'[16] In the event, Jones was poached by Condé Nast to take over *GQ* shortly before the first issue of *Deluxe* was published.

'*Deluxe* is here because a group of people got tired of being told that the same clapped-out subjects were the be-all and end-all of men's interests,' Harrison announced when the magazine was launched in May 1998, with a predictable photograph of cocky Jarvis Cocker dragging on a cigarette on the cover. 'They got bored of pro-celebrity shark-fishing and Z-list actresses in their knickers. The world is more interesting and more complicated than all that.'[17]

Complicated, certainly. *Deluxe* didn't reach anywhere close to its 150,000 circulation target – again modest since this was a third of what *Loaded* was selling every month – and a redesign after four issues included a switch to a perfect-bound format and the inclusion of more photographs of women, who, while neither Z-list nor down to their knickers, were presented as 'babes', to use the era's tiresome terminology. These changes did not achieve the required response; industry babble grew when an association with advertising agency Mother ended. After four more issues Logan terminated publication; group advertising manager Rod Sopp cited 'lacklustre sales'.[18]

'Nick's attention to detail was what made his magazines so brilliant, but it would make you want to jump out of the window sometimes,' says Richard Benson. 'When it was obvious *Deluxe* wasn't working, Nick and I spent two hours going through paper samples, talking about whether it would be better to go for 120gsm or matt finish. The problem was much bigger than the paper stock. It was important, but there were other matters which needed attending to.'[19]

By this time Benson had taken on the role of Wagadon group editor; as well as *Arena*, *The Face* and *Deluxe*, his purview extended to the failing *Frank*: monthly sales were now hovering around 40,000 copies, half the adjusted target figure.

Tina Gaudoin's exit had been followed by the departures of deputy editor Lisa Markwell and senior fashion editor Maddy Christie, leaving Harriet Quick to steady the buffs in the face of all-out aggression from rival publishers. Emap soon unveiled a £5m campaign to promote its recently launched rival *Red*.[20]

At *The Face*, Charles Gant was asked whether he was interested in replacing Benson as editor. 'I had done my time there; the magazine was running out of energy,' says Gant.

'I felt it needed an injection of something fresh and new. I wasn't the person to supply that and anyway wanted to be a full-time film journalist. Basically I was sick of production.'[21]

Gant stayed for the summer months and left the magazine in autumn 1998 to join the Emap team planning new entertainment weekly *Heat*. The brains behind the launch were Mark Ellen and David Hepworth, who had launched *Q* in the

1980s and *Mojo* in the 1990s, and, of course, had both started on *Smash Hits* in Logan's day, as well as contributing to early issues of *The Face*.

In Benson's place, Adam Higginbotham was appointed from the Emap film magazine *Neon*; he had been a regular contributor to *The Face* with a reputation for being visually aware as well as a tough editor.

There was an interregnum in his arrival during which Gant was acting editor for two issues. These featured the fashion designer Alexander McQueen and French club duo Air on consecutive covers. 'In that time I received incredible support from the editorial team, people like Craig McLean, [associate editor] Johnny Davis and Ashley Heath, who made the Alexander McQueen cover happen,' says Gant. 'I loved that period, probably because it's easier to be acting editor. No-one is expecting miracles or a blueprint for the future. They're pleased you're delivering to a decent standard.'[22]

The McQueen cover issue – featuring a goth-style portrait by Nick Knight showing the designer with a bleached-out face, green tresses and red contact lenses – is a fabulous example of *The Face* in its late period (see page 320). McQueen represented both the extremes of fashion and the street-culture

THE FACE

SPEED

Suburban Motor Mayhem

SEX

Johnny Vaughan v Jamie Theakston

GORE

Resident Evil 2 and Computer Horror

AGGRO

Jerry Springer rules KO

No 15 APRIL 1998 £2.40•US $7.50

YOU'RE NOT GOING OUT LIKE THAT! Alexander McQueen by Nick Knight

Jude Law
Cleopatra
Monkey Mafia

McQueen

is dead: Long live Alexander McQueen

dreaded public speaking, it was a failing on my part that I was incapable of doing that.'

At *The Face*, Higginbotham's instructions were to revert the downward circulation spiral, yet this was caused by circumstances beyond his control: tough competition in a crowded market and the fact that youth culture was going through a periodic dip in terms of potency.

Richard Benson believes that it is this factor that ultimately proved insurmountable. 'After all, we'd managed the competition when it was at its height in the mid-1990s,' says Benson. 'Our clear pitch to a potential cover subject was: "You'll get a story comprising very high-end journalism and photography which will be seen across the world, particularly in America." That was an offer *Mixmag*, *Muzik* or *Loaded* couldn't deliver. But there was a cyclical element to the story of *The Face* which was far more important. It was its fate each decade to pick a load of talented people, focus on them and for their talents to cross over. When that faded there was a regrouping until a new aesthetic came along and the process would be repeated. The late 1990s were one of the low points.'[23]

It seems Higginbotham did not receive the necessary support from staff to help him steer the magazine through this becalmed era in popular culture. 'He was essentially an outsider and was treated as such,' says one source. 'Having to deal with that complex mix of talents and egos was an extremely tricky management challenge.'

'Whatever small misgivings I might have had, my view was that, as deputy editor, it was my job to support the person in the editor's chair,' says Charles Gant. 'Adam also encouraged and brought in new people, including Ben Mitchell and Rupert Howe; Rupert in particular was a magic-sprinkler. He was quite a shy backroom boy but could transform copy, writing great intros and really making text shine.'[24]

Higginbotham opted to make a statement with his first issue by breaking the established pattern of dedicating the front cover to an individual. Instead, he used the subject-matter of the main story – drugs – as the basis for a text-only design. This was an assertive move but, with copy sales under Benson having recorded the biggest falls of the magazine's history, it was soon clear that Higginbotham's task in attempting to take *The Face* mainstream was a poisoned chalice.

The atmosphere was not improved by Logan's decision to move *The Face* staff to the second floor of Exmouth House, even though this had been instituted in an attempt to boost morale. They were granted input into the office layout, which, as it turned out, incorporated a dividing wall between the editorial team and the design department. This became a new demarcation point between harried journalists and the designers, who were felt to be more interested in servicing

values that the magazine had celebrated since its launch, and Heath's gobby text ('Are you still trying to keep that hardcore gay clubbing thing going?' is but one of the questions) gave readers an insight into the mindset of the gifted twenty-seven-year-old who was at that time chief designer at Givenchy and heading for the stratosphere.

Higginbotham arrived to take over the editor's job for the June 1998 issue, charged with the unenviable job of introducing a more populist approach in the teeth of not only a mutinous editorial team but a seriously deteriorating corporate atmosphere. Logan blames his taciturn nature for much of what ensued: 'I might have avoided some of the problems that divided staff if I'd been able to stand in front of them and explained my thinking and why it was important for the company to keep moving forward and not rest on its laurels, and also to explain the rationale behind the new titles. Unfortunately, as someone who

opposite
Vol. 3, no. 15, April 1998.

above
Vol. 3, no. 18, July 1998.

outside clients. '"The Wall" became quite an issue,' says one source.

Logan began to feel a growing sense of estrangement from his staff, citing an incident when he employed a joiner friend to produce custom-made desks for those who logged in long hours at their computers. 'Someone I had no history with was po-faced enough to tell me that he wouldn't be "compromised" in his working conditions; what a fucking word to use to me,' exclaims Logan. 'I wasn't his friend or even his colleague. I was a "suit". That was a wake-up; memories of the union disputes which crippled *Time Out* and *City Limits* in the 1980s flashed through my mind and a future of unionization and health and safety loomed.'

There was also an occasion when a member of the team Logan considered a friend failed to invite him and his wife Julie to a party. Referring to the inter-staff backbiting suffered by Dylan Jones, Logan said: 'Silly as it may sound, I was hurt. Along with Dylan's mistreatment, I began to wonder whether it may be time to get out of publishing.'[25]

During a particularly concentrated engagement in the day-to-day at *Arena*, *Deluxe* and *Frank*, Logan's contact with Higginbotham became minimal, and then non-existent after he dropped by *The Face* editor's office in the final production week of a particular issue. 'Adam said he didn't have a cover,' says Logan. 'I felt literally sick to my stomach. I'd been in that situation myself so many times and the memories came hurtling back.

I left, saying under my breath, "Well you'd better fucking find one quick".'[26]

Higginbotham's occupation of the editor's chair coincided with industry sniping against Wagadon going public. In *The Independent*, Richard Cook reported claims that the publishing company was using its Condé Nast distributive power to obtain 'big-league paper-buying and distribution deals; [it] has started to get a lot bigger and a lot more aggressive. Suddenly the benevolent condescension shown by its rivals had degenerated into all-out war.'[27]

Cook also condemned Higginbotham's decision to go with the text-only June cover. Despite the fact this marked a 'hard-hitting and well-received report on drugs', Cook wrote that the rejection of the usual cover star 'wasn't a move calculated to go down well with a company proud of its publishing traditions'.[28]

Then the next set of ABC data showed circulation sliding another 10 per cent in the first half of 1998. These, of course, could not be attributed to Higginbotham, but subsequent selections for the front of the magazine – including Blur, Kate Moss, Robbie Williams and Manic Street Preachers – ruffled feathers among some at *The Face* who viewed them as either insufficiently cutting edge or too forced. 'We thought *The Face* could always feature interesting, possible avant-garde subjects on the cover and maintain a healthy circulation,' says Lee Swillingham. 'The thinking seemed to be that we had to have

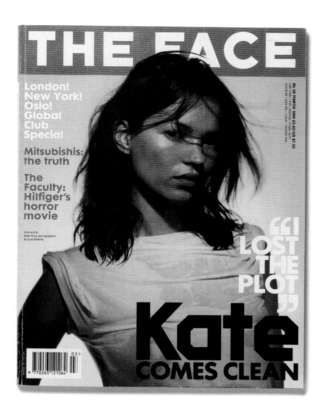

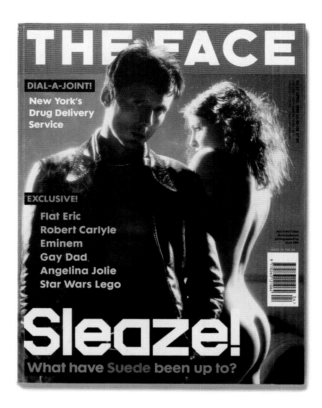

"commercial" people on the cover because of the competition. But at the time, having to deal with Robbie Williams or the Manic Street Preachers made you feel a bit ill. They're a long way from Hard Times!'[29]

Says one former staff member: 'Robbie Williams with a nose bleed as an obvious allusion to coke-taking was too laddish, and I don't know what the thinking was behind Kate Moss with too much make-up and a beetroot-coloured face. And the time had gone for the Manics to be on the cover of *The Face*.'

There was also talk that having been tasked with axing 'dead wood' staff members, Higginbotham did not receive Benson's support. Benson rejected this vehemently.[30] Whatever the truth, there is no doubt that Higginbotham was butting heads with both staff and management against a backdrop of plummeting copy sales. In April 1999 he was fired by Benson after ten months in the post as editor. 'The magazine wasn't feeling right,' said Benson at the time. 'If Nick feels the mag is right, he'll cut you a lot of slack on the circulation.'[31]

News of Higginbotham's replacement – Johnny Davis, who had been contributing to the magazine for the previous three years – broke with the latest ABCs, which showed another serious circulation fall, by 30 per cent to just above 70,000 (*Arena*, meanwhile, was also hurting, down 30 per cent to 60,000 copies a month).[32]

Popular as Logan was in the industry, many felt that not only had he taken his eye off the ball in regard to Wagadon's priority title through his devotion to *Frank* and *Deluxe*, but that the entire publishing house was now exposed to the vagaries of the marketplace. 'Cast in the image of its maker, critics say that Wagadon has failed to direct sufficient attention to creating a viable business structure and even Logan's supporters privately admit that the company is still run as it was twenty years ago,' wrote John Naughton in *The Guardian*, noting that tensions continued to simmer between Wagadon and Condé Nast.[33]

opposite left
Vol. 3, no. 17, June 1998.

opposite right
Vol. 3, no. 23, January 1999.

above left
Vol. 3, no. 26, March 1999.

above right
Vol. 3, no. 27, April 1999.

text **RICHARD BENSON, LAURA CRAIK** and **CRAIG McLEAN**

the X factor:

Who's Rulin' Who?

Have you got a party to go to this month? **60%** of 18-24-year-olds haven't.

For the first time in British history, more than half of them said they'd rather stay at home than vote on election day. Bloody typical: we go through 2,500 years of philosophy, endless war, revolutions and a Red Wedge tour to achieve democracy, and what happens? Everybody just loses interest. It's not as if the politicians could have tried any harder – Election 97 demands attention if only because, with its sleaze, stunts, celebs and D:Ream anthem, it is our first pop election. Still fewer takers though. So: if this generation has chosen not to choose, who will direct us to a bright radical future? There is only one person...>

THE FACE

< poor who see no point in voting. Those marginalised masses may be ignored, but many still fight

X Old labour, old danger

FOR 18 MONTHS now, 329 Liverpool dockers have been campaigning against their dismissal by the Mersey Docks and Harbour Company. Few people outside Liverpool know anything about the dispute: the national media ignore it, their union won't recognise it – telling them to accept the £28,000 (originally £10,000) settlement – and, pro-election, political parties, particularly "New" Labour, are keen to avoid an industrial relations debate. It's the sort of dispute that many politicians would like to imagine doesn't happen any more. The dockers were sacked for refusing to cross a picket line set up by others who had previously been made redundant. By acting illegally – picketing after being sacked – intervention from the outside has been legitimately avoided. The dispute has embarrassed not only their union, but also the city's business community: an ad campaign which it had prepared, featuring Robbie Fowler and Ian Rush with the slogan "Liverpool's down to a handful of strikers" had to be ditched. Ironically, only when Fowler was fined £900 for wearing a T-shirt in support of the dockers while playing for Liverpool, did the national press recognise the issue. *Claire Stocks*

500 MEN SACKED FOR NOT CROSSING A PICKET LINE

X Britain's Most Imp[ortant]
< who our leaders really [are]

photography **JUSTIN DE DENEY**

opposite and below
'The X Factor: Who's Rulin' Who?', vol. 3, no. 4,
May 1997.

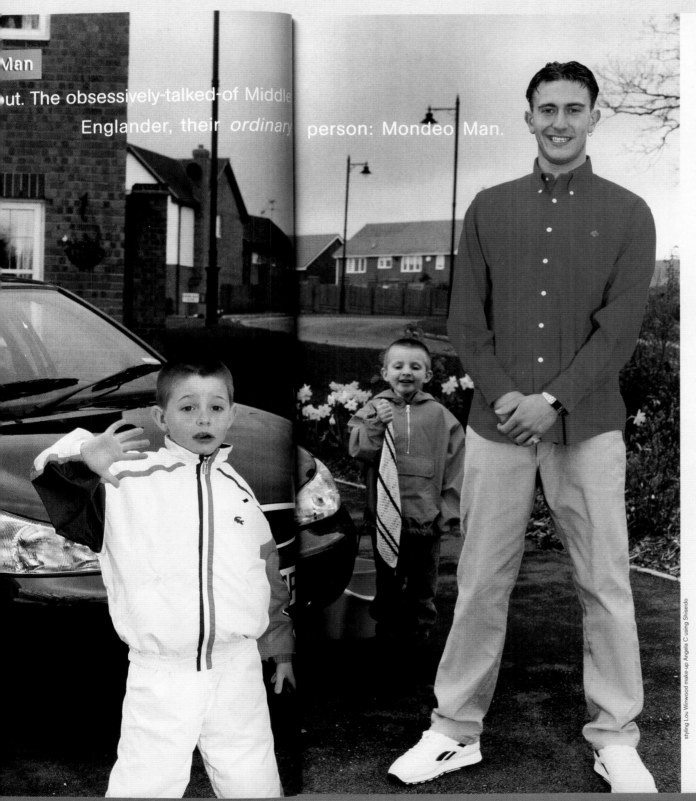

...ut. The obsessively-talked-of Middle Englander, their *ordinary* person: Mondeo Man.

But there are other kinds of ordinariness: the ordinariness of four million missing from the electoral roll. Or of the 39% of the working >

MONDEO MAN, identified by Tony Blair in a speech to the Labour Party Conference last October, is the latest character to join the election-watchers' cartoon cast list of Essex Boys, Basildon Men and Worcester Women. He lives in "Middle England" and *is*, to all intents and purposes, Middle England. He's in the drive, soaping and buffing his gleaming saloon, next to his neat garden, outside the Wimpey house that he bought under Thatcher. He dresses comfortably, from Next and Marks & Spencer, and he listens to Simply Red and Wet Wet Wet. He is married with a couple of kids and they all go on a foreign holiday once a year; and he still has some of the social traits of his working-class roots in that, while he goes for the odd Mexican or Greek meal and enjoys a pint at the local theme bar, he still goes to the game of a Saturday. He's conservative with a small "c", and although he was previously likely Tory fodder, New Labour have now moved in on his concerns: taxes, crime, whether his kids are out taking Ecstasy. He is the middle-ground on which both Left and Right have converged, the major minority on which the result of this election will depend; his sudden popularity among politicians reflects their obsessive desire to relate to the "ordinary", without having to use difficult words like "class". Have a good look at them: your life could be in their hands. *Graeme Wilson & Craig McLean*

styling Lou Winwood make-up Angela C using Shiseido

THE FACE **41**

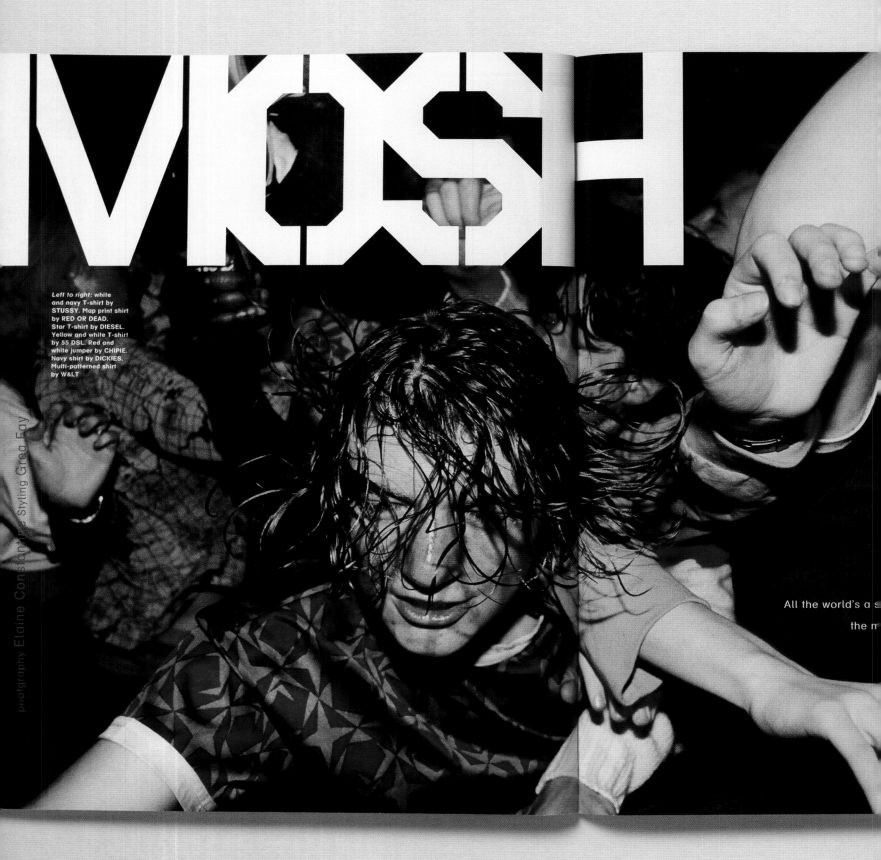

MOSH

Left to right: white
and navy T-shirt by
STUSSY. Map print shirt
by RED OR DEAD.
Star T-shirt by DIESEL.
Yellow and white T-shirt
by 55 DSL. Red and
white jumper by CHIPIE.
Navy shirt by DICKIES.
Multi-patterned shirt
by W<

photography Elaine Constantine Styling Greg Fay

All the world's a s

the m

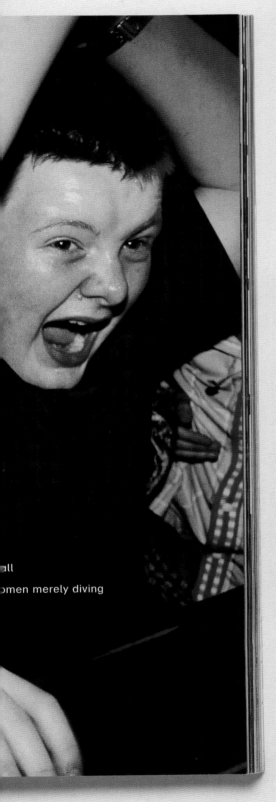

all

omen merely diving

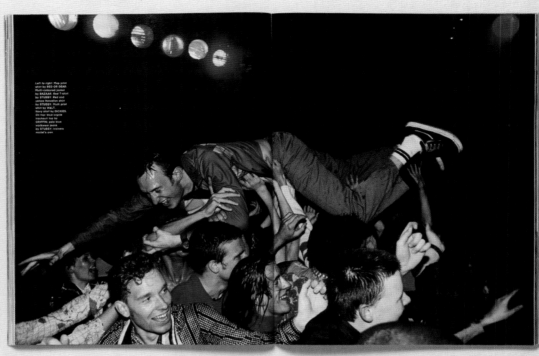

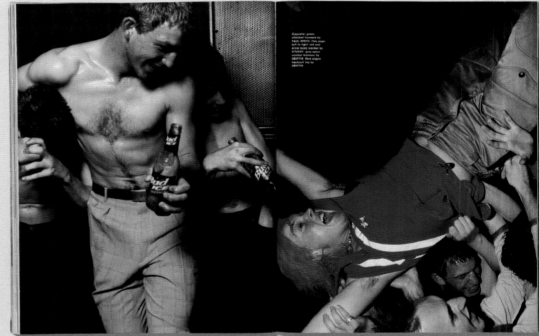

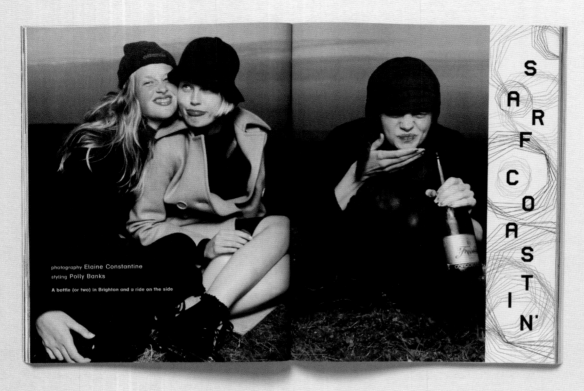

photography Elaine Constantine
styling Polly Banks

A bottle (or two) in Brighton and a ride on the side

SARF COASTIN'

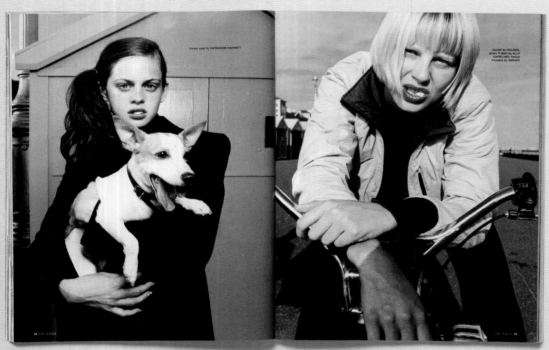

*Previous spread, left to right: Sarah wears blue hooded
CAPELLINO; shoes by BIRKENSTOCK; woolly hat by OSH
MOORE; lace socks by HUE; black hat by KANGOL. Mich

82 THE FACE

A Long Way from Hard Times

opposite, below and overleaf
'Sarf Coastin'', vol. 3, no. 11, December 1997.

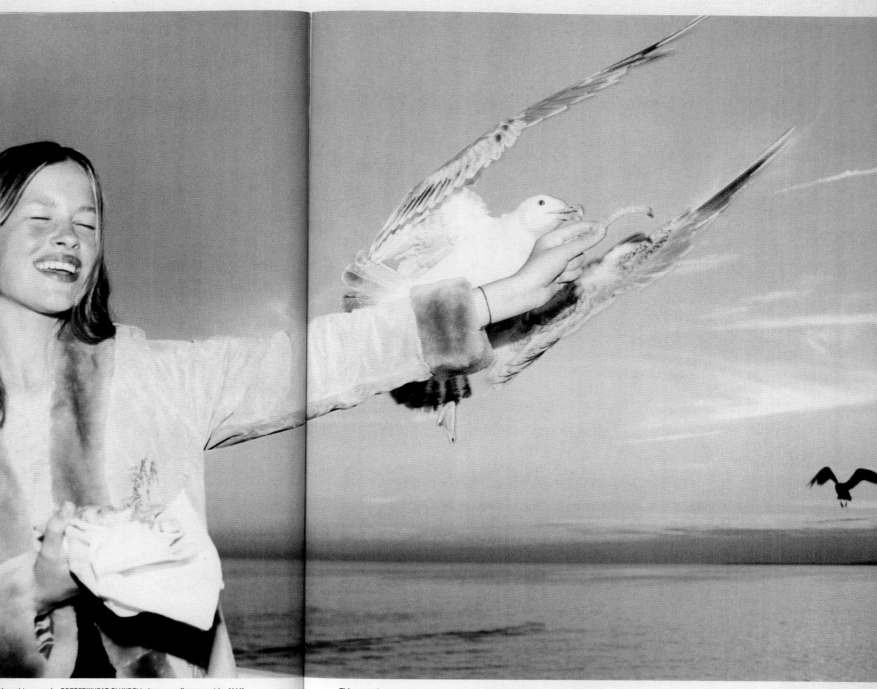

d wool trousers by COPPERWHEAT BLUNDELL; long grey fleece coat by ALLY
wears leatherette top and skirt by SERAPH; long blue coat by JOSEPH; boots by JOHN
elvet dress by PAUL SMITH WOMEN; sweater by ICEBERG; purple boots by DR MARTENS

This spread: suede embroidered coat by JOSEPH; red Fair Isle sweater by HOLMES

THE FACE **83**

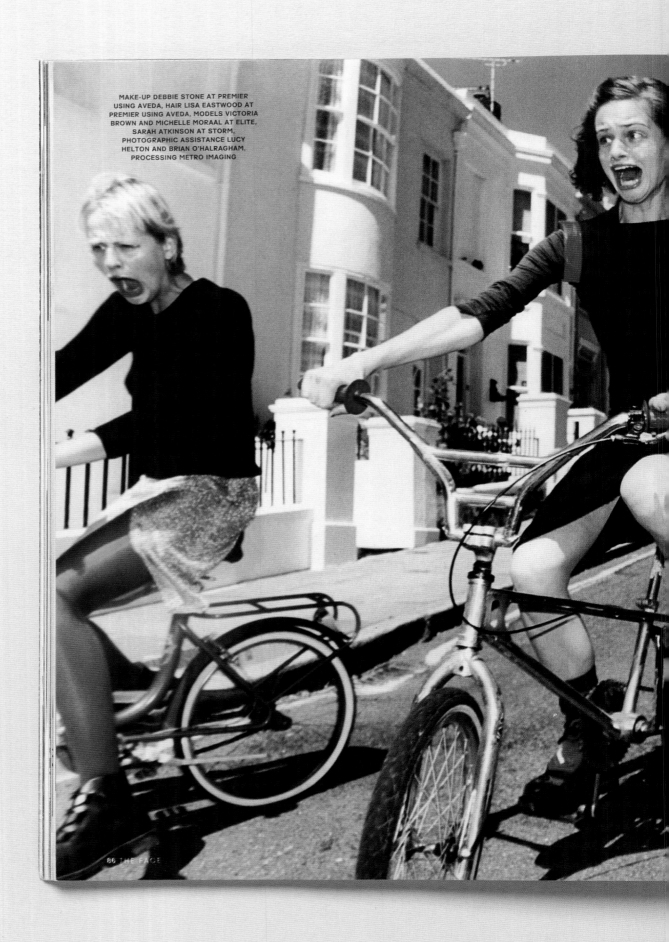

MAKE-UP DEBBIE STONE AT PREMIER USING AVEDA, HAIR LISA EASTWOOD AT PREMIER USING AVEDA, MODELS VICTORIA BROWN AND MICHELLE MORAAL AT ELITE, SARAH ATKINSON AT STORM, PHOTOGRAPHIC ASSISTANCE LUCY HELTON AND BRIAN O'HALRAGHAM, PROCESSING METRO IMAGING

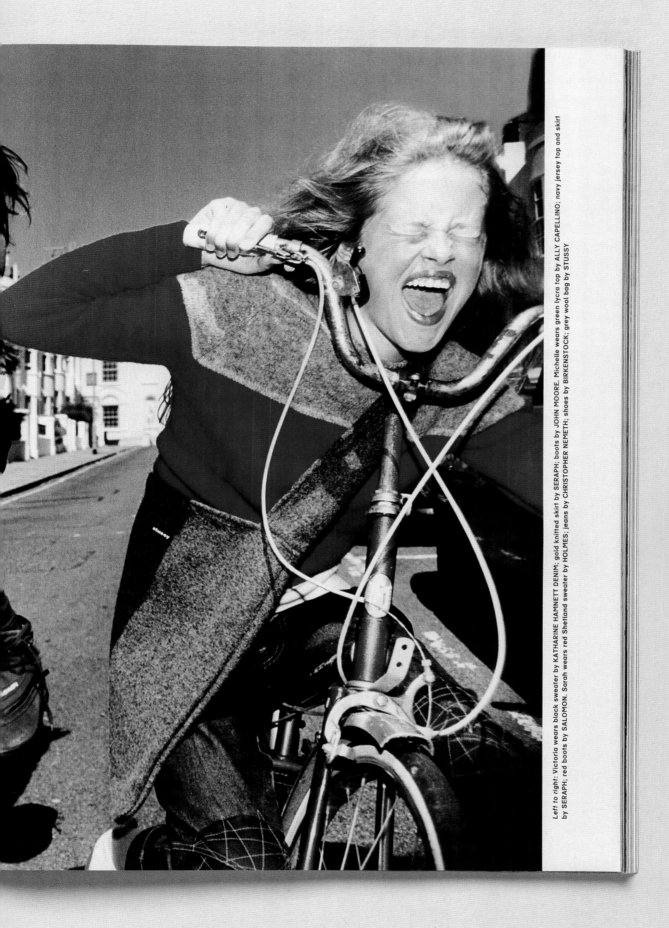

Left to right: Victoria wears black sweater by KATHARINE HAMNETT DENIM; gold knitted skirt by SERAPH; boots by JOHN MOORE. Michelle wears green lycra top by ALLY CAPELLINO; navy jersey top and skirt by SERAPH; red boots by SALOMON. Sarah wears red Shetland sweater by HOLMES; jeans by CHRISTOPHER NEMETH; shoes by BIRKENSTOCK; grey wool bag by STUSSY

WE ASKED ALEXANDER McQUEEN TO EXPLAIN
THE IMAGE HE CREATED WITH NICK KNIGHT.
THIS IS HIS HAND-WRITTEN RESPONSE

Joan

Deep inside of me I have no regrets of the way I portray myself to the General Public.

I will face fear head on if necessary but would run from a fight if persuaded.

The fire in my soul is for the love of one Man but I do not forget my women whom I adore as they burn daily from Cheshire to Gloucester.

A. McQueen x 98'

86 THE FACE

photography **Nick Knight**
art direction **Alexander McQueen**

image manipulation Steve Seal, model Shirley Mallmann at Select, make-up Val Garland at Untitled° using Nars
Cosmetics, hair Guido for Nicky Clarke, bald cap specialist Katia Sisto, shot at Metro Studios

above and opposite
'Killer Queen', vol. 3, no. 15, April 1998.

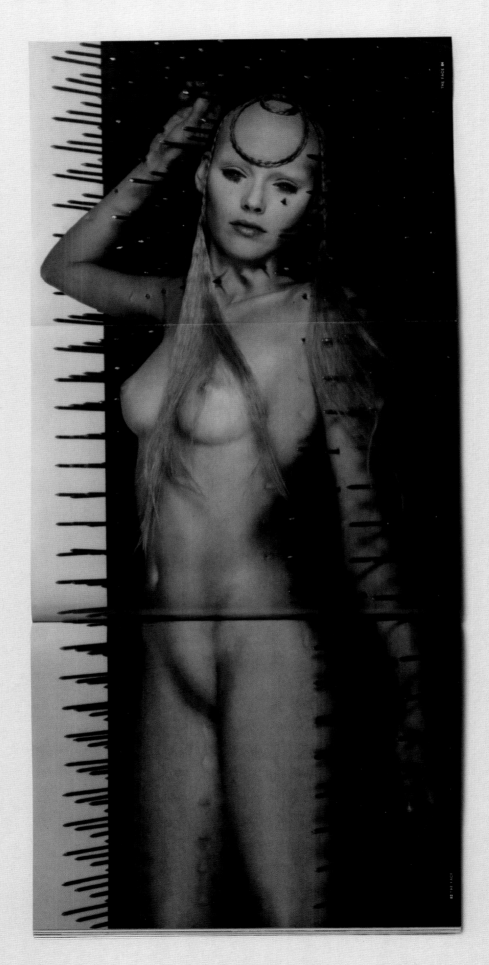

main photography Peter Robathan

still life photography Ola Bergengren

Bad Medicine

By the time they're 24, almost half of the British population have taken illegal drugs. Recent surveys indicate 2.5 million people in England and Wales alone have taken speed. 1.3 million have taken acid. 730,000 have taken E. The same number have taken cocaine. 6.3 million have smoked grass. What do all those pills, powders, tabs and joints really do to your body? ▶▶▶

THE FACE 86

Acid

Using LSD can permanently damage your brain. You may suffer flashbacks up to 30 years after taking it. But for up to 16 hours you will be able to "see" sounds and "hear" colours

TEXT CLARK COLLIS

Three stories: after taking acid a man torturises his wife with a gun, becomes "grandiose" for several weeks, and goes to live in the desert. Another man, despite not having tripped for years, is pursued down the street by a giant black hole that only he can see. Finally, a 25-year-old woman threatens her boyfriend while under the influence of LSD. Two days later she kills him.

These tales of acid-inspired mental instability are not urban myths, but clinically-recorded case histories. Even the most scientific reports on the drug contain similar anecdotal evidence: after alongside bizarre observations on animal experimentation such as tripping cats that relentlessly pursue invisible mice. While colourful, such stories are extremely misleading. Psychotic reactions rarely follow an acid trip. Acid-linked fatalities are even scarcer. Although a considerable range of physical and mental problems can be attributed to LSD, it poses serious dangers for only a minute section of the population.

This disparity between popular myth, clinical research and the experience of regular users – most of whom suffer no lasting ill-effects – might help explain LSD's enduring popularity. Despite accounting for only one per cent of police and customs seizures, research published by the *Independent On Sunday* in January 1998 revealed that acid was the third most commonly experienced drug in the UK after cannabis and amphetamines.

The classic elements of the acid trip were first experienced by the man who originally synthesised LSD (lysergic acid diethylamide). In 1943 Sandoz pharmaceutical chemist Albert Hoffman accidentally ingested some of the drug during tests – 40 minutes later he became restless and slightly giddy. Then his visual and mental faculties became confused. Finally, after becoming terrified that he might be losing his mind, Hoffman experienced strange optical phenomena.

"It was particularly striking how acoustic perceptions such as the noise of water gushing from a tap or

experience confusion, anxiety, depression, discrimination, insomnia, "depersonalisation", panic-attacks, paranoia and psychosis. For some, these symptoms may be permanent. Two case-studies published in 1981 in the *Journal Of Clinical Psychopharmacology*

NEUROTRANSMITTERS

Chemicals released by neurons into the synaptic area between two neurons. Readings of pleasure, for instance, will cause an increased concentration of neurotransmitters (such as dopamine) in the synapse itself. There are over a hundred different varieties of neurotransmitter – most of which have specifically defined functions – present in the chemistry of the brain

described disturbing reactions to MDMA. In the first, a patient became so lethargic after taking Ecstasy she was unable to leave her home. She then developed a delusion that "someone was pumping something through her system" and her anxiety increased to a point of "constant panic" during which she was unable to go anywhere unaccompanied and began sharing a bed with her mother. After five weeks the symptoms abated, but new panic-attacks could be precipitated simply by thinking about her "MDMA experience" or travelling near the house where she took the drug.

The second describes a man who developed hallucinations – "seeing, feeling bordering on insult" – and loss of short- and long-term memory. He forgot his mother's name and suffered paranoid delusions – that a stranger in the street was his brother – before undergoing psychotic treatment.

Such symptoms – akin to the milder, midweek depression users often feel after taking Ecstasy – are believed to be the result of acute depletion of serotonin. Under normal conditions, serotonin is replenished by brain cells. But since they decay naturally with age, and are the only cells in the body which lose the capacity to reproduce, as they disappear so does the ability to manufacture serotonin. In tests on squirrel monkeys, certain regions of the brain failed to recover several years after being dosed with MDMA – whether in a single high dose (20mg) or several lower doses comparable to those in street Ecstasy tablets (four or five mg). This implies permanent brain damage is possible in humans after taking four pills.

"If you misuse your brain cells at an early age, you're going to be more prone to developing mood and cognitive problems later in

life," says Dr Adam Winstock of the National Addiction Centre in London. "Not asking 'How much Ecstasy am I going to have to take for me to fall into that category?' is like saying, 'How much water have you got to add to a bath until it overflows?' It depends how much bath water you've got in the first place and how far you are. You don't know. You don't know your reserves, and unfortunately it's not going to become evident until some time in the future. Although there is no doubt that increasing numbers of people are turning up at my clinic with psychiatric presentations relating to Ecstasy."

There's no concrete evidence that regular users of Ecstasy incur brain-damage, but the animal studies are not reassuring. Experiments into nicotine use in the 1950s, for instance, found that cigarettes presented cancer in animals decades before a similar link was found in humans.

"It's only one virus," admits Winstock of recent Ecstasy research, "but if you believe that the development of psychiatric illness is a result of change in brain function due to the number of available brain cells then, if they fall off normally with age, it makes sense to see that if you're knocking them off much quicker, you're going to be presented with a psychiatric syndrome at an earlier point.

"People say the information is not convincing enough. OK. But there's a different amount of information required to be 100 per cent certain than there is to be really concerned. And it's good enough for me to be really, really worried."

In the meantime, the bulk of experimentation into Ecstasy is being carried out by the millions of people who continue to use the drug on themselves

THE FACE 88

SEROTONIN

A neurotransmitter which acts on the pleasure/reward centre in the brain. Serotonin regulates feelings of calm and well-being. Subsidiary effects relate to cognition, appetite, movement and body temperature. There is also a profusion of serotonin synapses in the cerebral cortex suggesting a link to the processes of perception

Despite sparse central patented by pharmaceuti effects of Ec are still only understood. swallowed, s injected, MD methylenedie mine – acts o brain's prima transmitters, dopamine. Se naturally to c pleasure and you're "in lov produces high serotonin – w acts as a pair chemicals pla

Random drug sample 1

ECSTASY. BOUGHT IN LONDON APRIL 1998
ACTIVE INGREDIENTS:
100%
KETAMINE

Ecstasy

Known side-effects include p depression, panic-attacks an loss. These symptoms may pr permanent. But one pill will a to make friends with total str

TEXT JOHNNY DAVIS

regulating bo balance distu of MDMA, w neurotransmi fact that the overheating b transmission discomfort. H numbers of b casualties an associated wi

Ecstasy's p are equally ra perception, s and an increa interact with to the suppre insecurities a normally moe Although mor effects are si Prozac – first Britain in 198 has 19 million Prozac, like E way in which by the brain,

opposite top
'Bad Medicine' opening pages,
vol. 3, no. 17, June 1998.

opposite bottom
'Bad Medicine: Acid'.

below
'Bad Medicine: Ecstasy'.

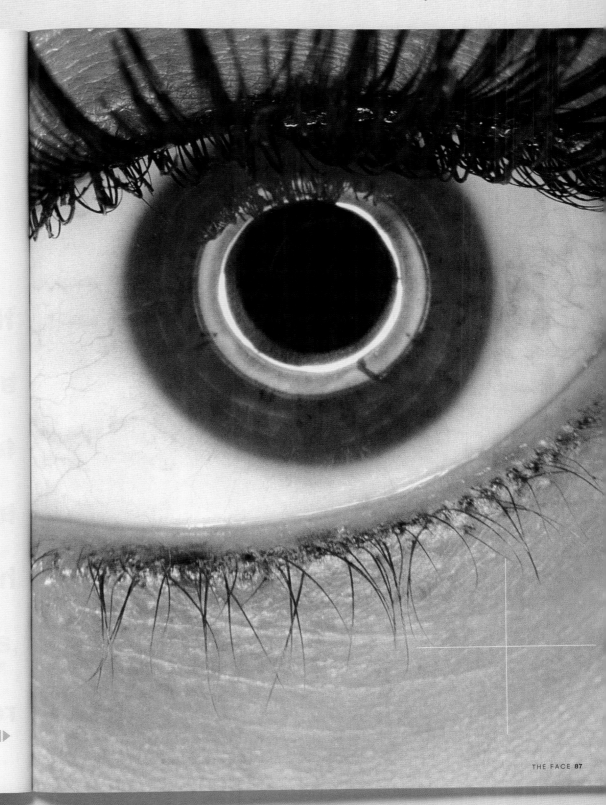

evidence of long-term effects.

Ecstasy is unique amongst recreational drugs for many reasons, not least for the feelings of empathy it produces and the social nature of the "Ecstasy experience". Yet the vast majority of writings on Ecstasy in both the media and medical journals focus on its toxicity. The most severe reactions include hyperthermia (extremely high-temperature fever), convulsions, blood clotting and severe kidney failure – most of which will prove fatal. Other deaths have been attributed to users drinking large amounts of water in an attempt to counter overheating. High levels of water in body fluids cause brain tissues to expand and press against the skull, irreversibly damaging the parts of the brain which regulate heart-rate and breathing, leading to cardiac or respiratory arrest and death.

Unfortunately, such extreme reactions are both sporadic and impossible to predict. The effects of Ecstasy depend upon a number of uncertain factors – the dosage of MDMA (in 1988 one tablet of Ecstasy contained an average of 100mg of MDMA, today the figure is closer to 70mg); the physiology of the person taking the drug; his or her surroundings at the time; and his or her previous experience with the drug. According to Alan Houghton of Manchester-based drugs charity Lifeline: "You can't compare it to a game of Russian roulette, because this particular revolver has two million chambers."

In the case of the death of Leah Betts, the fact that many of her friends took Ecstasy from the same batch, and did not suffer any major adverse reactions, was widely overlooked. Despite stories of Ecstasy being cut with everything from rat poison to brick dust, the vast majority of tablets contain a mix of amphetamine, hallucinogens and MDMA, or MDMA substitutes such as MDA or MDEA. Although in one

incident six people suffered kidney failure in a European club after buying a toxic clothes dye sold as "Ecstasy", deaths from poisonous impurities are surprisingly rare. Much more common are idiosyncratic reactions to MDMA itself.

In 1996, *Time Out* reported the case of 23-year-old Megan Reese. She and her friends went out to celebrate her twentieth birthday, and they all took Ecstasy. Everything was fine until they were returning home at 10am the following day, when Megan became nauseous and began vomiting. Shortly afterward, her face turned blue and she began having a fit.

"My friends saved my life," she said. "One of them managed to pull my tongue out of my throat as I was choking. Then I lapsed into unconsciousness. The ambulance took me to hospital and I lay unconscious for the next 48 hours. When I woke up, I had no idea where I was, how to count, what year it was and absolutely no clue what had happened."

Even so, the number of deaths directly related to Ecstasy are very small compared to the number of users. In 1996 the Institute for the Study of Drug Dependency estimated that one-in-twelve 16-24 year olds had tried Ecstasy at least once. There were 42 recorded fatalities in Britain up to 1995, a period in which Lifeline guesstimated one million people were taking Ecstasy each weekend. Hence the much-touted fact that the drug was less dangerous than going fishing or riding a horse. Although statistically incalculable, given that such large numbers of people have been taking it and so few fatalities have resulted from it, it's hardly surprising that the high profile deaths have had little impact on the number of people taking Ecstasy.

While sudden deaths from Ecstasy are widely reported, there are equally serious concerns surrounding its long term effects. Users may **Ecstasy Continued** ►

THE FACE **87**

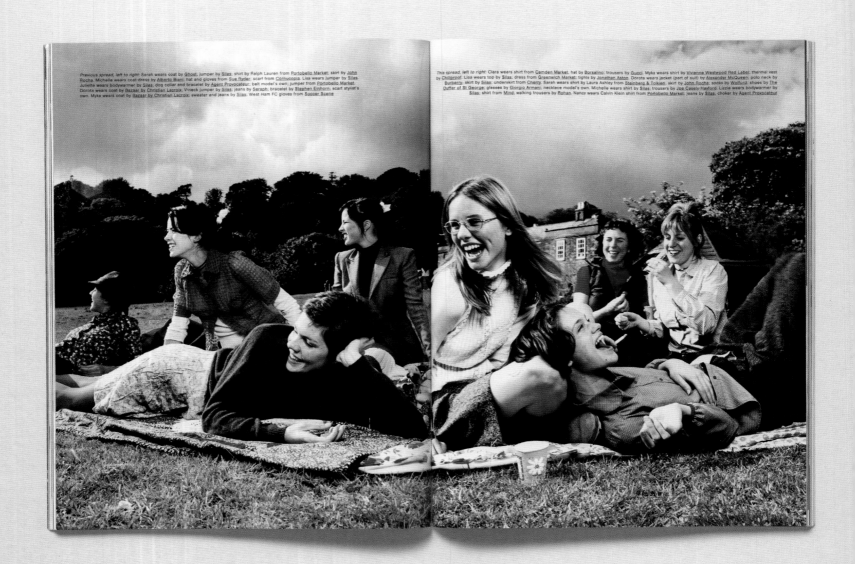

Previous spread, left to right: Sarah wears coat by Ghost, jumper by Silas; shirt by Ralph Lauren from Portobello Market; skirt by John Rocha. Michelle wears coat-dress by Alberto Biani; hat and gloves from Sue Ryder; scarf from Cornucopia. Lisa wears jumper by Silas. Juliette wears bodywarmer by Silas; dog collar and bracelet by Agent Provocateur; belt model's own; jumper from Portobello Market. Dorota wears coat by Bazaar by Christian Lacroix; V-neck jumper by Silas; jeans by Seraph; bracelet by Stephen Einhorn; scarf stylist's own. Myka wears coat by Bazaar by Christian Lacroix; sweater and jeans by Silas; West Ham FC gloves from Soccer Scene.

This spread, left to right: Clara wears shirt from Camden Market; hat by Borsalino; trousers by Gucci. Myka wears shirt by Vivienne Westwood Red Label; thermal vest by Chillproof. Lisa wears top by Silas; dress from Greenwich Market; tights by Jonathan Aston. Dorota wears jacket (part of suit) by Alexander McQueen; polo neck by Burberry; skirt by Silas; underskirt from Cherry. Sarah wears shirt by Laura Ashley from Steinberg & Tolkien; skirt by John Roche; socks by Wolford; shoes by The Duffer of St George; glasses by Giorgio Armani; necklace model's own. Michelle wears shirt by Silas; trousers by Joe Casely-Hayford. Lizzie wears bodywarmer by Silas; shirt from Mind; walking trousers by Rohan. Nancy wears Calvin Klein shirt from Portobello Market; jeans by Silas; choker by Agent Provocateur.

above and opposite
'To the Manor Born', vol. 3,
no. 22, November 1998.

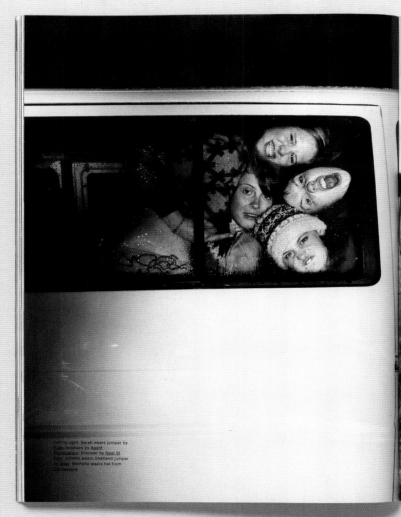

Left to right: Sarah wears jumper by
Silas, knickers by Agent
Provocateur; bracelet by Neal St
East. Juliette wears Shetland jumper
by Silas. Michelle wears hat from
Portobello

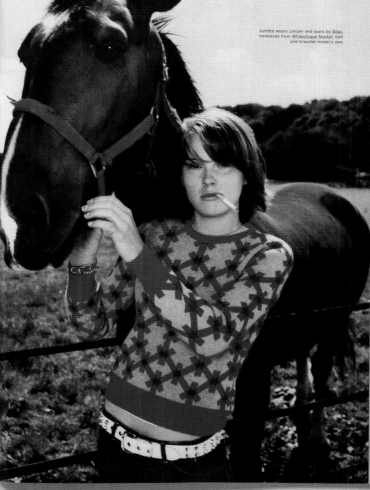

Juliette wears jumper and jeans by Silas;
necklaces from Whitechapel Market; belt
and bracelet model's own

Chapter Fourteen

There is No Such Thing as a Bad Press

There is No Such Thing as a Bad Press

In the spring of 1999, the British monthly magazine sector had become mightily crowded with titles appealing to leisure-hungry sixteen- to thirty-five-year-olds, particularly males.

Once upon a time, Nick Logan had the field to himself. After all, just fourteen years previously he had started to explore the idea of launching *Arena*. Then there were no youth culture general-interest magazines beyond *The Face*, *Blitz* and *i-D*. Now, at the end of the twentieth century, the blighters were everywhere, avaricious in their appetite for readers, determined to undercut the premium advertising rates that sustained Wagadon and bolstered by hefty promotional budgets.

IPC's *Loaded* was declared 'the publishing phenomenon of the decade'; that must have smarted, since this was the accolade that had previously been heaped upon *The Face*. But *Loaded*'s sales were peaking at around 450,000 copies. While other titles including *Front*, *Maxim* and *Sky* mopped up respectable New Lad business, the market leader was in fact *FHM*, published by Logan's nemesis Emap, with monthly sales of 775,000 (and it was edited by Logan's brother-in-law Mike Soutar, who had worked at *Smash Hits* in the early days). The company had recently launched *Heat* – having snaffled *The Face*'s deputy editor Charles Gant – in an initial manifestation as an upmarket pop-culture title along the lines of America's authoritative *Entertainment Weekly*; its music division was thriving on the back of successes including *Smash Hits*, *Q*, *Kerrang!* and *Mojo*.

Changes were afoot at Condé Nast, where relations with Logan's company had become strained over the conglomerate's 40 per cent share. Dylan Jones, the former Wagadon mainstay, was about to usher in a new era for *GQ* in Britain after being appointed editor, replacing *Loaded*'s James Brown, whose laddish inclinations had received a frosty reception in the sedate corridors of the publishing company's London headquarters, Vogue House.

While not specifically targeting male readers, *Wallpaper** – on which Logan had passed but which had nevertheless been launched two years earlier by Tyler Brûlé with Austrian journalist Alexander Geringer and was now within the Time Warner group – was the publication rewriting the lifestyle publishing rulebook for the start of the next millennium.[1]

The fallen circulation of *The Face* – by now selling around 50,000 copies in Britain each month, a reversion to the figures achieved by its first issues two decades earlier – was the result not only of the type of style journalism it had pioneered

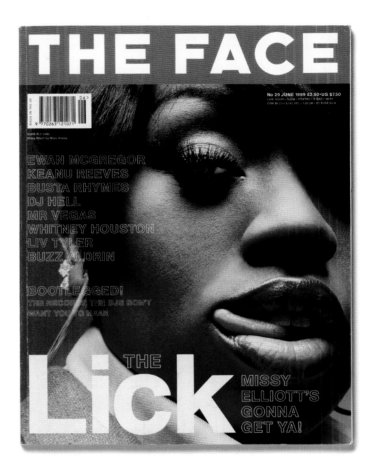

being reinvigorated by the likes of *Wallpaper** but also by the proliferation of general interest print media. This, it was reported, had removed 'the singularity *The Face* once enjoyed and rendered the magazine's rationale extremely unclear…it is unable to decide whether it needs to become more mainstream and commercial or try to recapture the hipper higher ground.'[2]

The failure of *Deluxe* and Adam Higginbotham's departure from *The Face* coincided with the exit of Stuart Spalding and Lee Swillingham to rival *Dazed & Confused*; despite their extensive fashion experience the duo had not been called upon to contribute to *Frank*, a source, some say, of grievance. 'We left when we were asked to do our second Robbie Williams cover,' says Swillingham amusedly. 'It was bad enough having to do the first one!'[3]

Speculation about Wagadon's future rose to a clamour when Nick Logan announced the closure of *Frank*, its readership finally crashing at 35,000. A considerable amount of money had been lost on the venture and Logan had revealed himself to be off his turf in the cut-throat world of women's magazine publishing, Paul Smith's advice of a year earlier ringing in his ears. As the editor Harriet Quick later pointed out,

right
Vol. 3, no. 29, June 1999.

the sector was becoming saturated: 'Unlike *The Face*, *Frank* was not the first of its type'.[4]

According to Richard Benson, the final issues under Quick's stewardship 'were getting there. It was on the way to becoming a decent magazine but it was all too late'.[5]

'I initially thought *Frank* was going to be so great,' says Logan. 'After seeing the first proofs I remember pulling up outside my house one night after work, feeling very proud and good about where Wagadon was headed. It turned out to be hubris'.[6]

At this distance we can see that *Frank* broke the magazine publishing sector's conventions of patronizing female readers. Logan's impulse was that modern womanhood is interested in 'strong fashion with a strong stylistic and cultural bent as well as punchy socio/political articles and humorous essays,'[7] to quote Quick, who was retained while Logan considered whether to go quarterly with the title.

The public fall-out from the failure of *Frank* was unedifying to behold. Former deputy editor Lisa Markwell plunged the knife into Logan with a catalogue of criticisms including a claim he had been unwilling to invest in a mirror in the office lavatory.[8] Around this time Richard Benson was summoned by Logan for a private chat: 'Nick called me into Julie's office and said: "I've got to stop these rumours about the company being sold". I said, "Then put out a statement saying that you're not selling the company." I remember there was a beat, and then Nick said, "I can't do that." I thought, "Oh right, that's it then"'.[9]

In fact, Logan was in the process of organizing a loan from Lloyds Bank to buy Condé Nast out of its 40 per cent investment in Wagadon; the relationship had soured and he was eager to open up his options to either find a new partner or sell.

In July 1999 Logan announced that he had sold Wagadon to Emap, amid media speculation over the undisclosed sum Logan received.[10] *The Face*, *Arena* and *Arena Homme Plus* had maintained sufficient marquee value for the publishing giant to acquire Wagadon; it was particularly interested in the last two titles since ownership would bolster their share of the now booming men's market. Logan made it

clear that he was not interested in continuing at the magazines he had conceived and nurtured over nearly two decades.

Group editor Richard Benson was on a coach in Milan with other journalists on the way to the seasonal menswear shows when the news broke: 'I remember Dylan [Jones, by then *GQ* editor] came over and said that it was good news because finally the magazine would receive the investment it deserved. I knew it was coming and I knew I wouldn't survive Emap because of the tier I was at, but also because I'm not the kind of person to thrive in middle management at a corporation'.[11]

On a personal level, Benson had bigger fish to fry. His family's Yorkshire farm had gone bust, so he returned to assist his father and brother in grappling with the situation.[12] Ashley Heath was made editorial director of the three Wagadon titles at Emap. One of his first appointments was of *Dazed & Confused*'s Katie Grand to fashion director of *The Face*. 'I grew up with *The Face*, this is a job I used to fantasize about,' Grand told *PR Week*.[13]

The final issue of *The Face* on Logan's watch carried the July 1999 publication date and went to press before the Emap buyout was announced. While it contained social commentary unique to *The Face* in the form of a study of the lives of recently arrived immigrants in the city of Leicester in the Midlands, along with several other publications that month – including *Premiere*, *Vanity Fair*, *Newsweek* and *Time* – the issue was dedicated to the return of George Lucas's *Star Wars* series with the blockbuster *The Phantom Menace* (the cover image was a stock shot of cast member Natalie Portman).

Over the previous couple of years, a tiny, changing message to readers which proceeded with the instruction 'Remember' had appeared above the final entry on the last editorial page – the colophon containing details of distribution, printing, reproduction, subscriptions and the 'strictly no go, Jack' warning about lifting material. For example, in the two-hundredth edition of January 1997 it had read: 'Remember: Life is nothing without a dream'. Above the colophon in the final issue published under Nick Logan's direction the message ran: 'REMEMBER: THERE IS NO SUCH THING AS A BAD PRESS'.

opposite
Vol. 3, no. 30, July 1999.

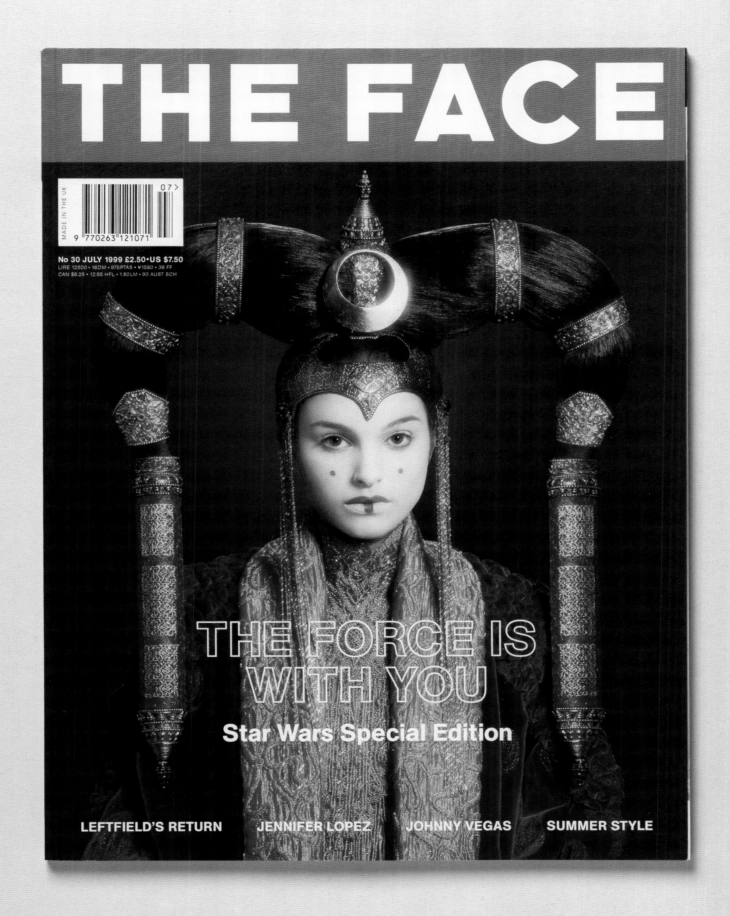

Aftermath

The letters page of the final issue of *The Face* to be published by Wagadon contained messages of support from readers anguished by what they had read about the publication's travails. 'Your's is the only magazine I buy, so I'd be heartbroken to see anything happen to it', wrote Victoria from York. But by the time Victoria's letter was printed, something had happened; *The Face*'s independence finally at an end after nineteen years, it had been drawn into Emap's maw, where – despite the best efforts of Johnny Davis, Ashley Heath and others – it became just another title with *Arena* and *Arena Homme Plus* in the company's Metro division alongside *FHM* and *FHM Collections* under Nick Logan's bugbear designation 'lifestyle'.

The signs of a lack of understanding of what had been acquired were evident from the get-go. In his first meeting with Emap management overseeing the transfer of the titles, Richard Benson was told by one executive: 'The first thing we're going to do is get a fucking rocket, slap *The Face* logo designed by Neville Brody on the side of it and fire it into space!'[1] It goes without saying that this did not occur.

Scant respect was paid to the magazine's rich archive. In fact, there are stories of hard drives containing huge numbers of back issues being lost. Certainly, as the publishing industry geared up for the onset of wholesale digitization, no preservation effort was made in regard to *The Face*.

Much format fiddling and tinkering with editorial tone ensued. Staff changes became a constant, though the magazine stablized under the capable and inventive editor Neil Stevenson, co-founder of the Popbitch gossip website. In the hot-seat between 2002 and 2004, Stevenson's stewardship was not enough to stave off the inevitable as ABC (British Audit Bureau of Circulation) monthly sales slumped 4.6 per cent to 40,286[2] (according to publishing industry buzz these masked actual circulation of just 25,000). When figures were announced in March 2004, Emap consumer division head Paul Keenan announced the suspension of publication of *The Face* 'pending its radical reinvention, sale or closure'.[3]

The last option was soon taken when reports of a takeover bid from a consortium – headed by none other than Jason Donovan – proved to be fanciful. A further indignity came in the announcement that the shuttering came alongside that of the short-lived teen girls cash-in *J17*.

The final issue of *The Face* was published in April 2004; the cover star was actress Mischa Barton of popular TV show *The O.C.*, trailing an interview by Barney Hoskyns, who had started his career at the *New Musical Express* the same year Logan had launched his magazine.

That Emap was the wrong custodian was one aspect of the story. 'I really believe I experienced one of the golden ages of journalism', opines Amy Raphael. 'The access we had was staggering. To be able to spend all that time in New York one-to-one with Nirvana without any interference wouldn't happen now; groups of that size are unapproachable.'[4]

There is also the question of scale, believes Richard Benson. 'No publisher would be happy with selling 70,000

copies, even though it was influencing the world,' he says. 'Emap asked: "How do we make this work?" The answer was simple. You don't print very many and you charge a premium for the advertising. They were like, "No, no, no, we can't do that".'[5]

Five years later, by which time Emap had been acquired by the German behemoth Bauer Media for £1.14bn, *Arena* was terminated, out of time and out-run by the welter of rivals launched in its wake, in particular *GQ* under Dylan Jones. Logan declared himself 'a little bit sad; it was so great in its time but in later years, with due respect to the people who were editing it and doing a good job, it was always going to be difficult to find a place in the market'.[6]

Arena Homme Plus was retained with Ashley Heath returning from an extended sabbatical as editorial director of both the rechristened title (as *Arena Homme+)* and fashion biannual *Pop*, which Heath had launched with editor Katie Grand and former art directors of *The Face*, Lee Swillingham and Stuart Spalding within a year of the Emap acquisition.[7]

Grand, Spalding and Swillingham's launch of the rival *Love* within Condé Nast and the installation of fashionista Darya 'Dasha' Zhukova, partner of the oligarch Roman Abramovich, as editor-in-chief of *Pop*, signalled a new era as the late 2000s recession began to bite.

At the same time as Heath was engineering a buyout of both *Arena Homme Plus* and *Pop*, green shoots were emerging elsewhere in the field of design-based independent magazine publishing, resulting half a decade later in the current proliferation of biannuals and quarterlies on the shelves of magazines sellers the world over. These had of course been foreshadowed by *Wallpaper** and subsequently *Monocle* in the combination of physical publishing underwritten by adept multi-platform online manipulation overseen by Tyler Brûlé, described memorably by the *New York Times* in 2017 as 'a Martha Stewart for the global elite'. As Charles Gant claims: 'In a way Tyler Brûlé came up with what *The Face* could have become without the acid house moment, along the lines of *Interview* in its heyday, not aimed at a particular audience but about cool people in movies, cool people living in and travelling to cool places in cool clothes with cool things.'[8]

This commercial success was also achieved by the Vice Media empire (which swallowed *i-D* in 2012) as well as the Dazed Group, which spawned *Another* and *Another Man*, and on a smaller, but no less influential, scale by *The Gentlewoman*, edited by the academic Penny Martin, who had worked as editor-in-chief at Nick Knight's fashion website SHOWStudio. It was she who took the scene back home by launching *The Gentlewoman* in 2010 out of the stable that publishes *Fantastic Man*, presaging a revival of interest among style-obsessed consumers of all ages in physical magazines dedicated to the latest developments in visual culture.

There is a direct line to *The Face* from such titles, whether they focus on post-material living such as *apartamento* or the high-brow architectural considerations of the occasional *Real Review*, as identified by one-time staffer Lindsay Baker's

description of the magazine as 'an intelligent encapsulation of the energy bursting forth from culture'.[9]

Ahead of the inclusion of covers of *The Face* in the Victoria and Albert Museum's 'British Design' blockbuster exhibition, confirmation of the magazine's significance came in 2011 when London's Design Museum acquired a complete run of the magazine's issues from DJ Giles Field.

'*The Face* is important because it lifted the idea of "style" into the mainstream so that it became the saleable version of fashion,' says Nick Knight. 'Style became a commodity that people wanted to buy into, whether it was Joseph or your local bank. Style expresses a certain knowingness and is thought more lofty than fashion.'[10]

But just as titles such as the post-feminist *Mushpit* have carved a niche by kicking against the prevailing political pricks in the launch of humorous and subversive campaigns, including their 'New Labia' support for the hard left segments of Britain's Labour Party, there is a sense that in the 1980s and 1990s *The Face* thrived in adversity, so that, when the Western world became more '*Face*-like', its job was done.[11] After all, Nick Logan began making plans for the launch within six months of Margaret Thatcher's installation at 10 Downing Street. With the exception of the final two years, the existence of his publication replete with liberal attitudes regarding background, diversity, freedom of expression, gender, race, sexual preference, tolerance and youth was spanned by the dominance of the Conservative Party at its most right wing.

Sheryl Garratt believes that the post-punk, DIY attitude on which *The Face* was founded permeated the magazine throughout Logan's ownership. 'It was always oppositional, even in the 1980s when people thought it too glossy and "cool",' she adds. 'Our politics were the politics of inclusion so that every part of the spectrum was represented, because we loved lots of stuff.'[12]

According to James Truman, the influence of *The Face* resides in 'how it was edited – less by subject, and more by sensibility. That obviously prefigured what we now see in digital media, where everyone now has the opportunity to express their own sensibility via Instagram and Facebook.'[13]

Twelve years after the Wagadon sale, Logan still bore the bruises of having sustained the magazine's independence for so long, wearily telling Jack Roberts and Daniel Stacey about their plans to launch literary compendium *Bad Idea*: 'Whatever you do, don't go into publishing. That is my ultimate advice. It is not what you think it is.'[14]

In the spring of 2017, British independent publishing house Mixmag Media, run by former Emap executives Jerry Perkins and David Hepworth, announced that they had acquired rights to *The Face* with a view to publishing an online version, to be followed by a print iteration. Mixmag is understood to have paid £100,000 for the magazine. Garratt has been among those who have welcomed the news, on the basis that application of core editorial values could provide a boon to readers searching for subject-matter of worth amid the welter of visual information delivered in the digital age.

What is it about *The Face* that justifies our interest nearly four decades after Logan began piecing together his plans for the magazine which might have been titled *Real World*?

'If you come from Mars, or even from 2017, and you want to know what was happening in popular culture in the 1980s and 1990s, pick up an issue of *The Face* and it will pretty much tell you all you need to know,' says Sheryl Garratt. 'If you want to see the early work of some of the best photographers in the world, look in *The Face*. If you want to know where some of the best art directors cut their teeth, look in *The Face*. If you want to understand the point at which one of the greatest figures in British publishing was at his peak, look in *The Face*.... I'm very proud that I edited a magazine which won an Amnesty International award for Gavin Hills's piece on child soldiers in Somalia at the same time as it was at the cutting edge of fashion and inspiring Calvin Klein campaigns. And all of those things happened in the same year. That was *The Face*.'[15]

Giorgio Armani

Milan, 12th January 1995

Dear Mr. Logan,

Congratualations on winning the Mark Boxer prize for your editorial contribution to magazines in the UK. You certainly deserve it! Both The Face and Arena are touchstones for all of us in the fashion business.

I look forward to meeting and talking to you next week after the show.

Best regards,

References

References

Introduction

1. *Nick Logan, interview with author, September 2013.*
2. Nick Logan, interview with author, June 2016.
3. Ibid.
4. Ibid.
5. Nick Logan, 16 April 2012: testpressing.org.
6. Logan, interview, 2016.
7. Logan, interview with author, March 2001.
8. Ibid.
9. Ibid.
10. Ibid.
11. Nick Logan, cited in Gareth Ware, 'A New Crisis Never Seemed Far Away', in *DIY Magazine*, 23 February 2013.
12. Smith returned to music journalism towards the end of the decade at the short-lived independent rival to *NME*, *New Music News*.
13. Logan, testpressing.
14. Logan, interview, 2001.
15. Logan, interview, 2016.
16. James Truman, interview with author, May 2016.
17. Logan, interview, 2013.
18. Knighted in 2005 for services to British business, Sir David Arculus was High Sherriff of Cambridgeshire from 2016–17.
19. Miller was knighted in the Queen's Birthday Honours List, June 2003.
20. Logan, interview with author, July 2012.
21. Logan, interview, 2016.
22. These are produced to establish colour balance and accuracy.
23. See Dave Rimmer, *Like Punk Never Happened*, London, 1985.

Chapter 1

1. Nick Logan cited in 'Face's Greatest Hits', *The Guardian*, 4 December 2011.
2. James Callaghan, *Time and Chance*, London, 1987.
3. Nick Logan, interview with author, June 2016.
4. Logan, interview with author, July 2012.
5. Chalkie Davies, interview with author, August 2016.
6. Logan, interview with author, October 2016.
7. Gareth Ware, 'It Could Only End in Tears', *DIY Magazine*, 24 February 2013.
8. Logan, interview with author, June 2016.
9. Davies, interview.
10. Logan, 'Introduction', *Lloyd Johnson: The Modern Outfitter*, exh. cat., Chelsea Space, London, 24 January–3 March 2012.
11. See Robert O'Byrne, *Style City: How London Became a Fashion Capital*, London, 2009.
12. Logan, 'Introduction'.
13. Paul Gorman, *In Their Own Write: Adventures in the Music Press*, London, 2001.
14. Julie Burchill, *I Knew I Was Right*, Portsmouth, 1998.
15. Ibid.
16. Tony Parsons, 'Introduction', *Dispatches from the Front Line of Popular Culture*, London, 1994.
17. Sheryl Garratt, interview with author, July 2016.
18. Logan cited in 'Face's Greatest Hits'.
19. Kathryn Flett, interview with author, May 2015.
20. James Truman, interview with author, May 2016.
21. Robin Katz, 'Logan's Law', *Evening Standard*, 1 May 1980.

Chapter 2

1. Nick Logan, interview with author, June 2016.
2. 'Introduction', *Lloyd Johnson: The Modern Outfitter*, exh. cat., Chelsea Space, London, 24 January–3 March 2012.
3. Logan, interview, 2016.
4. Steve Taylor, interview with author, August 2016.
5. Logan, interview, 2016.
6. Robert Elms, interview with author, June 2016.
7. Paul Gorman, *In Their Own Write: Adventures in the Music Press*, London, 2001.
8. Elms, interview.
9. Logan, interview, 2016.
10. Ibid.
11. Nick Logan, testpressing.org, 16 April 2012.
12. Gorman, *In Their Own Write*.
13. Elms, interview.
14. Malcolm McLaren cited in Luise Neri, 'Cannibal of Looks and Sounds', in Maria Luisa Frisa and Stefano Tonchi (eds), *Excess: Fashion and the Underground in the '80s*, Milan, 2004.
15. Peter York and Charles Jennings, *York's Eighties*, London, 1995.
16. Nick Logan, 'i-D', *The Face*, October 1980.
17. Jones cited in Cat Callender, 'i-D Magazine: Identity Parade', *The Independent*, 14 October 2005.
18. Ibid.
19. Terry Jones, *Catching the Moment*, London, 1997.
20. Gorman, *In Their Own Write*.
21. Ibid.
22. Ibid.
23. Ibid.
24. Nick Knight, interview with author, March 2015.
25. A reference to the British prime minister's nuclear advocacy.
26. Joseph was at this time British Secretary of State for Industry.

Chapter 3

1. Robert Elms, interview with author, June 2016.
2. Paul Gorman, *In Their Own Write: Adventures in the Music Press*, London, 2001.
3. Elms, interview.
4. Gorman, *In Their Own Write*.
5. Nick Logan, interview with author, July 2012.
6. Steve Taylor, interview with author, August 2016.
7. Elms, interview.
8. Taylor, interview.
9. Logan, interview, 2012.
10. James Truman, interview with author, May 2016.
11. Ibid.
12. Ibid.
13. Taylor, interview.
14. Logan, interview, 2016.
15. Truman, interview.
16. Elms, interview.
17. Liz Jobey, 'There's a New Kid on the Block to take on *Time Out*', *The Observer*, 27 September 1981.
18. Truman, interview. *Blitz* closed in 1991.
19. Ibid.
20. Logan, interview. Logan gives as an example the first issue of *Arena* in 1986 in which 'the order of the content was meticulously planned to bring a range of readers on board'.
21. Taylor, interview.
22. Logan, interview.
23. Rick Poynor, *No More Rules: Graphic Design and Postmodernism*, London, 2003.
24. Jon Wozencroft, *The Graphic Language of Neville Brody*, London, 1988.
25. Catherine McDermott, *Twentieth-century Design*, London, 1997.
26. Frank Mort, *Cultures of Consumption: Commerce, Masculinities and Social Space*, London, 1996.
27. Jim Davies, '200 Issues of the Face', 7 February 1997: campaignlive.co.uk.
28. Lesley White, interview with author, June 2016.
29. White, 'Dexys Midnight Runners: Fact and Fiction', *The Face*, September 1982.
30. Dave Rimmer, *Like Punk Never Happened*, London, 1985.
31. Gorman, *In Their Own Write*.
32. Suzi Feay, 'At the Sharp End', 1 June 2008: independent.co.uk/voices/columnists.
33. Elms, interview.

Chapter 4

1. Lesley White, interview with author, June 2016.
2. Nick Logan, interview with author, June 2016. Logan is referring to either Charles or David H. Koch, businessmen and scions of Koch Industries who regularly fund Libertarian and Republican political causes in America.
3. Fiona Russell Powell, 'Old, Jilted and Fat: I Knew I Was Right', *Punch*, February 1998.
4. Logan, interview.
5. James Landers, *The Improbable First Century of Cosmopolitan Magazine*, Columbia, MO, 2010.
6. White, interview.
7. Ibid.
8. 'An Interview with Neville Brody', *Architectural Review*, August 1986.
9. Simon Frith and Howard Horne, *Art into Pop*, London, 1987.
10. James Truman, interview with author, May 2016.
11. Paul Rambali, interview with author, September 2016.
12. White, interview.
13. Logan, interview.
14. Chet Flippo, *The Serious Moonlight Tour*, London, 1984.
15. White, interview.
16. Robert O'Byrne, *Style City: How London Became a Fashion Capital*, London, 2009.
17. Logan, interview.
18. Truman, interview.
19. Nick Logan, interview with author, July 2012.
20. Anthony Fawcett and Jane Withers, 'Beuys' Adventures', *The Face*, August 1983.
21. Rambali, interview.
22. Quoted by Savage in *The Face*, October 1983.
23. Dick Hebdige, 'The Bottom Line on Planet One: Squaring up to *The Face*', in *Hiding in the Light: On Image and Things*, Abingdon, 1988, reproduced in Jessica Evans and Stuart Hall (eds), *Visual Culture: The Reader*, London, 1999.
24. White, interview.
25. Jean-Francois Bizot, *200 Trips from the Counterculture*, London, 2007.
26. Rambali, interview.
27. Jon Wozencroft, *The Graphic Language of Neville Brody*, London, 1988.
28. Robert Elms, 'London Fashion Week', *Evening Standard*, 6 March 1984.
29. Rambali, interview.
30. Nicholas Coleridge, *The Fashion Conspiracy: A Remarkable Journey Through the Empires of Fashion*, London, 1989.

Chapter 5

1. Paul Rambali, interview with author, September 2016.
2. Dave Rimmer, *Like Punk Never Happened*, London, 1985.
3. Nick Logan, interview with author, June 2016.
4. Ibid.
5. Robert Elms, interview with author, June 2016.
6. Nick Logan quoted in Jon Wozencroft, *The Graphic Language of Neville Brody*, London, 1988.
7. Sean Nixon, *Hard Looks: Masculinities, Spectatorship and Contemporary Consumption*, London, 1996.
8. Logan quoted in *Media Week*, 16 March 1984.
9. Logan, interview.
10. Lesley White, interview with author, June 2016.
11. Rambali, interview.
12. White, interview.
13. Logan, interview.
14. Bryony Gomez-Palacio and Armin Vit, *Graphic Design Referenced: A Visual Guide to the Language, Applications and History of Graphic Design*, New York, 2012.
15. Logan in Wozencroft, *The Graphic Language of Neville Brody*.
16. Quoted in Tony Brook and Adrian Shaughnessy (eds), *Herb Lubalin: Typographer*, London, 2016.
17. Gomez-Palacio and Vit, *Graphic Design Referenced*.

References

18 Frank Mort, *Cultures of Consumption: Commerce, Masculinities and Social Space*, London, 1996.
19 Logan, interview.
20 Phil Bicker, '*i-D*, *Jill* and *The Face*: Fashion's Maverick Magazines', *Aperture*, no. 216, 2014.
21 Nick Knight, interview with author, March 2015.
22 Ibid.
23 As reported in *Media Week*, 3 May 1985.
24 Mort, *Cultures of Consumption*.
25 Andrew Bolton, 'New Man/Old Modes', in Maria Luisa Frisa and Stefano Tonchi (eds), *Excess: Fashion and the Underground in the '80s*, Milan, 2004.
26 Robin Derrick, interview with author, August 2016.
27 Julian Morey, 'Interview with Neville Brody', *The Magazine*, 1985.
28 Derrick, interview.
29 Robert Elms, '1984: Style', *The Face*, January 1985.
30 Mhairi Graham, 'How Buffalo Shaped the Landscape of '80s Fashion', *Dazed & Confused*, 24 August 2015.
31 White, interview.
32 Tony Arefin and Alex Noble, catalogue essay, *5 Years with the Face*, exh. cat., Photographers Gallery, London, 18 April–19 May 1985.
33 Ibid.
34 White, interview.
35 Simon Frith and Howard Horne, *Art into Pop*, London, 1987.
36 Dick Hebdige, 'The Bottom Line on Planet One: Squaring up to *The Face*' [1988], reproduced in Jessica Evans and Stuart Hall (eds), *Visual Culture: The Reader*, London, 1999.
37 Frith and Horne, *Art into Pop*.
38 Elms, interview.
39 Derrick, interview.
40 Logan, interview.
41 White, interview.
42 Ibid.
43 Frith and Horne, *Art into Pop*.
44 Michael Wolff, Truman Being, *New York*, 21 June 1999.
45 James Truman, interview with author, May 2016.
46 White, interview.
47 Bolton, 'New Man/Old Modes'.
48 Derrick, interview.

Chapter 6

1 Robert Elms, interview with author, June 2016.
2 Kathryn Flett, 'Sally Brampton: The Woman Who Made "*Elle* Girls" the New Normal', *The Guardian*, 11 May 2016.
3 Lesley White, interview with author, June 2016.
4 Paul Rambali, interview with author, September 2016.
5 https://thisisnotadvertising.wordpress.com: 22 November 2012.
6 Nick Knight, interview with author, March 2015.
7 Ibid.
8 Catherine McDermott, *Street Style: British Design in the '80s*, London, 1987.
9 'An Interview with Neville Brody', *Architectural Review*, August 1986.
10 Steve Taylor, interview with author, August 2016.
11 White, interview.
12 Logan, interview with author, June 2016.
13 Rosen later found Logan the Exmouth House premises for Wagadon in Clerkenwell.
14 Sheryl Garratt and Sue Steward, *Signed Sealed and Delivered*, London, 1984.
15 Sheryl Garratt, interview with author, July 2016.
16 Robin Derrick, interview with author, August 2016.
17 Ibid.
18 This weekly pop culture magazine programme had previously been presented by Steve Taylor.
19 Emily King, 'The Art of Minimalism from Arena to Apple', 18 September 2013: creativebloq.com.
20 Simon Esterson, 'Brody Condensed: A Lesson in Typography', *The Face*, April 1988.
21 Derrick, interview.
22 Alex Seago, *Burning the Box of Beautiful Things*, Oxford, 1995.
23 Derrick, interview.

24 Elms, interview.
25 Hardy died in 1992 at the age of thirty-four.
26 James Truman, interview with author, May 2016.
27 Sarah Mower, 'Year In Review: Fashion', *The Face*, January 1987.
28 Frank Mort, *Cultures of Consumption: Commerce, Masculinities and Social Space*, London, 1996.
29 Kathryn Flett, 'Obituary: Kimberley Leston', *The Independent*, 14 February 1995.
30 Leston's friend Neil Tennant wrote the Pet Shop Boys' song 'The Survivors' about her.
31 Kathryn Flett, interview with author, May 2015.
32 Derrick, interview.
33 Daniel Alonso, 'Q&A with Creative Director Phil Bicker', 9 January 2013: https://honorabledanielsan.wordpress.com/2013/01/09/interview-with-phil-bicker/.

Chapter 7

1 James Truman, interview with author, May 2016.
2 Judah Robinson, 'Condé Nast Halts Publication of *Details* Magazine', *Huffington Post*, 18 November 2015.
3 Simon Esterson, 'Brody Condensed: A Lesson in Typography', *The Face*, April 1988.
4 Paul Jobling, 'Who's That Girl? Alex Eats: A Case Study in Abjection and Identity in Contemporary Fashion Photography', *Fashion Theory*, vol. 2, no. 3, 1998.
5 Kathryn Flett, interview with author, May 2015.
6 Lindsay Baker, interview with author, August 2016.
7 Sheryl Garratt, interview with author, July 2016.
8 Paul Gorman, *In Their Own Write: Adventures in the Music Press*, London, 2001.
9 Peter York, 'Culture as Commodity: Style Wars, Punk and Pageant', in John Thackara (ed.), *Design after Modernism: Beyond the Object*, London, 1988.
10 As quoted in *The Face*, no. 100, September 1988.
11 Garratt, interview.
12 Gorman, *In Their Own Write*.
13 Nick Logan, interview with author, June 2016.
14 Flett was subsequently stricken with ME. On recovery she returned to Wagadon as editor of *Arena*, from 1992 to 1995.
15 Garratt, interview.
16 Ian Chambers, *Border Dialogues: Journeys in Postmodernity*, Oxon, 2015.
17 Baker, interview.
18 Charlotte Cotton (ed.), *Imperfect Beauty: The Making of Contemporary Fashion*, London, 2000.
19 A reference to the fact that Glen Luchford, Craig McDean and Juergen Teller had all separately assisted Knight. Nick Knight, interview with author, March 2015.
20 Cotton, *Imperfect Beauty*.
21 Ibid.
22 Ibid.
23 Baker, interview.
24 Cotton, *Imperfect Beauty*.
25 Dylan Jones and Nick Logan, 'Ray Petri', *The Face*, October 1989.

Chapter 8

1 Ashley Heath, interview with author, August 2013.
2 Richard Benson, interview with author, April 2014.
3 Sheryl Garratt, interview with author, July 2016.
4 Charlotte Cotton (ed.), *Imperfect Beauty: The Making of Contemporary Fashion*, London, 2000.
5 Lesley White, interview with author, June 2016.
6 Lindsay Baker, interview with author, August 2016.
7 Christopher Breward and Ghislaine Wood (eds), *British Design from 1948: Innovation in the Modern Age*, London, 2012.
8 Cotton, *Imperfect Beauty*.
9 Maureen Callahan, *Champagne Supernovas: Kate Moss, Marc Jacobs, Alexander McQueen and the '90s Renegades Who Remade Fashion*, New York, 2014.

10 Garratt, interview.
11 Daniel Alonso, 'Q&A with Creative Director Phil Bicker', 9 January 2013: https://honorabledanielsan.wordpress.com/2013/01/09/interview-with-phil-bicker/.
12 Garratt, interview.
13 Callahan, *Champagne Supernovas*.
14 Cotton, *Imperfect Beauty*.
15 Alonso, 'Q&A'.
16 Garratt, interview.
17 Glenn O'Brien, *May the Circle Remain Unbroken*, London, 2014.
18 Phil Bicker, '*i-D*, *Jill* and *The Face*: Fashion's Maverick Magazines', *Aperture*, no. 216, Autumn 2014.
19 Nick Knight, interview with author, March 2015.
20 Ibid.
21 Nick Logan, interview with author, June 2016.
22 Garratt, interview.
23 Ibid.

Chapter 9

1 http://www.ppa.co.uk/events/the-marcus-morris-award/
2 *British Journal of Photography*, no. 6788, 1990.
3 Charlotte Cotton (ed.), *Imperfect Beauty: The Making of Contemporary Fashion*, London, 2000.
4 Cotton, *Imperfect Beauty*.
5 Lesley White, interview with author, June 2016.
6 Sheryl Garratt, interview with author, July 2016.
7 Lindsay Baker, interview with author, August 2016.
8 Charles Gant, interview with author, August 2013.
9 Jim White, 'Changing The "Face" of the Nineties', *The Independent*, 2 October 1995.
10 Ashley Heath, interview with author, August 2013.
11 Scott Hughes, 'CV: Ashley Heath', *The Independent*, 30 March 1997.
12 Amy Raphael, interview with author, August 2016.
13 Gant, interview.
14 Raphael, interview.
15 Richard Benson, interview with author, April 2014.
16 Garratt quoted in *Corinne Day: The Face*, exh. cat., Gimpel Fils, London, 1 September–1 October 2011.
17 Garratt, interview.

Chapter 10

1 Sheryl Garratt, interview with author, July 2016.
2 Lee Swillingham, interview with author, December 2014.
3 Garratt, interview.
4 Summerskill is director of the consortium the Criminal Justice Alliance and former head of LGBT equality lobby group Stonewall.
5 David Rolph, *Reputation, Celebrity and Defamation Law*, Abingdon, 2008.
6 Garratt, interview.
7 Charles Gant, interview with the author, August 2013.
8 Nick Logan, 'Jason Donovan and the Face', *The Face*, May 2002.
9 Lesley White, interview with author, June 2016.
10 Ashley Heath, interview with author, August 2013.
11 Amy Raphael, interview with author, August 2016.
12 Rachel Borrill, 'Jason Donovan Awarded £200,000 Damages for "Queer" Libel – The Face Magazine', *The Independent*, 4 April 1991.
13 Editor of the much-litigated British satirical and investigative fortnightly *Private Eye*.
14 Nick Logan, interview with author, June 2016.
15 Logan, 'Editorial', The Face, May 1992.
16 Garratt, interview.
17 Richard Benson, interview with author, April 2014.
18 Raphael, interview.
19 Benson, interview.
20 Garratt, interview.
21 Rolph, *Reputation, Celebrity and Defamation Law*.
22 Jason Donovan, *Between the Lines*, London, 2011.
23 Kathy Bowrey and Michael Handler (eds), *Law and Creativity in the Age of the Entertainment Franchise*, Cambridge, 2014.

24 Garratt, interview; Garratt is referring to the May 1995 issue, the second-biggest selling issue history with a circulation of 120,000.

Chapter 11

1 Sheryl Garratt, interview with author, July 2016.
2 Richard Benson, interview with author, April 2014.
3 Scott Hughes, 'Ashley Heath: CV', *The Independent*, 30 March 1997.
4 Ashley Heath, interview with author, August 2013.
5 Charles Gant, interview with author, August 2013.
6 Heath, interview.
7 Benson, interview.
8 Garratt, interview.
9 Ibid.
10 Benson, interview.
11 Heath, interview.
12 Garratt, interview.
13 Amy Raphael, interview with author, August 2016.
14 From his speech to the Conservative Group For Europe, 22 April 1993.
15 Benson, interview.
16 Eva Wiseman, 'Still Dazed at 20: The Gang Who Changed Pop Culture', *The Guardian*, 5 November 2011.
17 Charlotte Cotton (ed.), *Imperfect Beauty: The Making of Contemporary Fashion*, London, 2000.
18 Lindsay Baker, interview with author, August 2016.
19 Garratt, interview.
20 Gant, interview.
21 Amy Raphael, 'My Night with Kurt Cobain', *Esquire Weekly*, 26 April 2014.
22 Raphael, interview.
23 Heath, interview.
24 Robin Derrick, interview with author, August 2016.
25 Lee Swillingham, interview with author, December 2013.
26 Stuart Spalding, interview with author, December 2013.
27 Heath, interview.
28 Benson, interview.
29 Swillingham, interview.
30 Garratt, interview.
31 Gant, interview.
32 Nick Logan, interview with author, September 2013.
33 Cotton, *Imperfect Beauty*.
34 Swillingham, interview.
35 Benson, interview.
36 Spalding, interview.
37 Garratt, interview.
38 Nick Logan, interview with author, June 2016.
39 'Loaded: Covers from the Classic Years', *The Guardian*, 20 August 2010.
40 Benson, interview.

Chapter 12

1 Letter from Giorgio Armani to Logan, 12 January 1995.
2 Nick Logan, interview with author, June 2016.
3 Richard Benson, interview with author, April 2014.
4 Ashley Heath, interview with author, August 2013.
5 Ibid.
6 Charles Gant, interview with author, August 2013.
7 'Pretend We're Cred' was a play on the title of the L7 track 'Pretend We're Dead'.
8 Benson, interview.
9 Gant, interview.
10 Lee Swillingham, interview with author, December 2013.
11 Heath, interview.
12 Benson, interview.
13 Felix Dennis, 'The Wayward Child Who Conquered the World', *Maxim*, 18, April 2009.

14 Ibid.
15 Benson, interview.
16 Gant, interview.
17 Heath, interview.
18 Amy M. Spindler, 'Where Men's Wear Strikes A Fearless Pose', *The New York Times*, 30 April 1996.
19 Mari Clark, 'The Survival of Alternative Magazines', *Campaign*, 12 April 1996.
20 Leo Benedictus, 'Elaine Constantine's Best Shot', *The Guardian*, 24 May 2007.
21 Benson, interview.
22 Jim Davies, '200 Issues of the Face', *Campaign*, 7 February 1997.
23 Logan, interview.
24 Davies, '200 Issues of the Face'.
25 Ibid.

Chapter 13

1 'Daily Dish', Frank Magazine, part 2, 17 October 2012: bcfamily.ca/frank-part-2.
2 Lisa Markwell, 'Franks for the Memory', *The Independent*, 9 May 1999.
3 Nick Logan, interview with author, June 2016.
4 Sheryl Garratt, 'The Twenty-first Century Boy Who Never Saw the Millennium', *The Guardian*, 1 October 2000.
5 Richard Benson, interview with author, April 2014.
6 Charles Gant, interview with author, August 2013.
7 Lee Swillingham, interview with author, December 2013.
8 Benson, interview.
9 Spalding and Swillingham designed the record sleeves for the group's 1997 album *White on Blonde*, which featured photography by Juergen Teller and Elaine Constantine.
10 Benson, interview.
11 Karen Dempsey, 'Profile: A Frank Examination of the Facts', *PR Week*, 5 September 1997.
12 Logan, interview.
13 Ibid.
14 Leo Benedictus, 'Elaine Constantine's Best Shot', *The Guardian*, 24 May 2007.
15 Benson, interview.
16 Logan, interview.
17 Anna Griffiths, 'Wagadon's *Deluxe* Set for Men's Mid-Market, *Campaign*, 20 March 1998.
18 'Wagadon Axes *Deluxe* after Lacklustre Sales', *Marketing Week*, 10 December 1998.
19 Richard Benson, interview.
20 Richard Cook, 'Fall of the House of Wagadon', *The Independent*, 10 August 1998.
21 Charles Gant, interview.
22 Ibid.
23 Benson, interview.
24 Gant, interview.
25 Logan, interview.
26 Ibid.
27 Cook, 'Fall of the House of Wagadon'.
28 Ibid.
29 Swillingham, interview.
30 John Naughton, 'Face Off', *The Guardian*, 19 April 1999.
31 Ibid.
32 'Wagadon Promotes from within for New *Face* Editor', *Campaign*, 13 April 1999.
33 Naughton, 'Face Off'.

Chapter 14

1 Alicia Kennedy, Emily Banis Stoehrer and Jay Calderin, *Fashion Design, Referenced: A Visual Guide to the History, Language and Practice of Fashion*, New York, 2013.

2 John Naughton, 'Face Off', *The Guardian*, 19 April 1999.
3 Lee Swillingham, interview with author, December 2013.
4 Lou Stoppard, 'Interview: Harriet Quick', 2015: showstudio.com.
5 Richard Benson, interview with author, April 2014.
6 Nick Logan, interview with author, June 2016.
7 Stoppard, 'Interview'.
8 Lisa Markwell, 'Franks for the Memory', *The Independent*, May 1999.
9 Benson, interview.
10 Anne-Marie Crawford, 'Emap Buys *Face* Publisher Wagadon', *The Guardian*, 9 July 1999.
11 Benson, interview.
12 This experience led Benson to write the acclaimed book *The Farm: The Story of One Family and the English Countryside* (London, 2005).
13 Jemimah Bailey, 'Media: Face Names New Fashion Director', *PR Week*, 15 October 1999.

Afterword

1 Richard Benson, interview with author, April 2014.
2 Cited in Gordon MacMillan, *Campaign*, 22 March 2004.
3 Patrick Barrett, 'Emap Closes Down *The Face*', *The Guardian*, 22 March 2004.
4 Amy Raphael, interview with author, August 2016.
5 Benson, interview.
6 'Media Talk Extra: Nick Logan', *The Guardian*, 6 March 2009.
7 Cited in *InPublishing*, 17 January 2011.
8 Charles Gant, interview with author, August 2013.
9 Lindsay Baker, interview with author, August 2016.
10 Nick Knight, interview with author, March 2015.
11 Robert O'Byrne, *Style City: How London Became a Fashion Capital*, London, 2009.
12 Garratt, interview.
13 James Truman, interview with author, May 2016.
14 Jack Roberts and Daniel Stacey, 'Introduction' in Roberts and Stacey (eds), *Bad Idea: The Anthology*, London, 2008.
15 Garratt, interview.

Further Reading

Books

Arefin, Tony, and Alex Noble, catalogue essay, *5 Years with the Face*, exh. cat., Photographers Gallery, London, 18 April–19 May 1985

Bizot, Jean-Francois, *200 Trips from the Counterculture*, London, 2007

Bowrey, Kathy, and Michael Handler (eds), *Law and Creativity in the Age of the Entertainment Franchise*, Cambridge, 2014

Breward, Christopher, and Ghislaine Wood (eds) *British Design from 1948: Innovation in the Modern Age*, London, 2012

Brook, Tony, and Adrian Shaughnessy (eds) *Herb Lubalin: Typographer*, London, 2016

Burchill, Julie, *I Knew I Was Right*, Portsmouth, NH, 1998

Calderin, Jay, Emily Banis Stoehrer and Alicia Kennedy, *Fashion Design, Referenced: A Visual Guide to the History, Language and Practice of Fashion*, New York, 2013

Callaghan, James, *Time and Chance*, London, 1987

Callahan, Maureen, *Champagne Supernovas: Kate Moss, Marc Jacobs, Alexander McQueen and the '90s Renegades Who Remade Fashion*, New York, 2014

Chambers, Ian, *Border Dialogues: Journeys in Postmodernity*, Abingdon, 2015

Coleridge, Nicholas, *The Fashion Conspiracy*, Abingdon, 1988

Cotton, Charlotte (ed.), *Imperfect Beauty: The Making of Contemporary Fashion Photographs*, London, 2000

Donovan, Jason, *Between The Lines*, London, 2011

Flippo, Chet, *The Serious Moonlight Tour*, London, 1984

Frisa, Maria Luisa, and Stefano Tonchi (eds) *Excess: Fashion and the Underground in the '80s*, Milan, 2004

Frith, Simon, and Howard Horne, *Art into Pop*, London, 1987

Garratt, Sheryl, and Sue Steward *Signed Sealed and Delivered: True Life Stories of Women in Pop*, London, 1984

Gomez-Palacio, Bryony, and Armin Vit, *Graphic Design Referenced: A Visual Guide to the Language, Applications and History of Graphic Design*, New York, 2012

Gorman, Paul, *In Their Own Write: Adventures in the Music Press*, London, 2001

Hebdige, Dick, *Hiding in the Light: On Image and Things*, Abingdon, 1988

Jones, Terry, *Catching The Moment*, London, 1997

Landers, James, *The Improbable First Century of Cosmopolitan Magazine*, Columbia, MO, 2010

Logan, Nick, 'Introduction', *Lloyd Johnson: The Modern Outfitter*, exh. cat., Chelsea Space, London, 24 January–3 March 2012

McDermott, Catherine, *Street Style*, London, 1987

—, *Twentieth-century Design*, London, 1997

McRobbie, Angela, *British Fashion Design: Rag Trade or Industry?*, Abingdon, 1998

Mort, Frank, *Cultures of Consumption: Commerce, Masculinities and Social Space*, London, 1996

Nixon, Sean, *Hard Looks: Masculinities, Spectatorship and Contemporary Consumption*, London, 1996

O'Brien, Glenn, *May the Circle Remain Unbroken*, London, 2014

O'Byrne, Robert, *Style City: How London Became a Fashion Capital*, London, 2009

Parsons, Tony, *Dispatches from the Front Line of Popular Culture*, London, 1994

Poynor, Rick, *No More Rules: Graphic Design and Postmodernism*, London, 2003

Rimmer, Dave, *Like Punk Never Happened*, London, 1985

Roberts, Jack, and Daniel Stacey, *Bad Idea: The Anthology*, London, 2008

Rolph, David, *Reputation, Celebrity and Defamation Law*, Abingdon, 2008

Seago, Alex, *Burning the Box of Beautiful Things*, Oxford, 1995

Thackara, John (ed.), *Design after Modernism: Beyond the Object*, London, 1988

Wozencroft, Jon, *The Graphic Language of Neville Brody*, London, 1988

York, Peter, and Charles Jennings, *Peter York's Eighties*, London, 1995

Articles/Magazines/Online

Alonso, Daniel, 'Q&A with Creative Director Phil Bicker', 9 January 2013: honorabledanielsan.wordpress.com

Barrett, Patrick, 'Emap Closes Down *The Face*', *The Guardian*, 22 March 2004

Benedictus, Leo, 'Elaine Constantine's Best Shot', *The Guardian*, 24 May 2007

Bicker, Phil, '*i-D, Jill* and *The Face*: Fashion's Maverick Magazines', *Aperture*, no. 216, 2014

Borrill, Rachel, 'Jason Donovan Awarded £200,000 Damages for "Queer" Libel: *The Face* Magazine', *The Independent*, 4 April 1991

Callender, Cat, '*i-D* Magazine: Identity Parade', *The Independent*, 14 October 2005

Crawford, Anne-Marie, 'Emap Buys *Face* Publisher Wagadon', *The Guardian*, 9 July 1999

Cook, Richard, 'Fall of the House of Wagadon', *The Independent*, 10 August 1998

Davies, Jim, '200 Issues of *The Face*', *Campaign*, 7 February 1997

Dennis, Felix, 'Maxim, the Wayward Child Who Conquered the World', *The Week*, 18 April 2009

Farrelly, E. M., 'An Interview with Neville Brody', *Architectural Review*, August 1986

Garratt, Sheryl, 'The Twenty-first Century Boy Who Never Saw the Millennium', *The Guardian*, 1 October 2000

Graham, Mhairi, 'How Buffalo Shaped the Landscape of '80s Fashion', *Dazed & Confused*, 24 August 2015

Griffiths, Anna, 'Wagadon's *Deluxe* Set for Men's Mid-Market', *Campaign*, 20 March 1998

Hughes, Scott, 'CV: Ashley Heath', *The Independent*, 30 March 1997

Jobey, Liz, 'There's a New Kid on the Block to take on *Time Out*', *The Observer*, 27 September 1981

Jobling, Paul, 'Who's That Girl? Alex Eats: A Case Study in Abjection and Identity in Contemporary Fashion Photography', *Fashion Theory*, vol. 2, no. 3, 1998

Katz, Robin, 'Logan's Law', *Evening Standard*, 1 May 1980

King, Emily, 'The Art of Minimalism from Arena to Apple', 18 September 2013: creativebloq.com

Logan, Nick, 'Media Talk Extra', *The Guardian*, 6 March 2009

—, 'The Face's Greatest Hits in Pictures', *The Guardian*, 4 December 2011

—, 16 April 2012: testpressing.org

Markwell, Lisa, 'Franks for the Memory', *The Independent*, 9 May 1999

Morey, Julian, 'Interview with Neville Brody', *The Magazine*, 1985

Naughton, John, 'Face Off', *The Guardian*, 19 April 1999

Raphael, Amy, 'My Night with Kurt Cobain', *Esquire Weekly*, 26 April 2014

Robinson, Judah, 'Condé Nast Halts Publication of *Details* Magazine', *Huffington Post*, 18 November 2015

Russell Powell, Fiona, 'Old, Jilted And Fat: I Knew I Was Right', *Punch*, February 1998

Stoppard, Lou, 'Interview: Harriet Quick', 2015: showstudio.com

Ware, Gareth, 'It Could Only End in Tears', *DIY Magazine*, 24 February 2013

White, Jim, 'Changing The "Face" of the Nineties, *The Independent*, 2 October 1995

Wiseman, Eva, 'Still Dazed at 20: The Gang Who Changed Pop Culture', *The Guardian*, 5 November 2011

The Face Contributors: May 1980–July 1999

John Akehurst, Mark Alesky, Vaughan Allen, Annette Aurell, Lisa Anthony, Stephen Armstrong, Peter Ashworth, Joseph Astor, Enrique Badalescu, BDI, Steven Baillie, Caroline Baker, Lindsay Baker, Tom Baker, Polly Banks, Tim Barr, Denise Barricklow, Steve Beard, Malcolm Beckford, Janette Beckman, Max Bell, Boris Bencic, Richard Benson, Jessica Berens, Jonathan Bernstein, Orion Best, Andrew Bettles, Phil Bicker, Ian Birch, Judy Blame, Andreas Bleckmann, Isabella Blow, Adrian Boot, Colin Booth, Marissa Bourke, Eddie Bowen, Kim Bowen, Colin Boyle, Martin Brading, Sophie Bramly, Sally Brampton, Carrie Branovan, Julian Broad, Neville Brody, Andrew Brucker, Julian Broad, Julie Burchill, Chris Burkham, Gordon Burn, Steve Bush, Steve Callaghan, Peter Calvin, Alan Campbell, Graham Caveney, Anna Chapman, Jake Chessum, Katrina Christie, Johnny Cigarettes, Chris Clunn, Anna Cockburn, Julie Cockle, Matthew Collin, Clark Collis, Nick Compton, Elaine Constantine, Carol Cooper, Anton Corbijn, David Corio, Douglas Coupland, Stuart Cosgrove, Laura Craik, Ian Cranna, Richard Croft, Gary Crowley, Erin Culley, Peter Culshaw, Kevin Cummins, Monica Curtin, Giovanni Dadomo, Steven Daly, Dawid, Johnny Davis, Kevin Davies, Chalkie Davies, Sophie Davies, Corinne Day, Camilla Deakin, Justin de Deney, Geoff Dean, Patrick Demarchelier, Robin Derrick, Bruce Dessau, Babeth Djian, James Dimmock, Dave Dorrell, Brian Duffy, Celia Duncan, Mark Edwards, Sean Ellis, Robert Elms, Mark Ellen, Robert Erdmann, Ekow Eshun, Kodwo Eshun, Bart Everly, Dele Fadele, Anthony Fawcett, Greg Faye, Patrice Felix-Tchicaya, Kevin Fitzgerald, Marianne Fiore, Matt Fiveash, Saul, Fletcher, Tony Fletcher, Kathryn Flett, Emma Forrest, Simon Fowler, Simon Foxton, Paul Frecker, Jill Furmanovsky, Charles Gant, Kate Garner, Sheryl Garratt, Andre Giacobbe, Glen Gibson, Ryan Gilbey, Jitt Gill, Jonathan Glynn-Smith, Lynn Goldsmith, Anthony Gordon, Greg Gorman, Jean-Paul Goude, Karl Taro Greenfield, Colin Greenland, Dodi Greganti, Gareth Grundy, Tania Guha, Michael Halsband, Laura Hardy, Amanda Harlech, Keith Haring, Lee Harpin, Andrew Harrison, Patrick Harrison, Dave Haslam, Sheila Hayman, Ashley Heath, Chris Heath, David Hepworth, Jamie Hewlett, Adam Higginbotham, Dave Hill, Gavin Hills, Tom Hodgkinson, Jocelyn Bain Hogg, Mark Hooper, Adam Howe, Rupert Howe, Glyn Howells, Pierre Hurel, Mandi James, Janvier, James Jarvis, Lee Jenkins, David Johnson, Dean Johnson, Cliff Jones, Dylan Jones, Cathy Kasterine, Jason Kelvin, Nick Kent, Jeff Kerr, Rahma Khazam, Steven Klein, Nick Knight, Marek Kohn, Steve Kokker, Marcelo Krasilcic, Thomas Krygier, David LaChappelle, Inez van Lamsweerde, Mike Laye, Lulu Le Vay, Mark Lebon, William Leith, Gene Lemuel, Kimberley Leston, Mark Lewis, Stephen Linard, Peter Lindbergh, Christian Logan, Julie Logan, Nick Logan, Mitzi Lorenz, Ray Lowry, Glen Luchford, Andrew Lucre, Katy Lush, Peter Lyle, Dorian Lynskey, Ian MacDonald, Viki MacDonald, Andrew Macpherson, Don Macpherson, Kevin Maher, Andrew Male, Paul Mardles, Tim Marsh, Margit Marnul, Vie Marshall, Vinoodh Matadin, Robert Matheu, Neil Matthews, Mark Mattock, Oliver Maxwell, John May, Eammon J. McCabe, Ian McCann, Jim McClellan, Philippe McClelland, John McCready, Craig McDean, Peter McDermott, Tony McGee, Iain McKell, Joe McKenna, Steven Meisel, Metro, Jeffrey Miller, Donald Milne, Jean-Baptiste Mondino, Johnny Mono, Eddie Monsoon, Mark Moore, Caitlin Moran, Jamie Morgan, Sarah Mower, Paul Murphy, Patrick Neate, Zed Nelson, Robert Newman, Seta Niland, Neil Norman, Michael Odell, Perry Ogden, Sean O'Hagan, Cindy Palmano, Tony Parsons, Sian Pattenden, Sylvia Patterson, Deanne Pearson, Ian Penman, Ray Petri, Sean Phillips, Jacqui Pinto, Elissa Van Poznak, Derick Procope, Steve Pyke, Paul Rambali, Amy Raphael, Roz Reines, Bettina Rheims, Derek Ridgers, Dave Rimmer, Peter Robathan, Helen Roberts, Sheila Rock, Nancy Rohde, Carine Roitfeld, Cynthia Rose, Francois Rotger, Graham Rounthwaite, Mark Rusher, Fiona Russell Powell, James Ryan, Jimo Salako, Chris Salewicz, Honey Salvadori, Lou Salvatori, Vernon Samuels, Luis Sanchis, Franck Sauvaire, Miranda Sawyer, Jon Savage, John Scarisbrick, Norbert Schoerner, Nina Schultz, Danny Scott, Venetia Scott, Stéphane Sednaoui, Nigel Shafran, Beverly D'Silva, Kate Simon, David Sims, Paul Slattery, Julie Sleaford, Alison Smith, Andrew Smith, Graham Smith, Jo-Anne Smith, Monty Smith, Pennie Smith, Sandra Sodano, Rod Sopp, Mario Sorrenti, Stuart Spalding, John Spinks, Steve Speller, Neil Spencer, Kate Spicer, Bob Stanley, Carol Starr, Christopher Stocks, John Stoddart, Andy Stout, Matthew Stradling, Jay Strongman, Kevin Sutcliffe, Mike Sutcliffe, Adam Sutherland, Pat Sweeney, David Swindells, Ian Swift, Lee Swillington, Chris Taggart, Steve Taylor, Juergen Teller, Julien Temple, Karl Templer, Mario Testino, Joanna Thaw, Adrian Thrills, David Thomas, Shazzy Thomas, Phil Thornton, Paul Tickell, Craig Tilford, Marcus Tomlinson, David Toop, Vaughn Toulouse, James Truman, Virginia Turbett, Steve Tynan, Ellen von Unwerth, Albert Watson, Norman Watson, Pierre Winther, Max Vadukul, Richard Varnden, Jeff Veitch, Tony Viramontes, Peter Joanne Wain, Walsh, Melanie Ward, William Ward, Emma Warren, Bruce Weber, Irvine Welsh, Alex White, Lesley White, Jane Withers, John Williams, Michael Wooley, Kelly Worts, Ian Wright, Steven D. Wright, Lucie Young, Firooz Zahedi, Patrick Zerbib.

Acknowledgments

First and foremost, thanks are due to Nick Logan, an inspiration to generations. Give that man a knighthood.

Thanks also to Maxwell Logan, for enabling access to The Face archive, to Dylan Jones for his foreword, and

to my agent Maggie Hanbury and Jamie Camplin, who breathed life into this project, as well as Sophy Thompson and her team at Thames & Hudson, in particular Blanche Craig, Therese Vandling, Paul Hammond, Johanna Neurath, Natalie Kontarsky, and Sam Ruston, and to Heather Vickers for her help in regard to the illustrations.

I am grateful to the following for their memories, insights and assistance: Sonia Adamczak; Peter Ashworth; Susie Babchick; Lindsay Baker; Carrie Branovan; Janette Beckman; Richard Benson; Adrian Boot; Elaine Constantine; Anton Corbijn; Kevin Cummins; Juliette David; Dawid Björn Dawidsson; Chalkie Davies; Robin Derrick; Kayte Ellis; Sean Ellis; Robert Elms; Mika Ebbesen; Robert Erdmann; Kathryn Flett; Paul Frecker; Jill Furmanovsky; Charles Gant; Sheryl Garratt; Andrea Giacobbe; Lukas Gimpel; Jonathan Glynn-Smith; Jean-Paul Goude; Ashley Heath; Jocelyn Bain Hogg; Anne Kennedy; Steven Klein; Charlotte Knight; Nick Knight; Inez van Lamsweerde; Mike Laye; Mark Lebon; Jeremy Leslie; Glen Luchford; Vinoodh Matadin; Candice Marks; Margit Marnul; Mark Mattock; John May; EJ McCabe; Craig McDean; Niall McInerney; Felix Mondino; Jean-Baptiste Mondino; Jamie Morgan; Julian Morey; Jen O'Farrell; Perry Ogden; Harriet Poland; Paul Rambali; Amy Raphael; Derek Ridgers; Sheila Rock; Cybele Sandy; Vicky Saperstein; Norbert Schoerner; Stéphane Sednaoui; Nigel Shafran; Graham Smith; Pennie Smith; Mario Sorrenti; Stuart Spalding; Gregory Spencer; John Stoddart; Mark Szazy; Lee Swillingham; Steve Taylor; Juergen Teller; Mario Testino; Virginia Turbett; Ellen von Unwerth; Aaron Watson; Albert Watson; Norman Watson; Harriet Whitaker; Lesley White; Leon Wong.

Photo Acknowledgments

Illustrations, unless otherwise stated, are copyright of Nick Logan/The Face Archive. The work of the following photographers is included in the magazine layouts reproduced from the archive:

a = above, b = below, l = left, r = right, c = centre

Mark Alesky 339; Peter Ashworth 81r, 96–97; Enrique Badalescu 172a; Janette Beckman 48; Adrian Boot 74–75; Martin Brading 113; Carrie Branovan 158–59, 160–61; Peter Calvin 249; Donald Christie 258–59; Elaine Constantine 222–23, 293l, 326–29, 330–31, 336–37; Anton Corbijn 36–37, 195; David Corio 115a; Richard Croft 224–25; Kevin Cummins 86–87; Chalkie Davies 25; Kevin Davies 163b, 170–71, 200–201; Estate of Corrine Day 197, 199, 260–63, 204–7, 216–17, 220–21; Patrick Demarchelier 276–77; Justin de Deney 324–25; Brian Duffy 44; Sean Ellis 316, 323r; Robert Erdmann 117l; Patrice Felix-Tchicaya 243; Simon Fowler 81l; Jill Furmanovsky 32–33, 63, 66a, 79b, 80; Kate Garner 240–41; Andrea Giacobbe 278–79; Jonathan Glynn-Smith 213; Lynn Goldsmith 41; Greg Gorman 116; Anthony Gordon 167, 169; Jean-Paul Goude 71a, 76–77, 134a; Bob Gruen 94–95; Michael Halsband 84, 95; Patrick Harrison 194, 202–3; Jocelyn Bain Hogg 244–45; Pierre Hurel 134b; Inez & Vinoodh 252, 256; Ivan Jones, author photo on jacket; Jeff Katz 198a; Andy Kent 52–53; Trevor Key 48, 237; Nick Knight 115b, 135, 139, 141, 148–51, 154–55, 320, 332–33; Thomas Krygier 231; David LaChappelle 287r, 290, 304–5, 316; Mark Lebon 174–75, 196; Mark Lewis 163a; Mitzi Lorenz 243; Glen Luchford 248r, 270–71; Andrew Macpherson 138, 143, 152–53, 212l; Margit Marnul 88; Robert Matheu 142; Mark Mattock 61; EJ McCabe 156–57; Tony McGee 82, 83; Steven Meisel 109, 212r; Donald Milne 293r, 319; Jean-Baptiste Mondino 191, 195, 209, 238, 248r, 288, 291, 292l, 322r; Eddie Monsoon 198b; Jamie Morgan 101, 104, 106, 107l, 118–19, 122, 124–31, 136, 146–47; Steve Pyke 89; Derek Ridgers 15b, 50–51, 79a, 91, 112; Peter Robatham 292r, 280–81, 302–5, 311, 317; Sheila Rock 2–3, 34–35, 40, 47, 61, 66b, 67, 71b, 72–73, 90, 102, 114; Francois Rotger 308–9; Mark Rusher 62; Luis Sanchis 314l, 323l; Norbert Schoerner 274–75; Stéphane Sednaoui 165, 166a, 172b, 178–79, 188–89, 211, 287; Nigel Shafran 186–87; David Sims 267–69, 318l; Graham Smith 65; Pennie Smith 28–31, 58–59; Matthew Stradling 237; John Stoddart 140; Juergen Teller 192, 215, 226–27, 251l, 272–73, 314r; Mario Testino 294, 298–99, 306–7; Virginia Turbett 42, 49; Ellen von Unwerth 240, 251r; Tony Viramontes 133, 144; Albert Watson 254–55; Norman Watson 264–66, 285, 300–301. We have endeavoured to provide accurate credits. The author (and publisher) apologize for any omissions or errors which we will be happy to correct in future printings and editions of this book.

Index

Index

Index